Delacroix

The Late Work

Delacroix

The Late Work

Arlette Sérullaz

Vincent Pomarède

Joseph J. Rishel

Lee Johnson

Louis-Antoine Prat

David Liot

Thames and Hudson

Philadelphia Museum of Art

This book is dedicated to the memory of Maurice Sérullaz.

In Philadelphia, the exhibition was supported in part by Elf Atochem North America, Inc.

Additional support has been provided by The Pew Charitable Trusts, the Robert Montgomery Scott Endowment for Exhibitions, the National Endowment for the Arts, the Greater Philadelphia Tourism Marketing Corporation, and an indemnity from the Federal Council on the Arts and the Humanities. US Airways is the airline sponsor. NBC 10 WCAU is the broadcast media sponsor. The Philadelphia Inquirer and the Daily News are the print media sponsors.

Published on the occasion of the exhibition *Delacroix: The Late Work*

Galeries Nationales du Grand Palais, Paris
April 7–July 20, 1998

Philadelphia Museum of Art
September 15, 1998–January 3, 1999

First published in the United States of America in hardcover in 1998 by Thames and Hudson Inc., 500 Fifth Avenue, New York, New York 10110

First published in Great Britain in 1998 by Thames and Hudson Ltd, London

Produced by the Publications Department of the Philadelphia Museum of Art
George H. Marcus, Head of Publications

Editor: Jane Watkins

Editorial assistance: Juliana Keyser, Mary Christian, Ellyn Allison, and P. M. Gordon Associates
Translators: Jill Corner, Lory Frankel, John Goodman, Donald McGrath, Donald Pistolesi, Robert Sandler, and Judith Terry

Production: Matthew Pimm, assisted by William Rudolph
Coordination of French edition: Céline Julhiet-Charvet
Design: Cécile Neuville

Color separations: Professional Graphics, Inc., Rockford, Illinois
Printed and bound by Arnoldo Mondadori Editore, S. p. A., Verona, Italy

Library of Congress Catalog Card Number 98-60336
ISBN 0-500-09275-3

British Library Cataloguing-in-Publication data
A catalogue record for this book is available from the British Library

Printed and bound in Italy

Contents

Lenders to the Exhibition

To all the individuals and institutions who generously cooperated in the realization of this exhibition, we express our gratitude, especially to

E. G. Bührle Foundation, Zurich
Eric G. Carlson
Dr. Peter Nathan, Zurich
Prat Collection, Paris
Manuel and Robert Schmit
Waterhouse Collection

and all those who prefer to remain anonymous.

We thank those individuals in the following institutions who made this exhibition possible:

AUSTRIA
Vienna, Graphische Sammlung Albertina

BRAZIL
São Paulo, Museu de Arte de São Paulo Assis Chateaubriand

CANADA
Fredericton, New Brunswick, Beaverbrook Art Gallery
Ottawa, National Gallery of Canada
Toronto, Art Gallery of Ontario

DENMARK
Copenhagen, Ordrupgaard

FRANCE
Amiens, Musée de Picardie
Arras, Musée des Beaux-Arts
Besançon, Musée des Beaux-Arts et d'Archéologie
Bordeaux, Musée des Beaux-Arts
Dijon, Musée des Beaux-Arts
Lyon, Musée des Beaux-Arts
Metz, La Cour d'Or, Musées de Metz
Montauban, Musée Ingres
Montpellier, Musée Fabre
Paris, Musée Eugène Delacroix
 Musée du Louvre, Département des Arts Graphiques
 and Département des Peintures
 Musée d'Orsay
 Musée du Petit Palais
Reims, Musée des Beaux-Arts

GERMANY
Bremen, Kunsthalle Bremen
Frankfurt, Städelsches Kunstmuseum
Hamburg, Hamburger Kunsthalle
Karlsruhe, Staatliche Kunsthalle
Stuttgart, Staatsgalerie

GREAT BRITAIN
Birmingham, The Trustees of The Barber Institute of Fine Arts,
 The University of Birmingham
Cambridge, The Syndics of the Fitzwilliam Museum
London, The National Gallery

GREECE
Athens, Pinacothèque Nationale, Musée Alexandre Soutzos

HUNGARY
Budapest, Szépmüvészeti Múzeum

IRELAND
Dublin, The National Gallery of Ireland

JAPAN
Tokyo, The National Museum of Western Art

THE NETHERLANDS
Amsterdam, Rijksmuseum
Rotterdam, Museum Boymans–van Beuningen

ROMANIA
Bucharest, Muzeul Naţional de Artă al României

RUSSIA
St. Petersburg, The State Hermitage Museum

SWEDEN
Stockholm, Nationalmuseum

SWITZERLAND
Bern, Musée des Beaux-Arts

UNITED STATES OF AMERICA
Baltimore, The Baltimore Museum of Art
 The Walters Art Gallery
Boston, Museum of Fine Arts
Brooklyn, Brooklyn Museum of Art
Chicago, The Art Institute of Chicago
Fort Worth, Kimbell Art Museum
Hartford, Wadsworth Atheneum
Kansas City, The Nelson-Atkins Museum of Art
Minneapolis, The Minneapolis Institute of Arts
New York, The Metropolitan Museum of Art
 The Pierpont Morgan Library
Norfolk, The Chrysler Museum of Art
Philadelphia, Philadelphia Museum of Art
Phoenix, Phoenix Art Museum
Portland, Portland Art Museum
Princeton, The Art Museum, Princeton University
Providence, Museum of Art, Rhode Island School of Design
Richmond, Virginia Museum of Fine Arts
St. Louis, The Saint Louis Art Museum
Toledo, The Toledo Museum of Art
Washington, D.C., The Corcoran Gallery of Art
 National Gallery of Art
 The Phillips Collection

Acknowledgments

The organizers of the exhibition would like to thank, in particular, Christine André, Marielle Dupont, and Pauline Pons for their indispensable daily help and kindness. We extend the same gratitude to Catherine Chagneau, Alain Madeleine-Perdrillat, and Céline Julhiet-Charvet, without whose attentive, rigorous, and affectionate support the organization of the exhibition and the publication of this catalogue would have been impossible.

To Françoise Dios, who proofread the texts of this book, and to Cécile Neuville, the designer, we extend our gratitude.

As always, this exhibition benefited from the support and continuous goodwill of Pierre Rosenberg, Irène Bizot, Françoise Viatte, and Jean-Pierre Cuzin.

The work of the organizers has clearly been enriched by the catalogue raisonné and published works of Lee Johnson. In addition to his participation in this project, he was of invaluable help in locating certain missing works. We express to him our most sincere and profound thanks.

Likewise, the research on Delacroix and Morocco conducted for many years by Maurice Arama has once again been tremendously beneficial.

In the Department of Graphic Arts at the Louvre, we must thank everyone, particularly Bruno Alet, Dominique Boizot, Valérie Corvino, Patrick Cyrille, Régine Dupichaud, Anne Giroux, Clarina Guillou, Alain Le Bas, Catherine Legrand, André Le Prat, Norbert Pradel, Richard Renia, Jean-François Sainssard, Philippe Sirop, and the entire secretarial staff, as well as Brigitte Donon and Michèle Gardon.

In the Department of Paintings, thanks, above all, should go to Mathieu Bard, Sylvain Laveissière, Stéphane Loire, Philippe Lorentz, Brigitte Lot, Olivier Meslay, Marie-Catherine Sahut, Renzo Sarti, and, in particular, Aline François, Nathalie Texier, Anne de Wallens, and the secretarial staff, as well as Jacques Foucart.

The Conservation Department, led by France Dijoud and Nathalie Volle, showed its professionalism in the presentation, restoration, and transportation of specific works for this exhibition, and also contributed important research into Delacroix's technique. All our thanks go as well to Marguerite Alain-Launay, Claire Bergeaud, Anne Bouin, Jacqueline Bret, Brigitte Crespelle, Catherine Haviland, Nathalie Houdelin, Annick Lautraite, Christiane Naffah, and, in particular for their help in obtaining loans, to David Cueco and Regina Moreira. One must single out David Liot, whose passion for the technique of Delacroix is evidenced both by his essay in this catalogue, and by his continuous participation in the preparation for this exhibition.

In the research laboratory of the Musées de France, directed by Jean-Pierre Mohen, we thank above all Élisabeth Ravaud and Anne Roquebert, who especially immersed themselves in the study of Delacroix, and also Bénédicte Chantelard, Élisabeth Martin, Jean-Paul Rioux, and the whole team from the Painting Department, as well as the branch of radiography and photography at Versailles.

At the Musée Delacroix, we worked in collaboration with Catherine Adam and Marie-Christine Mégevand.

Working at the Grand Palais is always an agreeable occasion; we wish to thank the entire staff of that establishment, led by David Guillet, and all those who facilitated the public reception, installation of the works, and their security. This daily work, lasting for the duration of the Paris exhibition, is the best guarantee of its success.

Finally, we wish to thank the following people: Élisabeth Belarbi, Michèle Bellot, Dana Bercea, Gilles Berizzi, Thierry Bodin, Béatrice de Boisséson, Bénédicte Boissonas, Jean-Paul Boulanger, Claude Bouret, France de Charentenay, René Citroën, Karen

Cohen, Sylvie Columbo, Annie Delot, Annick Doutriaux, Annick Dubosc, Frédéric Dumont, Anne-Birgitte Fonsmark, Rosella Froissard-Pezzone, Jean-Luc Gall, Donald Garland, Martine Guichard, Nicholas Hall, Natascha Hanscomb, Mr. and Mrs. Neison Harris, Sybille Heftler, Christoph Heillmann, Catherine Hély, Caroline Imbert, Caroline Larroche, Isabelle Le Masne de Chermont, Rufus and Patricia Lumry, Ian G. Lumsden, Annie Madec, Isabelle Mancarella, Anne de Margerie, Jane Munro, Jean Naudin, Jill Newhouse, Marie-Dominique Nobécourt, Michael Pantazzi, Marie Pessiot, Laurence Posselle, Hélène Prigent, Gilles Romillat, Brigitte Scart, Mrs. Eve Scharf, David Scrase, Serge Sordoillet, Regina Weinberg, Anne-Elisabeth Wisniewsky, and, above all, Luis Hossaka, Michel Laclotte, Luis Marques, Julios Neves, Beatriz Pimenta Camargo, Eneida Pereira, Margaret Stuffman, and Maaro Viera, who participated in the acquisition of several essential loans.

In addition to those listed above, in Philadelphia we are particularly indebted to Stephen Gritt for teaching us so much about the making of these pictures and the evolution of Delacroix's materials and techniques; he, in turn, would like to thank Irene Konefal in the Conservation Department of the Museum of Fine Arts, Boston. We are also indebted to Alexander Apsis of Sotheby's for his assistance with our indemnity application. We would like to add to this our gratitude to Jane Watkins for her close attention to the English edition of this catalogue; Irene Taurins and Elie-Anne Chevrier for managing logistical problems of the transatlantic shipment; Mari Jones for her efforts to fund the project; and Lauren Chang and Jennifer Vanim of the European Painting Department of the Philadelphia Museum of Art. The person on whom the success of the American showing of this exhibition most clearly depends, through her skills at organization and research, is Kathy Sachs.

Preface

Thirty-five years after the celebrated Eugène Delacroix retrospective organized at the Musée du Louvre by the late Maurice Sérullaz on the occasion of the centenary of the painter's death, it seems appropriate to revisit an oeuvre that occupies a unique and essential place in the history of French art. Although the fame of Delacroix's work derives largely from the fact that it so wonderfully expresses, in the domain of painting, French Romanticism—like the oeuvre of Berlioz in the domain of music—it seemed exciting, at this time, to show that his body of work cannot be reduced to that role, and that it carries within it singular intimations of the future.

Thus the exhibition offers a panorama focusing on the final thirteen years of Delacroix's career, which reveals simultaneously the persistence of certain themes and memories—notably those of his trip to Morocco, an inexhaustible source of inspiration—and the emergence of, to use Charles Baudelaire's term, new "postulations." One senses here a great painter's spiritual crisis but also a more direct relation with nature that anticipates the Impressionist revolution—to which one must add a freer technique that emphasizes the use of color as a means of expression, and that, as is well known, greatly influenced such masters as Cézanne, Renoir, Seurat, and Matisse.

We must thank the French organizers, Arlette Sérullaz and Vincent Pomarède, as well as their American colleague at the Philadelphia Museum of Art, Joseph J. Rishel, who enthusiastically signed on to the project, for having initiated such an exhibition, one that will deepen our knowledge of Delacroix and make his modernity more apparent and appreciated.

Françoise Cachin
Director of the Musées de France
President of the Réunion des Musées
Nationaux

Anne d'Harnoncourt
The George D. Widener Director of the
Philadelphia Museum of Art

Introduction

Eugène Delacroix, the bicentennial of whose birth is being celebrated this year, in 1998, died on August 13, 1863, in his apartment at 6, rue de Furstenberg, in Paris. It was a discreet death that had relatively little public impact, for the artist had devoted his monastic final years almost exclusively to work. Of course, a small group of friends and connoisseurs were deeply affected by his death, but for the official French art world, Delacroix remained a respectable but controversial painter whose greatest merit seemed, perhaps, to have reconciled the world of the Second Empire with the taste for large-scale decorative painting.

The unexpected success of the posthumous sale of all the paintings, drawings, and engravings remaining in the artist's studio, held at the Hôtel Drouot from February 17 to 29, 1864, rekindled the debate. Those who had shown varying degrees of hostility when Delacroix exhibited his works publicly, and others who were reluctant to acknowledge him as a superlative painter and draftsman, were no doubt astounded to see, from the auction's opening day, the throngs of people who flocked as spectators or potential buyers to what had been anticipated as little more than a society event. As Théophile Silvestre reported at the time, mingling with the painter's friends were "a crowd of artists, dealers, and agents, from Paris, the provinces, and abroad," as well as a number of critics, each armed with a "freshly sharpened pencil with which to note down the price of each object included in this memorable sale." He stated: "Everyone sensed that here was a master whose name and work would live on."

A short while later, eager to convince the diehards and skeptics once and for all, the Société Nationale des Beaux-Arts held a retrospective exhibition in its galleries on the boulevard des Italiens, Paris, simultaneously commissioning a bronze bust of Delacroix from Albert-Ernest Carrier-Belleuse. Marred only by "a few wounded vanities," "a few hatreds stronger than death," and "a few examples of parochial pettiness," this exhibition—which opened on August 13, 1864—was, in the opinion of its organizers, "splendid." The critic d'Arpentigny had no qualms about ending his preface to the catalogue with the following words: "There is no longer any need to do him justice; justice has long since been done; there remains nothing now but to crown a genius who existed for the greater glory of French painting."

The first biographies devoted to Delacroix, generally highly acclamatory, nevertheless illustrated the degree to which opinions remained divided. "Eventually, the truth will always triumph over certain blind hostilities," wrote Amédée Cantaloube in 1864. And in the same year, Ernest Chesneau mused: "Has Eugène Delacroix's hour of justice finally come? Will the hand that marked the time of his death also mark the time of his repose? Will the storm surrounding his name abate? . . . Will the serene peace of eternal glory envelop his memory, or will his name remain perpetually the subject of fruitless argument, sure to disturb the final rest of a body worn by the inner flame, emaciated by the daily struggle, sapped by the fever of lengthy meditations, scourged by the profound tempests of thought, by the ceaseless study of the passion of which he was this era's greatest interpreter?"

Passion. The word first employed by Baudelaire and considered by the poet to capture the very essence of Delacroix's inspiration, has since been, and will ever be, at the heart of any discussion focusing on either the man or the artist. Every one of the major events held to commemorate the various phases of the artist's life and career has stressed this unique feature of his character and practice, but without truly clarifying his role and place within the history of French painting.

In 1885 a huge retrospective of Delacroix's work, aimed at raising the funds to erect a monument to the artist, was held at the École Nationale des Beaux-Arts. Auguste

Vacquerie saw the event as a vindication: "The one-time outcast, the revolutionary, the Salon reject is taking the École by storm and triumphantly entering the citadel of tradition." The following year, however, Maurice Tourneux offered a different view: "Is this supposed to mean that Delacroix has now become popular? He is not and will never be." One of the goals of the mammoth 1930 exhibition at the Musée du Louvre devoted entirely to the work of Eugène Delacroix, and timed to coincide with the centennial of Romanticism, was to resoundingly refute this categorical statement. Eight-hundred-and-sixty paintings, drawings, and prints—not to mention a host of mementos and assorted documents—were assembled in an effort to vanquish what Paul Jamot termed the "indifference" of the public. In his preface to the catalogue, Jamot sounded firmly convinced that the bringing together of so many masterpieces would "overcome any remaining resistance to the compelling prestige of this genius" and remove the mystery surrounding "this great and solitary man among men."

Finally, in 1963—the one hundredth anniversary of Delacroix's death—an exhibition was held in the Salon Carré and the Grande Galerie of the Louvre, which, although it included fewer works (164 paintings and 369 drawings from public and private collections across the world), was no less ambitious, for it was accompanied by an extraordinarily comprehensive monographic catalogue that summarized the state of Delacroix research to date. During the same period, other commemorative events were held in Paris and in Bordeaux, as well as in Germany, Switzerland, England, Canada, and the United States. A lively international rivalry then ensued, resulting in major publications of all kinds—including Lee Johnson's catalogue raisonné of the painted work—as well as new exhibitions both in France and abroad.

Apart from the commemoration of the artist's bicentennial, what is the justification for mounting a new exhibition devoted to the work of Eugène Delacroix in 1998? Hasn't everything worth saying about this multifaceted artist already been said? Hasn't his work been thoroughly catalogued and studied? Haven't the controversies of the nineteenth century been finally laid to rest? Our initial response to these questions is to emphasize the special nature of a project that aims to discover—or rediscover—the essence of the artist's work through an examination of the paintings and drawings executed during the latter part of his life. Regardless of the lingering controversy, this was a time when, having achieved a certain critical and commercial recognition—a phenomenon whose importance should not be underestimated—the artist was looking back upon his life and his artistic accomplishments.

In fact, to trace Delacroix's work from 1850 to 1863 is to encounter all the main features of an oeuvre that certainly had its beginnings during the Romantic era, but that never turned its back on a thoroughly classical training. We are conscious of the great temptation to confine Delacroix's daring and innovative investigations within an exclusively Romantic context, ignoring the numerous references—iconographical, technical, and aesthetic—to the painting of the Old Masters. The public has become familiar with the early paintings, which some see as veritable manifestos of the Romantic movement, and many specialists have concentrated their studies on Delacroix's youthful works more than the powerful creations of his mature years. However, while there may be a need to redress the balance of aesthetic influence and focus, it would, in our view, be just as excessive and misleading to adopt the diametrically opposite position and to define Delacroix as a purely "classical" painter.

Must we, today, opt firmly for one position or the other? Or should we not rather strive to show how Delacroix was actually aiming to achieve a synthesis of historical and

modern art? "Delacroix has his own secret," observed Jean Cassou, but "he guards it jealously for his painting." He attained undeniable fame, but he did so "at the cost of daily labor." "[Glory] is attained through a creator's gradual recognition of his value and his difference, his deep-seated awareness of the originality of his message." In his final years, Delacroix, driven by an urgent desire to link the past to the present, reflected constantly on his creative approach; and the works that he chose to show at the Exposition Universelle of 1855, from *The Barque of Dante*, first exhibited at the Salon of 1822, to the *Lion Hunt* (cat. 14), specially commissioned for the occasion, illustrate the permanence of his inspirational sources and their rejuvenation between 1850 and 1863.

It is the analysis of this characteristic dualism that has served as the conceptual basis of this exhibition. The organizational approach adopted for both the exhibition and the book has been deliberately thematic, favoring a comparison of Delacroix's subjects rather than their chronological ordering (a general chronology of the artist's life and work has been provided on pages 16 to 25). Our intent is that this approach will clarify the distinction between the subjects that appeared or were developed during the final years of the artist's career—images of wild animals and hunts, landscapes and flowers, and religious scenes—from those that accompanied in a more linear way the artistic development begun in 1820, with the paintings focusing on literature and the theater, Oriental scenes, and allegorical and mythological subjects. It is also our hope that this new view of the repetitions and variants executed between 1850 and 1863 of pictures from his youth will encourage the rediscovery of Delacroix's work as a whole, while drawing a more definite link between the legacy he inherited from the Renaissance masters and from classicism, the aesthetic obsessions of his era, and his extraordinary individual creativity.

Visitors may regret the deliberate decision to focus only briefly on Delacroix's major decorative projects (in a didactic section of the exhibition and in two of the catalogue entries, cats. 64 and 65). However, apart from the fact that these large compositions—by their very nature untransportable—are concentrated in Paris and accessible there, we wished to stress that this decorative component of the artist's oeuvre, initiated in 1833 with the Salon du Roi of the Palais Bourbon, can be considered to have culminated in 1854 with the unveiling of the decoration for the Salon de la Paix of the Paris Hôtel de Ville. The aesthetic preoccupations manifested in the compositions for the chapel of the Saints-Anges in the church of Saint-Sulpice were more closely linked to Delacroix's private work than to the major public commissions of the Palais Bourbon, the Palais du Luxembourg, or the Louvre. Moreover, the religious content of the Saint-Sulpice wall paintings clearly relates them to the spiritual issues being explored in the easel painting of the period.

During his final years, for reasons both aesthetic and practical—his health was deteriorating steadily—Delacroix's creative energy seems to have been focused on easel painting, executed variously for commercial ends, for public exhibition, or as part of his personal artistic quest. This realization reinforced our conviction that only those drawings, watercolors, and pastels judged to be of intrinsic iconographical or aesthetic value should be selected to hang alongside the oil paintings, and that preparatory studies should be deliberately eliminated in favor of works in which Delacroix's technique is fully apparent. The works on paper have therefore been presented to illustrate, like the oils, the various themes explored in the exhibition: wild animals and hunts, landscapes and flowers, allegorical or mythological nudes, and religious scenes. The two preparatory studies for major decorative projects from this period—the ceiling of the Galerie d'Apollon in the Louvre (see cat. 64) and the central panel of the Salon de la Paix in the

Hôtel de Ville (see cat. 65)—were chosen for the same reason, because their chromatic and expressive power lends them the impact of autonomous works. For conservation reasons, transport of the study for the Louvre ceiling ultimately proved impossible. Similar considerations prevented the loan of *Clorinda Rescues Olindo and Sofronia*, the important painting owned by the Neue Pinakothek in Munich, and legal conditions imposed by the donors precluded presentation of paintings from the Wallace Collection in London and the Musée Condé in Chantilly. On the other hand, research undertaken for this exhibition has led to the rediscovery and presentation of several important pictures belonging to private collections; and viewers will also be able to admire a handful of key works by Delacroix that have rarely, if ever, been seen, notably *The Four Seasons* series now in the Museu de Arte de São Paulo, unfinished paintings that represent the artist's final tribute to Baroque painting.

In light of these thematic choices and the intentional concentration on the latter part of the artist's career, we believe that the exhibition will facilitate understanding and appreciation of the rigor and fundamental unity of Eugène Delacroix's work as a whole. In fact, the quest for unity was for him an ongoing preoccupation. On November 20, 1857, he wrote in his *Journal:* "It is this feeling of unity and the power to realize it in one's work that make a great writer or a great artist." These words should remind us that Romanticism and classicism, drawing and oil painting, decorative works and easel paintings, personal inspiration and commercial or social imperatives were merely complementary aspects of a single aesthetic vision. The great painter is indeed he who succeeds in reconciling opposites and transcending constraints.

Arlette Sérullaz, Vincent Pomarède, and *Joseph J. Rishel*

NOTE TO THE READER

Provenance, Bibliography, and Exhibition History for works in the catalogue are found on pages 352 to 383.

Citations of books, articles, and exhibitions are given in abbreviated form in the notes. For full citations, see the List of Sources Cited and the List of Exhibitions Cited on pages 395 to 399.

The dimensions of the works are given in inches and centimeters, with the height preceding the width.

The source used for the journals of Eugène Delacroix is the edition published by Plon (Paris) in 1996; those quotations from the Plon edition (*Eugène Delacroix: Journal, 1822–1863*) that have been newly translated from the French for this book are cited in abbreviated form as *Journal,* followed by the date and page number of the entry. Two English editions of selections from the artist's journals, a 1951 edition translated by Lucy Norton and a 1937 edition translated by Walter Pach, were consulted. Those quotations that are cited as Norton, 1951, have been published in English in *The Journal of Eugène Delacroix: A Selection,* edited with an introduction by Hubert Wellington, translated by Lucy Norton (London: Phaidon, 1951). Those quotations from the journals cited as Pach, 1937, are published in English in *The Journal of Eugène Delacroix,* translated by Walter Pach (New York: Friede, 1937).

Catalogue entries were written by:

Vincent Pomarède *(V. P.)*
Arlette Sérullaz *(A. S.)*
Louis-Antoine Prat *(L.-A. P.)*

CHRONOLOGY

Arlette Sérullaz

1798

April 26 (7 Floréal, year VI, by the calendar year of the first French Republic). Ferdinand-Victor-Eugène Delacroix is born in Charenton-Saint-Maurice (fig. 1). He is the fourth child of Charles Delacroix (1741–1805; fig. 2), ambassador plenipotentiary to the Netherlands, and Victoire Oeben (1758–1814; fig. 3), daughter of the renowned cabinetmaker to Louis XV. Their other children are Charles-Henry (1779–1845; fig. 4), who retired with the rank of general and the title of baron de l'Empire after Napoleon's defeat; Henriette (1780–1827; fig. 5), who married Raymond de Verninac (1762–1822), "former ambassador of the Republic to the Porte" (Turkey); and Henri (1784–1807), who was killed at the battle of Friedland.

1800

April 10. The family moves to Marseille, where Charles Delacroix has been named Prefect.

1803

April. The family moves to Bordeaux, where Charles Delacroix serves as Prefect until his death on November 4, 1805.

1806

January. The family moves back to Paris, living at 50, rue de Grenelle.
October. Delacroix attends the Lycée Impérial (now the Lycée Louis-le-Grand).

1813

August–September. Delacroix takes a vacation in Valmont, staying with his cousin Nicolas-Auguste Bataille, owner of the former Benedictine abbey (fig. 6).

1814

September 3. Delacroix's mother dies, leaving her children in a highly precarious financial situation resulting from their father's poor investments. He lives with his sister at 114, rue de l'Université.

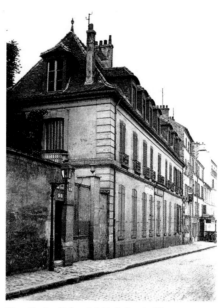

Fig. 1. Eugène Delacroix's birthplace in Charenton-Saint-Maurice. Photograph by H. Roger-Viollet, Paris.

1815

October. Studies under Pierre-Narcisse Guérin (1774–1833) at the artist's studio. Enrolls at the École des Beaux-Arts the following year.

1819

Receives his first commission, *The Virgin of the Harvest* (p. 30 fig. 1), for the church at Orcemont, near Rambouillet.

1820

April. Moves to 22, rue de la Planche (now rue de Varenne).
July. Théodore Géricault, whom Delacroix knew at Guérin's studio, asks the artist to replace him in executing a commission to decorate the cathedral of Nantes for the comte de Forbin, director of the Musées Nationaux. The painting, *The Triumph of Religion*, is in the cathedral of Ajaccio today.
Late August–early September. Takes a brief trip to Le Louroux, near Montbazon, Indre-et-Loire, where his brother General

Charles-Henry Delacroix owns a small house that had previously been the village presbytery.

1821

Summer. Delacroix paints *The Four Seasons* for the dining room of the actor François-Joseph Talma, rue de la Tour-des-Dames, in Montmartre.

1822

April 23. Death of Delacroix's brother-in-law, Raymond de Verninac.
April 24. *The Barque of Dante* (Musée du Louvre, Paris), Delacroix's first painting exhibited at the Paris Salon, receives mixed reviews. Nevertheless, it is purchased by the government for 2,000 francs.
September 3. On vacation at Le Louroux, Delacroix begins writing his *Journal:* "My keenest wish is to remember that I am writing only for myself; this will keep me truthful, I hope, and it will do me good" (*Journal* [Norton, 1951, p. 1]).

He continues to write in the *Journal* until 1824, then resumes in 1847, continuing for the rest of his life.

1823

Lives at 118, rue de Grenelle.
November 23. Sale of the Boixe property near Mansle, in Charente, where Delacroix had spent several summers. At this time Delacroix and his sister are in dire financial straits.

1824

The comte de Chabrol commissions the artist to paint *The Agony in the Garden* for the city of Paris. After exhibition at the 1827–28 Salon, it is installed in a side chapel of the church of Saint-Paul-Saint-Louis, where it is still hanging.
August 25. Delacroix exhibits four paintings at the Salon, including *The Massacre at Chios* (Musée du Louvre, Paris).
October. Moves to 20, rue Jacob, the Parisian address of the English painter Thales Fielding, who returns to England.

1825
Moves into a new studio at 14, rue d'Assas.
May 19–late August. Travels to England. On his return to France, Delacroix lives with his friend Jean-Baptiste Pierret at 46, rue de l'Université.

1827
April 6. Death of Delacroix's sister, Henriette de Verninac.
November 4. Nine Delacroix paintings are exhibited at the Salon, which continues until early the following year.

1828
Moves to 15, rue de Choiseul, and rents a studio at 9, passage Saulnier.
January 14. Adds three paintings, including *The Death of Sardanapalus* (Musée du Louvre, Paris), to the nine already on exhibit at the Salon. Publishes seventeen lithographs illustrating *Faust*, by Goethe, with the author's portrait on the frontispiece.
Late October. Visits his brother General Charles-Henry Delacroix in Tours.

1829
Late January. Moves to 15, quai Voltaire, where he uses an available studio.
May. His essay "Des Critiques en matière d'art" is published in the *Revue de Paris*.
Mid-October. Second trip to Valmont.

1830
February 25. *The Murder of the Bishop of Liège* is exhibited at the Royal Academy in London.
Spring–Summer. His essays on Raphael and Michelangelo are published in the *Revue de Paris*.
October. *Young Tiger Playing with Its Mother* (p. 32 fig. 5) is among the works ex-hibited at the Palais du Luxembourg, with the proceeds going to victims of the July Revolution.

1831
Accepted into the Légion d'honneur.
March 1. Expresses his views on competitions in an extensive letter published in *L'Artiste*.
April 14. Eight paintings and three drawings are shown at the Paris Salon, including *Liberty Leading the People* (Musée du Louvre, Paris).
September. Third trip to Valmont.

1832
Late January–July. Accompanies the diplomatic mission to Spain and North Africa headed by the comte de Mornay.

1833
March 1. Exhibits four oil paintings and four watercolors at the Salon.
August 31. Commissioned to decorate the Salon du Roi at the Palais Bourbon. He finishes this project in December 1837.

1834
March 1. Sends five paintings to the Salon, including *Women of Algiers in Their Apartment* (Musée du Louvre, Paris).
July. Delacroix is deeply saddened to learn that his nephew Charles de Verninac has died of yellow fever in New York.
September 7–October 10. He attempts three frescoes—*Bacchus*, *Leda and the Swan*, and *Anacreon* (Musée Delacroix, Paris)—at the home of his uncle Alexandre-Marie Bataille in Valmont.

1835
March 1. Exhibits five paintings at the Salon.

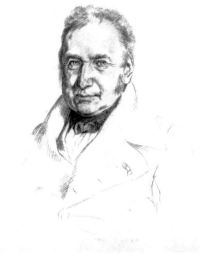

Fig. 4. EUGÈNE DELACROIX, *Portrait of General Charles-Henry Delacroix*, graphite on paper, Paris, Musée Delacroix.

October. Moves to 17, rue des Marais-Saint-Germain (now rue Visconti), where he occupies three studios on the fourth floor of a small lodging. Jenny Le Guillou (1801–1869), recommended by Jean-Baptiste Pierret, becomes Delacroix's housekeeper, and remains with him until his death.

1836
Saint Sebastian is his only painting at the Salon. It is purchased by the French government and sent to Nantua (church of Saint-Michel).

1837
February 4. First—unsuccessful—candidacy for election to the Institut de France, to fill the seat left vacant by François Gérard.
March 1. Only one of Delcaroix's paintings, *The Battle of Taillebourg*, is exhibited at the Salon. It was commissioned for the Galeries Historiques de Versailles, which were inaugurated in June. The work is still housed there.

1838
February. Second rejection by the Institut, where he was a candidate for Jean-Charles Thévenin's chair.
March 1. Delacroix exhibits five paintings, including *Medea About to Kill Her Children* (Musée des Beaux-Arts, Lille).
August. Commissioned to decorate the Palais Bourbon library, work he completes in December 1847. The public is invited to view the Salon du Roi in October and November.

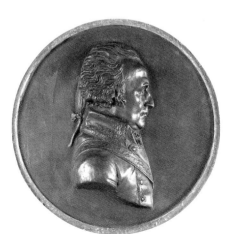

Fig. 2. JOSEPH CHINARD, *Portrait of Charles Delacroix,* plaster, Paris, Musée Delacroix.

Fig. 3. JOSEPH CHINARD, *Portrait of Victoire Delacroix*, plaster, Paris, Musée Delacroix.

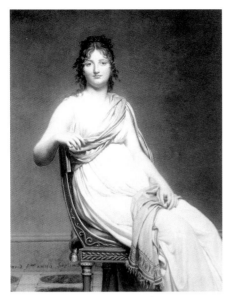

Fig. 5. Jacques-Louis David, *Portrait of Henriette de Verninac*, oil on canvas, Paris, Musée du Louvre.

September. Fourth trip to Valmont.
November. Sets up a studio on the rue Neuve-Guillemin to train his assistants for the Palais Bourbon project.

1839
February. Third unsuccessful candidacy for admission to the Institut, this time for Jérome-Martin Langlois's chair.
March 1. Two of his paintings are exhibited at the Salon.
September. Travels to Belgium and Holland.

1840
March 5. *The Justice of Trajan* (Musée des Beaux-Arts, Rouen) is his only painting exhibited at the Salon.
June 4. The comte de Rambuteau, Prefect of the Seine, offers Delacroix a commission refused by Robert-Fleury, to decorate the chapel of the Virgin at the church of Saint-Denis-du-Saint-Sacrement. After considering an *Annunciation* (Musée Delacroix, Paris), the artist decides on a *Lamentation* (cat. 124 fig. 1), which he completes in the spring of 1844 with the assistance of Philippe Lassalle-Bordes. The work is still housed there.
September. Delacroix is commissioned to decorate the Palais du Luxembourg library. He completes the work in December 1846.

1841
March 15. *Entry of the Crusaders into Constantinople* (cat. 88), *The Shipwreck of Don Juan*, and *Jewish Wedding in Morocco* (Musée du Louvre, Paris) are shown at the Salon.

1842
June. First trip to Nohant, where he visits George Sand (Amandine Aurore Lucie Dupin). At the author's house, Delacroix renews contact with Frédéric Chopin, whom he first met in 1836.

1843
Delacroix publishes a series of thirteen lithographs based on Shakespeare's *Hamlet*. He also completes a series of seven lithographs on the theme of *Goetz von Berlichingen* by Goethe.
July. Second trip to Nohant.

1844
June. Rents a small house in Champrosay (fig. 7), near Fontainebleau, owned by a Monsieur Rabier.
October. Moves to 54, rue Notre-Dame-de-Lorette (fig. 8). The rent is 600 francs per year, as indicated in a document signed by the concierge handling the rental: "I, the undersigned, declare to have rented an apartment on the second floor in the front, for the price of six hundred francs per year, to Monsieur Delacroix. I am bound by the present agreement to have the small apartment ready for occupancy by the 15th of this month f. robillard" (Archives Piron, Archives des Musées Nationaux, Paris).

1845
March 15. Four Delacroix paintings, including *The Sultan of Morocco and His Entourage* (Musée des Augustins, Toulouse), are exhibited at the Salon.
July 22–late August. On the advice of his doctor, Delacroix goes for treatment at Eaux-Bonnes, a small, highly regarded spa in the Pyrenees. He writes to his cousin Léon Riesener: "The natural landscape is very beautiful here. There are mountains wherever you turn, and the visual effect is magnificent. What surprised me the most, even more than their beauty, is the indifference with which everyone looks at them, including the artists, such as [Camille Joseph Étienne] Roqueplan and [Paul] Huet, both of whom I found here. . . . Spas are all the rage right now, so it's quite difficult to find a place to stay" (*Correspondance*, vol. 2, pp. 221–22).

On his return, Delacroix finds a letter, dated July 14, from his cousin Pierre-Antoine Berryer, a lawyer with royalist convictions, who has just fought a case against Adolphe Thiers to defend the principle of freedom of religious assembly: "Dear Cousin, We see each other so seldom, and to my great regret, my life has been swept up in a whirlwind of affairs, which prevents me from keeping in touch as often as I would like. However, I can't allow myself to lose touch with a relative who kindles such fond memories in me and who has always treated me so decently" (Archives, Musée Delacroix, Paris).

Delacroix answers on September 3: "Dear Cousin, I have come back from Eaux-Bonnes, where I stayed for two months to try to put an end to an infernal indisposition that for more than four years has forced me into total seclusion. Work is my only consolation. So I can't begin to tell you how truly pleased I am that you decided to get in touch with me, and how sorry I am for the unintentional delay in answering."
Late December. Alarmed by the news that his brother General Charles-Henry Delacroix is ill, the artist hurriedly leaves for Bordeaux, but Charles-Henry is already dead by the time he arrives.

1846
January 2. General Delacroix's funeral. The artist, who is the sole heir, stays in

Fig. 6. Exterior view of the abbey of Valmont.

Fig. 7. Delacroix's house in Champrosay.

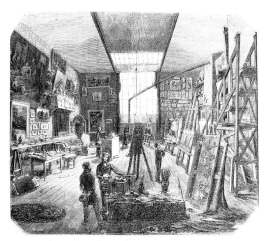

Fig. 8. Delacroix's studio on the rue Notre-Dame-de-Lorette (from *L'Illustration*, 1852).

Bordeaux until late January to settle his brother's affairs and to look after the repair of his father's headstone at the large Chartreuse cemetery.

March 16. Delacroix exhibits three oil paintings and one watercolor at the Salon.

July 5. He is made an officer in the Légion d'honneur.

August. Third trip to Nohant.

September. Fifth trip to Valmont.

November 1. Publication of his article on Pierre-Paul Prud'hon in the *Revue des Deux Mondes.*

1847

January 19. Resumes writing in his *Journal* and continues to do so for the rest of his life.

March 16. Six Delacroix paintings are presented at the Salon, including *Christ on the Cross* (cat. 120), done the previous year.

1848

January 9. Having completed the decoration of the Palais Bourbon library in December 1847, Delacroix sends the *Constitutionnel* a detailed description of the paintings ornamenting the two half domes and five cupolas of the library.

March 15. Six Delacroix paintings are exhibited at the Salon, including *The Lamentation* (cat. 125), begun in February 1847 and purchased the same year by Théodore de Geloës.

September 1. His article on Antoine-Jean Gros is published in the *Revue des Deux Mondes.*

1849

March 22. Goes to the church of Saint-Sulpice to study the architecture of the chapel that he may decorate. The original assignment is to decorate the transept near

the chapel that will house the baptismal fonts; then the commission evolves to include the chapel itself.

April 28. The order for the work at Saint-Sulpice is signed, and the artist is officially notified on May 21.

June 15. Five Delacroix paintings are shown at the Salon, including *A Basket of Flowers Overturned in a Park* (cat. 29).

September 1. Victor Baltard informs Delacroix that the chapel he is to decorate has been dedicated to Saint Sulpice, patron saint of the parish: "The parish priest had forgotten this when you spoke with him about it. He has just given me this information, as well as a biographical note covering the main events in the life of Saint Sulpice. The chapel housing the baptismal fonts already exists, at one end of the large hall on this side of the church. The fonts were only temporarily in the first chapel on the right. I am deeply sorry for the annoyance. I thought that I should inform you as soon as I found out what had happened, realizing that the sooner you knew, the less advanced you would be in your work" (Archives Piron, Musée Delacroix, Paris).

October 2. The chapel is given a different dedication, becoming the chapel of the Saints-Anges. The priest of Saint-Sulpice indicated this in a letter of September 24 to Delacroix, who was in Champrosay at the time. The priest wrote that "a place [can] be found later for the two patron saints, Saint Peter and Saint Sulpice" (Archives Piron, Musée Delacroix, Paris). The work is not completed until 1861 (see fig. 12).

October. Sixth trip to Valmont.

December. Fourth unsuccessful candidacy for election to the Institut, to fill the seat left vacant by Étienne Garnier. In the same month, Delacroix withdraws his fifth candidacy, for François Granet's chair.

1850

March 8. Commissioned to paint the central ceiling of the Galerie d'Apollon at the Musée du Louvre, which he finishes in 1851 (fig. 9).

July 6–August 14. Travels to Ems for a cure, stopping in Brussels, Antwerp, and Cologne. On the return trip, he makes stopovers in Malines and again in Antwerp. From Ems, he writes to Charles Soulier on August 3: "Neither you nor Villot can begin to imagine what Rubens is about. In Paris you don't have anything one can really call a masterpiece. I hadn't seen the ones in Brussels, which were hidden away when I first visited Belgium. There are still some I haven't seen yet. Just accept, my fine friend Crillon [a play on a remark by Henry IV to Louis de Crillon], that you don't know Rubens, and believe in my love for this madman. You only have sanitized Rubenses, with their souls encased in a sheath. . . . Don't you find that I've recaptured my youth? It isn't the spa—it's Rubens who has worked this miracle" (Johnson, 1991, p. 114).

September 15. *Revue des Deux Mondes* publishes his article on the teaching of drawing, inspired by the method of his student and friend Élisabeth Boulanger Cavé.

December 30. Opening of the Salon, which continues until March 31, 1851. Five of Delacroix's paintings are exhibited, including *The Raising of Lazarus* (Offentliche Kunstsammlung, Basel) and *The Good Samaritan* (cat. 109).

1851

Sixth unsuccessful candidacy for election to the Institut. Drölling's chair is filled instead by Jean Alaux, whose restorations at Fontainebleau Delacroix found deplorable.

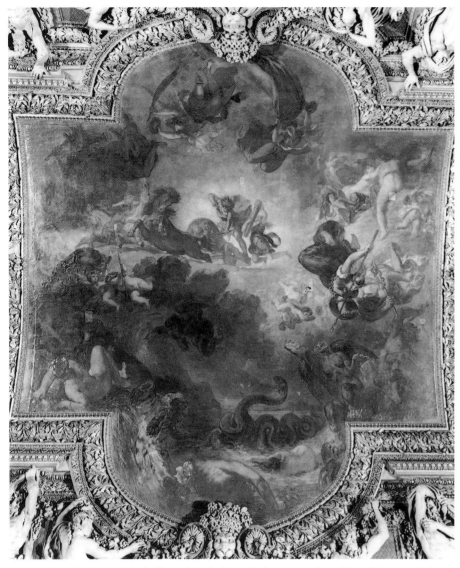

Fig. 9. Eugène Delacroix, *Apollo Vanquishing the Serpent Python*, 1850–51, Paris, Musée du Louvre, Galerie d'Apollon.

Late August. Delacroix travels to Dieppe, staying until September 12. He returns three times over the next several years.

December. Commissioned to decorate the Salon de la Paix at the Hôtel de Ville. He finishes the project in 1854. All of the works are destroyed by fire in 1871.

He is elected a Paris city counselor.

1853

May 15. Three Delacroix paintings are shown at the Salon, including *Disciples and Holy Women Carrying Away the Body of Saint Stephen* (cat. 111), which is acquired by the city of Arras in 1859, and *The Supper at Emmaus* (cat. 112), sold by the artist to the miniaturist Madame Herbelin in April.

May–June. Trip to Champrosay.

June 26–30. *Moniteur universel* publishes Delacroix's article on Nicolas Poussin.

July. Seventh failed attempt to be elected to the Institut. Joseph Blondel's seat is filled instead by Hippolyte Flandrin.

October 16–29. Returns to Champrosay.

December 7. Sends the Prefect of the Seine his resignation as a member of the Académie des Beaux-Arts.

1854

February 15. Delacroix thanks the president of the Royal Academy of the Fine Arts in Amsterdam for having accepted him as a member.

July 15. His essay "Questions sur le Beau" is published in the *Revue des Deux Mondes*.

August 17–September 26. Second trip to Dieppe.

October 23–November 7. Travels to Augerville-la-Rivière, to visit his cousin Pierre-Antoine Berryer.

1855

Delacroix is involved in preparing for the Exposition Universelle. He makes a great effort to assemble as many paintings as possible, in order to show not only recent works but also older pieces that he deems essential. The artist approaches collectors and friends who own certain of his paintings, as well as government officials, who can lend works purchased by the State.

March 2. Delacroix writes to Pierre-Antoine Berryer, asking his cousin to help him find the piece he painted for the duchesse de Berry, *The Battle of Poitiers* (Musée du Louvre, Paris): "This painting was sold after 1830, with the royal family's other paintings and their private furniture. It was purchased by the marquis or comte d'Osembray, who I believe was a high-ranking officer in the bodyguards. I'd like to show this work if possible. It was never seen at the retrospective on the Champs-Élysées as promised." Thanks to Berryer's intervention, d'Osembray finally agrees to temporarily part with the work: "I cannot turn down any request from a man like you, so he can send for it whenever he wishes, preferably as late as possible" (Archives, Musée Delacroix, Paris).

April 14. Delacroix instructs Étienne-François Haro on the work to be done on the paintings he intends to exhibit at the Exposition Universelle: "Aside from transporting the paintings, it is very important to remove the varnish from *Justinian*. When you come for the paintings, don't forget to take the sketch of the *Convention*. It is not on the list and I would love to show it. I have the *Barricade*. I don't know if there's anything to do on it, as I haven't seen it" (Dossier Haro, Archives des Musées Nationaux, Paris).

May 15. Opening of the Exposition Universelle at the new Palais des Beaux-Arts on the avenue Montaigne. The exhibition is a triumph for Delacroix, with thirty-six of the artist's paintings presented in a gallery devoted to his work (fig. 10). *Lion Hunt* (cat. 14) is among the new pieces.

Summer. From July to October, he does much traveling, particularly to visit family members, with whom he has attempted to form closer ties since his brother's death. The artist visits Berryer in Augerville-la-Rivière from July 12 to 18. He returns to Paris, and then spends several days in Champrosay. On September 10 he travels to Croze (between Brive and Souillac in Creuse), going by way of Argenton and Limoges. He arrives on September 12 and

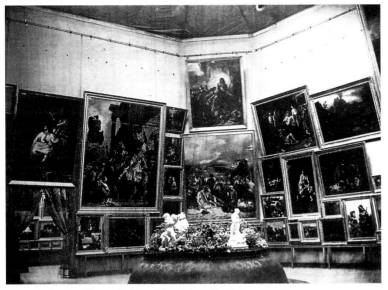

Fig. 10. Delacroix gallery at the Exposition Universelle of 1855.

visits the Verninacs, relatives of his sister Henriette, who own a chateau there. Delacroix returns to Paris on the 17th, and leaves for Strasbourg on the 18th to visit his cousins the Lameys. The morning of September 25, on the advice of his cousins, he leaves for Baden-Baden, where he goes on several excursions. He returns to Strasbourg on the evening of the 28th, continuing to take his walks around the city. On October 2 he departs for Paris, but meets Jenny Le Guillou the next day at Dieppe, where he stays until October 14. Relentless despite his fatigue and the inclement weather, he resumes his walks along the seashore.

November 15. Made commander of the Légion d'honneur following the Exposition Universelle.

November 17. Berryer immediately congratulates him: "Dear and illustrious Cousin, I congratulate you, with enough joy to match the satisfaction you must be feeling, on both the Grande Médaille and the Croix de Commandeur. But I regret the fine days that have been taken away from me on account of these honors you have been awarded. Your glory lies entirely in the exhibition of your works, and from the bottom of my heart, I am delighted at the impact that this exhibition has had, allowing you to triumph over both the ill will of jealous souls and faulty judgment stemming from ignorance. Although I'm thankful for this timely appeal to the European public, whose approval has led to your winning these awards, I still don't forgive these vain ceremonies for causing you to leave me in too great a hurry" (Archives, Musée Delacroix, Paris).

1856

Resumes his work on the chapel of the Saints-Anges, assisted by Pierre Andrieu and Louis Boulangé.

May 17–26. Travels to Champrosay, and takes another trip there from June 28 to July 8.

October 1. Leaves for Ante, near Sainte-Menehould in the Meuse, to visit his first cousin Philogène Delacroix. He stays several days, spending his time drawing, hunting, and fishing.

October 8. Goes to Givry-en-Argonne, the birthplace of Delacroix's father: "This place, which I knew only from the stories of all whom I have loved, has rekindled their memory once more, and tender emotions with it. I saw the paternal house as it is, but, as I suppose, without many changes. My grandmother's tombstone is still standing at the corner of the cemetery, which is to be expropriated, just like everything else" (*Journal* [see Pach, 1937, p. 518]).

November. Eighth unsuccessful candidacy for election to the Institut, to fill the seat left vacant by Paul Delaroche. Delacroix's poor health prevents him from making the customary visits to members of the Academy.

1857

January 10. Delacroix is elected to the Institut. On January 12, Constant Dutilleux is one of the first to congratulate him: "The Institut has finally changed its mind. You have been admitted and are held in highest esteem. Redress is late in coming but it has come at last. . . . This event, since it is indeed an event, shows the slow but steady progress being made in our era. I think back to the

very beginning of your career when you were almost universally condemned. And now the gates of the Institut have been opened to you—by its members, admittedly, but members who were influenced by the weight of *public opinion*, which, whether one likes it or not, everyone gives in to, in the final analysis. Your friends have good reason to be delighted at this news" (Archives Piron, Fondation Custodia, Paris).

Three days before, Berryer had advised him that the vote would be in his favor this time: "I went to the academy and I'm returning there tomorrow. The election will definitely take place on Saturday, and I'm quite pleased that among your detractors, only M. Lehmann will oppose your candidacy. There's no chance that you'll be defeated in a choice between two rivals. Since this is a battle between great talent and large-scale intrigue, your fame is not at stake here. I know that M. Robert-Fleury is making every effort to ensure that justice is done; and Mme Czartoryska seemed to share my feelings" (Archives, Musée Delacroix, Paris).

January 11. Delacroix answers his cousin: "It could not have gone better; *16* votes in the first ballot, and *22* in the *second* and final ballot. So now I'm your colleague, which makes me twice as happy. As for my health, I really can't say another word on account of the comrades who brought me the news, for whom I have to hold firm" (Archives, Musée Delacroix, Paris).

January 14. Delacroix writes to François de Verninac, nephew of his brother-in-law, Raymond de Verninac: "Basically, though late in coming, this election is useful, and now that it has taken place, seems more relevant than I had previously imagined: judging by the congratulations I've been receiving, I see that certain members of the public consider it practically a precondition to granting me a certain status. The worth of the man didn't change at all, but it seems that a stamp of approval was also required" (Johnson, 1991, pp. 27–28).

Prevented by serious health problems from sending any work to the Salon, Delacroix increasingly considers moving in order to be closer to Saint-Sulpice, where he is making little progress with his work. His dealer, Haro, finds him a flat at 6, rue de Furstenberg, but must use all his powers of persuasion to convince the artist to make up his mind. After lengthy discus-

sions with the building manager, Monsieur Hurel, and the owners, Haro sends Delacroix this detailed report: "Since you are allowing me to give you my opinion on this matter, . . . what is most important is that they are willing to accept 3,000 francs, which is excellent. Once your studio has been built and the repairs done, . . . you will have:

1. a complete second-floor apartment
2. a garden, a rare thing in Paris
3. a fully equipped studio
4. a suitable place to put all your things, a storage room, etc.
5. and, the best part, the enjoyment of excellent accommodations, worthy of your position.

All of this for 2,900 francs in principal plus 300 francs in interest, totaling 3,200. You couldn't find this for 5,000 anywhere else and in a neighborhood so close to the Institut" (Archives Piron, Archives des Musées Nationaux, Paris).

May–June. Delacroix is in Champrosay to regain his strength, but his health does not improve substantially.

June 28. Writes to Jules Laroche, an architect living in Corbeil, near Champrosay, asking him to visit the flat on the rue de Furstenberg and examine the work to be done (Johnson, 1991, p. 73).

June 30. Delacroix learns that the Academy of Fine Arts in Rio de Janeiro has elected him as a corresponding member.

July 15. Publication of his article "Des variations du Beau" in the *Revue des Deux Mondes.*

July 21. Summoned for jury duty at the Assize Court in the first two weeks of August, Delacroix writes to the presiding judge to inform him that his "continuous suffering" over the past six months forces him to ask for an exemption (Johnson, 1991, p. 145). The same day, he pays Hurel the sum of 1,518.85 francs "for a deposit amounting to six months of rent, to cover the final six months of residence at the premises he will occupy in the house located at 6, rue Furstenberg" (Archives Piron, Archives des Musées Nationaux, Paris). At the same time, he negotiates, with some difficulty, the terms for vacating the apartment on the rue Notre-Dame-de-Lorette. He postpones his trip to Strasbourg until late July. From there, he goes to Plombières, where Jenny Le

Guillou rejoins him. Back in Paris, he must closely supervise the renovations on his new apartment. The contract has been given to the architect Laroche, who is also responsible for relations with the landlords. The latter are extremely concerned about the construction of a studio in the garden and in a letter of April 7 demanded detailed plans and a guarantee "that all additions, improvements, or beautifications that may be done, . . . and in particular the building herein mentioned, remain the property of the lessors at the end of the lease with no compensation owing" (Archives Piron, Archives des Musées Nationaux, Paris). Given the major investment incurred, Delacroix asks Hurel to begin renovating the walls facing the courtyard and garden (*Correspondance*, vol. 4, pp. 413–14).

August 10–30. Goes to Plombières for a cure.

October 6–19. Short visit at Berryer's home in Augerville-la-Rivière.

December 28. Moves into the flat on the rue de Furstenberg (fig. 11).

1858

July 11–early August. Delacroix returns to Plombières. The emperor is there as well. "I'm feeling better now," the artist writes to Berryer on July 23: "It's entertaining— in a foolish sort of way, I admit—living in the public eye as one does while taking on the waters, and meeting all sorts of people. The entertainment and activity—such a change from my regular life—are giving me back my energy and strength. . . . The presence of the head of state, as he's called, poses no disturbance to life here. Actually, he's the only one who gets disturbed, when he lets his guard down too much. . . . We met by accident and he did me the honor of asking how I was doing" (Archives, Musée Delacroix, Paris).

August 15. Delacroix buys the house in Champrosay. In a letter of September 6 he explains to his cousin Berryer the reasons behind this decision: "The man who was renting me my little pied-à-terre told me off the cuff that he was going to sell the house and that I would soon have to decide what to do. So my life's been disturbed, though not terribly so. But this is home: for fifteen years I've been coming to this region, seeing the same people, the same woods, the same hills. What would you have done in my

place, dear cousin, you who have walled yourself up in the same apartment for the past fifty years, out of fear of having to find another one? Probably what I did. In other words, I bought the house. It wasn't expensive, and with a few minor changes in addition to the purchase price, it will provide me with a small refuge in keeping with my humble fortune" (Archives, Musée Delacroix, Paris).

Early October. Having read in the newspapers that Delacroix has finished the chapel of the Saints-Anges, Berryer is concerned that the artist has not informed him of this. On October 4 Delacroix answers: "What kind of villainous journalists, on what basis I can't imagine, would say that I'm about to unveil a work that under the best of circumstances couldn't be finished in a year? This has earned me more than my share of trouble. Last year they said I had died, which caused a certain to-do among the champagne set and those who were no doubt interested in my estate. One day, they'll say that you have carried off the sultan's favorite wife and your friends will be surprised they haven't been invited to the wedding. So that's the flaming torch, the fruit of the Revolution that they call the press. And the serial stories don't compensate me for the inaccuracy of the news reports" (Archives, Musée Delacroix, Paris).

Late October. Delacroix is invited to Compiègne.

November–December. The artist returns to Champrosay. On November 16 he writes to Berryer, "I've spent six weeks doing all kinds of odd jobs including planting. *No building yet!* But I've planted, laid sod, leveled, and through it all I've worked a great deal, much more than I could have in Paris" (Archives, Musée Delacroix, Paris).

1859

April 15. For the last time, his paintings are exhibited at the Salon. Eight works are presented, including *The Road to Calvary* (cat. 128) and *The Entombment* (cat. 127).

August. Visits Strasbourg, then Ante.

October. Returns to Champrosay, then travels to Augerville.

November. Goes back to Champrosay.

December. Works on the Saint-Sulpice project.

Fig. 11. Delacroix's studio at 6, rue de Furstenberg.

1860

Early in the year, Delacroix becomes too ill to leave his room.

February 15. He writes to the comte de Nieuwerkerke, director-general of the Musée du Louvre, concerning the restoration of his painting *The Barque of Dante* (*Correspondance*, vol. 4, p. 151). Over the course of the same month, Delacroix sends sixteen paintings dating from different periods in his career to an exhibition organized by Francis Petit at the Galerie Martinet, 26, boulevard des Italiens. The works are borrowed from various collectors. Among the religious subjects are *Christ on the Cross* (cat. 123) and *The Supper at Emmaus* (cat. 112). Seven paintings are added later.

May. Trip to Champrosay.

July 18–27. Final trip to Dieppe. Delacroix stays at the Hôtel Victoria, located on the harbor, but the cold and rain prevent him from drawing on the pier.

September. Returning from Champrosay, Delacroix resumes his work at Saint-Sulpice, after a period of inactivity.

October 14. He writes to Berryer: "Dear Cousin, I promised that I would keep you up to date on the heroic resolution that I made, and have kept until now, to rise every morning at 5:30 to take the first train to Saint-Sulpice, where I work for a few hours, and then return here for an early, quiet dinner, to go to bed at eight o'clock and then start all over again the next day. This is how my life has been for a month now, and it has succeeded beyond my wildest hopes. Not only do I dare entertain the hope of finishing or almost finishing my large project, which I've left uncompleted for such a long time, but my health is totally restored. I've found a remedy that doctors perhaps are just as familiar with as I am, but which they don't recommend to anyone for fear of lowering the value of their of own services. Not only am I being forced to exercise, rather than simply taking a walk with no purpose other than the walk itself, but I don't have a single quiet or boring moment, which is also a great recipe for health—at least mine. During all of these excursions, I am intoxicated with my interest and passion for work, and the trips themselves, which are not very long, are more enjoyable than they are tiring" (*Correspondance*, vol. 4, pp. 203–4).

1861

In the first few months of the year, Delacroix concentrates all his efforts on completing his work at Saint-Sulpice. He writes to Berryer on January 15: "I rise at daybreak and I don't bother about my beard. Finishing requires an iron-clad will. I have to make decisions about everything, and I'm encountering difficulties that I truly didn't expect. To keep this up, I go to bed early and do nothing out of the ordinary. The only thing that allows me to keep up my resolution to deprive myself of all pleasures, and primarily the pleasure of meeting with those I love, is the hope of completing my work. I think that it will be the death of me. It's at times like this that you become aware of your own frailty, and the extent to which a work that man considers finished or complete continues to have aspects that are incomplete and impossible to complete" (*Correspondance*, vol. 4, p. 230).

He carefully prepares his presentation, then summons his friends, admirers, journalists, and officials.

February 28. Writes to Dutilleux that he accepts the invitation to be an honorary member of the Société des Amis des Arts in Arras. They name him honorary president.

July 29. Invites Berryer to come and view his work. Berryer, held up by numerous court cases, does not arrive until August 13, when he writes to Delacroix: "Dear Cousin, I have seen it! I have seen it! Seen as much of it as my untrained eyes could see. I am delighted. I send you my love, but I'm leaving tonight. I'll write you about my trips. I expect you to come and see me before you go and see *anyone else*" (Archives, Musée Delacroix, Paris).

August 21. The chapel of the Saints-Anges at Saint-Sulpice (fig. 12) is opened to the public, receiving both praise and criticism according to most accounts. The works are photographed, but with poor results. The painter, staying in Champrosay until the beginning of September, is extremely disappointed at the indifference shown by officials. On September 1, he writes to his cousin Léon Riesener: "I received neither a visit from the minister, nor from the prefect, nor from Nieuwerkerke, nor from anyone from the court or any qualified person, despite my invitations. As for the crowd from the Institut, few of them came" (*Correspondance*, vol. 4, pp. 269–70).

September 2–14. Trip to Augerville.

September 15–late November. Stays in Champrosay and takes only brief trips to Paris.

November. Resigns from his duties as city counselor: "The impossible situation in which I have found myself for a long time, of having to reconcile my private work and frequent trips away from Paris, with the absolute precision which these important offices demand, has led me to make a decision, not without deep regret for the fine relationships I have established with members of the council" (Archives Piron, Archives de la Ville de Paris).

December. *The Death of Sardanapalus* (Musée du Louvre, Paris) is exhibited at the Galerie Martinet until late January 1862.

1862

Exhausted after completing the chapel of the Saints-Anges, Delacroix is content to finish several paintings that he has already started. *The Murder of the Bishop of Liège* is displayed at the International Exhibition in London.

June. Travels to Champrosay, where he stays until November, taking one short trip in September to Ante. From there he writes to the secretary of the Académie des Beaux-Arts to express his opposition to dividing up the Campana collection. He then takes a short visit to Augerville in October.

July 1. His article on Nicolas Charlet is published in the *Revue des Deux Mondes*.

November 20. Delacroix returns to Paris.

1863

During the first few months of the year, Delacroix, despite his dread of the cold, makes appearances at dinners and official evening functions. In the spring, his health

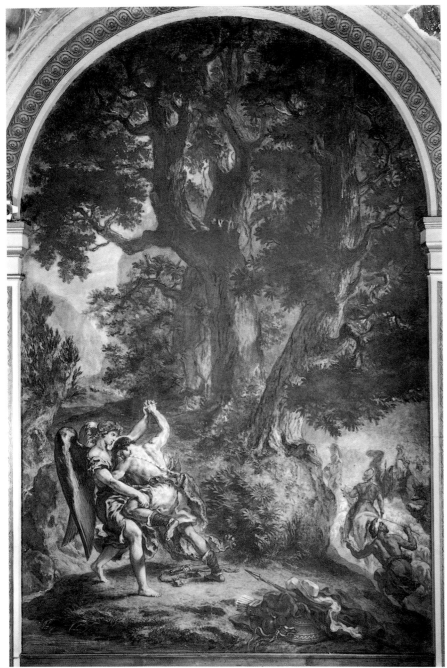

Fig. 12. EUGÈNE DELACROIX, *Jacob Wrestling with the Angel*, 1861, Paris, church of Saint-Sulpice.

what kinds of plans I can make just now. I was supposed to go to a spa, but couldn't get into the coach" (Archives, Musée Delacroix, Paris).

Early August. Returns to Paris, so weak that he can no longer hold a pen.

August 3. Dictates his will. Delacroix's sole heir is his old friend Achille Piron, former postal service director, who is charged with carrying out his last wishes, particularly with regard to distributing the works in his studio.

August 6. Jenny Le Guillou takes down a short note dictated by Delacroix, which he then signs. The message is for Berryer: "My dear Cousin, I'm so weak that I can no longer write, but on the other hand, all my illnesses have disappeared. I now hope that patience is all I'll need. I won't go into details. I send you my love" (Archives, Musée Delacroix, Paris).

August 13. The artist dies at 7:00 A.M., with Jenny Le Guillou at his bedside. The same day, she informs the painter's relatives and friends about her employer's death. Describing the last moments of the man whose career he had followed, Théophile Silvestre concluded, in his epitaph: "And so died Ferdinand-Victor-Eugène Delacroix, on August 13, eighteen hundred and sixty-three, with a faint smile on his lips. He was a master painter, with sunshine in his mind and storms in his heart. Over the course of forty years, he touched the entire range of human passions with his magnificent brush, sometimes fearsome and sometimes tender, going from saints to warriors, from war-

takes a serious turn for the worse, and his doctors send him to Champrosay, hoping for an improvement, which does not occur.

July 13. Delacroix writes to Berryer: "It has been two months now since I last left my room, and I am writing to you with great difficulty. All winter, I have had an incurable cold and, in short, at the very moment that you were being honored, I was spitting blood. Ever since, I have been unable to regain my strength—just the contrary, in fact.

"My main illnesses, and others that came about as a result, have subsided, but my fever, which had been latent, has come back

with a vengeance. I break out in sweats, which weaken me to the point that I can't stand up when going from my bed to my sofa. Throughout all of this, I haven't been able to write or speak. And would I have dared to allow myself, in such a serious condition, to give my opinion to a man such as yourself? Your society friends tell you that it is a great success—on the other hand, they were only too happy to pull the wool over your eyes, and you're too good-natured. Freedom, damn it! It warms our spirit.

"This is what I'm saying, and you must forgive me for daring to say it. My excuse for everything else is my illness. You see

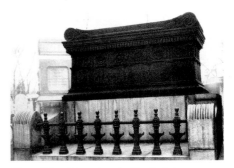

Fig. 13. Delacroix's tomb at the Père-Lachaise cemetery.

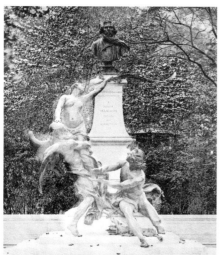

Fig. 14. JULES DALOU, *Monument to Delacroix*, 1890, Paris, Jardin du Luxembourg.

1929

A foundation is established by Maurice Denis, Paul Signac, André Joubin, and Georges Viau of the Société des Amis d'Eugène Delacroix, to save the painter's studio on the rue de Furstenberg, which is threatened with demolition.

1930

To commemorate the centenary of Romanticism, the Musée du Louvre organizes a large exhibition of Delacroix's oil paintings, watercolors, pastels, drawings, prints, and documents.

1951–54

The building on the rue de Furstenberg is put up for sale. The Société des Amis d'Eugène Delacroix gives part of its collections to the State on the condition that a museum be set up in the painter's apartment and studio (fig. 15).

1963

Exhibition at the Musée du Louvre held to mark the centenary of the artist's death.

1971

The Musée Eugène Delacroix becomes a national museum.

riors to lovers, from lovers to tigers, and from tigers to flowers."

August 17. The painter's funeral is held at Saint-Germain-des-Prés. The funeral cortege is led by Philogène Delacroix. In accordance with his wishes, Delacroix is buried at the Père-Lachaise cemetery (fig. 13). Two eulogies are delivered, one by the sculptor Jouffroy, on behalf of the Institut, and the other by Paul Huet, on behalf of the friends of the deceased.

1864

February 17–29. The works in Delacroix's studio are auctioned off at the Hôtel Drouot. The preface to the sale catalogue is written by Philippe Burty. The paintings are sold in the first auction (February 17–19), the drawings in the second (February 22–27), and the engravings in the third (February 29). On March 1, plaster casts, easels, tools, and other objects from Delacroix's studio are distributed directly from his home.

1885

March 6–April 15. A retrospective exhibition of Delacroix's work is held at the École des Beaux-Arts, on the quai Malaquais, to finance the monument to be erected in his memory at the Jardin du Luxembourg. The catalogue's foreword is written by Auguste Vacquerie and the preface by Paul Mantz.

1890

October 5. Unveiling of the monument in honor of Delacroix, created by Jules Dalou (fig. 14).

Fig. 15. Entrance to the Musée Eugène Delacroix, 6, rue de Furstenberg, Paris.

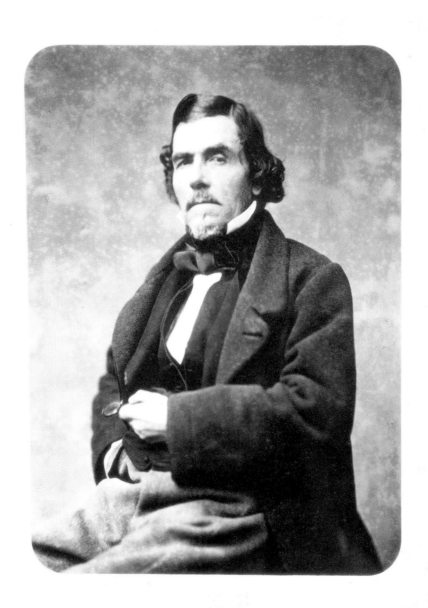

PIERRE PETIT,
Portrait of Eugène Delacroix,
1860, albumen print, Paris,
Musée Delacroix.

The Late Work:
Continuity and Variation

Lee Johnson

> *In my end is my beginning.*
> ("En ma fin gît mon commencement.")
> —Mary, Queen of Scots

The late work of Eugène Delacroix did not, needless to say, spring into being fully formed, like Athena from the head of Zeus. It was the richly varied culmination of an exceptionally productive thirty-year career, of experimentation, and of ceaseless reflection on the arts. As background for an exhibition devoted to the later period, therefore, it seems worthwhile to trace some of the many strands that connect the works of these years with those of Delacroix's youth and early maturity, and to point out analogies, developments, and variations between the beginnings and the end. This essay will concentrate first on the religious subjects, since they comprise a large group of his paintings and drawings in the exhibition, and on Raphael's continuing influence, which is prominent both in Delacroix's first commission for a religious painting and in his last. The wild animal and hunt scenes, another large group in the exhibition, will also be discussed with some reference to Rubens's influence.

Delacroix painted more biblical subjects between 1850 and 1860 than in any earlier decade of his career—more than thirty: that is, about three times as many as in his first ten years of activity. He seems to have shown little enthusiasm for painting the two official commissions he received in the 1820s, *The Triumph of Religion* (usually mistitled the *Virgin of the Sacred Heart*), which had been passed on to him by Théodore Géricault (1791–1824) and is now in the cathedral of Ajaccio, and *The Agony in the Garden* for the church of Saint-Paul-Saint-Louis, Paris. So it is difficult to account for the proliferation of religious pictures in Delacroix's late years, especially in view of his well-attested agnosticism. There was, however, a growing demand for paintings to decorate the churches of Paris during the Second Empire—more were commissioned by the Prefecture and installed between 1850 and 1860 than in the previous twenty years. This officially sanctioned piety may have had its effect on the demands from collectors and dealers for Delacroix's religious pictures and encouraged him to increase their numbers. But there may be deeper, more personal, reasons for some of his choices of theme. Often ill during his later years, he was preoccupied with thoughts of old age and death since the early 1850s, and he was ever anxious to assure his immortality through his work. These concerns may be related to his interpretation, in 1852, of the resurrection of Christ as death

conquered: "Christ rising from the tomb (Death Conquered)."[1] Hence it seems possible that an element of personal symbolism is contained in *The Supper at Emmaus* (cat. 112), *The Incredulity of Saint Thomas* (Wallraf-Richartz Museum, Cologne), and *The Raising of Lazarus* (Öffentliche Collection, Basel), all themes of triumph over death that do not occur in his earlier works.

Delacroix's remarkably successful series of paintings of *Christ on the Sea of Galilee* (cats. 113 to 118) may also allude indirectly to his anxieties about the fragility of human existence and the uncertainty of the survival of his reputation after death. He may have seen in the figure of Christ—calm and serene in the face of the storm that terrifies lesser mortals—an example to emulate in confronting his own "sea of troubles" (as one of his secular heroes, Hamlet, would have put it). A passage in his 1830 essay on Michelangelo may have some relevance to his choice of the storm-tossed boat as a symbol of the vicissitudes of life. He quoted from the famous sonnet by Michelangelo:

> Borne in a fragile bark upon a stormy sea, I complete the course of my life. I draw near that common bourne where all must go to give account of the good and evil that they have done. Ah! How clearly I perceive that this art, which was the idol and tyrant of my imagination, has plunged it in error. All is error here below. Thoughts of love, sweet and vain imaginings, what will become of you now that I approach a double death—one that is certain, the other menacing me?[2]

And then he commented: "Let those spirits who have shaken off all popular prejudices jeer, if they will, at this sublime genius wondering at the doors of death if he had spent his life well."[3] This, it might be thought, is precisely the situation Delacroix experienced in his late years.

Whatever layers of spiritual meaning the pictures in this sublime series may contain, we should not lose sight of their sheer technical brilliance, for as well as a thinker Delacroix was a supreme master of the material aspects of his craft. In the New York (cat. 115) and the Zurich (cat. 116) versions of *Christ on the Sea of Galilee,* the spatial disjunction of his most controversial painting of the 1820s, *The Death of Sardanapalus* (Musée du Louvre, Paris), is resolved in a magisterial synthesis of respect for the picture plane and diagonal recession into depth. Nor should we forget that the critic Paul de Saint-Victor hailed the version now in the Walters Art Gallery, Baltimore (cat. 118), as simply "the most beautiful marine painting of the French school."[4]

Compared with the works discussed here and with the harrowing scenes of martyrdom and Crucifixion from the late years (cats. 110, 111, and 119 to 123), Delacroix's first religious picture—in fact, his first known commission—*The Virgin of the Harvest* (fig. 1), an altarpiece painted in 1819 for the village church of Orcemont, near Rambouillet, is tame and conventional. But, being profoundly influenced by Raphael's Florentine Madonnas, it signals a debt to one Renaissance master that was to last throughout Delacroix's life and to culminate in his final, grand religious mural, *Heliodorus Driven from the Temple,* in the chapel of the Saints-Anges in the church of Saint-Sulpice (fig. 2). While the early picture seems a deferential tribute from a student to a great master, and more like an Ingres than a Delacroix, the *Heliodorus* is the challenge of the former student who has himself become a master, now confident enough deliberately to match his conception against one of the most revered monuments of the Italian Renaissance, Raphael's fresco of the same subject in the Vatican. And, closer to home, Delacroix invited comparison between his ceiling in the chapel of the Saints-Anges, *Saint Michael Defeats the*

Devil, and Raphael's two versions of the subject in the Musée du Louvre, Paris. His audacity was found presumptuous and ineffectual by some critics, glorious and triumphant by others.

Whereas *The Virgin of the Harvest* is Raphaelesque in composition, handling, and color, the *Heliodorus* has little in common with Raphael's fresco, other than the subject, and is highly original in technique. It is the most advanced expression of Delacroix's color practice, based on the observation of exchanges of colored reflections between adjoining objects and figures and combined with arbitrary touches of color (unconnected with the realistic depiction of nature) added to unite the separate elements into a chromatic whole and to heighten the textural variety of the surface and its appeal to the eye. Just as the pictures of *Christ on the Sea of Galilee* mark an advance over *The Death of Sardanapalus* in the harmonious organization of space, so the *Heliodorus* is much more subtle and complex in its handling of color harmonies than is the early *Virgin of the Harvest.*

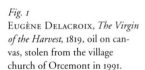

Fig. 1
EUGÈNE DELACROIX, *The Virgin of the Harvest*, 1819, oil on canvas, stolen from the village church of Orcemont in 1991.

Fig. 2
EUGÈNE DELACROIX, *Heliodorus Driven from the Temple*, 1861, oil and wax, Paris, church of Saint-Sulpice, chapel of the Saints-Anges.

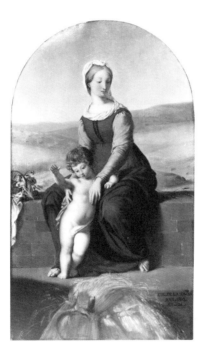

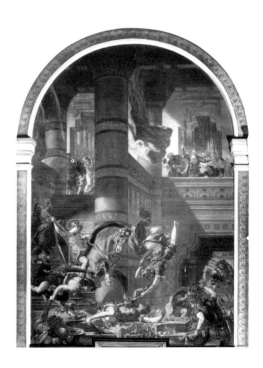

Although the influence and adulation of Raphael are more commonly associated with Ingres, and although Delacroix may seem to have closer affinities of temperament with Michelangelo, he, in fact, owes more to the former than to the latter in terms of specific pictorial influences over the full span of this career. He wrote an essay on Raphael a little earlier in the same year as his piece on Michelangelo. He also painted a picture of the young Raphael meditating in his studio (location unknown), shown at the Salon of 1831, but it was not until 1850 that he paid the same compliment to Michelangelo in *Michelangelo in His Studio* (Musée Fabre, Montpellier), and then only after, and perhaps because, a rival had just painted the same scene.

In harsh contrast to the sweetness of *The Virgin of the Harvest,* the influence, in composition, of Raphael's Florentine Madonnas recurs in the savage and pagan *Medea*

About to Kill Her Children of 1838 (Musée des Beaux-Arts, Lille), together with an apparent borrowing from the engraving of Raphael's *Massacre of the Innocents* by Marcantonio Raimondi (c. 1480–c. 1534), from which Delacroix had made sketches as early as 1819 and again about 1824 of the mother bundling her naked infant under her arm. Two sources of Christian imagery are thus amalgamated in this forceful depiction of a scene from Greek mythology, reversing the Renaissance tradition of adapting classical forms to Christian iconography. In the last years of his life, Delacroix painted three smaller versions of the *Medea* (fig. 3), with only slight variations on the original and no significant psychological refinement of his initial conception.

When treating *Marfisa and Pinabello's Lady* (cat. 87), a subject borrowed from Ariosto, Raphael's contemporary, Delacroix again looked to the Renaissance master— this time for a nude model of grace and elegance derived from the Minerva in an engraving of the Judgment of Paris. Even a picture based on his own observation of an actual

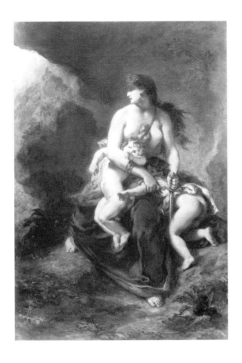

Fig. 3
EUGÈNE DELACROIX, *Medea About to Kill Her Children*, 1862, oil on canvas, Paris, Musée du Louvre.

Fig. 4
EUGÈNE DELACROIX, *Two Women at a Fountain*, probably 1832, watercolor, Paris, Musée du Louvre, Département des Arts Graphiques.

scene in North Africa in 1832 can be conflated with reminiscences of Raphael. Thus, in the mellifluous watercolor *Two Women at a Fountain* (fig. 4), Delacroix subtly adapted water carriers from Raphael's *Fire in the Borgo* to his Orientalist theme. In 1854 he developed an exquisite painting from this watercolor. Lost for the past seventy years, it has recently been found and cleaned.[5] The woman on the left of a comparable picture that is in the exhibition, *Horses at a Fountain* (cat. 136), may also have been adapted from a water carrier in the *Fire in the Borgo*.

The contrast between the number of wild-animal paintings Delacroix produced in his later years and in his youth is as striking as the proliferation of religious subjects. Toward the end of his life, between 1850 and 1863, he painted about thirty, including the great hunt scenes (cats. 13, 14, 21, and 23), but finished only three paintings in the ten years

after his first showing at the Salon in 1822. As with the religious pictures, the later works are generally more dynamic in action, with bolder and more fragmented brushwork and often more savage content. Though in the 1820s Delacroix executed several watercolors and a lithograph of imagined scenes with tigers attacking horses, as well as a small painting of an encounter between a lion and tiger (National Gallery, Prague), it is the naturalism of his studies and the quiescent (or dead) or sometimes playful nature of his big cats that stand out in these years. It was in this period that he made studies of felines in the Jardin des Plantes in the company of Antoine-Louis Barye (1796–1875), and this activity led, at the end of the decade, to his two famous lithographs of recumbent cats, *Lion from the Atlas Mountains* and *Royal Tiger,* and, most surprisingly in view of the lack of antecedents or detailed preliminary drawings, the large painting *A Young Tiger Playing with Its Mother* (fig. 5). This was first shown in 1830 at the Palais du Luxembourg, then at the Salon of 1831. In a review of the earlier exhibition, an anonymous critic underlined its assured naturalism with a two-edged compliment: "This curious artist has never painted a man who looked as much like a man as his tiger looks like a tiger."[6]

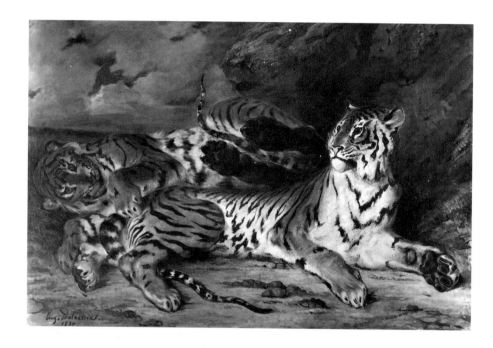

Fig. 5
Eugène Delacroix, *A Young Tiger Playing with Its Mother,* 1830, oil on canvas, Paris, Musée du Louvre.

In Delacroix's later, small easel paintings, the felines are usually more active and more predatory. Even when they are shown alone, not seizing wild boar or crocodiles (cat. 5) or mauling Arabs and their mounts, they are often menacing—growling, stalking an invisible prey, or about to spring (cat. 132). Nevertheless, there are later versions in oil that repeat the designs of the two early lithographs with only slight changes: *Indian Tiger* of 1846–47 (The Art Museum, Princeton University) derives from the *Royal Tiger,* and *Lion Devouring a Rabbit* (cat. 16) from *Lion from the Atlas Mountains.*

A source of wild-animal images that Delacroix had consulted in the 1820s but had not exploited—and shared with Barye—also reemerged in his late years. He painted only one picture of a woman mauled by a carnivore, the bizarre *Young Woman Attacked by a Tiger* of 1856 (cat. 17), but he apparently thought of treating another similar theme in oil. A drawing exists of a woman who shares some of the features of the tiger's victim and

who also seems to be on a riverbank, but her arm is clamped in the jaws of a crocodile while another looks on, equally gluttonous (Département des Arts Graphiques, Musée du Louvre, Paris, RF 9797). The two crocodiles in this study were borrowed from small wood engravings designed by William Harvey (1796–1866) to illustrate *The Tower Menagerie,* of which Delacroix obtained a set shortly after it was published in 1829. In addition, both the *Tiger Startled by a Snake* (cat. 20) and the *Tiger Growling at a Snake* (cat. 133) seem clearly to have been influenced by illustrations from the same book. Perhaps there is an oblique and piquant personal message in the pictures of tigers encountering vipers, as well as in that of a lion actually crushing a snake (cat. 18 fig. 1): while painting Apollo slaying the serpent Python for the ceiling of the Galerie d'Apollon in the Louvre (see cat. 64), and angry at his failure to be elected to the Institut de France on his sixth application, Delacroix turned to his assistant, Pierre Andrieu, and cried: "Come on, take heart, we must crush the snakes."[7] And a snake was included among the enemies of virtue in his unrealized project for *The Triumph of Genius* (see cat. 63).

The fullest expression of Delacroix's lifelong fascination with wild animals lies in the series of lion hunts that he painted between 1854 and 1861 (cats. 14, 21, and 23). The first and largest was commissioned by the State for the retrospective show of his work at the Exposition Universelle of 1855, but the choice of subject was his own and marks a significant departure from the religious, historical, or literary themes that he normally composed for canvases on this scale. Exotic fantasies (it seems that Delacroix never witnessed a real lion hunt), they are nevertheless informed by a lifetime's study of equine and feline form. On May 21, 1853, he wrote: "Worked all the morning at pastels of the lions and trees, which I had drawn the day before in the Jardin des Plantes."[8] He made another excursion to the zoo in April 1854, a few weeks before he received the commission for the Exposition Universelle, and no doubt made others as well as consulting his many earlier studies when preparing his great hunts.

The uncertainty of the outcome in these pictures, the impression they convey that the lions might well win the day or at least take a heavy toll on their assailants, can be interpreted as a metaphor for Delacroix's acute concern over the precariousness of civilization, his fear that the law of the jungle might prevail over humanity's fragile defenses against barbarism. Such interpretations of similarly inconclusive combats in Delacroix's work have been proposed. But it can be argued that suspense is a vital ingredient of dramatic episodes, whether in the theater, in novels, or in the fine arts, and need not connote weighty social significance. Furthermore, if such meaning is to be read into these pictures, what is to be said about Rubens's hunts and battle scenes, which are a primary source for Delacroix's? Was Rubens as pessimistic about the prospects for humankind as Delacroix? Also, in the face of the sheer inspirational brilliance of the latter's oil sketch for the Bordeaux *Lion Hunt* (cat. 14), with its riotous, swirling brushwork and frenzied splashes of color, philosophical speculation seems futile. Here, if anywhere in the work of Delacroix, is an example of what may be considered pure painting, art for art's sake—to employ terms that are anathema to the social historians of art.

As Delacroix measured himself against Raphael in his work for Saint-Sulpice, so in the Bordeaux *Lion Hunt* and its successors he threw down the gauntlet before Rubens, the master he admired above all others. In January 1847 he made a shrewd and detailed analysis of Pieter Claesz. Soutman's etching of a Rubens *Lion Hunt,* from which, beginning in the 1820s, he had already sketched some details. He also packed a folio sheet with scrupulously drawn, highly animated details of five separate figures taken from Schelte Adams

Bolswert's etching of Rubens's *Lion Hunt* in the Alte Pinakothek, Munich. This sheet, which seems to have gone unnoticed since Alfred Robaut listed it, without illustration, in 1885,[9] is in the Musée-Centre des Arts at Fécamp (fig. 6). It may well have been made in direct preparation for the Bordeaux *Lion Hunt,* and the artist, in any case, surely referred to it as the *Lion Hunt* progressed.

Although he found the Rubens he scrutinized in the Soutman print "admirable" in execution and full of wonderful details designed to strike the imagination, Delacroix considered the end effect confusing and chaotic. His Bordeaux *Lion Hunt* is the pictorial outcome of this critique: he retained the exotic and striking aspects of Rubens's composition without literally copying his motifs, but he reorganized its structure to make it more stable and to emphasize the principal lines in a manner that he felt Rubens

Fig. 6
EUGÈNE DELACROIX, *Studies of Figures after Rubens*, c. 1847 (?), graphite on paper, Fécamp, Musée-Centre des Arts.

had failed to do, and that he thought exercised a powerful influence on the way a picture is viewed.

The Boston and Chicago *Lion Hunt*s (cats. 21 and 23) are inventive and ingenious variations on the problem Delacroix had set himself when painting the Bordeaux *Lion Hunt:* How to preserve the vitality and excitement of Rubens's hunts, yet vary and clarify his designs. In the Boston picture, he devised a Y-shaped composition in depth, and in the Chicago version, an ellipse in depth, breaking away in both cases from the relief-like design of Rubens's and of his own Bordeaux version.

After this review of some continuities and variations in Delacroix's religious and wild-animal pictures, it will be worth recalling the enduring classical element in his art exemplified by his two series of decorative paintings of *The Four Seasons* for private patrons. In 1821 he painted his first surviving scheme of decorations, four semicircular

overdoors for the dining room of the famous French tragedian François-Joseph Talma (1763–1826) in his newly built townhouse in Paris.[10] Each season is represented as a single figure placed against a plain background and accompanied by a few apt attributes. They are developed from studies of Greco-Roman paintings from Herculaneum and its environs, of antique sculpture, and of seventeenth-century French decorative paintings. Freer in handling than *The Virgin of the Harvest* of two years earlier, they are nevertheless somewhat labored. By contrast, in the artist's late *Four Seasons* for Hartmann (cats. 151 to 154), as with late pictures of other themes, the whole conception is more dynamic and complex and the setting more expansive. Instead of making a single figure represent each season, Delacroix symbolized the seasons with pairs of mythological characters set against deep landscape and marine prospects: *Orpheus and Eurydice* for Spring, *Diana and Actaeon* for Summer, *Bacchus and Ariadne* for Autumn, *Juno and Aeolus* for Winter. In the end as in the beginning, the snake is ever present and grows more dangerous. In Talma's *Winter,* it lies listlessly in the snow, half-frozen; in Hartmann's *Spring,* it has fatally bitten Eurydice. The pose of the woman gathering flowers who witnesses the tragedy is borrowed from the figure of Eurydice herself in Nicolas Poussin's painting of the same subject in the Musée du Louvre, Paris. In 1853 Delacroix had written admiringly that this picture "so effectively presents . . . these eternal contrasts of joy and sadness,"[11] an ideal that he no doubt sought to emulate in his own canvas as in many other of his works, most of all, perhaps, in his secular mural decorations for public buildings in Paris.

1. *Journal,* November 28, 1852, p. 315.

2. Eugène Delacroix, "Michel-Ange," *Revue de Paris,* 1830; reprinted in Delacroix, 1923, vol. 2, pp. 51–52. Delacroix had recorded the same lines from the sonnet in his *Journal* entry for January 4, 1824 (Norton, 1951, p. 20).

3. Eugène Delacroix, "Michel-Ange," *Revue de Paris,* 1830; reprinted in Delacroix, 1923, vol. 2, p. 52.

4. Paul de Saint-Victor, "Eugène Delacroix," *Moniteur universel,* June 27, 1881.

5. Johnson, 1986, vol. 3, no. 394, pl. 199, before cleaning.

6. *Journal des Artistes et des Amateurs,* November 7, 1830, p. 324.

7. Pierre Andrieu in A. Bruyas et al., *La Galerie Bruyas* (Paris, 1876), p. 89.

8. *Journal,* May 21, 1853 (Norton, 1951, p. 188).

9. Robaut, 1885, no. 1732.

10. Location unknown; Johnson, 1981, vol. 1, nos. 94–97, pls. 82, 83.

11. Eugène Delacroix, "Poussin," *Le Moniteur,* June 26–30, 1853; reprinted in Delacroix, 1923, vol. 2, p. 91.

Eugène Delacroix as Seen by His Contemporaries

Arlette Sérullaz

Now that calm has settled over this grand name—one of those that posterity will not forget—it is difficult to imagine the tumult, the scorching dust, in which he lived. Each of his works occasioned deafening clamors, storms, furious discussions. The artist was showered with insults more offensive and ignominious than would ever have been addressed to a thief or an assassin. All critical urbanity ceased with regard to him, and, when at a loss, authors borrowed epithets from the Catechism of Vulgarity. He was a savage, a barbarian, a maniac, an *enragé,* a madman who should be sent back to his birthplace: Charenton. He had a taste for the ugly, the ignoble, the monstrous; and then he did not know how to draw, he broke more limbs than any doctor could have set. He hurled buckets of color against the canvas, he painted with a drunken broom—this drunken broom was found very pretty and for a time made an enormous effect. . . . Thus it is that geniuses are greeted at their dawn: strange error that astonishes each generation after the fact, and that it then naïvely repeats.[1]

This affidavit, drawn up by Théophile Gautier on the occasion of the retrospective exhibition organized in 1864 by the Société Nationale des Beaux-Arts, shortly after the sale of the works remaining in Delacroix's studio, rightly makes manifest the discrepancy that persisted throughout the painter's career, characterized on the one hand by dependable official recognition, and on the other by profound misunderstanding: "Even his admirers, even his most committed partisans in the Romantic battle, even writers who felt obliged to brandish swords in his honor in the press freely admitted that there was in Eugène Delacroix a bizarre internal contradiction between the tendencies of his mind, which dictated to him the wisest opinions in art and literature as well as in politics, and the turbulence of his imagination, which had full control of his brush," wrote Paul Jamot in 1930.[2] Without pretending to evoke in full detail the polemics engendered by each of Delacroix's appearances at the Salon, we should at least recall that the artist himself fostered them by refusing at every opportunity to allow himself to become hemmed in by any movement. The Romantics claimed him as their spokesperson after the death of Théodore Géricault (1791–1824), but Delacroix always strove to distance himself from this moniker. Although close to the second Romantic generation, like Charles Baudelaire he found it impossible to adhere to the revolutionary aesthetic and aspirations, in every domain, of the first French Romantics. His classical culture and his humanism carried him, willy-nilly, toward acknowledgment of the classical tradition. And the evolution of his

work, like the development of his career, attests to his determination to take his place in the lineage of great artists who, like him, made original contributions while forging the links of a transformation affecting both art and humanity. Delacroix upset the established order and made himself vulnerable to all those exasperated by his posture as a solitary and supercilious dandy, by his refusal to make concessions, and by his quite distinctive way of painting, consciously animated by a double aim: to communicate a poetic impression or an idea and to please the eye.

"The duel between Delacroix and the critics began with his first painting, and it did not end until long after his death," observed Maurice Tourneux in 1886.[3] When Delacroix made his first appearance at the Salon, in 1822, the one painting he exhibited, *The Barque of Dante* (Musée du Louvre, Paris), left none of the reviewers indifferent, but it cannot rightly be said to have met with an enthusiastic reception. The praise of Adolphe Thiers, who served as mouthpiece for the painter François Gérard (1770–1837), was answered by the final judgment of Étienne-Jean Delécluze, the voice of Davidian nostalgia:

> Obligation leads to study. M. Delacroix indicates this in his painting of Dante and Virgil; this painting is not a painting; it is, as they say in studio lingo, a real *tartouillade*. However, amid the bizarre objects that the painter wanted to render, he was obliged to execute figures whose contours and color are full of energy; there is talent in the bodies of the damned who try to force their way into the barque carrying the two poets. We will observe with regard to this painter only that it will be absolutely essential for him to make a fine work for the next Salon, for two attempts of this kind will not be accepted.[4]

The word *tartouillade*—in the argo of studios, pictures that are jumbled and slackly drawn in which one sacrifices all for a bit of color—had been uttered, and it was to have quite a future. Witness this passage from 1853, in which Claude Vignon employed it with manifest delight:

> M. E[ugène] Delacroix knows that he has made some masterpieces and that he will make others. In the meantime, he makes *tartouillades* to keep his hand in, and he sends them to the Salon, something for which we do not congratulate him.
>
> In effect, in these *tartouillades* there is never any drawing, everyone agrees on this point, and sometimes there isn't even the expression appropriate to the subject represented.—"Yes; but what color!" cry all our gourmets of the rough sketch, all our tasters of the palette.
>
> "Color, messieurs!"—Yes, without doubt. But, as unfortunately there is still a certain portion of the public that does not understand pure colorism . . .
>
> "That's the fault of the gods who made them so *stupid!*" and . . . the mission of criticism is . . . so to speak, to educate the public even as it echoes, with regard to artists, people of taste, permit us to explain to those bereft of intelligence that which in artistic language we properly call color.[5]

Every time Delacroix submitted his works to the public for judgment, commentary proliferated, sustaining from one year to the next a debate that gradually became formulaic. A caricature by Bertall, published in the *Journal pour rire,* gave it definitive visual form, staging a "duel to the death" in the front of the Institut de France between "M. Ingres, the Thiers of line, and M. Delacroix, the Prud'hon of color." Like jousting knights on powerful caparisoned steeds, Ingres, brandishing a portcrayon (symbol of drawing), attacks Delacroix, who is armed with a brush (symbol of color). The caption specifies the

nature of the stakes: "There is to be no quarter. If M. Ingres triumphs, color will be forbidden all down the line." It was in this way that contemporary opinion fell into the trap of a comfortable opposition: on one side, Delacroix, reactionary, revolutionary; on the other, Ingres, guarantor of a heritage, in other words, of the will to style. This dichotomy appeared clearly at the Exposition Universelle of 1855, a robust moment of Delacroix's career, even if Charles Perrier tried to elevate the level of the debate:

> France is for genius, in all its forms, a hospitable pantheon that is open to every glory and burns incense at every altar. . . . Variety is a sign of riches, as union is of strength: no nation in the world can lay claim to a glory composed of elements that are more heterogeneous, and at the same time more national, than that of the people who know how to honor a Victor Hugo as it honored a Corneille, and that worships in like manner M. Delacroix and M. Ingres.
>
> Nothing could be more different in essence and mode of action than the talents, so profoundly original, of these two painters. The ideal that M. Ingres pursues in supernatural beauty, and that he expresses through purity of line and harmony of drawing, M. Delacroix finds in the heat of expression and the splendor of coloring. To condemn one of these two methods by the other, to exclude color in the name of drawing or drawing in the name of color, would be all the more unjust, as each of these two painters, by excelling in his genre, has thereby victoriously demonstrated its advantages, and, furthermore, as both submit not to a predetermined cause, not to a calculated tactical program, but to an imperious and irresistible impulse of their individual natures. . . . Let us be grateful, first of all, to Messrs. Ingres and Delacroix for having remained quite as nature shaped them, and let us remember then, save by exercising superhuman sovereignty over his own faculties, a man can never willfully revoke with impunity whatever destiny has decreed for him.[6]

But his advice went largely unheeded. Paul Mantz, for example, declared his prejudices without apology:

> No one, in the vast tournament in which we must judge the passing arms, asserts himself as audaciously as M. Eugène Delacroix; no one sustains more valiantly a flag that, although riddled with bullet holes, will doubtless remain upright for some time to come. Through the sustained virility of his brush, through the profound feeling with which he has imbued his work, through the imperfections of a manner whose shortcomings are visible to all, through the qualities he possesses as well as those he lacks, the author of the *Triumph of Trajan* and the *Medea* is one of the most original and vibrant personalities of this era. An artist both admirable and crippled, one must either hate him intensely or worship him. . . . Whether one glorifies him or rips him apart, M. Eugène Delacroix remains what he is, which is to say a violent master, a passionate colorist, a tireless inventor.[7]

Thirty years later, in his preface to the catalogue of the 1885 retrospective exhibition, Mantz justified his position in lyrical terms:

> If we loved Delacroix so much, it was not only because of his genius; it was because he spoke in the name of our hopes, because he was the very expression of our avowed or latent lyric tendencies, because we recognized in him the charmer who instructs and consoles. . . . Let us be precise about the situation. Nothing is more bitter for the decent people than to live in a period in which one no longer knows how to paint. We were in the presence of the last representatives of the school of David, priests of a preemptive cult that, for many reasons, was inventive no longer, and whose cold reminiscences chilled us to the bone. . . . The figures they staged in their poorly furnished theater

affected us like mannequins, all the more criminal for being declamatory. Delacroix arrived and he showed us men. . . . He was one of the chosen few for whom the humble realities of prose do not suffice and who breathe freely only in an atmosphere charged with passion. Delacroix was not a naturalist smitten with precise detail: he was a lyric spirit, a man transported, on occasion a visionary. [His] apparent serenity hid interior storms. Although his eye was skilled at seeing forms, colors, light, his spirit and his hand did not permit him to reckon, like Holbein, with facial wrinkles or to inventory, like Breugel, the blades of grass in a field. Delacroix transfigured things; he shook up leaves, gestures, souls. From the first day to the last, he was a great agitator. Man was for him passion in movement. Delacroix saw above all the human drama; if need be, he would have invented it. That is why he had such a tender regard for poets, and why he understood them so well. . . . Delacroix saw his paintings before painting them. . . . During the period of realization, the artist had fits of impatience that he did not sufficiently control, fevers that agitated his hand. Hence, from a purely graphic standpoint, the singularities, perhaps weaknesses, that once astonished tranquil people. In painters who express nothing, these accidents do not occur: vacuity protects them from error, indigence is their guarantee. Delacroix always remained oblivious of these serene allures, which some find enviable but which are too reminiscent of cold-blooded labor, of calmly painting the panels of a carriage door. . . . Delacroix's drawing and his decor-smitten style provoked interminable quarrels in the past; but witnesses to the old battles are there to affirm that, even when combat was at its most intense, the colorist escaped every attack. One could not help but recognize in him a musician skilled at tonal harmony and at devising brilliant and disciplined ensembles. Color and the seductions that it implies are in effect one of the privileges of Delacroix. From his first youth, he dreamed of it through a kind of instinctive feeling, and he had a violent desire to restore to the French school the gift it had lost; soon he joined to this natural predisposition a true science of accords based on prolonged observation. . . . His paintings speak to you from very far away: you are warned; you know that the painter is going to recount for you a happy story or a sinister adventure. He has a fanfare or something frightening, a smile or a sob. With Delacroix, color never ceased to be a language.

Thus lived, amid battles that we must now forget even in memory, the great painter, the great poet to whom, tomorrow, we will erect a well-deserved if belated monument. True artists are always of their time: the contemporary soul penetrates them, it inspires them, and it celebrates when it recognizes itself in their ideal. Delacroix bestowed this drunkenness upon us. May he be thanked for it.[8]

In fact, those who resolutely took Delacroix's side never stopped pointing out the inanity of the reproaches addressed to the painter, which evidenced in their eyes a distressing obscurantism:

In the presence of a public whose sole education in the arts consists of familiarity with the forms exhibited to it and a routine of ideas whose yoke it must endure, the man of original talent encounters only the incredulity of the masses and the malevolence of established artists, whose rules he overthrows through his innovations and whose work he discredits through his discoveries. So we should not be surprised to see, in every branch of art, men who distinguish themselves from others becoming the object of the bitterest criticism of his rivals and of the constant persecution of the academies. Mediocrity favors domestic calm, but it rebels against superiority of any kind, since it views it as an enemy ready to seize its crown and overthrow the chair from which it governs the arts and instructs its disciples. . . . Works of art that are too strikingly original, too boldly executed, startle the eyes of our bourgeois society, whose narrow minds can no longer embrace either vast conceptions of genius or generous humanitarian transports. Opinion treads close to the earth; all that is too vast, all that rises above, escapes it.

The public does not reject men who are stronger then it is; it does not see them. It does not understand them; the public likes those who flatter its tastes and preferences, those who descend to its level and speak its language. Hence the success of so many artists; hence the isolation and suffering of a few superior unrecognized men.[9]

Supporters stressed the courage of the artist, who was determined not to let himself be beaten down by the unjust charges levied against him at each of his official appearances:

Never in the course of his long and brilliant career has Eugène Delacroix failed to respond to the call of art; never has his "controversial" talent withdrawn into a privileged precinct. Blame, praise, he has borne everything bravely, and he has lived amid tumult. The great contested painter did not cool toward the public from wounded self-regard; storms did not frighten him; he knows that birds with broad wingspans fly best into the wind; sometimes this courage goes as far as recklessness.[10]

The same affirmation is found in the writing of Clément de Ris, who proclaimed his support high and wide:

All the annual exhibitions from 1833 to 1848 saw the artist faithfully deliver his quota. That is one of the most beautiful statements of praise one could address to him. . . . The artist never drew back from publicity. Each Salon found him dependably in the breach, responding to attacks with new works, defending his flag with imperturbable assurance, renewing the fight under all forms, giving blow for blow, always harassed, never diminished, in the end forcing his adversaries to admire his constancy, if not his talent. . . . We have never hidden the extent of our sympathy for this painter, who, of all contemporary artists, is the one closest to the great tradition of the Venetians and the Flemish. And this sympathy does not come solely from the admiration that his talent inspires in us, but still more from the persistence and dignity he displayed in conquering the eminent position he now occupies. Never has an artist been attacked at such length and as blindly as this one. Jury refusals, the hostility of blind or unintelligent critics, the indifference of the crowd—he has had to field everything. . . . This upright way of acting succeeded for him, and, while he is not admired by all—something I am far from wishing on him—at least he is accepted, and that's what matters.[11]

In this permanent combat, some had no qualms about tearing to pieces those who vaguely berated Delacroix for his indifference to beauty and his disregard for drawing. In 1841 Théophile Gautier had launched into a ringing defense:

We have written about several Salons now, and the name of M. Eugène Delacroix is always the first at the tip of our pen. That is because, in effect, M. Eugène Delacroix is the adventurous painter *par excellence,* and one rushes to him before all others, for he, more than anyone, is likely to produce masterpieces; he can displease at first, but in the end one must admit that the future of painting is being argued in his canvases; he is a true child of this century, and one senses that all contemporary poetries have colored his palette. There may be better paintings than his at the Salon, but there is certainly no better painter. . . . For our part, we do not know whether M. Delacroix draws well or ill, whether his figures deviate from the classic type or not, whether his execution is good or bad; he has for us a quality worth all of these things. He exists, he lives by himself, in a word, he carries within himself the *microcosm.* Excuse this heteroclite and cabalistic term, but it communicates our meaning perfectly: a small world that is complete. This precious faculty for interior creation belongs

only to elite organisms, and it is the secret of the power that M. Delacroix possesses, despite all his faults. . . . His color, before traveling from his eye to the tip of his brush, has passed through his brain and there accrued nuances that might initially seem bizarre, exaggerated, or false, but each brushstroke contributes to the general harmony and renders, if not an object's prosaic aspect, at least one of the painter's feelings or ideas.[12]

When Delacroix was—finally—named to the Institut, some of his supporters, among them Clément de Ris, saw this as a harbinger of unhoped-for change in artistic education:

What will be the effect on the development of French art of M. Delacroix's influence in the wake of his nomination to the Academy? . . . One can hope that it will be favorable to the progress of our artists, and briefly say why. For what is already too many years, the school's development has been increasingly circumscribed by the practical matter of material procedures. Skill in execution, whether in terms of drawing or of color, makes distressingly little progress. Forty years ago, paintings were composed from cliches used by everyone. In our day, it is execution that has become a matter of cliche. Dextrous handling is everything and thought counts for little. After five years in the studio and sojourning in Rome, one makes a painting as one turns a baluster or paints a venetian blind. If we aren't careful, this invasion of mechanics into art, a sad corollary of the spread of industry into literature, will conduct it on a forced march into decadence. Preaching by example, M. Delacroix can lift it out of this rut. He will teach beginners that, despite incorrect execution, one is an artist truly worthy of the name when one knows how to instill one's work with an idea; when, moved oneself, one manages to agitate the soul of the spectator, when one awakens in him the emotions and feelings that make for the grandeur of Man, every time, finally, that one elevates the intelligence to the good by means of the beautiful. . . . We should thank the Academy in advance for having done right by the entire body in giving a chair to the most agitated, but the most thoughtful and most moving painter of our century.[13]

But on this point, the artist was more lucid, and had different views, realizing that this recognition came too late: "I would have had time to become a professor at the École: it is there that I would have been able to exercise some influence. . . . I doubt that I will ever manage this, seeing as it would be too great a concession for these gentlemen to give me any control over an education that they prefer to conduct as they see fit."[14] Events were to prove him right. At the Salon of 1859, his last, Delacroix had to endure critical crossfire whose mocking tone was especially unpleasant:

Has death, then, also struck down M. Eugène Delacroix? I mean the premature death that paralyzes the hand, blinds the eye, and deprives the mind of any notion of the apt and true. What are these ghostly paintings being exhibited under his name? It is a cruel trial to which M. Delacroix now subjects his admirers. . . . This is a warning to M. Delacroix that the time for him to retire has arrived. Today he puts everything into question. Does he have a right to make the members of the Institut repent of their obliging votes in this way? There comes a moment in life when the rebellious hand no longer submits to the mind; then one must have the courage to withdraw in silence. . . . In the middle of the battle waged around him, M. Delacroix, hailing the two armed regiments in the alternation, tenaciously followed the route he had marked out for himself; he has finally reached his goal; may that suffice him! In the interest of his reputation, may he never again leave his retreat; it is ill advised to induce laughter when those who laugh are no longer on one's side.[15]

For his part, Jean Rousseau propagated alarmist remarks:

> Here is a painful spectacle. We are at the bedside of a genius who is taking his leave. . . . Never, perhaps, has a genius more richly gifted, better armed in every respect, made such victorious advances, and in all directions, through the vast domain of the fine arts.
>
> Driven by a consuming activity, served by an inexhaustible and unprecedented fecundity, Delacroix has grappled successively with every genre. . . . Delacroix has traveled through all countries; he has restaged the course of all periods; he has seen everything, understood everything, rendered everything with an intuitive power that is perhaps without equal. . . . Finally, this encyclopedic genius has, in the thousand faces of his colossal oeuvre, made sparkle almost all of the beauties in painting's domain, only one of which would ordinarily have sufficed to empower a talent and establish a reputation. . . . Here we find ourselves in front of his last canvases. . . . The faculties of Delacroix seem to us to die out not successively, one after another, but all at once—save for a single one that survives: . . . the taste of the colorist. This particular sense, for example, he has kept intact, and perhaps more subtly than ever. Indeed, it is almost as though Delacroix's taste is vitiating itself by dint of refining itself. . . . The time is near—should Delacroix not recover—when he will occupy himself only with coupling tones, without troubling to represent anything, making bouquets in which one won't even be able to find any flowers![16]

More nuanced, Ernest Chesneau, who later helped to prepare the catalogue raisonné published by Alfred Robaut in 1885, avowed his inability to deliver an authoritative judgment:

> I know it seems inappropriate for a critic to be perplexed, much less admit to his perplexity; however, out of penitence for my many acts of summary and sometimes harsh judgment, I want to impose upon myself the humiliation of acknowledging that, for the moment, I am incapable of delivering a just verdict with regard to M. Delacroix. May the public indulge this admission! May it manage to appreciate the causes of this silence! If, my friend, I make no apology for remaining so piteously in default, it is because I am sure that you will permit me to abstain, given the doubt into which this artist's work has plunged me. I have studied it in good faith, illumination has yet to strike me, the scales covering my eyes have yet to fall away. It would have been very easy for me to repeat yet again all the banalities, all the absurdities, all the insults that have been written, slobbered, and screamed about M. Delacroix; this role would never suit me. Drawing inspiration from all the enthusiastic articles wrenched from real or feigned admiration for his talent, I could have constructed a long and beautiful page for you full of exclamations and discussions about line and color. I did not do this: you will understand. If one day I broach publicly this sphinx of modern painting, it will be because that day I will have wrung his secret from him, because he will have uttered his final words to me.[17]

The copious and habitual verve of Alexandre Dumas counterbalanced whatever was arbitrary in such judgments:

> There is always something to say about a man like Delacroix.
>
> Go to the Salon and you will see bourgeois pass by laughing, young people pause and collapse into hilarity, *demoiselles* from the rue Breda clustering in front of it agitated like wagtails; but whenever you see artists stop, lean over the guardrail, talk among themselves in piously lowered voices while tracing lines in the air with their fingers, you can say: there, there's a Delacroix. And, in effect,

the genius of Delacroix is not debatable, it is not demonstrable, it is something one feels. . . . Delacroix was born to paint; deprived of pigment, palette, brushes, canvas, he would paint on the wall, on the sidewalk, on the ceiling, he would paint with the first piece of wood that came to hand, with plaster, with charcoal, with saliva and ashes; but paint he would, or die from not being able to paint.[18]

Delacroix, however, fielded the blows. And the terms he used to thank his supporters indicate that he was not fooled: "You recall, friend, an old comrade; you already treat him like someone installed in his little immortality," he wrote to Dumas, while he observed to Baudelaire, his stalwart admirer: "You treat me as one treats only the eminent dead. You make me blush while giving me much pleasure."[19]

In fact, four months after the painter's funeral there appeared, in three installments in *L'Opinion nationale*, the most beautiful homage ever rendered to painting by a poet: Baudelaire's essay "The Life and Work of Eugène Delacroix." Written in a state of profound consternation, it was to induce an entire generation of artists and writers to bow down before the genius of Delacroix:

> Delacroix was passionately in love with passion, and coldly determined to seek the means of expressing it in the most visible way. In this duality of nature—let us observe in passing—we find the two signs which mark the most substantial geniuses—extreme geniuses who are scarce made to please those timorous, easily-satisfied souls who find sufficient nourishment in flabby, soft and imperfect works. An immense passion, reinforced with a formidable will—such was the man. . . .
>
> It is evident that in his eyes the imagination was the most precious gift, the most important faculty, but that this faculty remained impotent and sterile if it was not served by a resourceful skill which could follow it in its restless and tyrannical whims. He certainly had no need to stir the fire of his always-incandescent imagination; but the day was never long enough for his study of the material means of expression.
>
> It is this never-ceasing preoccupation that seems to explain his endless investigations into colour and the quality of colours, his lively interest in matters of chemistry, and his conversations with manufacturers of colours. In that respect he comes close to Leonardo da Vinci, who was no less a victim of the same obsessions.[20]

In a way, the success of the posthumous sale of the master's works confirmed this judgment:

> The day the studio of Eugène Delacroix, bereft of its master, emptied itself into the banal rooms of the auction house, when one saw the walls covered with studies, copies, oil sketches, unfinished paintings, compositions interrupted by death yet palpitating with life, when more than six thousand drawings, overflowing from stuffed portfolios, displayed their marvels to every eye, documenting sustained and fruitful work ceaselessly renewed over scarcely fifty years, that day the Parisian public was able to say: We do not know Eugène Delacroix. Criticism, sarcasm, jeers, all were forgotten. A new artist was revealed to all, shining forth with henceforth incontestible glory. It was a revelation.
>
> And what enthusiasm! What a sudden and contagious fever! During the exhibition it was stifling; during the sale one could scarcely breathe. It proved necessary to augment the largest room in the Hôtel Drouot, and still space was short. An impatient crowd pushed against the banquettes, tables, doors, and into the hallways. From the moment the ivory hammer gave the signal, it was a

matter of whoever would first throw themselves into the fray. Never has such a running fire of bids echoed through this stock exchange of the fine arts. Never has an auctioneer commanded a more valiant army. Strategy became pointless, the combatants' ardor doing duty for everything. No sooner was an opening bid announced than it was exceeded, bouncing from one corner of the room to another, flying from hand to hand and attaining unanticipated heights, with the hoarse criers exhausting themselves trying to collect [the closing bids].

There we saw, for two weeks, all that Paris boasted in the way of distinguished amateurs, wealthy foreigners, famous dealers. The provinces and neighboring countries sent reinforcements. Princes of every dynasty were represented by their agents. Artists themselves left their work to view this picture of a new genre. Men of letters wanted to be present at this drama. Idlers flocked to this exhausting event. For two weeks, from one to six, the crowd appeared with exemplary punctuality, giving its time, its sympathy, its gold to an artist over whose work one haggled when he was alive, and supplementary evening sessions for the drawings brought together again, for two or three hours, the most devoted and the most avid. To have a bit of Delacroix, to have it at any price, such was the ambition of half of Paris last month. . . . Thus it was not an ordinary painter but rather an eminent artist that France lost on August 13, 1863. Posterity has begun for him, and begun well, with a return to justice. To be sure, during his lifetime he did not lack for admirers. Criticism, more enlightened than opinion, supported him, and one of its practitioners, a writer full of science and taste whose Salon reviews are worth rereading, M. Ch[arles] Lenormant, paid him homage more than once. However, only a small group of intimate friends can have known him such as the sale revealed him to be, for a resolute feeling of modesty, honorable in a controversial artist, made him insist on keeping closed both his atelier and the portfolios from which so many insights suddenly emerged for the public. Some artists, more skillful, deftly allow a crack in the sanctuary door. Some artists, more generous, give away their trifling sheets to the first comer, confident of their thought. It seems that Eugène Delacroix retained the totality of his drawings, refusing to surrender a single one, because he was afraid of losing a part of his personality. Or perhaps he confidently awaited the hour of a solemn reparation.

That hour has sounded. Some partisans of a rival school will still, for a longer or shorter time, feel obliged to protest. For the public, the matter is settled. It has seen Delacroix close up, and it has hailed him as one of the greatest artists of our time.[21]

And yet, despite the equally satisfying reception that greeted the exhibition organized shortly after the sale, the painter's detractors did not surrender their arms. The speech delivered at the Institut in 1876 by vicomte Delaborde, on the occasion of the annual public meeting of the Académie des Beaux-Arts, is significant in this regard, for it tempered its praise with criticism, although this was more or less veiled:

The name of Eugène Delacroix is not among those one honors through compunction, at the risk of allowing its glory to fade and its memory to vanish. It is, on the contrary, one of those whose importance survives a period's favors and prejudices To appreciate Delacroix's rare merits at their true worth, and to resign oneself to the errors he was capable of committing, one must, in effect, coolly consider him in both his person and his work; one must recall what he was and what he did instead of what was said about him, not only, of course, by his enemies but by his panegyrists, sometimes as vexing as his most intractable adversaries. In reality, excessive slavishness to his talents only detracts from them. Delacroix was on more than one occasion victim to excessive devotion of this kind. At a time when, according to the sanctioned expression, the classics and the romantics were grappling with one another, he had the misfortune to be falsely praised almost as often as he

was unjustly descried, and, as the enthusiasm of the one side increased proportionately with the obstinate ill will of the other, one soon arrived on both sides at a point where objections gave way to challenges, principled convictions to prejudice and sectarian enmity, and discussion to quarrels. . . . In this austere life without sadness, laborious without ostentation, even glorious in its simplicity, everything expressed elevation and virility of spirit, as, despite the ardor of his imagination, the artist in Delacroix invariably remained superior to passion and sectarian impulse. Those who, confusing his cause with the outspoken ambitions and intrigues of those by his side, attributed to him the intention to disown the entire legacy of French art, to reform everything about it, to repeal all its glories, those individuals slandered him unawares and gave him credit for a courage that he did not, thank God, possess. . . . Whether "necessary" or not, the imperfections sometimes encountered in Delacroix's work from the second half of his life are more than compensated for by the merits of these works as regards everything having to do with dramatic or poetic expression; by the painter's special gift for determining the meaning of a scene, for characterizing its spirit and moral physiognomy by means of a colorism as eloquent, as persuasive as the art with which the scene is invented and arranged: an art sometimes brilliant, sometimes profound, always original. . . . Examining the ensemble of works by Eugène Delacroix, how can one not be struck, first of all, by the persistence of the inclinations that these works express? And yet never has a painter treated such a broad range of subjects. From New Testament scenes to anecdotal subjects drawn from contemporary life in the Orient, from themes provided by ancient fable and medieval legend, by poetry and the theater, by history and fiction, to scenes in which animals are the only heroes, to seascapes, landscapes, and even flowers: Delacroix attempted everything, rendered everything, but with the intractable originality of his feelings, or, to be more precise, of his passion.

Passion: such is the dominant faculty and effective *raison d'être* of this talent, more powerful through the spontaneous energy of its enthusiasm than through the premeditated rigor of its calculation. . . . Delacroix, during his lifetime, encountered much unjust resistance, much vehement enmity, as well as, partly by way of reaction, admiration sometimes carried to the point of infatuation. Some saw him only as a prophet of destruction, a kind of Antichrist come into the world of the arts to destroy its beliefs and precipitate its end; in the eyes of others, he fulfilled the mission of an avenger of all current prejudices, of a redeemer of all past sins. What was to remain, what remains today of these extreme prejudices, of these opposed exaggerations? . . . No one, save through blindness or even ingratitude, can disparage the glorious legacy with which Delacroix has enriched our century and our country. . . . If . . . Delacroix was a great painter, and by virtue of this commands admiration, doubtless it is because he combined high skill with imaginative brilliance; but it is also because, like all the great masters, he never sought to say anything save what he believed, to translate anything save what he had felt, and because, even at the risk of pushing frankness to the point of impudence he always had it in his heart to reveal and to surrender the whole of himself.[22]

In 1885, another occasion arose for exploring the various and multiple aspects of Delacroix's personality, devoted entirely to pictorial creation and driven solely by the desire to erect a unique and particular world—that of great painting:

The exhibition of the work of Eugène Delacroix, on the quai Malaquais, is a definitive, if much delayed, act of atonement on behalf of the greatest genius in which the quite impoverished French School can take pride. . . . Did he ever foresee, in a radiant flight of hope, the triumphal exhibition of his work at the École des Beaux-Arts, that enemy Bastille in which was invented the bloodiest critical sally wielded against him, the legendary "drunken broom"? Perhaps, but certainly not so soon. Twenty years have passed since the hour of his death, and in this enemy camp, its hostility

underscored by a bust of Ingres bearing his famous dictum: "Drawing is the probity of art"—a Prudhommesque phrase as ridiculous as would be the analogous "Syntax is the probity of literature," but a perfidious one amounting to a final insult engraved in marble and directed against a rival—the author of *The Barque of Dante* finally receives the consecration due his genius, which managed to combine and fuse the magic of color, the fiery boldness of execution, and the most intense profundity of thought.

In the bitter struggles that, from 1822 until the death of Delacroix, marked the appearance of each of his works, everything that could and should have been said about him, was, by the great clairvoyants that do honor to French art criticism: Thoré, Paul de Saint-Victor, Théophile Gautier, Théophile Silvestre, Gustave Planche, Charles Blanc, Paul Mantz, Ernest Chesneau, and a number of others. We will not, then, attempt to add our own note to this concert of praise but rather—an easier, simpler task—try to summarize it.

Eugène Delacroix is one of those extraordinary individuals in the history of art who, standing outside all traditions, imitating no one, leaving no imitators behind, discover, invent a new "canon" of the beautiful.[23]

Misunderstood during his lifetime, perhaps ill served by the excessive praise of overzealous admirers, Delacroix, from the end of the nineteenth century, became for many artists the guarantor of painting at its most vibrant. The Impressionists and Symbolists aside, Matisse and Rouault, Dufy and Bonnard, the Cubists and the Expressionists, the Tachistes and abstract painters are all indebted in varying degrees to his work, in which they admired, beyond its imperfections, a quest for the absolute:

Woe to he who sees only a specific idea in a beautiful painting, and woe to the painting that shows nothing beyond finish to a man blessed with imagination. The merit of a painting is undefinable: it is precisely that which escapes specification: in a word, it is that which the soul has added to colors and lines so as to reach the soul. Line and color, in their precise meaning, are crude words like the crude texts on which the Italians embroider their music. Painting is, without contradiction, of all the arts the one that makes the most material impression in the hands of vulgar artists, and I maintain that it is the one that great artists can take farthest toward the obscure wellsprings of our most sublime emotions, from which we receive those mysterious shocks that our souls, somehow disengaged from earthly ties and sequestered in what is most immaterial about them, receive almost unawares.[24]

1. Théophile Gautier, "Eugène Delacroix," *Le Moniteur universel*, November 18, 1864; reprinted in *Correspondances esthétiques sur Delacroix, Charles Baudelaire, Théophile Gautier, Classiques* (Paris: Editions Olbia, 1998), p. 158.

2. Paul Jamot, preface to 1930, Paris.

3. Tourneux, 1886, p. 7.

4. Delécluze, 1822.

5. Vignon, 1853.

6. Perrier, 1855.

7. Mantz, 1855.

8. Mantz, 1885.

9. Decamps, 1838.

10. Gautier, 1851.

11. Clément de Ris, 1851.

12. Gautier, 1841.

13. Clément de Ris, 1857, pp. 414–24.

14. *Correspondance,* vol. 4, pp. 363, 365.

15. Du Camp, 1859.

16. Rousseau, 1859.

17. Chesneau, 1859.

18. Dumas, 1859.

19. Burty, 1878, vol. 2, pp. 213, 217; *Correspondance,* vol. 4, pp. 97, 111.

20. Baudelaire, 1863; quoted in *The Painter of Modern Life and Other Essays,* translated and edited by Jonathan Mayne (London: Phaidon, 1964), pp. 45–46.

21. Lagrange, 1864, p. 630.

22. Delaborde, 1876.

23. Ponsonailhe, 1885.

24. Supplement to the *Journal,* undated, pp. 850–51.

EUGÈNE DELACROIX: THE STATE, COLLECTORS, AND DEALERS

Vincent Pomarède

Contrary to the powerful imagery imposed by a reductive and fictionalized conception of the history of art, pictorial genius is not systematically premised on a resistance to social norms and a rejection of material preoccupations; artistic creation, while it indeed implies a certain moral anguish and at least a degree of physical exertion, no more necessarily entails marginality than does an absence of altruism. Without harking back to medieval and monarchical periods, during which artists always operated within an artisanal framework or were associated with a center of ecclesiastical or political power, modern art historians have long since demonstrated that this supposed deliberate break on the part of the artist with the social, professional, and institutional matrices of his period is a decidedly recent phenomenon—if, in fact, it exists at all—that is often identified, mistakenly, with Romanticism.

Despite the myth of the *artiste maudit* (the "cursed" or "damned" artist), which in fact applies only to a few rare creatures at the beginning of the present century, art history has carefully analyzed the importance of the complex ties existing between painters, the art market, and the economic circles that ensure their survival. The study of artists' financial practices and "commercial" dealings with their professional partners—amateurs, dealers, and public commissioning agencies—is no longer considered iconoclastic: on the contrary, it provides specific explanations for some of their aesthetic choices and often accounts for a work's very genesis. An understanding of how an artist organizes the material aspect of his craft and of the relationships he sustains with his social and professional environment, like the study of his aesthetic conceptions and the attentive examination of his works, now seems indispensable.

Knowledge of the financial and material circumstances of Eugène Delacroix at each stage of his life, augmented by historical and archival research into his relations with collectors and dealers, is especially essential, for his personality, indissolubly and sometimes caricaturally linked with Romanticism (at least during the first phase of his career), has often been described as that of a solitary figure, even a rebel, imperiously and disdainfully rejecting material concerns as well as concessions of the kind pervasive in the artistic circles of his day. Thus the historian is obliged to sift legend from established fact, the better to approach the reality of the painter's personal choices in his life and career.

It is true that the patient work of André Joubin from the beginning of the century, coupled with his preparation of an annotated edition of Delacroix's *Journal,* made it possible to reconstruct the fortunes of the Delacroix family, revealing the poverty of the painter's early years,[1] his bohemian life in the studio of Pierre-Narcisse Guérin (1774–1833), and his constant quest for financial resources, all of which seemed to confirm his legendary Romantic image. Later, however, the publications of Maurice Sérullaz, then those of Lee Johnson, which provided the historical specifics of each of his works, restored the author of *The Barque of Dante* to the heart of the institutional and commercial art world of his period,[2] clarifying as well his dependence on public commissions, his complex relations with a few dealers, and his pliancy before the taste of some collectors. There can no longer be any doubt that Delacroix's youth of destitution and need was succeeded by a rather profitable career. The appearance of the painter's estate inventory, an indispensable tool for analysis of his fortunes and its centers of interest, published by Henriette Bessis,[3] also led to a reconstitution of the social position of a man who enjoyed, at the end of his career, a comfortable and regular way of life identical to that of the bourgeois of his day. Gradually, the image of an exacting and ambitious professional desirous of achieving social success through his craft has imposed itself, and we have been able to discover a character that was occasionally opportunistic, perfectly capable of exploiting friends in high places as well as professional ties with the commercial world: in short, an artist at odds with received ideas, one for whom the creative imagination was not incompatible with a certain material well-being and with economic compromise.

However, despite these essential and well-documented art historical contributions, which have complicated our image of the painter and enriched our understanding of his social context, the perception of Delacroix as a misanthropic creator who rejected the inherent constraints of his profession and his century tenaciously remains. In the eyes of posterity, Delacroix is above all the painter of *The Death of Sardanapalus* (1827–28, Musée du Louvre, Paris), thus a Romantic and a rebel whom it is difficult to imagine keeping meticulous daily accounts, investing in the stock market, and courting the powerful in hopes of obtaining commissions for decorative schemes in public buildings. Yet this reputedly somber and antisocial creator managed to seduce and convince the bureaucrats in the administration of the Beaux-Arts, to negotiate the subjects of his works with dealers, and even to be elected to the Institut by his peers, though only after numerous attempts.

It is true that the artist himself sometimes maintained an ambiguous stance with regard to his apparent lack of interest in material things, declaring with panache in his *Journal* in 1824, for example:

> What will be my fate? Without fortune and no aptitude for acquiring one, much too indolent when it's a question of bestirring myself to such a purpose, although periodically uneasy about the outcome of it all. When one is prosperous, one doesn't take any pleasure in being so; when one isn't, one misses the delights that prosperity provides. But as long as my imagination continues to be my torment and my pleasure, what matter prosperity or the lack of it? It's a concern, but not the greatest one.[4]

In addition, solitude appears during his youth like a veritable obsession, one that attracted him in his role as creator as well as by generational reflex, but one that also frightened him. This has led some authors to the mistaken conclusion that he spontaneously fled worldly pleasures as well as professional and social obligations:

What torments my soul is its solitude. The more it expands among friends and everyday pleasures, the more, it seems to me, it eludes me and withdraws into its inner fortress. The poet who lives in solitude but produces much is the one who possesses the treasures that we carry within our breast, but that forsake us when we give ourselves to others.[5]

However, in the same period, dreaming of a restorative trip to exotic Egypt, as "living is cheaper out there," we already see him tempering his attraction for Romantic excesses and his apparent lack of interest in material possessions, and analyzing the dependence entailed by his poverty, adding bitterly: "Is it living to vegetate like a mushroom attached to a rotted tree trunk?"[6]

It is not difficult to understand why the painter did not retain fond memories of this difficult period of his apprenticeship, between 1819 and 1822. Before mastering his professional life and gaining access to various profitable markets, he experienced an adolescence and youth that in many respects resembled the bohemian lifestyle later identified with the Romantic spirit of 1830, one based to some extent, of course, on a rejection of convention, but also on deprivation and material anxieties.

His father, Charles Delacroix (1741–1805), a diplomat, minister of foreign affairs under the Directoire, then Prefect of the Bouches-du-Rhône and the Gironde under the Empire, amassed a considerable fortune, estimated at his death at more than 800,000 francs[7] and invested for the most part in real estate.[8] Having grown up in the luxurious State residences made available to his father as a prerequisite of his administrative and political posts, and having benefited in his youth from the latter's considerable financial resources, the young man discovered the extent of his family's bankruptcy only upon the death of his mother, when he was just emerging from adolescence.

In effect, in 1805 the estate of his father revealed, on the one hand, a large debt—almost 175,000 francs—owed by his associate and legal agent Jean-Pierre Louis Boucher, an unscrupulous, not to say shady, businessman who was later imprisoned, and, on the other hand, the ill-considered investments that the two men had made. By way of security for Boucher's debt, Delacroix's mother accepted a mortgage on his property,[9] notably the immense forest of Boixe, near Angoulême. But the speculator had never really paid for these various holdings, which in any event proved less valuable than had been claimed; over a period of a few years the fortune of the Delacroix family simply vanished, disappearing as suddenly as it had been acquired. At her death in 1814, Madame Delacroix was ruined, her sole means of support at the time being her late husband's government pension of 2,400 francs and an annuity of 2,000 francs provided by a tobacco shop in Aix-la-Chapelle for which she held the license.

This situation profoundly marked the painter, who throughout his life remained literally anguished by the possibility of a reversal of fortune and poor financial investments, and was always animated by a veritable quest for material stability. Raymond de Verninac (1762–1822), diplomat and prefect, the painter's brother-in-law (having married his elder sister, Henriette), assumed, from the death of his mother until he attained his majority in 1819, material and financial responsibility for Delacroix, then a student at the Lycée Impérial; he lived with the couple at 114, rue de l'Université. Throughout this period, Raymond de Verninac kept a careful accounting of the minor's expenses:[10] his records tell us that each month the adolescent received 100 francs for food and 12 francs of pocket money, and that he took courses in drawing and guitar at the Lycée, his passions for painting and music having already manifested themselves. Beginning in 1816, Raymond de

Verninac increased the young man's allotment by 96 francs, needed to cover four months' teaching in the studio of Pierre-Narcisse Guérin. André Joubin calculated that the average annual expenses of the young Delacroix during this period of his life came to roughly 1,800 francs, inclusive of the Guérin studio fees.[11] While the young man could not have led an extravagant lifestyle on such a sum, neither would he have been obliged to deprive himself.

On April 26, 1819, when he came into his majority, his brother-in-law provided him with a detailed accounting of income and expenses relating to the estate of Madame Delacroix, from which monies required for the young man's education had been deducted: it listed 70,319 francs of income from various sources but a total of 88,033 francs of expenses incurred after her death. Thus the painter began his career without money, and even with a theoretical debt of 17,712 francs for which he was beholden to Raymond de Verninac.

Beginning in this period—and above all after 1822, when his brother-in-law died—Delacroix increasingly had to provide for himself, and, consequently, to make a living solely from his art.[12] During these few years he surely knew poverty. There can be no doubt that his memories of this period explain his ambiguous attitude toward money and determined his professional ambitions, which led him to do everything possible to obtain commissions and to avoid becoming dependent on any individual protector or dealer. On October 4, 1854, summing up in a few lines his attitude toward money and his carefully gauged choices in the management of his assets—neither luxury nor needless expenditure, but no deprivation and no human, social, or professional dependency—he wrote:

> I understood early on how a certain fortune is indispensable to a man in my position. It would be just as troublesome to have a very large one as to have none at all. Dignity, respect for one's character come only with a certain degree of prosperity. That's what I have learned to appreciate and what is absolutely necessary, much more so than the small comforts provided by a bit of wealth. What comes immediately after this necessity for independence is tranquillity of mind, freedom from those upsets and demeaning expedients entailed by financial difficulties.[13]

In addition, one of the first consequences of the poverty of his youth was that Eugène Delacroix, far from being a profligate in the Romantic mode, was always very thrifty, almost stingy, noting with a near-maniacal precision all his daily expenses in account books or in the notebooks of his *Journal*. One amusing notebook, written between December 31, 1819, and August 26, 1820, is especially telling in this regard:

> On [April] 8 to the tailor for fitting of a pair of pants and two waistcoats, 15 francs. Received a note from the tenant for 500 fr. He owes only 472 francs. Repaid 27 fr. 10 sous to my brother-in-law. Thus, toward all my brother-in-law's money, I will put 50 fr. in my sister's purse. Toward my sister's 65 fr., I paid 44 fr. for her book on botany. I still have to pay 3 fr. postage. He was still due 27 fr. which I had taken for myself; I returned them to him today.[14]

Between 1822 and 1824, many annotations of expenditures appear in the *Journal* as well: "I still have about 240 francs left. Pierret owes me 20 francs. / Today, lunch, eggs and bread 0 fr. 30 / To Bergini 3 fr. / Belot, paints 1 fr. 50 / Dinner 1 fr. 20. Total 6 fr."[15] These expenses were often professional in nature, for example, when he paid for painting supplies and modeling sessions: "Gave Marie Aubry, after Géricault's death 7 or 8 fr. / To the beggar woman who had posed for the study in the cemetery 7 / To old Nassau 5 / To young

Nassau 1.50 / To Jucar 5 / To Émilie Robert, Monday, Sunday, Saturday, February 12, 14, 15, and 16 12."[16]

The recent rediscovery of archives formerly in the possession of Achille Piron[17] (one of the painter's testamentary executors and his residuary legatee) concerning Eugène Delacroix's daily life after 1845 has made it possible to verify that this need to keep daily records of his expenditures was deeply rooted in his personality, for he continued the practice in his last years, though his financial security as well as his fame were by then assured. A small notebook,[18] written this time by the painter's housekeeper, Jenny Le Guillou,[19] provides us with an intimate and touching glimpse of the household's daily expenditures in 1857:

15 [September]		2 [October]	
milk	1.15	*flûte* [long French roll]	1.10
mutton	1.40	milk	0.30
green beans	0.35	butter	1
butter	0.60	veal	1.25
oysters	0.60	rabbit	1
15 L sugar	14.25	chicory for coffee	0.15
2 L mocha	3.60	green beans *mangetout* [*sic*]	0.45
2 L bourbon	3.20	two onions	0.50
12 L lamp-oil	10.20	water	0.29
3 L refined oil	6	3 breads	0.41
Marseille soap	0.95	milk	0.20
liter of vinegar	0.90	beef and vegetables	1.35
sparkling water	0.15	boneless steak	2.25
[etc.]		butter	1
		egg	0.50
		[. . .]	
		Red Peruvian bark	0.45

In addition to anecdotal indications regarding the painter's tastes (he definitely liked oysters!) and information about his odd relationship with his housekeeper ("Given to monsieur. . . . 0.25"), these daily accounts tell us about more than his diet; they also demonstrate that Delacroix lived quite simply, entertaining little during this period (though going out quite often) and budgeting himself with the rigor of a man for whom money was an object of concern and was to be carefully kept track of. He always rented his successive lodgings, including his last apartment on the place Furstenberg, where he moved in December 1857, shortly before making the only real-estate purchase of his life: the small house at Champrosay, which he acquired in 1858.

He managed his expenditures for studio materials in the same spirit. The Piron archives contain professional account books in which he and his assistants entered all purchases made from his usual paint merchant, Étienne-François Haro (1827–1897): canvas, pigment, oils, turpentine, wax, and so forth.

The modest scale of these expenditures and the simplicity of the artist's life should not be allowed to obscure his considerable financial gains from the sale of his work. Public commissions and purchases made by the government as well as by private collectors were in no way hindered by his reputation as a rebellious Romantic (against which

he nonetheless struggled with a will); if anything, the contrary was the case: aside from a five-year period following the scandal of *The Death of Sardanapalus,* clients and patrons, whose numbers rose consistently beginning in 1840, always appreciated his style, soliciting decorative schemes, portraits, and easel paintings. Obviously, his financial resources increased as a result of this professional success and this craze for his work, which astonished even him: "It's like my little vogue with the collectors; they will make me rich after having despised me," he wrote on April 4, 1853,[20] at a time when dealers had already been fighting over his work for several years.

In this regard, Delacroix's handling of his financial affairs and the regular growth of his personal fortune constitute the best evidence of his professional success. Aware of the "commercial" potential of his calling and desirous of making the best of his income, from the moment of his first sales to the State (1822) the painter entrusted the management of his affairs—scarcely demanding at the time—to his friend Jean-Baptiste Pierret, as evidenced by a notarized document now in the Département des Arts Graphiques of the Louvre.[21] But in 1833, when he received the first of several government commissions for monumental decorations, which involved larger sums of money, he asked a businessman, one Lenoble, to manage his holdings. Several entries in the *Journal* record the financial investments, increasingly numerous, made by the painter beginning in 1835 and especially after 1845. In 1847 alone,[22] soon after having been paid for his work at the Palais Bourbon, he invested 2,000 francs in the Banque Laffitte, then acquired 5,000 francs worth of stock through Lenoble and his broker at the time, Monsieur Gavet, an enlightened collector who had married the eldest daughter of one of his cousins.

Subsequently, after one of the most passionate admirers of his work, Adolphe Moreau (1800–1859), became his regular stockbroker, his financial investing accelerated considerably, as recorded in the *Journal:* "Wrote Moreau, authorization enclosed, asking him to sell for me at the Exchange this day: 1° A 4%, 100-year annuity for 3,760 fr. no. 49267, series 3 / 2° An annuity for 900 fr. No. 66509, series 3 / Total: 4,660 fr. / with instructions to buy for me the same day for the sum produced by this sale a 3%, 100-year annuity."[23] Again, the Piron archives provide important information regarding investments in stocks made by the painter through the office of the broker Adolphe Moreau, situated at 129, rue Montmartre. They record buy and sell orders from Delacroix to his broker,[24] attesting to the acquisition of stock in canals in Burgundy[25] and "Lyon" (doubtless the Lyon railroad[26]) as well as 3% annuities.[27] The amounts involved are substantial: in 1856 alone, more than 40,000 francs for stock in the Burgundy canal, a sum presumably earned exclusively from the sale of easel paintings, for he received no payments for public commissions during this period. One transaction involving the purchase of 4,118 shares of a 3% annuity and the sale of shares in a 4% annuity, effected by Adolphe Moreau on December 29, 1858, doubtless at the painter's request, involved no less than 100,000 francs, a considerable sum at the time,[28] and apparently only a portion of the capital that he had invested in the stock market.

Beginning in 1845, the acceleration of these investments evidences a significant increase in his professional activity and painting sales, hence an increasing interest in his work among dealers and collectors, for his productions were his only means of income. Furthermore, the painter had retained from his youth the habit of considering his creations as his only capital, as evidenced, for example, by insurance policies against fire taken out on his various lodgings with the Société d'Assurance Mutuelle Parisienne.[29] Identifying himself as a "history painter," on November 30, 1837, he insured his apartment and studios at 17,

rue des Marais-Saint-Germain for a value of 41,000 francs,[30] only 4,000 francs of which covered his personal effects, furniture, and bibelots, with the remaining 37,000 francs corresponding to his "merchandise," in other words, the unsold paintings kept in his studio:

Studies of tigers	12,000
Natchez	800
Marino Faliero	6,000
Boissy d'Anglas	2,000
Sardanapalus	6,000
Greece	2,000
Saint Sebastian	2,000
Medea	1,800 [etc.]

This list of works provides one of the best illustrations of Delacroix's desire to confer monetary value on his creations, one corresponding to his investment in terms of raw materials and production time as well as to their intrinsic aesthetic merit.

It is true that Delacroix knew precisely how much it cost to execute a given work, for from the start of his career he was sometimes obliged to work solely to ensure his survival: "I'll soon be squeezed for cash. I must work hard," he wrote on April 8, 1824.[31] From time to time, in the best enterprising spirit, he even "worked" clients who might offer him lucrative painting commissions: "I'm trying to warm the chapter and the curates to [the idea of] my making paintings for the church. I prepared a magnificent prospectus which I distributed to them."[32] As a consequence of these efforts, his first public commissions were religious paintings: in 1819, *The Virgin of the Harvest,* executed for the church of Orcemont for the sum of 15 francs (p. 28 fig 1),[33] and, in 1820, *The Triumph of Religion* (cathedral of Ajaccio), a commission he took over from Théodore Géricault, and for which in the end he received 1,500 francs.[34] Thinking he had found in such religious commissions a means of resolving his financial difficulties, the painter also sought the aid of his sister, Henriette de Verninac, writing to request that she intervene on his behalf with the clergy in Angoulême, a city close to her new residence in the Boixe forest: "Might there be some way [to have] the church in Angoulême commission a painting from me? . . . If the city lacks the funds for such an expense, perhaps in the last resort it could ask the Minister of the Interior for one from my hand."[35]

But the diverse payments forthcoming from a few public patrons as well as private ones who, from time to time, asked him to paint portraits for a few sous would not have sufficed to launch the career of Eugène Delacroix if more substantial sales had not made it possible for him to make a decent living from his art and thus emerge from this difficult period. This material security was acquired gradually, thanks in large part to the active support of contemporary art on the part of the governments of Louis XVIII, Charles X, and Louis-Philippe; over the next decade of his career, regular State commissions and purchases brought Delacroix an average of between 2,000 and 4,000 francs annually. Thus Louis XVIII offered 2,000 francs for *The Barque of Dante* in 1822 (Musée du Louvre, Paris), intended for the new Musée Royal du Luxembourg, then 6,000 francs for *The Massacre at Chios* in 1824 (Musée du Louvre, Paris). Despite the scandals provoked by certain of his works at the Salon, during the next twenty years the State was to provide Delacroix with at least one commission or purchase every two years.

Beginning in 1830, the painter—aided by the violent criticism expressed by artistic circles toward his *Death of Sardanapalus*—had understood that he had to distance himself from the Romantic coterie, which fostered ideas that were often too republican for his taste. For several years he had already been visibly wary of the scandals and provocations generated by this small circle of artists and writers, whose intransigent views were at odds with his professional ambitions, and between 1830 and 1840 he drew closer to economic and political circles influential under the July Monarchy, attending on a regular basis exclusive dinner parties as well as theatrical and musical soirees frequented by businessmen and government ministers—in other words, by potential purchasers and patrons. The revolutionary and Bonapartist origins of his family's reputation initially handicapped Delacroix's career; but he regained an aura of legitimacy in monarchical circles in 1832, when his friend Adolphe Thiers, one of the first critics to write about his work in 1822, became Minister of the Interior. Thereafter, the painter revealed a genuine gift for cultivating political protection through his professional and social connections, as in his solid relations, based on reciprocal favors, with the painter Adrien Dauzats (1804–1868), close to those in power during the Restoration, and the ties he developed after 1830 with Frédéric Villot, future curator of paintings at the Musée du Louvre. His political allies were numerous, thanks not only to Adolphe Thiers, whom he continued to frequent, but also to Charles de Mornay (1803–1878), with whom he traveled to North Africa in 1832.

Later, after the reestablishment of the Empire, Delacroix turned to the old friends of his parents and profited unself-consciously from his ties with the emperor and some of his ministers, for example, Achille Fould (1800–1867), whose brother, Benoît Fould, commissioned from him the superb *Ovid Among the Scythians* (cat. 95) and was surely behind the retrospective of Delacroix's work organized on the occasion of the Exposition Universelle of 1855. Some of those close to the emperor played important roles as supporters of the painter, for example, Narcisse Vieillard (1791–1857), the former tutor of Napoleon III's brother and a friend of Delacroix's from his youth, and the duc de Morny, the ruler's famous half-brother. It is also important to recall the crucial support provided by one of the painter's cousins, the lawyer and politician Pierre-Antoine Berryer (1790–1868), a member of the Académie Française, who was quite influential in Parisian political and economic circles.

Delacroix also knew how to turn more discreet support to account, for example, that of the director of the Opéra, Charles-Edmond Duponchel (1795–1868), and of the Bertin family, owners of the *Journal des Débats*, edited first by Monsieur Bertin, painted by Ingres (Musée du Louvre, Paris), then by Édouard Bertin, his son, a talented landscapist and friend of several painters, including Corot. Delacroix likewise made intelligent use of his many female friends, some of whom were the wives or mistresses of "great men": it is worth recalling in particular the urbane and cultivated Pauline Villot; the actress Mademoiselle Mars; the singer Pauline Viardot; Élisabeth Boulanger, who became Madame Cavé, wife of the head of the fine arts division of the Ministry of the Interior; and, above all, his cousin Joséphine de Forget, who fondly helped him recover a place at the center of Bonapartist circles and backed him throughout his campaign to win a seat at the Institut.

It is also amusing to note the trouble the painter took, whenever a new man was appointed director of fine arts at the Ministry of the Interior, to remain on excellent terms with the bureaucrats occupying influential posts—a project in which he was aided by the presence in the ministry of a childhood friend, Jean-Baptiste Pierret, who made his entire

career there. Thus Delacroix made a concerted effort to win the friendship of Frédéric Bourgeois de Mercey (1805–1860), a landscape painter and writer named head of the fine arts section of the Ministry of the Interior in 1840, then director of the Beaux-Arts in 1853, as well as that of Charles Blanc (1813–1882), engraver, writer and art critic, and founder of the *Gazette des Beaux-Arts* in 1859, who held the same post between 1848 and 1850.

These powerful supporters, a strikingly diverse group—as well as the painter's constant presence at literary salons, musical soirees, and society gatherings—gave him ready access to the influential circles of his day, attracting a few private purchasers but, more important, facilitating procurement of large decorative commissions, projects that permitted Delacroix to gratify his ambition to equal the great masters in the history of painting even as they brought him material rewards. Despite the considerable expenditure these enterprises entailed, obliging the painter to buy costly materials and equipment as well as to engage indispensable collaborators, they proved quite lucrative. In 1837 he was paid 35,000 francs for his decorations in the Salon du Roi of the Palais Bourbon, while he received 60,000 francs for his paintings in the library of the same building, completed in 1847, one year after receiving another 30,000 francs for his decorations in the library of the Palais du Luxembourg. And, in the middle of this period of intense activity, he found time to execute, in 1843–44, for the sum of 6,000 francs, a mural of *The Lamentation* in the church of Saint-Denis-du-Saint-Sacrement in Paris (cat. 124 fig. 1).

During the last years of his career, Delacroix continued to pursue such profitable large-scale commissions while selling some of his large canvases to the State. Now quite famous, he also began to receive at this time numerous commissions from collectors and dealers desirous of acquiring easel paintings from his hand. Thus, after 1850, in parallel with the major project of this period, the mural decorations in the chapel of the Saints-Anges in the church of Saint-Sulpice, the execution of reduced replicas of some of his paintings and the creation of works specifically earmarked for the art market was, in fact, a constant occupation. He continued from time to time, though irregularly, however, to receive public commissions—we recall the *Lion Hunt* painted for the government in 1855 (cat. 14)—as well as to sell works to the State and to provincial museums. But after 1850, by contrast with the preceding period of his career, the State was no longer Delacroix's most important client, having been left far behind by Parisian dealers.

In effect, with success, the work of Eugène Delacroix very early attracted collectors who could be described as "institutional," for example, the duc d'Orléans, who in 1830 acquired several important canvases from the painter for his gallery of contemporary art (*Cardinal Richelieu Saying Mass,* which disappeared in 1848; *The Murder of the Bishop of Liège,* Musée du Louvre, Paris; *Jewish Wedding in Morocco,* Musée du Louvre, Paris; *The Prisoner of Chillon,* Musée du Louvre, Paris); the duchesse de Berry, with whom Delacroix never reached agreement about the price for *King Jean at the Battle of Poitiers* (Musée du Louvre, Paris), and the duc de Fitz-James, who acquired the superb *Milton and His Daughters* from the Salon of 1827–28. By nature close to those in power, these members of the royal family and these nobles who again flourished under the Restoration and the July Monarchy served as links between Delacroix and the State. Collectors in their own right, they also helped him in some of his dealings with officialdom. Certainly belonging to this group were the influential financier Benjamin Delessert (1773–1847), who entertained him frequently and who periodically sought to acquire his work,[36] and, quite obviously, the comte de Mornay, who commissioned and bought several paintings from him, including *Arab Cavalry Practicing a Charge* (1832, Musée Fabre, Montpellier),

Apartment Interior with Two Portraits,[37] and *Cleopatra and the Peasant* (1839, The William Hayes Ackland Memorial Art Center, Chapel Hill). The two men later had a definitive falling out, the diplomat having sold at auction, on January 19, 1850, without Delacroix's authorization, some works by him that he had not yet paid for.[38] We should also mention among the collectors close to power the members of the Arago family, Étienne (1802–1892) and Emmanuel (1812–1896), as well as several bankers: Charles Edwards, and the brothers Isaac Péreire (1806–1880) and Jacob Péreire (1800–1875), the last of whom acquired at an exorbitant price, in 1862, a replica of the *Medea* exhibited at the Salon of 1838 (Musée du Louvre, Paris; p. 29 fig. 3).

Certain paintings by Delacroix naturally found takers—sometimes at top prices, sometimes as gifts or through mutual exchange—among the artists, writers, and collectors in his intimate circle. Baron Louis-Auguste Schwiter (1809–1865), a childhood friend of the painter and one of his testamentary executors, commissioned him to paint his portrait in 1826 (National Gallery, London). Another of the painter's future testamentary executors, baron Charles Rivet (1800–1872), a politician and deputy, owned several canvases by him, including an oil sketch for *The Death of Sardanapalus* (1827–28, Musée du Louvre, Paris). Likewise, Frédéric Villot (1809–1875), a painter, an engraver, and an art historian who was appointed curator of paintings at the Louvre in 1848, solicited a portrait from him and collected other works as well, for example, *The Murder of the Bishop of Liège* (1831, Musée du Louvre, Paris) and *The Death of Ophelia* (1838, Neue Pinakothek, Munich). Several painters, including Paul Huet, Philippe Rousseau, Henri Lehmann, Narcisse Diaz de la Peña, Adrien Dauzats, and Constant Troyon (cats. 7 and 118), also owned canvases by him. One of his most passionate collectors, his paint merchant, Étienne-François Haro, possessed major works by Delacroix, beginning with *The Death of Sardanapalus, The Sybil with the Golden Bough, Demosthenes Declaiming at the Seashore,* and *The Four Seasons* (cats. 151 to 154), acquired at the painter's posthumous sale. A few friends belonging to the Romantic generation continued to admire the painter's work after he had distanced himself from their movement. The elder Alexandre Dumas, for example, acquired several works, including a *Christ on the Cross* (cat. 119), purchased in 1845, and *Hamlet and the Body of Polonius* (1855, Musée des Beaux-Arts, Reims), for which he paid 1,000 francs around 1855, while the younger Alexandre Dumas owned *Tasso in the Hospital of Saint Anna* (1830, Oskar Reinhart Collection, Winterthur). The writer, poet, and critic Auguste Vacquerie (1819–1895), a friend and admirer of Victor Hugo, also acquired several fine canvases by Delacroix, including *Woman Combing Her Hair,*[39] *The Good Samaritan* (cat. 109), as well as several drawings and watercolors.[40]

Increasingly, however, people outside this small circle of friends and powerful allies began to admire his work; many collectors, sensing the painter's importance in the art of his time or seeking solid investments, strove to acquire the paintings he exhibited at the Salon or commissioned original compositions from him. During the final years of his career, foreigners, too, assiduously frequented the painter; the Polish archeologist and collector count Tyszkiewicz swept up *Castaways in a Ship's Boat* (Pushkin Museum, Moscow) for 550 francs in 1847,[41] while count Grzymala, a close friend of Frédéric Chopin, acquired several pictures directly from the painter (see cat. 116). Some of these foreign collectors, attracted by his celebrity, arrived at his studio without warning, for example, the Dutchman Théodore de Geloës in 1847, who bought *The Lamentation* (cat. 125) for 2,000 francs,[42] then haggled with him to obtain *Daniel in the Lions' Den* (1849, Musée Fabre, Montpellier) for 1,000 francs, a portrait of the collector Alfred Bruyas for the same price,

and a portrait of the actor François-Joseph Talma (1763–1826) for 1,500 francs.[43] That same year there also appeared at his doorstep an enlightened collector of contemporary painting from Antwerp:

> M. Van Isaker came to ask me what paintings I had for sale. The *Christ* [cat. 120] and the *Odalisque* suited him. I showed him *The Women of Algiers* and the *Lion with Dead Hunter* in progress; he took the first one for fifteen hundred. M. Van Isaker from Antwerp;—in Paris, rue d'Amsterdam, 29. I am to let him know when it's finished.[44]

The *Tiger Hunt* in the Musée d'Orsay, Paris (cat. 11), serves as a reminder of the important collection of the Brussels stockbroker Prosper Crabbe, which included this masterpiece of Delacroix's maturity.

In addition to the increasingly numerous occasional purchasers, with whom the painter's relations were exclusively commercial and with whom he often drove a hard bargain, there were a few "faithful" who collected works by Delacroix on a regular basis, obtaining them either directly from him or from the dealers who, after 1850, managed to wrest most of his production from him. Thus J. P. Bonnet acquired a few key works from the painter, for example, *Marfisa and Pinabello's Lady* (cat. 87), a reduced replica of the *Entry of the Crusaders into Constantinople* (cat. 88), and one of the reductions of the ceiling of the Galerie d'Apollon in the Louvre (see cat. 64); and the businessman John Wilson acquired in 1845, for 6,000 francs, the legendary *Death of Sardanapalus*. These appealing figures clearly understood Delacroix's aims and collected his work without hoping to gain from it. Sales held during the artist's lifetime also proved a regular draw for a few collectors who are less well known: Davin, Collot, or Henri Didier, who bought several of his most important paintings.

Finally, it would be unforgivable to omit among passionate admirers of the painter's work his stockbroker, Adolphe Moreau, who over a period of twenty-one years put together one of the most beautiful ensembles of paintings by Delacroix, including several masterpieces, most of which were donated to the Louvre in 1906 by his grandson, Étienne Moreau-Nélaton: *Seated Turk in a Red Mantle, Turk Seated by a Saddle, The Shipwreck of Don Juan, Jewish Musicians from Mogador, Reclining Odalisque, Still Life with Lobsters,* the reduced replica of the *Crusaders* (cat. 88), and *The Prisoner of Chillon* (all of these paintings are now in the Musée du Louvre, Paris), as well as a few canvases later sold by his son: *The Lamentation* (cat. 126), *Perseus and Andromeda* (cat. 67), and *African Pirates Abducting a Young Woman* (Musée du Louvre, Paris).[45]

The provenances of the works owned by Adolphe Moreau, acquired for the most part between 1843 and 1854, point to the increasing importance of the role played by dealers in this period of Delacroix's career. Some ten picture dealers, profiting from the painter's celebrity and rising prices, became obligatory intermediaries for collectors. Adolphe Moreau, who was in constant contact with the painter and easily could have obtained works directly from the studio, did not do so, whether out of delicacy (to avoid obliging Delacroix to haggle over prices) or because the most interesting ones were already on the art market, available either at public auction[46] or at galleries: Durand-Ruel (*Turk Seated by a Saddle*), Chéradame (*The Shipwreck of Don Juan*), and Weill (*The Lamentation, Reclining Odalisque, View of Tangier,* and *African Pirates Abducting a Young Woman*).[47]

Delacroix's earliest dealings with picture dealers date from his youth, when the profession was poorly organized: in 1829, for example, *Woman with Parrot* (Musée des Beaux-

Arts, Lyon) was sold by the "expert" Francis Petit, the same man who was to oversee the painter's posthumous sale in 1864. But dealers did not develop a serious interest in his work until after 1850. At that time they began to acquire his work from the Salon and at public auction, but they also did not hesitate to commission treatments of specific subjects from him (animal paintings, Oriental themes, religious subjects), thereby attracting collectors who coveted replicas of works exhibited at the Salon or variants of his most successful compositions. Several dealers vied among themselves for the artist's productions, paying regular visits to his studio and contracting for paintings with predetermined subjects, something that Delacroix seems always to have accepted, despite the obvious creative constraints entailed by such arrangements.

Furthermore, dealers contributed to the gradual rise in the prices that his canvases could command,[48] and the large sums that they spent acquiring works by him prove just how certain they were of being able to resell them without difficulty. Thus, in 1849 Weill sold *The Lamentation* (cat. 126) to Adolphe Moreau for 205 francs, but in 1856 *Clorinda Rescues Olindo and Sofronia* (Neue Pinakothek, Munich) cost him 2,000 francs. And while the dealer Lefebvre, on March 13, 1849,[49] managed to acquire an *Odalisque* and a *Lion Hunt* for 150 francs each, Vaisse had to spend 2,500 francs for the *Lion Hunt* in Chicago (cat. 23) in 1860 and Durand-Ruel 4,700 francs for the one in Boston (cat. 21) on March 30, 1863, when prices for the painter's work reached a peak a few months before his death.

In any event, Delacroix seems to have remained on excellent terms with the dealers who competed with one another for his work: whether through professionalism or friendship—surely also out of personal interest—he tried not to refuse their requests, even when they asked for the third or fourth version of a theme he had illustrated previously or exhibited at the Salon. Thus the painter, who in 1847 had sold to Beugniet, one of his principal purchasers, the ravishing *Lélia*[50] for only 150 francs, agreed to deliver to him in 1853 replicas of *Christ on the Cross* (cat. 123), *Christ on the Sea of Galilee* (cat. 118), and one of his countless depictions of lions attacking their prey, *Lion Seizing a Wild Boar* (Musée du Louvre, Paris). Beugniet, who was to pay 1,000 francs for *Christ on the Cross* and *Lion Seizing a Wild Boar,* had also stipulated their dimensions ("toile de 6 pour le Christ"), doubtless because he already had a purchaser.

Two other dealers, Weill and Georges Thomas, were among the most regular purchasers of Delacroix's work, sometimes acquiring several canvases in a single transaction, all to be delivered at a specified date. Weill, who owned *The Bride of Abydos* (cat. 84), possibly *The Fanatics of Tangier* (cat. 104), *Arabs Stalking a Lion* (cat. 10), and *Tiger Hunt* (cat. 11), claimed that same day, March 21, 1849,[51] four works by the master commissioned several months earlier: *Odalisque* (200 francs), *Men Playing Chess* (200 francs), *Lion Mauling a Dead Arab* (500 francs; Nasjonalgalleriet, Oslo), and *Berlichingen Writing His Memoirs* (100 francs). Delacroix, who kept his professional records as meticulously as his household accounts, noted the status of each agreement with a client: "February 1, received from Weill, against my fee of 1,500 fr., 500 [francs] . . . April 4, received from Weill a second payment of 500 fr."[52] He likewise listed the works involved in each of these transactions: "1st deal with Weill: *View of Tangier / Orange Seller / Saint Thomas / The Bride of Abydos.* 1,500 [francs] / From Weill: I received against the account of February 1, on delivery to him of the *View of Tangier with Two Seated Arabs* [cat. 100] 500 [francs] / Since, he asked me for *Saint Sebastian* 500 [francs]."[53] He was just as meticulous about his commissions for Thomas:[54] "Agreement with Thomas: *Desdemona Cursed by Her Father* 400 fr / *Ophelia in the Stream* 700 / *Two Lions* on the same canvas

500/ *Michelangelo in His Studio* 500 / 2,100 fr. / (in April) *Desdemona in Her Bedroom* 500 fr."⁵⁵ Although he was then working on a decorative scheme for the Salon de la Paix in the Hôtel de Ville in Paris, he also managed to find time to prepare three important paintings for the Salon of 1853. Despite this heavy workload, none of these canvases—all delivered on time—were uninspired, and several must be numbered among the painter's best and most poetic works from the period—*Desdemona Cursed by Her Father, The Bride of Abydos* (cat. 84), and *Michelangelo in His Studio* (Musée Fabre, Montpellier).

The archives of Achille Piron, which include the painter's correspondence with several of his dealers, provide lively and convincing proof of the courteous professional relations that the painter maintained with his clients, even during negotiations for sales and commissions. These documents confirm that Delacroix was perfectly willing to make numerous concessions relating not only to format and technique but also to subject, which was often specified, and even concerning iconography, as evidenced by an astonishing exchange of letters concerning *Bathers,* or *Turkish Women Bathing* (see cat. 102), in which the patron dictated not only the subject and disposition of the figures but also the style, which was to emulate that of other contemporary painters. While unhappy with such conditions, Delacroix nonetheless followed his client's recommendations, just as he later indulged the whims of the patron when working on the commission for *The Four Seasons* (cats. 151 to 154).

Having mastered perfectly the rhythm of his deliveries to dealers, and profiting, not without delight, in this belated success avenging the trials of his youthful years, Eugène Delacroix managed, with remarkable efficiency and tact, to maintain a balance between the art market—which clamored for copies, replicas, and recensions—and his own inspiration, which frequently led him, especially in his last years, to revisit aesthetic experiments from his youth. Like all great artists, he succeeded in reconciling the development of his art with constraints external to his creativity, whether these were by nature technical and architectural, as in the decorative commissions, or commercial, as in commissions from dealers for groups of paintings. While managing to seduce and convince institutional patrons, dealers, and collectors, he nonetheless did not betray his convictions: like the masters he strove to emulate, he was obliged to negotiate the contradictions entailed by political and religious pressures, the realities of the art market, and the taste of the collectors of his time.

Far from being a rebellious and marginal painter, Delacroix demonstrated an obvious pragmatism and a rare grasp of the professional framework of his period. He seems to have made his own a maxim that he entered in his *Journal* in 1823, part career-development plan and part organizational principle designed to foster the desired balance between his intense personal creativity and the constraints entailed by his relations with the art market: "The habit of order in ideas is for you the only road to happiness; and to attain it, be orderly in everything, even in the smallest details."⁵⁶

1. Joubin, 1933, pp. 173–86.

2. On this subject, in addition to the indispensable works by Maurice Sérullaz and Lee Johnson cited frequently in this catalogue [M. Sérullaz, 1963(a) and (b); and Johnson, 1981–89], we would like to mention the interesting biography published by Maurice Sérullaz in 1989, an attempt to reinscribe the painter within the historical and artistic context of his time (M. Sérullaz, 1989).

3. Bessis, 1969, pp. 199–222.

4. *Journal,* June 6, 1824, p. 85 (see Norton, 1951, pp. 44–45).

5. *Journal,* May 14, 1824, p. 81 (see Norton, 1951, p. 40).

6. *Journal,* April 20, 1824, p. 69 (see Norton, 1951, p. 33).

7. Figure advanced by André Joubin, 1933, p. 177.

8. During his period of employment at the Commission d'Aliénation des Biens Nationaux, Charles Delacroix would have been extremely well placed to keep track of developments in the Parisian real-estate market.

9. According to Joubin, 1933, p. 178, Boucher's holdings consisted of a domain at Vassy, the Hôtel de Bazancourt in Paris, 5,500 square meters along the Champs-Elysées,

and many other tracts of land. He also owned the forests of Boixe and the Madeleine, both near Angoulême.

10. Joubin, 1933, pp. 181–82: between September 4, 1814, when he took charge of Delacroix's affairs, and August 1, 1815, for example, Raymond de Verninac spent 1,378 francs on his account.

11. Joubin, 1933, p. 184.

12. His sister and brother-in-law, likewise all but ruined, left Paris and settled in a house situated within the forest of Boixe, which they tried to turn into a source of income. At his death, Raymond de Verninac was encumbered by debts amounting to 50,000 francs.

13. *Journal,* October 4, 1854, pp. 479–80 (see Norton, 1951, p. 260).

14. This account book is published as an appendix in Joubin's edition of the *Journal* (pp. 810–14).

15. *Journal,* April 9, 1824 (Norton, 1951, p. 29).

16. *Journal,* February 17, 1824 (Pach, 1937, p. 63).

17. This large archive was auctioned on December 6, 1997, at the Hôtel des Ventes of the Théâtre de Caen by Tancrède and Lô Dumont, associated auctioneers (Alliances Enchères). The French government, acting through various agencies concerned with the national patrimony, succeeded in acquiring a considerable portion of it.

18. Archives Piron, Archives des Musées Nationaux, Paris.

19. To cite two examples, the painter gave Jenny Le Guillou 288 francs to cover daily expenses in September (of which 1 franc went unspent) and 170 francs for the month of October (of which 9.24 francs went unspent).

20. *Journal,* April 4, 1853, p. 326 (see Norton, 1951, p. 171).

21. Département des Arts Graphiques, Musée du Louvre, Paris, document notarized October 17, 1831 (AR19 L57).

22. "Given to Lenoble 1,000 francs to buy [shares in] the Lyon railroad, plus 2,000 francs to place with Laffitte" (*Journal,* April 4, 1847, p. 148).

"Ask Lenoble about the shares in Lyon that he bought me several months ago" (*Journal,* April 4, 1847, p. 148).

"Given to Lenoble 4,000 francs to buy three canals shares and make the payment for shares in the North[ern railroad]" (*Journal,* August 24, 1847, p. 161).

"Lenoble obtains fourteen shares in Lyon and six in the North to make the payments. Since the shares will henceforth belong to the bearer, he will have them held in my name at the brokerage firm" (*Journal,* September 24, 1847, p. 164).

"Lenoble brought me the fourteen shares in the Lyon railroad that he had to leave at the firm of the broker, M. Gavet, since they belong to the bearer" (*Journal,* October 29, 1847, p. 167).

23. *Journal,* December 29, 1858, p. 734.

24. Archives Piron, Archives des Musées Nationaux, Paris.

25. The Archives Piron preserve several purchase orders for shares in the Burgundy canals:

October 29, 1855: 6 shares in the Burgundy canals at 955 francs each, total cost 5,730 francs;

February 12, 1856 (delivered February 23): 16 shares in the Burgundy canals at 975 francs, total cost 15,600 francs;

March 24, 1856: 16 shares in the Burgundy canals at 975 francs each, total cost 15,600 francs;

February 19, 1857: 4 shares in the Burgundy canals at 950 francs each, total cost 3,800 francs.

26. The Archives Piron document the following stock purchases:

April 9, 1861: 12 Lyon at 948 francs each, total cost 11,392 francs;

March 29, 1861: 20 Lyon at 945.62 francs each, total cost 18,936 francs.

27. On May 1, 1863, the painter purchased a 3% annuity: 3,460 shares at 69.30 francs each, total cost 80,027 francs.

28. The Archives Piron also contain a bearer's warrant (no. 1492) for a 1/10th share (April 1, 1853) in the Union Centrale de la Guadaloupe. There is also a draft of a letter from the painter in which he writes that he had lost a warrant but wishes to reclaim on faith, in the wake of this enterprise's bankruptcy, 2,046 francs from the Caisse du Commerce et d'Industrie.

29. Archives Piron, Archives des Musées Nationaux, Paris.

30. This insurance policy was updated regularly after 1840, as evidenced by various documents in the Archives Piron, Archives des Musées Nationaux, Paris.

31. *Journal,* April 8, 1824, p. 62 (see Norton, 1951, p. 29).

32. Delacroix to Jean-Baptiste Pierret, October 26, 1828, Département des Arts Graphiques, Musée du Louvre, Paris, AR18L28.

33. The painter later told Achille Piron that he was all but penniless when he received this commission for a work in the manner of Raphael from a "patron fallen from the sky."

34. The comte de Forbin commissioned this work, intended for the convent of the Dames du Sacré-Coeur in Nantes, from Géricault in 1819. Unable to execute it, the painter of *The Raft of the Medusa* surreptitiously passed it on to his young colleague, who painted it anonymously.

35. *Correspondance,* vol. 5, p. 137.

36. Included in the Archives Piron is an undated letter from Benjamin Delessert to Delacroix in which the financier queries him about works available for sale: "Monsieur, would you be so kind as to tell me whether your painting of Lara, as yet unfinished, is still at your disposal and, if so, whether you would regret parting with it? I would also like to know whether your painting of Marino Faliero is still in your possession and, if so, whether you would be amenable to letting go of it one day" (Archives Piron, Archives des Musées Nationaux, Paris).

37. Destroyed by fire in 1914; Johnson, 1986, vol. 3, no. 220, pl. 41.

38. The comte de Mornay disposed of seven paintings by Delacroix at this sale: *Charles V at the Tomb of Saint-Just, Cleopatra and the Peasant, Combat of a Giaour and Hassan,*

The Women of Algiers, Jewish Family, and *Raphael in His Studio.*

39. Location unknown; Johnson, 1986, vol. 3, no. 168, pl. 5.

40. Pierre Georgel has published an amply documented article about the relations between Delacroix and Auguste Vacquerie (*Bulletin de la Société de l'histoire de l'art français,* 1968, pp. 163–89).

41. *Journal,* May 26, 1847, p. 157.

42. "Then M. de Geloës, who came to ask me for the *Christ* or *The Lifeboat.* After entering my studio, he asked me for the *Christ at the Tomb,* and we agreed to [a price of] 2,000 francs without the frame. M. le comte Théodore de Geloës d'Elsloo, at the château d'Osen, near Rocremond, Dutch Limbourg" (*Journal,* April 28, 1847, p. 150).

43. *Journal,* undated, following November 30, 1852, p. 317.

44. *Journal,* March 16, 1847, p. 144.

45. On the relations between Delacroix and Adolphe Moreau, see the contributions by Arlette Sérullaz, François Fossier, and Vincent Pomarède in the catalogue of the exhibition held in 1991 at the Galeries Nationales du Grand Palais in Paris: *De Corot aux impressionnistes, donations Moreau-Nélaton* (Paris: Réunion des Musées Nationaux, 1991).

46. Adolphe Moreau acquired *Seated Turk in a Red Mantle* at the Mennemare sale in February 1843, the replica of the *Crusaders* at the Bonnet sale in March 1853, *The Prisoner of Chillon* at the duchesse d'Orléans sale in January 1853, and *Perseus and Andromeda* at the Henri Didier sale in December 1854. *Still Life with Lobsters* was purchased directly from the painter Philippe Rousseau in March 1853.

47. The provenances of Adolphe Moreau's acquisitions are known to us thanks to account books, partly unpublished, in which he and his son entered their purchases as they were made (still in the possession of the descendants of Étienne Moreau-Nélaton).

48. Maurice Rheims has carefully analyzed fluctuations in the prices for Delacroix's work during his lifetime as well as after his death in an amusing, well-documented text published in 1963: Maurice Rheims, "La Cote de Delacroix," in *Eugène Delacroix* (Paris: Hachette, 1963), pp. 239–53.

49. *Journal,* March 13, 1849, p. 186 (see Norton, 1951, p. 93)

50. Private collection; Johnson, 1986, vol. 3, no. 289, pl. 108.

51. *Journal,* March 21, 1849, p. 186.

52. *Journal,* undated, following November 30, 1852, p. 316.

53. *Journal,* undated, following November 30, 1852, p. 317.

54. Mentions of purchases by Thomas are especially numerous in the *Journal.* He acquired the *Saint George* (Musée des Beaux-Arts, Grenoble) for 400 francs. Then in 1853 he commissioned an *Entombment,* as well as *"Christ on the Mount of Olives* and *Turkish Woman"* for 100 francs each (*Journal,* March 13, 1849; Norton, 1951, p. 93). Later, Delacroix referred to several sales: "December 27, 1852, received from Thomas for a *Small Tiger* 300 fr." (*Journal,* [see note 52 above], p. 316); "March 3, received from Thomas, against my bill for 2,100 fr. 1,000" (*Journal,* p. 316); "April 10, received from Thomas 1,100 (this payment covers the *Lions,* and when I deliver *Desdemona in Her Bedroom* he need give me only 500 fr.)" (*Journal,* p. 316); "May 1, received from Thomas to settle the account (except for the repetition of *Christ at the Tomb*) 500" (*Journal,* p. 316).

55. *Journal,* undated, following November 30, 1852, p. 317.

56. *Journal,* May 16, 1823, p. 35 (see Norton, 1951, p. 12).

Delacroix and America

Joseph J. Rishel

Writing in 1895, the French academician Paul Bourget recalled a visit he made to the collection of James J. Hill in Saint Paul, Minnesota (fig. 1):

> Pictures, pictures everywhere. Corots of the highest beauty, . . . a colossal Courbet, the *Convulsionnaires* of Delacroix, and a view of the coast of Morocco, before which I stood long, as in a dream. I saw this canvas years ago. I have sought for it since in hundreds of public and private museums, finding no book which could inform me who was its present possessor, and I find it here! . . . What ground has this canvas covered between the painter's studio and the gallery of a millionaire of the Western frontier![1]

James J. Hill (1838–1916) had made a great fortune by pressing the railroad through from the Midwest to the state of Washington.[2] His painting collection, begun seriously in 1881, was dominated by French artists: Camille Corot (1796–1875; represented by twenty-two works), Jean-François Millet (1814–1875; seven works), and other members of the Barbizon school. In many respects, his taste was typical of North American collectors of his generation;[3] however, his concentration on Eugène Delacroix—no less than eleven attributed paintings were acquired between 1886 and 1916[4]—was unprecedented, bespeaking an elusive strain in the long history of North America's love and pursuit of French art. The first reference to a work in the United States by Delacroix is in the catalogue of an exhibition held in 1855 at the Pennsylvania Academy of the Fine Arts, Philadelphia. Entitled *Two Fathers,* this as-yet-unlocated work is described as a watercolor "sketch" lent to the show by Hector Tyndale, a collector who owned other Romantic pictures, including Louis-Gabriel-Eugène Isabey's *Wreck on a Stormy Coast* and Alfred Dedreux's *Fighting Horses.*[5] If the attribution in the academy catalogue were correct, this "sketch" would have been the only work by Delacroix exhibited in America during the artist's lifetime; however, a description in *Art Treasures of America* (1878–80) of what was probably the same picture throws doubt on the attribution to Delacroix and suggests the general naïveté of American collectors (and cataloguers) in the 1850s: "a rude and satirical sketch showing a couple of profane monks lolling on a bench and smoking cigarettes beneath a gaunt and agonized crucifix."[6]

One is on firmer ground with the public appearance of a Delacroix at the forty-fifth annual exhibition of the same institution in 1868.[7] This was a *Lion Hunt,* and it can be firmly identified (though in the catalogue entry the artist is called L. Delacroix) as a picture now in the Museum of Fine Arts, Boston (cat. 21).[8] It was lent by Adolphe E. Borie (1809–1880), a Philadelphian who had prospered greatly during the Civil War, like many of the dominant collectors of the next generation. Borie was on particularly close terms with Ulysses S. Grant, who made him secretary of the U. S. Navy, and at the time of the academy exhibition he had become an important public figure in his native city. At his death, Borie owned four paintings by Delacroix, and therefore ranks as the first serious collector of the artist on this side of the Atlantic.[9] His family was Belgian by descent, and while in his late teens, from 1825 to 1828, Borie studied in Paris. It is tempting to speculate that his taste in art dates from those years; although there is no record of what pictures he saw, it is perhaps significant that *The Death of Sardanapalus* (Musée du Louvre, Paris), was displayed in Paris at the Salon of 1827–28.

Fig. 1
James J. Hill House, 240 Summit Avenue, Saint Paul, Minnesota, about 1905. The gallery with its skylight is at the left. From *Homecoming: The Art Collection of James J. Hill,* by Jane H. Hancock, Sheila ffolliott, and Thomas O'Sullivan (Saint Paul: Minnesota Historical Society, 1991), p. 44, fig. 31.

Shortly after Borie's death, the art chronicler Edward Strahan observed that his collection was based on French traditions:

> Various artists who are very, very sparsely represented in America assemble there and seem at home. Three autographs that you seldom see written on canvases hung in salons of the United States are those of Delacroix, of Decamps, and of Millet. In the case of either of these artists, each the inventor of a style, one should have seen a great number of examples before forming a judgement.[10]

As seen from the example of Hill, the "sparse representation" of French artists in American collections in the third quarter of the nineteenth century was quickly rectified; already in January 1872, Henry James reviewed for the *Atlantic Monthly* a large exhibition

of French paintings in Boston "at the rooms of Messrs. Doll and Richards."[11] He chose for special praise *An Arab Camp at Night* (cat. 138) by Delacroix, "a painter whose imaginative impulse begins where that of most painters ends."[12] By 1879, in his defense of American artists, G. W. Sheldon applauded the high price fetched in New York by Frederic Church's *Niagara Falls,* out of the otherwise French-dominated collection of John Taylor Johnson:

> Twelve thousand five hundred dollars . . . and that, too, in a city where buyers of pictures are generally supposed to subscribe to a creed the first and foremost article of which is, I believe, in the transcendent excellence of Parisian art.[13]

In the last quarter of the century, through purchase and inheritance, paintings by Delacroix entered prominent collections in New York, Philadelphia, Baltimore, Saint Paul, Chicago, Montreal, and Boston, until, by 1900, fifty works can be documented in North America.[14]

It would be imprudent to ascribe a pattern of particularly progressive taste to the collectors of Delacroix during those years—as one can, however, characterize Henry and Louisine Havemeyer, the New York couple who were beginning to purchase works by Courbet and Edouard Manet along with the Impressionists, thereby establishing a truly avant-garde American collection of French paintings and significantly shaping American taste.[15] The principal Delacroix collectors of the last decades of the century—William T. Walters (Baltimore); Erwin Davis, L. C. Delmonico, Alfred Corning Clarke, R. Austin Robertson, and George I. Seney (New York); Adolphe E. Borie, John G. Johnson, and H. S. Henry (Philadelphia); Mrs. Potter Palmer (Chicago); and James J. Hill (Saint Paul)—comfortably hung their Delacroix paintings on their walls alongside more conservative (and generally popular) works as well as those by Old Masters.

Attempts have inevitably been made to correlate the taste of these collectors with their social or political opinions. In a survey of modern French painting written in 1868 for the *Atlantic Monthly,* Eugene Benson had already proposed that contemporary French art had an implicit political bias:

> Yesterday, France had Delacroix exercising his genius in the highest realms of imagination, and dedicating his art to the suffering of humanity. . . . Understand well that the epoch of constitutional government and of revolution in France is present in painting by Géricault, Delacroix, Scheffer, Delaroche, Decamps and the overrated Vernet. The Empire is represented by Gérôme, Meissonier, Cabanel, Baudry, Chaplin, Diaz and Hamon.[16]

However, there is no concrete evidence to suggest, for example, that Hill, in his great partiality to Delacroix, reveals strong republican feelings (quite the contrary) or that collectors such as Cornelius Vanderbilt, A. T. Stewart, J. Pierpont Morgan, or Henry Frick—none of whom owned any major works by Delacroix—were particularly imperialistic in their views.

If generalizations can be made about the preferences of the post–Civil War generation of collectors, it is that the richest of the rich favored the most popular French artists of the Second Empire and the Third Republic. In 1876 Stewart paid $80,000 for J.-L.-E. Meissonier's *Friedland,*[17] while *The Death of Sardanapalus* could have been had in 1887 for $30,000.[18]

In the nineteenth century, public institutions as a rule followed the lead of local private collectors who were, in most cases, board members. The first work by Delacroix to enter an American museum was the *Interior of a Dominican Convent in Madrid* (fig. 2), which was purchased in 1894 by the (then Pennsylvania) Museum of Art in Philadelphia at the behest of John G. Johnson. Boston followed suit, buying the Adolphe E. Borie *Lion Hunt* (cat. 21) in 1895 and the large *Lamentation* (cat. 125) in 1896; the Metropolitan Museum of Art in New York purchased *The Abduction of Rebecca* in 1903.[19]

Nearly all the works by Delacroix that entered American collections before 1900 were purchased in New York—during the first decades at Knoedler's, established there as a branch of Goupil, Vibert and Company in 1846,[20] and, beginning in the late 1880s, also at Durand-Ruel's.

Fig. 2
EUGÈNE DELACROIX, *Interior of a Dominican Convent in Madrid,* 1831, oil on canvas, Philadelphia Museum of Art, Purchased with the W. P. Wilstach Fund.

In 1887, in his second attempt to "take" New York, the ambitious French dealer Paul Durand-Ruel provided what could have been a watershed opportunity for Americans to see the work of Delacroix, including *The Death of Sardanapalus.* The occasion was an exhibition entitled *Celebrated Paintings by Great French Masters,* held in May and June of 1887 at the National Academy of Design in New York under the auspices of the American Association for the Promotion and Encouragement of Art. Durand-Ruel was the agent for the exhibition. Prohibitive American taxes imposed on imported works of art (they ranged from ten to thirty percent of their value) forced Durand-Ruel to bring the paintings from Paris into the United States "for exhibition only," under temporary import licenses.[21] Two hundred and fourteen works by artists ranging from Eugène Accard to Eugène Verboeckhoven are listed in the catalogue. Many of the artists were already familiar to American collectors, but startlingly new were the eleven canvases by Claude Monet as well as Édouard Manet's *Execution of the Emperor Maximilian of Mexico.* Delacroix—proclaimed in Ernest Chesneau's introduction to the catalogue as "the greatest, noblest, and most illustrious painter of the French school of the nineteenth century"[22]—was represented

by two works: *Interior of a Dominican Convent in Madrid*, which would find its way to the Philadelphia Museum of Art seven years later (having returned, on account of the tax laws, to France to be reimported) and *The Death of Sardanapalus*. The potential of this colossal canvas to exert significant influence on private and public taste during the two months it was in New York seems remarkable, at least from a late-twentieth-century perspective. Yet, in fact, this extraordinary work received a merely bland and undiscerning, though favorable, response from the critics, as is suggested by a review that appeared in *The Collector* three years after the exhibition closed:

> Mr. Durand-Ruel followed his opening exhibition with a really glorious display of great French art at the National Academy of Design. It came, alas for it and for our public, in a season when the town was nearly dead, but still it sowed some seed in fertile ground. It was here that New York first learned of Puvis de Chavannes and saw the wonderful *Sardanapalus* of Delacroix. It was here, in those sweltering days of early summer, that we were shown Lefebvre's splendid *Diana Surprised,* the nobly symphonic *Eclogue* of Henner, a whole series of the subtle gray harmonies of Eugène Boudin, the *Death of the Bull* by Falguière, a painting by a sculptor worthy of a monument to itself, master-pieces by Gaillard, Huguet's African scenes, like pictures in a mirror, Manet's *Death of Maximilian*, powerful and awful for its inspiring sentiment and its very desperate defiance of every tradition of painting, and many more canvases equally worthy of enumeration, were there with space to spare.[23]

The Death of Sardanapalus had already received a New York review of sorts almost twenty years earlier. Under the heading "Parisian Topics," the *New York Tribune* for May 13, 1872, had printed a brief notice by Henry James of the works he had just seen at Durand-Ruel's:

> [It was] an immense affair, painted in [the artist's] early youth. The subject was not easy, and Delacroix has not solved its difficulties, much of the picture is very bad, even for a neophyte. But here and there a passage is almost masterly, and the whole picture indicates the dawning of a great imagination.[24]

An exhibition in 1889–90, also in New York, had a broader impact on American collecting. It allowed, albeit by exclusion, a clarification of a central thread of French art for an American public in a way the 1887 Academy of Design exhibition did not, in its attempt to reach several levels of sophistication. The American Art Association organized this exhibition to raise funds for a monument to the French animal sculptor Antoine-Louis Barye (1796–1875), which was to be erected behind the cathedral of Notre-Dame on the Île St.-Louis in Paris. The brainchild of William T. Walters of Baltimore and his Paris agent, George Lucas, the exhibition consisted almost entirely of loans from private collections. A large number of works by Barye himself dominated the space at the American Art Galleries; the selection of painters was remarkably restrained but advanced, including J.-F. Millet—whose *Angelus* was the main attraction of the exhibition—Théodore Rousseau, Charles Daubigny, Narcisse Diaz de la Peña, Alexandre-Gabriel Decamps, Camille Corot, Constant Troyon, Jules Dupré, Delacroix, and Géricault. Of the eighteen works by Delacroix in the show, only two were lent by dealers: Cottier and Company and M. Knoedler & Company. The others, from private collections, included two relatively minor works, a *Lion* and a *Tiger* (lent by W. T. Blodgett) and such major works as *Christ on the Cross* (William T. Walters), *The Fanatics of Tangier* (George I. Seney), *The*

Abduction of Rebecca (David C. Lyall, Brooklyn, New York), and the *Combat of the Giaour and Hassan* (Mrs. Potter Palmer, Chicago).[25]

Aside from these early collectors and the institutions they so strongly influenced through their gifts, a quite different level of interest in Delacroix emerged in America among artists and the critics who listened to them. In 1852 an American artist from Schenectady, New York, William James Stillman (1828–1901), established himself in Paris. His career was remarkable, though it was as a critic and journalist rather than as an artist that he distinguished himself.[26] Because he had not been able to secure sound technical training in the United States, and because so few paintings of high quality were available there for aspiring artists to study, Stillman sailed for Europe, attached himself to the atelier of the artist Yvon, and flung himself into the Paris art world. In his autobiography published many years after his student days, Stillman wrote:

> The afternoons of the weekdays were given to the galleries and visiting the studios of the painters whose work attracted me, and who admitted visitors. I thus made the acquaintance of Delacroix, Gérôme, Théodore Rousseau, and by a chance met Delaroche and Ingres; but Delacroix most interested me, and I made an application to him to be received as a pupil, which he in a most amiable manner refused, but he seemed interested in putting me on the right way and gave me such advice as was in the range of casual conversation. I asked him what, in his mind, was the principal defect of modern art, as compared with the ancient, and he replied "the execution." He has endeavored to remedy this in his own case by extensive copying of the old masters, and he showed me many of the copies—passages of different works, apparently made with the object of catching the quality of execution. . . .
>
> Admitting, therefore, as I do that the criticism of Delacroix was just, it is evident that, until we give to the modern student of painting a similar training to that which the early one had, we cannot expect him to attain the executive powers of the Italian Renaissance.[27]

As one can surmise by the direction of his thought, Stillman was deeply immersed in the writings of John Ruskin, who became his close friend and advisor. The young artist's penchant for theory and speculation led him to co-found the first successful American art journal, *The Crayon,* which was published in Boston from 1855 to 1862. The first issue reviewed the Paris Exposition Universelle, which contained a large retrospective of the works of Ingres and Delacroix, and the following excerpt gives some idea of the muddled, puritanical, and wildly overwritten criticism with which the American reader had to contend—theory firmly in advance of experience—but at the same time highly principled and tremendously stirring, particularly for a naïve and eager audience:

> Pictorial art may be divided into four great divisions—The Epic, or elevated teaching; the Ideal; the Instructive; the Informing and Entertaining, whose universal language is the Technical. Under the first, I would class such artists as Kaulbach, Cornelius, Ary Scheffer, Gérôme; under the second, Turner and Delacroix; under the third, Horace Vernet, Gallais, Chas. Muller, and all painters of fact in humanity, or views in landscape; and under the fourth, works of genre and landscape compositions. Nine-tenths of the Exhibition was composed of the last category, whose principal aim seemed the rendering of some picturesque effect, and the mastery of technical difficulties, setting aside some dozen men who alone aim at high Art in its true sense. . . . [Delacroix attempts] to catch and hold in glittering bondage the eye of the multitude . . . with sweeping brush and extended register of palette, fumes, frets and flourishes by the yard, producing vast, brilliant incoherences— wonderful as nightmares of varied color—impressive to erratic imaginations, doubtless—but,

being utterly devoid of form, classical or characteristic, it is a manner likely to produce great mischief among a people clamorous for novelty, and will have a most pernicious tendency over young minds. To be taught that such scenic bewilderment of line, combination, and hue is high Art, must be to the neophyte, the most disastrous of mirages. That it requires great talent, a vigorous, original organization to produce such works, all will admit; but the glare of fever, the frenzy of unrest is so manifest, a mind of healthy tone must turn away from such endeavor with sadness and regret.[28]

At nearly the same moment, two other young Americans arrived in Paris; their response to the city, and to Delacroix, was less moralistic than that of *The Crayon*'s reporter, more sensuous, and more likely to inspire a collector or critic in the next generation back home:

> That particular walk was not prescribed us, yet we appear to have hugged it, across the Champs-Elysées to the river, and so over the nearest bridge and the quays of the left bank to the Rue de Seine, as if it somehow held the secret of our future . . . *such* a stretch of perspective, *such* an intensity of tone as it offered in those days; . . . Art, art, art, don't you see? Learn little gaping pilgrims, what *that* is![29]

The writer, of course, is Henry James, who at the age of thirteen was on his second trip to France with his brother William, one year older, who was determined to be a painter. William James would later be tutored in Newport by the American artist William Morris Hunt (1824–1879) whom Henry was to describe as follows:

> The New Englander of genius, the "Boston painter" whose authority was greatest during the thirty years from 1857 or so, and with whom for a time in the early period W[illiam] J[ames] was to work all devotedly, had prolonged his studies in Paris under the inspiration of Couture and of Edouard Frère; masters in a group completed by three or four of the so finely interesting landscapists of that and the directly previous age, Troyon, Rousseau, Daubigny, even Lambinet and others, and which summed up for the American collector and in New York and Boston markets the idea of the modern in the masterly.[30]

But the brothers soon advanced beyond the teacher:

> For Eugène Delacroix, our next young admiration, though much more intelligently my brother's than mine, that had already taken place and settled, for we were to go on seeing him, and to the end, in firm possession of his crown, and to take even, I think, a harmless pleasure in our sense of having from so far back been sure of it. . . .
>
> I remember [William's] repeatedly laying his hand on Delacroix, whom he found always and everywhere interesting—to the point of trying effects, with charcoal and crayon, . . . They were touched with the ineffable, the inscrutable, and Delacroix in especial with the incalculable; categories these toward which we had even then, by a happy transition, begun to yearn and languish. We were not yet aware of style, though on the way to become so, but were aware of mystery, which indeed was one of its forms.[31]

As James described, William Morris Hunt's influence on his compatriots back in the United States beginning about 1860, both as an artist and a critic, formed a crucial bridge between America and France, although his instruction and criticism were more deeply

steeped in Couture and Millet than Delacroix. It is worth quoting his heated letter to the *Boston Daily Advertiser* in response to the generally unfavorable reception of works by Millet, Rousseau, Troyon, and other French artists represented at the Boston Atheneum:

> The standard of art education is indeed carried to a dizzy height in Harvard University, when such men as Jean François Millet are ranked as triflers. . . . The soil and schools of France within thirty years have shown the world the honored works of Géricault, Delacroix, Ingres, Rousseau, Troyon, Decamps, Meissonier, Regnault, Michel and Gérôme, Corot, Courbet and Couture, Millet and Diaz, Jules Dupré, Baudry, Daubigny, and a hundred others whose earnest work the world can never forget; while those who profess to teach art in our university, with the whisk of the quill undertake to sweep it all into oblivion. The unpardonable conceit of such stuff makes one's blood tingle for shame. . . . It is not worth while to be alarmed about the influence of French art. It would hardly be mortifying if a Millet or a Delacroix should be developed in Boston.[32]

Whereas Hunt was a general transatlantic conduit of things French, John La Farge (1835–1910), his pupil at one time, provided a more direct link with Delacroix. La Farge was the son of a French family that had emigrated to and prospered in the United States. In 1856 he left New York for Paris, where he was welcomed by his mother's relatives, including his cousin the critic Paul de Saint-Victor. La Farge joined the studio of Thomas Couture (1815–1879) and met—and even posed for—Pierre Puvis de Chavannes (1824–1898). His greatest enthusiasm, however, was for Delacroix, as he would recall much later in his life. He wrote that with Ingres's pupil Théodore Chassériau,

> the war raged all the time. At once one was asked what one held in regard to M. Ingres or M. Delacroix, for the head of the house had been a favorite pupil of Ingres, a promise of the right academic future, and then had been converted suddenly, like Paul, to Delacroix, for whom he professed, rightly, an extraordinary admiration. I may regret today that neither through him nor my cousin, nor my uncle, nor any social connection, I saw the great man whose works I knew about beforehand, through literature, especially, and whose astounding paintings had been, with those of the old masters, of the first great sensations of my first days in Paris.[33]

La Farge's admiration for Delacroix must, to some degree, have been reinforced after he returned home and then, in 1859, moved to Newport, Rhode Island, to work with William Morris Hunt. La Farge is arguably the American artist who was most profoundly moved by the work of Delacroix and who absorbed the lesson most fluently into his own work (fig. 3). Nor is there any other American artist who wrote so perceptively about Delacroix:

> As with Rodin, who is a great example, as with Barye, Delacroix's friend, as with the Greeks, as with the greater men of all time, except the present, so Delacroix felt the unexpressed rule that the human being never moves free in *space,* but always, being an animal, in relation to the place where he is, to the people around him, to innumerable influences of light, and air, wind, footing, and the possibility of touching others. This is the absolute contradiction of the studio painting, however dignified, where the figure is free from any interruption, and nobody will run against it.[34]

There is something essentially American about this reflection, soundly pragmatic but colored by a subjective sensibility. In this sense, it also illustrates how close in his way of

thinking La Farge was to the Jameses, particularly to William James, with whose life his own was so intertwined. In many ways, it is curious that William James, who formulated ideas about the state of things exterior and interior, experience and spiritualism, into his philosophy of "radical empiricism," never felt strongly enough about artistic matters to establish a formal aesthetic. Henry, in a more intuitive, suggestive, and perhaps more apt fashion, was William's mouthpiece for these views, which they shared with La Farge.[35]

Did such elevated philosophical speculations and aesthetic insights of these men have a direct influence on American collectors before the turn of the century? Certainly many of the ideas in Henry James's reviews were widely circulated in North America. It is tempting to surmise that there was a more profound critical perception and sophistication, moving away from the naïve and sometimes xenophobic press of the 1870s. However, one instance suggests that the question might be answered in the affirmative. In the same 1872 notice from Paris in which he found fault with *The Death of Sardanapalus*, Henry James described the artist's 1848 *Lamentation* (cat. 125):

> One of [his] masterpieces, [it] is a work of really inexpressible beauty; Delacroix is there at his best, with his singular profundity of imagination and his extraordinary harmony of colour. It is the only modern religious picture I have seen that seemed to me painted in good faith, and I wish that since such things are being done on such a scale it might be bought in America.[36]

Perhaps this astute and heartfelt passage was in the minds of the first president of the Boston Museum of Fine Arts, Martin Brimmer, and his staff when they purchased the painting in 1896.

The flow of works by Delacroix to North America subsided considerably after World War I. Several major works left for European and Japanese collections. There is considerable evidence, however, that a shift in taste in North America, for a time, relegated the pursuit of Delacroix's works to a secondary position. This shift is perhaps most clearly demonstrated in a 1930 article by Julius Meier-Graefe entitled "What Has Become of Delacroix?"

> Public admiration is dominated, at present, everywhere by Manet, Cézanne, Renoir, and other painters of the same period. People compete frantically for the possession of any trifle by these men, and Delacroix, from whom they all derive and who passed on to them more than they were able to assimilate, is somehow left out in the cold. Year by year he slips further into oblivion, as though his were a once over-rated talent.[37]

The first sentence in the catalogue of a Delacroix show in Chicago the same year is even more telling: "'Why Revive Delacroix?' many will ask when confronted with this, the first exhibition of his work in America."[38] The Chicago show served as a gathering point for American loans to a Delacroix retrospective that opened in Paris two months later. The sentiment expressed by Chicago's question was not uniquely American; in the catalogue for the Paris show, Paul Jamot observed:

> It's an illustrious name, a great name, but not a popular one. The extraordinary antagonism he aroused from his impressive initial appearance, which never abated during his lifetime, has left traces even to the present. It was not so long ago that Degas could say, in one of his familiar sallies, "He's the least expensive of the great masters." On the other hand, Eugène Delacroix was rarely to

be seen abroad, even in the most prestigious museums and collections that proved generally receptive to nineteenth-century French painters, to all the pioneers, all the independents, from Corot to the Impressionists. The number and quality of the works that have come to us from America demonstrate that world opinion today has undergone a change of heart.[39]

That the Chicago show contained 45 canvases from North American and Canadian collections (of which 18 found their way to the Paris exhibition) plus 76 works on paper, slightly blunts the sharpness of Jamot's last sentence. But the disproportion of works (the Paris show included 895 objects!) is very evident.

The reason for this shift in attitude is, as Jamot suggested, the price of twentieth-century modernist art. Particularly in North America, for a generation of collectors, critics, and museum curators after World War I, Delacroix's work—especially his most

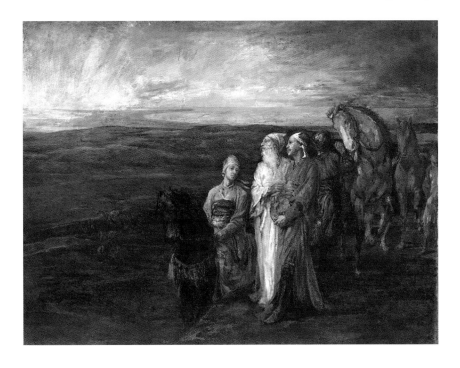

Fig. 3
JOHN LA FARGE, *The Three Wise Men,* oil on canvas, Boston, Museum of Fine Arts, Gift of Edward W. Hopper.

Romantic and narrative pictures—was too closely linked to the taste and values of an antiquated society made irrelevant by the war. It took one more generation of collectors, in the United States at least, to redeem these pictures from the context of their own grandfathers, who were quite delighted with the literary and sentimental nature of these works that fit so easily with their other, pan-European pictures. Interestingly, the reversal of taste was brought about by the same arguments that had sunk Delacroix in the 1920s, namely, that he was a central element in the modernist canon.

In 1938 Walter Pach, the influential New York critic who had published the first English edition of Delacroix's *Journal,* wrote, "What is Delacroix's meaning for us today? For all time, I think, it resides in his marvelous holding together of the creative, innovating faculty and the one through which genius continues the qualities like unity, variety and proportion that reached their highest point among the Greeks." Further, Pach said, the reconfirmation of the artist's classicism by the 1930 Paris exhibition, "would be proof enough of the remark I have more than once quoted from André Suarès: 'The whole of

modern art issues from Delacroix.'"[40] And this classicism links comfortably with formalism—the question of the subject matter left in gentle suspension—allowing Delacroix to be considered a historical precursor of Impressionism.

To link Delacroix with Impressionism became an essential element in his "revival." Charles C. Cunningham, who, when he was museum director, purchased *Bathers,* or *Turkish Women Bathing* (cat. 102) for the Wadsworth Atheneum in Hartford, Connecticut, made the connection clear by quoting the artist's *Journal* entry for April 29, 1854:

> "The more I think about colour, the more convinced I become that this reflected half-tint is the principle that must predominate, because it is this that gives the true tone, the tone that constitutes the value, the thing that matters in giving life and character to the object." These theories would not be surprising coming from the pen of Monet or Pissarro, but coming a generation earlier, from Delacroix, they show why French painters from Redon to Rouault have lavished their admiration upon him.[41]

This is the spirit now, particularly in American museums, in which Delacroix is praised and pursued, while the Salon successes, the amusing genre paintings inherited from the nineteenth-century collectors who founded those institutions are placed in the basement or sold outright.

Museum acquisition of works by Delacroix increased markedly from the 1930s through the 1960s, even as the availability of major paintings sharply declined. During the 1950s, for example, major works by Delacroix were purchased by museums in Los Angeles, Hartford, Chapel Hill (North Carolina), St. Louis, and Philadelphia, and in a reversal of the pre–World War I pattern, it was the private collectors who followed suit. The most astute, such as Grenville Winthrop, focused on drawings and watercolors, mediums in which a relatively broad selection of examples were still available for exploration.[42]

Since 1900, the greatest exception to this ascendancy of public (that is, "professional") taste over private was the acquisition by Albert Gallatin, New York, in 1910, of Delacroix's four monumental canvases depicting *The Four Seasons* (cats. 151 to 154). They joined his Greek and Egyptian antiquities as well as works by Whistler, Degas, and Gauguin. It is tempting to believe that they were admired by Albert's first cousin, Albert E. Gallatin, a most precise and disciplined modernist collector famous for his Cubist works by Braque and Picasso as well as his passion for Piet Mondrian and Fernand Léger.[43]

That the collecting of Delacroix had been brought to the very threshold of twentieth-century modernism is particularly fitting when one learns from Albert Gallatin's memoirs[44] that shortly after his purchase of *The Four Seasons* at the American Art Galleries, in New York, he was offered twice the price by James J. Hill, the Saint Paul collector with whom our story of Delacroix in America begins.

Much of the research for this essay was carried out by Katherine Sachs.

1. Paul Bourget, *Outre-Mer: Impressions of America* (New York, 1895), p. 148. This is an anthology of articles written for the *New York Herald. Les Convulsionnaires de Tanger* (*The Fanatics of Tangier,* 1835–38), now in the Minneapolis Institute of Arts (Johnson, 1986, vol. 3, no. 360, pl. 176) is the first version Delacroix undertook of the subject. The second painting Bourget mentioned is *View of Tangier from the Seashore* (cat. 106)

2. See Richard S. Davis, "The Collection of James J. Hill," *Minneapolis Institute of Arts Bulletin,* vol. 47 (1958), pp. 15–27; Gregory Hedberg and Marion Hirschler, "The Jerome Hill Bequest: Corot's *Silenus* and Delacroix's *Fanatics of Tangier," Minneapolis Institute of Arts Bulletin,* vol. 61 (1974), pp. 92–104; and Jane H. Hancock, Sheila ffolliott, and Thomas O'Sullivan, *Homecoming: The Art Collection of James J. Hill* (Saint Paul: Minnesota Historical Society Press, 1991).

3. See Edward Strahan [Earl Shinn], *The Art Treasures of America,* 3 vols. (Philadelphia: Gebbie and Barrie, 1878–80); Rene Brimo, *L'Évolution du goût aux États-Unis* (Paris: James Fortune, 1938); Aline B. Saarinen, *The Proud Possessors* (New York: Random House, 1958); and William George Constable, *Art Collecting in the United States of America: An Outline of a History* (London: Thames Nelson and Sons Ltd., 1964).

4. Davis (see note 2), p. 27. Of these eleven works, seven were accepted and one was rejected by Lee Johnson (Johnson, 1986, vol. 3, nos. 192, 206, 354, 360, 390, 408, and 419) and three were not recorded by Johnson. Four of the eleven—all oils on canvas—are in the present exhibition: *Arabs Skirmishing in the Mountains* (cat. 139), *View of Tangier from the Seashore* (cat. 106), *View of Tangier with Two Seated Arabs* (cat. 100), and *Tiger Growling at a Snake* (cat. 133).

5. *Catalogue of the 32nd Annual Exhibition of the Pennsylvania Academy of the Fine Arts* (Philadelphia: Collins, 1855), no. 310, p. 20.

6. Strahan (see note 3), vol. 3, p. 36.

7. *Catalogue of the 45th Annual Exhibition of the Pennsylvania Academy of the Fine Arts* (Philadelphia: Collins, 1868), no. 75, p. 10.

8. Johnson, 1986, vol. 3, no. 204, pl. 28.

9. Information on Borie was obtained from the clippings file of the Historical Society of Pennsylvania, Philadelphia.

10. Strahan (see note 3), vol. 2, p. 15. In Strahan's opinion, Borie's collection comprised the choicest works of art in the public and private collections of North America.

11. Henry James, *The Painter's Eye: Notes and Essays on the Pictorial Arts by Henry James,* ed. John L. Sweeney (Madison, Wisconsin, 1989), p. 43.

12. James (see note 11), p. 43; Johnson, 1986, vol. 3, no. 418, pl. 226.

13. G. W. Sheldon, *American Painters* (New York, 1879), p. 10.

14. See the Indexes of Locations in Johnson, 1981, vol. 1, pp. 249–50, and vol. 3, pp. 353–55.

15. See the Metropolitan Museum of Art, New York, *Splendid Legacy: The Havemeyer Collection,* March 27–June 20, 1993. Compared with the great collectors of the previous generation, the Havemeyers seem to have cared little for Delacroix. Of the three works by Delacroix they acquired, only one, *Christ on the Sea of Galilee* (Johnson, 1986, vol. 3, no. 454, pl. 263) is still attributed to him—whereas none of their forty Courbets and twenty-five Manets has been rejected.

16. Philadelphia Museum of Art clippings file.

17. Strahan (see note 3), vol. 1, p. 27. See DeCourcy E. McIntosh, "The Pittsburgh Art Trade and M. Knoedler & Co.," in Frick Art and Historical Center, Pittsburgh, *Collecting in the Gilded Age: Art Patronage in Pittsburgh, 1890–1910* (Pittsburgh, 1997), p. 114.

18. Caroline Durand-Ruel Godfroy kindly provided the price from the records of Durand-Ruel et Cie., Paris.

19. *The Abduction of Rebecca,* 1846; Johnson, 1986, vol. 3, no. 284, pl. 102.

20. The firm became M. Knoedler & Company in 1857.

21. See Frances Weitzenhoffer, *The Havemeyers: Impressionism Comes to America* (New York: Abrams, 1986), p. 41.

22. National Academy of Design, New York, *Catalogue of Celebrated Paintings by Great French Masters,* May 25–June 30, 1887, p. 3.

23. "Picture Sellers and Picture Buyers," *The Collector,* December 15, 1890, p. 44; quoted in Weitzenhoffer (see note 21), p. 43.

24. James (see note 11), p. 113.

25. American Art Association Managers, New York, *Catalogue of the Works of Antoine-Louis Barye, Exhibited at the American Art Galleries, for the Benefit of the Barye Monument Fund,* November 15, 1889–January 15, 1890.

26. See Edgar P. Richardson "William J. Stillman: Artist and Art Journalist," *Union Worthies* (Union College), no. 12 (1958), pp. 9–15; Brooklyn Museum of Art, *The New Path: Ruskin and the American Pre-Raphaelites* (Brooklyn, New York, 1985), p. 274.

27. William James Stillman, *The Autobiography of a Journalist* (Cambridge, Massachusetts, 1901), vol. 1, pp. 165–66.

28. T. P. Rossiter, "Notes on the Universal Exposition of Fine Arts in Paris," *The Crayon: A Journal Devoted to the Graphic Arts and the Literature Related to Them,* vol. 1 (January–June 1855), pp. 390–91.

29. Henry James, "A Small Boy and Others," in *Henry James: Autobiography* (Princeton, New Jersey, 1913), pp. 190–91.

30. James (see note 29), p. 193.

31. James (see note 29), p. 195.

32. Quoted in Helen W. Knowlton, *Masters in Art: A*

Series of Illustrated Monographs Issued Monthly: [William Morris] Hunt, part 104, vol. 9 (August 1908), p. 332.

33. Royal Cortissoz, *John La Farge: A Memoir and a Study* (New York: Houghton-Mifflin, 1911), pp. 85–88.

34. Cortissoz (see note 33), p. 149.

35. On this subject, see Robert M. Crunden, *American Salons: Encounters with European Modernism, 1885–1917* (Oxford: Oxford University Press, 1993); and Henry Adams, "William James, Henry James, John La Farge, and the Foundations of Radical Empiricism," *The American Art Journal,* vol. 17, no. 1 (Winter 1985), pp. 60–67.

36. James (see note 11), p. 113.

37. Julius Meier-Graefe, "What Has Become of Delacroix?" *International Studio,* May 1930, p. 25.

38. Daniel Catton Rich, "Delacroix and Modern Painting," in The Art Institute of Chicago, *Loan Exhibition of Paintings, Water Colors, Drawings and Prints by Eugène Delacroix, 1798–1863,* March 20–April 20, 1930, p. 5.

39. Paul Jamot in 1930, Paris, p. 1.

40. 1930, Paris; Walter Pach, "Delacroix Today," *Magazine of Art,* vol. 31 (January 1938), p. 17.

41. Charles C. Cunningham, "Eugène Delacroix (1798–1863): *Turkish Women Bathing,*" *Wadsworth Atheneum Bulletin,* 2nd series, no. 35 (November 1952), p. 1. For the *Journal* passage for April 29, 1854, see Norton, 1951, p. 228.

42. Dorothy W. Gillerman, Gridley McKin, and Joan R. Mertens, *Grenville L. Winthrop: Retrospective for a Collector,* Fogg Art Museum, Harvard University, Cambridge, Massachusetts, January 23–March 31, 1969, pp. xv–xvi.

43. See Gail Beth Stavitsky, *The Development, Institutionalization, and Impact of the A. E. Gallatin Collection of Modern Art* (New York, 1990), vol. 1, p. 22.

44. Albert Gallatin, *The Pursuit of Happiness by Albert Gallatin: The Abstract and Brief Chronicles of the Time* (New York: Scribner, 1950), p. 201.

DELACROIX: THE LATE WORK

EUGÈNE DELACROIX,
Portrait of the Artist or
Self-Portrait in a Green Vest,
c. 1837, oil on canvas, Paris,
Musée du Louvre.

I

FELINES AND
HUNTS

With a few notable exceptions, such as *Lion Attacking a Horse* by the English artist George Stubbs (1724–1806), large wild animals shown alone or in hunting scenes were not part of the standard repertoire of Romantic painting, although they had been regularly depicted by seventeenth- and eighteenth-century painters. The strange and exotic beauty of lions and tigers surely captivated the Romantic artists, but felines reemerged as a popular subject of painting only around 1840—due, in part, to Eugène Delacroix. On the other hand, the nobility of the horse fascinated the early Romantics, who drew inspiration from the violent conflict between men and their untamed mounts, as did Théodore Géricault (1791–1824) in his horse-racing series, or from the dramatic events when horses share in human destiny, as in the signal moments of the Napoleonic saga painted by Antoine-Jean Gros (1771–1835).

Whereas the painters of the late eighteenth and early nineteenth centuries partially abandoned the theme of the great cats, it remained more common in sculpture, due mainly to Antoine-Louis Barye (1796–1875), who had one of his first successes, at the 1833 Salon, with a *Lion and Serpent* (Musée du Louvre, Paris), which he executed on commission from Louis-Philippe. Little has been written about the similarity between certain animal scenes sculpted by Barye after 1835 and others painted by Delacroix after 1850, including a lion watching a snake (cat. 20), a lion devouring a wild boar, and a feline attacking a caiman (cat. 15). The theme of a confrontation between a predator and its victim became an integral part of Barye's work (as it did for Delacroix), and the sculptor's handling of his material was designed to produce realistic depictions of animal poses. But if art historians have not systematically examined Barye's work for some of Delacroix's sources of inspiration, they have emphasized the friendship that existed between the painter and the sculptor, a friendship that explains certain aspects of Delacroix's passionate interest in wild animals. Thus, writers have often pointed out the importance of the study sessions that both men undertook in the zoological section of the Muséum d'Histoire Naturelle in the Saint-Cloud marketplace, and perhaps also at the Théâtre de la Barrière, renamed the "Théâtre du Combat" because of the animal fights that were organized there up to 1837.

Because of Barye, but also because of his own ongoing quest for varied and unusual motifs, Delacroix amassed a collection of anatomical drawings of animals he had made

directly from nature during the early part of his career. These eventually became the basis for a number of lithographs and paved the way for later historic compositions, but they did not represent an end in themselves and rarely led to paintings during this period. In fact, aside from the superb *Young Tiger Playing with Its Mother* (p. 30 fig. 5), exhibited at the Salon of 1831, and the *Young Lioness Walking*, of 1832 (cat. 7 fig. 1), the theme of the great cats in action or at rest became a truly independent feature of Delacroix's art only a decade later, after 1840.

At that time, Delacroix tried his hand at a new genre, a sort of pictorial transposition of Barye's animal sculptures enhanced by his imagination and his personal technical concerns. *Lion Reclining Near Water* (1841, Musée des Beaux-Arts, Bordeaux), *Horse Downed by a Lioness* (1842, Musée du Louvre, Paris), and *Lion Devouring a Goat*[1] reveal his aesthetic intentions: to render the animals' physical demeanor, to paint their coats using bright and lively colors, to enliven compositions with anecdotal material—creating a serene effect when the feline is resting and a violent one when it is shown devouring its prey—and to blend the depiction of the animal into a richly elaborated landscape.

The quantity and quality of these animal scenes made after 1850 indicate that they had become a veritable obsession—a consequence, undoubtedly, of Delacroix's aesthetic motivations during the final phase of his career, which impelled him toward a renewal and a simplification of his themes and reinforced his belief in the primacy of imagination over the real world.

Delacroix's trip to Morocco in 1832 had given him a taste for exotic scenes and untamed landscapes. This is attested to by the numerous canvases painted late in his career "in memory" of North Africa. Delacroix remembered not only the dazzling desert landscapes around Meknes, which were to serve as backdrops for some of his animal scenes, but also the strange beasts encountered during this trip ("a lioness, a tiger, ostriches, antelopes, a gazelle"[2]). Thus, in practice, the artist's representation of animals constituted a subtle variant of his Orientalist mode, even when he studied animals in Paris at the Jardin des Plantes and set them within a landscape based on the Île-de-France.

The development of these themes after 1850 can also be explained by obviously commercial concerns. Art lovers clearly appreciated these pictures, which were painted in a highly Romantic manner but dispensed with the literary, psychological, and sentimental complications associated with the Romantic movement. Thus, a constant stream of commissions from dealers kept these works in production. Delacroix's *Journal* shows, moreover, that he did not hesitate to produce numerous works with very similar subject matter in order to satisfy his various clients. For example, at the end of 1852 he recorded:

> On December 27, 1852, received from Thomas 300, for a small *Tiger* . . . on March 22, received from Beugniet for the small *Christ* and the *Lion* and *Wild Boar* 1,000 . . . on April 10, received from Thomas 1,100 (I had to give him the *Lions* as part of this deal), . . . Deal struck with Thomas . . . *Two Lions* against the same painting.[3]

The artist's business dealings often explain repetitions and variations of the same motif, as well as a certain facility of execution. But the profit motive is not a sufficient explanation. It is clear that Delacroix, who was known for his intellectual independence—even during his tenacious and obstinate quest for a chair at the Institut de France—could not have maintained a long-term interest in a given pictorial motif if he had not been motivated by fundamental aesthetic concerns. The passionate study he undertook in 1849 in preparation

for the painting *Daniel in the Lions' Den* (Musée Fabre, Montpellier)—a subject that called for the depiction of felines—proves the subtlety and complexity of his inspiration as well as the central place the theme of animals occupied in his work, even in paintings with religious subjects. The appearance, in 1854, of his hunting scenes—those final variations on the theme of large wild animals in action—is further proof of his aesthetic ambitions in this genre.

Unlike his friend Géricault, who was a passionate painter of horses and an avid rider, Delacroix had little interest in hunting, although he had participated in hunts as a young man. On September 18, 1818, he had written to his friend Jean-Baptiste Pierret: "My heart pounds and I dash after my timid prey with the ardour of a warrior leaping a palisade and throwing himself into the midst of the carnage."[4] He acknowledged, however, that "decidedly, hunting is something unsuited to me," adding, this time in a letter to Félix Guillemardet, "I am so inept . . . I get easily disgusted with myself."[5]

Delacroix's interest in the theme of the chase was apparently intellectual and purely aesthetic. In his violent descriptions—the writhing bodies, the blood and sweat of the hunters, the spittle of the animals—he discovered pictorial concerns identical to those he had discerned in the battles and massacres of his youth. Thus, the *Lion Hunt* he presented at the Exposition Universelle of 1855 (cat. 14) represented a final variation on works such as *The Massacre at Chios* (1824, Musée du Louvre, Paris); *The Death of Sardanapalus* (1827–28, Musée du Louvre, Paris); and—more to the point—the Orientalist masterpiece entitled *Combat of the Giaour and Hassan* (1827, The Art Institute of Chicago).

Much has been written about Delacroix's sudden interest in hunting scenes after 1850, and some spurring event has been suggested as the inspiration for this development. Thus, Maurice Sérullaz has pointed to the publication of *Lion Hunt,* an amusing travel summary written about this time by Jules Gérard, a curious character dubbed "the lion killer." Delacroix seems to have discovered this text, which appeared as an article in the *Moniteur universel* in 1854,[6] when he had already made substantial progress on the large canvas he was painting for the Exposition Universelle of 1855. That account of Oriental hunts was part of a trend coinciding with Delacroix's research and attested to by the engravings Gustave Doré (1832–1883) made to illustrate an 1856 edition of Gérard's work based on the magazine articles.

Among the less frequently cited sources for Delacroix's hunts of the 1850s is a centerpiece by Barye, executed between 1834 and 1838 for the duc d'Orléans and much admired. This piece consists of five chase scenes, one of which is a superb *Lion Hunt.*[7] The violence of the clash between animals and hunters and the counterpoise of the figures in motion are undeniable qualities of the painter's hunts as well.

Yet, in one of the notes made in 1857 in preparation for his planned dictionary of fine arts, Delacroix indicated that he placed limits on the similarities between his work and Barye's. Commenting on the achievements of his fellow animaliers, he observed that they should not treat their subjects "with the perfection of drawing of the naturalists, especially when the painting or sculpture is in the grand style. Géricault too learned. Rubens and Gros superior. Barye mean in his lions."[8] Here Delacroix clearly expressed his intention not to seek a realistic description of animals, as Barye might have been inclined to do, but to explore their expressive potential, what is eternal and artistic in their demeanor. Far from imposing an additional Romantic theme, Delacroix wanted to prove that, in describing the confrontation between men and animals, his own personal genius

made him the equal of those great masters who had, in their own time, gone beyond the spatial and color constraints placed on hunting and battle scenes—for example, Leonardo da Vinci in *The Battle of Anghiari,* Raphael and his pupils in their scenes from the life of Constantine, and Charles Le Brun in his paintings of Alexander's battles and in his cartoons for the *Story of Meleager* tapestry.

Thus, Delacroix's hunting scenes contain numerous references to great paintings of the past. Especially notable—and often mentioned—are Delacroix's allusions to the work of Peter Paul Rubens (1577–1640), who repeatedly returned to the theme of the hunt. The series best known in France in Delacroix's time was the one the Flemish painter had executed between 1615 and 1617 for Maximilian of Bavaria's castle in Schleissheim. In 1800 Rubens's large compositions—with the exception of the *Crocodile Hunt,* which remained in Munich—were brought to France by the revolutionary armies under Napoleon. In 1803 they were placed in various provincial museums. The *Tiger Hunt* went to Rennes, the *Wild Boar Hunt* to Marseille, and the *Lion Hunt*—which was destroyed in 1870 in the same fire that damaged Delacroix's *Lion Hunt* (cat. 14)—to Bordeaux. Delacroix may have studied the *Lion Hunt* in 1846 when he went to Bordeaux because of the death of his brother Charles-Henry (1779–1845).

Even if Delacroix did not see all of Rubens's canvases on this theme,[9] he was thoroughly familiar with the engravings that Pieter Claesz. Soutman (1580–1657) made of them because he had copied them himself:[10] "There is as much to be learned from his exaggerations and his swelling forms as from exact imitations."[11] Delacroix has also left us a memorable description of the *Lion Hunt:*

> You can see the spear bending as it pierces the breast of the furious beast. In the foreground a Moorish horseman has been overthrown; his horse, also down, has already been attacked by an enormous lion which is looking back with a hideous grimace towards another fighter lying outstretched upon the ground, who with his dying effort is plunging a long dagger into the lion's huge body. The man is pinned to the ground by one of the brute's hind legs, and it is clawing at his face in a frightful manner as it feels the thrust. The rearing horses, the rough manes and tails, the thousand details, the unbuckled shields, the twisted bridles, all are calculated to stir the imagination, and the handling is admirable.[12]

Despite his admiration for Rubens, who had such great influence on his work, Delacroix never lost his remarkable critical sense. Still speaking of the *Lion Hunt* engraved by Soutman, in a passage that reveals the place he himself wanted to occupy in the history of painting, he added: "But the whole effect is one of confusion, the eye does not know where to rest; one gets the impression of a fearful conflict, but it seems as though art had not taken control sufficiently to enhance the effect of so many brilliant inventions by careful arrangement or by sacrifices."[13] Thus, Delacroix's ultimate aim was to avoid similar compositional "confusion," and it was probably with this purpose in mind that he studied the works of so many other animal painters.

Delacroix was also undeniably influenced by the engravings of Antonio Tempesta (1555–1630), who specialized in hunting scenes, and by the work of Jan van der Straeten, also known as Stradanus (1523–1605), who made cartoons for tapestries on behalf of Cosimo I de'Medici. Did Delacroix also study the hunting scenes of the Dutch painter Abraham Hondius (1625–1695) or those of French artists Alexandre-François Desportes (1661–1743) and Jean-Baptiste Oudry (1686–1755)? Since his youth, Delacroix had

maintained a passionate interest in the art of the eighteenth century—painting as well as music and literature—and it is likely that he appreciated the famous series of hunts that the young Louis XV commissioned in 1739 for the Petite Galerie at Versailles.[14]

One of the most important sources of inspiration for Delacroix's hunts was a series of etchings by Rembrandt (1606–1669). This connection, which has received less attention than the link with Rubens, may be sought in works such as *The Small Lion Hunt with One Lion* (c. 1629), *The Small Lion Hunt with Two Lions* (c. 1632), and *The Large Lion Hunt* (1641). A comparison between the central figure in Delacroix's *Lion Hunt* in the Musée des Beaux-Arts, Bordeaux (cat. 14)—a rider on a rearing horse—and an almost identical rider in Rembrandt's *Large Lion Hunt* reveals the extent of Delacroix's debt to the Dutch master. Likewise, the rider holding a lance in his left hand in Delacroix's *Tiger Hunt* (cat. 11) is modeled directly on one of the hunters in Rembrandt's *Small Lion Hunt with Two Lions.*

Although Delacroix's passionate interest in Rembrandt dates back to his youth, his discovery of the Dutch master's handful of animal pictures apparently came later. In 1847 he bought (from a Paris quayside dealer) a drawing by Dominique-Vivant Denon (1747–1825) based on a lion designed by Rembrandt, revealing his interest in this marginal aspect of the Dutch painter's work.[15] Certainly, Rembrandt's aesthetic helped to spur him on in developing his hunting scenes during this period. Some years later in his *Journal,* Delacroix emphasized one of the main qualities of the Dutch painter—his sense of the hierarchical relationship between what is essential and what is secondary: "It is really not until Rembrandt that you see the beginning of that harmony between the details and the principal subject which I consider to be one of the most important, if not the most important element in a picture."[16] A few weeks later, after criticizing Rubens for that artist's problems in controlling the relationships between his figures and landscapes—a major concern in his own animal paintings—Delacroix added: "With Rembrandt indeed—and this is perfection itself—the background and the figures are one."[17]

These various references to the art of the past help to explain the strange synthesis that Delacroix sought to achieve between the *terribilità* of these primitive battles and the aesthetic effect obtained through rigorous spatial organization and intensity of color. Clearly, Delacroix's life's work and personality are fully reflected in these terrific clashes between great cats and riders, which combine the expression of Romantic feeling with the pictorial homage rendered to the masters of Western painting.

Vincent Pomarède

1. Private collection, exhibited in the Salon of 1848; Johnson, 1986, vol. 3, no. 179, pl. 11.

2. Delacroix to Jean-Baptist Pierret, April 2, 1832, *Correspondance,* vol. 1, pp. 326–27.

3. *Journal,* December 27, 1852, pp. 316–17.

4. *Correspondance,* vol. 1, p. 18.

5. *Correspondance,* vol. 1, p. 17.

6. *Journal,* September 30, 1854, p. 478.

7. The plaster for the *Lion Hunt* is in the collection of the Musée du Louvre, Paris; the bronze cast is in the Walters Art Gallery, Baltimore.

8. *Journal,* January 13, 1857 (Norton, 1951, p. 333).

9. Rubens's work, dated to between 1615 and 1620, is now in Dresden, and Delacroix's copy of it is in the Neue Pinakothek in Munich.

10. *Journal,* January 23 and March 6, 1847 (Norton, 1951, p. 57).

11. *Journal,* March 6, 1847 (Pach, 1937, p. 156).

12. *Journal,* January 25, 1847 (Norton, 1951, p. 57).

13. *Journal,* January 25, 1847 (Norton, 1951, p. 57).

14. Jean-François de Troy, *The Lion Hunt,* Musée de Picardie, Amiens.

15. *Journal,* April 3, 1847 (Pach, 1937, p. 161).

16. *Journal,* July 5, 1854 (Norton, 1951, p. 234).

17. *Journal,* July 29, 1854 (Norton, 1951, p. 236).

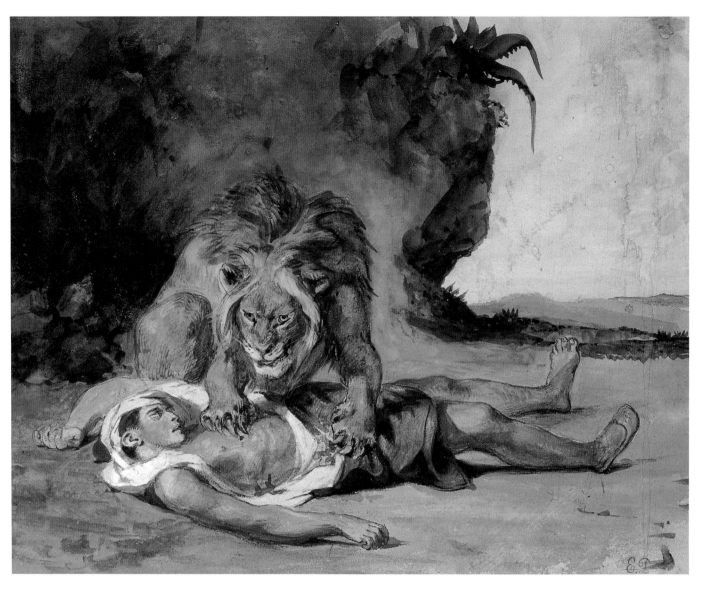

1. *Lion Mauling a Dead Arab*

c. 1847–50
Watercolor and graphite on paper;
8⅝ x 10⅝ inches (22 x 27 cm)
Private collection (courtesy of the Nathan
Gallery, Zurich)
Exhibited in Paris only

Fig. 1
EUGÈNE DELACROIX, *Lion
Mauling an Arab*, 1847, oil on
canvas, Oslo, Nasjonalgalleriet.

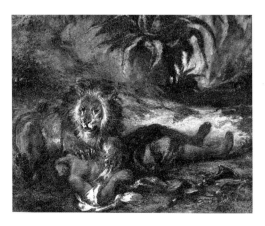

This watercolor illustrates a theme that was a favorite of Delacroix's in the years between 1840 and 1855—a fight between an Arab and a feline. The artist's most imposing version of this theme would be the *Lion Hunt* he presented in Paris at the Exposition Universelle in 1855 (cat. 14).

Delacroix had depicted the version of the subject seen in this watercolor—the fatal outcome of a confrontation between an Arab and a lion—in a painting he executed in 1847 and exhibited at the Paris Salon the following year (fig. 1). The variations are significant. In addition to a slight shift of the group toward the left, the painting shows a discernible change in the landscape, reflecting the artist's still vivid memories of his stay in North Africa. A black rifle in the right foreground heightens the "African" flavor of the composition, but the sense of drama is much more intense in the watercolor, since nothing diverts the attention of the cruel-faced lion crouched over its inert prey, whose limbs have not yet stiffened. In a second

version of the painting,[1] undoubtedly executed during the same period, the artist intensified the dramatic atmosphere by representing the Arab lying with his legs suspended over a precipice.

In 1849 the artist once again took up the theme, this time in an etching in which the lion is replaced by a lioness snarling with equal ferocity.[2]

A. S.

1. Location unknown; Johnson, 1986, vol. 3, no. 77, pl. 10.
2. Delteil, 1908, no. 25, repro.

2. *Reclining Tiger*

c. 1847–49
Brown ink on paper; 4¾ x 7¹⁵⁄₁₆ inches
(12.1 x 20.2 cm)
Paris, Musée du Louvre, Département des Arts Graphiques (RF 36 803)
Exhibited in Philadelphia only

Delacroix executed numerous studies of felines during the second phase of his career, and it is not always easy to date an individual example precisely. Such is the case with this study, which the artist quickly sketched with the tip of his pen and strengthened here and there with a more sustained application of ink. In 1841 Delacroix became a regular visitor at the zoo in the Jardin des Plantes in Paris after he received special authorization from Isidore Geoffroy Saint-Hilaire to "make studies of wild animals outside of, or even during, feeding times."[1] In the 1830s Delacroix had had an opportunity to work alongside his friend the sculptor Antoine-Louis Barye (1796–1875) when a traveling menagerie visited the Paris suburb of Saint-Cloud. The mastery of line evident in this drawing, however, would suggest a date around 1847–49.

A. S.

1. Unpublished letter, August 23, 1841, Archives Piron; sale, Caen, December 6, 1997, lot 55, repro.

3. *Heads of Roaring Lions and Lionesses*

c. 1850
Black ink over pencil on paper;
8¼ x 10½ inches (21 x 26.7 cm)
Dijon, Musée des Beaux-Arts (DG 105)
Exhibited in Philadelphia only

This drawing is a superb example of the life studies Delacroix made during his visits to the zoo in the Jardin des Plantes in Paris. The artist's attention is focused on the muzzles of these menacing or plainly angry felines.

A. S.

4. *Lioness About to Attack, Another Reclining*

c. 1850
Brown ink on paper; 6⅞ x 8⅝ inches
(17.5 x 22 cm)
Signed at lower right in brown ink:
Eug. Delacroix
Private collection (courtesy of the Nathan
Gallery, Zurich)

An energetic sketch of this type—executed on the spot or from memory—undoubtedly served as the basis for a lithograph executed in 1856, *Tiger Licking Itself*.[1] While the motifs are not the same, the way the powerful forms are achieved—by supple lines that are crosshatched and generally closely spaced—is identical in the print and in this drawing. It was not uncommon during this period for Delacroix to contrast felines in a single drawing.

A. S.

1. Delteil, 1908, no. 130, repro.

5. *Lion Stalking Its Prey*
or *Lion Watching Gazelles*

c. 1850
Oil on canvas; 9⅞ x 13¼ inches (24.5 x 33.5 cm)
Signed at lower left: *Eug. Delacroix.*
Private collection

The dating of this work is based on two different sources. Lee Johnson has suggested that this is the painting Delacroix gave to his friend Jean-Baptiste Pierret on Sunday, February 24, 1850.[1] If he is correct, it obviously can be dated no later than that. On the other hand, Alfred Robaut assigned the work a date of 1854 (without determining its relationship to the painting that had belonged to Pierret) on the basis of its striking similarity to a superb ink sketch in his possession (fig. 1).[2] An inscription on the drawing—which shows a lion in a position almost identical to the one in this painting—prompted Robaut to give both works the same title: *Lion Watching Gazelles.* Because of his own careful annotations on the back of the drawing, we have a fairly clear idea of its conception and provenance: "This sketch was made during one of the many evenings Delacroix spent at the home of his close friend Monsieur Fr. Villot, who gave it to me in exchange for another work—Alfred Robaut." It is likely that the date Robaut gave the painting in his catalogue is based on the date he assigned the drawing after a conversation with Frédéric Villot.

Thus, the chronological relationship between the two works is difficult to determine, especially since the drawing, which does not appear to have been made directly from nature, was not necessarily a sketch for the painting. It is possible that Delacroix made the drawing at Villot's before 1850, subsequently relying on memory for the figure of the lion in his painting. But he could also have done the painting in 1850 and later made a drawing of the subject in order to describe it to Villot. Alternatively, he may have completed both works around 1854 and given Pierret a different painting representing a lion. The superb rendering of the lion's coat and mane recalls another painting (cat. 7), which can be dated only imprecisely, between 1852 and 1854. On balance, however, the relatively straightforward history of the present painting following the death of Delacroix tends to support both Johnson's suggestion and a date no later than 1850. If this is true, then the drawing, in which Delacroix seems to concentrate on the lion's pose, may have been executed for Villot at a later date.

Forgoing any picturesque description of landscape and the opportunity to juxtapose a feline with another animal, Delacroix concentrated on the lion, on the subtle shades of its mane—ranging from white to light and dark brown—on the vital and energetic position of its body ready to pounce, and on the strange expression of quiet anticipation in its gaze. The rich surface and the effortless treatment of the big cat's body place this work among the finest of Delacroix's depictions of animals.

V. P.

Fig. 1
EUGÈNE DELACROIX, *Lion Stalking Its Prey,* c. 1850–54, ink on paper, Paris, Musée du Louvre, Département des Arts Graphiques.

1. Johnson, 1986, vol. 3, no. 182, pl. 14.
2. Robaut, 1885, no. 1249, repro.

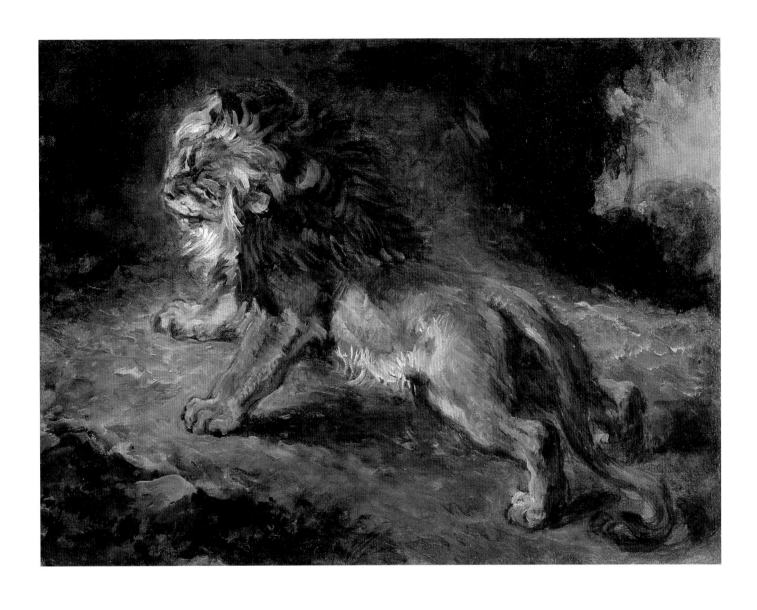

6. *Lion Clutching Its Prey*

c. 1852
Black ink on paper; 4¹⁵⁄₁₆ x 7⅞ inches
(12.5 x 20 cm)
Dated at lower right in black ink: *27 f ᵣ. 52.*
Dijon, Musée des Beaux-Arts (DG 377)
Exhibited in Philadelphia only

Fig. 1
EUGÈNE DELACROIX,
Lion Roaring, 1852, black ink on
paper, Amsterdam, Historische
Museum.

Throughout the year 1852, while he was working on his decorations for the Salon de la Paix at the Hôtel de Ville in Paris (see cat. 65), Delacroix continued to draw lions on paper. Some of these studies became the basis for small paintings, which soon found buyers. On February 8, the artist noted in his *Journal* that he had "spent the evening at [Fromental] Halévy's. Few people there. I worked all day finishing my small paintings: *Tiger and Snake, The Samaritan,* and worked on my sketch for my ceiling at the Hôtel de Ville."[1] On February 16 he drew, among other things, a roaring lion standing on its front legs (fig. 1). In May he went as usual to the Jardin des Plantes, where he did not seem to experience any fatigue working "among the crowd in the sunshine, drawing the lions."[2] The Musée du Louvre, Paris, possesses a sketch of a feline done in an identical style and dated October 10, 1852.[3]

A. S.

1. *Journal,* February 8, 1852, p. 287.
2. *Journal,* May 7, 1852 (Norton, 1951, p. 157).
3. Département des Arts Graphiques, RF 9683; M. Sérullaz, 1984, vol. 1, no. 1089, repro.

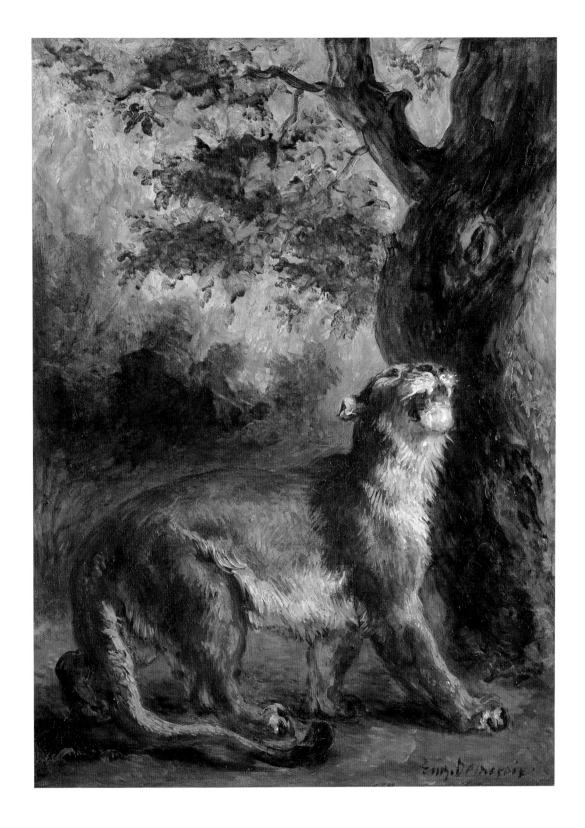

7. *Lioness Stalking Its Prey*
or *The Puma* or *Lioness Standing by a Tree*

c. 1852–54
Oil on wood; 16⅜ x 12 inches (41.5 x 30.5 cm)
Signed at lower right: *Eug. Delacroix*
Paris, Musée d'Orsay, Bequest of Alfred
Chauchard (RF 1815)

The actual type of feline depicted here has remained unidentified since the first public appearance of the painting in 1864, at the posthumous exhibition of Delacroix's work held in conjunction with his studio sale. Lent to the show by Madame

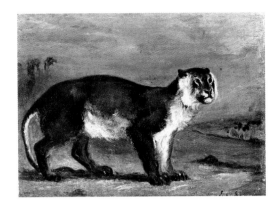

Eugène Delacroix,
Young Lioness Walking, 1832,
oil on canvas, Copenhagen,
Ny Carlsberg Glyptotek.

Fig. 2
Eugène Delacroix, *The Puma,*
1852, ink on paper, Paris, Musée
du Louvre, Département des
Arts Graphiques.

Troyon, mother of the landscape and animal painter Constant Troyon (1810–1865), the work was then titled *Lioness,* and it was listed under the same name in Alfred Robaut's 1885 catalogue of Delacroix's work.[1] At the sale in 1891 of the collection owned by the painter Émile Van Marcke (1827–1890), the authors who prepared the catalogue believed they were looking at a *Stalking Tiger.* However, when curators at the Louvre began cataloguing Alfred Chauchard's bequest in 1909, they called the subject *Puma.* Since then, art historians have pointed out that the body is too stocky (Maurice Sérullaz) and the coat is too long (Lee Johnson) for a lioness, while the lower jaw is too heavy for a puma (Lee Johnson).[2]

Whether lioness, puma, or lynx—a tiger being apparently excluded—the animal represented in this painting seems very close to the feline Delacroix depicted in *Young Lioness Walking* (fig. 1), executed in 1832. The similarity is striking enough to suggest that the subject of this painting of the 1850s may be a young lioness that still has the long coat normally shed upon attaining maturity. In any case, as Lee Johnson suggests, Delacroix may have based this composition on drawings made directly from nature, but he may also have worked partly from memory, and in addition may have taken certain liberties with the animal's anatomy, being more interested in its expressive potential and its integration into the land-

scape than in the realistic depiction of a particular species. Indeed, in a *Journal* entry of 1855, the painter wrote, "I managed to observe that generally speaking, the light tone noticeable beneath the stomach, under the paws, etc. [of wild animals], is merged more softly into the rest than I usually make it. I am apt to exaggerate the white."[3]

In 1963 Maurice Sérullaz compared this painting with an ink drawing dated December 10, 1852, representing a feline in a very similar pose (fig. 2). In doing so, he confirmed the difficulties involved in identifying the species and introduced new chronological considerations. The date given for this painting in Alfred Robaut's 1885 catalogue is 1859, but the thick, dense application of paint in the landscape is more typical of the canvases Delacroix painted around 1850–55 than of those he made during the last five years of his career, when his brushstrokes are characteristically more fluid and his colors lighter. By comparing the painting with the drawing made in 1852, Sérullaz has shown that the painting could have been made sometime between 1852 and 1854, that is, between the execution of the drawing and the presentation of the painting as a token of gratitude to Constant Troyon for having purchased the artist's *Christ on the Sea of Galilee* (cat. 118) from the dealer Beugniet. As Lee Johnson has pointed out, it is unlikely that the work was offered to Troyon long after he had purchased *Christ on the Sea of Galilee* (which was described as belonging to him in an 1855 exhibition in Bordeaux). In any case, if Delacroix gave Troyon this painting in 1854 or 1855, the date of execution proposed by Robaut is erroneous.

Lee Johnson has brought to our attention a series of three pencil studies of a feline's right foreleg (Musée Bonnat, Bayonne). Apparently drawn after a live animal, they may have served as inspiration for the subject of this painting. Unfortunately, they do not contain any clues as to the date of execution or the species described.

This work, which is characterized by brilliant handling and an aggressive vigor in the representation of the feline, is an exceptionally fine example of the qualities to be found in the animal paintings of Delacroix, who was more interested in the expressive potential of the great cats than in describing their anatomy. But the role of landscape is no less important here, and it is easy to understand why Delacroix would choose to offer this work to a landscape painter. The thick and vibrant brushstrokes used to describe the foliage and the animal's fur help to integrate its body with the vegetation, to the point that the tree on the right almost rivals the figure of the cat. It has been suggested that Delacroix drew his inspiration for this tree from the famous Antin oak located in the forest of Sénart, close by his house at Champrosay. Though this proposal seems unlikely—the Antin oak was larger than this tree by the 1850s—it is

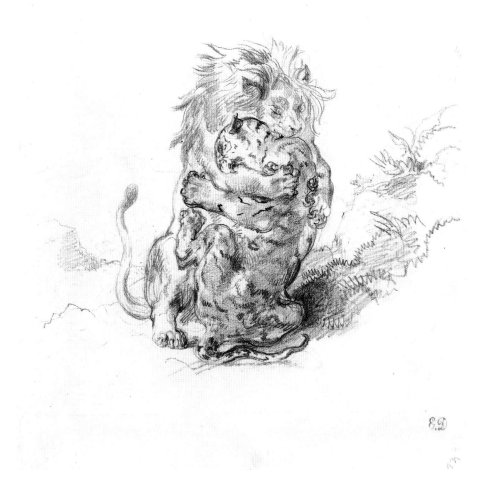

worth noting that the trees and other vegetation described in this work are reminiscent of the forests of the Île-de-France and contrast strangely with the exoticism of the animal.

<div align="right">

V. P.

</div>

1. No. 1390, repro.

2. M. Sérullaz, 1963(a), no. 436; Johnson, 1986, vol. 3, no. 188, pl. 17.

3. *Journal,* June 7, 1855 (Norton, 1951, p. 278).

8. *Struggle Between a Lion and a Tiger*

c. 1854
Graphite on paper; 12¹⁵⁄₁₆ x 9½ inches
(31.3 x 24.2 cm)
New York, The Metropolitan Museum of Art,
Bequest of Gregoire Tarnopol, 1979, and Gift
of Alexander Tarnopol, 1980 (1980.21.13)
Exhibited in Philadelphia only

This drawing and the following double study (cat. 9) belong to a series of variations on the theme of a brutal confrontation between two felines that are locked together in one huge mass. Among the other works in the series are another pencil drawing now preserved in the Graphische Sammlung Albertina in Vienna (24.094), a quick

sketch exhibited at Prouté's in 1978,[1] a watercolor in the former Adolphe Moreau collection,[2] a fine ink drawing that belonged to Alfred Robaut at the end of the nineteenth century,[3] and a painting in the Oskar Reinhart collection, Winterthur, on which Delacroix worked "in a frenzy of enthusiasm" during the autumn of 1854.[4] There is no way to predict the outcome of this mortal combat, since the animals bite and tear at each other with equally fierce energy. The lion holds its foe in the grip of its sharp claws, while the tiger writhes and twists in desperation.

A. S.

1. M. Sérullaz, 1963(a), no. 70, repro.

2. Rudrauf, 1963, p. 305, fig. 8.

3. Eugène Delacroix, *Struggle Between a Lion and a Tiger,* 1854, oil on canvas, Oskar Reinhart Collection, Winterthur.

4. *Journal,* October 12, 1854 (Norton, 1951, p. 263).

9. Two Studies of a Struggle Between a Lion and a Tiger

c. 1854
Graphite on paper; 8⁹⁄₁₆ x 12⅛ inches
(21.8 x 30.9 cm)
Paris, Musée du Louvre, Département des Arts
Graphiques (RF 9482)
Exhibited in Paris only

This double study of a fight between a lion and a tiger may be considered the point of departure for the drawing in the Metropolitan Museum of Art, New York (cat. 8). But the struggle between the two felines is rendered here with much greater savagery, for the pencil lines emphasize in highly suggestive fashion the violence of the clash between the two combatants.

A. S.

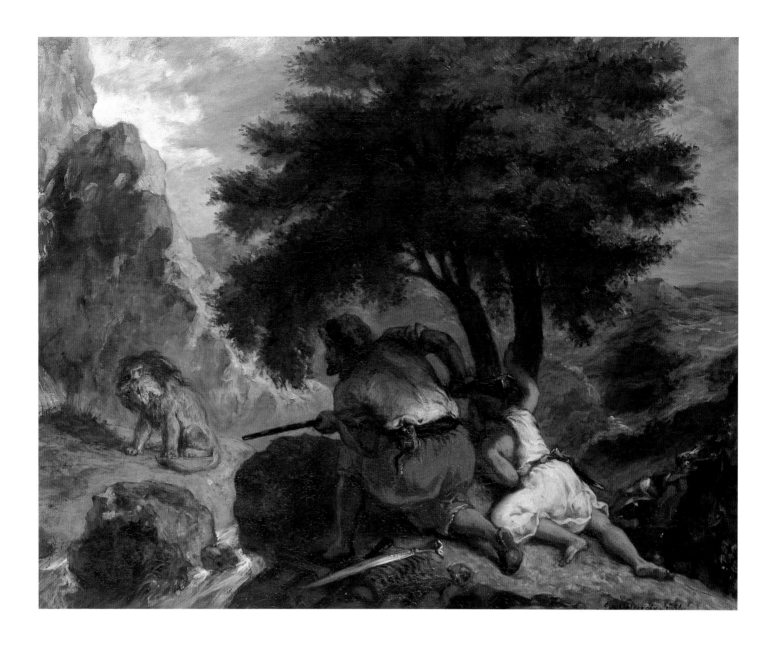

10. *Arabs Stalking a Lion*

c. 1854
Oil on canvas; 29⅛ x 36¼ inches (74 x 92 cm)
Signed and dated at lower right:
Eug. Delacroix. 1854.
St. Petersburg, The State Hermitage Museum
(inv. 3853)

This painting was commissioned by the dealer Weill, who was one of Delacroix's principal clients after 1850. By the time of the artist's death, the canvas was already in the collection of Nikolai Kusheleff-Besborodko of St. Petersburg—which explains why Delacroix's first two biographers, Adolphe Moreau and Alfred Robaut, were unaware of it and unable to connect it with the artist's references to it in his diary. In his *Journal* entry for March 24, 1854, Delacroix alluded to a commission from Weill, a work that could have

been this painting: "Worked on the lay-in of the *Lion Hunters,* for Weill."[1] The following month he mentioned a canvas he called the *Lion Stalkers,* probably the same work.[2] Some two weeks later, he referred to it by yet another title:

> Studying the trees by the roadside has helped me to tone up the picture of the *Lion Killers* which had got into a bad state yesterday when I was in an irritable mood, although it was going well the day before. I was seized with a kind of frenzy of inspiration, just as I was the other day when I began to work on the *Clorinde* again; there were not many alterations to make, but the picture had suddenly got into that flat and dreary state which invariably betrays a lack of enthusiasm. I'm sorry for people who work calmly and coldly.[3]

The artist's remark at the beginning of the quotation is a reminder of the artistic license he permitted himself when painting his Orientalist hunting scenes, where, for example, he might show exotic animals against a landscape modeled on the Île-de-

France. Before beginning work on this painting, Delacroix had made a drawing of trees along the road that runs through the forest of Sénart and links Mainville and Champrosay. This grove, observed on one of the artist's walks, served as inspiration for the tree that screens the Arab hunters while they watch the lion: "I spent some time on my way home studying the foliage of trees. There are plenty of lime trees and they come out before the oaks. It is easier to observe the principle of construction with this type of leaf."[4]

Despite the commercial considerations that were inevitable in commissions of this type (for example, this painting includes two themes that had proved very popular, namely, big cats and scenes of Oriental life), Delacroix adroitly handled the juxtaposition of the three main picture planes: the shadowed foreground with the Arabs lying in wait; the strongly lit middle ground with a small stream running down through tumbled rocks and the lion licking itself at the foot of a rugged escarpment; and in the background a valley and distant mountain chain drawn from memories of Morocco, in the midst of which a river winds its way through the greenery of a magnificent wilderness. In its complexity and savage beauty, the landscape contributes as much to the work's success as does the drama unfolding within it.

Abandoning the theme of wild animals overcoming hunters and devouring men (cats. 1 and 17), Delacroix deliberately chose a contrary theme. In this case the animal appears harmless, absorbed in grooming itself, while the humans have become the predators; avoiding physical confrontation, they prepare to kill the lion in a cowardly manner, with a rifle and without a struggle. In fact, Delacroix had already treated this theme several times, as shown by a small picture undoubtedly painted in 1849 titled *Arab Stalking a Lion*,[5] and another of 1847 titled *Arab Horseman Firing at a Lion*.[6] In 1859, Delacroix would return to the same theme in *Arabs Lying in Wait for a Lion*,[7] which shows Arabs at the base of a tree watching a lion headed toward a pool.

V. P.

1. *Journal,* March 24, 1854 (Pach, 1937, p. 368).

2. *Journal,* April 14, 1854, p. 411.

3. *Journal,* April 27, 1854 (see Norton, 1951, p. 226). In the original *Journal,* the terms used to distinguish the hunters are *chasseurs, guetteurs,* and *tueurs,* respectively.

4. *Journal,* April 27, 1854 (Norton, 1951, p. 226).

5. Private collection, London; Johnson, 1986, vol. 3, no. 180, pl. 12.

6. Location unknown; Johnson, 1986, vol. 3, no. L127, p. 270.

7. Private collection; Johnson, 1986, vol. 3, no. S3, p. 298, pl. 313.

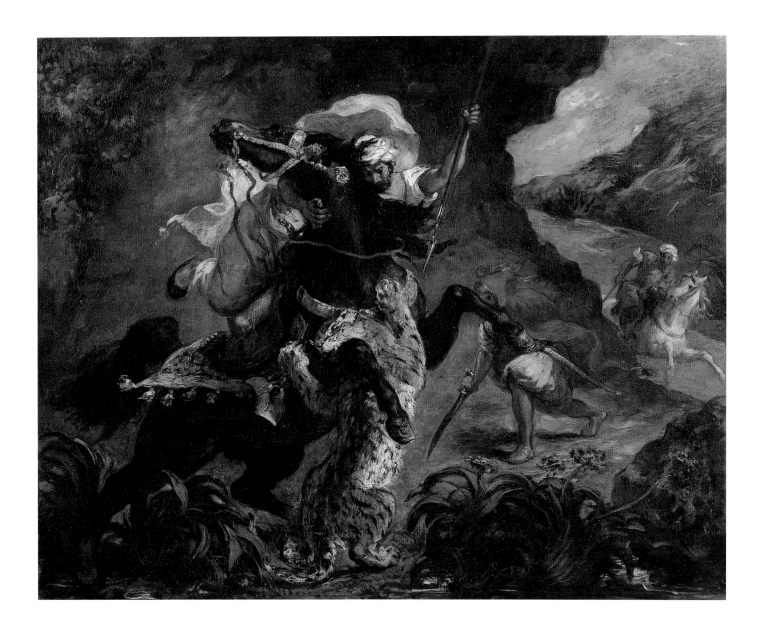

11. *Tiger Hunt*

1854
Oil on canvas; 28¹⁵⁄₁₆ x 36⁷⁄₁₆ inches
(73.5 x 92.5 cm)
Signed and dated at lower right:
Eug. Delacroix. / 1854.
Paris, Musée d'Orsay, Bequest of Alfred
Chauchard (RF 1814)

Like the canvas *Arabs Stalking a Lion* (cat. 10),
completed a few weeks earlier, this *Tiger Hunt* was
commissioned by the dealer Weill. Delacroix exe-
cuted it between May and June 1854. Despite its
commercial origin, this painting clearly reflects
Delacroix's aesthetic concerns with the theme of
lion and tiger hunts. His development of this sub-
ject dates back to a government-sponsored
commission of a painting for the Exposition Uni-
verselle of 1855 (cat. 14).

In his *Journal* entry for May 30, 1854, Delacroix
mentioned that he was working on this painting
while making the compositional drawings for the
large *Lion Hunt* planned for the Exposition
Universelle. "Started again on Weill's painting:
Tiger Attacking Horse and Rider."[1] About a month
later, he added the following detail: "During the
day, almost finished the *Arab Horseman and the
Tiger* for Weill."[2] The commission aside, Delacroix
had already given much thought to the composi-
tion of this work, undoubtedly because he saw it as
a dry run for the large canvas slated for the
Exposition Universelle. With this in mind, on
August 1, 1854, he solicited the opinion of his
friend the painter Paul Chenavard and sent him a
sketch representing "my original idea for the *Tiger
Attacking a Horse* that I did for Weill."[3]

It is appropriate at this point to emphasize the
patience with which this work was prepared[4] and
the perfect harmony between the violence of the
subject and the balance of the composition. Unlike

Delacroix's large *Lion Hunt* (cat. 14), whose true subject is the interweaving of the various figure groupings and the turbulent movement of the entwined bodies, the action here is more concentrated and is organized entirely around a central group surrounding a horseman who is on the point of spearing a tiger that has attacked his horse. In the right middle ground, a figure on foot and a second horseman rush to his aid. Their presence obviously enhances the animated quality of the composition. The main action takes place within a sort of rocky shelter, and visible in the right background is a magnificent, untamed mountainous landscape reminiscent of North Africa. Some sections of the foreground, which in Delacroix's view were too empty, have been embellished with plants of undetermined geographic origin. These introduce a note of exoticism.

As in Rembrandt's etching *Small Lion Hunt with Two Lions* and Antonio Tempesta's engraving *Lion Hunt*—both of which served as inspiration for Delacroix—the hunter holds his spear in his left hand in an attempt to find a favorable angle of attack. The preparatory sketch in the Yale University Art Gallery, New Haven, shows that Delacroix had planned to position the spear in the hunter's right hand, before coming back to Rembrandt's and Tempesta's arrangement.

Sold to Weill upon its completion, this work was not widely known during Delacroix's lifetime. It became famous, however, in 1890 with the posthumous publication of a text written in 1864 by Charles Baudelaire. Describing a tour he took in Brussels of an art collection belonging to the stockbroker Prosper Crabbe, who then owned the painting, the French poet wrote:

> *Tiger Hunt:* Delacroix is an alchemist of color. Miraculous, profound, mysterious, sensual, terrible; brilliant and dark colors, penetrating harmony. The actions of the men and animals. The grimace of the beast, the snorting of animality. Green, lilac, dark green, soft lilac, vermilion, dark red—a sinister bouquet.[5]

As often before, Delacroix's color scheme, which combined striking and subtle hues, profoundly moved the poet. Sometime later, Alfred Chauchard (1821–1909) brought this work back to France, and in 1909 he bequeathed it to the Musée du Louvre.

V. P.

1. *Journal,* May 30, 1854, p. 430.
2. *Journal,* June 27, 1854 (Pach, 1937, p. 392).
3. *Journal,* August 1, 1854, p. 447. According to Maurice Sérullaz and Lee Johnson, this drawing is the one now in the collection of the Fogg Art Museum, Harvard University, Cambridge, Massachusetts.
4. At least two studies exist for the entire composition, the one in the Fogg Art Museum mentioned above; the other in the Yale University Art Gallery, New Haven, Connecticut.
5. "Sur la collection Crabbe," in *Oeuvres posthumes de Baudelaire* (Paris, 1908).

12 to 14.　The Bordeaux *Lion Hunt*

The Exposition Universelle held in Paris in 1855 was designed to contrast the two main aesthetic currents of the century—classicism and Romanticism, represented respectively by Jean-Auguste-Dominique Ingres (1780-1867) and Eugène Delacroix. It was also the occasion chosen by the French government to commission from Delacroix a large painting to be included in the retrospective of his work planned for this exhibition. Delacroix's submission, *Lion Hunt* (cat. 14), a violent work on a theme frequently treated by sixteenth- and seventeenth-century Italian masters, was the artist's last major, grand-scale composition submitted for public exhibition during his lifetime. The works in his final Salon contribution, in 1859, were not comparable, in either size or ambition.

In his *Journal* entry for March 20, 1854, Delacroix recorded having gone, that same day, to the home of Frédéric Bourgeois de Mercey, head of the Fine Arts Section of the Exposition Universelle.[1] It was Monsieur de Mercey who had sent him the letter commissioning a painting for the exposition. This administrative document adopts a highly restrained tone, leaving the choice of subject entirely up to the artist:

> Sir, I have the honor of informing you that the Minister of State has just made a decision on my proposal that you be entrusted with the task of executing, on behalf of his ministry and for a sum of twelve thousand francs, a painting, the subject and sketches for which you will submit to me.[2]

Note that the date of payment clearly lagged behind the date of completion; the decree announcing the payment of the amount due is dated November 20, 1855, that is, six months after the opening of the Exposition Universelle:

> Payment of the sum of twelve thousand francs is authorized on behalf of the painter Monsieur Eugène Delacroix, a fee accorded him by a decision made on March 20, 1854, as payment for the execution of the painting representing a Lion Hunt. This amount of twelve thousand francs will be drawn from moneys set aside for artworks and decoration in public buildings, in the fiscal year 1855.[3]

Delacroix undoubtedly chose his theme in some haste—perhaps he had already negotiated with the administration—since, the day after receiving the commission, he wrote the following in his *Journal:* "Worked all day on the *Antaeus* for [Alexandre] Dumas [*fils*], and on the compositions for the *Lion Hunt,* etc."[4] While this passage does not refer explicitly to the commission received

from Monsieur de Mercey—the artist had already been working for a number of days on Weill's *Arabs Stalking a Lion* (cat. 10)—it confirms his interest in this theme, which had preoccupied him for several months.

Numerous preparatory drawings of different figure groupings attest to the first phase of these studies. The Louvre possesses nine key sketches for this painting, and they show the evolution of Delacroix's conception of both the overall composition (fig. 1) and the various figure groupings: the lion holding down a prostrate hunter and his horse in the left foreground,[5] the rider on the right being attacked by a lioness (fig. 2), and the roaring lion off to the left.[6] Other sketches showing a mounted Arab attacked by a lion are in the Fogg Art Museum, Harvard University, in Cambridge, Massachusetts; the Musée Bonnat in Bayonne;[7] and the Nationalmuseum in Stockholm.[8] The two drawings in Stockholm are studies for the bodies of Arabs bloodied in attacks by wild animals.

Delacroix appears to have been completely absorbed by the development of his work, apprising his student and collaborator Pierre Andrieu (1821–1892) of possible disturbances because of the commission for the church of Saint-Sulpice.[9] Moreover, his *Journal* reflects the creative anguish that was then a daily experience. In the entry for April 27, he wrote, "I am turning over in my head the two pictures of *Lions* for the exposition."[10] On May 3, he remarked with satisfaction: "This morning enthusiastically recommenced working on the sketch for the *Fight Between Lions.* I may make something of it yet."[11] On June 7, he wrote that he "went back to the small sketch for the *Lion Hunt.*"[12]

During the four months from April to the end of July 1854, Delacroix made numerous studies for different parts of his painting. The drawing he mentions in his entry for June 7 (cat. 12)—done,

Fig. 1
Eugène Delacroix, *Thrown Rider in a Landscape,* 1854–55, graphite on paper, Paris, Musée du Louvre, Département des Arts Graphiques.

Fig. 2
EUGÈNE DELACROIX,
Lions Attacking Thrown Riders,
1854–55, graphite on paper,
Paris, Musée du Louvre,
Département des Arts
Graphiques.

this time, in oils—undoubtedly represents one of the earliest stages in his attempt to define the composition, to place the main lines essential to overall movement, and to block in the main color masses. Executed with surprising energy and a vigorous use of color, it shows with what rigor Delacroix wanted to organize the pictorial space and balance the colors in his work. Having some years earlier criticized Rubens for a degree of confusion in the composition of his hunting scenes, Delacroix wanted to orchestrate the violence of the scene and clarify the movement of the human and animal groupings by a meaningful distribution of color in the various zones of his canvas. Later he would write: "The sensation of *the Terrible* and still more, that of *the Horrible* cannot be endured for long. . . . *The Terrible* is a natural gift in the arts, like charm."[13] Thus, the working out of the colors had truly become an obsession. This is proven by notes the artist set down in his *Journal* on July 15, 1854, two weeks before he began laying in the composition for the finished painting: "Shade for the horse in the foreground of the *Lion Hunt*. For the manes: burnt lake, raw

12. *Lion Hunt*
(compositional study)

1854
Oil on canvas; 33⅞ x 45¼ inches (86 x 115 cm)
Paris, Musée d'Orsay (RF 1984-33)

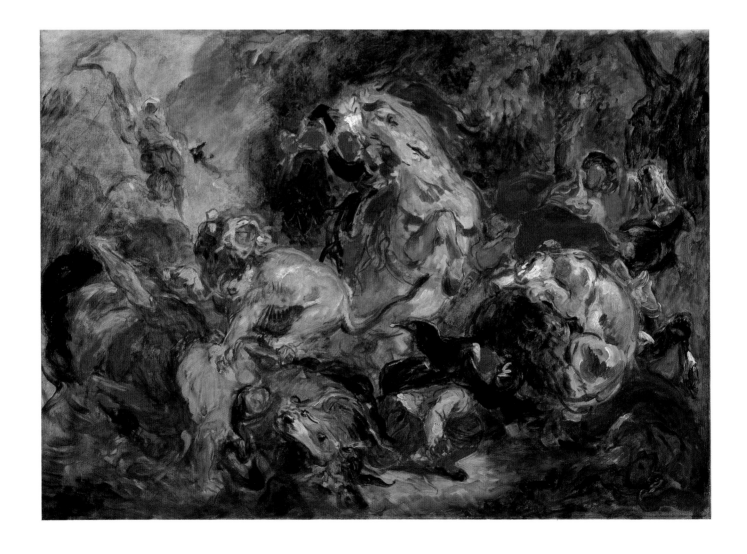

sienna, burnt sienna. For the body: mummy, gaude lake, dark chrome. All of these colors have a role to play in the picture. Hooves: Cassel earth, peach black, Naples yellow."[14]

A few days earlier, as called for in the letter announcing the commission, Delacroix undoubtedly submitted the sketch of his work for government approval. Lee Johnson has suggested that the *Lion Hunt* painting now in Stockholm (cat. 13), which is more finished than the one in the Musée d'Orsay (cat. 12), could be the oil the artist intended to show his patron. The composition and the aesthetic decisions appear very accomplished, while the overall construction of the scene, the use of color, and the various elements of the drama and its presentation display perfect mastery. This study indicates how Delacroix's finished painting must have looked before a fire at the city hall in Bordeaux destroyed the upper section; it indicates that the landscape in which the scene is set was, once again, based on views of Morocco and of the Île-de-France.

The artist faithfully recorded in his *Journal* the various stages in the development of the work, the

final version of which was begun on July 30, 1854. On August 1, Delacroix wrote: "Yesterday and the day before, did the first two sessions on the *Lion Hunt*. I think that it will go quickly."[15] August 2 he declared "a bad day, the third on the large painting. Still made progress, however. Worked on the right corner, on the horse, the man and the lioness leaping on the horse's hindquarters."[16] Later, the *Journal* returns to dwell on color choices:

> For the last day or two have recommenced working on the painting of the *Lion Hunt*. I believe that I am going to get

13. *Lion Hunt*

1855
Oil on canvas; 21¼ x 29⅛ inches (54 x 74 cm)
Signed and dated at lower right:
Eug. Delacroix. 1855 [or *1856*?]
Stockholm, Nationalmuseum (NM 6350)
Exhibited in Paris only

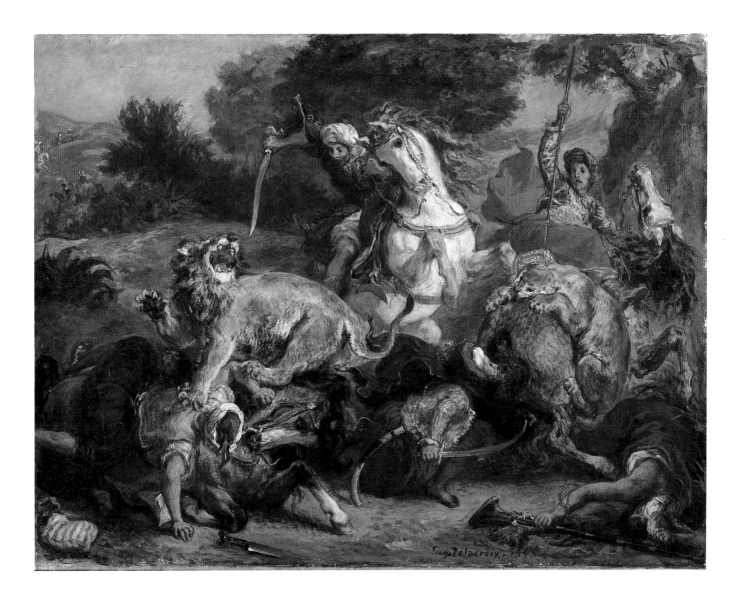

it on the right track. Avoid black; produce dark tones with fresh, transparent colors: either lake or cobalt, or yellow lake, or raw or burnt sienna. After unduly lightening the coffee-colored horse, I found that I improved it by reworking the shadows, particularly with strong greens. Keep this example in mind.[17]

At the end of the winter the painter could consider himself satisfied with his progress on the work, which had earlier been interrupted by commissions executed for other dealers (cats. 10 and 11). "I have worked an enormous amount within the last two weeks. . . . I had previously given the *Lions* a shape which I think, finally, is the right one. And now all I have to do is finish them, making as few changes as possible."[18]

In spite of this unflagging pace, Delacroix spent a long time applying the final touches, and the work was completed only a few days before the opening of the Exposition Universelle. He was still at work on March 14, the day he was supposed to approve the arrangement of the room where the *Lion Hunt* would hang. "I took time off from my relentless work on my *Lions* to go at one o'clock to see the exhibition room."[19]

It is important to recognize the almost universal incomprehension with which critics greeted the violence of the subject matter and the vigorous energy with which the painting was executed.

14. *Lion Hunt*
(fragment)

1855
Oil on canvas; 68⅛ x 141¾ inches
(173 x 360 cm);
original size: 102⅜ x 141⅜ inches (260 x 359 cm)
Signed and dated at lower center right:
Eug. Delacroix 1855.
Bordeaux, Musée des Beaux-Arts (Bx E 469,
then Bx M 6994)

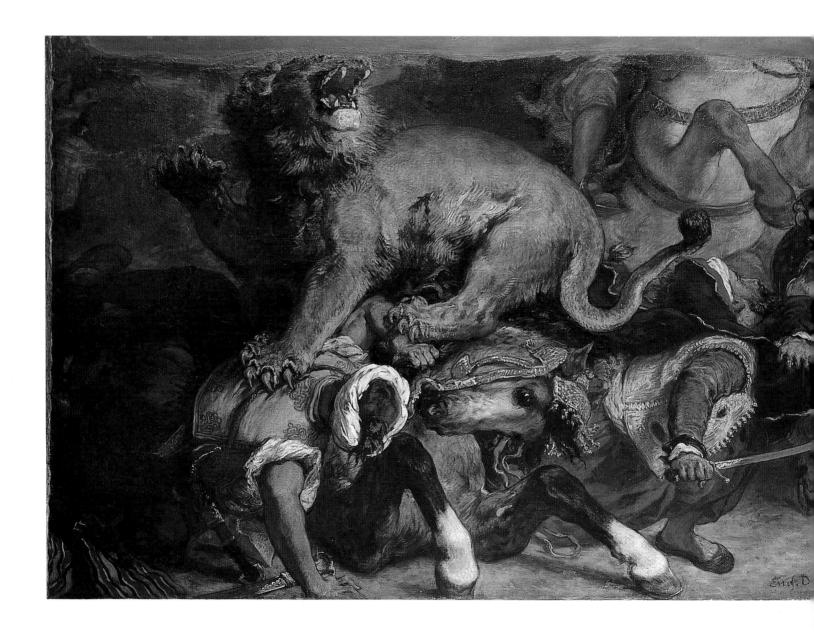

Maxime Du Camp quite faithfully summed up the general impression, speaking of "curious tangles of horses fallen to pieces, horsemen attacking heraldic lions with daggers, misshapen date peddlers scuttling around on their knees." And, even more expressively, he condemned Delacroix's aesthetic choices:

> Color here is at its most extravagant and verges on raging madness; and there is complete disregard for harmony, since all of the tonal values are about equal. . . . Monsieur Delacroix will endure neither as a history painter nor as a painter of genre scenes. If he does endure—which seems doubtful—it will be solely as a painter of the picturesque. As a classical writer once put it: Monsieur Delacroix is the leader, not of a school, but of a riot. This *Lion Hunt* is the height of eccentricity and does its utmost to rival the grotesque.[20]

Even some of Delacroix's supporters, astounded by the agitation of the scene and the boldness of the colors, rejected the violence of the canvas and

the manner in which it was painted. Paul Mantz found that it exhibited genuine flaws of execution:

> Only the landscape is superb; the brilliance of the backdrop is unrivaled. But the composition is unclear, and only through long-sustained attention can the eye, making order from disorder, find itself in this tangle of men and animals. The draftsmanship is slack, and the forms crumple like flimsy material; the lines flare up, twisting and turning about each other. It is more a parody of strength than strength itself.[21]

Only three of Delacroix's most loyal critics came to his defense on this occasion. It is to Delacroix, Edmond About asserted, that we come "for austere emotions, profound memories, strong ideas."[22] Théophile Gautier admired the "chaos of claws, teeth, cutlasses, lances, torsos, croups, the way Rubens liked them; all this in gleaming color so full of light that it almost makes you lower your eyes."[23] To Delacroix's numerous detractors, he responded, "We, for our part, are quite pleased with it; it is energetic and courageous painting." Charles Baudelaire was drawn mainly to the effects of color:

> The *Lion Hunt* is a veritable explosion of color (let the word be understood here in a positive sense). Never have more beautiful or more intense colors penetrated to the soul through the channel of the eyes. It is as if this painting, like the practitioners of magic or hypnotism, projected its thought from a distance. This remarkable phenomenon is owing to the power of the colorist, the perfect concurrence of tones and the harmony between the color and the subject.[24]

Upon leaving the Salon, the *Lion Hunt* was sent directly to the Musée des Beaux-Arts in Bordeaux, undoubtedly because a Rubens with the same theme had been in the collection of this museum since 1803. It was there that Pierre Andrieu saw the work again in 1861, at which time he wrote to Delacroix to convey his impressions and to underscore the undeniable success that the painting enjoyed on the local scene. Delacroix responded to the comments of his former student with a letter expressing his regret at the lack of understanding shown by the critics at the Exposition Universelle. "I am delighted by what you tell me about my paintings in Bordeaux and Toulouse. It is unfortunate that they make an impression when there are very few people to see them and completely miss the mark when in the presence of the Salon critics."[25]

In Bordeaux, the work was copied several times by Odilon Redon (1840–1916), and by the landscape painter Charles-François Daubigny (1817–1878) or Pierre Andrieu. It was in 1870 that it was partially destroyed by fire. The museum committee had decided to protect certain important works by

storing them in a wing of the city hall, an unfortunate decision since this chamber disappeared in the fire. Twenty other works were completely destroyed, including Rubens's *Lion Hunt,* and some sixty others were seriously damaged. Only the lower part of Delacroix's canvas escaped the flames.

Despite its lack of critical success at the start, *Lion Hunt* was undeniably the culmination of all of Delacroix's studies, combining as it does the three key themes that had occupied the artist throughout his career: Orientalist studies, hunts and battles, and animals. At a deeper level, this canvas also represents a striking synthesis, on one hand, of Delacroix's studies of movement and expression and his sense of the drama of violence and color—Romantic impulses that, despite his denials, he had pursued throughout his career—and, on the other, of his interest in scenes that derived from the classical tradition and recalled the masterpieces of the great Renaissance and eighteenth-century masters.

V. P.

1. *Journal,* March 20, 1854, p. 403.

2. Archives Nationales, Paris, F²¹74.

3. Archives Nationales, Paris, F²¹74.

4. *Journal,* March 21, 1854, p. 403.

5. RF 9473, RF 9474, RF 9478, RF 9479, and RF 9485.

6. RF 9479 and RF 30035.

7. N.I. 599 and N.I. 600.

8. 258/1972 and 259/1972.

9. Delacroix to Pierre Andrieu, April 24, 1854, *Correspondance,* vol. 3, p. 207.

10. *Journal,* April 27, 1854, p. 416.

11. *Journal,* May 3, 1854, p. 420.

12. *Journal,* June 7, 1854, p. 431.

13. *Journal,* January 25, 1857 (Norton, 1951, p. 345).

14. *Journal,* July 15, 1854, p. 440.

15. *Journal,* August 1, 1854, p. 447.

16. *Journal,* August 2, 1854, p. 447.

17. *Journal,* November 21, 1854, p. 492.

18. *Journal,* February 7, 1855, p. 500.

19. *Journal,* March 14, 1855, p. 501.

20. Du Camp, 1855, pp. 94ff.

21. Mantz, 1855, pp. 171–72.

22. About, 1855, pp. 179–80.

23. Gautier, 1855(a).

24. Baudelaire, 1855.

25. Delacroix to Pierre Andrieu, *Correspondance,* vol. 4, p. 277.

15. *Lion and Caiman*
or *Lion Clutching a Lizard*
or *Lion Devouring an Alligator*

1855
Oil on mahogany panel; 12⁹⁄₁₆ x 16½ inches
(32 x 42 cm)
Signed and dated at lower right:
Eug. Delacroix / 1855.
Paris, Musée du Louvre (RF 1395)

Set in a landscape of bushes and rocky mounds more reminiscent of the forest of Sénart than of the deserts of Africa, this work was clearly painted for commercial reasons. However, it provides an excellent example of the quality of the research undertaken by Delacroix while he was studying the adaptation of pictorial technique to the physical representation of large wild animals. The almost playful attitude of the lion, in contrast to the paroxysms of fear of its victim, is the central theme of this composition (which has a certain drama that is nevertheless secondary). The very free and lively brushwork, the clear sense of purpose in the actions, the freshness of the landscape colors—all these clearly reinforce the realism of the animals' poses and constitute the principal aim (which is uniquely pictorial and technical) of this engaging painting.

Some of the pictorial qualities of Delacroix's later works can be found in the landscape—for example, the fluidity of touch and the deliberate choice of bright and luminous colors, like the greens and light browns of the vegetation and the intense blue of the sky. A very spirited sketch now in the Louvre (fig. 1) attests to the painter's initial ideas for the figures of the lion and the reptile, revealing, even at this early stage, the vigorous draftsmanship of the final composition.

The identification of the creature captured by the lion has always posed a problem for art historians, but this is frequently the case in Delacroix's animal paintings due to their speed of execution and the artist's reluctance to adhere faithfully to anatomical canons. Whereas some see an alligator and others a caiman, the title chosen at the time of the artist's 1855 retrospective *(Lion Clutching a Lizard)* suggests another identification, although the lion's prey is exceptionally large for a saurian.

In any case, Delacroix seems to have been particularly proud of his rendering of this scene. After selling the painting, undoubtedly sometime before 1860, he undertook a second version of it in 1863

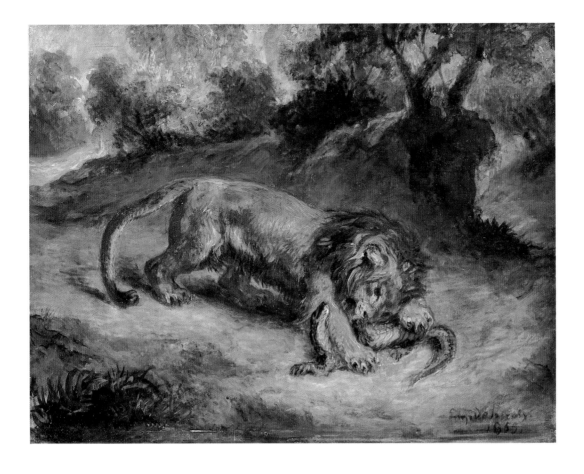

(fig. 2), this time reversing the composition and imposing upon it a greater degree of structure. This was the version he gave a few weeks before his death to the painter Constant Dutilleux (1807–1865). On May 8, 1863, he wrote to Dutilleux, who was one of his most faithful friends:

> After you had gone, I remembered that you seemed to like the little picture of the lion, on one of the easels. I hope I am not mistaken in thinking that you took a fancy to it. I would have sent it to you there and then, but it needed one or two finishing touches, which I added yesterday.[1]

In reply, Dutilleux noted with amusement that his moment of doubt before another painting had "earned me the *Lion*."[2]

V. P.

1. *Journal,* May 8, 1863 (Norton, 1951, p. 413).
2. Dutilleux to Delacroix, May 8, 1863, Archives Piron, Fondation Custodia, Paris.

Fig. 1
EUGÈNE DELACROIX,
Lion Devouring a Caiman,
c. 1855, graphite on paper, Paris,
Musée du Louvre, Département
des Arts Graphiques.

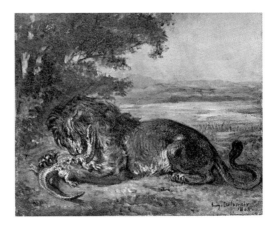

Fig. 2
EUGÈNE DELACROIX,
Lion Devouring an Alligator, 1863,
oil on canvas, Hamburg,
Kunsthalle.

16. *Lion Devouring a Rabbit*

c. 1851–56
Oil on canvas; 18¼ x 21⅞ inches (46.5 x 55.5 cm)
Signed at lower right: *Eug Delacroix.*
Paris, Musée du Louvre (RF 1394)
Exhibited in Paris only

Delacroix painted the theme of a reclining lion devouring an animal several times. He appreciated the cruelty of these tumultuous scenes as daily reminders of the violent and eternal realities of nature. Other examples include an 1829 lithograph, *Lion from the Atlas Mountains*,[1] and a watercolor dated by Alfred Robaut to 1837 (Musée National des Beaux-Arts, Algiers) showing lions setting upon their prey. Delacroix had already worked up the present composition in *Lion Devouring a Hare* (fig. 1), a striking red chalk drawing dated August 21, 1851; the date may raise doubts about the later dating of the Louvre painting (if the authenticity of the drawing can be confirmed). But he treated this subject in numerous pictorial works, the most interesting of which include: *Lion Devouring a Horse* (1844, private collection),[2] *Lion Devouring a Goat* (1847, private collection),[3] *Lion and Wild Boar* (fig. 2), and *Lion Devouring an Alligator* (cat. 15 fig. 2).[4]

Lion Devouring a Rabbit, considered by Alfred Robaut to be one of the painter's masterpieces, is incontestably one of the finest examples of the artist's animal paintings.[5] Its success resides mainly in the concentration of the scene, which, in a realistic and expressive manner, focuses on the calm cruelty of the feline and the terror-stricken eyes of the rabbit. But equally noteworthy is the perfect integration of the subject into a wild and turbulent landscape reminiscent of the mountainous regions of the North African desert. Set against a sort of dark cavern and illuminated only by light coming from a rocky gorge, this scene has indisputable dramatic power. The palette is more somber and theatrical than that found in some of the artist's other animal compositions. This painting was celebrated in the nineteenth century, thanks both to Robaut's impassioned descriptions and to its romantic flavor.

When, with patriotic pride, he bequeathed the entirety of his collection to the Louvre, the financier and industrialist Georges-Thomy Thiéry (1823–1902) considered the acquisition of this painting a victory. In his book on donors to the Louvre, Louis Legrand attested to this: "I was told that, when [Thiéry] acquired Delacroix's *Lion Devouring a Rabbit,* he exclaimed, 'What a pleasure! This will be one more painting for France.'"[6]

V. P.

Fig. 1
EUGÈNE DELACROIX, *Lion Devouring a Hare*, 1851, red chalk on paper, Bremen, Kunsthalle.

Fig. 2
EUGÈNE DELACROIX, *Lion and Wild Boar*, 1853, oil on canvas, Paris, Musée du Louvre.

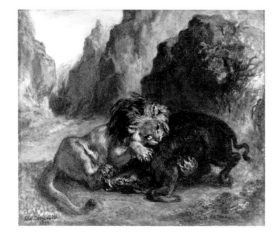

1. Delteil, 1908, no. 79.
2. Johnson, 1986, vol. 3, no. 174, pl. 9.
3. Johnson, 1986, vol. 3, no. 179, pl. 11.
4. Johnson, 1986, vol. 3, no. 208, pl. 32.
5. Robaut, 1885, no. 1299, repro.
6. Louis Legrand, *Les Donateurs du Louvre: Thomy Thiéry* (Paris: Imprimerie générale Lahure, 1907), p. 10.

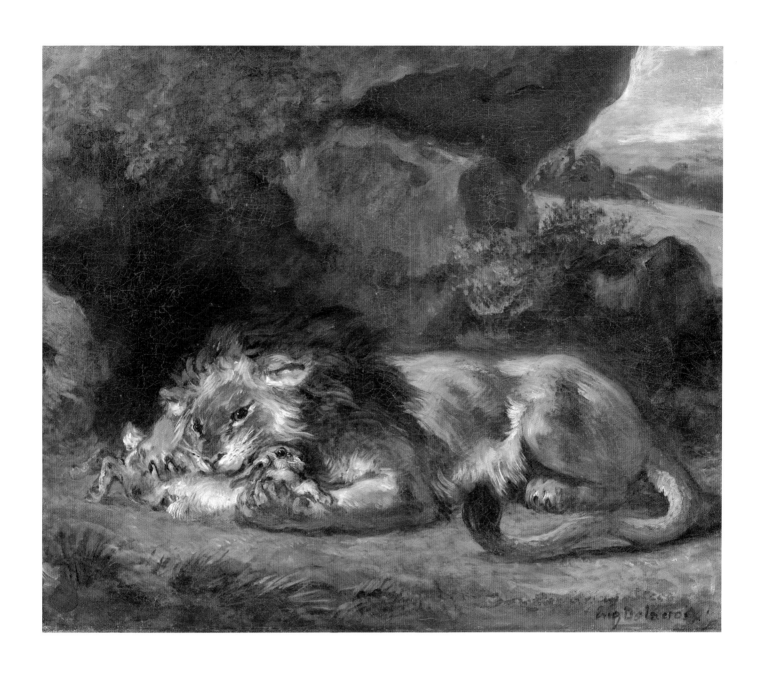

17. *Young Woman Attacked by a Tiger*

or *Indian Woman Bitten by a Tiger*

1856
Oil on canvas; 20⅛ x 24⅛ inches (51 x 61.3 cm)
Signed and dated at lower center right:
Eug. Delacroix. 1856.
Stuttgart, Staatsgalerie (inv. 2695)

In this vigorously and vibrantly handled work, Delacroix took a quasi-mannerist approach in which the ferocity of wild animals and the sensuality of the female body are linked. As if fascinated by the horror of the scene, the artist passionately embarked upon this almost lascivious depiction of the body of the young Indian woman who, with bared breasts, seems to be hopelessly—but not ungracefully—submitting to the cruelty of the great cat. Delacroix's composition is elegant, developing a correspondence between the accentuated curve of the body of the young woman—who, as the dropped urn suggests, was caught by surprise while gathering water from a spring—and the tall rushes on the right. Several preparatory drawings for this painting (fig. 1) illustrate Delacroix's subtle development of this scene, focused from the outset on the study of the complex and graceful movements of the young woman, which contrast with the raw strength of the feline.

Michel Florisoone[1] has proposed a drawing by Francisco José de Goya y Lucientes (1746–1828) as a source for the treatment of the female body. In fact, Delacroix's appreciation of the Spanish painter went back to his youth, when he was introduced to Goya's work by his friend Félix Guillemardet, whose father had served as ambassador to Spain and owned a number of Goya's works. As early as 1824, Delacroix noted in his *Journal* that he had made studies based on prints by Goya.[2] And during a brief stay in Seville while en route to Morocco in 1832, he had admired several of the artist's paintings in the city cathedral. Thus, such an influence is conceivable, and even if the

Fig. 1
EUGÈNE DELACROIX, *Studies for Indian Woman Bitten by a Tiger,* c. 1856, graphite on beige paper, Paris, Musée du Louvre, Département des Arts Graphiques.

etching cited by Florisoone—Goya's *Woman Seized by a Horse*—was published after Delacroix's death, the latter obviously had been able to see a preparatory drawing or a proof.[3]

But the highly studied pose of the young woman's body also seems to derive from classical sources—it is reminiscent of the writhing bodies of abducted women in the paintings of Rubens. There may be Asiatic influences as well—Delacroix always had an interest in Indian statuary, where the female body is frequently submitted to comparable distortions. And other, more surprising, iconographic references are possible, as suggested by the similar pose of the hero attacked by a lion in the *Lion Hunt* by Bénigne Gagnereaux (1756–1795) painted about 1790 (Kunsthalle, Bremen). Finally, Nancy Anne Finlay has compared the body of the young woman to a figure from the Temple of Apollo at Bassae in a relief now in the British Museum, London.

V. P.

1. Florisoone, n.d. [1938].
2. *Journal*, March 19, 1824, p. 57.
3. On Goya and Delacroix, see Florisoone, n.d. [1938].

18. *Lion Playing with a Tortoise*

1857
Brown ink and brown wash over graphite on paper; 7 9/16 x 9 5/8 inches (91.2 x 24.2 cm)
Signed at lower right in brown ink: *Eug Delacroix*
Dated and annotated at lower left in brown ink: *Augerville 17 oct. 57.*
Rotterdam, Museum Boymans–van Beuningen
Exhibited in Paris only

From October 6 to October 19, 1857, Delacroix stayed in Augerville-la-Rivière (Loiret), a property belonging to the lawyer Pierre-Antoine Berryer (1790–1868), his cousin. In 1845 the latter had expressed his desire to reestablish contact with Delacroix. This was undoubtedly in return for the help the artist's father, Charles Delacroix, had given Berryer's own father, Pierre-Nicolas, first when he was called to the bar, and later, during the French Revolution, when he showed excessive zeal in his defense of the banished.

From that year on, the two men maintained a regular correspondence. Their letters, now in the

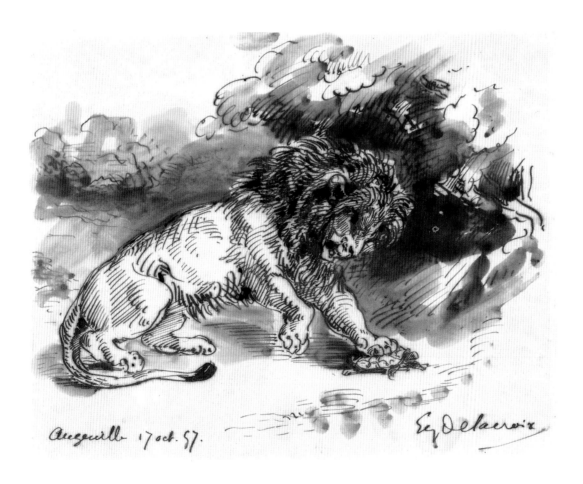

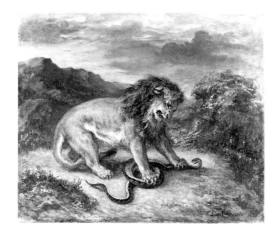

Batta/Augerville";[2] and a *Seated Tiger Watching Its Prey,* accompanied by the following lines: "Eugène Delacroix / to Alexandre Batta, a small memento in gratitude for the pleasure he has given me. May 1854."[3]

Composed like a small painting—the setting is, in some ways, reminiscent of that in *Lion Clutching a Snake* (fig. 1)—this drawing was probably made for the cellist in memory of the evening of October 16, described in Delacroix's *Journal* as follows: "Superiority of music; absence of reasoning (not of logic). I was thinking of this as I listened to the simple piece for organ and cello which Batta played for us this evening, after having played it over before dinner. The intense delight which music gives me—it seems that the intellect has no share in the pleasure."[4] Delacroix returned to Paris on October 20 and, one week later, wrote Batta a long letter that ends as follows: "I cannot but think, each instant, of the pleasure I experienced during my too brief stay at the home of the excellent and incomparable man whom we have just taken leave of. I am indebted to you, my friend, for a very large portion of this enjoyment and—I would say—happiness."[5]

A. S.

Musée Delacroix, clearly show that Berryer often helped his cousin obtain various of his already sold works for official exhibitions. Moreover, Berryer almost certainly played a role in the election of his cousin to the Institut in 1857.

Delacroix always took great pleasure in visiting Augerville-la-Rivière. There he delighted in the conversation of good company and in the walks he took with his companions around his cousin's estate. Regular visitors included the Dutch cellist Alexandre Batta (1814–1902), who received a number of ink drawings from the painter. These drawings, which often carried dedications, included a *Corner of the Berryer Park at Augerville,* which the artist signed using his famous rebus, "2 la +";[1] an *Arab Horseman* dedicated to "my dear

1. Robaut, 1885, no. 1180, repro.
2. Robaut, 1885, no. 1235, repro.
3. Robaut, 1885, no. 1260, repro.
4. *Journal,* October 16, 1857 (Norton, 1951, p. 369).
5. The letter is in the collection of the J. Paul Getty Center, Malibu; Johnson, 1991, p. 147.

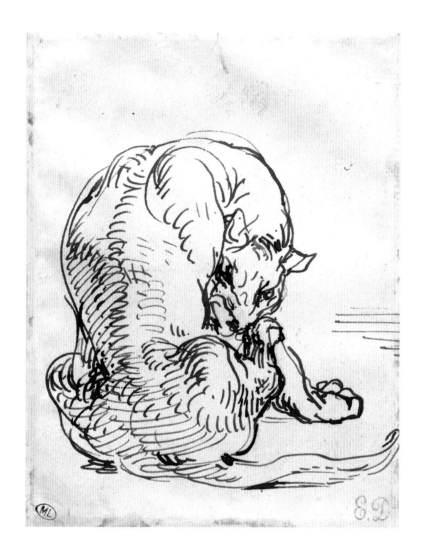

19. *Seated Feline Seen from Behind, Licking Its Paw*

c. 1855–63
Brown ink on blue paper; 5³⁄₁₆ x 4 inches
(13.1 x 10.2 cm)
Paris, Musée du Louvre, Département des Arts
Graphiques (RF 9682)
Exhibited in Paris only

In its subject matter and its incisive use of line, this drawing is comparable to the lithograph *Tiger Licking Itself* that the artist executed in 1856.[1] Also, in the foreground of *Daniel in the Lions' Den,* a painting of about 1849–50 (Musée Fabre, Montpellier), Delacroix placed a lioness licking itself, in a reversed yet similar position.

A. S.

1. Delteil, 1908, no. 130, repro.

20. *Tiger Startled by a Snake*

c. 1858
Oil on paper mounted on mahogany panel;
12¾ x 15⅞ inches (32.4 x 40.3 cm)
Signed at lower right: *Eug. Delacroix*
Hamburg, Kunsthalle (inv. 2400)
Exhibited in Paris only

For this work, like most of Delacroix's unanno-
tated animal paintings, the dating is a delicate
matter. Although Alfred Robaut's 1885 catalogue
assigns it to 1858, the work can be correlated with a
glass negative that dates from 1854 (fig. 1) and
shows a tiger in a similar pose.[1]

Fig. 1
EUGÈNE DELACROIX,
Halted Tiger, 1854, glass negative,
Paris, Bibliothèque Nationale de
France, Département des
Estampes et de la Photographie.

Fig. 2
EUGÈNE DELACROIX, *Halted
Tiger,* c. 1854, graphite on paper,
Paris, Musée du Louvre,
Département des Arts
Graphiques.

In 1854, through the painter Constant
Dutilleux, Delacroix was introduced to the glass-
negative photoengraving process by its inventors,
Cuvelier and Grandguillaume. Delacroix was keen
on learning the technical language of this new
mode of reproduction and decided that he would
try his hand at it. To Dutilleux he wrote: "I am
doubly indebted to you, first for the process of
photographic engraving, and second for so kindly
making me acquainted with Monsieur Cuvelier. I
was very pleased by the indulgence with which he
presided over my very imperfect attempt."[2]
Among Delacroix's first glass-negative prints was
that of the tiger mentioned above.

There are, however, several notable differences
between the glass negative and the painting. The
cat's crouch is more pronounced in the negative; a
steep, mountainous valley, absent from the glass
negative, enlivens the left side of the oil painting;
and the snake that emerges from the tall grass in
the foreground of the painting is not reproduced
in the negative. Delacroix, for obviously commer-
cial reasons, worked harder on the painting, which
he enlivened with a dramatic anecdote. In fact, a
drawing of a halted tiger (fig. 2) facing in the op-
posite direction probably influenced the artist's
choice of the feline's position in both the glass
negative and this painting. In that drawing,
Delacroix depicted the animal in a more supple
pose and gave it an elongated muzzle that is clearly
reminiscent of the head of the tiger seen here.
Another drawing, now in the Musée Marmottan,
Paris, is probably a study for the slender body of
the feline—assuming that the attribution to
Delacroix is correct.

In any case, the date proposed by Alfred
Robaut, who owned the unique, unsigned first
proof pulled from the glass negative, could be cor-
rect. For Delacroix could have made the print first
and gone back, four years later, to a similar motif
for this oil painting. Also, in its technique this
work is very close to *Tiger Growling at a Snake*
(cat. 133), of 1862—a date that tends to confirm
Robaut's hypothesis.

Lee Johnson has suggested that the pose of the
tiger could be derived from a woodblock print
dating back to 1828.[3] This print, based on a draw-

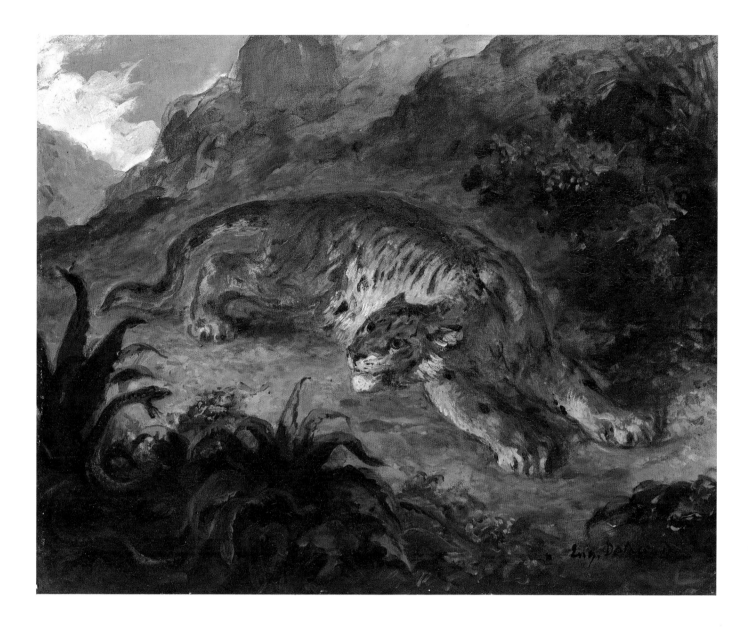

ing by William Harvey (*Puma Hunted*), was published the next year in *The Tower Menagerie.* In his depictions of animals, Delacroix did not always work directly from nature, even though he did spend many hours in the zoological section of the Muséum d'Histoire Naturelle. For he was also drawn to collections of anatomical engravings and scholarly studies in zoology like *The Tower Menagerie* (by his own admission a work of interest to him). Such works may have been the source of certain poses found in his animal paintings.

V. P.

1. Robaut, 1885, no. 1354, repro.
2. Delacroix to Constant Dutilleux, March 7, 1854, *Correspondance,* vol. 3, pp. 195–97.
3. Johnson, 1986, vol. 3, no. 196, pl. 20.

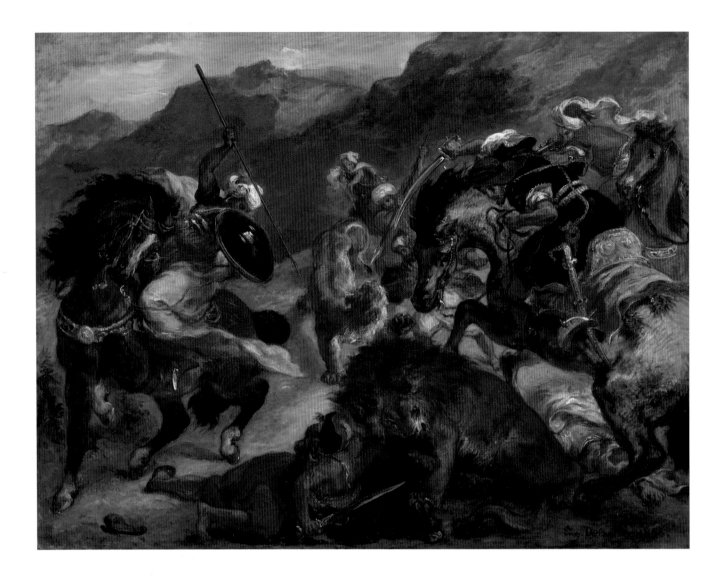

21. *Lion Hunt*

1858
Oil on canvas; 36⅛ x 46¼ inches
(91.7 x 117.5 cm)
Signed and dated at lower right:
Eug. Delacroix 1858.
Boston, Museum of Fine Arts, S. A. Denio
Collection (95-179)

We do not know exactly what prompted Delacroix to return to the theme of the lion hunt, which he had studied at length three years before. A dealer's commission was undoubtedly the motivation for the present painting and for Delacroix's return to battles between men and wild animals, a subject that had preoccupied him around 1855. In any case, by the time of his death in 1863, this canvas had already been on the art market for several years.

Whatever the circumstances, Delacroix seems to have been delighted to revisit the sources of his animal paintings. "It was a good day," he observed in his *Journal* entry for April 26, 1858. "Worked hard and in good humor on the *Lion Hunt,* which is now as good as finished."[1] Profiting by comments made in the extremely adverse articles aimed at his large *Lion Hunt* (cat. 14) during the 1855 Exposition Universelle, Delacroix simplified his composition, structuring it rigorously around four main groups that accentuate the violence of the scene. On the left, a horseman separated from the rest of the hunters is on the point of spearing a lion. In the right foreground, two horsemen are trying to kill a lion attacking a man without a mount while, behind them, three men on foot are battling a lioness.

The meticulous spatial and chromatic organization of this work, in conjunction with a landscape of extraordinary simplicity, which evokes the desert wastes of the Orient, emphasizes the work's classicism, which is more reminiscent of Tempesta's and Rembrandt's hunts than of Delacroix's large painting for the Exposition Universelle.

V. P.

1. *Journal,* April 26, 1858, p. 717.

22. *Three Studies of Lions*

1859
Black ink on paper; 6⅞ x 8¾ inches
(17.5 x 22.2 cm)
Signed at lower left in black ink: *ED*
Dijon, Musée des Beaux-Arts (DG 526)
Exhibited in Philadelphia only

When he illustrated these drawings in his 1885 catalogue of Delacroix's work, Alfred Robaut's reproduction changed the placement of the felines and reversed the pose of the animal on the left.[1] This anomaly undoubtedly stemmed from his practice of using tracings to produce his vignettes. Volume five of Robaut's papers,[2] now in the Bibliothèque Nationale, Paris, contains a sheet with three tracings of these studies (1859/1392). Moreover, there is a handwritten note on this sheet: "The original comes from the Lebas sale. Communicated by Rapilly in October 71. The sheet of 3 differently positioned 80 F."

According to Robaut, these sketches conveyed not only the master's knowledge but also his deep thinking: "Delacroix has always grasped—and with an intuitive strength that is the mark of his genius—the larger dimension of things. It is in the strength of his vision that he excels."[3] Whereas the animal in the center is barely outlined—a single, continuous sweep of the pen suffices to delineate the curvature of the spine—the drawing in the upper right attests to the virtuosity of the draftsman who, in the third sketch, suggested more than described the pose of the crouched lioness.

A. S.

1. Robaut, 1885, no. 1392, repro.
2. "Documents Robaut," Département des Estampes et de la Photographie, Bibliothèque Nationale de France, Paris, Dc 183 L folio.
3. Robaut, 1885, no. 1392.

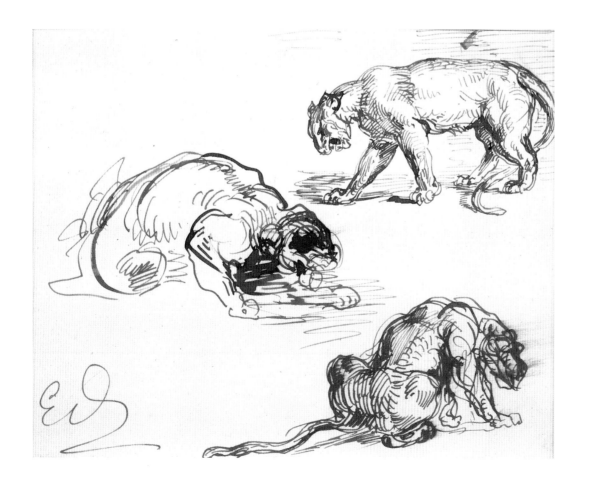

23. *Lion Hunt*

1861
Oil on canvas; 30¹⁄₁₆ x 38¹¹⁄₁₆ inches
(76.3 x 98.2 cm)
Signed and dated at lower left:
Eug. Delacroix. / 1861.
The Art Institute of Chicago, Potter Palmer
Collection (1922.404)

This final variation on the lion hunt theme must have been ordered by a dealer since the only mention of it is a sale price recorded in Delacroix's *Journal* entry for April 28, 1860. Opposite a painting described as "Une toile de trente, *Fantasia ou chasse*" (A painting [of 73 x 92 cm], *Fantasia or Hunt*), the painter has noted the price of three thousand francs.[1]

Though painted on commission, this canvas is one of Delacroix's last great masterpieces. By returning to subject matter he had already used extensively (cats. 14 and 21), he was once again able to endow the movement of his figures with a surprising vigor and to display unrivaled proficiency in the arrangement of his color scheme. In preparation for this painting, Delacroix made systematic studies of figure groupings, as can be seen in a drawing now in the Musée du Louvre.[2]

As he had in 1858 with a *Lion Hunt,* now in Boston (cat. 21), Delacroix rigorously organized this composition, placing the action within a seaside setting that is more credible than an Oriental context might have been. Once again, the artist structured his canvas around four figure groupings. To the left, a rider has been thrown to the ground. His horse has been attacked by a lioness, which another rider attempts to spear. This group recalls one at the left of Rembrandt's print *Small Lion Hunt with Two Lions,* although the motif in Delacroix's version is reversed. In the center background, a horseman rushes toward the melee. Meanwhile, in the lower center of the canvas, a man is being crushed by a roaring lion, while a second man attempts to free him, and from the right two men come running toward this same lion. Behind them, a third figure lies prostrate on the ground.

While the scene may have lost something in savagery and violence, it is clearer and more effective than Delacroix's earlier lion hunts. The artist has attained perfect mastery over the various elements of his narrative. The classical references emphasize the perpetual cruelty in the relation between human beings and animals.

V. P.

1. *Journal,* April 28, 1860, p. 781.
2. RF 9477.

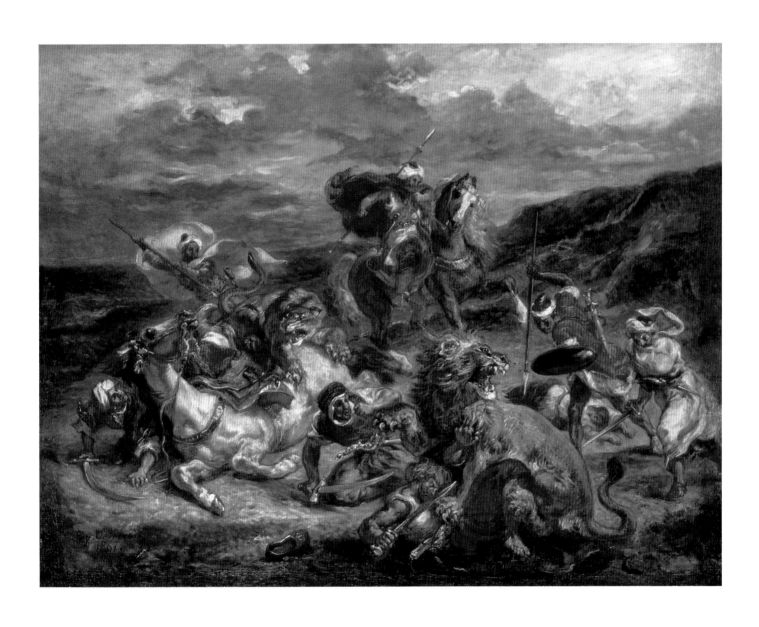

II

THE FEELING FOR NATURE

Although Delacroix never exhibited "pure" landscapes at the Salon and his forays into this genre of painting were episodic, the depictions of nature he painted during the last years of his career undoubtedly tell us more about his artistic ideas, aesthetic decisions, and even his personality than most of his history paintings. The intense scrutiny, stripped of intellectualism, with which he portrayed nature is evident in both his rapid sketches and in the pages of his *Journal*. Indeed, these sketches and notations help us to realize the importance of landscape painting in his professional life after 1840. On March 5, 1842, he wrote the following to his friend Jean-Baptiste Pierret: "You have to take a trip in March to a poor village in the vicinity of Paris—they're all the same—to have your mind changed completely about all systems pertaining to the beautiful, the ideal, and [aesthetic] choice, etc."[1] This passage proves that Delacroix's work sessions in the woods around his house at Champrosay or on the shores of Normandy, where he undertook a systematic and almost scientific examination of natural phenomena and their impact on his techniques, had become absolutely indispensable to his creativity during this period.

A knowledge of Delacroix's landscape studies, a genre he had practiced since his youth and returned to more regularly after 1840, is undeniably very useful in decoding some of his decorative compositions and literary or history paintings. But he had an intrinsic interest in the aesthetic decisions of a landscape painter. One can see this in his passion for technical problems, the treatment of light and shadow, the development of his color schemes, and in the rigorous balance he sought to create between the work he painted from nature (executed, almost instinctively, out-of-doors) and the necessary maturing process of studio painting. In this way he brought out the valuable role of memory and imagination in his work.

By enabling us to understand some of his poetic feelings and his philosophical relationship to the world, the discovery of Delacroix's landscape paintings and flower "portraits" allows us a more intimate insight into this demanding and austere man who detested compromises. He scorned, for example, the poet Alphonse de Lamartine's outpourings over tranquil lakes and longed-for storms: "I am beginning to feel a violent dislike for people like Schubert, the dreamers like Chateaubriand (this began a long while ago), Lamartine, etc. Why will nothing of theirs endure? Because it is utterly untrue. Does a lover gaze at the moon when he is holding his mistress in his arms?"[2] Delacroix railed

against such commonplaces of Romanticism, preferring instead a serene, daily relationship with a rustic, faithful, and soothing nature. During this period he also found that as he grew older, he was "becoming less susceptible to those feelings of deepest melancholy that used to come over me when I looked at nature."[3] Breaking with a certain excitability from his youthful days, in his walks and his work sessions throughout the countryside, he sought to enjoy "the most delicious feeling of . . . perfect freedom I enjoy here. I cannot be hunted down by tiresome people."[4]

The intimacy and complexity of this aspect of Delacroix's work require that the art historian remain modest and rigorous when studying the artist's sketches of trees, plants, and flowers, which are often difficult to date. In painting these with love, but also following an arduous technical process (this is why he never showed them publicly), the painter was obviously not seeking fame nor any form of recognition from his peers—even if he did decide, for the Salon of 1849, to exhibit several flower paintings that were much more ambitious than his landscape studies (cats. 29 and 30). On the other hand, the attention he devoted to his representation of nature had a determining—if hidden—influence on the progressive and relentless transformation of his career during his maturity and old age.

Writers have often rightly pointed out the importance of Delacroix's early relationships with the English painters—his friendships with Richard Parkes Bonington and the Fielding brothers and his admiration for the landscapes of John Constable, which he discovered at the Salon of 1824. Remember that he never took the obligatory trip to Italy, and therefore he had not seen the landscape painters who revitalized the genre there around 1820. But in 1826 he spent some time in England, an experience that deepened his interest in watercolor and the realistic treatment of luminous nature. His relationship with contemporary English landscape painters—who were regarded with some disdain by their Neoclassical French counterparts—further supports the increasingly common image of Delacroix as an active member of the Romantic avant-garde.

From this period on, landscape would clearly occupy a central position in Delacroix's concerns as a history painter. The backgrounds of his major early literary and historical paintings show that he was capable of infusing as much passion and violence into their settings as into the arrangement of their figures in the foreground. What words can describe the somber, splendid, and fiery depiction of the city of Dis in the background of *The Barque of Dante* (1822, Musée du Louvre, Paris), the transparency of the sky overlooking the city of Chios ransacked by the Turks in *The Massacre at Chios* (1824, Musée du Louvre, Paris), or the archaeologically inaccurate yet dramatic architecture of *The Death of Sardanapalus* (1827–28, Musée du Louvre, Paris)? And how can one not admire the determining role played by the view of the city of Paris in *Liberty Leading the People* (1830, Musée du Louvre, Paris), or by the walls of the Moroccan city in *The Fanatics of Tangier* (cat. 104)?

Prior to 1840 Delacroix had consistently designed the settings of his historical compositions (as he would later do for his decorative paintings) by adapting the environment—whether architecture, landscape, or vegetation—to better chronicle the human drama. In addition, during those years, in works as different as his *Portrait of Baron Louis-Auguste Schwiter* (1826, National Gallery, London) and the interior he painted for the dining room of the tragedian François-Joseph Talma,[5] he also executed superb still lifes of flowers, thereby showing his interest in these purely technical pieces that forced the painter to masterfully adapt touch and color to each species of flower.

However, at that time, Delacroix had not yet begun to paint landscapes and flowers for their own sake. If we exclude the two works that belonged to Frédéric Villot and George

Sand (Amandine Aurore Lucie Dupin), there are no flower paintings from before 1848.[6] And even when we learn that Delacroix—driven, often enough, by the need to paint a setting for one of his compositions—did occasionally accumulate a few studies over the course of a voyage, he rarely practiced landscape techniques before 1840. But he revealed his outstanding potential in 1826, when he painted the acclaimed *Still Life with Lobsters* (Musée du Louvre, Paris), a unique work he intended as a synthesis of the genres of landscape and still life.

In fact, Delacroix's growing interest in representing nature for its own sake coincided with comparable developments in his personality. A clear need for solitude made itself felt in this mature and somewhat misanthropic man who wanted to take stock of his life amid the turmoil caused by his career. And we must not ignore the first signs of the illness that was to considerably undermine his health and that, from 1840 onward, lead to numerous rest cures in the mountains, by the seaside, and in the country. It is clear that his various stays in Frépillon with Léon Riesener in 1841, in Nohant with George Sand in 1842 and 1843, and at Eaux-Bonnes in 1845 (when he studied landscape with obvious pleasure) were initially prompted by reasons related to his health and friendships, and were in no way connected with his career. George Sand has left us a remarkable account of the first landscape painting sessions—particularly the first flower studies—that Delacroix undertook during a vacation in Nohant around 1846:

> I saw Delacroix try for the first time to paint flowers. He had studied botany during his childhood and since he had an admirable memory he still knew it. . . . I found him in an ecstasy of delight before a yellow lily, having just grasped its fine *architecture.* . . . He painted in haste, seeing that with every second his model was springing into full blossom in the water, changing constantly in shape and color. He decided he had finished and the results were marvelous; but the next day, when he compared the art with nature, he was dissatisfied and touched up the painting. The lily had completely changed. . . . The day after, the plant was beautiful in a completely different way. It was becoming more and more architectural.[7]

However, Delacroix's increased passion for evoking nature cannot be explained simply by sightseeing jaunts, stays with his friends, or the state of his health. During this period, his studies seem to have been motivated by two veritable obsessions that had already guided the production of his history paintings and decorative compositions, and that would also condition the small studies he completed during his strolls at Champrosay or on the beach at Dieppe. On the one hand, he sought to master all the technical constraints and material aspects of his craft, and when he wrote "the true painter is one who knows all of nature," he articulated perfectly his ambition to paint *everything,* including the landscapes he had previously somewhat neglected.[8] On the other hand, he was determined more than ever to balance the secondary elements of his paintings—including the natural or architectural settings of his narratives—with the central subject of the composition. The main artistic discovery of his mature years remained "the question of harmony between the accessories and the principal object," which, in his view, was "lacking in the majority of great painters."[9] He attempted a reply to this difficult professional question that would guide his aesthetic approach until his death: How can a painter render the details of a work—for example, the background landscape—with the same talent and intensity as the main elements of his aesthetic discourse? Thus, whatever his personal investment in the practice of landscape painting for its own sake, his conception of nature remained closely linked to his efforts to develop his historical or religious paintings.

To resolve these complex issues, Delacroix sought to improve his abilities as a landscape painter by drawing upon traditional methods of the genre, methods perfected first by the Neoclassical landscape painters, then by the Barbizon school. At that time, it was held that the landscape painter should begin with an overall visual and poetic appreciation of the site. This would be followed by open-air sessions in which the artist recorded his visual impressions through rapid sketches in pencil, watercolor, or oils. Once he had finished working directly from nature, the painter could begin the next phase of the work, the production of studio studies for a finished painting.

Delacroix remained totally faithful to this technical approach and felt, like the majority of history painters of his time, that he could not be content with slavishly copying from notes taken out-of-doors, nor with reproducing on a larger canvas simple studies made from nature. In his *Journal* entry for April 26, 1853, he wrote: "You must have complete freedom of imagination when you are painting a picture. The living model, compared with the figure which you have created and harmonized with the rest of the composition, is apt to confuse you and to introduce a foreign element into the ensemble of the picture."[10] In this passage Delacroix recalled his convictions that commanded him to maintain the vital "umbilical cord" with nature but also led him to value the role of memory and imagination and to question realism, which he described "as the antipodes of art."[11] He also expanded on this verdict in a more explicit *Journal* entry, affirming that "the true painter is one whose imagination speaks before everything else" and recalling that "conscientiousness over showing only what is seen in nature always makes a painter colder than the nature he believes he is imitating."[12]

To stimulate his creativity and to ensure that he did not remain too dependent on working directly from nature, Delacroix produced many *ressouvenirs,* or "reminder" sketches, which were complete studio reworkings, done from memory, of studies made from nature. This exercise facilitated greater coordination of hand and eye but also enabled the artist to preserve visual memories and nourish his imagination. "This process of idealization happens almost without my realizing it whenever I make a tracing of a composition that comes out of my head. The second version is always corrected and brought closer to the ideal."[13]

In doing this Delacroix was merely applying the advice of the great theoretician and practitioner of landscape painting Pierre-Henri de Valenciennes (1750–1819), who had described the qualities and conditions of this practice in his key treatise, published in 1800: "We would urge you, once you have completed a study, to redo it without looking at the model. Then, after you have endeavored to not forget anything and your memory no longer serves you, make the comparison with the original."[14] Thus the many sessions that Delacroix spent sketching animals, plants, and flowers at the Jardin des Plantes were frequently followed up by several hours in the studio, where he redid his outdoor studies. For example, on May 20, 1853, he went to the Jardin des Plantes, where "I made some studies of lions and trees for the picture of Rinaldo [and Armida]. It was unpleasantly hot and the crowd was most annoying."[15] The following day he made pastel drawings "of the lions and trees, which I had drawn the day before in the Jardin des Plantes."[16] Likewise, his stays at his favorite vacation spot of Champrosay, where from 1844 onward he found a veritable laboratory for the practice of landscape, inspired striking studies of the sky (cats. 58 to 62). Executed out-of-doors, they were later extensively reworked in the studio before being used as backdrops in such decorations as the Galerie d'Apollon at the Louvre.

Unlike the animal scenes, which he often painted for income, Delacroix's flower "portraits" (reserved for visitors to the Salon of 1849 and the Exposition Universelle of 1855) as

well as his landscapes (which he kept, until his death, in his studio for his own pleasure and his personal archives) were truly at the center of his technical interests. His ideas on landscape became increasingly sophisticated after 1850, and his regular practice, supported by frequent conversations with his fellow landscape painters—especially Paul Huet and Théodore Rousseau—clarify many technical questions whose difficulty he noted in his *Journal*. For example, in the entry for May 5, 1852, he recalled the importance of the placement of tonal values—deemed essential also by Corot (see cat. 38)—before stressing the need to synthesize the colors proposed by nature: "A picture should be laid-in as if one were looking at the subject on a grey day, with no sunlight or clear-cut shadows. Fundamentally, lights and shadows do not exist. Every object presents a colour mass, having different reflections on all sides. Suppose a ray of sunshine should suddenly light up the objects in this open-air scene under grey light, you will then have what are called lights and shadows but they will be pure accidents."[17] In another entry, dated April 29, 1854, he elaborated: "I am beginning to understand the *principle* of the trees better, although the leaves are not yet fully out. They must be modelled with a coloured reflection, as in treating flesh. . . ."[18]

In the same vein, he had distilled his ideas about "flower portraits" to such a high degree that he could sum up in a few lines the program of five paintings he was working on for the Salon (cats. 29 to 31). These lines appear in a letter written to his friend Constant Dutilleux on February 6, 1849: "You were kind enough to talk to me about the flower paintings I am in the process of finishing. I have . . . subordinated the details to the whole as much as possible. . . . I have tried to fashion pieces of nature, such as they present themselves to us in gardens, simply by bringing together, within the same frame and in a highly unlikely manner, the greatest possible variety of flowers."[19]

This aesthetic ambition did not, however, prevent the painter from humbly observing flowers in the countryside, sometimes under very bucolic conditions: "I took it into my head to collect a bunch of wild flowers and scrambled about amongst the undergrowth at the cost of pricked fingers and badly torn clothes."[20] During his working sessions in nature, Delacroix was not always solving the technical problems he encountered in landscape painting. Rather, nature had gradually become for him a friendly place where, encouraged by the "charming music of the birds of the spring: the maybirds, the nightingales, the blackbirds that are so melancholy,"[21] he found much to inspire him. Thus, he mused with fascination on a tiny battle he witnessed while walking through the forest of Sénart on May 17, 1850:

> I saw a battle between a particular species of fly and a spider. I saw them arrive together, the fly fixed relentlessly on the back of the spider, who stabbed away furiously. After a brief resistance, the spider expired from the attack and the fly, having sucked his juices, took it upon himself to drag him off somewhere with incredible vivacity and fury. . . . I observed this little Homeric duel with a kind of emotion. I was Jupiter contemplating the battle between this Achilles and Hector.

But at the end of this intriguing scene the painter reclaimed his rights, accurately noting—for it might be useful in a future composition—that "this fly was black and very long, with red spots on its body."[22]

Thus, whether drawing trees in the forest of Sénart, ocean waves off the coast of Normandy, or sunsets on the Seine by Champrosay, Delacroix was thinking about the composition of his future paintings, the rules of his trade, and the practice required for landscape painting. Despite the dryness of his technical studies, and above and beyond his

sentimental contemplation of French forests and their sunsets, it seems that in working directly from nature, Delacroix found a joy in living that brightened his last days. On April 29, 1850, upon returning from a work session in the forest of Sénart, he wrote: "I don't know why I got the fanciful idea to write about happiness."[23]

Vincent Pomarède

1. *Correspondance,* vol. 2, pp. 91–92.

2. *Journal,* February 14, 1850 (Norton, 1951, p. 109).

3. *Journal,* June 24, 1849 (Norton, 1951, p. 100).

4. *Journal,* April 26, 1850 (Norton, 1951, p. 115).

5. Location unknown; Johnson, 1981, vol. 1, nos. 94–97.

6. *Flower Bouquet,* 1833, National Galleries of Scotland, Edinburgh; and *Still Life, Bouquet of Flowers in a Stoneware Pitcher,* 1842, Kunsthistorisches Museum, Vienna.

7. *Nouvelles Lettres d'un voyageur* (Paris: Calmann-Lévy, 1877); quoted in *Eugène Delacroix et sa "consolatrice"* (Paris: Escholier, 1932), pp. 127–28.

8. *Journal,* March 10, 1850, p. 184.

9. *Journal,* April 15, 1853 (Norton, 1951, p. 172).

10. *Journal,* April 26, 1853 (Norton, 1951, p. 175).

11. *Journal,* February 22, 1860 (Norton, 1951, p. 396).

12. *Journal,* October 12, 1853 (Norton, 1951, p. 195).

13. *Journal,* October 12, 1853 (Norton, 1951, p. 196).

14. *Réflexions et conseils à un élève sur la peinture et particulièrement sur le genre du paysage* (Paris: Dessene et Duprat, 1800), p. 418.

15. *Journal,* May 19, 1853 (Norton, 1951, p. 186).

16. *Journal,* May 21, 1853 (Norton, 1951, p. 188).

17. *Journal,* May 5, 1852 (Norton, 1951, pp. 154–55).

18. *Journal,* April 29, 1854 (Norton, 1951, p. 227).

19. *Correspondance,* vol. 2, pp. 372–73.

20. *Journal,* June 24, 1849 (Norton, 1951, p. 100).

21. *Journal,* May 9, 1850 (Pach, 1937, p. 221).

22. *Journal,* May 17, 1850 (Pach, 1937, p. 222).

23. *Journal,* April 29, 1850, p. 233.

24. *Flower Studies*

c. 1845–50
Watercolor over graphite on paper;
12 3/16 x 8 3/16 inches (31 x 20.9 cm)
Paris, Musée Eugène Delacroix (M.D.1980.1)
Exhibited in Philadelphia only

Similar in composition to the plates in nineteenth-century books on botany, this ethereal and subtle drawing foreshadows the flower studies that Odilon Redon (1840–1916), a great admirer of Delacroix, undertook early in his career, during the 1860s, when he was forcing himself to "closely examine blades of grass and pebbles."[1] This approach enabled him subsequently to move away from reality toward the imaginary. "After having meticulously copied a pebble, a blade of grass, a hand, a profile or anything else derived from animate or inorganic life, I feel the first stirrings of a mental ferment; at such moments I have to create, to let myself go toward the representation of the imaginary."[2]

A. S.

1. See, for example, two of Redon's flower studies in the Musée du Louvre given by Arï and Suzanne Redon, RF 40 751 and RF 40 756; Réunion des Musées Nationaux, Paris, *Donation Arï et Suzanne Redon* (Paris, 1984), by R. Bacou, nos. 357 and 360, repro.; Odilon Redon, *À soi-même: Journal [1867–1915]. Notes sur la vie, l'art et les artistes,* introduction by Jacques Morland (Paris, 1922; rev. ed., 1961), p. 30.
2. Redon (see note 1), p. 30.

25. *Bouquet of Flowers*

1848 (?)
Watercolor over graphite on paper;
8¹/₁₆ x 10⅜ inches (20.5 x 26.4 cm)
Montpellier, Musée Fabre (876.3.101)
Exhibited in Paris only

Without explanation, Alfred Robaut dated this floral bouquet composed of a rose, a sunflower, asters, marigolds, and poppies to 1843.[1] Difficult to date because its composition is so timeless, the picture should be compared with the next work, executed in 1848 (cat. 26). The art historian Théophile Silvestre was asked by the Montpellier dealer Alfred Bruyas to represent him in the Constant Dutilleux sale, which included this study:

> The *Flowers* watercolor costs 410 francs, plus auction expenses. It is not cheap, but what delicacy and freshness of color! It does not have the dazzle of a Diaz, but how much superior in feeling and refinement are Delacroix's flowers, even when they are, like these, incompletely formed. Seen from a few feet away—rather than from under your nose—this Delacroix bouquet is ravishing. . . . A rare piece, intentionally imperfect, but of an astonishing simplicity and poetry. I said this to Corot yesterday, standing in front of it. "Delectable, totally delectable," he replied. . . . "Only that Orientalist imagination so despised by Saint John could have produced these rose petals, which seem to open out so awkwardly in primitive flutings and expansions. . . . What innocence, what love of wild and barren things there is in the unopened marigold bud! And even more so in this roadside flower, whose acrid petals seem to sprout from a hard, thyrsus-shaped stem between the marigold bud and the scabiosa! And what divine curvature in the stalk of the poppy with its tiny bud."[2]

Fig. 1
EUGÈNE DELACROIX, *Bouquet of Flowers,* 1848, watercolor over graphite on paper, location unknown.

A watercolor of a similar bouquet, but with flowers pushed farther down into the neck of the vase (fig. 1), was in the 1956 Venice Biennale.[3]

A. S.

1. Robaut, 1885, no. 776, repro.
2. Silvestre to Alfred Bruyas, March 27, 1874, Bibliothèque Municipale, Montpellier, MS 365.
3. 1956, Venice, no. 55; in a private collection at that time.

26. *Flower Studies: Indian Roses, Marigolds, and Geraniums*

1848
Graphite on paper; 10 x 14¹⁵⁄₁₆ inches
(25.5 x 38 cm)
Dated at lower right in pencil: *13 oct.*
[crossed out] *nov 1848*
Annotated overall in pencil: *rose d'inde / rose d'inde / rose d'inde / souci / souci*
Paris, Prat Collection
Exhibited in Philadelphia only

Delacroix's *Journal* for 1848 has never been found. Pierre Andrieu, who was one of Delacroix's closest collaborators, told the collector Adolphe Moreau that the painter lost it in a coach while coming home from the Gare de Lyon. André Joubin has raised questions about the existence of this daybook, having found, on the final pages of the 1847 *Journal,* comments written later in 1848 and in 1849.[1] But we know from Delacroix's correspondence that, beginning in September, he was at Champrosay, where he worked hard on flower paintings that he hoped to exhibit in the Salon of 1849 (cats. 29 and 30). "My present undertaking is so heavy, given the fleeting nature of the season, that I do not want to be disturbed by the idea of public turmoil; moreover, I have models that wilt from one day to the next and leave me no time to breathe."[2] The grouping of the various drawings—which are sketched in with different degrees of completeness—is a good illustration of Delacroix's state of mind while he was drawing from nature.

A. S.

1. *Journal,* pp. 168–70.
2. Delacroix to Madame de Forget, October 3, 1848, *Correspondance,* vol. 2, p. 369.

Jussieu (1797–1853)—the son of the famous classifier of plants Antoine-Laurent de Jussieu—whom Delacroix had met at the residence of Louis Napoléon on February 14 of that same year. "Had a long conversation with Jussieu after dinner on the subject of flowers in connection with my pictures; I have promised to visit him in the spring. He is going to show me the greenhouses and will arrange for me to have every opportunity to study there."[2]

Delacroix was not interested in drawing with total accuracy each flower he selected. He focused his attention on the diversity of their shapes seen in full sunlight and on the subtlety of the colors.

A. S.

1. Johnson, 1995, no. 46, repro.
2. *Journal,* February 14, 1849 (Norton, 1951, p. 88).

27. *Flower Studies*

c. 1848–49
Pastel on paper; 9⁷⁄₁₆ x 12³⁄₁₆ inches (24 x 30.9 cm)
Private collection (courtesy of the Galerie Schmit, Paris)
Exhibited in Paris only

The particular arrangement of this sheet, on which the flowers are carefully aligned, has led Lee Johnson to suggest that the study was executed in the spring of 1849 at the Jardin des Plantes in Paris.[1] This could have been made possible by the botanist Adrien de

28. *Foliage and Arch with Morning Glories*

c. 1848–49
Pastel on gray paper; 12¹⁄₁₆ x 18 inches
(30.6 x 45.7 cm)
New York, The Metropolitan Museum of Art,
Bequest of Miss Adelaide Milton de Groot
(67.187.4)
Exhibited in Paris only

The motif of this arch is found, with appreciable variations, in the painting titled *A Basket of Flowers Overturned in a Park* (cat. 29).

A. S.

29 and 30. Paintings of Flowers and Fruit in the Salon of 1849

We do not know what was behind Delacroix's original decision to present five flower paintings at the Salon of 1849. In the end, however, he exhibited only two, keeping a more sizable shipment for the Exposition Universelle of 1855 (see cat. 31). Undoubtedly, he was predisposed to paint flowers by a passion for flower gardens and gardening, which he shared with his acquaintance George Sand and his great friend Joséphine de Forget—in whose company the artist "prowled around rose bushes." Delacroix may have developed a now-forgotten pictorial or decorative scheme meant to unite the three paintings brought together here—*A Basket of Flowers Overturned in a Park* (cat. 29), *Still Life with Flowers and Fruit* (cat. 30), and *A Vase of Flowers on a Console* (cat. 31)—with two works that have since been lost, *A Bed of Marguerites and Dahlias* and *Hydrangeas and Agapanthus by a Pond*.[1] Delacroix's references—perfectly outlined by art critic Théophile Gautier—to the masterpieces of the genre painted by Jean-Baptiste Monnoyer (1634–1699), Jan Davidz. de Heem (1606–1684), and Jan van Huysum (1682–1749), as well as his admiration for certain Spanish and Italian still lifes, also explain his passion for a genre he had studied very little up to that point. Consideration should also be given to Delacroix's overriding desire during this period to attempt all genres and explore all techniques so that he could present himself as a great master, a "pure classic." We should note, however, that his interest in these attempts at still-life painting was intrinsic and personal enough to prevent him from selling or giving away any of the flower paintings he did for the Salon of 1849. In fact, he kept them until his death.

Taking advantage of a hiatus in his great decorative commissions in Paris—he had just finished the library in the Palais Bourbon and had not yet begun the decorations for the Galerie d'Apollon in the Louvre or the church of Saint-Sulpice—Delacroix spent the entire first quarter of 1849 working on these flower paintings. Although the painter apparently lost his *Journal* for 1848—in a coach, as Pierre Andrieu says—leaving us few notes on his work for that year, numerous sketches (see cat. 32) show that, as early as that fall, he was preparing for his flower paintings and had, during the same period, already begun to bring one or another of the compositions to completion. On February 7, 1849, he visited the dealer Beugniet to look for a frame "for [his] flowers,"[2] a fact that implies at least one of these works was already almost finished. Several drawings showing "marigolds" and "Indian roses"—including one dated November 13, 1848—reveal the artist's ongoing concerns in the autumn preceding the Salon. Throughout this period, his letters to Joséphine de Forget abound with references to the arrangement of flowers growing in the garden at Champrosay.

Whatever the case may be, Delacroix's *Journal* gives us a sufficiently accurate idea of the various stages of his work. For example, the entry for February 14, 1849, recalls a discussion with Adrien de Jussieu: "Had a long conversation with Jussieu after dinner on the subject of flowers in connection with my pictures; I have promised to visit him in the spring. He is going to show me the greenhouses and will arrange for me to have every opportunity to study there."[3] This friendly exchange may have restored the artist's self-confidence because the next day, after he had gone back to work on the flower paintings and made progress particularly on the "fruit basket" (cat. 30), he noted: "I was feeling badly and did but little. That, however, put me back into a good mood for work, and I think that if I soon finish the things that are not done at all, the parts which are already pushed ahead will immediately look finished."[4] On February 16, he added that he had also "worked on the Flowers and Fruits."[5] During the spring of that year, Delacroix was not to rediscover the tranquillity of nature or the inspiration of live models, since he did not stay at Champrosay, nor did he—within this period—take Jussieu up on his invitation to visit the Jardin des Plantes. Rather, he continued working regularly on his paintings in the studio, as is proven by various passages in his *Journal:* "Sunday, March 11 [1849].—Got working early on the painting of the *Hydrangeas and the Agapanthus.* I concerned myself only with the latter."[6]

Although he explicitly told Constant Dutilleux that he wished to paint "these pieces of nature . . . as they present themselves to us in gardens" in his compositions for the Salon, Delacroix adhered to most of the genre's conventions regarding subject and presentation, obligatory since the seventeenth century. These included: a mix of fruit and flowers—or highly diversified flower species—that made for a greater variety of painterly effects or color choices; a sophisticated arrangement of flowers in the basket in which they were collected, overturned in one case (cat. 29) and displayed proudly on a console in the other (cat. 31); and a careful placement of flowers that took into consideration their relationship to the landscape in which they were set. *A Basket of Flowers Overturned in a Park,* for example, makes use of a natural architectural motif in the leafy arch above the overturned flower basket (see also cat. 28). And in *Still Life with Flowers and Fruit,* a patch of sky is seen through a

curtain of trees, and growing flowers enliven the left foreground of the composition. These artistic devices obviously accentuate an already somewhat mannered theatricality. That Delacroix was seeking this very quality in these carefully considered compositions is a judgment based on the various pastel or watercolor studies that Delacroix made for the paintings.

With the date of the Salon drawing near, and four of his paintings already finished (including cat. 31), Delacroix decided, for reasons that remain unknown, to limit his ambitions and exhibit only two of the five works he had painted during the winter. As a member of the jury, he had full control over his decisions, and it was easy, at the last moment, to ask his friend and relative Léon Riesener to withdraw the two paintings he no longer wanted to show Salon audiences.[7] It should be pointed out

here that both Alfred Robaut and André Joubin were mistaken in claiming that Delacroix exhibited three works at the Salon of 1849; the exhibition booklet mentions only the two paintings presented here (cats. 29 and 30).

This retrenchment did not dampen the enthusiasm of the critics, who, for once, were almost unanimous in praising Delacroix's work. (It is true, of course, that his Salon presentation that year included three other paintings: *Women of Algiers in Their Apartment,*[8] *Othello and Desdemona,*[9] and *Syrian Arab with His Horse.*[10]) Thus, L. Cailleux affirmed that "Delacroix has caught the secrets of flowers and their casualness, subsequently translating them for us with that impulsive energy he is known for."[11] Louis Peisse was warmly enthusiastic, finding the two paintings "sparkling with color, graciously composed and arranged, generously and

29. *A Basket of Flowers Overturned in a Park*

c. 1848–49
Oil on canvas; 42¼ x 56 inches
(107.3 x 142.2 cm)
New York, The Metropolitan Museum of Art,
Bequest of Miss Adelaide Milton de Groot
(67.187.60)

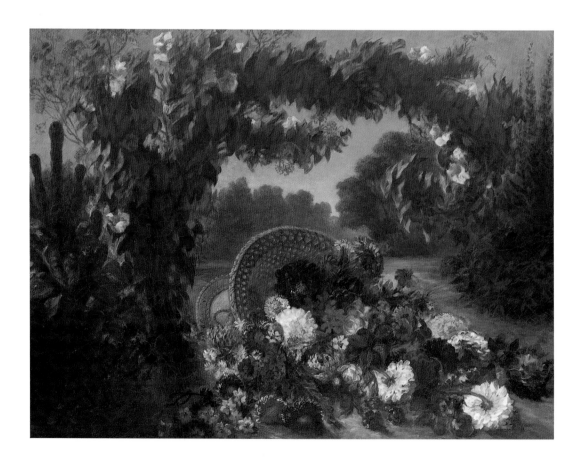

vigorously painted." He noted that "these flowers and fruit are excellent and perfectly suited for their purpose, which is not to be picked or eaten, but to simply be looked at."[12] Champfleury remarked that he had "never seen flowers that could match those of Delacroix."[13] Once again, the most subtle and judicious appraisals came from the pen of Théophile Gautier:

> One would have to go back to Baptiste, to Monnoyer, or indeed to the fruit and flower paintings of Juan de Avellaneda and Velázquez . . . one must not look for painstaking renditions of individual veins or fuzz on leaves. . . . This is, quite simply, an orgy of color, a feast for the eyes. What is praiseworthy in these two canvases, aside from the excellence of the color, is the stylistic treatment of the flowers, which are usually treated in a totally botanical fashion, without any regard for their bearing, poise, physiognomy, or character. Each flower has its own particular mode of expression, be it gay, sad, silent, noisy, brash, modest, demure, lascivious, open or closed, mild, fierce, unsettling or soothing. They also display specific attitudes, their own special brands of coquettishness or haughtiness—none of which is conveyed by common flower painters concerned with trifles.[14]

With one or two exceptions, all the critical reactions were perfectly positive and in agreement with that of P. Haussard: "In no work by any master of the genre is there anything to equal the dazzling touch and delicate feeling of these *Flowers,* nor the tender harmony of the greenery that frames them; nothing surpasses the gravity of the style, the breadth of execution, of these *Fruit,* nor the skillful arrangement of their setting."[15]

Veritable windows opening on a tranquil nature, these two works, one of which was undoubtedly

30. *Still Life with Flowers and Fruit*

c. 1848–49
Oil on canvas; 42⅜ x 56⅜ inches
(108.4 x 143.3 cm)
Philadelphia Museum of Art, John G. Johnson
Collection (cat. 974)

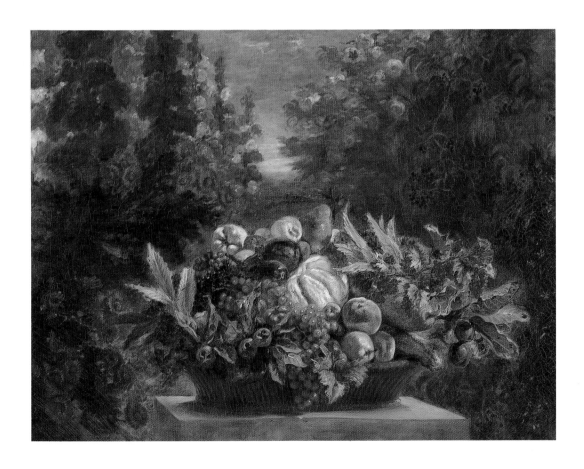

shown again at the Exposition Universelle of 1855 (see cat. 31), exude great freshness despite the intellectual recombination of elements used by the artist in homage to seventeenth- and eighteenth-century Dutch and French painters. Bravura works, they reveal Delacroix's deep-seated ambition to revitalize the genre by means of a kind of realism in which stylistic convention and decoration would serve the contemplation of nature—and not the reverse.

V. P.

1. Johnson, 1986, vol. 3, nos. L213 and L214.
2. *Journal,* February 7, 1849, p. 175.
3. *Journal,* February 14, 1849 (Norton, 1951, p. 88).
4. *Journal,* February 15, 1849 (Pach, 1937, pp. 184–85).
5. *Journal,* February 16, 1849 (Pach, 1937, p. 185).
6. *Journal,* March 11, 1849, p. 184. The painting mentioned in this quotation is one of the two floral works originally intended for the Salon of 1849 whose whereabouts are presently unknown.
7. Delacroix to Riesener, June 9, 1849, *Correspondance,* vol. 2, p. 380.
8. Musée Fabre, Montpellier; Johnson, 1986, vol. 3, no. 382, pl. 171.
9. National Gallery of Canada, Ottawa; Johnson, 1986, vol. 3, no. 291, pl. 110.
10. Private collection; Johnson, 1986, vol. 3, no. 348, pl. 161.
11. Cailleux, 1849.
12. Peisse, 1849.
13. Champfleury, 1849, p. 167.
14. Gautier, 1849.
15. Haussard, 1849.

31. *A Vase of Flowers on a Console*

1849–50
Oil on canvas; 53³⁄₁₆ x 40³⁄₁₆ inches (135 x 102 cm)
Montauban, Musée Ingres (M.N.R. 162; D.51.3.2)

In taking up the genre of flower painting, Delacroix admitted to his friend Constant Dutilleux that he wanted to "break somewhat away from the conventions that seem to condemn all flower painters to paint the same vase with the same columns, or with the same outlandish drapery serving as a backdrop or foil."[1] The two examples he exhibited at the Salon of 1849 (cats. 29 and 30) show a studied arrangement of growing plants and cut flowers set in an artfully unkempt garden; they reflect the artist's search for a natural look quite free of symbols and fussy settings.

Delacroix had the same ambition for these works as he had for his animal paintings: He wanted to show that he could equal the great masters, displaying all his virtuosity by painting flower bouquets in a completely decorative manner. It was undoubtedly for this reason that he began this *Vase of Flowers* during the first quarter of 1849. It reveals a perfectly traditional pictorial universe with a setting that stems from seventeenth- and eighteenth-century still lifes. Delacroix placed a vase full of flowers on an ornately sculpted console, within a bourgeois interior adorned with wood paneling, a framed mirror, and a curtain of sumptuous fabric. On the opulent console he also arranged a piece of white cloth and a string of pearls, two accessories that subtly evoke the life of high society. Daniel Ternois has pointed to the existence of a watercolor that seems to be a study for the corner of the room and the console depicted in this painting.[2] In the watercolor, the space is shown without the lively presence of the bouquet of flowers.

Begun in early March 1849—as is indicated by various passages in Delacroix's *Journal*[3]—this aristocratic flower painting brings together a dozen or so different plant species, identified by Ternois as daisies, gladiolus, wallflowers, foxgloves, cinerarias, bellflowers, cockscombs, poppies, and roses. This work undoubtedly posed various technical problems for Delacroix, who was working at the same time on four other flower paintings for the Salon. On May 3 of that year it was still unfinished and on that day Delacroix wrote to his framer, the paint dealer Souty, to let him know that he was probably not going to show the picture:

> I now realize that I will have difficulty finishing the smallest of the five flower paintings (the vertical one). I hasten to notify you of this so that you can suspend work on its frame. . . . In the event that I find myself with more time

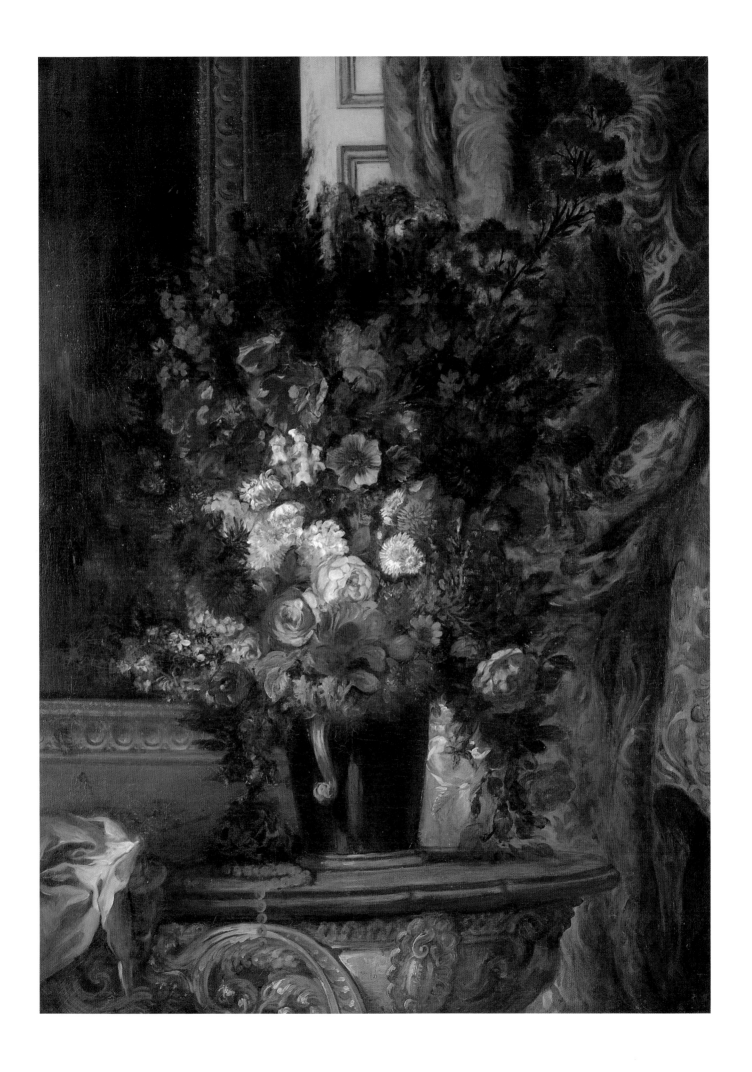

Fig. 1
EUGÈNE DELACROIX, *Bouquet of Flowers in a Stoneware Vase,* c. 1848–49, oil on canvas, Cairo, Gezira Museum.

than I anticipate, the time to make it would be after receiving the pictures, in the course of the month, up to June 15.[4]

Much has been written about the artist's decision to keep this work out of the Salon show. It was no closer to completion in June, by which time the exhibition was already open to the public. Some scholars—Ternois, for example—have conjectured that Delacroix was dissatisfied with it technically or aesthetically, considering the canvas flawed or a failure. Others, such as Lee Johnson, have emphasized his lack of time to complete it.[5] Of course, these two hypotheses are not incompatible. In any case, the painter was sufficiently concerned with finishing the painting to start work on it again a year later. This is clear from his *Journal;* in the entry for March 11, 1850, he tells us that he went back to work on "the last picture of *Flowers.*"[6]

Despite its note of classicism and obvious conventions, the final result must have seemed particularly convincing to Delacroix since he decided, in 1855, to add this canvas to his selection for the Exposition Universelle, where he was also showing

three floral still lifes.[7] It would hang in a distinguished position, between *The Justice of Trajan* (Musée des Beaux-Arts, Rouen) and *The Massacre at Chios* (Musée du Louvre, Paris).

In 1986 Lee Johnson identified this painting as the work Delacroix bequeathed in 1863 to Eugène-François-Charles Legrand, the lawyer he had hired to counsel Achille Piron, his executor and sole legatee.[8] But Geneviève Lacambre[9] has suggested that the "large vertical painting of flowers"[10] bequeathed to Legrand by Delacroix—along with a reduced version of *The Death of Sardanapalus,* a Japanese vase, and two lamps—must have been the *Bouquet of Flowers in a Stoneware Vase* that is now in the Gezira Museum in Cairo (fig. 1). In making this suggestion, she was following the lead of Henriette Bessis, who published the inventory of works in the artist's possession upon his death.[11] Despite the interest of this thesis, Johnson's line of thinking seems more compelling since the phrase "large vertical painting" seems to better describe this present work, which is fifty-three inches high. The Cairo picture, although beautifully painted and certainly datable to the same period, is only half as large.

V. P.

1. Delacroix to Dutilleux, February 6, 1849, *Correspondance,* vol. 2, pp. 372–73.
2. Daniel Ternois, "Un tableau de fleurs d'Eugène Delacroix: Le Vase à la console," *Revue du Louvre et des Musées de France,* nos. 4/5 (1965), pp. 233–36.
3. *Journal,* March 10 and 13, 1849, pp. 184, 185.
4. *Correspondance,* vol. 2, p. 375.
5. Johnson, 1986, vol. 3, no. 503, pl. 300.
6. *Journal,* March 11, 1850, p. 227.
7. Cats. 31 and 32 and the work titled *Hydrangeas and Agapanthus by a Pond* (location unknown; Johnson, 1986, vol. 3, no. L214).
8. Johnson, 1986, vol. 3, no. 503, pl. 300.
9. Musée d'Orsay, Paris, *Les Oubliés du Caire* (Paris: Réunion des Musées Nationaux, 1994), no. 15, p. 52.
10. Burty, 1878, p. 9.
11. Bessis, 1969, no. 151, p. 314.

32. *Bouquet of Flowers in a Vase*
or *Two Vases of Flowers*

c. 1848–49
Oil on cardboard; 17¾ x 23 3/16 inches
(45 x 59 cm)
Bremen, Kunsthalle (796-1959/15)
Exhibited in Philadelphia only

In 1885, in his catalogue of Delacroix's work, Alfred Robaut noted the poor quality of the support of this painting—"poor, severely warped cardboard."[1] Like a sketch, it was executed with a vibrant and intuitive touch, but without any attempt to provide a setting for the various species of plants and flowers that are arranged in two perfectly ordinary glass or glazed earthenware vases. At that time, cardboard and paper were used mainly for sketches,

life studies, or drawings from nature, since these materials could be easily stored in drawing portfolios. In any case, such works were not intended for public display. Given the nature of the support and the existence of certain areas intentionally left unworked, this painting may be considered a study "from the model," a working sketch for the five paintings that Delacroix was making for the Salon in late 1848 and early 1849.

Long before settling on his choice of subjects for the Salon of 1849, Delacroix was preparing the groundwork for his considerable efforts in flower painting, a genre he hoped to revitalize. Since 1842 he had divided his time between decorative compositions and numerous studies in pencil, pastel, watercolor, and oils. Delacroix accumulated these studies in the course of walks, travels around France or visits at Nohant or Champrosay, and also during a number of studio sessions—although he had no preconceived idea of how he might use them in paintings intended for public display.

tensive range of flower species itemized by Alfred Robaut as "dahlias, wild chicory, coreopsis, datura, elderberry." Thus, Delacroix combined, without a specific purpose or any concern for their arrangement, decorative flowers (dahlias and coreopsis) and medicinal plants (wild chicory and datura) with the branches of more rustic shrubs, such as the elderberry, with its pretty black and red berries. In its great variety and its use of complementary colors, this assortment of plants and natural flowers provided the painter, who was not interested in "pictorial anecdote" or arrangement, visual elements that enabled him to focus exclusively on technical matters.

In his will of August 3, 1863, Delacroix bequeathed this flower painting, which exemplified the quality of his studies, to one of his executors, baron Charles Rivet (1800–1872). The painter must have wanted to prolong certain intimate memories shared at a time when he was working on his bouquets of flowers with this very close friend, who also possessed a superb sketch of *The Death of Sardanapalus* that is now in the Musée du Louvre. As proof of his friendship, Delacroix also bequeathed to Rivet a copy (made about 1850) of Velázquez's portrait of Charles II, and two studies by the English painter Richard Parkes Bonington (1802–1828).

V. P.

1. Robaut, 1885, no. 1012, repro.

When he decided in the fall of 1848 to show five flower paintings at the Salon, he must have immediately set out to broaden his research by patiently working from nature. He had to master the technique required to reproduce the colors and textures of countless species of plants. The artist's desire to paint in the Jardin des Plantes is clear evidence of this concern. Thus, with the pencil and watercolor studies sketched from nature, and prior to the Salon paintings (which were shaped from memory and executed in the studio), he made several oil paintings that must have been an intermediate step in the creative process. In this way, while continuing to work informally from nature, Delacroix was already testing himself against the conditions governing the execution of finished compositions. This work, titled *Bouquet of Flowers in a Vase* or *Two Vases of Flowers,* was undoubtedly the product of this approach, as was *Basket of Flowers* (fig. 1) and perhaps even *Bouquet of Flowers in a Stoneware Vase* (fig. 2). None of these works was exhibited during the painter's lifetime.

Perhaps it was in just such a spirit of study that Delacroix arranged, side by side in two vases, an ex-

33. *Bouquet of Flowers*

1849
Watercolor, gouache, and pastel highlights
over graphite sketch on gray paper;
25⁹⁄₁₆ x 25¾ inches (65 x 65.4 cm)
(on two sheets of different sizes)
Paris, Musée du Louvre, Département des Arts
Graphiques (RF 31 719)
Exhibited in Philadelphia only

Both in size and in the innovative way the subject
is placed on the sheet, this is incontestably the most
impressive and original of Delacroix's flower pic-
tures on paper. Still in its frame in the artist's stu-
dio, it was included, in accordance with his will,
among the works that were to be sold after his
death: "It is my express wish that a large brown-
framed painting, showing flowers as if placed hap-
hazardly against a gray background, be included in
the sale."[1] One day, while visiting Ambroise Vollard,
Paul Cézanne (1839–1906) came across this *Bouquet*

in a room of the dealer's gallery.[2] The painter was so taken by it that he gave Vollard no peace until he obtained permission to take it home, where he could study it at his ease. A short while later, Cézanne's acquaintance Émile Bernard (1868–1941) also had the opportunity to admire it:

> The finest sight in this room [Cézanne's] was a watercolor of flowers by Delacroix, which he [Cézanne] had purchased from Vollard after the Chocquet sale. He had always admired it at the gallery of his old friend the collector, and had often drawn some fine lessons in harmony from it. He took very great care of this watercolor; it was framed and, to avoid discoloration by the light, he had turned it toward the wall, within easy reach.[3]

In memory of this "love affair," Cézanne made a free copy of the painting in oil (Pushkin Museum, Moscow).

<div align="right">A. S.</div>

1. Copy, Département des Arts Graphiques, Musée du Louvre.
2. Paul Cézanne to Ambroise Vollard, Aix-en-Provence, January 23, 1902; see *Paul Cézanne: Correspondance recueillie,* rev. ed., annotated and with a preface by John Rewald (Paris: Bernard Grasset, 1978), pp. 243–44.
3. Émile Bernard, *Souvenirs sur Paul Cézanne: Une conversation avec Cézanne* (Paris: R. G. Michel, 1926), p. 40.

34. *Flower Bed with Hydrangeas, Scillas, and Anemones*

1849 (?)
Watercolor over graphite on paper;
7⅜ x 11⅝ inches (18.7 x 29.6 cm)
Annotated at lower center in pencil: *feuille d'hortensia jaune / les autres sur le devant plus foncé*
Paris, Musée du Louvre, Département des Arts Graphiques (RF 4508)
Exhibited in Philadelphia only

This expanse of somber vegetation, with its bunch of pink hydrangeas, its bluish scillas, and its red anemones, attracted the attention of Edgar Degas (1834–1917). It is one of the most captivating creations of Delacroix, that tireless observer of nature. It can be linked with the artist's watercolors or pastels of flower beds in the park surrounding George Sand's house at Nohant, or at Valmont, around the abbey that belonged to Alexandre-Marie Bataille and later to Louis-Auguste Bornot, Delacroix's relatives.

<div align="right">A. S.</div>

35. *White Daisies and Zinnias*

1849 or 1855 (?)
Watercolor and gouache over graphite on gray
paper; 9⅞ x 7⅞ inches (25 x 20 cm)
Paris, Musée du Louvre, Département des Arts
Graphiques (RF 3440)
Exhibited in Philadelphia only

This watercolor was probably executed at Champrosay in 1849, at a time when Delacroix was working on the flower pictures he planned to present at the Salon that year—unless it belongs to the series of watercolors painted in September 1855 during a trip the artist took to a chateau in Croze, residence of the Verninac family.[1]

White Daisies and Zinnias serves as a sort of pendant to another study in the Musée du Louvre, executed in the same technique and also painted on gray paper, showing marigolds, hydrangeas, and asters.[2] Neither picture shows traditional bouquets but rather flowers as they appear in gardens and as the artist liked to draw them.

A. S.

1. On this possibility, see the sheet of studies included in the Verninac sale, Hôtel Drouot, Paris, December 8, 1948, lot 10, repro.
2. Département des Arts Graphiques, Musée du Louvre, Paris, RF 3441; M. Sérullaz, 1984, vol. 2, no. 1229, repro.

36. *Flower Studies with a Branch of Fuchsia*

1855
Graphite and watercolor on paper;
5⅞ x 7¾ inches (15 x 19.6 cm)
Annotated at upper right in pencil: *boutons*
On the verso: studies of flowers and foliage in
graphite and watercolor
Paris, Musée du Louvre, Département des Arts
Graphiques (RF 9803)
Exhibited in Paris only

Delicately highlighted in watercolor, this study, which is remarkable for its simplicity, may be compared with a watercolor titled *Pot of Fuchsias*[1] as well as with the study of pink laurels in the Musée Bonnat, Bayonne (fig. 1). As he approached his last years, Delacroix was drawn to the charm of flowers and painted them everywhere he went, for his own pleasure, but also, in a certain sense, for his own instruction. Although it is often difficult to determine where the artist executed most of these studies, this watercolor may have been done near the chateau of François de Verninac in Croze, where Delacroix spent several days in September 1855. Fuchsias remain in bloom until the autumn and the *Pot of Fuchsias* mentioned above figured in the sale of the Verninac collection.[2] The simplicity with which the flowers are placed on the page in no way lessens the quality of this study, in which the painter strove to vary each stroke of color in keeping with the direction of the light.

A. S.

1. Private collection; M. Sérullaz, 1963(a), no. 480, repro.
2. Verninac sale, Hôtel Drouot, Paris, December 8, 1948, lot 11, repro.

37. A Garden Path at Augerville

c. 1855
Pastel on paper; 11¹³⁄₁₆ x 16½ inches (30 x 42 cm)
Private collection, England

Freely sketched in a harmonious blend of strong colors where intense blues predominate, along with flecks of white, yellow, and vibrant red, this landscape may seem unremarkable yet retains our attention with its modern touch and deftness in handling the light. In his will Delacroix indicated that Ferdinand Leroy could have his pick of a "fine pastel" from among the artist's landscape studies. The reasons for this decision are easy to understand. Entries in his *Journal* indicate that the painter maintained friendly relations with Leroy although he did not specify the circumstances in which they had met. "I went during the day to invite F. Leroy to come and dine on Monday with Bouchereau: I had great pleasure in seeing him again."[1] Or again: "F. Leroy came to see me this morning. Another person whom I always see with pleasure."[2] In June 1856 Leroy's name appears on the list of people whom Delacroix planned to name in his will.[3]

Obvious analogies in subject matter, size, and style between this pastel and another one dated July 1855 (fig. 1) suggest that both drawings were executed in Augerville during the week that Delacroix spent there with his cousin, the lawyer Pierre-Antoine Berryer, from July 12 to 18.

A. S.

1. *Journal,* May 30, 1856 (Pach, 1937, p. 510).
2. *Journal,* September 26, 1857, p. 679.
3. *Journal,* June 21, 1856, p. 586.

38. *Forest Scene Near Sénart*

c. 1850
Oil on canvas; 12¹¹⁄₁₆ x 18⅛ inches (32.2 x 46 cm)
Private collection (courtesy of the Nathan Gallery, Zurich)

Lee Johnson has advanced the idea that this rapidly sketched study could be one of the views executed by Delacroix in the forest of Sénart around 1849–50.[1] At that time, the painter was looking for landscapes that might eventually serve as settings for his religious paintings, particularly for sketches he was making for the paintings commissioned by the church of Saint-Sulpice. The Sénart forest contained many trees like the proud oak that is the main subject of this small canvas.[2] The tree is painted with energetic and precise brushstrokes, using a narrow range of greens and browns set off by the blue of the sky, which can be glimpsed between the branches.

In its brisk execution, this canvas (which must have been done partially—or even entirely—in the studio) is strangely reminiscent of some of the small studies that Jean-Baptiste Camille Corot (1796–1875) painted in the Fontainebleau forest between 1830 and 1840 (Musée des Beaux-Arts, Pau; Kunsthalle, Bremen). In fact, Delacroix had had an opportunity to see Corot's nature studies when he visited the painter's studio on March 14, 1847, at a time when his own interest in landscape was growing stronger.

Delacroix's *Journal* entry for that date includes the following observation: "Corot is a true artist. You need to see a painter in his own studio to gain any real idea of his merit."[3] During his visit, Corot also gave Delacroix some advice with respect to the technique of landscape: "He told me to let myself go a little and to allow myself to take things as they come, so to speak, that is how he works most of the time. . . . Corot goes deeply into a subject; his ideas come to him and he develops them as he goes along; this is the right way to work."[4] In Corot's studio at this time, Delacroix—although an experienced painter but nevertheless a novice at landscape—admired the landscape of *The Baptism of Christ* (Saint Nicolas-du-Chardonnet, Paris), the memory of which would come back to him years later when he was working on *Jacob Wrestling with the Angel* for the church of Saint-Sulpice (p. 24 fig. 12). Despite this strong influence, it is surprising to see the extent to which Delacroix as a painter of nature remains a very personal artist. This is evident in his fresh—though sometimes awkward—perspective, and in his passion for light and natural colors.

V. P.

1. Johnson, 1986, vol. 3, no. 482*a*, pl. 280.
2. The tree in this scene resembles the famous Antin oak rather than the Prieur oak—a "gigantic senior" (in Moreau-Nélaton's phrase) that had served several times as a model for the painter.
3. *Journal,* March 14, 1847 (Norton, 1951, p. 72).
4. *Journal,* March 14, 1847 (Norton, 1951, p. 72).

39. *Patch of Forest with an Oak Tree*

c. 1853
Watercolor over graphite on paper;
12⁵⁄₁₆ x 8⁷⁄₈ inches (31.5 x 22.5 cm)
New York, The Pierpont Morgan Library,
Thaw Collection
Exhibited in Paris only

This landscape, which is in the same spirit as an oil study made of a site near Champrosay (cat. 40), was undoubtedly executed in the woods of Sénart. The tree at left is not, however, either of the two most famous oak trees in this forest, known as the Antin and the Prieur, located a few minutes' walking distance from the house that Delacroix occupied during his country holidays.

Cara Denison has compared this watercolor with another landscape painted at Champrosay and dated May 9, 1853 (private collection), suggesting that the tree could have been an initial idea for the one that serves as a backdrop for Jacob's struggle with the angel in Delacroix's decoration for the church of Saint-Sulpice in Paris. While the date of 1853 seems convincing, this work, in its spontaneity and its realism, must be understood as a simple study from nature executed for pleasure and for the sole purpose of training the eye and the hand. There is no reason to believe that Delacroix, at this point, thought about using it as the setting for a specific scene.

V. P.

40. *Autumn Landscape, Champrosay*

1853–56
Oil on canvas; 10¹³⁄₁₆ x 15¹⁵⁄₁₆ inches
(27.5 x 40.5 cm)
Private collection

Although there is no proof, Delacroix's biographers have traditionally identified Champrosay as the site of this delightful study of a garden at sunset. Certainly, the poetic atmosphere and the technique of this work recall studies by Delacroix—done from nature or executed later in the studio—that were inspired by views in his small property located at the edge of the forest of Sénart.

Maurice Sérullaz[1] has linked this study to an excerpt from a *Journal* entry written when Delacroix was preparing the second version of *The Education of the Virgin* (National Museum of Western Art, Tokyo), for which Delacroix made many sketches from nature in the Sénart forest:

> After a day of work and—I believe—a little sleep, I started out late for Soisy. The roads were soaking from the rain. I did the sketches from the washhouse at sunset. . . . I worked all through this rainy day on the small *Saint Anne*, and made a sketch from the *Sunset* that I did yesterday from the washhouse.[2]

As Lee Johnson has remarked, this painting does not show any structure resembling a washhouse, but it is possible that the term was used at that time to designate a locality, and not an actual washhouse.[3] In any case, as he so often did during this period (see cats. 58 to 62), Delacroix first went outdoors to make a drawing of the site that inspired him before going back (perhaps on the same day) and reworking the same motif in oils in the comfort of the studio.

With evident mastery, the painter structured this landscape around the contrast between the view at right, blocked by a curtain of trees, and the left side, which opens out via a strange-looking gate toward a superb evening sky. In the middle, two scrawny poplars constitute a dividing line skillfully placed to attenuate the contrast. The picture is notably classical in inspiration—Claude Lorrain (1600–1682) adopted the very same approach in his landscape compositions, and Jean-Baptiste Camille Corot (1796–1875) made extravagant use of such scenes. However, the rigidity of the construction is moderated by a light, energetic touch and a sophisticated color scheme.

In this landscape, as in other works from the same period, Delacroix seems to have been striving to master the pictorial treatment of "distances," using effects of aerial perspective and atmospheric transparency at the left side of the painting, opening toward the horizon. The depiction of the tree branches and vegetation remains broad and allusive. The artist focused on the study of color, shadows, and light, choosing not to define in any realistic way the plant and tree species.

Maurice Sérullaz has suggested another linkage between this study and a passage from Delacroix's *Journal:* "Gave [the dealer] Haro: . . . for restoration, the study on canvas done at Champrosay, from Baÿvet's fountain; a sunset effect."[4] The *Journal* indicates that Baÿvet was one of Delacroix's neighbors at Champrosay, and that Delacroix met him on October 17, 1853, during a work session that may have resulted in the present study. It is likely that this view represents one of the walls and gates on Baÿvet's property.

After 1864 this work found its way into the collection of the painter Frédéric Bazille (1841–1871), a fervent admirer of Delacroix who inspired him to paint some of his Orientalist compositions and flower bouquets. Lee Johnson has pointed out that Bazille was not among the buyers at Delacroix's posthumous sale and must, therefore, have pur-

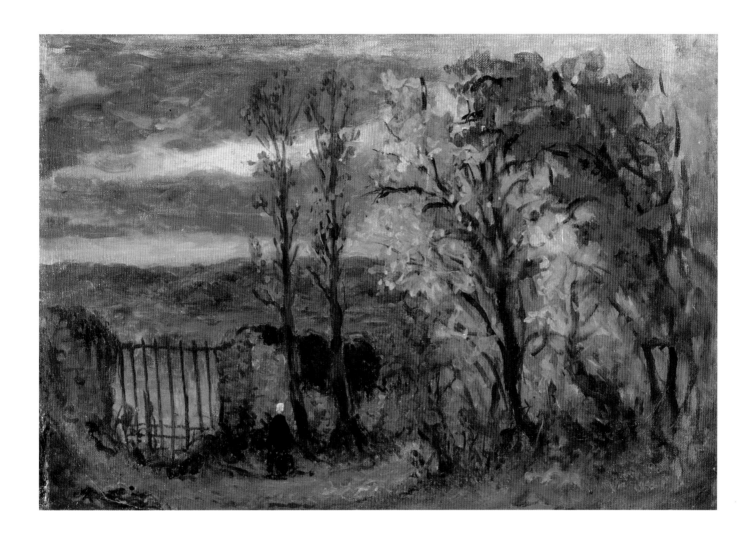

chased the work from a dealer at a later date. However, although there is no proof that Bazille was a buyer at this historic sale, we do know that he attended because, in a letter of February 1864, he wrote to his mother: "I crossed the Seine only yesterday to attend the sale of Delacroix's sketches."[5] Thus, it does seem likely that Bazille was able to purchase the work at the artist's posthumous sale, where it may have been part of a lot made up of drawings, oils, and watercolors.[6] During the same period, this painter from Montpellier, who was perhaps still deeply impressed by his discovery of Delacroix's flower paintings at the sale, executed a flower study influenced by him.

V. P.

1. M. Sérullaz, 1963(a), no. 445, repro.

2. *Journal,* October 17, 1853, pp. 368–69.

3. Johnson, 1986, vol. 3, no. 483, pl. 283.

4. *Journal,* April 2, 1856, p. 573.

5. Bazille to his mother, n.d., quoted in Musée Fabre, Montpellier, *Frédéric Bazille et ses amis impressionnistes,* July 9–October 4, 1992.

6. See Provenance for cat. 40 in the Appendix to the Catalogue (p. 359).

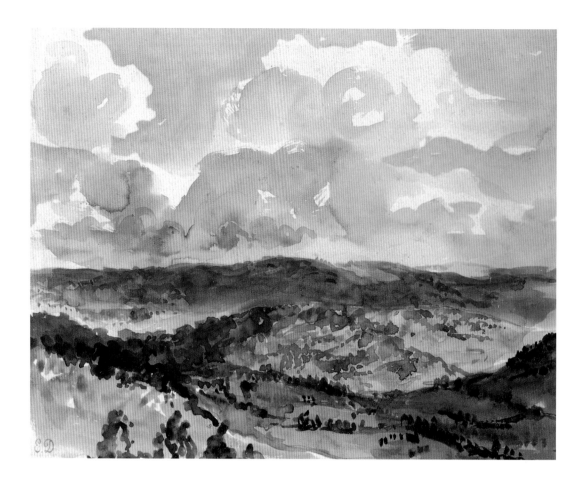

41. *Panoramic View of the Vallée de la Tourmente*

1855
Watercolor on paper; 8¼ x 10⅜ inches
(21 x 26.3 cm)
Paris, Musée du Louvre, Département des Arts
Graphiques (RF 9448)
Exhibited in Paris only

This vast landscape in which dark greens predominate was identified through comparison with a view in a sketchbook at the Art Institute of Chicago, dated "15 7^bre [September] / Croze 55" (fig. 1).

Delacroix traveled extensively throughout the summer of 1855 after his dazzling success in the Exposition Universelle. Among those he visited were the members of his family, becoming closer to them following the death of his brother. From September 12 to 16 he stayed at Croze, located between Brive and Souillac, in the chateau belonging to the Verninac family (Madame de Verninac was the sister-in-law of the artist's sister, Henriette). In Delacroix's *Journal* we read: "Walked with François along the grass-lined paths among the fruit and fig trees; the nature here pleases me and reawakens sweet impressions within me." And again:

> The day before yesterday, the 15th, I spent part of the day drawing the mountains from my window. After lunch, during the hottest part of the day, I drew the lovely valley where François planted poplars. I am charmed by this spot; I came back up to the chateau under a scorching sun that always leaves me tired for the rest of the day.... How can I describe

what I find charming about this place? It is a mix of all the emotions that are pleasant and sweet to both the heart and the imagination.[1]

Executed in the technique so dear to Delacroix—broad swaths of color highlighted by a few allusive brushstrokes—this watercolor shows the view from the northern facade of the Verninac chateau.

<div style="text-align: right">A. S.</div>

1. *Journal,* September 15, 1855, p. 536.

42. *Landscape Near Ante*

1856
Oil on canvas; 10 13/16 x 23 7/16 inches
(27.5 x 59.5 cm)
Private collection (courtesy of the Galerie Schmit, Paris)

Between October 1 and 7, 1856, Eugène Delacroix took up an invitation extended to him by his first cousin Commander Philogène Delacroix, a former senior staff officer who had retired to the tiny village of Ante in the vicinity of Sainte-Menehould. The son of the painter's paternal uncle Jean Delacroix, Philogène owned a charming property at Ante in the forests of the Meuse. There Delacroix had a restful and relaxing stay, until the somewhat noisy and inopportune arrival of other cousins who moved in as neighbors on October 6. Despite this, however, the painter enjoyed a week of his cousin's good meals, in addition to long walks and several fishing trips. These country pleasures were enhanced by his reading of the fables of La Fontaine and his rediscovery of Dante's work, in between studies of the surrounding landscape that he drew with great gusto. A flock of sheep encountered at a turn of the road proved to be such a pleasing sight that it even inspired a small sketch.

In 1961 Maurice Sérullaz linked this painting to a drawing (fig. 1) dated October 6, 1856, that exhibits the same framing and groups of trees.[1] The painter himself has shed light on the circumstances surrounding the execution of these two works. In his *Journal* entry for October 6, he commented on the drawing made from nature: "I had gone up to the height to have another view of my cousin's house. . . . In the morning I had drawn a very comprehensive view, toward the right, marked October 6 in the album."[2] When Delacroix returned to Paris on October 9, he used the drawing made around his cousin's residence as the basis for an oil painting executed entirely in the studio: "Painted two views of my cousin's place from memory, in oils."[3] (Later that day, he learned the sad news of the death of the painter Théodore Chassériau; he took part in the funeral procession the next day along

Fig. 1
Eugène Delacroix, *View Near Ante,* 1856, graphite on paper, private collection.

with his friends Adrien Dauzats, Narcisse Diaz de la Peña, and Gustave Moreau.)

This Ante landscape is apparently one of the best illustrations of Delacroix's technique of re-working outdoor sketches in the studio. A traditional technical exercise, this was an indispensable step in the work of a landscape painter, to which Delacroix frequently devoted himself during the 1850s. Scrawled in pencil among the features of the Ante drawing were enough notations to remind him, later in the studio, of the various species of trees (birch, apple, fir) and the range of colors (bright green, yellow, blue-gray). Despite this working method involving two distinct steps, Delacroix was able to retain the spontaneity and freshness of execution of paintings made from nature. He achieved this through an energetic touch, a precise description of luminosity, and highly sophisticated color choices involving the alternate use of browns, greens, and grays.

V. P.

1. M. Sérullaz, 1961, p. 59.
2. *Journal,* October 6, 1856, p. 593.
3. *Journal,* October 9, 1856 (Norton, 1951, p. 320).

43. *Trees in a Park*

1856 (?)
Pastel on gray paper; 10¼ x 14⅜ inches
(26 x 36.5 cm)
Private collection (former collection of David David-Weill)
Exhibited in Paris only

This autumn landscape, which has not been exhibited since 1930, may have been executed during the week from October 1 to 7, 1856, when Delacroix visited his first cousin Commander Philogène Delacroix, owner of a house near Sainte-Menehould, in the village of Ante. The artist made several drawings of trees in the surrounding area (cat. 42).

The close framing adopted for this pastel recalls the placement of elements in several sketches in a sketchbook now at the Art Institute of Chicago.[1] It emphasizes the imposing mass of the trees' dense foliage, silhouetted against a very high horizon line.

One cannot be anything but captivated by the balance of color harmonies. The very dark greens

in the center are warmed ever so slightly by the bright red of a bush on the left, and this in turn offsets the yellow, the red, and the light green of the clumps.

A. S.

1. Folios 3 verso and 4 recto (see cat. 41 fig 1); M. Sérullaz, 1961, vol. 2, p. 35.

44. *Landscape at Champrosay*
or *George Sand's Garden at Nohant*

1858
Graphite on paper; 10¼ x 15⅞ inches
(26.1 x 40.3 cm)
Dated at lower right in pencil:
14 mai Samedi 1858
Amsterdam, Rijksmuseum (RP-T-1956-38)
Exhibited in Philadelphia only

As the autograph inscription on the lower right edge shows, this drawing was executed on Saturday, May 14, 1858. On that day Eugène Delacroix once again stayed in his country cottage at Champrosay, having arrived there on May 11. His *Journal* records his "great happiness at finding [himself] there."¹ Even if the framing of this drawing—undoubtedly sketched out-of-doors—recalls some of the motifs studied a few years earlier in George Sand's garden in Nohant, this clearing with its two groves was prompted by a natural scene that Delacroix chanced upon in the Sénart forest during one of the daily walks he so dearly loved to take.

Although near Paris and its professional obligations, this lovely stretch of countryside provided Delacroix with peace and solitude in the company of a few close friends. In 1857 he aptly summed up his feeling for it as follows: "I am greatly enjoying being in this delightful place. It is an exquisite pleasure to open my window in the morning."² His stay

in May 1858 was free of petty annoyances and devoted entirely to relaxation, to the preparation of subjects for his paintings, and, of course, to the constant practice of landscape painting. On May 23 he made an impressive list of possible literary themes for potential works.[3]

V. P.

1. *Journal,* May 14, 1858, p. 719.
2. *Journal,* May 12, 1857 (Norton, 1951, p. 362).
3. *Journal,* May 23, 1858, pp. 719–20.

45. *Landscape Near Cany*

1849
Watercolor over graphite on paper;
4⅝ x 4⅝ inches (11.8 x 11.8 cm)
Dated and annotated at lower right in pencil:
10 oct. / Cany
Annotated overall in pencil: *ciel à travers les arbres / croissant d'érable* [?] / *ocr[e] oc[re] / bl[anc] / v[ert] / v[ert]*
On the verso: sketch of rigging in graphite
Paris, Musée du Louvre, Département des Arts Graphiques (RF 9790)
Exhibited in Paris only

At the age of fifteen Delacroix had paid a visit to the Bataille family, cousins of his who owned the Abbey of Valmont near Fécamp. And it was during this trip that he discovered the region of Normandy, a locale that would eventually occupy a key place in his life and work. During each stay—Delacroix visited the region fifteen times between 1813 and 1860—the painter found quiet and a place where he could escape. He enjoyed the tranquillity of walks punctuated by the serene observation of nature amid the grounds and the rapturous feeling of escape he experienced before the vast seascapes,

which inspired boundless daydreams. Although the length of his stays varied—the shortest, in Valmont in September 1838 lasted only a few days—the daily routine was always more or less the same—numerous walks and excursions, as well as a number of visits to museums (in Rouen) and churches (in Dieppe and Rouen, but mainly in Caen). The evenings were spent conversing at home with a few friends and neighbors. Sometimes, depending on his mood or the weather, he spent protracted periods working or meditating.

This watercolor was probably part of a sketchbook. It was inspired by the walk that Delacroix took in Cany on October 10, 1849. Upon arriving at Valmont a few days earlier, after a trip marked by a string of incidents, he had been perturbed by the changes he noticed in the foliage. Although the poor weather deepened his melancholy, it did not prevent him from going out. So on October 10, 1849, he traveled to Cany, some nine miles from Valmont, and went for a walk in the park of the chateau designed by Mansart. He recorded in his *Journal:*

> Some of the woods beside the road have gone, but this has not yet spoiled the view of the house. I have never enjoyed this enchanting place so much. I must try to remember those masses of trees; the avenues, or rather glades, continuing along the side of the hill above the lower roads and giving an effect of trees piled one above the other.

Upon his return, Delacroix added: "Magnificent view as we climbed the hill out of Cany; tones of *cobalt* visible in the green masses of the background in contrast to the vivid green and occasional gold tones in the foreground."[1]

<div style="text-align: right;">

A. S.

</div>

1. *Journal,* October 10, 1849 (Norton, 1951, p. 104).

46. Landscape at Les Petites-Dalles

1849
Watercolor over graphite on paper;
4⅝ x 13½ inches (11.8 x 34.3 cm)
Dated and annotated at lower left in pencil: *petites dalles 148.*
Annotated overall in pencil: *vert / vert jaune herbes / id brun / mont à travers les arbres*
On the verso: landscape in graphite and splashes of watercolor; dated at lower right in pencil: *14.8*
Paris, Musée du Louvre, Département des Arts Graphiques (RF 9426)
Exhibited in Paris only

This watercolor was apparently executed on a double album page. In the course of his second-to-last trip to Valmont (October 6 to 24, 1849), Delacroix visited Les Petites-Dalles in the company of his cousin Louis-Auguste Bornot. After passing the chateau of Sassetot, both men walked down to the seashore: "The effect produced by these large clumps of beech. Reached the sea by a narrow path; one comes upon it suddenly at the end of the road."[1] The fishing village of Les Petites-Dalles, not far from Sassetot-le-Mauconduit, is located at the opening of a verdant valley with abundant trees and gardens.

<div style="text-align: right;">

A. S.

</div>

1. *Journal,* October 14, 1849, p. 210.

47. *Cliffs in Normandy*

1849 (?)
Watercolor over graphite on paper;
6⅞ x 9 inches (17.4 x 22.9 cm)
Annotated at upper right in pencil by Alfred
Robaut: *J*
Paris, Musée du Louvre, Département des Arts
Graphiques (RF 35 828)
Exhibited in Philadelphia only

Fleeing the noise and countless annoyances of the capital and temporarily setting aside his creative anxieties, Delacroix sometimes retreated to his Norman refuge. He did not remain inactive there, however, since his attentive and curious eye led him to sketch even the slightest details of nature and architecture. He sketched the seaside with equal interest. The imposing shapes of the cliffs overlooking the sea that broke at their feet, the lively activity of the port of Dieppe (cat. 52), the movements of the tides, the brisk passage of clouds over the sea, their rainbow transparencies and their reflections in the water (cats. 55 to 57)—Delacroix noted everything, determined not to leave out anything that might inspire him.

The artist reworked the motif of these cliffs in a small canvas that eventually belonged to his cousin Louis-Auguste Bornot.[1] The watercolor shown here—as well as the oil version of it—must have been based on a small, shaded pencil sketch with color notations executed on a page of an album with various views sketched at Valmont and by the seashore (fig. 1).

A. S.

1. Location unknown.

Fig. 1
Eugène Delacroix, *Cliffs in Normandy*, 1849 (?), graphite on paper, formerly in the collection of Pierre Bérès.

48. *Cliffs of Étretat*

1849 (?)
Watercolor over graphite on paper;
5⅞ x 7¹³⁄₁₆ inches (15 x 19.9 cm)
Montpellier, Musée Fabre (876.3.102)
Exhibited in Philadelphia only

Delacroix had many opportunities to visit Étretat during his various stays in Valmont. Unfortunately, there is nothing in either his *Journal* or his *Correspondance* that would allow dating with any certainty this view of the most famous cliffs on the Normandy coast. Like all the other artists who came to work in this region, Delacroix was captivated by the singular outline of the cliffs and depicted them in ways that reflected his moods. We usually see them at low tide, from Fécamp by the Amont Gate (as in this watercolor), or from the Aval Gate, on the other side (cat. 49).

On the advice of Théophile Silvestre, who had seen it in the company of Corot, Alfred Bruyas decided to acquire this work during the sale of the Dutilleux collection. The day after the sale, Silvestre confirmed the soundness of his decision in the following words:

> It is expensive, but charming and infinitely delicate. . . . *The Cliff of Étretat* on the clearest morning of summer is the most pleasant portrait that one could possibly make of this place. Delacroix, out of sheer delight, painted it on the spot during a brief vacation. . . . Despite its relative superiority, Delacroix, when painting this small piece, obviously had not forgotten that period of his youth when he made a number of watercolors with his friend Bonington.[1]

A. S.

1. Letter of March 27, 1874, Bibliothèque de la Ville, Montpellier, MS 365.

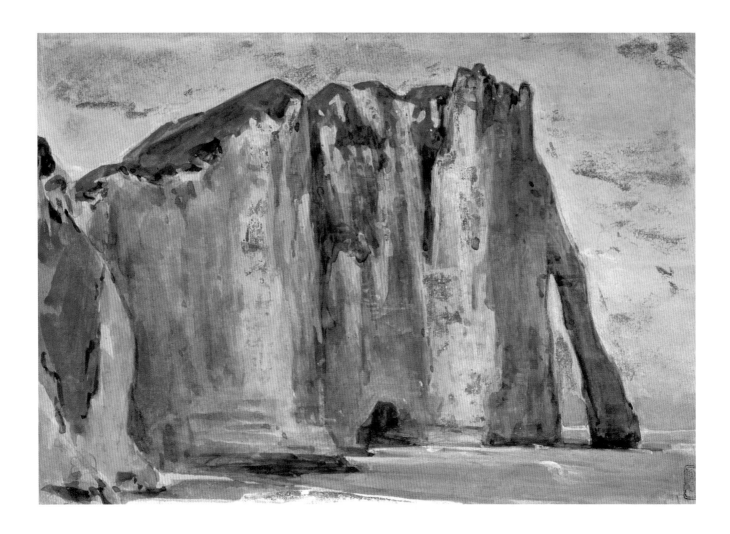

49. *Cliffs of Étretat*

1849 (?)
Watercolor with gouache highlights on paper;
5 11/16 x 9 3/8 inches (14.5 x 23.8 cm)
Rotterdam, Museum Boymans–van Beuningen
(F II 163)
Exhibited in Paris only

Delacroix made this watercolor from a vantage point very close to the imposing mass of the Aval cliff wall. At this proximity the Aiguille d'Étretat—a tall, needle-shaped rock rising up from the sea nearby—seems to be part of the cliff.

Another watercolor with gouache highlights, now in the Musée Marmottan in Paris (inv. 5063), presents a similar view but from a little farther away.[1] And the same view seen from a slightly different angle appears in a watercolor formerly in the Maurice Gobin collection.[2]

A. S.

1. 1993–94, Paris, no. 71, p. 48, repro.
2. Maurice Gobin, *L'Art expressif au XIXᵉ siècle* (Paris: Quatre-chemins, 1960), repro.

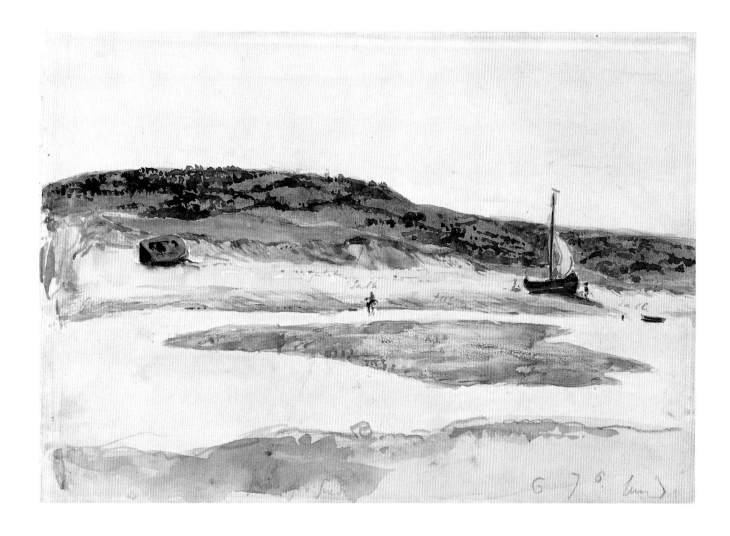

50. *Boats Aground on a Riverbank*

1852
Watercolor over graphite on paper;
4⅜ x 7¹¹/₁₆ inches (11.8 x 19.6 cm)
Dated at lower right in pencil: *6 7ᵇ lundi*
Annotated overall in pencil: *galet / sable / talus /
sable / lac / jaune g. de Suède*
New York, The Pierpont Morgan Library,
Bequest of John S. Thacher (1985.35)
Exhibited in Paris only

Sketched in with a few brisk and supple brush-strokes, this fluid watercolor done with a reduced range of colors was probably executed in 1852. That year, the sixth of September did fall on a Monday as the artist's date indicates. In Delacroix's *Journal* we also find the following note for September 6: "Left for Dieppe at eight o'clock. . . . Arrived in Dieppe at one o'clock and put up at the Hôtel de Londres. I have been given the room I hoped for, with the view over the port. This is delightful; it will be a great distraction."[1] The river shown here is the Arques, which flows into the sea at Dieppe.

A. S.

1. *Journal,* September 6, 1852 (Norton, 1951, p. 157).

51. View of the Duquesne Quay at Dieppe

1854
Graphite on paper; 6⅞ x 13⁷/₁₆ inches
(17.5 x 34.2 cm)
Dated and annotated at the lower right in
pencil: *du quai Duquesne 2 7ᵇʳᵉ. 54.*
Paris, Musée du Louvre, Département des Arts
Graphiques (RF 3710)
Exhibited in Philadelphia only

After completing work on the interior of the Salon
de la Paix at the Hôtel de Ville in Paris (see cat. 65),
Delacroix treated himself to a long rest at Dieppe,
where he remained from August 17 to September
26, 1854. While there, he and Jenny Le Guillou
stayed at number 6 on the Duquesne Quay. Dela-
croix occupied his time by walking around Dieppe
and Pollet, and by excursions to the seaside or the
cliffs. From his room he could see the busy port,
and he noted the movements of the tides as well as
the arrivals and departures of boats. On August 25
he wrote to Madame de Forget: "I bounced around
from house to house before settling down. Finally,
here I am on the Duquesne Quay, right in the mid-
dle of the seascape. I can see the port and the hills
by the Arques. It is a charming view, with enough
variety to provide continual distractions when we
stay inside."[1]

This famous drawing, dated September 2, 1854,
and often reproduced and exhibited, belongs to a
series of studies that Delacroix made from his bed-

room window. In his *Journal* entry for August 18 he
remarked: "The view from the window is enchant-
ing."[2] On September 1 he added: "Worked all day.
Sat at my window before dinner drawing boats."[3]

A. S.

1. *Correspondance*, vol. 3, p. 220.
2. *Journal*, August 18, 1854 (Norton, 1951, p. 243).
3. *Journal*, September 1, 1854 (Norton, 1951, p. 248).

52. View of the Port of Dieppe

1854
Watercolor and gouache over graphite on
paper; 9⅓ x 12⅓ inches (23.7 x 31.3 cm)
Dated and annotated at the lower right with
brush: *7 7ᵇʳ. jeudi / Chanteurs.*
New York, The Pierpont Morgan Library,
Bequest of John S. Thacher (1985.44)
Exhibited in Philadelphia only

The somewhat elliptical annotation "Thursday,
September 7/Singers," inscribed at the lower right of
the drawing was incorrectly deciphered in the cata-
logue for the sale of 1962, with *Chanteurs* being re-
placed by *Chartreux*. Its meaning is explained,
however, in Delacroix's *Journal*. On September 7,
1854, Delacroix left Jenny Le Guillou at the Dieppe
baths and visited the church of Saint-Jacques, where

a Mass was in progress, accompanied by a group of singers from the Pyrenees. Upon hearing them, Delacroix experienced as much pleasure as surprise: "It was a very touching spectacle for a simple man like myself to see, those young people and those children in their poor and uniform clothes forming a circle and singing without written music while they looked at each other." After Mass was over, Delacroix painted this watercolor to overcome a bad mood caused by an "infernal cigar," without spending much time on the details: "A small unfinished watercolor of the port filled with curious green water. . . . Noted the contrast, on that water, of the very black ships, the red flags, etc."[1] On September 26, the day of his departure, Delacroix drew a similar view in pencil (fig. 1) on the pages of a small notebook he must have kept constantly in his pocket.

A. S.

1. *Journal,* September 7, 1854 (Pach, 1937, p. 424).

Fig. 1
Eugène Delacroix, *View from the Bay of Dieppe,* 1854, graphite on paper, folios 31 verso and 32 recto, sketchbook, Amsterdam, Rijksmuseum.

53. *The Sea at Dieppe*

1852
Oil on wood; 13¾ x 20¹⁄₁₆ inches (35 x 51 cm)
Paris, Musée du Louvre (RF 1979-46)

Although this painting was titled *The Sea Seen from the Heights of Dieppe* in the catalogue of the sale after the artist's death, the position of the boat in the left corner of the composition obviously shows that Delacroix was not up on the cliff when he memorized all the details that would result in this tiny masterpiece. This is undoubtedly the painting that Delacroix alluded to in his *Journal* entry for September 14, 1852:

> Towards three o'clock I went down to take my last look at the sea. It was perfectly calm and I have seldom seen it more lovely; I could hardly bear to tear myself away. I spent the whole time on the beach and didn't go near the pier all day. How passionately one clings to things when one is about to leave them.
>
> The sketch I made from memory was of this sea: golden sky, boats waiting for the tide to return to harbour.[1]

When presented at the sale of Delacroix's studio, this seascape made a strong impression on those following the developments at the auction. According to Théophile Silvestre, its sale—at a high price—to comte Duchâtel was met with a round of applause from the room.[2] Since that time, people have rightly continued to admire the work. This was the case, for example, in 1970, when it was shown in the painter's studio at the Musée Delacroix next to Claude Monet's celebrated *Impression: Sunrise* (Musée Marmottan, Paris). Whether or not it was painted from nature, this seascape has the appearance of a direct study and, in its breakup of the brushstrokes, announces the rapid notations of the Impressionists.

A. S.

1. *Journal,* September 14, 1852 (Norton, 1951, p. 160).
2. Silvestre, 1864, p. 13.

54. *The Sea at Dieppe*

1854 (?)
Watercolor with gouache highlights on paper;
9¹⁄₁₆ x 12 inches (23 x 30.5 cm)
Private collection (courtesy of the Nathan Gallery, Zurich)

Delacroix undoubtedly executed this watercolor during his second stay in Dieppe, from August 17 to September 26, 1854. The notebook he used during this trip, now in the Rijksmuseum in Amsterdam, contains a similar view from farther away, executed in pencil, across two pages (fig. 1). Note that the use of gouache to highlight the foam on the waves does not in the least weigh down this strongly colored composition.

A. S.

Fig. 1
EUGÈNE DELACROIX, *The Sea at Dieppe,* 1854, graphite on paper, folios 25 verso and 26 recto, sketchbook, Amsterdam, Rijksmuseum.

55 to 57. Studies of the Sea

55. *Sunset on the Sea*

1854 (?)
Watercolor over graphite on paper;
9 x 13¹⁵⁄₁₆ inches (22.8 x 35.4 cm)
Annotated at lower right in pencil: *sur la pointe des vagues verticalement sous le soleil, paillettes / lumineuses dans un espace très circonscrit*
Vienna, Graphische Sammlung Albertina
(24 099)
Exhibited in Philadelphia only

In his catalogue raisonné Alfred Robaut noted that "when he had to compose a sky, Delacroix turned more readily toward watercolor; he executed a certain number of these using this procedure."[1] During his various stays in Dieppe, specifically during the one of 1854, Delacroix made many variations on this theme, moving closer or farther away from the beach to obtain the best viewing angle, thickening his watercolors with light dabs of gouache or diluting his pigments to the sheerest tint to reproduce as faithfully as possible, on paper, the slightest nuances of the sky as they appeared reflected in the water.

A. S.

1. Robaut, 1885, no. 1084.

56. *Sunset on the Sea*

1854 (?)
Watercolor on paper; 10¹⁄₁₆ x 13⁷⁄₁₆ inches
(25.5 x 34.5 cm)
Private collection (courtesy of the Galerie Schmit, Paris)
Exhibited in Philadelphia only

This seascape, more elaborate than the preceding watercolor (cat. 55), illustrates in an equally significant manner the hypersensitivity of Delacroix's eye, which never tired of observing the "sun set amid bands of clouds, red and with sinister gilding, as they reflected in the sea, which was dark at every place that did not catch this reflection."[1]

A. S.

1. *Journal,* September 17, 1854 (Pach, 1937, p. 434).

57. *Seascape*

1854 (?)
Watercolor on paper; 11 x 17¹⁵⁄₁₆ inches
(28 x 45.6 cm)
Annotated along the right border in pencil: *presque toujours brume grisatre violete* [sic] *à l'horizon entre le ton de la mer / et le bleu du ciel / par le beau temps / les montagnes / violatres / le ton de la mer / paraissant d'un vert / charmant mais / melé de vert* ["de vert" crossed out] *d'arc en ciel / où le vert domine*
Private collection
Exhibited in Paris only

The annotations along the right border of this evanescent watercolor attest to Delacroix's acuity and sensitivity in recording the slightest nuances of the sea in different light conditions during his stays at Dieppe. This seascape was painted there between August 17 and September 26, 1854. This is clear from similar comments on colors and reflections Delacroix recorded in his *Journal* and from his rapid pencil sketches in a notebook he used during that period.[1] On the verso of folio 19 of this notebook, a brief note about waves (dated August 25 [1854]) is accompanied by the following annotations: "violet shadow / blue-green / purplish green shadow / yellower green / blue-white yellow reflection / yellow gilded violet / reflection of the sky in the shade / seems colder and metallic / the sun behind the viewer / shadow of the cliff / expanse of foam." Likewise, on the recto of folio 27 and scattered across a sketch of whitecaps, one reads: "The sun being / behind the viewer / the tonal value of the green / is weak / the same clear color throughout / which is the sky reflected— green shade / weak tonal value in the / open / —violet shade / in the cast shadow / of the quay / reflection of the q[uay] / the green waves have / the same tone." Similar observations are visible on the watercolor *Sunset on the Sea* (cat. 55).

A. S.

1. Sketchbook, Rijksmuseum, Amsterdam (inv. 1968-85).

55

56

57

58 to 62. Studies of the Sky

In 1840 Delacroix embarked upon his solitary apprenticeship in landscape painting. He assimilated the technical freedom of the English watercolorists and the precise rules of the great classical tradition embodied by the seventeenth-century masters—Claude Lorrain (1600–1682) and Nicolas Poussin (1594–1665)—and the Neoclassical landscape artists who had dominated the genre around 1820. At that time Delacroix had followed the teachings of Pierre-Narcisse Guérin (1774–1833). Despite friendships with Romantic figures that eventually brought him closer to a few "rebels" like Théodore Rousseau (1812–1867), he had learned more from the example of Paul Huet (1803–1869), and Jean-Baptiste

Camille Corot (1796–1875), who saw themselves as more or less continuing the classical tradition.

Whatever he may have thought about the genre of landscape painting, which he certainly placed at the service of his ambitions as a history painter, Delacroix had thoroughly assimilated the rule that landscape artists should regularly practice the perilous exercise of making studies directly from nature and attentively observing atmospheric phenomena to be able to reproduce their every nuance. Just as a musician would assiduously practice his scales, the landscape painter had to study even the most nondescript places in order to paint the ever-changing spectacles of different times of the day.

58. *Study of the Sky at Sunset*

c. 1849
Pastel on paper; 7½ x 9⁷⁄₁₆ inches (19 x 24 cm)
Frankfurt, Städelsches Kunstmuseum (16728)
Exhibited in Paris only

Of all the landscape studies Delacroix has left us, the most spectacular and aesthetically interesting are the studies of skies, sunsets, and night scenes that he based on landscapes seen in the forest of Sénart or in the vicinity of Champrosay. These paintings and drawings, executed around 1849–50, are exceptional for their flamboyant sensibility and analysis of color.

As early as 1800 Pierre-Henri de Valenciennes had convincingly demonstrated the need to be particularly attentive to skies when making landscape paintings. "The painting as a whole depends on the color of the sky . . . and . . . if one fails to render it in its true color the rest will be necessarily false."

Therefore, landscape painters had to always "start their studies with the sky, . . . which provides the background color." Then they would "gradually work toward the foreground, which is, as a result, always in harmony with the sky that served to create the local color."[1] This advice was also potentially helpful to history painters, who could use it in painting the settings for their biblical or historical scenes.

Although he did not mention it in his *Journal*, when he was young Delacroix must have read Valenciennes's treatise on landscape, which was one of the most famous theoretical works of its time. Delacroix followed its precepts to the letter,

59. *Study of the Sky at Sunset*

c. 1849
Pastel on gray paper; 7½ x 9⅞ inches (19 x 24 cm)
Paris, Musée du Louvre, Département des Arts Graphiques (RF 3706)
Exhibited in Philadelphia only

including Valenciennes's recommendations for the amount of time to be devoted to working under natural conditions. The sessions had to be short to enable the artist to capture the fleeting ambient light conditions of a particular time of day: "All nature studies must be completed in a maximum of two and a half hours. No more than a half hour must be spent on sunrises and sunsets."[2] Likewise, Delacroix regularly practiced what Valenciennes called "memorization studies," that is, the reworking in the studio of elements or sites previously sketched or painted out-of-doors.

Despite his commitment to Neoclassicism, Valenciennes had merely offered reminders of a few of the basic requirements of landscape painting. His advice was followed by nature painters, who applied themselves to the indispensable exercise of making studies of skies as they appeared in the morning, at sunset, or on cloudy days. Following Valenciennes,

the English painters John Constable (1776–1837) and Joseph Mallord William Turner (1775–1851), the French Neoclassical landscape artists Achille-Etna Michallon (1796–1822) and Jean-Joseph-Xavier Bidauld (1758–1846), and even most Romantics, like Théodore Rousseau and Paul Huet, spent many hours outdoors painting skies all over Europe. It was only logical, then, that Delacroix should follow their example at a time when he decided that landscape would play a more important role in his painting.

The spectacle of the sun setting amid the clouds was one that Delacroix never tired of observing. In addition to being a poetic and theatrical moment, it was also a purely visual one that sometimes led the painter to take late evening walks near his vacation spots in Normandy and on the Île-de-France: "There was wonderful moonlight this evening in my little garden. Walked about until

60. *Vast Plain Against the Sky at Sunset*

c. 1849
Pastel on paper; 7½ x 9⁷⁄₁₆ inches (19 x 24 cm)
Paris, Musée du Louvre, Département des Arts Graphiques (RF 3770)
Exhibited in Paris only

very late. I felt as though I could never sufficiently enjoy the gentle light on the willows, the sound of the little fountain, and the delicious scent of the plants which seem to give out all their hidden treasures at such times."[3]

But, leaving private feelings and sentimental commonplaces aside, Delacroix returned to the reflexes and technical concerns of his trade, as we can see from his account of an evening spent with Frédéric Villot at Champrosay in November 1853. On this occasion their conversation was clearly confined to painterly matters as they sought to find the pigments most likely to reproduce the nuances of a fiery sky at sunset:

> During this walk we observed a number of striking effects. The sun was setting: the most brilliant chrome and lake in the light, and the cold blue shadows between. The shadow cast by the trees yellow, Italian earth, reddish brown and il-luminated in front by the sun, set off against a bunch of clouds varying in color from gray to blue. . . . This law of opposites is precisely what made the effect seem so vivid in this landscape. Yesterday, November 13, I noticed the same phenomenon at sunset. If it is more dazzling, more striking, than at noon, this is because the contrasts are sharper. In the evening, the gray of the clouds shades to blue. The pure part of the sky is bright yellow, or orange colored. As a general rule, the greater the contrast, the more striking it is.[4]

In making his watercolor studies of the sky, Delacroix wanted, above all, to depict a cloud realistically or to reproduce precisely a specific blue. But when he took up his pastels in the studio and began to conjure up memories of his days out-of-doors, he was more interested in combining two or three predominant colors and registering the breakup of the declining light and the subtle changes that occurred in the shade or sunshine.

61. *Study of the Sky at Dusk*

c. 1849
Pastel on gray paper; 7½ x 9⁷⁄₁₆ inches (19 x 24 cm)
Paris, Musée du Louvre, Département des Arts Graphiques (RF 23 315)
Exhibited in Philadelphia only

This deliberate synthesis of a sunset sky above the Île-de-France, based on a purely visual impression, could eventually be incorporated into a more ambitious composition as the setting for a religious, allegorical, or literary theme. Thus, Delacroix's *Journal* tells us that the golden sky over Apollo's chariot on the ceiling of the Galerie d'Apollon at the Louvre (see cat. 64) was inspired by this series of pastel and watercolor studies executed, for the most part, during 1849.[5]

V. P.

1. Pierre-Henri de Valenciennes, *Réflexions et conseils à un élève sur la peinture et particulièrement sur le genre du paysage* (Paris: Dessene et Duprat, 1800), p. 407.
2. Valenciennes (see note 1), p. 408.
3. *Journal,* May 23, 1850 (Norton, 1951, p. 121).
4. *Journal,* November 14, 1853, p. 269.
5. *Journal,* May 8, 1850, p. 237.

62. *Sunset*

c. 1850
Pastel on paper; 8³⁄₁₆ x 10¼ inches (20.8 x 26 cm)
Private collection
Exhibited in Philadelphia only

III

ALLEGORIES AND MYTHOLOGIES

In 1856, in one of the lapidary phrases so skillfully scattered through the *Journal* pages devoted to his profession, Eugène Delacroix passed a simple and severe judgment on Neoclassical art, which in his opinion was still vainly seeking its justification—thirty years after the death of Jacques-Louis David (1748–1825)—in the art of antiquity. Rephrasing a remark by Voltaire, one of his favorite writers, Delacroix exclaimed half angrily, half humorously: "*Greek tragedies are for Greeks.* . . . It is thus ridiculous to try to go back, to be consciously archaic."[1]

In another, more explicit note the following year, Delacroix openly attacked the Neoclassical movement. In an unusual way, he contrasted the notion of classicism with that of copying antiquity:

> The school of David has been wrongly seen as the outstanding classical school, although it has been based on the imitation of ancient art. It is precisely this often unintelligent and exclusive practice of imitation that deprives this group of the main characteristic of classical schools, which is longevity. Instead of entering into the spirit of the classical age and adding this insight to that of nature and so on, it has been the echo of an age when people had fantasies of antiquity.[2]

A few years earlier, in an article published in the *Revue des Deux Mondes*, he had lamented the dogmatic stance of this school that, in his view, aimed at "teaching beauty as if teaching algebra."[3]

These statements of principle, with their provocative tone, together with the commonplace view of art historians regarding the young Delacroix's connection with Romanticism, might lead us to believe that he had definitively rejected not only Neoclassical doctrine but also subjects from antiquity and mythology. Certainly the paintings of his early years, from 1820 to 1830, on themes taken from literature or strictly contemporary events—such as the Greco-Turkish war in *The Massacre at Chios* (1824, Musée du Louvre, Paris) and the July Revolution in *Liberty Leading the People* (1830, Musée du Louvre, Paris)—seem to confirm that the artist had deliberately given up the mythological subjects and archaeological interests so dear at the time to Jean-Auguste-Dominique Ingres (1780–1867) and his many pupils.

Nevertheless, despite all the written evidence and the testimony of his paintings, we should not confuse Delacroix's violent criticisms of his contemporaries, whom he accused of blindly following ancient precepts and of believing that beauty could be handed down like "the inheritance of a farm," with his opinions on the precepts themselves and on the art of antiquity in general. His idea of art was neither one-sided nor fixed. Indeed, in the articles he published from time to time and in the notes in his *Journal,* he developed a careful definition of the links that the art of his day should maintain with the subjects and aesthetic viewpoint of antiquity.

Thus, while forcefully criticizing the followers of David, Delacroix gave his own definition of classicism in painting: "I would call classical all honest works that are satisfying to the soul, not only by their precise or grandiose or unusual depiction of things and feelings, but also by their unity, their logical order—in a word, by all those qualities that impress by their simplicity."[4] Delacroix believed fully in this conception of classical art, and throughout his career he would try to put it into practice in his painting. It led him to see the themes of antiquity, with their allegorical and mythological subjects, as an essential source of inspiration for the contemporary painter, provided that two basic rules of aesthetics be respected: first, acknowledgment of the classical principles of simplicity without artifice; and second, enrichment of one's knowledge of ancient art by working from nature and from models.

For Delacroix, the true artist was the one who rejected gratuitous imitation of Greek and Roman art, "the caricature of its drapery," and created truly original works—one who was not content with reproducing that art's outward form but sought to capture its essence, as did Titian and the Flemish painters.[5] In 1854 Delacroix had already reiterated his disapproval of servile copies of antiquity, specifying the limits for reproducing Greek and Roman art and re-evaluating its intrinsic qualities: "We are right to believe that imitating the art of antiquity is worthwhile, but that is because we find that it conforms to the immutable rules of all the arts, which are a proper degree of expressiveness, a natural quality, and an overall concept." Distinguishing between aesthetics and subject, he added, "These means may be used for something other than the endless reproduction of the gods of Olympus, who are no longer ours, and the heroes of antiquity."[6]

Carried away by the logic of his own reasoning, Delacroix, who nevertheless admired these artists passionately, went so far as to accuse "Raphael, Correggio, and the Renaissance in general" of having given in to prettiness, whereas the artists of the ancient world "had no such affectations." Noting that the works of the Renaissance masters—like those of most modern artists—had "outmoded parts," he summed up his attraction to the art of antiquity in a simple phrase: "There is no such thing in ancient art. . . . There, one finds always the same gravity and restrained power."[7]

Painting a mythological subject, therefore, did not itself seem to Delacroix like a concession. At some key moments in his career, in fact, he was able to make adroit use of the grand classical subjects so dear to his epoch. His love of subjects from the past sprang from a firm conviction that the subject of a work was much less important than the manner of presenting it—"the manner of feeling it," as Charles Baudelaire wrote in 1846 in his definition of Romanticism in art. "To say the word Romanticism is to say modern art," said the poet, "that is, intimacy, spirituality, colour, aspiration towards the infinite, expressed by every means available to the arts."[8] This was a concise summary of the convictions of a whole generation, convictions that Delacroix had held in his youth and had not abandoned. In his later years these principles remained relevant to Delacroix's notion of beauty.

For Delacroix, artistic talent had a calling to be universal. It therefore should not reject the subjects and aesthetics of antiquity but instead should assimilate them in all their subtlety, gravity, and grandeur, giving them new life through the painter's sensitive and modern attitude toward man and nature.

Delacroix's interest in mythological and allegorical subjects is one of the best examples of a reconciliation that developed in his work after 1845. He was able to combine vestiges of the passionate Romanticism of his youth—which had diminished as he became weary of the "Romantic set," with its excesses and intrigues, and angry at critics who did not understand his work—with the noble quality of the art of the great masters, whom he wanted to equal and, in a sense, modernize. His famous retort, "I am a pure classicist," hurled at the librarian of the Palais Bourbon who meant to flatter him by a comparison with Victor Hugo, is thus easily explained. In another note in his *Journal*, he eloquently summed up his attitude: "Many people do not distinguish between the notion of coldness and that of classicism. It is true that many artists think themselves classical because they are cold. Similarly, there are those who believe themselves passionate because they are dubbed Romantics. True passion is what moves the viewer."[9]

Nevertheless, subjects from antiquity—themes taken from Greek and Roman history and mythology—came late in Delacroix's work. His classical education with the academic Pierre-Narcisse Guérin (1774–1833)—an original and independent thinker and teacher who, before the Romantics, had tried to reconcile Neoclassical strictness with the *terribilità* of Michelangelo—enabled Delacroix to steep himself in the tradition imposed by the École des Beaux-Arts of Paris and to practice the academic painting of nudes. Even though he could not find in Italian art the ancient model in all its perfection, the artist completely absorbed the "canons" of antiquity and their metamorphosis in the theories of the Renaissance. Indeed, it was in his youth, between 1818 and 1820, that he painted his first canvases on ancient themes, many of them executed while he was studying. For the drawing competitions at the École des Beaux-Arts, he submitted *Nemesis* in 1817 and *Roman Ladies* and *Death of a Roman General* in 1818.[10]

But it was not until 1827, after two triumphs at the Salon—in 1822 with *The Barque of Dante* (Musée du Louvre, Paris) and in 1824 with *The Massacre at Chios* (Musée du Louvre, Paris), one inspired by a literary subject and the other by a contemporary event—that Delacroix painted for the Salon his first two truly classical subjects, *The Death of Sardanapalus* (1827–28, Musée du Louvre, Paris) and *Justinian Drafting His Laws*.[11] These paintings demonstrate a new aesthetic approach and subject matter.

In the first of these two canvases, which was submitted very late to the Salon, the artist clearly attempted a renewal of ancient themes, choosing his subject (undoubtedly inspired more or less directly by Byron's play published in December 1821) not from Greek or Roman mythology but from Assyrian and Babylonian history, of which archaeologists were just beginning to find traces. Delacroix's independence of spirit—fueled by the criticism and poetry of modern writers (Byron and Goethe) or those of the past (Dante and Shakespeare), each of whom had adapted ancient history in his own way—led him to seek out the origins of Greek civilization and to become interested in ancient Egypt before the Assyrian Empire: "Greek art," he noted, "sprang from Egyptian art. It required all the wonderful gifts of the Greek people, who still followed a sort of hieratic tradition like that of the Egyptians, to arrive at the full perfection of their sculpture."[12] The mysteries and excesses of this "primitive" antiquity, in contrast to the calm and balanced version of antiquity portrayed by some followers of Ingres, excited the young Delacroix (but not

the critics of the Salon). Here Delacroix saw a way to pursue his quest to renew traditional themes. *The Death of Sardanapalus* constitutes at once a flamboyant attempt to synthesize the Romantic attitude and ancient subjects, a proposal for renewing the iconography of history's great paintings, and a testing ground for new theories of painting, full of blood and fury. Some years later the artist would return to these ideas in his *Medea About to Kill Her Children* (Musée des Beaux-Arts, Lille; replica, Musée du Louvre, Paris), a subject taken from the tragedies of Euripides and Corneille.

On this topic, we should note another difference between Delacroix and the majority of his Neoclassical colleagues. As demonstrated in his approach to *The Death of Sardanapalus,* he often took his initial inspiration for paintings on ancient subjects not from history or mythology but rather from the work of writers and poets, thus conferring on the subject the intellectual and literary legitimacy that to his mind was essential to the renewal of classical themes. One of his submissions to the Salon of 1839, *Cleopatra and the Peasant,*[13] was based on Shakespeare's *Anthony and Cleopatra* (act 5, scene 2), while *The Justice of Trajan* (Musée des Beaux-Arts, Rouen), exhibited at the Salon of 1840, was, according to the artist, drawn from Dante's *Purgatorio,* canto 10.

By the same token, the Greek and Roman philosophy Delacroix had imbibed so eagerly in his youth provided him with frequent subjects for paintings, as can be seen in his *Death of Marcus Aurelius* (Musée des Beaux-Arts, Lyon), shown at the Salon of 1845. In his *Journal* he often mentioned this passion for the ancient philosophers, which later became, in the murals for the Palais Bourbon and the easel paintings developed from these (cats. 95 and 97), one of his favorite pictorial themes: "The moralists, the philosophers, I mean the real ones such as Marcus Aurelius and Christ (looking at the latter simply in human terms), never mentioned politics. . . . They only recommended that mankind resign itself to destiny—not to the obscure canons of the ancients, but to that eternal necessity that cannot be denied, and against which philanthropists can make no headway, of submitting to the decrees of stern nature."[14]

In 1827, at the same time as his *Sardanapalus,* in an institutional commission for the Conseil d'État, Delacroix expressed the new artistic convictions he had developed from the themes of ancient philosophy. In *Justinian Drafting His Laws,* a painting of Byzantine emperor Justinian I, famous for his written legislative texts, the background is no longer the conflagration of an Assyrian palace but the decadent grandeur of the last lights of the Roman Empire in Byzantium. The artist was thus able to depict "another" antiquity, a late baroque one in contrast to tales taken from Homer or the early days of the Roman State. In his *Justinian,* abandoning moralistic subjects and heroic sagas, Delacroix handled a completely original intellectual and philosophical theme, which contributed—as much as the violent sensuality of his *Sardanapalus*—to a renewal of the ideal of antiquity in painting. It was this personal approach to antiquity, the presentation of noble, calm, and serious situations rendered by a painter who was both an intellectual and a lover of beauty, that was to become paramount in the later years of his career, in masterpieces like *Ovid Among the Scythians* (cat. 95) and *Demosthenes Declaiming by the Seashore* (cat. 97).

After 1833, taking this same approach, Delacroix also began to tackle allegorical themes, which for him were linked inextricably to subjects from antiquity. He was initially spurred by a commission, won with the help of Adolphe Thiers, to paint the Salon du Roi in the Palais Bourbon. The artist created symbolic decorations taken directly from antiquity—*Justice, Agriculture, War,* and *Industry*—illustrated with characters and accessories inspired by Greek and Roman mythology.[15] This commission was soon followed by

others: the library of the Palais Bourbon (1838–47; see cats. 95 and 97) and the Palais du Luxembourg (1840–46); the Galerie d'Apollon at the Louvre (1850–51; see cat. 64); and the Salon de la Paix in the Hôtel de Ville, Paris (1851–54; see cat. 65). These paintings use classical iconography and aesthetics, inspired by other renderings of antiquity. The subjects are sometimes taken from mythology, as in the reworking of Ovid for the Hercules series in the Salon de la Paix (see cat. 135) or the *Orpheus* in the Palais Bourbon. Sometimes they are incidents from Greek or Roman history, such as the deaths of Pliny the Elder and of Alexander, both at the Palais Bourbon. At other times, the subjects derive from ancient poetry and philosophy: *Hippocrates, Archimedes, Herodotus, Seneca, Socrates, Cicero, Demosthenes, Ovid, Hesiod, Homer,* and *Aristotle,* all executed for the Palais du Luxembourg or the Palais Bourbon.

These references to antiquity and to allegory were perfectly adapted to the decorative function dictated by the taste of the time. They remained true, moreover, to Delacroix's theoretical thoughts in his *Journal.* When he stated on February 23, 1858, that "the antique is always even, always serene, complete in every detail and irreproachable in the general effect," to the point that "all the works seem to come from the hand of a single artist,"[16] he was also justifying the huge symbolic depiction of the triumph of light over darkness in his *Apollo Victorious Over the Serpent Python* (cat. 64) and the elegiac landscapes of his *Four Seasons,* inhabited by gods and nymphs, painted between 1856 and 1863 (cats. 151 to 154).

Between 1830 and 1850 Delacroix's views on art were broadened by assiduous and in-depth studies of anatomical models, as recommended by the masters of the Renaissance and the seventeenth century. He also studied these artists' own "readings" of the art forms of antiquity. The nudes Delacroix so often painted after 1845 in his allegorical compositions, which were in the best sense academic exercises but executed also for the pure pleasure of artistic research, show emphatically how the artist's pictorial studies of the human form developed in his later years into a perfect equilibrium—a balance between his preference for modernism in the choice of colors and forms and his direct references to classical and ancient examples and precepts. Some drawings illustrate this perfectly (cats. 69 to 71).

Thus, the nudes that Delacroix rendered with an antique style in a mythological setting were prepared from copies of classical works and old marbles, from a study of the masters both ancient and modern, but also from frequent recourse to photographic plates. This recent invention, which allowed for uncompromising modern realism, in no way fettered the artist's imagination. Delacroix was always in search of new forms, worked out either in contradiction to or in continuity with the eternal values of beauty defined since ancient times. When he painted these nudes, his approach was not dictated by his artistic training or by a need to suggest the antique; in these moments the one thing that mattered was his observation of the human body, the subject. The pictorial handling became secondary, eclipsed by his intentness on the throbbing and color of the flesh, apparently indissolubly linked: "Flesh only takes on its real color in fresh air,"[17] he wrote, recalling the importance of painting from life and from observations of nature.

The antique thus disappeared behind the real, as did classicism and Romanticism behind the handling of the brush and the rediscovery of the eternal forms of the body. In speaking of Michelangelo some years earlier, Delacroix had made a statement that might well apply to himself as well: "Michelangelo, like us, had seen the ancient statues; history tells us how passionately he admired these marvelous relics, and we admire them as he did; yet seeing and admiring these pieces in no way changed his vocation or his nature; he never stopped being himself, and his creations can stand beside those of antiquity."[18] And in his

Journal Delacroix gave a definitive reply to the primary question of his relationship with antiquity: "Whence comes this special quality, this perfect taste found only in the antique? Perhaps it is because we compare it to all that has been done in supposed imitation of it."[19]

Vincent Pomarède

1. *Journal,* April 9, 1856, pp. 574–75. At this time Delacroix was considering publishing the *Journal,* especially his personal comments on the fine arts.

2. *Journal,* January 13, 1857, p. 615.

3. Delacroix, 1854.

4. *Journal,* January 13, 1857, p. 615.

5. *Journal,* January 25, 1857, p. 636.

6. Delacroix, 1854.

7. *Journal,* January 25, 1857, p. 636.

8. Quoted in *The Painter of Modern Life and Other Essays: Charles Baudelaire,* translated and edited by Jonathan Mayne (London: Phaidon, 1995), p. xi.

9. *Journal,* January 13, 1857, p. 615.

10. The location of these works is unknown.

11. Burned in the 1871 fire at the Conseil d'État; Johnson, 1981, vol. 2, no. 123, pl. 107.

12. *Journal,* February 23, 1858, p. 707.

13. Ackland Memorial Art Center, Chapel Hill, North Carolina; Johnson, 1986, vol. 3, no. 262, pl. 80.

14. *Journal,* February 20, 1847, p. 133.

15. This was Delacroix's first attempt to deal with such themes, except for the 1821 murals of the *Seasons* painted for the actor François-Joseph Talma's dining room (location unknown; Johnson, 1981, vol. 1, nos. 94–97, pls. 82–83).

16. *Journal,* February 23, 1858, p. 707 (see Norton, 1951, p. 377).

17. *Journal,* January 23, 1857, p. 618 (see Norton, 1951, p. 354).

18. Delacroix, 1854.

19. *Journal,* January 25, 1857, p. 635.

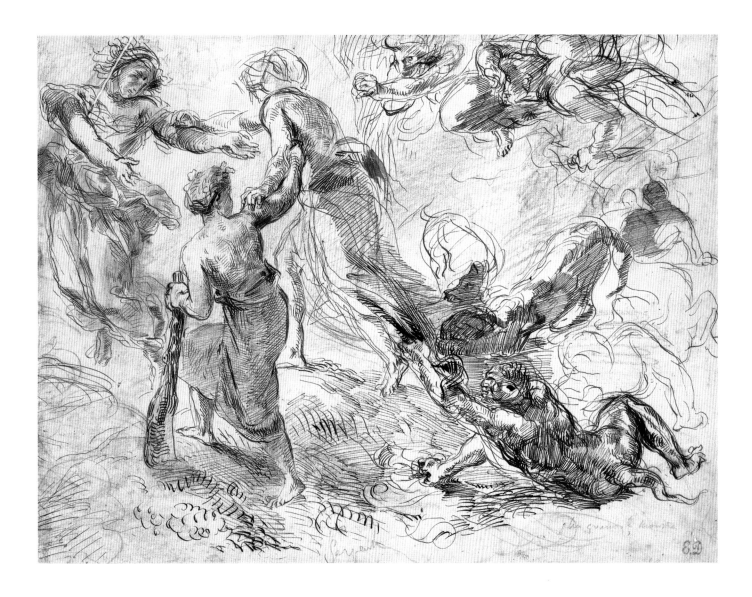

63. *The Triumph of Genius*

1849–51
Brown ink over graphite on paper;
10⅜ x 13¹³⁄₁₆ inches (26.3 x 35.1 cm)
Annotated in pencil at lower center: *serpent;*
and at lower right: *plus grand le monstre*
New York, The Metropolitan Museum of Art,
Rogers Fund, 1961 (61.160.1)
Exhibited in Paris only

Throughout his life, at regular intervals, Eugène Delacroix returned in his *Journal* to the allegorical theme of the genius welcomed by posterity, a subject intimately linked to his own personality and individual experience. As early as 1823, when his career had just begun and he had been confiding his impressions to the *Journal* for scarcely a year, he wrote:

> Do not lose from view the allegory of the *Man of genius at the doors of the tomb.* . . . A suspicious eye follows his last sigh, and the harpy still retains him by his mantle or shroud. For his part, he throws himself into the arms of Truth,

supreme deity: his regret is extreme, for he leaves error and stupidity behind him: but he goes to find rest. One might personify him in the person of Tasso. His shackles fall off and remain in the monster's hands. The immortal crown escapes from its clutches and poison drools from its lips onto the pages of the poem.[1]

That description, a remarkable premonition of some of the preoccupations of his maturity, seems to anticipate the self-assured iconography of this drawing by some twenty-five years.

On October 17, 1849, he again wrote about this iconographic theme in the *Journal,* declaring, not without pride: "I thought with pleasure about returning to certain subjects, above all *Genius Attaining Immortality.* It is time to get that and the *Lethe* underway";[2] on June 14, 1851, he once more revisited this theme, which clearly must be considered one of the most personal and constant of his career: "*Allegory of Glory*—Freed from earthly ties and supported by *Virtue, Genius* reaches the abode of *Glory,* his ultimate goal: he abandons his remains to livid monsters, who personify envy, unjust persecution, etc."[3] This passionate interest manifests it-

Fig. 1
EUGÈNE DELACROIX, *Sheet of Studies with Two Figures, a Dog, and a Wolf,* 1849–51, graphite with watercolor on paper, Paris, Musée du Louvre, Département des Arts Graphiques.

Fig. 2
EUGÈNE DELACROIX, *Studies of Monsters with Human Heads,* 1849–51, graphite on tracing paper, Paris, Musée du Louvre, Département des Arts Graphiques.

self again on April 27, 1854: "I also think about *Genius Attaining Glory.*"[4]

Alfred Robaut drew attention to two drawings by Delacroix that treat this theme, which he dated to 1840.[5] Maurice Sérullaz, in a discussion of drawings in the Louvre of the same subject, suggested instead a dating of 1849, the year in which Delacroix dwelled on the theme at greatest length in his *Journal.*[6] In fact, the Louvre owns several compositional studies for this allegory—which never saw the light of day as a painting, remaining at the sketch stage—including a drawing (fig. 1) with significant variations and two others that seem to be preparatory studies for a projected painting (fig. 2 and RF 9362).

V. P.

1. *Journal,* May 16, 1823, p. 37.
2. *Journal,* October 17, 1849, p. 212.
3. *Journal,* June 14, 1851, p. 281.
4. *Journal,* April 27, 1854, p. 416.
5. See Robaut, 1885, no. 728, repro.
6. M. Sérullaz, 1963(a), no. 294, repro.

64. *Apollo Victorious Over the Serpent Python*
(oil sketch)

1850
Oil on canvas; 54⅛ x 40⅛ inches
(137.5 x 102 cm)
Brussels, Musées Royaux des Beaux-Arts de Belgique (inv. 1727)
Not in exhibition

In 1849 Eugène Delacroix was informed by his friend Frédéric Villot (1809–1875), then curator of paintings at the Musée du Louvre, of work about to be undertaken in the Galerie d'Apollon, one of the most prestigious galleries in the palace, adorned since the seventeenth century with large decorative compositions conceived by Charles Le Brun (1619–1690). After a law was passed on December 12, 1848, allocating two million francs for the renovation of various rooms in the Louvre, the museum administration and the directors of the Beaux-Arts envisioned restoring the old decor of the Galerie d'Apollon and commissioning one or more contemporary artists to execute new decorative paintings in this historic space. Delacroix first referred to the possibility of such a commission in his *Journal* on April 13, 1849: "Villot came this morning. He spoke to me of Duban's project to have me execute in the restored Galerie d'Apollon the painting corresponding to that by Le Brun. He spoke to him about me in very flattering terms."[1] The painter was officially awarded the commission only a year later.

In a letter of February 20, 1850, Félix Duban (1797–1870), the architect in charge of coordinating the restoration work and overseeing the execution of the new monumental paintings, recommended to the Minister of Public Works that the project be entrusted to Delacroix. On March 8, 1850, the minister wrote to the painter officially informing him of the commission for eighteen thousand francs.[2]

Thus the friendship of Frédéric Villot, the political support of Joséphine de Forget, a close friend of Delacroix, and his own network of social and professional relations—beginning with the sometimes stormy amorous friendship he had maintained since 1833 with Élisabeth Cavé, previously the wife of the painter Clément Boulanger, who then married the head of the Beaux-Arts division at the Ministry of the Interior, François Cavé—had again permitted Delacroix to prevail over opposition from the Institut, as well as the antipathy of certain critics to obtain a major institutional commission.

Having considered its composition even before receiving the commission, Delacroix quickly settled on the subject of this ambitious work, taking up the original project of Le Brun, who had envisioned

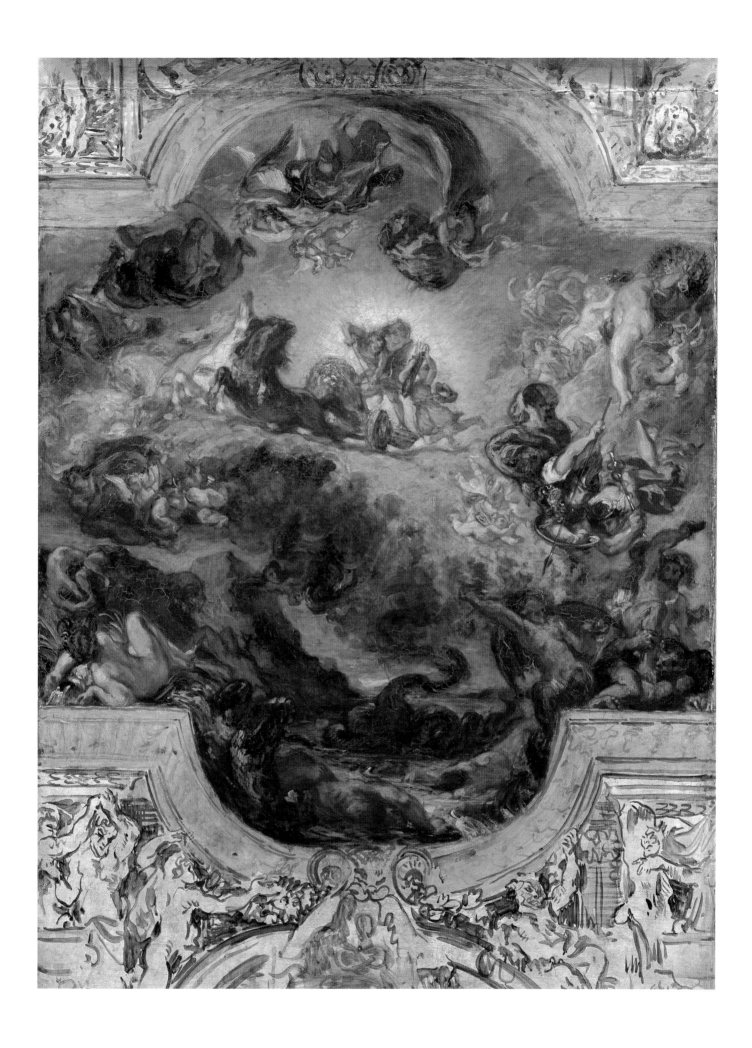

painting in this central ceiling compartment Apollo in his chariot. Delacroix must have been aware of this iconographic choice—discussed by Philippe Chennevières in 1851 in his *Notice sur la galerie d'Apollon*—even if he did not know the preparatory drawing, rediscovered only later, that Le Brun had made for this unrealized composition. But Delacroix did not settle on the precise theme, taken from Ovid's *Metamorphoses*, without hesitation: "I initially considered *The Horses of the Sun Unharnessed by Sea Nymphs*. At present I still favor a return to *Python*."[3]

In the end, the pictorial program departed significantly from the intentions of Le Brun, as is indicated by a short text written to accompany invitations to the inauguration of the ceiling in 1851:

> The god, mounted on his chariot, has already fired some of his shafts; Diana, his sister, flying in his wake, presents him with her quiver. Already pierced by the arrows of the god of warmth and life, the bloody monster twists, exhaling in a fiery vapor what remains of his life and his impotent rage. The flood waters begin to recede, depositing on mountain peaks or carrying away with them the bodies of men and animals.

The painter enriched his composition with several purely decorative figures—for example, the group consisting of Cupid, Victory, and Iris, "messenger of the gods," flying through the sky, and the figure of the river god at the lower left—placing them carefully to stabilize or animate the composi-

tion. But this was not all: he also incorporated other deities participating fully in the action:

> The gods grew indignant on seeing the earth abandoned to deformed monsters, impure products of the slime. Minerva, Mercury hurl themselves forward to exterminate them, until eternal wisdom should repopulate the solitude of the universe. Hercules crushes them with his club; Vulcan, the god of fire, chases away night and impure vapors, while Boreas and the Zephyrs dry the waters with their breath and finish dissipating the clouds.

Beyond this mythological theme and the many literary and poetic references fostered by it, the work is a veritable allegorical and philosophical evocation of the struggle between light and darkness, of the victory of the forces of life and the spirit over obscurantism and death. That victory is what Delacroix sought to describe in this "very important work that will be placed in the most beautiful site in the world, beside the beautiful compositions of Le Brun."[4]

Despite the fatigue and anxiety this commission would cause him, Delacroix worked with care and ardor, painting first an oil sketch in April–June 1850—doubtless a kind of *modello* for presentation to his patrons, as Maurice Sérullaz suggested in 1963.[5] The sketch would permit him not only to establish the definitive construction of his decor, with the placement and relations of the various figures, but also to perfect the audacious chromatic choices that he envisioned developing in this work. Only on June 8 of the same year did he begin to feel that he was well along on the right path: "I said to myself, looking at my ceiling composition which has pleased me only since yesterday, thanks to changes I made in the sky with pastel, that a good painting is exactly like a good dish made from the same ingredients as a bad one: the artist makes all the difference."[6] Even before completing this *modello* and after executing a precise graphite drawing of the decor (fig. 1), Delacroix painted another, smaller oil sketch—of the ceiling. (The smaller sketch was the subject of a 1988 article by Lee Johnson.[7])

Thanks to these numerous preliminary studies, Delacroix was able to synthesize with precision in his *Journal*, on Monday, June 10, 1850, a list of the various pigments needed to realize his decor, drafting in the process a kind of aide-mémoire for execution of the work at full scale:

> The part of the sky after the largest areas of sunlight, that is to say, already dark: *chrome yellow shot with white—lacquer white and vermilion. Cassel earth* and *white* form the diminishing halftones. In general, excellent for all halftones. The

lights pale yellow on the clouds below the chariot: *cadmium, white,* a point of *vermilion.* The more orangy part of the sky, beginning with the luminous circle: on an orangy preparation, brush lightly *à sec* a tone of *Naples yellow, blue green,* and *white,* allowing a little orange to appear. Orange tone, very beautiful for the sky: *natural Italian earth, white, vermilion.—Vermilion, white, lacquer* and sometimes a little *cadmium* and *white."*[8]

This sky was, in fact, inspired by a study executed in the open air, during a stay at Champrosay (see cats. 58 to 62). And the artist's *Journal* specifies that it was entirely recomposed—literally recreated—from "memory" in his atelier in the country: "I executed, on returning, a kind of *pastel* of the *sun effect,* with a view to my ceiling."[9]

On the basis of elements assembled in numerous preparatory studies in pencil (including fig. 2),[10] and with constant reference to this oil sketch, Delacroix continued to specify in his *Journal* the pigments envisioned for execution of the final work:

> *Apollo,* the robe painted in a *red tone* a bit pale in the lights, frosted with *lacquer yellow* and *lacquer red.* Area of the *flesh of Diana: Cassel earth, white,* and *vermilion.* Rather gray throughout. Lights: *vermilion white,* a bit of *vermilion.* The reflections [a] warm tonality, *almost citron;* a little *antimony* here, the whole very boldly [applied]. Area of the *horses of Apollo: Umbrian earth, white, cadmium,* a very little *Italian earth* and *ocher.* . . . Halftone of the *horse, milk soup* ([as in] *Arab Crossing a Ford*): *natural* and *white Umbrian earth, antimony, white* and *brown red:* the red and yellow predominant, as expedient.[11]

He completed this list, which was to prove indispensable to the technical advancement of his work, in August 1850, after spending several weeks in Belgium. In Antwerp he had studied some large paintings by Rubens, about which he noted on August 10: "All this will be useful for my ceiling."[12] Then on the occasion of a summer cure taken at Ems he wrote: "Yellow tone for the sky after the very bright tone of *Naples yellow* and *white,* which surrounds the [figure of] Apollo: *ocher yellow white, chrome no. 2."*[13]

By this time the oil sketch had been completed with sufficient detail in its drawing and its subtlest coloristic nuances. Thus, on his return home, Delacroix could begin, on September 3, the necessary squaring of a preparatory cartoon. This cartoon could then be transferred to the final canvas—the composition was painted on a canvas, first stretched on a provisional chassis and then fixed to the ceiling of the gallery—using a tracing, faithfully adhering to the contours and restrictions imposed by the architecture. Delacroix frequently modified his initial thoughts at this stage by reworking passages directly on the tracing.

Beginning with the squaring stage, the painter was assisted by a student who later became one of his most faithful collaborators, Pierre Andrieu (1821–1892). During this period, Delacroix maintained an enriching and amusing correspondence with Andrieu. The painter sometimes "scolded" his collaborator, who was charged with faithfully adhering to Delacroix's precepts. On September 23, 1850, his *Journal* reveals a veritable "battle plan" defining the stages of work necessary to transfer the painted sketch to the preparatory cartoon, then the cartoon to the final canvas:

> To prepare the figures on the painting: begin with a good outline, and when A[ndrieu] has applied the color and begun to *shape* his figure, correct him in this initial work and try to get him to master it with this help. This will make my retouching easier. It will be necessary to retain the outline of the pounced drawing and perfect it even before using it, such that it can be pounced again on the painted preparation should the drawing get lost.[14]

The new decoration was officially opened to the public on October 23, 1851. Three weeks later, on November 8, Delacroix received the sum of twenty-five thousand francs, corresponding to the eighteen-thousand-franc fee for the commission and seven thousand francs for additional expenses. The critics were unanimously positive (even the severe Delécluze), praising the painter for having achieved a tour de force. Some discerned the influence of Veronese or Tiepolo, others the touch of Rubens. For its part, the administration sought to continue the collaboration with Delacroix by entrusting to him the decoration of the small loggia at the end of the Galerie de Diane in the Louvre. But Duban explained to the painter that this second project had been canceled, "despite the glorious victory of the Galerie d'Apollon."[15]

Fig. 2
EUGÈNE DELACROIX, *Apollo in His Chariot,* c. 1850, graphite on tracing paper, Paris, Musée du Louvre, Département des Arts Graphiques.

Fig. 3

Eugène Delacroix, *Apollo Victorious Over the Serpent Python* (oil sketch or autograph replica), 1850, oil on canvas, Zurich, E. G. Bührle Foundation.

The present sketch—doubtless the *modello* presented to the administration—manifests all of Delacroix's fire and technical mastery. It shows the originality of his chromatic choices: the violent reds and yellows answer the subtleties of the blue-green sky; but it also demonstrates the influence of French decorative compositions of the seventeenth century, beginning, of course, with those by Charles Le Brun and Eustache Le Sueur (1617–1655), as well as the intentional references, noted in 1963 by Maurice Sérullaz, to monumental compositions by the Bolognese painters Annibale Carracci, Guercino, and Guido Reni.

Finally, we should mention the reduced replica of the decor commissioned from Delacroix in 1853 by the collector J. P. Bonnet, perhaps the version now in the E. G. Bührle Foundation in Zurich (fig. 3). Moreover, the painter's estate inventory listed two oil sketches for the ceiling of the gallery in the Louvre (one on paper, valued at fifteen francs, and one on canvas, at fifteen hundred francs), perhaps the one that Johnson cites and the work under discussion. Also listed in the inventory was a reduced replica of the same decor (valued at one thousand francs), which could be either the one in the E. G. Bührle Foundation or the one cited by Lee Johnson.

V. P.

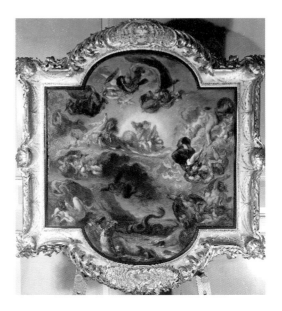

1. *Journal,* April 13, 1849, p. 192.

2. Unpublished letter, Archives Nationales, Paris, F²¹ 1510–11.

3. *Journal,* March 21, 1850, p. 229.

4. Delacroix to Constant Dutilleux, October 5, 1850, *Correspondance,* vol. 3, p. 36.

5. M. Sérullaz, 1963(a), no. 419, repro.

6. *Journal,* June 8, 1850, p. 241.

7. Johnson, 1988, pp. 35–36. We leave aside the sketch in the Hamburg Kunsthalle, which is clearly a replica by Pierre Andrieu.

8. *Journal,* June 10, 1850, p. 241.

9. *Journal,* May 8, 1850, p. 237.

10. An ensemble of drawings, critical for comprehension of this work, is now in the Musée du Louvre: RF 9488, RF 11964, RF 37303, RF 1927, RF 11965, RF 3711 (fig. 2), RF 29108, RF 11966, RF 11967, RF 11969, RF 9491, RF 9492, RF 9490, and RF 11968.

11. *Journal,* June 10, 1850, p. 242.

12. *Journal,* August 10, 1850 (Norton, 1951, p. 135).

13. *Journal,* August 17, 1850, pp. 263, 265.

14. *Journal,* September 23, 1850, p. 267.

15. Félix Duban to Delacroix, Archives Piron, Archives des Musées Nationaux, Paris.

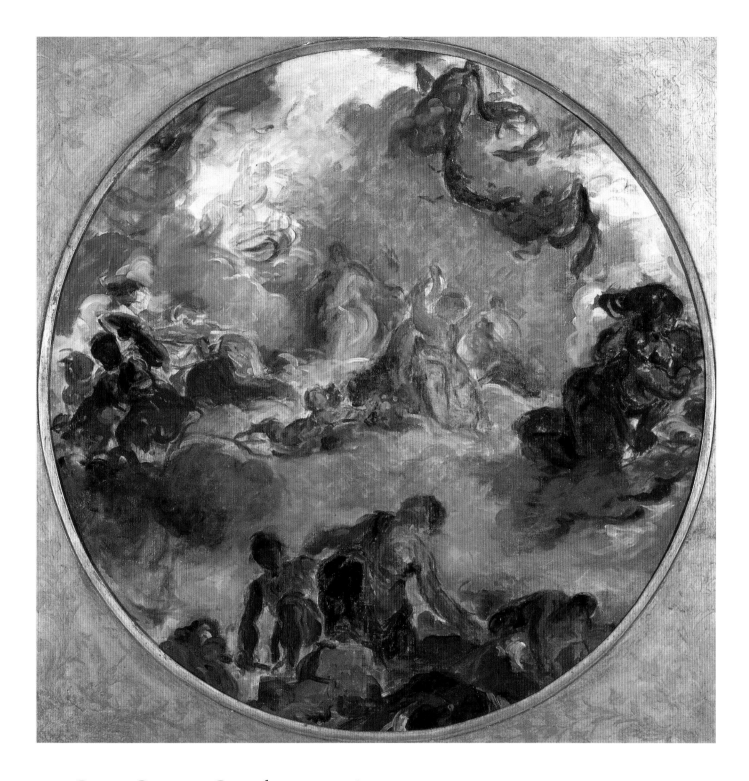

65. *Peace Come to Console Men and Restore Abundance*

or *The Disconsolate Earth Lifting Her Eyes Heavenward to Secure an End to Her Misfortunes*

Central panel of the ceiling of the Salon de la Paix in the Hôtel de Ville in Paris
(oil sketch)

1852
Oil on canvas; diameter 30 5/16 inches (77 cm)
Paris, City of Paris, Musée du Petit Palais
(inv. P.I.550)

Scarcely had the ceiling of the Galerie d'Apollon been inaugurated (see cat. 64) when Eugène Delacroix announced his next decorative project in a letter of October 20, 1851, to his friend George Sand, declaring that he sought an "important place to decorate."[1] In the subsequent weeks he revealed to his circle that he envisioned executing a pictorial ensemble for the Salon de la Paix in the Hôtel de Ville in Paris.

The important decorative ensembles executed in this period for the old Hôtel de Ville, among others by Ingres and Delacroix, were destroyed in 1871 when the building was burned during the Commune. The administrative archives of the City of Paris were also destroyed, with the result that details about the commission—date, circumstances—elude us, save for the amount of Delacroix's fee (thirty thousand francs). However, it is likely that his election to the Paris City Council, in December of the same year, helped Delacroix to obtain this decorative project (which was to occupy him until March 1854), as did his extensive network of social and political connections.

Although we cannot ourselves assess the quality, coloring, and general aspect of the final works, we have full knowledge of the iconographic program elaborated by the painter for the Salon de la Paix. Our knowledge derives in part from a series of drawings executed by Pierre Andrieu (1821–1892), who worked closely with Delacroix on the project, as well as from various published descriptions by journalists, beginning with those by Théophile Gautier and Pierre Petroz. Furthermore, many autograph preparatory studies for this important undertaking survive. In fact, the thematic groupings of the twenty decorative paintings executed in the Salon de la Paix were dictated in part by architectural constraints. A large central ceiling composition five meters in diameter, of which the present sketch is the best evidence, developed the theme of Peace coming to console men and restore abundance. Eight coffers situated around this composition represented various ancient gods and goddesses: Ceres, the muse Clio, Bacchus, Venus, Mercury, Neptune, Minerva, and Mars. Eleven rounded lunettes above the doors and windows contained depictions of scenes from the life of Hercules (see cat. 135 fig. 1).

On February 2, 1852, Delacroix wrote that in the morning he had "nearly found on canvas the composition for the Hôtel de Ville ceiling." Doubtless he was then working diligently on the painted sketch for the central composition,[2] executing at the same time pencil sketches for its various figures and groups (fig. 1).[3] In any event, his work seems to have matured quite rapidly, for on the tenth of the same month he announced to the merchant Haro, who supplied him, as usual, with the canvas needed for the ensemble, that his oil sketch was finished.[4]

While working on the other compositions for the coffers and lunettes, Delacroix noted in his *Journal* the pigments he wished to use in the central one. In this way he prepared for the work to be done later by himself and his collaborators, and he gave concrete, written form to the research carried out in his sketch.[5]

Begun in March 1852, the execution of the works in the ensemble had to be completed within a very short period—this had also been the case for the ceiling of the Galerie d'Apollon—and Delacroix once more chose to surround himself with collaborators: again, Pierre Andrieu (see cat. 64), but also the painter-decorator Louis Boulangé (1812–1878). The final paintings were completed on October 18, 1852. In the course of the following winter, the painter oversaw their attachment to the room's walls and ceiling. Then, in the spring of 1853, he began an extended period of retouching the paintings in place. This task, repeatedly interrupted, lasted until March 1854. Before undertaking this disagreeable process of refinement—which deeply depressed him, vexed as he was by the room's poor light and by his belief that some parts of his work were wanting—Delacroix revisited all of his sketches in order to compare them with the final result.[6]

Unveiled to the public in March of 1854, Delacroix's decorative ensemble was appreciated by most of the critics, but it did not prompt as much enthusiasm as his work for the Galerie d'Apollon in the Louvre, despite favorable analyses by Gustave Planche and Théophile Gautier. In fact, some of the commentaries devoted more space to the work's iconography than to its execution, and they insisted on staging a confrontation between the ensembles painted for the Hôtel de Ville by the two *chefs d'école* of contemporary French painting: Eugène Delacroix, of course, as represented by his Salon de la Paix; and Jean-Auguste-Dominique Ingres, as represented by his Salon de l'Empereur.

A wonderful description—both literary and quite detailed—of the ensemble's iconography and central composition was left to us by Théophile Gautier. His words apply to this oil sketch as well:

> The subject of the principal composition is the disconsolate Earth, lifting her eyes heavenward to secure an end to her misfortunes. In effect, Cybele, the august mother, some-

times has quite bad sons who bloody her robe and cover it with smoking ruins; but the time of trials is past; a soldier extinguishes under his iron heel the torch of the conflagration; groups of relatives, pairs of friends separated by civil discord, are reunited and embrace one another; others, less fortunate, piously collect wretched victims. Above, in a sky of azure blue, gilded with light, from which the clouds are fleeing—the last vestiges of the tempest swept away by a powerful wind—appears Peace, serene and radiant, bringing abundance and the sacred choir of the Muses, who were only lately in flight; Ceres . . . repels the pitiless Mars and the pygmies, who delight in public calamity; Discord, wounded by this luminous tranquillity, flees like a nocturnal bird surprised by daylight and seeks out the darkness of the abyss to hide itself there; while, from the height of his throne, Jupiter, with the same gesture that struck down the Titans, still threatens the malevolent deities, enemies of the repose of men.[7]

In its iconographic conformity, the central ceiling composition in the Hôtel de Ville seems distinctly less original than that of the Salon du Roi in the Palais Bourbon or that of the Galerie d'Apollon in the Louvre, which likewise feature allegorical subjects rife with mythological references. Yet, this oil sketch is quite spirited and assertive in its coloring, mixing reds and blues with skill and refinement. The prints of the final decor published by Victor Caillat and Marius Vachon,[8] as well as a series of drawings by Pierre Andrieu, permit us, in any event, to confirm the sketch's close correspondence to the final composition. The only discernible variation occurs in the upper right. This sketch, then, along with those for the coffers and the tympani, as well as several replicas (see cat. 135), now constitutes irreplaceable evidence of Delacroix's important decorative ensemble.

Alfred Robaut mentions two other oil sketches[9] for the central ceiling composition, one belonging to Andrieu and the other to Diot. The painter's estate inventory likewise indicates that two sketches of the central ceiling composition were left to Pierre Andrieu, while others—including the present one—were included in the estate sale. As a result of this multiplicity of studies, there has been a tendency since the late nineteenth century to confuse the oil sketches painted by Delacroix at the time of the ensemble's realization (bequeathed by him to Pierre Andrieu) with copies of these sketches made by the same Andrieu (retained by Delacroix, who left them to his student in his will). One of the copies of the central ceiling composition by Andrieu is now in the Musée Carnavalet, which acquired several works at the estate sale of Pierre Andrieu in 1892.

In the entry devoted to this sketch in the *Mémorial* of 1963,[10] Maurice Sérullaz masterfully disentangled the certainties regarding the autograph sketches from the shadowy areas, clarifying as well the ambiguous status of some of Pierre Andrieu's copies.

V. P.

1. *Correspondance,* vol. 3, pp. 90–91.
2. *Journal,* February 2 and 8, 1852, pp. 286, 287.
3. These sketches also include three at the Musée du Louvre, Paris (RF 9949, RF 9543, and RF 9544), as well as one at the Musée Carnavalet, Paris (inv. D 7 864).
4. *Correspondance,* vol. 3, pp. 105–6.
5. *Journal,* February 26, 1852, p. 294; pigments for the other compositions are listed in the entries for June 1 and July 11, 12, and 13.
6. *Journal,* October 20 and November 27, 1852, pp. 312, 315.
7. Gautier, 1854.
8. Victor Caillat, *Monographies de l'Hôtel de Ville* (Paris, 1856); Marius Vachon, *L'Ancien Hôtel de Ville de Paris* (Paris, 1882).
9. See Robaut, 1885, no. 119. According to Robaut, both sketches were 46 cm in diameter.
10. M. Sérullaz, 1963(a), no. 459.

66 and 67. *Perseus and Andromeda*

Cassiopeia praised to excess the beauty of her daughter, Andromeda, maintaining that it surpassed that of the Nereids, the daughters of Poseidon. To punish her, Poseidon sent a sea monster to ravage the kingdom of Cassiopeia and her husband Cepheus, the king of Ethiopia. After consulting an oracle, Cepheus decided to sacrifice his daughter to Poseidon's monster, in order to lift the vengeance of the sea god. Chained to a rock, Andromeda was waiting to be devoured by the monster when the Greek hero Perseus, son of Zeus and Danaë, arrived unexpectedly among the Ethiopians, killed the monster, freed the young girl, and married her.

Fig. 1
EUGÈNE DELACROIX, *Saint George and the Dragon,* c. 1847, oil on canvas, Grenoble, Musée des Beaux-Arts.

Fig. 2
EUGÈNE DELACROIX, *Andromeda,* 1852, oil on canvas, Houston, Museum of Fine Arts.

Before the period when he painted one of the two *Perseus and Andromeda* paintings brought together here (cat. 67), Eugène Delacroix, whose literary and pictorial culture was quite extensive, was well aware of the similarity among the themes of Perseus delivering Andromeda (inspired by the *Metamorphoses* of Ovid), Ruggiero delivering Angelica (taken from *Orlando Furioso* by Ariosto), which the painter still dreamed of adapting in 1860,[1] and *Saint George and the Dragon,* which he illustrated around 1847, in the context of a commission from the dealer Thomas (fig. 1 and sketch in the Musée du Louvre, Paris). During this period, the painter seemed especially preoccupied with these various subjects, perhaps because of the fantastic universe in which they were set and the beautiful descriptions of marine landscapes that they occasioned.

However, in these two successive treatments of the myth of Perseus and Andromeda, Delacroix's primary interest seems to have been to infuse with emotion and sensuality the slender figure of Andromeda, the superb nude that is the central aesthetic element of his composition. Thus the diverse chromatic elements—the red of her robe, cast aside on the rocks, answering the red of the princess's hair, which contrasts with the blue green of the waves and the golden tint of the sky—are intended above all to set off the body of the young girl, for which the rocks serve as a kind of jewel case. Furthermore, at the same time the painter executed another version of the theme, depicting only the enchained young girl (fig. 2).

Delacroix had doubtless also studied, in the form of prints after paintings, some of the most famous pictorial treatments of the theme of Perseus delivering Andromeda: for example, the painting by Titian for Philip II (Wallace Collection, London). Delacroix's figure of Perseus—the body of the Greek hero is rendered in bold perspective, flying through the sky—resembles the analogous figure in a famous version by Veronese (Musée des Beaux-Arts, Rennes) that influenced most French painters who depicted this mythological subject, from François Lemoyne (1688–1737) to Charles Natoire (1700–1777). For further proof that Delacroix consulted treatments by the great masters, we can note the astonishing similarity in the pose (though not in the anatomy or the facture) between Delacroix's and one by Rembrandt (1631, Mauritshuis, The Hague). These resemblances indicate the diversity of Delacroix's sources of inspiration.

Furthermore, the painter also recorded in his *Journal* his special appreciation for the way Rubens had developed the iconography of the theme of Perseus delivering Andromeda:

66. *Perseus and Andromeda*

1849–53
Oil on cardboard mounted on wood;
17 x 13¼ inches (43.2 x 33.6 cm)
The Baltimore Museum of Art, The Cone
Collection, formed by Dr. Claribel Cone and
Miss Etta Cone of Baltimore, Maryland
(BMA 1950.207)

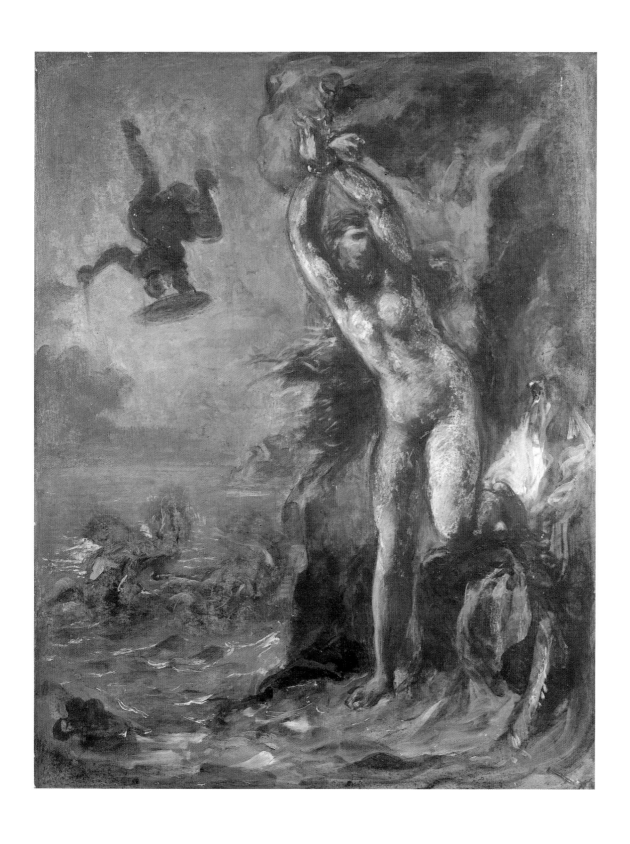

1853
Oil on paper mounted on canvas;
17¼ x 12¹¹⁄₁₆ inches (43.8 x 32.2 cm)
Signed at lower left: *Eug. Delacroix.*
Stuttgart, Staatsgalerie (inv. no. 2636)

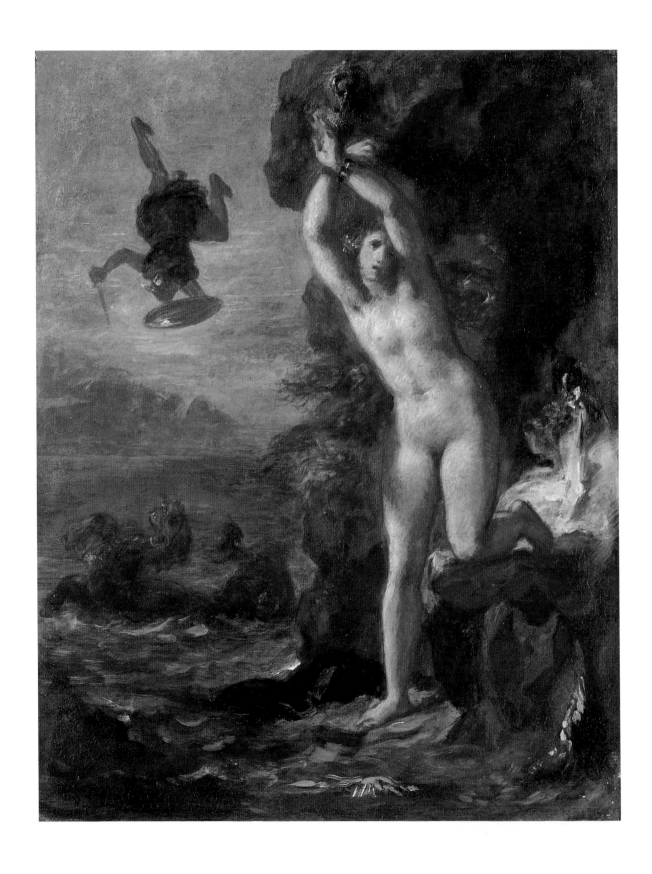

He [the miniaturist Auguste-Joseph Carrier, who had come to visit Delacroix] noticed the small *Andromeda;* and in this connection, I recall the one by Rubens that I saw a long time ago. I've seen two, in fact, one in Marseille at Pellico's, the other at Hilaire Ledru's in Paris, both very beautiful in color; but they make me think of the disadvantage of the hand of Rubens, who paints everything as if in the studio.[2]

The two works in question were in fact copies or studio replicas—one of them is now in the museum in Arles—of a famous original by Rubens in the Kaiser Friedrich Museum in Berlin. The influence of Rubens's paintings of Perseus and Andromeda should not be overestimated, however, for the several versions executed by the Flemish master represent the delivery of Andromeda by Perseus after the latter has killed the sea monster. This is not the moment Delacroix chose for his own treatments.

The artist's interest in the subject may also have been prompted by the exhibition at the Salon of 1849 of a *Perseus and Andromeda* by Jules Jollivet (1794–1871). Delacroix remembered this work with a certain interest when, on May 31, he drafted a list of "beautiful subjects" for future paintings: *"The hero on a winged horse battling the monster to deliver the nude woman* (see in the [Salon] catalogue the subject of the painting by *Jollivet*)."[3]

In any event, Alfred Robaut was mistaken in dating these two works to 1847, for all of the passages in the *Journal* concerning them date from 1851–53, and one of the two versions (cat. 67) was sold by Delacroix in 1853.[4] The *Journal* entry of May 13, 1851, provides interesting details about the pigments Delacroix used in these works: "In the

Andromeda, on account of the very warm background, probably mix a lot of *Naples yellow* with *vermilion* in the highlights." And in another passage, from January 1853, the painter evoked the technique of Titian in connection with the underpainting of the Andromeda figure: "The warm shadows having been placed and the highlights put in with suitable tones, the effect was complete. (Could be successfully applied to all preparations made in the manner of Titian with tones of *Siena* or *reddish brown,* etc., as, for example, was that of the small Andromeda.)"[5]

It seems likely that the version retained by the painter in his atelier was executed first (cat. 66), followed by a work of identical composition intended for the art market (cat. 67). Doubtless it was on March 10, 1853—"On March 10, received from M. Didier, for the *Andromeda . . .* 600 francs"[6]—that the painter turned over the latter work to a Parisian collector, Henri Didier. The other painting whose wood support was consolidated by Haro in June 1854[7] was probably begun in 1849, and certainly before 1853. Mentioned in the estate inventory, it was assigned a value of three hundred francs.

V. P.

1. *Journal,* March 1, 1860, p. 769.
2. *Journal,* April 8, 1860, p. 777 (see Pach, 1937, p. 681).
3. *Journal,* May 31, 1849, p. 195.
4. See Robaut, 1885, no. 1001, repro.
5. *Journal,* May 13, 1851, p. 278, and January 15, 1853, p. 321 (see Norton, 1951, p. 168).
6. *Journal,* undated, following November 30, 1852, p. 316.
7. *Journal,* June 16, 1854, p. 433.

68. *Triton Bearing a Winged Genius on His Shoulders*

c. 1860
Brown ink on paper; 6¹¹⁄₁₆ x 8¹¹⁄₁₆ inches
(17 x 22 cm)
Annotated in pencil in an unknown hand [by
Alfred Robaut?]: *1863/1421*
Paris, Musée du Louvre, Département des Arts
Graphiques (RF 9552)
Exhibited in Paris only

This amusing mythological composition, which
represents a small winged genius being carried by a
Triton of imposing stature, belongs to the painter's
late period; it was probably executed around 1860.
Alfred Robaut, who perhaps owned it after his
father-in-law, the painter Constant Dutilleux, dated
it to 1861.

In 1984 Maurice Sérullaz noted this drawing's
similarity to an unfinished oil painting found in
Delacroix's studio after his death, *The Triumph of
Amphitrite* (fig. 1). At the lower left of the painting
is a motif almost identical to that in the drawing;
only the Triton's head and the position of the
winged genius on his shoulders differ. Although
there are no references to such a commission in the
documents, this painting and its pendant *The*

Triumph of Bacchus (also in the E. G. Bührle Founda-
tion in Zurich) have sometimes been identified
as the two overdoors acquired by the collector
Hartmann at the estate sale (see cats. 151 to 154).
Other authors have cast doubt on the attribution
of these two works to Delacroix. However, a
Bacchus and an *Amphitrite* are indeed mentioned in
the Delacroix estate inventory, where they are de-
scribed as *ébauchés* ("sketched in") and listed im-
mediately after the *Four Seasons* compositions.[1] If
the two works in Zurich seem weak in execution,
that is probably because they are unfinished and,
above all, because of many retouches, probably ex-
ecuted by Pierre Andrieu after the death of
Delacroix, as was perhaps the case with the *Four
Seasons* (cats. 151 to 154).

Fig. 1
Eugène Delacroix, *The
Triumph of Amphitrite*, c. 1860,
oil on canvas, Zurich,
E. G. Bührle Foundation.

In any event, the present drawing, which might well be a preparatory study for the Zurich painting, offers moving and decisive testimony that Delacroix's verve remained intact after 1860, when he drew inspiration from Baroque painters of the seventeenth century and Rococo artists of the French eighteenth century to invent images as evocative and humorous as this one.

V. P.

1. Bessis, 1969, pp. 199–222.

69. *Nude Man Crouching*

c. 1850 (?)
Brown ink on paper; 6¼ x 8 inches
(15.8 x 20.3 cm)
Annotations near the top in pencil in the hand of Alfred Robaut, almost invisible; sketch of a composition in a frame at right.
On the verso of the old mount was an annotation in another hand, in black ink:
Arabe à l'affût / provenant de la vente d'Eugène Delacroix nº 453 du catalogue / ce dessin a appartenu à Monsieur Robaut / et a été publié par lui dans le catalogue / raisonné et illustré de

l'oeuvre du Maître / sous le nº 1229
Paris, Musée du Louvre, Département des Arts Graphiques (RF 9462)
Exhibited in Paris only

Robaut saw in this drawing a first idea for the painting entitled *Arab Stalking a Lion* (1849–50),[1] but the connection is not totally convincing. Furthermore, the Musée du Louvre has an Arab figure keeping watch, executed in graphite on tracing paper,[2] that is obviously related to the painting.

Probably executed in the 1850s, this magisterial study illustrates the persistence with which Delacroix analyzed the morphology of the human body in ways that defied naturalist notation. Beginning with a remarkably concise outline, the artist underscored the tension of the muscles by means of a network of energetic hatchings.

A. S.

1. Collection of Mr. and Mrs. Eliot Hodgkin, London; Johnson, 1986, vol. 3, no. 180, pl. 12.
2. MI 892; M. Sérullaz, 1984, vol. 1, no. 378, repro.

70. *Three Studies of a Nude Woman Reclining and Sketch of a Head*

1850–55
Brown ink and graphite (head) on paper;
10⁷⁄₁₆ x 16⅝ inches (26.5 x 42.3 cm)
Paris, Musée du Louvre, Département des Arts Graphiques (RF 4617)
Exhibited in Philadelphia only

Because it presents stylistic analogies with certain drawings now in the Louvre[1] and in Besançon[2] executed after photographs, this sheet might have similar origins. But the precise model has not been identified. In any case, this manifold study offers an accomplished example of the mastery attained by Delacroix as a draftsman in his maturity. With this strict representation of forms in multiple lines, he created the effect of plenitude in space.

A. S.

1. For example the double study of a seated nude woman, RF 9623; M. Sérullaz, 1984, vol. 1, no. 906, repro.
2. Study of a seated nude man, D 2402.

71. *Nude Women Bathing*

1854
Brown ink over graphite sketch on paper;
9¹⁵⁄₁₆ x 15⁷⁄₁₆ inches (25.2 x 39.2 cm)
Annotated in pencil at lower right: *les nus em-presses d'oublier les maux de la vie, d'autre avec regret*
Cambridge, The Syndics of the Fitzwilliam Museum (no. 2031B)
Exhibited in Philadelphia only

The subject of this drawing has yet to be clearly identified. The annotation in the lower right of the sheet ("nudes eager to forget the hardships of life, another with regrets") suggests that Delacroix may have been illustrating souls bathing in the waters of the Lethe.[1] His interest in the subject seems to be corroborated by a particularly concise note in the *Journal,* dated January 3, 1860: "For the souls in the Lethe."[2] This refers to a mythological theme: Lethe (Forgetfulness), daughter of Eris (Discord), gave her name to a spring in Hell whose waters could make anyone who drank from them forget the past. There the shades of the dead found oblivion from the hardships and pleasures of earthly life.

The drawing has also been linked to a painting executed in 1854, *Bathers* (cat. 102), also known as *Turkish Women Bathing,* but there is nothing to confirm that it is a preparatory study for that work.

A. S.

1. See the exhibition catalogue Galerie Heim, Paris, *Cent dessins français du Fitzwilliam Museum de Cambridge,* 1976, no. 21, repro.
2. *Journal,* January 3, 1860, p. 748; see also *Journal,* October 17, 1849, p. 212.

72. Semi-Nude Man, from the Back, and Reclining Lion

1856
Brown ink and brown wash on paper;
9³⁄₁₆ x 14⅛ inches (23.3 x 35.8 cm)
Dated in brown ink at right: *5 nov. 56*
Annotated on verso in pencil at lower right, in
another hand: *voir tableau 37ᶜ* [?] / *chez M.
Brun* [line marked out] / [illegible word]
1898 = 6. 400 / 0ᵐ 31 x 0,50
Paris, Musée du Louvre, Département des Arts
Graphiques (RF 9483)
Exhibited in Paris only

The annotation on the verso of the drawing refers
to the estate sale of the composer Antoine Mar-
montel (1816–1898). In that sale, a *Reclining Lion*,
sold to M. Brun for sixty-four hundred francs,
figured notably.[1] Alfred Robaut dated that painting
to 1848 but did not reproduce it. In his catalogue
raisonné, Robaut also described a pen drawing,
likewise dated *5 nov. 56*, but of smaller dimensions

(16 x 18 cm): "This sketch, so simple, so complete,
recalls in its disposition the painting entitled: *Lion
in Front of a Goat . . .* as well as the beautiful can-
vas belonging to M. Brun."[2]

In some respects this drawing can be considered
a counterpart to *Reclining Lion and Semi-Nude
Man, from the Back* (cat. 73). One side of the sheet
concentrates on the study of a feline, the other side
on the form of a man, seen from the back.

In the autumn of 1856 Delacroix took a three-
week holiday, first in Augerville with his cousin
Berryer, then at Champrosay (October 21 to Nov-
ember 2). After returning, he seems to have sacri-
ficed the first week of November to various social
obligations, escaping them to make these two
drawings. Nonetheless, on November 1, after read-
ing an article just written about him by Théophile
Silvestre, which clearly pleased him, the painter,
not without wit, suggested a few corrections.[3]

A. S.

1. Sale, Hôtel Drout, Paris, May 11, 1898, lot 7; Johnson,
1986, vol. 3, no. L 128; location unknown since 1938.
2. Robaut, 1885, no. 1301.
3. Delacroix to Silvestre, November 1, 1856,
Correspondance, vol. 3, pp. 341–42.

73. *Reclining Lion and Semi-Nude Man, from the Back*

c. 1857 (?)
Brown ink on paper; 8⅜ x 12¹⁄₁₆ inches
(21.3 x 30.7 cm)
Rotterdam, Museum Boymans–van Beuningen
(F II 83)
Exhibited in Philadelphia only

Dated 1840 by Alfred Robaut, who included it in his publication of facsimiles, this drawing was placed by Lee Johnson around 1857, on the basis of comparison with a drawing of similar technique depicting two male nudes and dated *7 7ʰʳ 57*.[1]

During this period Delacroix seems to have been partial to similar arrangements on his drawing sheets. He juxtaposed without apparent reason the two constant preoccupations of his working life: the observation of animals and the study of the nude (see cat. 72).

A. S.

1. Robaut, 1885, no. 724, repro.; former collection of Henri Rouart; Badt, 1946, pl. 26.

74. *Half-Length Bearded Man, from the Back, Turned Toward the Left, and Horse's Buttocks*

1857
Brown ink on paper; 8¼ x 10¹¹⁄₁₆ inches
(20.9 x 27.1 cm)
Dated in brown ink at lower right: *3. 7ᵇʳᵉ 57;*
annotated below: *revᵗ. de Pl.ʳᵉˢ*
Paris, Musée du Louvre, Département des Arts
Graphiques (RF 9511)
Exhibited in Paris only

The instability of Delacroix's health obliged him to take a cure at Plombières, in the company of Jenny Le Guillou, from Monday, August 10, to Thursday, August 30, 1857. Four days after his arrival, the artist confided his first impressions to Joséphine de Forget: "I am told of the marvels these waters can work for the kind of illness from which I suffer, and I am already at my fifth bath. I do nothing but eat and walk when foot pains, gout, and rheumatism permit me."[1]

Notes in the *Journal* nonetheless indicate that, as his sojourn progressed, Delacroix recovered his taste for work. In the course of his walks he drew trees, rocks, and the banks of a stream. The artist returned to Paris on September 2, and the next day he received a visit from his physician, Dr. Laguerre. During the ensuing days he completed more studies of nude men and horses, using the same technique and sheets of more or less the same dimensions.

In addition to this drawing, the Musée du Louvre preserves one of a *Reclining Nude Woman Holding a Mirror*, dated September 7, 1857.[2] In his catalogue Robaut reproduced two other sheets from this week in September. One of these, bearing three silhouettes of male nudes in various postures, is dated September 7, 1857. The other, dated September 5, 1857, includes three sketches of horses and a study of a seated young male nude, grouped on two registers.

A. S.

1. Delacroix to Madame de Forget, August 14, 1857, *Correspondance,* vol. 3, pp. 403–4.
2. Département des Arts Graphiques, Musée du Louvre, Paris, RF 9629; M. Sérullaz, 1984, vol. 1, no. 832, repro.

75. Old Shepherd and Nude Young Man Conversing in a Landscape

c. 1858–62
Brown ink on paper; 7¹⁵⁄₁₆ x 12¹⁄₁₆ inches
(20.1 x 30.6 cm)
Annotated in pencil at lower right, in the hand
of Alfred Robaut:
M. V. [Villot] *doit en avoir la peinture à la
détrempe*
Annotated on the verso in pencil: *Villot n'en
avait-il pas une peinture à la détrempe?;* and in
brown ink: *reproduit dans l'ART 1882*
Paris, Musée du Louvre, Département des Arts
Graphiques (RF 9527)
Exhibited in Paris only

Alfred Robaut linked this drawing[1]—engraved on
zinc for the April 23, 1882, issue of *L'Art*—to one
of the paintings exhibited at the Salon of 1859,
Erminia and the Shepherds (cat. 94). This idea was
repeated by Eugène Véron, who reproduced the
sheet as a full-page illustration in *Les Artistes
Célèbres: Eugène Delacroix.*[2] Such a connection
seems rather surprising, for neither of the figures
depicted here is in the painting. The subject of the
composition remains enigmatic. Is it a study for a
scene of mythological inspiration, or is it purely an
interpretation of a work by a Renaissance artist?

A. S.

1. Robaut, 1885, no. 1385, repro.
2. Véron, 1887, p. 97.

76. *Three Semi-Nude Figures, One a Woman Holding a Flower*

1859
Brown ink on paper; 9⁹⁄₁₆ x 11⁷⁄₁₆ inches
(23 x 29.1 cm)
Dated and annotated in brown ink at lower
center: *Str⁸. 27 aout / 59.*
Paris, Musée du Louvre, Département des Arts
Graphiques (RF 9526)
Exhibited in Paris only

"When Delacroix went to Strasbourg," Robaut explained, "it was to see his relative M. Lamey. The master made many sketches there, at the family table, chatting all the while; he also worked there, with his poet's soul, whether at the cathedral, whose old statues and mysterious tombs interested him, or in the city, whose picturesque character appealed to him."[1] To corroborate these remarks, Robaut catalogued and reproduced other drawings executed in Strasbourg on August 27, 1859—variations on the theme of women at their toilette (see cat. 77) as well as a sketch of a *Lion Licking His Paw.*[2]

A. S.

1. Robaut, 1885, no. 1401.
2. Robaut, 1885, no. 1399; sale, Hazlitt, Gooden & Fox, London, June 15–July 14, 1978, lot 14, repro.

77. *Three Studies of Nude Women at Their Toilette*

1859
Brown ink on paper; 8¹¹⁄₁₆ x 13¾ inches
(22 x 35 cm)
Dated and annotated in brown ink at lower
right: *27 aout Stras^b 59.*
Eric G. Carlson Collection
Exhibited in Philadelphia only

This interpretation of a theme dear to many artists anticipates the obsessive and audacious variations of Edgar Degas (1834–1917), who was one of the best-informed collectors of Delacroix's work at the end of the nineteenth century. Profoundly resistant to all forms of realism—"Realism should be described as the antipodes of art. It is perhaps even more detestable in painting and sculpture than in history and literature"[1]—Delacroix was often extremely bold in his observation of people, not hesitating to draw upon all the resources of his imagination: "The forms of the model, whether this be a tree or a man, are but a dictionary where the artist goes to strengthen his fugitive impressions or rather to find confirmation for them, for he must have memory."[2]

A. S.

1. *Journal,* February 22, 1860 (Norton, 1951, p. 396).
2. Delacroix, 1923, vol. 1, p. 58.

78. *Two Studies of a Nude Man*

1860
Brown ink on paper; 9¼ x 14⅟₁₆ inches
(23.5 x 35.7 cm)
Dated in brown ink at the center: *6 fʳ. 1860.*
Besançon, Musée des Beaux-Arts et
d'Archéologie (D 2401)
Exhibited in Philadelphia only

In early 1860 Delacroix reflected intently on a dictionary of the fine arts, a project he had undertaken in 1857. It is possible that the nude studies to which he devoted so much attention in these years were connected to this project, which was dear to him but never realized: "The principal goal of a dictionary of the fine arts is not recreation, but instruction," he wrote in his *Journal*.[1] At the beginning of 1860 Delacroix also decided to reorganize his drawings.

A study after a Renaissance bronze oil lamp in the form of a satyr by Andrea Riccio (1470/75–1532),[2] the present sheet is noteworthy for its energetic and powerful facture, in which the influence of Rubens is also manifest. It should be compared with a drawing in the same technique (fig. 1), dated January 31, 1860, and reproduced in facsimile by Léon Marotte and Charles Martine.[3] It is a significant example of Delacroix's late studies, in which forms are rendered by means of intricately crisscrossed hatchings.[4]

A. S.

1. *Journal*, January 16, 1860, p. 755.
2. As pointed out by Jennifer Montagu and Lee Johnson. For an example of the bronze, see Gaston Migeon, *Musée National du Louvre: Catalogue des Bronzes & Cuivres du Moyen Age, de la Renaissance et des Temps Modernes* (Paris: Librairies-Imprimeries, 1904), no. 103; and *L'Antiquité expliquée . . . par Dom Bernard de Montfaucon* (Paris, 1722), vol. 5, pl. CLII; noted by Maurice Sérullaz, in "Shorter Notices: A Comment on the Delacroix Exhibition Organized in England," *The Burlington Magazine,* vol. 107, no. 748 (July 1965), p. 369.
3. Marotte and Martine, 1928, pl. 55.
4. See also the double study of a seated male nude, Musée du Louvre, Département des Arts Graphiques, Paris, RF 9591; M. Sérullaz, 1984, vol. 1, no. 883, repro.

Fig. 1
EUGÈNE DELACROIX, *Two Studies of a Nude Man,* 1860, brown ink on paper, location unknown.

79. *Sheet of Studies with Semi-Nude Man and Feline Advancing Toward the Right*

1860
Brown ink on paper; 12⅜ x 8⅜ inches
(31.4 x 21.3 cm)
Dated and annotated in brown ink at lower
right: *9 aout Champrosay / 60.*
Paris, Musée du Louvre, Département des Arts
Graphiques (RF 9733)
Exhibited in Paris only

Arriving in Champrosay on the evening of July 27, 1860, after a short sojourn in Dieppe, Delacroix remained there until October, dividing his time between work, walks in the forest, and invitations from his neighbors. Thus he wrote in his *Journal,* under the date of August 9: "I return from Mme Barbier's, who invited me. She was alone with her son, and I passed an agreeable evening."[1]

As in the drawing now in Rotterdam executed several years earlier (cat. 73), the present sheet offers some of Delacroix's tireless investigations into the rendering of human and animal forms. The treatment of the model reflects, without any doubt, Delacroix's admiration for Rubens: "I take note . . . that his principal quality, if it is possible to choose one quality in particular, is the prodigious relief of his figures, which is to say their prodigious vitality."[2]

A. S.

1. *Journal,* August 9, 1860, p. 788.
2. *Journal,* October 21, 1860, p. 790 (see Norton, 1951, p. 406).

IV

LITERARY INSPIRATION

Eugène Delacroix, passionately committed to his profession, was also an erudite and sophisticated man who, since his adolescent studies at the Lycée Impérial (now the Lycée Louis-le-Grand), had derived much satisfaction from reading and philosophical reflection—as well as from music, of which he was so fond. He cultivated his constant and habitual intellectual vitality with pleasure and perseverance during the little leisure time left to him by his eventful and productive career.

Not content simply to savor the prose of authors from all periods, Delacroix also wrote throughout his life; it was a form of expression that came naturally to him. He was that rare being—a painter who maintained a close and intense relationship with language—and his extraordinary *Journal,* which contains the inextinguishable stream of biographical and artistic references that he recorded regularly in his notebooks, became for posterity a unique tool for understanding his pictorial work, his personality, and his epoch. Delacroix pursued this secondary vocation as an author—already manifest in his admiration for the writings of others and in the daily composition of the *Journal* (for which he had genuine literary pretensions)—with some energy, especially during the last twenty years of his career. He published numerous articles, notably in the *Revue des Deux Mondes* and the *Moniteur universel,* on general aesthetic issues ("Questions sur le Beau" in 1854) and on artists he admired (on Prud'hon in 1846, Gros in 1847, Poussin in 1852, and Nicolas Charlet in 1862). The writing of the monumental dictionary of the fine arts, undertaken after his election to the Institut on January 10, 1857, and never completed, also testifies to the crucial relation that existed in Delacroix's life and work between painting and aesthetics, on the one hand, and writing and literature, on the other.

To one end or another (if only to support the voluminous correspondence he maintained with friends and professional contacts), Eugène Delacroix wrote several hours a day. Having had the insight to realize early on that he was "someone . . . who has had no time to learn to be an author," he adopted, instinctively or otherwise, "Pascal's plan of writing down each thought on a separate sheet of paper," which enabled him to have "all the headings and subheadings . . . spread out like a game of patience which would make it easier to decide on their proper order."[1] These loose pieces of paper—some of which were published in the supplement to the *Journal*[2]—and, of course, the famous diaries of the

Journal itself, which were more orderly in composition and classification, formed the daily repository for his personal thoughts, his painting plans, and even lists of pigments to be used for specific works.

With admirable precision and patience, the painter also copied out literary extracts that he felt were of particular significance—ones that annoyed him or sparked his curiosity and, above all, ones that might nourish future theoretical reflection. The *Journal* reveals much about the painter's assessment of the authors whom he read "pen in hand" and who peopled his literary universe. They reinforced his own aesthetic, ethical, and social convictions and sometimes provided him with subjects for his paintings. Delacroix's innumerable notes are vivid proof of just how much and how widely he read.

Everything engaged him, from the ancient philosophers to the contemporary novels of his longtime Romantic friends, including the poets of the Italian Renaissance and the French authors of the seventeenth century—not to mention the young yet-unknown writers of his own era, who could sometimes absorb him for days at a time. "Spent the whole day reading *La Foire aux idées [Vanity Fair]* in the *Revue,* abridged and translated by Chasles from the novel by Thackeray. I was fascinated by it. Let us hope that everything he writes will be translated,"[3] he wrote on March 4, 1849, about William Thackeray's satire, which appeared in French in 1847 in a translation by Delacroix's friend Philarète Chasles under the title (which the artist misquoted) of *La Foire aux vanités (Vanity Fair).* Similarly, he discovered with fascination as soon as they were translated (some by another friend, Louis Viardot) the novels of Ivan Turgenev, whose Russian stories he read in 1853: "After walking up and down the studio for some time and looking at my paintings, I threw myself into the armchair by the fire, stuck my nose into the *Nouvelles russes,* and read two of them, the *Fatalist,* and *Dombrowski,* which I greatly enjoyed."[4]

Generally, once he began reading one of the great "classics" of history, literature, or philosophy, Delacroix would be unable to stop until he had read the complete works, however prolific the author may have been. In October 1849, for example, taking advantage of a holiday in Valmont to re-explore the works of Montesquieu, which he had already read as a young man, he began with the better-known philosophical and political writings and then moved on to various more obscure works, such as *Arsace et Isménie,* which inspired the following harsh comments: "All the author's talent cannot disguise the triteness of these boring adventures, these love-affairs with their everlasting fidelity. I think that fashion and perhaps a feeling for truth have condemned this kind of thing to oblivion."[5] And the month of January 1860 was given over entirely to reading *Mémoires d'outre-tombe* by François-René Chateaubriand, selections from which he copied in the pages of his current diary.[6] During a visit to the house of his cousin, Philogène Delacroix, at Ante in October 1856, the artist rediscovered the works of Jean de La Fontaine, and this fresh reading triggered a reassessment of the work of a poet who, he wrote, "says it all without superfluous elaboration and without circumlocution."[7]

This intimate knowledge of the finest texts from the past and the present, supported by a thorough grounding in the classics acquired during his training at the atelier of Pierre-Narcisse Guérin (1774–1833), combined to give Delacroix a keen understanding of stylistic restrictions and a genuine critical sensitivity to literary works and their translation.

The painter, who felt himself competent to make such judgments, often severely criticized "the falsity of the modern system in novels" by contemporary authors, denouncing "that mania for optical illusion in descriptions of places and costumes, which

at first gives an impression of severity, but only still more to falsify the impression of the work later on, when the characters turn out to be false, when they talk inappropriately and interminably. . . . "⁸ This strict and personal view of stylistic constraints and obligations prompted Delacroix generally to favor literature from the past rather than the present. Thus he was sometimes a harsh judge of contemporary works, even those written by close friends.

Any personal affection he may have had for these writers would take second place to his lucid, caustically severe, and irrevocable opinions of their work. For example, despite his warm affection for the novelist George Sand, Delacroix criticized her writing mercilessly in his *Journal,* reproaching her for not working hard enough, for writing too much (and for "so much a line"⁹), and, above all, for filling her works with ill-drawn characters and affected over-descriptions. Delacroix read all of Sand's novels faithfully and was moved by some of them. He was pleased to rediscover *Consuelo,* for example, some twenty years after it was published,¹⁰ and he meticulously copied extracts from *Elle et Lui* into his *Journal,*¹¹ but he was nevertheless extremely irritated by Sand's "boring" peasants and "overly virtuous" characters who were forced to take part in "absurd situations."¹²

Possessed of a remarkable understanding and insight that enabled him to keep his friendships with authors quite separate from his opinions of their work, Delacroix also confided to the *Journal* his feelings about two other writers he had known since his youth and whom he still saw occasionally after 1840: Alexandre Dumas and Honoré de Balzac. Having read the whole of Dumas's oeuvre—the artist liked his complex plots and lively action—he nonetheless found fault with his friend (who so praised Delacroix in his own *Mémoires!*) for an overly loose style, careless composition, and lack of psychological depth. In 1847 the painter admitted to having found *The Count of Monte Cristo* entertaining but complained of the endless dialogues, "when you've finished reading it, you've really read nothing at all."¹³

Similarly, although during his youth Delacroix had appreciated the descriptive power and realism of Balzac's best-known works (*Eugénie Grandet* and *Un Provincial à Paris*) as well as some of the more obscure pieces (*La Fausse Maîtresse*), he nevertheless deplored the style and psychological situations of some of the novels. Of *Ursule Mirouet,* which he was reading—or rereading—in July 1860, he wrote severely: "I have borrowed Balzac's *Ursule Mirouet* from the lending library. Still the same elaborate portraits of pygmies, all described in minute detail, whether they are principal or merely secondary characters. In spite of the generally overrated opinion of his talent I still think that he has a wrong conception of the novel and that his characters are not true to life. Like Henri Monnier, he creates his people through the jargon of their trades, in other words, from the outside. He knows how janitors and shop-assistants talk, and all kinds of professional slang, but nothing could be less true than these too neat and wholly consistent characters."¹⁴

Of the wide range of authors he appreciated and the many different literary genres he analyzed, whether through professional duty or pure literary pleasure, it is fascinating to observe that Delacroix spontaneously, and no doubt unconsciously, divided writers into three distinct categories that can be deduced from the notes he made in his *Journal.* One group of writers who gave him literary sustenance and satisfied his penchant for the abstract enjoyment of beautiful language included Molière, Corneille, and, especially, Racine, whose tragedies *Athalie, Mithridate, Britannicus,* and *Iphigénie* he quoted frequently in the *Journal.* The painter also occasionally re-explored the great authors of the seventeenth century, such as François de Salignac de la Mothe Fénelon and his *Adventures*

of Telemachus, La Bruyère, or La Rochefoucauld. But this category also included certain ancient works, the Greek dramas of Aeschylus and Euripides and, above all, Homer, whom Delacroix felt foreshadowed Shakespeare and Dante with his sense of the "sublime, this astonishing naïveté, which makes poetry of commonplace details and transforms them into paintings for the delight of the imagination."[15] And although they are rife with Romantic overtones and philosophical maxims, Casanova's *Mémoires* were also a source of purely literary pleasure; in 1847 the artist described the work as "more adorable than ever,"[16] and he was equally impressed by its dramatic episodes—such as the famous escape from the Plombs prison[17]—and such pithy witticisms as *"I have loved women to distraction, but I have always loved freedom more."*[18]

Other authors, also great stylists, served Delacroix principally as philosophical, ethical, and metaphysical sources. For Delacroix, the philosophers of the Enlightenment—Rousseau, Voltaire, Kant, and Diderot—were, like Plato, unquestionable "gods" of thought. They were among the writers most frequently cited in the *Journal,* and they nourished his most personal reflections, dreams, and anxieties. On September 22, 1854, he wrote: "This night, I was turning over in my head the *Cogito, ergo sum,* of Descartes."[19] Sometimes his readings even dictated his moral beliefs and personal rules of conduct. For example, Delacroix justified his circumspect attitude toward marriage and over-effusive sentimental attachments by reiterating Socrates' misogynist remark, "We must fight love with flight,"[20] and he found echoes of his own professional ambition in this observation from Tacitus: "The last passion that people, even the most wise, relinquish is the desire for glory."[21] Similarly, Plutarch, by pointing out "the use one can make of one's friends," confirmed the intellectual and moral legitimacy of the painter's network of political protectors and society contacts: "There is only one way to profit by one's friends: first they should be powerful and then you must get them to intrigue for you or you must cling to their fortune."[22]

This philosophical and ethical roaming led the artist to copy in his *Journal* all sorts of literary extracts, ranging from a Confucian maxim ("The superior man lives in peace with all men, but without behaving exactly like them"[23]) to an autobiographical reflection from Benjamin Constant concerning solitude ("The outcome of independence is solitude"[24]), which the artist went on to analyze at some length.

Although telling us much about Delacroix's personality and playing a vital role in the formation of his philosophical and literary opinions, the authors that fall into these two groups did not provide subjects for his pictures and were never directly linked to the thematic aspect of his painting. But there is a third category of writers who were a source of immediate inspiration to Delacroix as a painter. While the scope of his general reading was extraordinarily wide, defined by the ceaseless quest for knowledge that dominated his intellectual life, the number of authors he selected as sources for painting subjects was remarkably restricted. In fact, Delacroix had already established this list of fewer than ten authors by 1820, at the start of his career, and it remained the same after 1850, providing an extremely limited range of subject choices.

There are, admittedly, a few works inspired by authors not featured on this list, such as the adaptations of texts by Euripides (*Medea About to Kill Her Children,* 1838, Musée des Beaux-Arts, Lille; replica, 1862, Musée du Louvre, Paris), George Sand (*Lélia,* 1848, private collection), and even Chateaubriand (*The Natchez,* 1835, The Metropolitan Museum of Art, New York), but each of these writers served as inspiration to Delacroix for only a single painting.

Delacroix himself clearly defined the types of legendary, historical, and literary

subjects that could be adapted in painting. A precondition, for him, was the power of the text to complement the painter's imagination—a power that would exist if the writer's images were sufficiently strong, suggestive, and original to have a substantial impact. As he explained: "Although we stimulate our ideas by reading good books—and that is one of the first claims of such reading—we involuntarily merge them with those of the author; his images cannot be so striking as to prevent our forming a picture of our own as well as the one which he creates for us."[25] This implies that only those books capable of triggering immediate and powerful pictorial images could be transformed naturally into subjects for paintings: "The poet's salvation is the succession of images; the painter's, their simultaneity."[26]

Lord Byron was one of the poets whose works Delacroix most frequently illustrated in his paintings: *The Combat of the Giaour and Hassan* of 1826 (The Art Institute, Chicago); *The Death of Sardanapalus* (Musée du Louvre, Paris) and *The Execution of Marino Faliero* (The Wallace Collection, London), both exhibited in 1828; *The Prisoner of Chillon* of 1835 (Musée du Louvre, Paris); and *The Shipwreck of Don Juan* of 1841 (Musée du Louvre, Paris). Byron possessed an imaginative power that transcended the tortuous vicissitudes of his heroes and awakened in Delacroix "the insatiable longing to create."[27] In a similar way, the hallucinatory horror of Dante Alighieri's lyrical writings, especially *The Divine Comedy*, inspired Delacroix from the very start of his career to create original pictorial solutions; striking evidence of this was provided as early as 1822 in *The Barque of Dante* (Musée du Louvre, Paris) and again in 1840 in *The Justice of Trajan* (Musée des Beaux-Arts, Rouen). And what Delacroix appreciated above all in the writings of Shakespeare—*Anthony and Cleopatra*, *Hamlet*, *Othello*, and *Romeo and Juliet*—was his narrative and theatrical genius: the violence, the realism, the profound knowledge of human nature, the constant fusion of comedy and tragedy. "The poverty of our poets deprives us of tragedies made for us," Delacroix wrote; "We lack creative geniuses. Shakespeare is too much of an individualist, his beauties and effusions spring from too inventive a mind for us to be completely satisfied when modern writers try to produce plays based on the Shakespearean model. He is not a man who can be plundered; his works cannot be compressed. His genius is not only completely his own, unlike anything else, but he is an Englishman."[28] During his visit to London in 1825, Delacroix had attended various performances of *The Tempest*, *Othello*, and *Richard III* starring Edmund Kean and Charles Mayne Young, the greatest actors of the time; memories of these experiences remained with him all his life. Analyzing Shakespeare's genius some thirty years later in his *Journal*, he revealed one of the keys to his unswerving admiration:

> I think Chasles was right in our conversation about Shakespeare, of which I have made a note in one of the diaries: "Properly speaking," he said, "he is neither a tragic nor a comic writer. His art is unique, and it is as much psychology as poetry. He does not set out to portray Ambition, Jealousy, or Consummate Villainy, but one particular jealous or ambitious man, not so much a type, as a human being with all his characteristic lights and shades. Macbeth, Othello or Iago are anything but types; their characteristics, or rather their individuality, make them seem like real people, but give us no absolute idea of their passions. Shakespeare has such a strong sense of realism that he forces us to accept his characters as though they were people we knew personally."[29]

To these writers must be added the names of Goethe, whose *Faust* and *Götz von Berlichingen* Delacroix illustrated in two magnificent series of lithographs (produced in

1826 and 1836), and Sir Walter Scott, whose novels often provided the artist with source material—notably Scott's *Ivanhoe* (see cat. 91); *Quentin Durward,* which inspired *The Murder of the Bishop of Liège,* 1831 (Musée du Louvre, Paris) and *Quentin Durward and the Scarred Man,* c. 1828 (Musée des Beaux-Arts, Caen); and *The Bride of Lammermoor.*[30] Although Goethe's direct thematic influence was restricted to *Faust* and *Götz von Berlichingen,* reading notes throughout the *Journal* bear witness to the artist's unflagging interest in the German writer's personality and ideas. It was an interest, however, that did not preclude criticism: "The beautiful idea of a Goethe, with all his genius, if it is one, to go and begin Shakespeare over again three hundred years later! . . . The beautiful novelty of those plays filled with digressions, with useless descriptions, and so distant, really, from Shakespeare, in the creating of characters, and in the strength of the situation."[31]

Thus, a group of only five authors supplied Delacroix with most of the literary subjects of his youth; it is therefore no surprise to see them reappear after 1850 among those writers whose poetic and dramatic visions he strove, with an almost obsessive intensity, to reconstruct in his paintings. The canvases depicting *The Bride of Abydos* (cats. 83 to 85) and *The Death of Lara* (cats. 80 and 81) illustrate the painter's enduring passion for Byron, although the warm praise of his Romantic period had given way to a more critical attitude: "The heroes of Lord Byron are Hectors, mere lay figures, one would seek in vain for such types in nature," he observed brutally in 1844.[32] Two years later, however, his remarks were more ambiguous:

> I maintain that, in general, it is not the greatest poets who lend themselves best to painting; it is those who give a greater place to description. . . . Why does Ariosto . . . inspire less than Shakespeare or Lord Byron, for example, the representation of his subjects in painting? I believe it is for one thing because the two Englishmen, although possessing a few principal features that strike the imagination, are often bombastic and pompous.[33]

These equivocal judgments, rather than dampening Delacroix's inventiveness, stimulated it, spurring him during the 1850s to delve once again into Byron's work for new subjects, invariably violent or sensual, which he treated with a theatricality that bordered on mannerism. An example is the picture *The Two Foscari* (Musée Condé, Chantilly), exhibited in 1855, in which the opulence of the palette is in sharp contrast to the dramatic intensity of the scene. Similarly, *Lady Macbeth Sleepwalking* (cat. 82), *Hamlet and Horatio in the Graveyard* (cat. 93), and *Desdemona Cursed by Her Father* (cat. 86) are all manifestations of the artist's attempt to capture in painting the emotions he had experienced during performances of Shakespeare's plays or of operas based on them. During the same period, Delacroix turned with renewed interest to the narrative potential of the works of Scott (cat. 91) and Dante (cat. 98). While capitalizing again on the literary sources of his youth, however, during the last ten years of his career, Delacroix was evidently seeking a new and personal aesthetic vision, one whose goal was almost academic. He was attempting to recover the grandeur of the classical subjects depicted by the masters of the Renaissance and the seventeenth century, but to interpret them using the most modern of technical means.

Delacroix's overwhelming preoccupation during this period was with iconographical and aesthetic renewal—an impulse that had been fueled by the execution of his series of major decorative projects, which had radically altered the relationships in his work between form and content. It was also at this time that he introduced several new—or as yet only

occasionally interpreted—authors into his small circle of potential thematic sources. Ariosto (cat. 87), Tasso (cat. 94), and Ovid (cats. 64, 66, 67, and 95), classical authors par excellence, provided him with a wealth of subjects, and Delacroix evidently took enormous pleasure in developing an iconographical and formal approach suited to rarely illustrated themes. Moreover, the *Journal* provides evidence throughout the years of the artist's maturity and old age of his deep-seated desire to expand his powers of pictorial invention. Having explored the possibilities offered by his favorite novels—such as *Ivanhoe,* of which he had singled out the interesting scenes—he began noting the potential of authors he had never considered representing; for Racine, for example, he listed "Athalie Questions Eliacin" and "Junie Dragged Off by Soldiers" as possible themes.[34] He reread such diverse works as Alain René Lesage's *Gil Blas* and the *Arabian Nights,*[35] imagining the visual and dramatic possibilities that could be developed in future paintings. These various projects were never realized, and other themes—flowers, tiger hunts, and religious subjects—provided him during the last ten years of his career with scope for the technical and thematic renewal that he felt was so vital to his work.

Nevertheless, literature was the constant companion of Delacroix's work as a painter, reinforcing his artistic choices and soothing the anxieties of his final years. To the end, the pages of his *Journal* are filled with aesthetic reflections, such as this taken from *Obermann,* by Pivert de Sénancour: "Regularity, proportion, symmetry, simplicity, according as one or another of these qualities is found to be more or less essential to the nature of the whole composed by these relationships. This whole is *unity,* without which there is no result, nor any work which can possess beauty."[36] Metaphysical speculations reveal his apprehensions of old age, such as this thought: "These reflections were suggested by an idea from Montesquieu that I found recently, which is that at the time a man's mind has attained maturity, his bodily powers weaken."[37] And this, finally, from Marcus Aurelius: "Dying is also one of the actions of life; death, like birth, has its place in the system of the world; death is perhaps nothing more than a change of place."[38]

Vincent Pomarède and *Arlette Sérullaz*

1. *Journal,* May 12, 1853 (Norton, 1951, p. 183).

2. *Journal,* pp. 810–81.

3. *Journal,* March 4, 1849, p. 181 (see Norton, 1951, p. 89).

4. *Journal,* October 28, 1853 (Norton, 1951, p. 205).

5. *Journal,* October 13, 1849 (Norton, 1951, p. 105).

6. *Journal,* January 1860, pp. 749–54.

7. *Journal,* October 5, 1856, p. 592 (see Norton, 1951, p. 320).

8. Supplement to the *Journal,* undated (Pach, 1937, p. 720).

9. *Journal,* October 17, 1853 (Norton, 1951, p. 198).

10. *Journal,* January 3, 1860, p. 748.

11. Supplement to the *Journal,* January 28, 1859, p. 864.

12. *Journal,* November 28, 1853 (Norton, 1951, p. 212).

13. *Journal,* February 5, 1847 (Norton, 1951, p. 62).

14. *Journal,* July 22, 1860 (Norton, 1951, p. 405).

15. *Journal,* September 3, 1858, p. 731.

16. *Journal,* February 5, 1847 (Pach, 1937, p. 143).

17. *Journal,* June 8, 1850, p. 241.

18. *Journal,* March 8, 1857, p. 645.

19. *Journal,* September 22, 1854 (Pach, 1937, p. 436).

20. *Journal,* May 1823 (Pach, 1937, p. 49).

21. *Journal,* September 9, 1859, p. 745.

22. *Journal,* September 14, 1854 (Pach, 1937, p. 430).

23. Supplement to the *Journal,* undated, p. 868.

24. *Journal,* May 14, 1850 (Norton, 1951, p. 119).

25. *Journal,* September 23, 1854 (Norton, 1951, p. 259).

26. *Journal,* December 16, 1843, p. 860.

27. *Journal,* May 14, 1824 (Norton, 1951, p. 40).

28. *Journal,* February 23, 1858, p. 708.

29. *Journal,* March 25, 1855 (Norton, 1951, p. 273).

30. Département des Arts Graphiques, Musée du Louvre, Paris, RF 9997 and RF 9998; M. Sérullaz, 1984, vol. 1, nos. 533 and 534.

31. Supplement to the *Journal,* April 24, c. 1846 (Pach, 1937, p. 724).

32. Supplement to the *Journal,* June 21, c. 1844 (Pach, 1937, p. 717).

33. *Journal,* September 17, [1846], p. 880.

34. *Journal,* May 23, 1858, p. 720.

35. *Journal,* May 23, 1858, and December 23, 1860, pp. 720,793.

36. *Journal,* March 22, 1857 (Pach, 1937, p. 580).

37. *Journal,* October 9, 1849, p. 207 (see Norton, 1951, p. 103).

38. *Journal,* June 6, 1855, p. 511.

80 and 81. The Death of Lara

Lara, first published in 1814, is one of four Oriental tales by Lord Byron. It inspired Delacroix on two occasions, in works created ten years apart. Byron's poem tells of a strange man, count Lara, who returns home after a lengthy and unexplained absence. He is accompanied by a mysterious young page, Kaled, who never leaves his side. During a party held at the home of his neighbor, count Otho, Lara is recognized by a man named Ezzelin, who disappears after the gathering, never to be seen again. Lara then becomes the leader of a peasant uprising, which, after several triumphs, is finally quashed by count Otho. Mortally wounded by an arrow, Lara dies in the arms of his page, who faints away. But as the vanquishers raise the page's inert body, they realize that Kaled is actually a woman. She does not long survive the man whose mysterious life she shared.

Delacroix's two versions of *The Death of Lara,* inspired by stanzas 15, 17, and 20 of the second canto, are radically different in conception and composition. In the first (cat. 80), Delacroix—who had probably seen the illustrations created by the Englishman Thomas Stothard (1755–1834) for an edition of Byron's poems—focused attention on the group formed by Lara and his page, which occupies the entire foreground of a vast plain that shows evidence here and there of the recent battle:

> Beneath a lime, remoter from the scene,
> Where but for him that strife had never been,
> A breathing but devoted warrior lay:
> 'Twas Lara bleeding fast from life away.
> His follower once, and now his only guide,
> Kneels Kaled watchful o'er his welling side,
> And with his scarf would staunch the tides that rush,
> With each convulsion, in a blacker gush;
> And then, as his faint breathing waxes low,
> In feebler, not less fatal tricklings flow:
> He scarce can speak, but motions him 'tis vain,
> And merely adds another throb to pain.

80. *The Death of Lara*

1847–48
Oil on canvas; 20⁄16 x 25⅝ inches (51 x 65 cm)
Signed and dated at lower left:
Eug. Delacroix / 1857.
Private collection

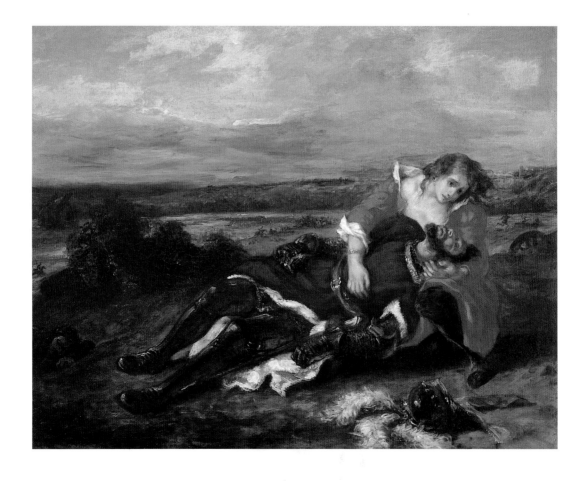

81. *The Death of Lara*

1858
Oil on canvas; 24³⁄₁₆ x 19¹¹⁄₁₆ inches (61.5 x 50 cm)
Signed and dated at lower left:
Eug. Delacroix. / 1858.
Private collection (courtesy of the Nathan
Gallery, Zurich)
Exhibited in Paris only

He clasps the hand that pang which would assuage,
And sadly smiles his thanks to that dark page,
Who nothing fears—nor feels—nor heeds—nor sees—
Save that damp brow which rests upon his knees;
Save that pale aspect, where the eye, though dim,
Held all the light that shone on earth for him.

(canto 2, stanza 17)

Théophile Thoré was very enthusiastic about
the work when he saw it at the Salon of 1848:

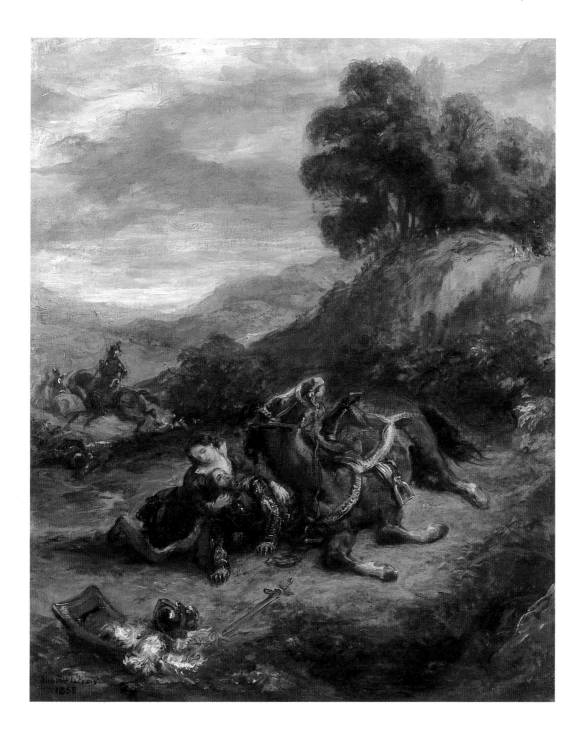

The Death of Lara is terrible and mysterious, like Byron's poem. [Lara] seems gigantic, like a Michelangelo statue, because of the character of the forms. Bending over him, hair loosened, is his mistress, a sorrowing angel whose soul is already passing through the visible world before rising toward heaven. The landscape has a sublime grandeur and the sky is in perfect harmony with this moral tempest. No one has translated better than Monsieur Delacroix the tragic poetry of Shakespeare in *Hamlet,* of Byron, and of Goethe.[1]

Another critic, F. de Mercey, was particularly moved by the grief of the enigmatic Kaled, whose identity was revealed in the Salon catalogue entry ("The mysterious page who usually accompanied him and who was none other than a woman"):

> The passionate and almost maternal demeanor of the mysterious page whose sex, at this supreme moment, is subtly revealed; the inexpressible grief written on her face, the fervent and despairing gaze she fixes upon the visage of her dying master—all this could only have been imagined so successfully and rendered with such ease by a man of genius.[2]

Théophile Gautier, although clearly harboring some reservations about the quality of the work's execution, nevertheless wrote: "*The Death of Lara* is simply a very small and rather sloppily painted sketch, but the passion with which the mysterious page throws herself onto her master's body, betraying her sex by the sobs that cause her bodice to burst open, make it as precious as a monumental and perfectly accomplished painting."[3]

An obvious problem is the date of 1857 that appears on the picture, which makes no sense in light of its identification as a work shown in the Salon of 1848. Without entirely discounting the premise that the work may be a replica painted ten years after the Salon picture, which would thus be lost, Lee Johnson has suggested two possible explanations for the anomaly.[4] If the painting is indeed the one shown at the Salon, the date may have been added by Delacroix after a reworking, or by another hand—but why?

When Delacroix took up the subject again in 1858 (cat. 81), he depicted, instead of the death itself, the moment when the count had just fallen, mortally wounded, from his horse. For this work, the artist chose a vertical format better adapted to the hilly landscape conceived for the event, whose main elements were to reappear in the 1863 work *Arabs Skirmishing in the Mountains* (cat. 139). In contrast to the 1847–48 version, the figures of Lara and the page are integrated into the natural setting, which is one of the work's predominant features. It has been handled with exceptional freedom: here, the brush suggests, rather then describes.

The deeply tragic character of the earlier painting has been replaced by a diffuse and poetical lyricism, reflecting the imaginative fluctuations to which Delacroix was subject toward the end of his life. The 1858 painting is the last in the series of Byronic themes that Delacroix interpreted over a period of thirty years.

A. S.

1. Thoré, 1848; see also Théophile Thoré, *Les Salons de T. Thoré* (Paris: J. Renaud, 1870), p. 563.
2. De Mercey, 1848, p. 299.
3. Gautier, 1848.
4. Johnson, 1986, vol. 3, no. 290, pl. 107.

82. *Lady Macbeth Sleepwalking*

1849–50
Oil on canvas; 16 1/16 x 12 13/16 inches
(40.8 x 32.5 cm)
Signed at lower right: *Eug. Delacroix.*
Fredericton, New Brunswick, Canada,
Beaverbrook Art Gallery, Gift of
Mr. and Mrs. John Flemer

This painting, one of the two works of literary inspiration shown by Delacroix at the Salon of 1850–51 (the other was *The Giaour,* based on Byron's poem), earned a number of positive reviews despite its small size. As noted in the Salon catalogue, the painting illustrates act 5, scene 1 of Shakespeare's play: "Lady Macbeth / She returns to her chamber, still sleepwalking, after the horrifying scene of which the doctor and the gentlewoman were involuntary witnesses / To bed, to bed, to bed. . . . "

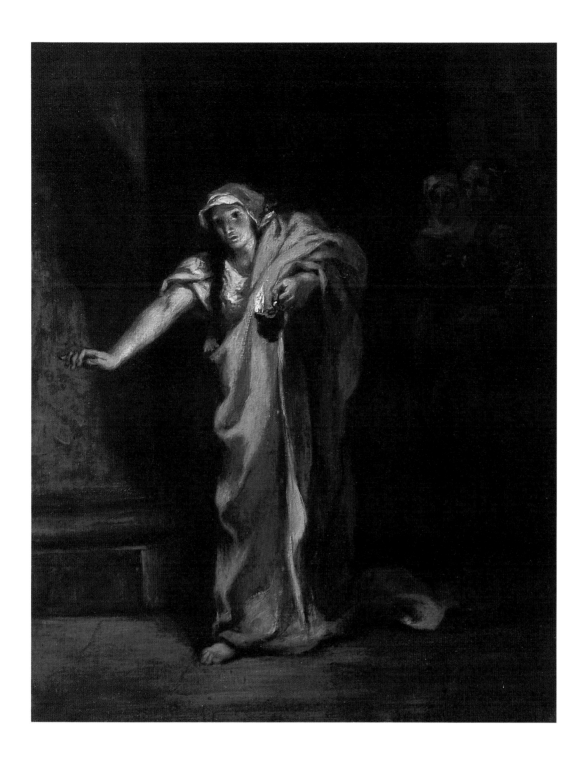

The critics were full of praise for the accuracy with which the scene, stripped of all anecdotal element, is portrayed, and they congratulated the painter on having so skillfully made the best of his canvas's small format. Théophile Gautier, to whom Delacroix apparently gave the painting (although it is not known when), had this to say:

> *Lady Macbeth,* a tiny figure moving across a canvas no bigger than a vignette, possesses more grandeur and energy than many huge works: there is something strange, wild, mad, mechanical about this nocturnal walker, wrapped in a colorless piece of drapery, illuminated by a yellow glow, and whose own shadow follows her like the black phantom

of conscience through the blood-stained corridors of Dunsinane Castle. All the horror of Shakespeare's drama is captured here in a few strokes of the brush.[1]

Clément de Ris concurred, going even further: "*Lady Macbeth . . .* proves beyond a doubt that the greatness of a work does not lie in size, but in the effect produced. All the dreadful Gothic phantasmagoria with which Shakespeare imbued the scene can be found in this painting. It is a great poet interpreted by a great artist."[2] Auguste Desplaces was struck by the lugubrious darkness of the scene: "This little picture is the best of the painter's five submissions. . . . The pallid light,

extremely well distributed, adds, in phantasmagorical concert, to the spectator's impressions."[3] Paul Mantz judged that at this Salon, Delacroix had successfully maintained "in all its fullness that precious gift of interpretation and poetic intelligence that has been accorded him in such plenty."[4]

Pierre Petroz was also impressed with the lighting projected onto the tragic figure of Lady Macbeth: "No one these days is able to capture a realistic effect as well as Monsieur Delacroix, and by the most diverse means. In *Lady Macbeth* it is through the play of light, the admirable balance of chiaroscuro, and the sobriety of the color."[5] In support of his position, Petroz suggested a comparison of Delacroix's painting with another on the same theme by Charles Müller (1815–1892) that had been exhibited at the previous year's Salon, thus taking an entirely opposite view to the one expressed by Alfred Dauger, for whom "Monsieur Müller's *Lady Macbeth* had, despite its confusion, a dignity, a grandeur, a delicacy that nevertheless did not detract from the terror of the subject."[6] Even if Delacroix's work was little more than a sketch, continued Petroz, "it has to be admitted that everything in it is brilliantly rendered." F. Sabatier-Ungher, reporting with amusement some of the exclamations of "comical horror" uttered in front of the painting, was equally enthusiastic: "All of Shakespeare's magnificent scene has been concentrated here into a restricted space. By other means than the poet, the painter arrives at the same terror, the same pity. . . . This little canvas is immense."[7]

This chorus of praise nonetheless included a few jarring notes, which ranged from the sarcastic to the frankly negative: "*Lady Macbeth* is the work I like least," claimed Anatole de Montaiglon,[8] while Paul Rochery admitted he was disappointed by the heroine's ugliness:

> Why give these large and horrible hands to she who says of herself: "All the perfumes of Arabia will not sweeten this little hand"! Does Monsieur Delacroix think that beauty is incompatible with expression, and will we always see this sad divorce between thought and feeling, between line and color, between heaven and earth?[9]

Auguste Galimard ridiculed the painter's "blundering" friends, who dared to claim that he had never been "so great, so noble, so moving." For, he maintained, in front of *Lady Macbeth*, "emotion leaves converts speechless; they are content to make extremely grotesque gestures that could become the subject of a pictorial production of the new school."[10] Courtois took a gleefully gibing tone:

> The *Lady Macbeth* by Monsieur Delacroix is an excellent caricature; it equals the *Good Samaritan*. Leonardo da Vinci said so often that caricature had proven very useful to him, it is little wonder that others try to achieve success using the same means. I would venture one criticism, however: does not the rock that serves this poor woman as a mantle lack a certain lightness?[11]

The worst insults came from Claude Vignon:

> Monsieur Delacroix has been crushed beneath the weight of the accolades of his idolatrous admirers, and the most insignificant sketch impastoed by his brush has been declared by the densest of these disheveled disciples to be worth alone all the works of our Academy; . . . it is Dame Blodgett or Dame Grimshaw sleepwalking! Nothing more.[12]

We know very little about the origin of the painting. According to the *Journal,* Delacroix was working on it at Champrosay on June 17, 1849, apparently at the same time as several other pictures which caused him certain logistical problems: "I often find myself in a predicament in the morning, when I want to continue a task, for I worry that my paintings will not be sufficiently dry."[13] This picture remains the only major work based on *Macbeth*, with the exception of an 1825 lithograph, *Macbeth and the Witches,*[14] which may have been the inspiration for two paintings whose whereabouts are now unknown.[15]

A. S.

1. Gautier, 1851.
2. Clément de Ris, 1851.
3. Desplaces, 1851.
4. Mantz, 1851.
5. Petroz, 1851.
6. Dauger, 1851.
7. Sabatier-Ungher, 1851.
8. De Montaiglon, 1851.
9. Rochery, 1851.
10. Galimard, 1851.
11. Courtois, 1851.
12. Vignon, 1851.
13. *Journal,* June 17, 1849, p. 197.
14. Delteil, 1908, no. 40, repro.
15. Johnson, 1984, vol. 1, nos. 107, 108, pl. 93.

83 to 85. The Bride of Abydos

Of Byron's four Oriental tales, Delacroix drew most frequently for inspiration from *The Giaour* and *The Bride of Abydos*. The artist probably became acquainted with the English poet's work through Amédée Pichot's translations, published between 1819 and 1824. *The Bride of Abydos*, a two-canto poem that first appeared toward the end of 1813, tells of the tragic love affair between Selim—the rejected son of the pasha Giaffir and a slave woman—and his half sister, Zuleika, who has been promised in marriage to the elderly bey Carasman. Having decided to flee, the two lovers take refuge in a seaside grotto. There Selim reveals to Zuleika that he is the chief of a band of pirates that awaits him offshore. But Giaffir and his men catch up with the couple, who cannot escape. Selim is killed by their father Giaffir, and, in despair, Zuleika falls lifeless.

Between 1849 and 1857 Delacroix painted four versions of the dramatic moment when Selim and Zuleika are at the point of being surrounded by Giaffir's forces.

> Dauntless he stood—" 'Tis come—soon past—
> One kiss, Zuleika—'tis my last:
> But yet my band not far from shore
> May hear this signal, see the flash;
> Yet now too few—the attempt were rash:
> No matter—yet one effort more."
> Forth to the cavern mouth he stept;
> His pistol's echo rang on high,
> Zuleika started not, nor wept,
> Despair benumbed her breast and eye!—
> "They hear me not, or if they ply
> Their oars, 'tis but to see me die;
> That sound hath drawn my foes more nigh.
> Then forth my father's scimitar,
> Thou ne'er hast seen less equal war!
> Farewell, Zuleika!—Sweet! retire:
> Yet stay within—here linger safe,
> At thee his rage will only chafe.
> Stir not—lest even to thee perchance
> Some erring blade or ball should glance.
> Fear'st thou for him?—may I expire
> If in this strife I seek thy sire!
> No—though by him that poison poured;
> No—though again he call me coward!
> But tamely shall I meet their steel?
> No—as each crest save *his* may feel!"
>
> (canto 2, stanza 23)

On June 1, 1849, Delacroix wrote in his *Journal:* "Worked hard this morning and the previous days to finish the small 'Bride of Abydos.'" And again, on June 17: "Worked on the small 'Bride of Abydos.'"[1] As Lee Johnson has explained, these were almost certainly references to the small horizontal painting now in England (fig. 1).[2] Delacroix must have executed the version belonging to the Musée des Beaux-Arts in Lyon (cat. 83) around the same period, opting this time for a vertical and slightly larger format. The picture from the Louvre, once owned by George Sand (cat. 84), was probably executed around 1852–53. It seems likely that this is the work mentioned by Delacroix in the summary of his accounts for the year 1852–53: "1st deal with Weill: *View of Tangier / Orange Seller / Saint Thomas / The Bride of Abydos.* 1,500 [francs]."[3] On February 1 Weill had given him a deposit of five hundred francs for the *View of Tangier with Two Seated Arabs* (cat. 100), and on April 4 another installment of the same amount. The dates of the two other payments unfortunately are not known, nor did Delacroix make a note of when and in which order the paintings were delivered to Weill.

In 1857 Delacroix returned to the subject one last time. Upon moving to a new apartment at 6, rue de Furstenberg, he presented the final version (cat. 85) to Monsieur Hurel, the landlord—no doubt in order to establish cordial relations from the outset. Toward the end of 1857 the artist left the apartment and studio he had occupied on rue Notre-Dame-de-Lorette since 1844, and on March 15, 1858, he wrote the following to Hurel, a lawyer who also acted as manager of the building:

> You should have been in possession long ago of the small painting it is my pleasure to send you. This delay was beyond my control: an oversight on the part of Monsieur Haro was the cause, for I asked him for the surround two and a half months ago, but he mixed it up with another order. He is just as upset as I about this misunderstanding. If you like the painting, then the situation will be somewhat remedied. It represents a subject taken from Lord

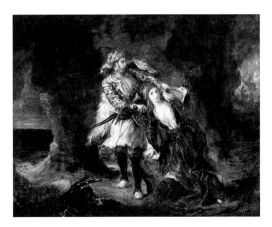

Fig. 1
EUGÈNE DELACROIX, *The Bride of Abydos*, 1849, oil on canvas, Cambridge, King's College.

Byron and depicts the final stanzas of one of his poems, entitled *The Bride of Abydos*. A young Greek is caught with his fiancée on the seashore, just as he is preparing to take her off in a boat; the boat's failure to arrive delivers them both into the hands of their enemies.[4]

In the fall of 1857 the painter had asked Hurel to "renovate as far as possible the exterior [of the building] facing the yard, the garden . . . and the carriage entrance giving onto the street."[5] As the dilapidated

83. *The Bride of Abydos*

c. 1849–51
Oil on wood; 22¹⁄₁₆ x 17¾ inches (56 x 45 cm)
Signed at lower right: *Eug. Delacroix*
Lyon, Musée des Beaux-Arts (B-1039)

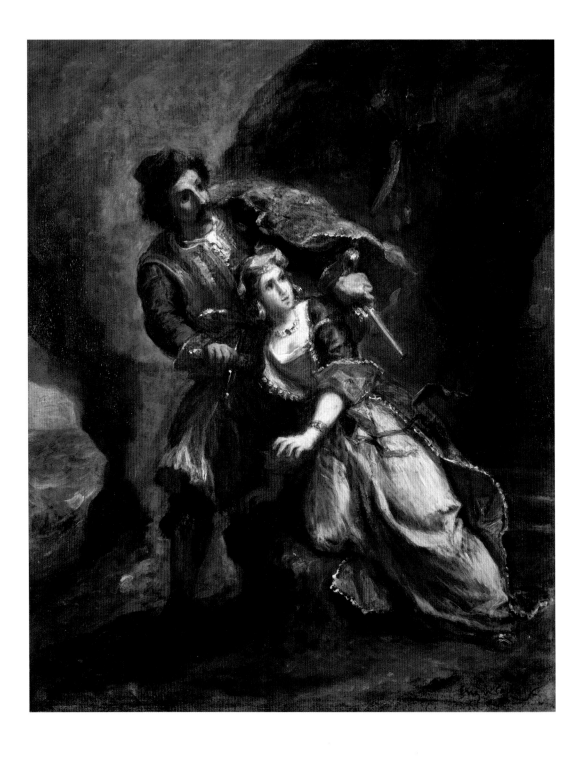

84. *The Bride of Abydos*

c. 1852–53 (?)
Oil on canvas; 13⅞ x 10⅝ inches (35.3 x 27 cm)
Signed at lower left: *Eug Delacroix*
Paris, Musée du Louvre (RF 1398)

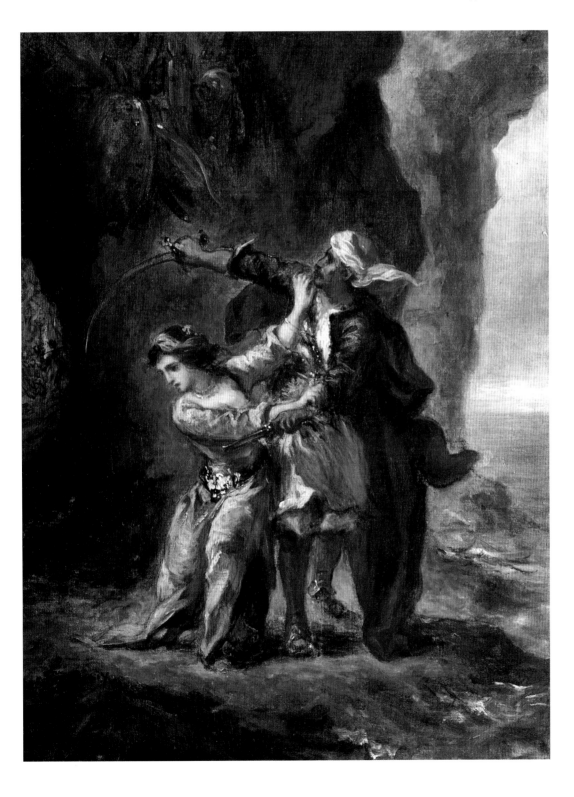

85. *The Bride of Abydos*

1857
Oil on canvas; 18½ x 14¹⁵⁄₁₆ inches (47 x 38 cm)
Signed and dated at lower left:
Eug. Delacroix. / 1857.
Fort Worth, Texas, Kimbell Art Museum

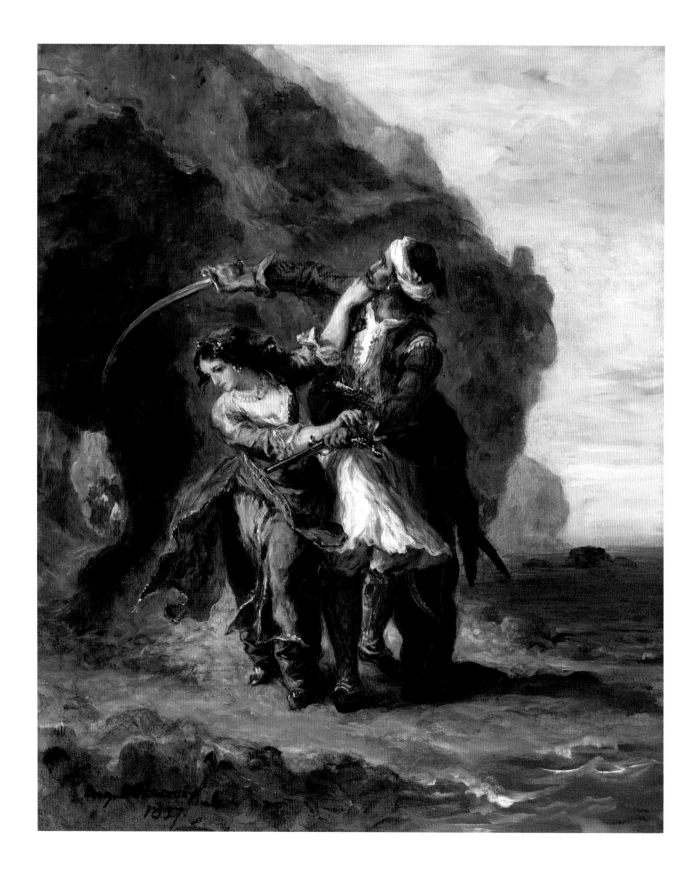

state of his flat had led to unexpected and expensive repair work, Delacroix felt he was within his rights in demanding that the building be brought into "harmony with the new appearance of the second-floor apartment."

Although there is no indication of how Hurel reacted to this request, formulated in polite but insistent terms, we do know, thanks to the recently rediscovered Achille Piron archives (Archives des Musées Nationaux, Paris), that the artist's arrival caused something of a stir in the building on the rue de Furstenberg, largely because of the construction of his studio in the garden. It was thus probably to guarantee himself a well-placed ally that Delacroix made Hurel the gift of a painting.

In any case, the picture that found its way into Hurel's hands was unquestionably the finest of the four versions. The changes introduced successively by the artist with each rendering had the effect of making the scene more comprehensible and, as a result, more dramatic. The vertical format focuses the composition tightly on the ill-fated couple, and the two figures, which originally filled nearly the whole canvas (cat. 83), stand out in the final version against a finely drawn rocky background that leaves room for a delicately transparent and luminous sky (cat. 85). In the later painting, the forms of Selim and Zuleika, with their harmoniously complementary movements, the rock, and the waves lapping on the shore (a recollection of observations made on the beach at Dieppe) are portrayed with supple brushstrokes particularly well suited to enhancing the contrasts between warm and cool colors. The addition of the group of armed men, whose sunlit silhouettes can be glimpsed in the left background in the Louvre and Kimbell Art Museum versions, reinforces the tragedy and emotional impact of the scene.

A. S.

1. *Journal,* June 1 and June 17, 1849, pp. 195, 197.

2. Johnson, 1986, vol. 3, no. 297, pl. 122.

3. *Journal,* undated, following November 30, 1852, p. 317.

4. Johnson, 1991, p. 151.

5. *Correspondance,* vol. 3, pp. 413–14.

86. *Desdemona Cursed by Her Father*

1852
Oil on canvas; 23¼ x 19⁵⁄₁₆ inches (59 x 49 cm)
Signed and dated at lower right:
Eug. Delacroix / 1852
Reims, Musée des Beaux-Arts

Nothing is known about the early provenance of this painting, which is one of the jewels of the collection bequeathed to Reims by Henry Vasnier. However, the Musée du Louvre possesses two drawings (once owned by Alfred Robaut) that originally formed a single work whose composition was very similar to that of the painting seen here— with the exception of the group formed by Othello and his friends, who are placed in the background, framed by a doorway, in the painting.[1] Robaut also possessed a drawing in pen and ink showing Desdemona kneeling at her father's feet.[2]

It is generally agreed that in executing this painting Delacroix drew on both Shakespeare's play, a performance of which he had attended in London in 1825, and Rossini's opera, whose second and third acts he saw on March 30, 1847, in the company of Madame de Forget.[3] Although the curse uttered by Desdemona's father takes place during the finale of the opera's first act, it occurs in the middle of scene 3 of the first act of Shakespeare's play. In fact, each time Delacroix illustrated the tragic love story of Othello and Desdemona, the same blending of sources occurred—and the painter himself was quite conscious of it. On April 1, 1853, recalling a visit from his friend Charles Rivet, the artist wrote in his *Journal* of the latter's emotion before the little "Desdemona, Kneeling at Her Father's Feet" and his humming of the aria "Se il padre m'abbandona" from act 2, scene 6 of the opera.[4] On the other hand, featured in the long list of possible painting subjects drawn up by the artist on May 23, 1858, is "*Brabantio Cursing His Daughter* (after the session with the duke),"[5] which is clearly a Shakespearean reference, since Brabantio is the name of Desdemona's father in the play, while in Berio's opera libretto he is called Elmiro.

Although the Reims painting undoubtedly owes much to Rossini, we cannot discount the influence of Shakespeare, for the pose of the two protagonists, bathed in a sharply contrasting light, seems so theatrical. The gazes of the two figures— like their arms—are locked in conflict. Heavy and threatening, the hands of Desdemona's father— magnificent in his red robe—seem ready to crush the kneeling woman, who tries vainly with her own slender, white hands to ward off the dreadful curse. The starkness and severity of the background heighten the extraordinary emotionalism of the scene.

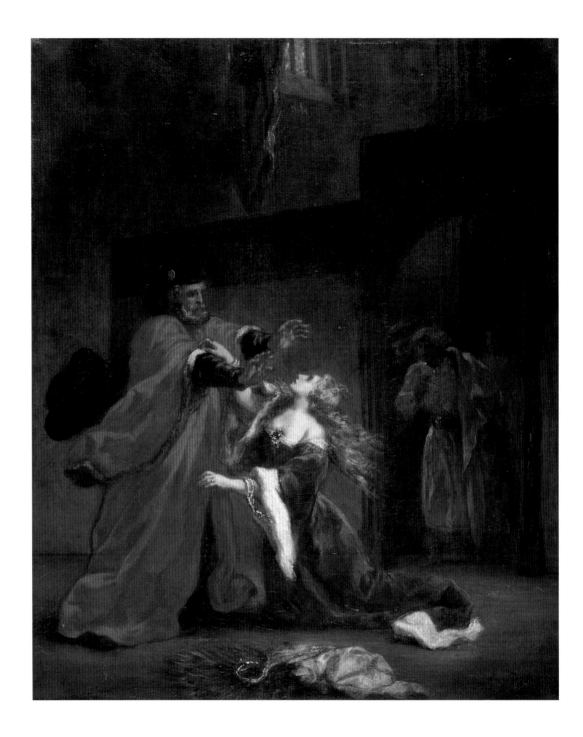

According to a note in the *Journal,* Delacroix received a commission for four paintings from the dealer Thomas, for which on March 3, 1853, he received a first payment of one thousand francs toward the total of twenty-one hundred francs agreed upon for the four works.[6] Among these was a painting titled *Desdemona Cursed by Her Father.* We do not know the whereabouts of this second version—apparently executed at the same time as the Reims picture, and probably somewhat smaller.[7]

A. S.

1. Département des Arts Graphiques, Musée du Louvre, Paris, RF 9360 and RF 10 041; M. Sérullaz, 1984, vol. 1, nos. 435, 436, repro.

2. Robaut, 1885, no. 699.

3. *Journal,* March 30, 1847, p. 146.

4. *Journal,* April 1, 1853, p. 325.

5. *Journal,* May 23, 1858, p. 720.

6. *Journal,* undated, following November 30, 1852, pp. 316–17.

7. Johnson, 1986, vol. 3, no. L 152.

87. *Marfisa and Pinabello's Lady*

1850–52
Oil on canvas; 32¼ x 39¾ inches (82 x 101 cm)
Signed and dated at lower left:
Eug. Delacroix / 1852
Baltimore, The Walters Art Gallery (37.10)

Starting in 1850, Delacroix broadened his repertoire of painting subjects to include the heroic adventures of several characters from the romantic narrative *Orlando Furioso* by Ludovico Ariosto (1474–1533). He chose to represent not only the episodes frequently depicted by seventeenth- and eighteenth-century painters—such as the amorous entanglements of Ruggiero, Medoro, and Angelica—but also certain rarely illustrated episodes featuring secondary characters, includ-

ing Astolfo, Prince Leo, and, particularly, Marfisa and Pinabello.

Orlando Furioso (Roland Mad) is a long poem in Italian, begun around 1502 and presented in 1507 by Ariosto in abbreviated form to his patron, Isabella d'Este. A first version of forty cantos was published to considerable acclaim in 1516; an additional six cantos appeared in 1532. Written in a clear, epic style, *Orlando Furioso* tells the story of Roland, the legendary knight from the days of Charlemagne and hero of the eleventh-century *Chanson de Roland (Song of Roland)*. While preserving the original medieval text's structure of successive warrior exploits, Ariosto strove to imitate the literary spirit and poetic tone—lyrical, direct, occasionally informal, even humorous—of the earlier Renaissance poem, *Orlando Innamorato (Roland Enamored)*, published by Matteo Maria Boiardo (1441–1494) between 1476 and 1495. In the same spirit as Boiardo, but with even greater wit, Ariosto introduced a host of minor characters,

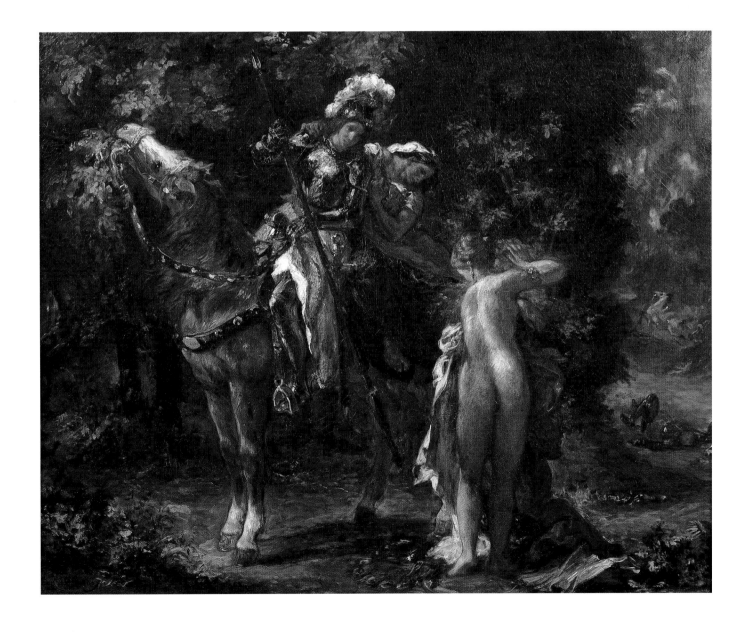

leading the reader through the labyrinth of intrigue and subplot for which this romantic and military epic soon became famous.

As she is among the most extravagant and appealing of the characters created by the poet, Marfisa was frequently chosen by Delacroix as a source of inspiration. One of the few examples in classical literature of the female warrior (see also cat. 94), she wears armor like a man and roams the Italian and French countryside on horseback, leading a wandering existence that is as consciously militaristic as it is unconsciously romantic:

> And ever, night and day, the armed dame
> Scowered, here and there, by hill and plain, the land;
> Hoping with errant cavalier to meet,
> And win immortal fame by glorious feat.[1]

Marfisa, whose innocence of heart is matched by her nobility of feeling, appears in canto 18 of *Orlando Furioso*. She is encountered at a bend in the road by the two paladins Astolfo and Sansonnet, friends of Roland, who are on their way to Damascus to attend a major tournament. Charmed by this independent young woman, whom they at first take to be a man because of her "marvelously fierce" appearance, the two knights suggest that she accompany them and join them in the tournament—an offer she accepts with alacrity.

Delacroix, who perhaps recognized in the character of Marfisa some of the qualities he admired in his friend George Sand, chose in this painting to represent an episode described in canto 20 (stanzas 108–16) of Ariosto's poem, which follows Marfisa's many adventures after her initial meeting with Astolfo and Sansonnet. Recently re-

turned from Syria, Marfisa is traveling through France's Rhone Valley:

> Beyond the Durence, Rhone, and Saone she strayed,
> And to the foot of sunny mountain came;
> And there approaching in black gown arrayed,
> Beside a torrent, saw an ancient dame;
> Who with long journey weak, and wearied sore,
> Appeared, but pined by melancholy more. . . .
>
> The semblance now of foreign cavalier
> She in Marphisa saw, in arms and vest;
> And hence she flies not her, though wont to fear, . . .
>
> And next implored the maid, she of her grace
> Would bear her on the croupe to the other shore.
> Marphisa, who was come of gentle race,
> The hag with her across the torrent bore;
> And is content to bear, till she can place
> In a securer road the beldam hoar,
> Clear of a spacious marsh: at its end
> They see a cavalier toward them wend.

It is thus, with the old woman riding pillion, that Marfisa first meets Pinabello:

> In shining armour and in fair array,
> The warrior rode on saddle richly wrought
> Towards the river, and upon his way
> With him a single squire and damsel brought.
> Of passing beauty was the lady gay,
> But little pleasing was her semblance haught;
> All overblown with insolence and pride . . .
>
> As wanton and ill-customed, when she spies
> Marphisa's aged charge approaching near,
> She cannot rein her saucy tongue, but plies
> Her, in her petulance, with laugh and jeer.
> Marphisa, haught, unwont in any wise
> Outrage from whatsoever part to hear,
> Makes answer to the dame, in angry tone,
> That handsomer than her she deems the crone.
>
> And that this she would prove upon her knight
> With pact that she might strip the bonnibell
> Of gown and palfrey, if, o'erthrown in fight,
> Her champion from his goodly courser fell.

The inevitable combat takes place:

> Marphisa grasped a mighty lance, and thrust,
> Encountering him, at Pinabello's eyes;
> And stretched him so astounded in the dust.
> That motionless an hour the warrior lies.
> Marphisa, now victorious in the just,
> Gave orders to strip off the glorious guise
> And ornaments wherewith the maid was drest,
> And with the spoils her ancient crone invest.

This is the precise moment—as Marfisa forces the damsel to disrobe and Pinabello lies unconscious

Fig. 1
EUGÈNE DELACROIX, *Marfisa*, 1849–50, graphite on paper, Lille, Musée des Beaux-Arts.

on the ground—that Delacroix chose to portray: he shows a triumphant Marfisa astride her horse, still holding the lance with which she has just unseated Pinabello, and, behind her, the old woman greedily examining the rich garments she is about to inherit. Pinabello's lady, labeled "impertinent" (or occasionally "capricious") in the work's French title—*Marphise et la femme impertinente* or *La Femme capricieuse*—because of her mockery of the old woman, stands naked near the horse, her back to the viewer, with her clothes at her feet and clutched before her. In the background, the figures of Pinabello (lying on the ground) and his fleeing horse impose a rhythm on the open vista at the right side of the composition, a device—reminiscent of the strange constructions of Paolo Uccello (c. 1396–1475)—that lends depth to the landscape. And Delacroix added a final, almost humorous detail to this charming scene: Marfisa's horse takes advantage of the drama to munch a few leaves from a nearby tree.

After comparing Ariosto's text with several passages in the *Journal* where Delacroix mentions a painting featuring the "capricious" or "impertinent" woman, Maurice Sérullaz dated the execution of this painting to 1850, linking it to an amicable difference of opinion between the painter and the strong-minded princess Delphine Potocka, the friend of Frederic Chopin's whom Delacroix had nicknamed the Enchantress. Paying a visit to Delacroix one day when he was working on the *Marfisa*, as recorded in his *Journal* on February 14, 1850, she was visibly shocked by the sensuality of the nude: "Mme P[otocka] called today, with her sister Princess de B[eauvau]. She at once noticed the nudes, the *Femme Impertinente* and the *Femme qui se peigne:* 'What is it that you artists, all you men, find so attractive in this?' she said. 'What makes it more interesting to you than any other object in its nude or crude state; an apple, for instance?'"[2]

The picture was apparently finished by May 13, 1851, for on that date Delacroix wrote in the past tense of his meticulous choice of pigments used for the young girl's skin:

> The underpainting for the *Femme Impertinente* was made with a very thick impasto and in a very warm and above all, a very red tint. On this I laid a glaze of *terre verte* with perhaps a little *white*. This produced the half-tone of iridescent opal-grey, and over it I very simply touched in the lights with the extremely good tone of *Cassel earth, white* and a little *vermilion,* followed by a few orange tones, strong in places. All this was still merely an underpainting, but an exceedingly subtle one. The half-tone was entirely flesh colour."[3]

Although destined for an art lover—as soon as it was finished, it was purchased by the collector J. P. Bonnet, who already owned several paintings

by Delacroix (cat. 88 and see cat. 64),—and thus prompted by a partially commercial motive, the work nevertheless represents a key point in Delacroix's aesthetic and thematic explorations. In the refined and complex handling of the central nude, the artist recaptured the sensuality of *The Death of Sardanapalus* and of the Oriental women he had portrayed in his youth.

This nude has, moreover, proved an object of considerable interest to art historians, who see it either as reminiscent of classical statuary or as a pictorial variation based loosely on one of the goddesses (Minerva) in Raphael's *Judgment of Paris,* with which Delacroix was familiar through the engraving made by Marcantonio Raimondi (c. 1488–1534).[4] The painter also probably had in mind the two magnificent adaptations of Raphael's *Judgment of Paris* by Peter Paul Rubens (1577–1640), executed in 1600 and 1605 (both now at the National Gallery, London). In fact, the figure of Hera (the goddess on the far right) in the later version is similar in both technique and composition—even the hairstyle—to Delacroix's figure of Pinabello's lady.

René Huygue and, later, Sara Lichtenstein have both also noted the similarity between the painting's overall composition and the traditional iconography of Saint Martin sharing his cloak—and, more specifically, Anthony Van Dyck's rendering of this theme (church of Saventhem, Belgium), of which Delacroix possessed a copy by Théodore Géricault (now in the Musées Royaux des Beaux-Arts, Brussels).[5]

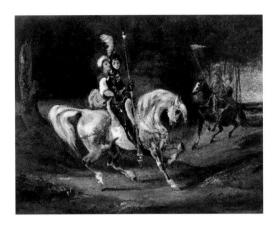

Delacroix was especially preoccupied by this work, whatever its sources, and devoted considerable time to developing it, executing numerous preparatory drawings. Seven drawings for the work were included in the posthumous sale (lot 364), of which five have come down to us.[6] He also worked at some length on the position of the young woman, initially considering a frontal view before settling on this marvelous rear-view pose.

Two other paintings by Delacroix illustrate this episode featuring Marfisa: one without the old woman (private collection) and the other showing the meeting between Marfisa and Pinabello (fig. 3).

V. P.

1. This and subsequent extracts from *Orlando Furioso* are taken from the translation by William Stewart Rose, edited by Stewart A. Baker and A. Bartlett Giamatti (Indianapolis and New York: Bobbs-Merrill, 1968).
2. *Journal*, February 14, 1850 (Norton, 1951, p. 110).
3. *Journal*, May 13, 1851 (Norton, 1951, p. 141).
4. Johnson, 1986, vol. 3, no. 303, p. 125.
5. Huyghe, 1963, p. 483; Sara Lichtenstein, *Delacroix and Raphael* (New York and London: Garland, 1979), pp. 131ff.
6. Albertina, Vienna, inv. 24.104; The Art Institute, Chicago, inv. 57.332; private collection; and figs. 1 and 2.

88. *Entry of the Crusaders into Constantinople*
(*April 12, 1204*)

1852
Oil on canvas; 32⅛ x 41⅜ inches (81.5 x 105 cm)
Signed and dated at lower left:
Eug. Delacroix 1852.
Paris, Musée du Louvre, Gift of Étienne Moreau-Nélaton (RF 1659)
Exhibited in Paris only

Dated 1852, this picture is a smaller variant of the large painting that the king, Louis-Philippe, had commissioned from Delacroix on April 30, 1838, to adorn the crusades room of the Pavillon du Roi at Versailles (fig. 1). It was included in the major sale (held on February 19, 1853) of works belonging to the collector J. P. Bonnet, who had almost certainly purchased it as soon as it was finished and may actually have commissioned it, as he had commissioned a smaller version of the ceiling in the Galerie d'Apollon of the Musée du Louvre (see cat. 64).

In any case, this work is mentioned in a letter of February 9, 1853, from Delacroix to Bonnet, in which the painter requested permission for it to be photographed by Théophile Silvestre:

> [Silvestre] is very desirous of obtaining permission to photograph the *Christ* by me that you own to put with others of his important photographs. . . . I wonder if you would be good enough to agree to the same for *Entry of the Crusaders,* which in my view is more significant in my work as a whole than the one at Versailles.[1]

This canvas was bought at the Bonnet sale by the stockbroker and collector Adolphe Moreau (1800–1859), who had it reproduced in a very fine engraving by Achille Sirouy;[2] it remained for some years in the possession of this remarkable family of art lovers and patrons, and was finally donated to the Musée du Louvre by Adolphe Moreau's grandson, Étienne Moreau-Nélaton, as part of a unique group of paintings and drawings representing all the main pictorial movements of the nineteenth century, from Neoclassicism to Impressionism.

For the catalogue of the Salon of 1841, at which he exhibited his large picture for Versailles (no. 509), Delacroix had provided a summary of the theme of this historical work that obviously also applies to the 1852 variant: "Baldwin, count of Flanders, was in command of the French who had

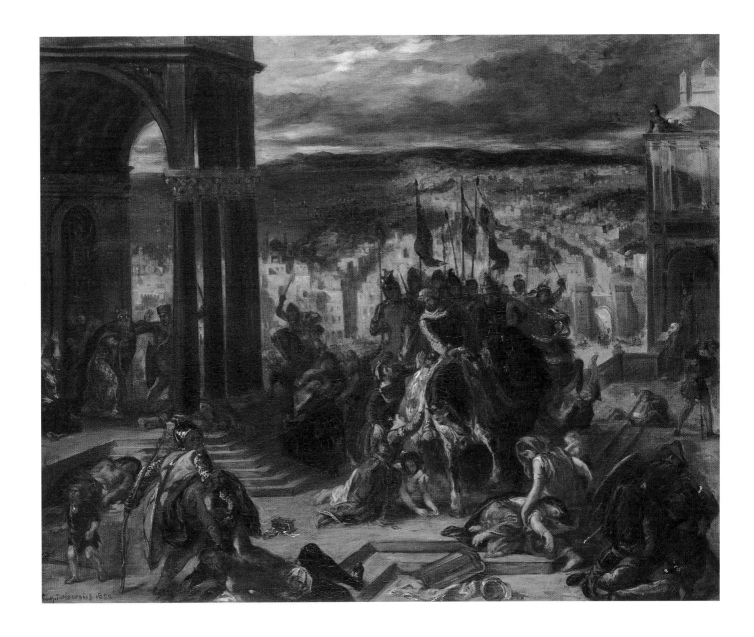

mounted an assault from the land side, and the
aged doge Dandolo, leader of the Venetians, had
attacked the port with his ships; the leaders move
through the different sectors of the city, and weep-
ing families beg for mercy as they pass." During
the Fourth Crusade (1202–4), organized by Pope
Innocent III to liberate Jerusalem (occupied since
1187 by the Muslims), the crusaders were diverted
from their original goal (the deliverance of
Christ's tomb) by various plots, several of which
had been fomented, for commercial reasons, by
the Venetians. The Christian forces had therefore
put Constantinople under siege with the aim of
restoring to the throne the recently usurped em-
peror. Captured in 1203, Constantinople fell once
more into the hands of the emperor's enemies
after the departure of the papal armies, but in 1204
the crusaders again took the Byzantine city, this
time sacking it. This is the event portrayed by
Delacroix. In the foreground are the city's inhabi-
tants, terrified by the horrors of the pillaging, im-
ploring one of the leaders of the Fourth Crusade,

Fig. 1
EUGÈNE DELACROIX, *Entry of
the Crusaders into Constantinople*,
1841, oil on canvas, Paris, Musée
du Louvre.

Fig. 2
EUGÈNE DELACROIX, *Entry of
the Crusaders into Constantinople*
(sketch), c. 1840, oil on canvas,
Chantilly, Musée Condé.

upper part of the painting. The frieze of characters is more spread out and includes additional figures, such as the lone dwarf and the soldier attempting to carry off his victim in the left foreground, as well as the other crusaders continuing the massacre in the wake of Baldwin and his knights. In a manner characteristic of Renaissance works, the right side of the painting is structured by a succession of figures placed at strategic points in the perspective—one of whom can be seen on a rooftop, arm raised. Though it is more narrative and more brutal—the rapes and murders are depicted even more vividly than in the earlier work—and of a looser overall construction, the 1852 painting has nonetheless lost some of the majesty and theatricality of the large picture exhibited in 1841. This does not seem to have been a source of regret for Delacroix, however, judging by his remarks to Bonnet in the 1853 letter quoted above.

When the artist executed this superb variant, the monumental *Crusaders* painting was still at Versailles. It was replaced by a copy by Charles de Serres (1823–1883) in 1885 and transported to the Musée du Louvre, where it is still on view today. Consequently, in creating the smaller work, Delacroix must have worked from memory and from one or more preparatory sketches made for the Salon painting rather than from the painting itself, since the gallery was at that time closed. He may have used a small study (fig. 2), now at the Musée Condé in Chantilly and owned successively by the painter Adrien Dauzats (1804–1868) and the duc d'Aumale, which has a composition very similar to the 1852 picture. Because of this similarity, some scholars (Alfred Robaut and Maurice Sérullaz) have suggested that the Chantilly study is actually an early version of the variant rather than of the large 1841 painting.[3] However, we continue to believe that it is a sketch made for the 1841 commission, which Delacroix may well have employed ten years later in executing the variant, spontaneously returning to aesthetic solutions he had rejected for the first version.

V. P.

Baldwin IX, count of Flanders (1171–c. 1206), to protect them. Later that year, under the name Baldwin I, this man would be crowned emperor of Constantinople.

In both versions of the painting, the central figure is Baldwin, who enters the city at the head of his knights and at whose feet the vanquished throw themselves. But the framing of the large 1841 painting is much tighter, concentrating the action around four main figure groups: a wealthy citizen of Constantinople being dragged violently from his palace by a guard; another who kneels in the street, supporting his wife or daughter with his right arm and beseeching the crusaders for clemency; the group formed by Baldwin and his soldiers; and a nearly naked woman who evidently has just been raped and who holds another woman, unconscious or dead. The middle ground is structured around three inhabitants of the besieged city, to whom Delacroix has given a role that is both dramatic and compositional: on the left, a woman lies on the steps of the Byzantine palace; another has fallen to the ground to the right, in counterpoint to the first; and beyond the second victim, a third flees, arms raised. The stormy sky and brightly lit view of Constantinople and the Bosporus are partially hidden by a frieze of figures that fills the lower three-quarters of the canvas.

The composition of the 1852 variant, by contrast, is more animated, more complex, and more horizontal. Delacroix has added some buildings at the right side, thus eliminating the deliberate asymmetry of the 1841 version and accentuating the work's depth. The view of Constantinople is developed in far more detail, occupying the whole

1. *Correspondance*, vol. 3, p. 139.
2. *Journal*, June 2, 1855, p. 510.
3. M. Sérullaz, 1963(a), no. 297; Robaut, 1885, no. 709.

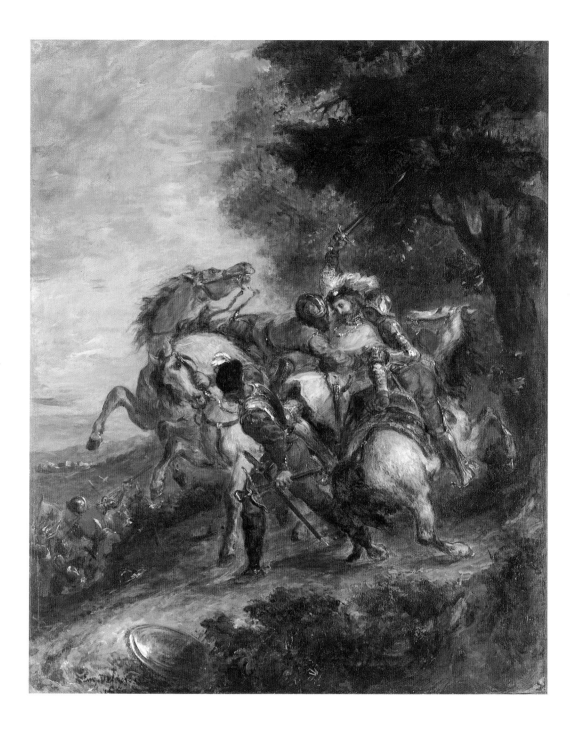

89. *Weislingen Captured by Goetz's Men*

1853
Oil on canvas; 28⅞ x 23⅜ inches (73.3 x 59.3 cm)
Signed and dated at lower left:
Eug. Delacroix / 1853
St. Louis, The Saint Louis Art Museum,
Emelie Weindal Bequest Fund (75: 1954)

The subject of this painting is taken from *Götz von Berlichingen,* a five-act play by Goethe, written in 1773 and translated into French in 1823.[1] In retaliation for the kidnapping of his son by the bishop of Bamberg, Goetz abducts the bishop's favorite knight, Weislingen. The latter falls in love with Goetz's sister, Marie, and proposes to her, but then succumbs to the charms of the bishop's envoy, the formidable Adelaide von Walldorff, whom he marries. Weislingen must then rid himself of his enemy. The Peasant War breaks out, and Goetz, who has been banished from the empire, is captured and condemned to death. Marie obtains his pardon, but Weislingen, poisoned by Adelaide von Walldorff, dies. Goetz is freed, but also dies, at Jaxthausen, a broken man.

Goethe drew inspiration for his play from the adventurous life of a sixteenth-century German knight nicknamed Ironhand, who, having served successively under the margrave Frederick of

Brandenburg, Albert V of Bavaria, and duke Ulrich of Württemberg, led a revolt known as the Peasant War. After his right hand was amputated, he had an iron hand fitted in order to continue wielding a sword. Goethe embellished the character of Goetz, depicting him as the ultimate defender of justice against the reigning princes and as the embodiment of the artist or the creative young poet rebelling against convention—or, at another level, as the symbol of man's struggle against his destiny. The painting illustrates a passage that occurs in act 1, scene 3 of the play. Pierre, one of Goetz's men, recounts to his master's wife, Elizabeth, how Weislingen was captured as he passed through the forest of Haslach accompanied by four outriders: "I and my comrade, as the master had commanded, crept up close to him as if we had grown together so that he couldn't stir or budge, and the master and Hans attacked the squires and took them prisoners. One of them got away."[2]

According to a note in his *Journal,* Delacroix was working on this canvas on August 28, 1853, the period when he was completing the Salon de la Paix ceiling at the Hôtel de Ville: "Made progress [with] the *Barlichingen* [*sic*] or *Weislingen*."[3] But we know nothing more about precisely when or how the painting was completed. On September 26, 1853, it appears in a list of miscellaneous works,[4] and on October 16 the artist, then at Champrosay, wrote simply: "Finished or nearly finished the *Weislingen*."[5] Finally, in another list of paintings, unfortunately undated, the work is referred to by the title *Weislingen enlevé* ("Weislingen abducted").[6]

Delacroix had already illustrated this episode in a series of seven lithographs after *Götz von Berlichingen* that he had executed between 1836 and 1843.[7] The idea may have first come to him in 1824, probably following a conversation with his friend Jean-Baptiste Pierret: "This evening I feel the desire to make compositions based on *Götz von Berlichingen*."[8] In a sketchbook used around 1827, Delacroix made a list of seven possible subjects from the play,[9] but it was not until about 1836 that he began work on the project, entrusting to the printer Villain the task of executing the lithographs. Comparison of the 1853 painting with the print depicting the same scene[10] shows that while Delacroix retained the right side of the composition virtually unchanged for the painting, the atmosphere of the work is quite different. In the lithograph, attention is focused almost entirely on the tightly knit group formed by Weislingen and his aggressors, which occupies almost the whole sheet. By positioning this group on a track that rises toward a stand of trees to the right, the painter not only modified the rigid structure of the print version, but—using a device that had become his practice—opened up the landscape on the left, which allowed him to show another fight taking place lower down the slope. The violence of the attack has also become more intense, and the whole group—horses and riders alike—seems on the verge of toppling over. This deliberate instability is offset by the harmonious correspondence between line and color.

In his 1860 review of the boulevard des Italiens exhibition for the *Moniteur universel,* Théophile Gautier wrote:

> We sense, because of the painting's light, matte look, the thicker paint layer, the shaded whites, that . . . the artist has executed many murals. The overall impression has something of both fresco and tapestry. The turquoise blue of the sky is as delicate as the sky of Paul Veronese's *Triumph of Venice* in the Doge's Palace. The struggling group of horses and riders, on the other hand, possesses the wild turbulence that Delacroix is so skilled at instilling into scenes of this kind. It is authentic and rare: one of the first conditions of art, which should be idealized transcription and not photography. A painted fight needs to be more terrible than a real fight, if the aim is to create an impact on the mind of the spectator.[11]

And in an article on the same event published in the *Gazette des Beaux-Arts,* Gautier had this to say: "Eugène Delacroix stands out brilliantly among this band of colorists. . . . The scene taken from Goethe's *Berlichingen,* which we have not seen included in any exhibition, . . . possesses that deeply medieval life so vividly recreated by Goethe."[12] According to Théophile Silvestre, the picture's setting must have been inspired by the forest of Sénart, since the work was partially executed at Champrosay.[13] If we take account of a sketch pointed out by Lee Johnson,[14] we must assume that Delacroix had the idea for the ambush scene very early—although it does not appear on the 1827 list of subjects—for this sketch bears a few lines apparently taken from the 1823 de Baer translation of Goethe's work.

A. S.

1. G. de Baer, *Chefs-d'oeuvre des théâtres étrangers. 25e livraison. Chefs-d'oeuvre du théâtre allemand.* Vol. 1, *Goethe* (Paris: Ladvocat Libraire, 1823).
2. This extract from *Götz von Berlichingen* is from the translation by Charles E. Passage (New York: Frederick Ungar, 1980).

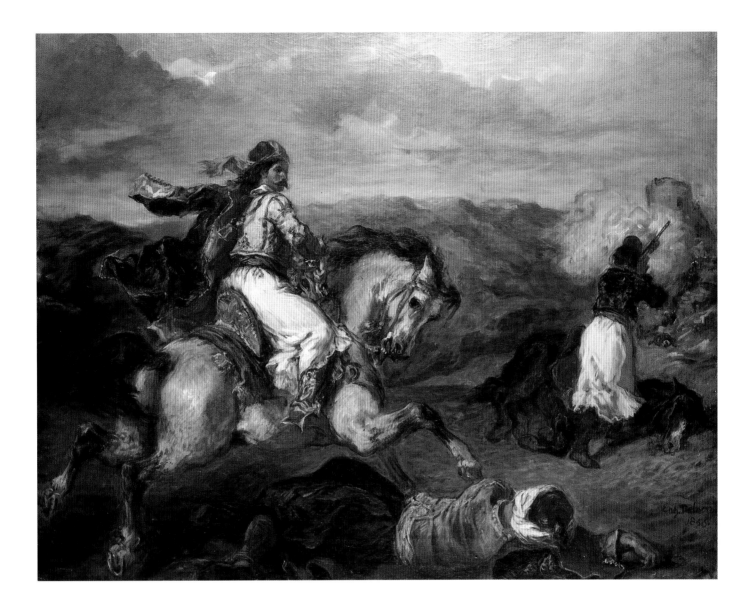

3. *Journal,* August 28, 1853, p. 360.

4. *Journal,* September 26, 1853, p. 361.

5. *Journal,* October 16, 1853, p. 368.

6. Supplement to the *Journal,* undated, p. 873.

7. Delteil, 1908, nos. 119–25.

8. *Journal,* February 28, 1824, p. 52.

9. Musée du Louvre, Paris, RF 9150, folio 25 verso; M. Sérullaz, 1984, vol. 2, no. 1753, repro.

10. Delteil, 1908, no. 120, repro.

11. Gautier, 1860(c).

12. Gautier, 1860(b), p. 202.

13. Silvestre, 1864.

14. Sale, Sotheby's, New York, June 12, 1982, lot 201.

90. *Scene from the War Between the Turks and Greeks*

1856
Oil on canvas; 25⅞ x 32⅛ inches
(65.7 x 81.6 cm)
Signed and dated at lower left:
Eug. Delacroix / 1856.
Athens, Pinacothèque Nationale, Musée
Alexandre Soutzos (5618)

The dramatic events of the war waged between 1821 and 1827 by the Greeks in an effort to break free from Ottoman domination triggered a wave of public sympathy throughout Europe, especially in France. Artists became actively involved: over a thirty-year period, close to one hundred and fifty paintings of philhellenic inspiration were exhibited at the Salons and at events held "in support of

Fig. 1
EUGÈNE DELACROIX, *Scene from the Present War Between the Turks and the Greeks*, 1827, oil on canvas, Winterthur, Oskar Reinhart Collection.

Greek rebel whose horse is plunging over the recumbent body of a Turk remains the central motif—the second version is markedly more imaginative. By slightly altering the position of the Greek horseman and his fiery steed, both now looking down at the fallen enemy, the painter has considerably heightened the work's symbolic impact. In the earlier version, the lighting was uniform and attention was focused principally on the attacker's headlong ride; in the second painting, the skillfully modulated light accentuates the agitated brushwork, emphasizing each movement of the bodies. The lowering, cloud-filled sky also lends a powerful emotional charge to the scene.

A. S.

1. Johnson, 1991, p. 62 n. 2.

the Greeks" at the Galerie Lebrun, located at 4, rue du Gros-Chenet (now the rue du Sentier), in Paris. Delacroix's interest in the Greek cause was expressed magnificently in two major works—*The Massacre at Chios* (Salon of 1824, Musée du Louvre, Paris) and *Greece on the Ruins of Missolonghi* (1826, Musée des Beaux-Arts, Bordeaux)—but also, less formally, in a number of small Orientalist paintings that consist largely of costume studies, which were an excellent opportunity for displaying the richness of his palette. His admiration for the English poet Lord Byron, who died at Missolonghi in 1824, had done much to focus the artist's imagination on a Greek "Orient" that was both opulent and tragic, and this inspiration did not cease when the Greek War of Independence came to an end. Until the final years of his life, Delacroix continued to return to subjects that had fired his enthusiasm as a young man. An example of this practice is the canvas seen here, on which, as Lee Johnson has suggested, he was probably working toward the end of 1855. On November 28 of that year Delacroix wrote to the dealer Thomas: "Your painting is well under way: I cannot tell you yet exactly when it will be finished, but I hope it won't be too long."[1]

The work is a repetition of a painting presented at the Salon of 1827 (no. 299) under the title *Scene from the Present War Between the Turks and the Greeks* (fig. 1), which was awarded a cool reception by critics at the time. Thirty years later Delacroix called upon the same theme to create a work of an entirely different spirit, in which the somewhat allusive reference to the Greek revolt (the battle depicted cannot be identified) is transformed by some obvious references to Morocco, such as the mountainous landscape that forms the horizon. Although the two paintings are identical in size and overall composition—the figure of a

91. *The Abduction of Rebecca*

1858
Oil on canvas; 41⅜ x 32⅛ inches (105 x 81.5 cm)
Signed and dated at lower center, on the stone:
Eug. Delacroix 1858.
Paris, Musée du Louvre (RF 1392)

At the Salon of 1846 Delacroix showed a painting based on a dramatic episode from chapter 31 of Sir Walter Scott's *Ivanhoe*. The work, which was violently attacked by the critics, was exhibited with the full title *Rebecca Abducted at the Order of the Templar Bois-Guilbert During the Sack of the Castle of Front-de-Boeuf* (fig. 1). It featured one of the young heroines of Scott's novel, Rebecca, who was daughter of the Jewish banker and merchant Isaac, and the treacherous knight Brian de Bois-Guilbert, commander of the Order of the Knights Templar. In the second chapter of the novel, Scott offers the following disturbing physical description of Bois-Guilbert:

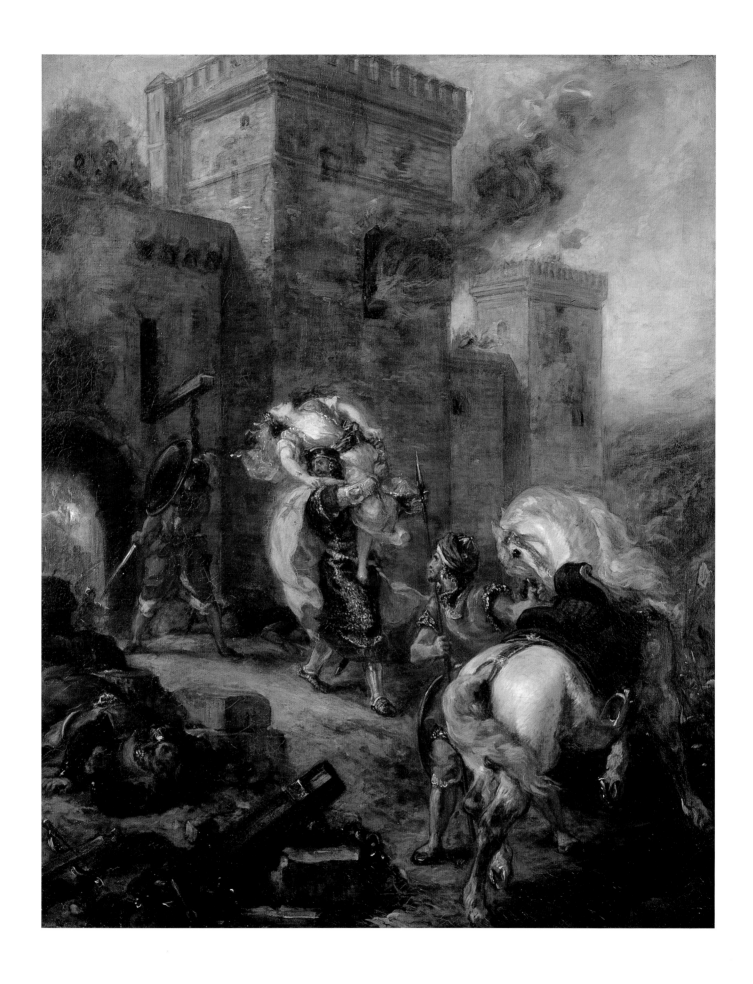

Fig. 1
EUGÈNE DELACROIX, *The
Abduction of Rebecca,* 1846, oil
on canvas, New York, The
Metropolitan Museum of Art,
Wolfe Fund, 1903.

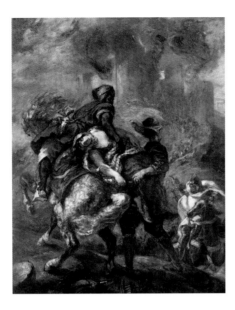

A man past forty, thin, strong, tall, and muscular; an ath-
letic figure, which long fatigue and constant exercise
seemed to have left none of the softer part of the human
form, having reduced the whole to brawn. High features,
naturally strong and powerfully expressive, had been burnt
almost into Negro blackness by constant exposure to the
tropical sun.

The Templar has taken part in the abductions
of Lady Rowena, with whom Ivanhoe is in love,
and Rebecca; both women have been imprisoned
with the wounded Ivanhoe in the castle of a friend
of Bois-Guilbert, Lord Front-de-Boeuf. Delacroix
strayed from the book in his portrayal of the cas-
tle, even though Scott described its architecture in
some detail: "It was a fortress of no great size, con-
sisting of a donjon, or large and high square tower,
surrounded by buildings of inferior height, which
were encircled by an inner courtyard. Around the
exterior wall was a deep moat, supplied with water
from a neighbouring rivulet." After Front-de-
Boeuf's castle is besieged by Ivanhoe's friends, Bois-
Guilbert, taking advantage of the hero's weakness,
snatches Rebecca, for whom he has developed a
passion, and carries her off: "So saying, [Bois-
Guilbert] seized on the terrified maiden, who
filled the air with her shrieks, and bore her out of
the room in his arms in spite of her cries, and
without regarding the menaces and defiance
which Ivanhoe thundered against him."

In the catalogue of the 1846 Salon (no. 502),
Delacroix described in his own words the exact
moment he had chosen to depict: "She [Rebecca]
is already in the hands of the two African slaves
who have been instructed to take her far away
from the scene of battle." In a smaller and more
modestly conceived work entitled *Rebecca and the
Wounded Ivanhoe* (private collection), Delacroix
also portrayed the scene that occurs immediately
before the one represented in the 1846 painting.

The first mention of Delacroix's return to this
theme employed in 1846 appears in a note in the
Journal dated May 26, 1856, although the painter
did not explain the circumstances of the new work's
execution—whether it was a commission or a
work made for the Salon: "I worked hard at
Champrosay. . . . I sketched out the Templar ab-
ducting Rebecca from the castle of Front-de-Boeuf
during the sacking and the fire."[1] A few brief subse-
quent comments enable us to follow the work's de-
velopment. On June 29, 1856, upon returning to
Champrosay, the painter expressed dissatisfaction
with his work: "I was not happy yesterday, on arriv-
ing [at Champrosay], with what I had left here, the
Erminia, the *Bois-Guilbert Abducting Rebecca,* the
sketches for Hartmann, etc."[2] And a *Journal* entry
of September 5, 1858, two years after the variant was
begun, indicates that Delacroix was still working
on it: "I've made considerable progress with sev-
eral paintings. . . . The *Little Ivanhoe and Rebecca.*"[3]

It seems clear that the numerous differences be-
tween this second version and the 1846 painting—
which make them, in fact, two entirely different
works—were the result of Delacroix's desire to
present the critics with an identical subject without
being accused of painting the same work twice.
The second painting definitely seems to have been
the source of a certain creative anxiety, for he exe-
cuted a number of preparatory drawings (fig. 2) for
the final composition. The Metropolitan Museum
painting is structured entirely around the four
figures, who occupy most of the picture's surface:
Bois-Guilbert, mounted, follows his two Arab ser-
vants, who are on the point of placing the uncon-
scious Rebecca upon the back of another horse.
The costumes are geographically and historically
accurate: Bois-Guilbert wears the large white cape
and red cross of the Templars, while the two slaves
are in Oriental clothing, and Rebecca is dressed in
the style of North African Jews studied by
Delacroix during his 1832 trip to Morocco. The
castle of Front-de-Boeuf is barely visible through
the smoke from the fire lit by the besiegers and
from the various combats taking place. The land-
scape has been handled in a deliberately summary
fashion that leaves the site's topography vague.

In the 1858 version, on the other hand, the im-
posing architecture of the medieval castle—imagi-
nary but nevertheless convincing—plays an
essential role, filling the whole of the background,
defining the pictorial space, and allowing the bril-
liant colors of the sky and the protagonists' cloth-
ing to stand out against the light brown of the
stone walls. The four figures are not arranged in
the pyramidal structure of the first version, but are
placed one in front of the other in an unusual pro-
cessionlike formation. Here Bois-Guilbert himself
carries the young woman on his shoulders, while
she struggles fiercely; one of the two slaves awaits
the Templar and his captive beside the white horse

while the other brings up the rear, sword drawn and face protected by his shield. The scene is better balanced and more skillfully structured around the areas of vivid color—the blue green of the sky; the red garments of the two Moorish slaves; and the whites of Bois-Guilbert's cape, Rebecca's dress, and the horse. Although less dynamic and controlled, it is considerably more expressive and pleasing to the eye.

In a series of masterpieces that include *The Death of Sardanapalus* (Musée du Louvre, Paris), painted in 1827, and *African Pirates Abducting a Young Woman* (Musée du Louvre, Paris), exhibited at the Salon of 1853, Delacroix explored a theme that had haunted him since his somewhat inflamed youth: the abduction of young women. In sharp contrast to the refined atmosphere of Poussin's *Rape of the Sabine Women* (Musée du Louvre, Paris) or the melancholy sensuality of Rubens's *Abduction of the Daughters of Leucippus* (Neue Pinakothek, Munich), it was the barbarism and ferocity of a sudden and apparently irrevocable abduction that seized Delacroix's imagination, and these elements are accompanied in this second version by a barely veiled erotic allusion to Rebecca's rape by the Templar, suggested by his rude embrace.

Shown at the Salon of 1859, this painting was hailed enthusiastically by Zacharie Astruc: "It is impossible to be more lucid, more clear, more dramatic, more precise in effect, or more marvelously interesting in vision as light and color. . . . What a golden dream, Rebecca and the Templar, and the white horse, so bold, so proud, with a coat that shimmers like mother-of-pearl."[4] Charles Perrier expressed some reservations, but saw the painting as a tribute by Delacroix to the music he loved so much: "It is music transported into the realm of visual art."[5] A few other critics, including Paul Mantz, were fascinated principally by the wild grandeur of the scene, taken from a simple adventure story: "There is a strange charm, a vigorous and moving grace in the curved figure of the young prisoner who struggles in the arms of her ravisher and who, exquisitely dressed in blue, orange, and white fabrics, shines in the center of this scene of carnage like a flower in a storm-wrecked field."[6]

Most of the year's reviews, however, were extremely hostile to Delacroix. Paul de Saint-Victor's acerbic remarks seem to sum up the general attitude of the critics:

> An unfortunate repetition of a subject already treated by Monsieur Delacroix.—Here, representation has become immoderation; the characters have lost their limbs in the battle; they grab them and stick them back on at random. Rebecca floats in her abductor's arms like a dress hanging from the branches of a misshapen tree. The Templar's slave stretches out a leg that seems seven leagues long. The horse he holds would fit well into the bestiary of heraldry. A

Fig. 2
EUGÈNE DELACROIX, *The Abduction of Rebecca*, 1856–58, graphite on paper, Paris, Musée du Louvre, Département des Arts Graphiques.

leaden sky, like those we imagine must hang over dead, atmosphereless planets, only increases the bleakness of this dreary scene."[7]

Thus, following the tremendous success of the Exposition Universelle of 1855 and his election to the Institut in 1857, the Salon of 1859 was for Eugène Delacroix, in a bizarre reversal of fortune, a major failure. Alfred Robaut summarized the violence and injustice of the reaction in his 1885 commentary on *The Abduction of Rebecca:*

> It is difficult not to feel a certain irritation when one has been a witness, as we were, to the attitude of the public in the galleries of the Salon of 1859 in front of the eight paintings, each more admirable than the next, that the master had submitted. . . . [P]eople laughed and exchanged derisive remarks. I cannot remember, in my long career as a critic, such a disgraceful scandal.[8]

A few years earlier, Philippe Burty had also spoken of this "veritable Waterloo," recalling that, following this affront, "Delacroix, profoundly hurt, exhibited no more."[9]

This second version of *The Abduction of Rebecca* was definitely sold during the painter's lifetime, and may be connected with the dealer Tedesco, who in December 1860 would commission another painting based on Scott's novel depicting the moment when Bois-Guilbert falls dead after his duel with Ivanhoe.[10] However, the second *Abduction of Rebecca* was once again in Delacroix's studio at the time of his death, probably, as the inventory of his estate suggests (no. 440), so he could execute another version. The work had been sold in 1858 to the collector Jacques Félix Frédéric Hartmann, as proven by a letter dated October 10 of that year and housed in the Archives Piron (Archives des Musées Nationaux, Paris): "Monsieur, Mr. Jacques Hartmann of Munster has charged me with the duty of seeing you on the subject of a painting of Rebecca, which he thinks is finished. I address you, Monsieur, to know if this is in fact the case, and if so to ask you to send it to Mr. Hartmann and son[s], at 32, rue du Sentier."[11] The author of this letter, J. Hirth, reiterated his request on January 29, 1859, but the painting was apparently not delivered to Hartmann until 1861.

The reworking of the theme of the abduction described in *Ivanhoe* illustrates the extraordinary recapitulation that Delacroix undertook in the final years of his career, as he focused on subjects that he had explored during his youth and that, as old age approached, he seemed to want to recreate completely.

V. P.

1. *Journal,* May 26, 1856, p. 581.
2. *Journal,* June 29, 1856.
3. *Journal,* September 5, 1858, p. 731.
4. Astruc, 1859, pp. 225–75.
5. Perrier, 1859, p. 295.
6. Mantz, 1859, p. 137.
7. De Saint-Victor, 1859.
8. Robaut, 1885, no. 1383, repro.
9. Burty, 1878, p. 312.
10. *Correspondance,* vol. 4, p. 79; see also Johnson, 1986, vol. 3, no. 326, p. 145.
11. Archives Piron, Archives des Musée Nationaux, Paris.

92. *The Death of Desdemona*

1858
Oil on canvas; 25⁹⁄₁₆ x 21⅝ inches (65 x 55 cm)
Private collection (courtesy of the Nathan Gallery, Zurich)
Exhibited in Paris only

This unfinished canvas, which has not been exhibited in Paris since its sale at the Hôtel Drouot on October 27, 1975, is as far as we know the final expression of Delacroix's interest in Shakespeare's tragedy *Othello.* Desdemona's death takes place in scene 2 of the play's final act, and she is seen here lying on the bed after being smothered by Othello. Emilia, who has just entered the room, discovers the Moor next to his wife's body.

Delacroix began the work in August 1858 at Champrosay, where he had returned after a stay of about a month in Plombières. On September 5 the artist noted in his *Journal*:

> I have been poorly for the past few days. I've interrupted my painting. I made great progress on some paintings. The *Horses Coming Out of the Sea.* The *Arab with a Wounded Arm and His Horse.* The *Entombed Christ in the Cave,* torches, etc. The *Little Ivanhoe and Rebecca.* The *Centaur and Achilles.* The *Lion and Ambushed Hunters,* evening effect. The sketch of *Othello on the Body of Desdemona.*[1]

Was it a matter for regret that Delacroix, deeply absorbed at the time in his work at Saint-Sulpice and often exhausted, failed to finish this painting? Perhaps not. For as it stands, the scene is one of extraordinary drama, heightened by the lighting that falls violently, like a well-directed spotlight, onto Desdemona's pale corpse, leaving in oppressive semidarkness the figures on each side of the deathbed. The artist, a consummate stage director, has composed the scene in a way that captures the imagination but leaves spectators free to reconstruct for themselves the dreadful event that has just taken place.

Outlined with quick, feverish brushstrokes, the characters possess astonishing presence. Counterbalancing the ambiguous figure of Othello kneeling in the foreground (Still in the grip of his insane jealousy or already racked by despair?) is the horrified figure of Emilia, seizing the arm of her lifeless mistress.

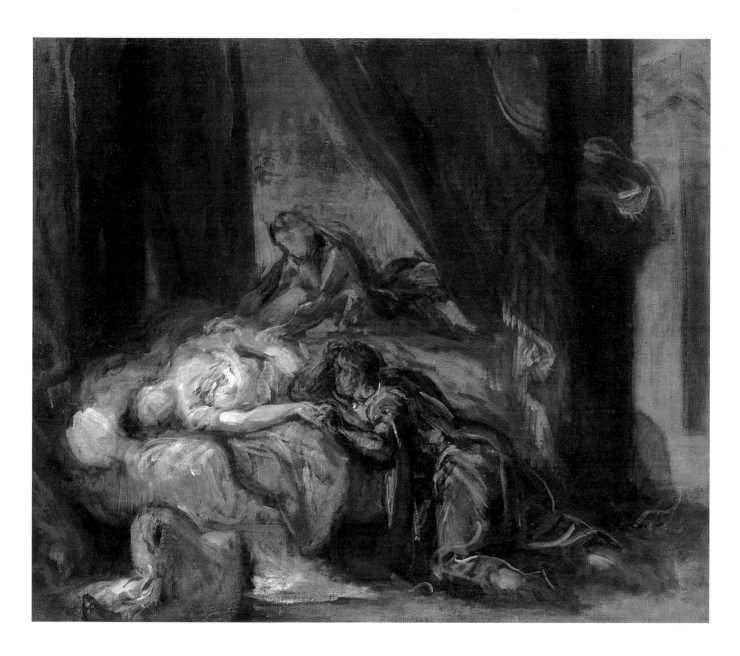

Compared to two drawings that Delacroix apparently executed in the 1820s,[2] which also depict Desdemona's death, this unfinished work exhibits a tragic force that testifies to the development of the artist's powers of expression in the later part of his life.

<div align="center">*A. S.*</div>

1. *Journal,* September 5, 1858, pp. 731–32.
2. One is in Paris, at the Musée du Louvre, Département des Arts Graphiques, RF 10 004 (M. Sérullaz, 1984, vol. 1, no. 548, repro.). The other was with Wildenstein in New York in 1978.

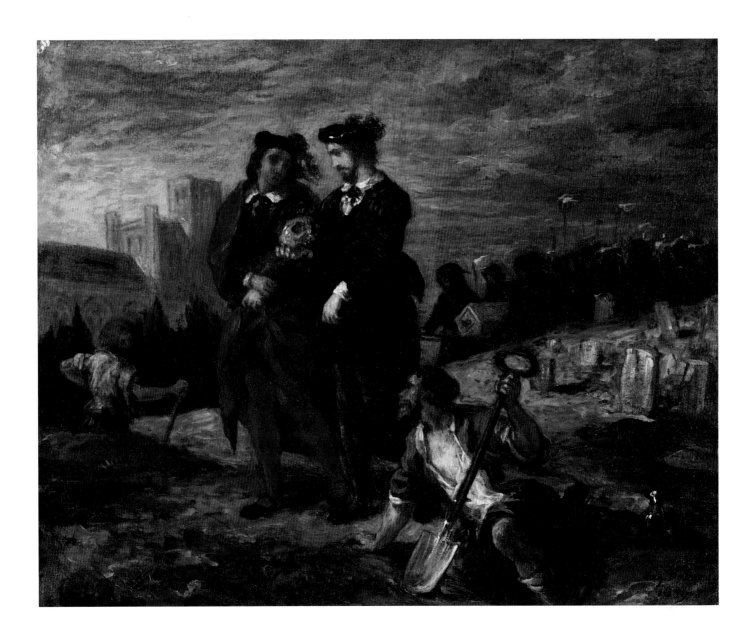

93. *Hamlet and Horatio in the Graveyard*

1859
Oil on canvas; 11⅝ x 14³⁄₁₆ inches (29.5 x 36 cm)
Signed and dated at lower right:
Eug. Delacroix / 1859.
Paris, Musée du Louvre (RF 1399)

This work, which is not mentioned in either Delacroix's *Journal* or his correspondence, is the last in the series of paintings and lithographs that the artist devoted to the famous dialogue between Hamlet and the gravedigger, which takes place in act 5, scene 1, of Shakespeare's play. In 1828 Delacroix had produced the lithograph *Hamlet Contemplating Yorick's Skull,*[1] and he executed a painting of the subject about the same time (location unknown), which in 1840 was included in the

posthumous sale of the painter Vauzelle.[2] The scene was also featured in the series of sixteen lithographs inspired by *Hamlet* that was completed in 1843.[3] In 1836 Delacroix submitted the canvas *Hamlet in the Cemetery* (Städelsches Kunstinstitut, Frankfurt) to the Salon jury, but the work was not accepted. He tried again in 1839, this time with more success: his *Hamlet* (Musée du Louvre, Paris) was both accepted by the jury and approved by the critics. Finally, in 1844, the artist painted a small vertical canvas on the same theme for Madame Cavé, which was shown in the boulevard des Italiens exhibition in 1864 (no. 80).[4]

The 1859 version, which presents essentially the same composition as the 1828 lithograph but in reverse, was moderately well received. In fact, the critics had more to say (and not all of it complimentary) about Delacroix's other Salon submissions for 1859—*Ovid Among the Scythians* (cat. 95), *Erminia and the Shepherds* (cat. 94), and *The Road to Calvary* (cat. 128). This was probably because

they felt that the painter had added nothing new to his earlier portrayals of the same subject. This, certainly, was the view expressed by A. J. Du Pays in *L'Illustration.*[5]

If we compare the painting to the one exhibited at the Salon of 1839, however, we notice several major changes in the format and the background, which now shows an additional architectural element at the left and a procession of monks carrying Ophelia's coffin at the right. The light emitted by the flickering torches reinforces the melancholy mood of the picture, in which Delacroix once again has combined two separate scenes from the drama: Ophelia's funeral and the discovery of Yorick's skull. Paul Mantz declared peremptorily that it was "a painting of no great interest, a remake hastily reaped from a field that once produced such splendid harvests."[6] Mathilde Stevens, although an enthusiastic supporter of the Delacroix cause ("Monsieur Ingres is a versifier, Delacroix is a poet; one has talent, the other genius") admitted her disappointment: "The execution is looser, and the impression created is less striking, in spite of the Shakespearean spirit inhabiting this small canvas. . . . I understand that we cannot always expect the painter to dot all the i's, but it is surely not too much to ask that all the dots have i's under them."[7] The reaction of Théophile Gautier, who was generally full of praise, was also rather circumspect:

> *Hamlet* is another of those figures that have taken on for Delacroix the status of obsessional specter. The Prince of Denmark brings the painter luck, and he owes him more than one masterpiece. The picture exhibited this year on the subject is not as important as the others. It is a little sketch that captures another moment: Ophelia's funeral procession leaves the cemetery.[8]

Several critics evidently disapproved strongly of the looseness of execution. H. Fouquier wrote: "Monsieur Delacroix . . . has eight paintings. *The Road to Calvary*, which is a small sketch of an unmade mural, *Erminia and the Shepherds, Rebecca Abducted*, a variant of *Hamlet, Ovid Among the Scythians, The Banks of the River Sebou, Saint Sebastian, Christ Entombed*. We will discuss only the four last works; the others are little more than unfortunate sketches."[9] Expressed in deliberately ambiguous terms, H. Dumesnil's comments betrayed similar reservations:

> There's no reason to dwell on either the *Abduction of Rebecca, Hamlet*, or *Erminia*; we have no wish to lose our deep respect for Monsieur Delacroix. We perceive the er-

rors, but it is not our place to offer advice; if we did have advice to give, it would be directed at a few of those detractors who have been so excessive in their criticism."[10]

Notable among some of the more favorable reviews are the rather confused remarks offered by Édouard Cadol in *L'Univers illustré*:

> Do you recall his Hamlet? It is one of the finest: it is the one that causes one to feel that Delacroix is the Shakespeare of painting. . . . To compare Delacroix with Shakespeare is right. They both possess the same power, the same impetuousness, the same faults. They will stay united in the future. And they are similar in another point; there are those who admit that they do not understand Shakespeare, as there are those who admit that they do not understand Delacroix. We can but feel pity for them all."[11]

Only a single critic—Zacharie Astruc—expressed unconditional admiration:

> You know this scene from Hamlet: it is the most powerful in this solid drama that should be as familiar to the masses as air, space, sky, infinity, plants. It sums up the human spirit, I believe, in perfect harmony. There is nothing missing from the moral and physical picture. . . . The lithograph popularized the first Hamlet. This one seems to me more complete as action. As sentiment, it goes further in its more intimate conception; as color, I believe it cannot be surpassed. In all justice, every element must be mentioned: Hamlet's striking vigor, the powerful demeanor of the seated gravedigger, the Horatio, the sunset, the sunlit towers, as well as the disorderly stones—the beautiful green background—and the very lifelike monks. Nothing overdone, contorted, meanly rendered. Everything is sweeping, broadly drawn in terms true to the idea. Shakespeare himself would not have drawn it otherwise. But look at the sky: it is bleak, uncertain, and yet vibrating with a secret passion! . . . Is it not the mirror of Hamlet's character? . . . Thus, one great poet translates another.[12]

A. S.

1. Delteil, 1908, no. 75, repro.
2. Johnson, 1986, vol. 3, no. L140.
3. Delteil, 1908, nos. 103–18, repro., especially no. 116.
4. Location unknown; Johnson, 1986, vol. 3, no. L148.
5. Du Pays, 1859, p. 339.
6. Mantz, 1859.
7. Stevens, 1859, pp. 28, 33.
8. Gautier, 1859.
9. Fouquier, 1859, p. 7.
10. Dumesnil, 1859, pp. 82–83.
11. Cadol, 1859, pp. 174–75.
12. Astruc, 1859, pp. 268–70.

94. *Erminia and the Shepherds*

1859
Oil on canvas; 32¼ x 40¹⁵⁄₁₆ inches
(82 x 104.5 cm)
Signed and dated at lower right:
Eug. Delacroix 1859.
Stockholm, Nationalmuseum (NM 2246)

At the same time he was exploring Ariosto's epic poems for new subjects (cat. 87), Eugène Delacroix was also rereading the heroic story of the delivery of Jerusalem as described by Tasso. In this text, much admired by nineteenth-century intellectuals, he found several potential themes whose poetic and imaginative content coincided perfectly with the lyrically mannerist aspirations embodied in the aesthetic vision of his later years.

On Friday, December 9, 1853, the artist noted in his *Journal* several possible themes for future works: "*Olindo and Sofronia, Clorinda, Erminia and the Shepherds*, and other subjects from the *Jerusalem*."[1] By April 14, 1856, he had settled on his choice: "I still have to do . . . the *Erminia*, 2,000 francs."[2] However, as was the case for all the works produced during this period, the painting's execution had its ups and downs. On June 29, 1856, he was beginning to doubt whether he would be able to complete the project: "I was not happy yesterday, on arriving [at Champrosay], with what I had left here, the *Erminia*, the *Bois-Guilbert Abducting Rebecca*."[3] But only a few days later, on July 4, he was congratulating himself on having finally arrived at the necessary technical solutions: "I spent the day at home. I went back to the painting of *Erminia* today, and I'm very pleased with it."[4]

The work is inspired by a secondary character in *Gerusalemme Liberata (Jerusalem Delivered)*, a romantic epic masterpiece by the Italian poet Torquato Tasso (1544–1595), produced between 1573 and 1581 and based on the capture of Jerusalem by Godfrey de Bouillon in 1099. The painting illustrates a short episode in the adventures of Erminia, daughter of the king of Antioch, who is hopelessly in love with one of the story's heroes, Tancred. He, among the bravest and most honorable of the Christian knights, is enamored of the young Clorinda, a Saracen warrior maid whom he eventually kills by mistake. After having been intercepted by a party of soldiers as she rides, Erminia, dressed as Clorinda, takes refuge in the Palestinian countryside to ascertain the state of Tancred's wounds. There, charmed by the singing of young shepherds, she draws near the group in order to listen. The shepherds are afraid of her military appearance, for she carries arms and wears armor, but the young woman reassures them by the gentleness of her words and demeanor. Tasso

eliminated this episode from the final version of his narrative, published in 1593 under the title *Gerusalemme Conquistata (Jerusalem Conquered)*; however, the first version was and remains the celebrated work.

Emphasizing the contrast between Erminia's friendly approach and the shepherds' fear, Delacroix has depicted their initial encounter, an uneasy moment that he described in the catalogue of the Salon of 1859, where the work was exhibited, by quoting the verse in canto 7 of *Jerusalem Delivered*:

> Beholding one in shining arms appear,
> The seely man and his were sore dismay'd
> But sweet Erminia comforted their fear,
> Her ventail up, her visage open laid.—
> You happy folk, of heav'n beloved dear,
> Work on, quoth she, upon your harmless trade;
> These dreadful arms I bear no warfare bring
> To your sweet toil, nor those sweet tunes you sing.[5]

This subject gave Delacroix the opportunity to explore further a theme of which he was particularly fond and which he had already treated in *Ovid Among the Scythians* (cat. 95): the encounter between civilization and the primitive world. It was a quintessentially Rousseauesque theme that the painter, a great admirer of the philosophers of the Enlightenment, could hardly fail to appreciate.

Once again, it seems that Delacroix's motives in painting this canvas were mixed; for although the subject was apparently the fruit of his efforts at the time to renew his sources of inspiration, the canvas was almost certainly commissioned, or at least reserved, by the dealer Tedesco, who paid the artist two thousand francs for it on March 29, 1859.[6] Moreover, on March 6 of the same year, Delacroix had complained to the dealer about the poor quality of the frame chosen for the Salon: "I have just placed your painting (the larger one) in the surround; it looks dreadful and will kill the painting at the Salon. I don't know where Gamba got that awful pattern. Another one must be made. Just allow me the time to finish my paintings and we can make the change."[7]

However, the fact that he selected this painting for exhibition at the annual Salon proves that Delacroix was genuinely proud of his unusual thematic choice. In this work, he revived the noble traditions of the Italian Renaissance—in fact, Domenichino (1581–1641) was one of the few painters before him to have used *Erminia and the Shepherds* as a subject (Musée du Louvre, Paris).

But the critics in general were not enthusiastic about this aesthetic experiment, which seemed so alien to Delacroix's character. Zacharie Astruc was one of the only defenders of the new direction, so clearly influenced by the Italian Renaissance and eighteenth-century French painters:

The groups of shepherds are of a superlative grandeur, the landscape can compare to Ovid's, the color, the light have a very special intensity and vitality, the characters are alive and mobile, the overall impression is one of a charming rusticity, an untamed grace, a naïveté, a simple and good nobility, a plain and benevolent peace for the passion-troubled soul, which exactly captures the spirit of Tasso.[8]

Maxime Du Camp, on the other hand, simply hated the picture: "Monsieur Delacroix has set his admirers a cruel test; how can they defend this Erminia, who is dressed like a Zouave and stands fifteen heads tall?"[9] A. J. Du Pays, who often gave Delacroix favorable reviews, reproached him for having introduced into the painting "the feeling and the manner of the decadent French painters of the eighteenth century."[10]

It is true that the compositional choices (the right side given over to an ill-defined landscape and the left side blocked by the shepherd's house), the scene's deliberate theatricality (Erminia makes an obviously soothing gesture to the shepherds, who

are rigid with fear), and the palette (far more conventional than usual) combine to give the work a mannerist quality—one that did not, fortunately, reappear in Delacroix's work. Nevertheless, the painting's admirable sense of tranquillity, the poetry of the landscape, and the rustic simplicity of the scene point to the subtlety of this brief digression in the painter's aesthetic development.

V. P.

1. *Journal,* December 9, 1853, p. 390.

2. *Journal,* April 14, 1856, p. 577.

3. *Journal,* June 29, 1856, p. 587.

4. *Journal,* July 4, 1856, p. 588.

5. Torquato Tasso, *Jerusalem Delivered,* translated by Edward Fairfax (1600), with an introduction by John Charles Nelson (New York: Capricorn Books, n.d.), p. 132.

6. *Correspondance,* vol. 4, p. 90.

7. *Correspondance,* vol. 4, p. 81.

8. Astruc, 1859, p. 264.

9. Du Camp, 1859, p. 32.

10. Du Pays, 1859.

95. *Ovid Among the Scythians*
or *Ovid in Exile*

1859
Oil on canvas; 34½ x 51¼ inches (87.6 x 130 cm)
Signed and dated at lower right:
Eug. Delacroix / 1859.
London, The National Gallery (NG 6262)

The idea of re-exploring the theme of Ovid in exile, which Delacroix had already illustrated in one of the pendentives for the ceiling of the library at the Palais Bourbon, seems to have come to the artist in 1849, only two years after this major decorative project was completed. On the list of possible subjects for easel paintings drawn up on Tuesday, April 10, 1849, the painter included "the subject of *Ovid in Exile* in a larger composition."[1]

The ceiling of the library of the Chambre des Députés in the Palais Bourbon, one of the most important decorative projects undertaken by Eugène Delacroix, consists of two half domes filled with contrapuntal works on allegorical themes *(Attila and His Hordes Overrun Italy and the Arts* and *Orpheus Civilizes the Greeks)* and a series of five cupolas, each with four pendentives. Delacroix decorated each pendentive of the five cupolas with allegorical paintings grouped under five themes— science, philosophy, legislation, theology, and poetry—that "echoed the divisions used for most libraries, although without following the precise classification."[2]

In the fifth cupola, devoted to poetry, alongside three compositions depicting *Alexander and the Poems of Homer, The Education of Achilles,* and *Hesiod and the Muse,* Delacroix included an *Ovid in Exile,* whose iconography he described in some detail in *Le Constitutionnel* on January 31, 1848: "He is seated sadly on the cold, naked earth, in a barbarian land. A Scythian family offers him simple gifts, mare's milk and wild fruit."[3]

The execution of this pendentive may have left Delacroix with a certain feeling of frustration, due, in part, to the restrictions of the hexagonal format imposed by the architecture—although he accommodated it with great virtuosity: the reclining figure of Ovid, at the left, and those of the Scythian peasants bringing him food, at the right, framed by a seaside landscape—but also because of the relatively small role that his pupils indicated he played in the work's execution. In fact, the pendentive devoted to Ovid is believed to have been painted around 1844 by one of Delacroix's assistants (possibly Philippe Lassalle-Bordes, but more likely Louis de Planet) after a detailed oil sketch.[4]

In any case, although he apparently had neither the time nor the opportunity to take up the subject again in the years that followed, Delacroix thought often of the Palais Bourbon *Ovid.* Moreover, a later note in the *Journal* lists the theme again as a subject for a possible future work.[5] It was not until 1856, though, through the mediation of his friend Benoît Fould, brother of a banker and minister to Napoléon III, that Delacroix was finally given the opportunity to return to the subject. On March 6, 1856, he noted that he had finished "the sketch for . . . Benoît Fould,"[6] and this drawing may well have been, as Lee Johnson has suggested, the sketch for a painting on the same theme as the Palais Bourbon pendentive, executed in order to obtain the sponsor's approval.[7] Furthermore, the painter visited Benoît Fould on March 11[8] (the two men saw each other at least once or twice a month), and it may well have been in order to present him with the sketch completed five days earlier.

Between March and May of 1856, Delacroix was very preoccupied with this painting. He mentioned it on March 21 in his *Correspondance* ("I've been busy with Monsieur Fould's commission"[9]), and he planned to transport it to Champrosay to be able to work on it in peace; however, it seems that he did not make much progress to start with, for on April 14 he wrote that he still had "to do the Ovid for Monsieur Fould," for six thousand francs.[10] On May 26, 1856, he recorded with satisfaction in his *Journal* that he had "made progress . . . with the painting of Ovid,"[11] and by November 24 of that year it was sufficiently advanced for him to consider sending it to the next Salon: "I could submit to the Salon: the *Small Landscape with Greeks,* the *Christ of Troyon* [cat. 118], and the *Landscape* I gave to Piron. Monsieur Fould's *Ovid.*"[12]

The death of Benoît Fould, which occurred in July 1858, could have compromised the original commission and thus affected the completion of the work, but Fould's widow, who was also a friend of the painter's, confirmed the purchase early in 1859.[13] And on June 17 of the same year she paid the artist for his work: "Allow me, sir, to discharge my debt to you and to tell you once again how much I am charmed by your beautiful painting, which I will make available to you as soon as you need it for the exhibition. . . . Enclosed 6,000 francs."[14]

The slowness with which the picture was executed (Delacroix worked on it for almost three years) apparently reflected the painter's fascination with this classical subject, which brought together two of his poetic and iconographical obsessions: the encounter between the artist of genius and uncultivated or uncivilized men, already treated in the 1839 work entitled *Tasso in the Hospital of Saint Anna* (Winterthur, Oskar Reinhart Collection), and the juxtaposition of civilization and barbarism, explored in some of his major decorative projects (cat. 64 and the pendant works

in the hemicycles of the Palais Bourbon library, *Attila* and *Orpheus*).

Delacroix wrote the title of this painting in pencil opposite an undated section of the *Journal* that describes the terrible but invigorating solitude of a man surrounded by uncivilized peoples:

> Setting for depicting the feeling of a heart and of a sick imagination, that of a man who, after a worldly life, finds himself enslaved among the barbarians, or cast onto a desert island like Robinson, forced to fall back on the strength of his body and his own industry—which restores to him natural feelings and calms his imagination.[15]

This idea of the return to a state of nature had been developed extensively by the philosophers of the Enlightenment, especially Jean-Jacques Rousseau, whom Delacroix reread regularly and admired passionately. Moreover, he obviously identified personally with the image of the poet living among savages. The content of this pivotal

work thus represented, a few years before the artist's death, something of a summary of his philosophical and aesthetic convictions.

Ovid, or Publius Ovidius Naso (43 B.C.–A.D. 17/18), was one of the most celebrated poets in aristocratic Roman society of the early Empire. He owed his initial fame to elegiac poems inspired by mythology and the Greek poets, and his major works include *Heroides*, *Ars amatoria (The Art of Love)*, and *Metamorphoses*. On several occasions, Delacroix had used *Metamorphoses* as a source of inspiration (cats. 64, 66, and 67). Banished in A.D. 8 by Emperor Augustus for some unknown indiscretion, Ovid was exiled to Tomi, a village on the shores of the Black Sea at the very farthest reaches of the Empire, in what is now Romania. This region was inhabited at the time by the Scythians, a rough Persian-speaking group of warriors and horsemen who had settled in the area between the Danube and the Don in the twelfth century B.C. Despite repeated poetic supplications to Rome for

pardon, Ovid remained there until his death. His remarkable writings were eventually published as two collections: the *Tristia* (called *Songs of Sadness* in some English translations) and the *Epistulae ex Ponto (Letters from the Black Sea)*.

Inspired by this rarely portrayed episode of ancient history, Delacroix chose to illustrate—both for the Palais Bourbon ceiling and the painting under discussion here (which cannot be described as a replica, given the fundamental differences between it and the first version)—the reception that the barbarian Scythians gave to Ovid when, newly arrived on the Romanian coast, the poet gave way to despair at his exile. In the Salon catalogue, Delacroix described the moment as follows: "Ovid in exile among the Scythians. Some of them examine him with curiosity, others welcome him in their own way, offering him mare's milk, wild fruit, etc."[16]

In order to capture the various reactions of the Scythians to the Roman poet, who is easily recognizable, reclining in a toga-like garment on the ground to the left of center, the painter has placed several groups of figures in the foreground: at the left, a child accompanied by a large dog stares curiously at Ovid; in the center, two hunters or shepherds and a woman holding an infant talk to him and offer him food; in the extreme right foreground, a man milks a mare; and to the far right of the composition, two seated shepherds discuss the event. Meanwhile, in the center middle ground, two men, one on horseback and the other walking, move toward the poet.

Great care has evidently been taken in the positioning of the various figures. By arranging them in a skillfully balanced frieze toward the front of the picture, Delacroix was striving for that blend of aesthetic and intellectual harmony characteristic of the paintings of the Italian Renaissance or, more obviously still, of the landscapes of Nicolas

Poussin (1594–1665)—*Landscape with a Man Killed by a Snake* (National Gallery, London), for example, or *Landscape with Orpheus and Eurydice* (Musée du Louvre, Paris). The proportions of the figures in relation to the landscape are also markedly Poussinesque.

The scene's setting contributes greatly to the strange but serenely poetic atmosphere conjured up by the work. The landscape may have been inspired by memories of Morocco—the wild mountains in the background seem to indicate this—or, as was suggested by one of the curators of the exhibition in Edinburgh and London in 1964, it may have been based on one of the landscapes illustrating the narratives of the Pacific Ocean voyages of James Cook (1728–1779).[17] On a sketch that is relevant to this painting, Delacroix noted his interest in those landscapes.

Ovid Among the Scythians was finally exhibited at the Salon of 1859, for which Delacroix had selected a number of works that varied widely in both iconographical and formal terms. While the rest of Delacroix's Salon submissions drew a good deal of hostile criticism, this painting was one of the works most admired by the critics that year. Despite a few negative comments concerning the proportions of some of the figures—Paul de Saint-Victor fumed about the "gigantic beast cluttering up the foreground" and looking, according to him, as if it had been "foaled by the Trojan Horse"— reactions to the work were generally good.[18] Paul Mantz, for example, was very enthusiastic, judging it "one of the most beautiful, one of the most poetic landscapes that ever transfigured his dreams," although he did disapprove of certain compositional oddities.[19]

But the most insightful and poetic discussion of the painting is the long essay published by Charles Baudelaire in *La Revue française*. One of the poet's finest texts on Delacroix's work, it

proves that he understood the significance of the painting's theme:

> Look next upon the famous poet who taught the *Art of Love;* there he is, lying on the wild grass, with a soft sadness that is almost that of a woman. Will his noble friends in Rome be able to quell the emperor's spite? Will he one day know again the luxurious pleasures of that prodigious city? No: from this inglorious land the long and melancholy river of the *Tristia* will flow in vain; here he is to live and to die. . . . All the delicacy and fertility of talent that Ovid possessed have passed into Delacroix's picture. And just as exile gave the brilliant poet that quality of sadness which he had hitherto lacked, so melancholy has clothed the painter's superabundant landscape with its own magical glaze. I find it impossible to say that any one of Delacroix's pictures is his best, for the wine always comes from the same cask, heady, exquisite, *sui generis;* but it can be said of *Ovid Among the Scythians* that it is one of those wonderful works such as Delacroix alone can conceive and paint. The artist who has painted this can count himself a happy man, and he who is able to feast his eyes upon it every day may also call himself happy. The mind sinks into it with a slow and appreciative rapture, as it would sink into the heavens, or into the sea's horizon—into eyes brimming with thought, or a rich and fertile drift of reverie.[20]

Despite Baudelaire's impassioned and reassuring words, Eugène Delacroix was profoundly hurt by the harsh reception offered his works that year, and when, on August 25, he copied into his *Journal* the preface of the first edition of Nicolas Boileau's writings, he no doubt had his own experience in mind:

> "I admit nevertheless, and it cannot be denied, that sometimes, when excellent works appear, intrigue and envy succeed in diminishing them and apparently throwing doubt upon their success; but this does not last, and what happens to these works is like what happens to a piece of wood that we push beneath the water with our hand: it stays at the bottom as long as it is held, but when the hand grows weary, it rises back up to the surface."[21]

V. P.

1. *Journal,* April 10, 1849, p. 190.
2. Delacroix, 1848.
3. Delacroix, 1848.
4. For more on how the work for this decorative project was divided among Delacroix's assistants, see M. Sérullaz, 1963(b), pp. 57–59.
5. *Journal,* December 9, 1853, p. 390.
6. *Journal,* March 6, 1856, p. 571.
7. Johnson, 1986, vol. 3, no. 334, p. 151.
8. *Journal,* March 11, 1856, p. 572.
9. *Correspondance,* vol. 3, March 21, 1856, p. 320.
10. *Journal,* March 27, 1856, and April 14, 1856, pp. 573, 577.
11. *Journal,* May 26, 1856, p. 581.
12. *Journal,* November 24, 1856, p. 598.
13. Unpublished letters of Hélène Fould, March 21 and June 19, 1859, Archives Piron, Archives des Musées Nationaux, Paris.
14. Unpublished letter of Hélène Fould, June 17, 1859, Archives Piron, Archives des Musées Nationaux, Paris.
15. Supplement to the *Journal,* undated, p. 839.
16. Catalogue, Salon of 1859, no. 822.
17. 1964, Edinburgh and London, no. 69.
18. De Saint-Victor, 1859.
19. Mantz, 1859, p. 137.
20. Quoted in *Charles Baudelaire: Art in Paris 1845–1862,* translated and edited by Jonathan Mayne (London: Phaidon Press, 1965), pp. 169–71.
21. *Journal,* August 25, 1859, p. 741.

96. *Amadis de Gaule Delivers a Damsel from Galpan's Castle*

1860
Oil on canvas; 21½ x 25¾ inches
(54.6 x 65.4 cm)
Signed and dated at lower left:
Eug. Delacroix 1860
Richmond, Virginia Museum of Fine Arts,
The Adolph D. and Wilkins C. Williams Fund
(57.1)

The chivalric epic of *Amadis de Gaule (Amadis of Gaul)* was enormously popular throughout Europe in the late Middle Ages. The first four books, long attributed to the Portuguese poet Vasco de Lobeira, were published in 1508 in Saragossa by the Spanish writer Garcia Rodriguez de Montalvo under the title *Los Quatro libros del virtuoso cavalerro Amadis de Gaula.* They recount the adventures of the knight Amadis; the remaining nine books tell the stories of his descendants. It is now acknowledged that Rodriguez de Montalvo adapted the chivalric adventures of this invincible and generous-hearted warrior from a medieval Spanish or possibly Provençal source, which itself was based on even earlier texts dating from the mid-thirteenth century and loosely inspired by the tales of the knight Lancelot, written in the twelfth century by the French poet Chrétien de Troyes. The Spanish translation of Egidio Colonna's *De regimine principum,* which appeared in 1350, already contained direct references to the exploits of Amadis.

As indicated by the many translations produced—the narrative was published for the first time in French by Nicolas de Herbelay in the early sixteenth century—and especially by the lyrical adaptation created by Jean-Baptiste Lully for an opera first performed at the court of Versailles in 1684, by the seventeenth century the text's fame had already spread far beyond the Iberian Peninsula, and it was eventually to become one of the great courtly epics of all time.

Delacroix could hardly have failed to admire the literary qualities of this romantic epic, and Lee Johnson has suggested that he probably used the very beautiful free translation by the comte de Tressan, which appeared in 1779 and in the mid-nineteenth century was still the finest available.[1] Although the painter chose for this work an extremely rare literary theme, hitherto unexploited in the fine arts, he was nevertheless in line with the latest literary fashion, for a popular version of the epic had just appeared in 1859 under the evocative title of *Chevalier de la mer (Knight of the Sea).*[2] The painting was acquired by the dealer Cachardy, who may have had a special fondness for the text, by then easily available in bookstores, or a broader taste for the romantic medieval narratives that had become so popular since the beginning of the century. But it seems that the initial inspiration for the picture was entirely Delacroix's own: the work is first mentioned on August 6, 1859, by Cachardy, who spotted it in the painter's studio, purchased it, and then apparently sold it to Claudius Gérantet, a collector from Saint-Étienne:

> I have not forgotten that on my last visit to your studio you were good enough to promise for sometime this summer a painting that was started, a subject taken from *Amadis,* I believe. I liked this canvas. I still remember it and I am now asking if, as you promised, I can hope to hear from you soon. I am always impatient when it comes to possessing one of your works.[3]

By November 27 of that year, Delacroix still had not delivered the painting to the dealer, and Cachardy was energetically negotiating the final price:

> Though I have reached the age of reason, my passions must be weakened. For each time I see one of your paintings, I am transported, and I would pay any amount of money if I could and if you asked it, but once back home I am forced to consult my resources and my budget. This is to say, dear Sir, that I sensibly (I told you) saved 2,000 francs for your transaction. If it is impossible for you to give up your painting for this sum, it would be difficult for me to go higher. If you refuse me, I shall be sorry, and I think that if a sacrifice is to be made, it should be on the side of he who possesses. . . .[4]

By December 20, the deal had been settled.

Amadis de Gaule, an exemplification of all the chivalric ideals of valor, purity, and fidelity, who fought injustice and defended the poor wherever he went, was the illegitimate son of noble parents: his father was the king of France and his mother the princess of Brittany. According to the story, he falls in love at the age of twelve with the sweet and beautiful Oriana, daughter of the king of Denmark, and must subsequently undertake a series of tests and courtly penances in order to win her affection. Nicknamed both the "Lion Knight" and "Beltenebros" (darkly beautiful), he travels widely, engaging in endless battles against the most formidable opponents and surviving almost impossible initiatory exploits, emerging each time stronger, more courageous, and more loyal. Despite his unwavering love for his eternal fiancée, however, Amadis spends a good deal of time and energy saving desirable and mysterious young women who have been abducted or assaulted by a series of dark knights. One such is the

Princess Grindaloia, imprisoned in the castle of Arcalaüs at Valderin; another is the unnamed damsel dishonored by the traitor Galpan, whom the gallant Amadis expeditiously decapitates.

As Lee Johnson noted in 1962, although Delacroix evidently knew the original text, it seems that in his choice of subject for this painting he confused two separate episodes from the narrative.[5] The artist summarized his subject in a charming letter to the work's owner, Claudius Gérantet:

> My dear Sir, I thank you for your concern. I am myself a little indisposed and it would have been difficult for me to go and see you. I am very happy that you like the painting: nothing you could say would give me greater pleasure: do not varnish it, even lightly, is all I would ask. Your devoted servant, Eug. Delacroix. This is the picture's subject: Amadis de Gaule storms the castle of Galpan the traitor and rescues the princess imprisoned therein.[6]

Comparing the original text of *Amadis de Gaule* with Delacroix's painting, Johnson rightly pointed out that the damsel avenged by Amadis in this episode, whom he encounters on a country road, was not imprisoned inside Galpan's castle, nor was she a princess. An event that occurs in a later chapter of book 1—the deliverance of Grindaloia, imprisoned and enchained inside a castle that the knight, after heroic efforts, finally captures—seems far closer to the scene depicted by Delacroix. Moreover, the artist included this latter episode in a list of possible painting projects drawn up some ten years earlier: "Among the prisoners he frees, having slaughtered the guards, Amadis finds a young woman dressed in rags and chained to a pillar. As soon as he frees her, she clasps him around the knees."[7] It therefore seems that Delacroix combined two extracts from the chivalric tale—either because he no longer pos-

sessed a copy of the original and conflated the many turns of the plot, or because he chose to blend the two episodes for the sake of iconographic and dramatic power.

The artist evidently began thinking about the painting at least two years before it was finally signed and sold, for he mentioned the subject in his *Journal* on May 23, 1858, this time giving an account that is far closer to the original story: "The unfortunate lady at Amadis's feet during the sacking of the castle."[8]

Having created a background of medieval architecture very similar to that seen in *The Abduction of Rebecca* (cat. 91), exhibited at the previous year's Salon, Delacroix evidently aimed to enliven his composition and give added depth to the pictorial space by placing several groups of fighting soldiers at different points in the perspective. But in addition to these lively and expressive scenes, the carefully balanced composition, and the extraordinarily skillful handling of the various objects that lie, apparently by chance, in the foreground, the artist has devoted considerable attention to the scene's two main protagonists: Amadis, who stands, and the young woman, whom he is about to help to her feet but who still kneels, in chains, her tattered garments revealing a complexion of luminous sensuality. A preparatory drawing in the Louvre (Département des Arts Graphiques, RF 9736) bears witness to the extreme care with which Delacroix rendered these two figures. A sol-dier's corpse lying on the ground behind them serves as a reminder of the fierce struggle that led to the prisoner's release.

Aesthetically and iconographically, this work is rather conservative, and in its unusual but somewhat naïve and mannered subject, Delacroix was making obvious concessions to the current bourgeois taste for the legendary Middle Ages. Nevertheless, the artist has achieved some interesting chromatic effects, including the way the brilliant red of the tunics worn by the two soldiers on either side of Amadis and Grindaloia enhances the delicate contrast between the blue of the knight's garment and the orange red of the young woman's skirt.

V. P.

1. Johnson, 1986, vol. 3, no. 336, p. 153.

2. *Première série d'Amadis de Gaule: Réimpressions des romans de chevalerie. . .*, edited by Alfred Delvau (Paris, 1859).

3. Cachardy to Delacroix, August 6, 1859, Archives Piron, Archives des Musées Nationaux, Paris.

4. Cachardy to Delacroix, November 27, 1859, Archives Piron, Archives des Musées Nationaux, Paris.

5. Johnson in 1962–63, Toronto and Canada, no. 24.

6. Delacroix to Gérantet, January 4, 1860, transcribed by Alfred Robaut and housed in the Robaut Annoté at the Bibliothèque Nationale de France, Paris.

7. Supplement to the *Journal*, undated, p. 873.

8. *Journal*, May 23, 1858, p. 720.

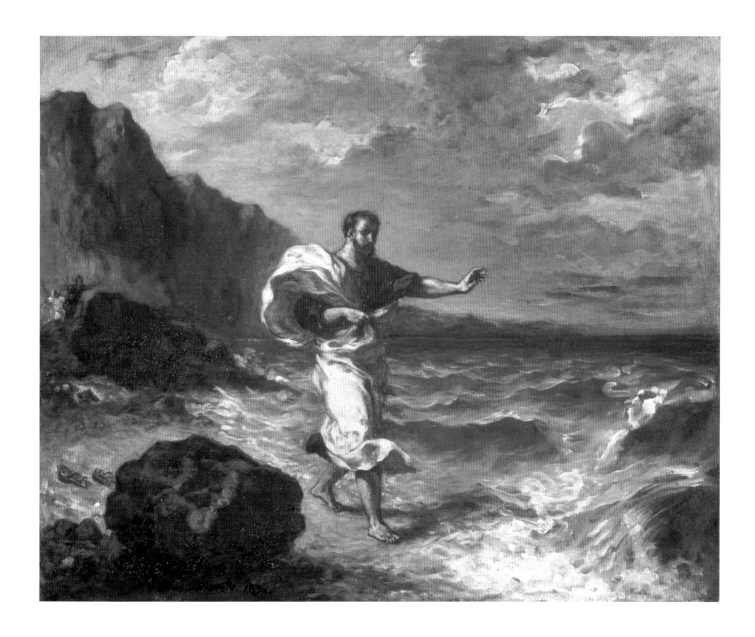

97. Demosthenes Declaiming by the Seashore

1859
Oil on paper mounted on wood;
19⁹⁄₁₆ x 23⁷⁄₁₆ inches (49 x 59.5 cm)
Signed and dated at lower left, below the rock:
Eug. Delacroix. 1859.
Dublin, The National Gallery of Ireland
(inv. 964)

After 1850 Delacroix began to receive frequent requests from dealers and art lovers to paint variants (generally incorporating a number of changes) of the murals he had executed for public buildings throughout Paris (see cats. 64 and 95). That was probably how this picture came about. Possibly executed for the dealer Francis Petit, who owned it in 1860, it is a remake of *Demosthenes Declaiming by*

the Seashore, a subject first explored in the pendentive devoted to legislation at the library of the Palais Bourbon.

After overcoming serious speech defects, the Greek Demosthenes (384–322 B.C.) gained fame as a lawyer, orator, and one of the most important political figures in Athens (he dared to oppose both Philip of Macedonia and his son, Alexander the Great). This classical figure was thus for Delacroix the ideal embodiment of the themes he had chosen to illustrate as part of the decoration for the Chambre des Députés of the Palais Bourbon. When this major project was finished in 1847, almost ten years after it was undertaken, the artist described the pendentive that inspired it in the following terms: "Demosthenes declaims to the waves in order to harden himself to the turmoil and excitement of the assemblies of the Athenian people. He is standing, barely covered by a mantle, which the furious wind lifts around his head. Half hidden by some rocks, two young peasants watch him in surprise."[1]

Fig. 1
EUGÈNE DELACROIX,
*Demosthenes Declaiming by the
Seashore.* c. 1859, graphite on
paper, Paris, Musée du Louvre,
Département des Arts
Graphiques.

98. *Ugolino and His Sons in the Tower*

1856–60
Oil on canvas; 19¹¹⁄₁₆ x 24 inches (50 x 61 cm)
Signed and dated at lower right:
Eug Delacroix 1860.
Copenhagen, Ordrupgaard

In spite of its identical subject, the 1859 variant differs in a number of ways from the 1847 decoration: in its format, which is strictly rectangular, in contrast to the polygonal shape imposed by the architectural setting; in the emphasis on the sky and landscape, which here possess a marked lyricism; and in the pose of Demosthenes, which in this second version recalls the traditional iconography of Christ walking on the water (a similarity that is even more evident in the preparatory drawing now at the Louvre; fig. 1). During this period Delacroix made several depictions of this episode in the life of Demosthenes, and at least two other variants are known today.[2]

The 1859 work inspired by the Palais Bourbon decoration was first shown to the public at the boulevard des Italiens exhibition, which included several of Delacroix's recent paintings. Théophile Gautier was impressed above all with the landscape: "One of the best marine paintings I have ever seen. It is apparently a study from nature, to which the artist added the classical figure later, to make the painting! The sea ripples, breaks, foams, crashes, and does its best to drown the voice of the orator."[3] On the same occasion, Zacharie Astruc could not refrain from the following naïve but touching outburst of admiration: "Who could convey as Delacroix does the great voice of the Ocean! He is the poet of philosophies and of the furies of nature."[4]

V. P.

1. Thoré, 1848.
2. Private collection; Johnson, 1986, vol. 3, no. 347, pl.
149, and no. R48. Lee Johnson has identified the second of
these two works as a studio replica.
3. Gautier, 1860 (b), p. 202.
4. Astruc, 1860.

Near the end of his career, only three years before his death—thirty-eight years after exhibiting *The Barque of Dante* (Musée du Louvre, Paris) at the Salon of 1822 and exactly twenty years after the success of *The Justice of Trajan* (Musée des Beaux-Arts, Rouen)—Eugène Delacroix returned to one of the favorite authors of his youth, Dante Alighieri (1265–1321). This picture of Ugolino and his sons, painted for the dealer Estienne,[1] probably was inspired by various motivations—it is not easy to disentangle the threads of commercialism, personal inspiration, and the artist's desire to re-explore the themes of his younger days. Nevertheless, in the painting's theatrical power and technical virtuosity there are definite echoes of Delacroix's earlier romantic preoccupations, as if he were striving to call up one last time the passionate spirit and dramatic excesses of 1830 that he had relinquished, to some extent, in his mature work and major decorative commissions.

The theme of Ugolino's dramatic death, taken from Dante's *Inferno,* seems to have haunted the painter for over a decade, for we learn from his *Journal* that he was already working on a depiction of the subject in June 1847—although it is not known whether the reference was to this particular work or to an earlier one. In fact, Lee Johnson has suggested that some entries in the *Journal*—which up until 1850 contain regular and detailed references to the execution of a painting of Ugolino— may be related to another picture, possibly a first version of the subject begun in 1849, which may have belonged to Paul Tesse: "Regained interest in . . . Ugolino";[2] "Took up the *Ugolino* again; made several improvements";[3] "Worked on the *Ugolino*";[4] "Worked today, yesterday, and the day before on the *Count Ugolino.*"[5] A rather odd letter to Delacroix from the dealer Estienne indicates, moreover, that the subject had attracted the attention of more than one enthusiast: "I forgot to ask you this morning not to tell Monsieur Tesse when he comes to visit you that you are doing two paintings for me; if he sees them, you would oblige me by not letting him know they are for me because I do not wish to sell him either."[6]

Recalling the 1864 statement by Cantaloube that Delacroix had painted two canvases of the subject, Johnson pointed out that the drawing in the Louvre (fig. 1), generally considered to be a preparatory sketch for the Copenhagen painting,

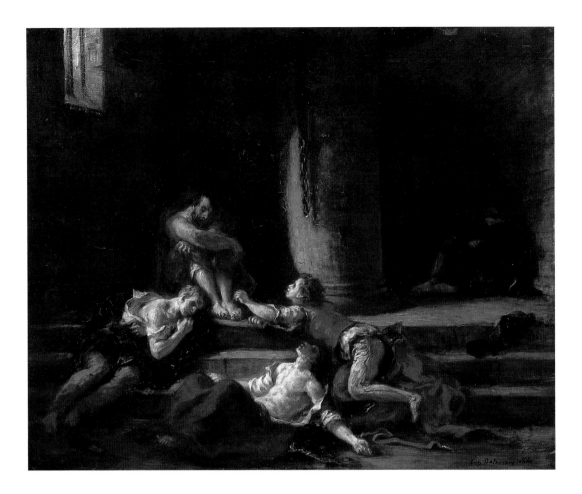

differs from it in several ways and may therefore be related to an earlier version, whose whereabouts are today unknown.[7]

If we accept this hypothesis, two later *Journal* entries would seem to be related to the present work. The first note would imply that Delacroix began this second version around 1856: "I went back to the painting of *Erminia* today. . . . Yesterday, did the same for *Ugolino*."[8] The second *Journal* entry apparently indicates that the work was completed in 1860: "What I have done in the space of three weeks or a month and more, until today June 14 [*sic*] . . . is incredible. I've finished for Estienne . . . *Ugolino*."[9]

It is a cruel and dramatic episode of Dante's *Inferno* that Delacroix chose to portray: the story of count Ugolino della Gherardesca, who died in 1288. This historical figure was a tyrant from Pisa originally affiliated with the Ghibelline party, which he betrayed in order to take power by allying himself with the Guelphs (whom Dante himself supported during the latter part of his life). Ugolino earned a reputation as one of Italy's most bloodthirsty politicians. Accused of treachery by his principal rival, Ruggieri degli Ubaldini, archbishop of Pisa, Ugolino was arrested and imprisoned in a tower with his sons and grandsons, where they were left to die of starvation.

During their imaginary trip through the realm of the damned, Dante and Virgil encounter many

sinners, among them Ugolino, who tells them of the terrible days leading up to his death:

> When I awoke before the light of dawn,
> I heard my children sobbing in their sleep
> (you see they, too, were there) asking for bread. . . .
>
> And then they awoke. It was around the time
> they usually brought our food to us. But now
> each one of us was full of dread from dreaming;
>
> then from below I heard them driving nails
> into the dreadful tower's door; with that,
> I stared in silence at my flesh and blood.

Fig. 2
EUGÈNE DELACROIX, *The Prisoner of Chillon,* 1834, oil on canvas, Paris, Musée du Louvre.

I did not weep, I turned to stone inside; . . .

A meager ray of sunlight found its way
 to the misery of our cell, and I could see
 myself reflected four times in their faces;

I bit my hands in anguish. And my children,
 who thought that hunger made me bite my hands
 were quick to draw up closer to me, saying:

"O father, you would make us suffer less,
 if you would feed on us: you were the one
 who gave us this sad flesh; you take it from us!"

I calmed myself to make them less unhappy. . . .

The fourth day came, and it was on that day
 my Gaddo fell prostrate before my feet,
 crying: "Why don't you help me? Why, my father?"

There he died. Just as you see me here,
 I saw the other three fall one by one,
 as the fifth day and the sixth day passed. And I,

by then gone blind, groped over their dead bodies.
 Though they were dead, two days I called their names.
 Then hunger proved more powerful than grief."[10]

Of this nightmarish and hopeless tale, in which the father ends by eating the flesh of his children before dying himself, Delacroix chose the moment when one of the sons, the youthful Gaddo, throws himself at his father's feet before expiring, which marks the start of Ugolino's own protracted death, both physically and morally. This powerfully composed and extraordinarily gripping painting is strikingly reminiscent of certain of Delacroix's early works, notably *The Prisoner of Chillon* (fig. 2),

inspired by the poem written by Lord Byron for the duc and duchesse d'Orléans in 1834, and *Tasso in the Hospital of Saint Anna* (Oskar Reinhart Collection, Winterthur), exhibited at the Salon of 1839. As in these two works, which can be classified both thematically and aesthetically as Romantic, Delacroix has employed an emphatic chiaroscuro for his image of Ugolino: the room is plunged into a pervasive gloom, out of which emerge, lit by the gleam from a window high up on the left, the lonely and pathetic forms of the doomed prisoners. The figures of Ugolino and three of his children are carefully arranged in the lower-left section of the painting, each in a pose that suggests a different psychological state. As Gaddo reaches imploringly toward his father, another son, arms outstretched, appears to be already dead, while the third crouches at his father's feet, crushed by suffering. The fourth child lingers alone in the shadows toward the back of the cell to the right, cut off from his family.

In the same spirit that marks his youthful works, Delacroix concentrated here on the expressiveness of the figures, the evocation of their physical and mental pain, and the dramatization of the action. In this, he remained true to the Romantic approach to a subject that had already been treated by Antoine-Jean Gros (1771–1835) and Théodore Géricault (1791–1824)—two members of this movement to whom he was very close at the start of his career—and that would be interpreted again two years later by one of the most Romantic sculptors of the new generation, Jean-Baptiste Carpeaux (1827–1875).

V. P.

1. *Journal,* April 14, 1860, p. 780.
2. Johnson, 1986, vol. 3, no. 337, p. 154; *Journal,* June 29, 1847, p. 159.
3. *Journal,* February 3, 1849, p. 174.
4. *Journal,* June 17, 1849, p. 197.
5. *Journal,* May 6, 1850, p. 235.
6. Undated, unpublished letter, Archives Piron, Archives des Musées Nationaux, Paris.
7. Johnson, 1986, vol. 3, no. 337, p. 154.
8. *Journal,* July 4, 1856, p. 588.
9. *Journal,* April 14, 1860, p. 780; note the discrepancy in the month.
10. *Dante's Inferno,* translated and with notes and commentary by Mark Musa (Bloomington and London: Indiana University Press, 1971), canto 33, pp. 272–73.

V

THE LESSON OF
MOROCCO

"My dear friend, I am about to take off for a fairly important affair. I will probably leave for Morocco next week. Don't laugh; it's perfectly true. I am therefore very harried."[1] Eugène Delacroix had just been called on to drop everything and accompany Charles de Mornay, who had been summoned by the king, Louis-Philippe, to appear before the sultan of Morocco, Moulay Abd er-Rahman. As he dashed off these lines to his friend Frédéric Villot on December 8, 1831, Delacroix had no inkling of the impact that this journey abroad would have on his work. Nonetheless, the unexpected invitation proved thrilling to the artist, who had been bewitched since his youth by the enchantments of a more or less imaginary Orient.

There is no need to recount in detail the many episodes in a visit that would last nearly six months (from the end of January to June 1832) and that was the subject of the exhibition *Delacroix: Le Voyage au Maroc* held by the Institut du Monde Arabe in Paris in 1994–95. It is worth noting, however, that the purpose of the legation rushed to Morocco was to put out several diplomatic brushfires. Among them, the most urgent concerned the setting of borders, which had been a constant source of conflict between the two countries since France's recent occupation of Algeria. While a partial solution was achieved, tensions remained so high that only a military encounter would ultimately dispel them. In addition, everything conspired to make de Mornay's mission problematic. The French party had barely set foot on Moroccan soil (on January 25, 1832) when the beginning of Ramadan prevented them from traveling to Meknes, where the sultan was in residence. Authorization to travel was finally granted on February 15, 1832. Ten days later, however, came the announcement of the death of the sultan's brother, Moulay Meimoun, near Marrakech. This left everything unsettled as the Moroccan court went into mourning. And when, on March 5, the delegation finally set off, it was entirely enveloped by a troop of more than one hundred cavalrymen from the garrison at Tangier, because the route passed through dangerous territory. On their arrival in Meknes on March 15, the French envoys faced another situation guaranteed to test a diplomat's nerves. By order of Moulay Abd er-Rahman—who was unwilling to run the risk of a dangerous confrontation between the French envoys and the deputation from Tlemcen, Algeria, that had come to render allegiance to the sultan—the French were constrained to remain within specific bounds.

On March 22, the much-awaited audience was finally granted, allowing the negotiations to begin. No fewer than eleven meetings were required to arrive at the promise of an agreement, a promise that could not be definitively confirmed until the beginning of June—though de Mornay and his companions had gone back to Tangier on April 12. On June 10, the delegation left Morocco on the same boat *(La Perle)* that had brought them there, putting in at Oran and then Algiers before arriving on July 5 at Toulon, where health regulations required them to stay under quarantine at a hospital until July 20.

With absolutely no official obligations to bind him, Delacroix had complete freedom to slake the curiosity that consumed him from the moment he arrived in Tangier: "I have just gone through the city. I am giddy with all that I've seen. . . . We have landed amid the most extraordinary people. The pasha of the city received us surrounded by his soldiers. A person needs twenty arms and forty-eight hours in a day to do a passable job of conveying all this."[2] As the days slipped by while the delegation awaited word from the sultan, the painter gradually learned the customs of a land rich in secular traditions. Stimulated by and filled with wonder at his discoveries, he tried to retain every detail, as witnessed by the accumulation of notes and sketches that turned his notebooks into a lively illustrated journal: "Little by little I am insinuating myself into the ways of the country, so that I can easily draw many of these Moroccan figures. They have enormous prejudices against the fine art of painting, but a few coins here and there settle their scruples. I am making excursions into the outskirts by horse, which give me immense pleasure, and I have moments of delectable indolence in a garden at the gates of the city, under the profusion of orange trees in flower and covered with fruit."[3]

Delacroix pursued this education of the eye and the senses to the rhythm of the stopovers and the numerous incidents that marked the passage between Tangier and Meknes. Despite weariness and discomfort, the painter did not let a single detail of the grand panorama that unrolled before him escape. He drew rapidly, sometimes even from the saddle, the bluish or purplish (depending on the time of day) curves of the Atlas Mountains, the movements of the cavalry, the hubbub of setting up camp, and the noisy confusion of the Arab displays of shooting called "powder plays." As soon as authorization was given to move freely around Meknes, and despite the inhabitants' hostility—"You are surrounded by an abominable crowd to whom the dress and countenance of the Christian is abominable and who hurls in your face every possible insult"[4]—Delacroix tirelessly surveyed the city, as he had done in Tangier. He could sketch only hastily the sudden appearance of Moulay Abd er-Rahman in the public square; but when he was not looking for the best views from the terraces of the Jewish quarter, not far from the royal palace, he ventured through the city gates of Meknes to go horseback riding in the countryside. By the end of his sojourn, the lively action of the markets and streets held no secrets for him. On the return trip, traveling the same route that had brought the party to Meknes, Delacroix noted the changes that had taken place in the vegetation, now profusely colored by spring: "Crossed many mountains. Large areas of yellow, white, purple flowers" (April 6, 1832); "innumerable flowers of a thousand species forming the most variegated carpet" (April 8); "beautiful mountainous country, rich blue violet, to the right. Violet mountains morning and night. Blue during the day. Carpet of yellow and purple flowers before arriving at the river Whad el Maghazin. . . . Very lovely blue mountains to the left as far as the eye can see; carpet of white, bright yellow, dark yellow, purple flowers."[5]

Devoting himself to his daily exercise—drawing—up to the day of his departure for France, Delacroix took advantage of the hospitality of Tangier's Jewish community to

enrich his repertoire of shapes and colors: costumes and jewelry, woodwork and mosaics in intense hues decorating the interiors of houses, rituals of traditional ceremonies—nothing was omitted. But the primary discovery of this visit was the light, which at first he found hard to bear: "Even when the sun is not yet very strong, the glare and the reflection of the houses, all of them painted white, tire me greatly."[6] In Morocco, Delacroix realized a new relationship between light and color. Struck by the brightness of the whites of a painted wall, a ceramic, a marble statue, a textile, even a flowering tree, the artist also observed the subtlety of the interplay between shadow and light as well as the importance of colored reflections. All his notes show the degree of visual acuity he achieved: "The shadow of white objects, highly reflected in blue. The red of saddles and the turban, almost black;" "observed the shadows that stirrups and feet form. Shadow always outlining the curve of the thigh and the lower leg. . . . The spur and the clip of the harness breastplate very flat white. Gray horse. Bridle, worn white velvet."[7]

The first painter to penetrate the heart of Moroccan culture, Delacroix assimilated its many facets. From the striking events of his visit, he conceived many canvases (Lee Johnson catalogued close to sixty-five, not including those whose location is unknown); all these bear witness to the intensity of his impressions. Aware of having passed "at each step ready-made paintings that would bring fortune and glory to twenty generations of painters,"[8] he strove to his dying day to convey to the French public his admiration for a people who appeared to him as the living incarnation of ancient heroes (this comparison was a recurring theme throughout his visit). But the response to his Moroccan paintings was not always everything he expected. Since he eliminated from his compositions all that smacked of facile picturesqueness, and since he emphasized the greatness and nobility of the Arabs he had been able to approach, Delacroix came up against the puzzlement of those who expected to see extremely lively and colorful scenes. Indeed, in order to appreciate the true value of the canvases that emerged from his Moroccan experience and relive with Delacroix the powerful moments of his African adventure, it is essential, above all, to understand the state of mind in which the artist worked on his return to France. He eschewed the artifice of later painters who sought to transfer to canvas, using whatever gimmicks were at hand, what they considered the characteristic aspects of these foreign countries—scenes flooded with light and traversed by tribespeople wearing unusual costumes. Instead, Delacroix, while constantly returning to his memories, deliberately let his imagination take the lead, particularly as his memory blurred the details that he had so carefully collected but later deemed uninteresting.

If we look over this portion of his work, a trend emerges clearly: the peaceful scenes, pretexts for admirable compositions showing man and nature in perfect harmony outweigh the violent, warlike scenes focused on games, fights, or battles. On the other hand, "sunlit" compositions, glowing in their intensity, are rare (the first version of *The Fanatics of Tangier* is a masterly exception). The majority are enveloped in a warm light, sometimes subdued, which might surprise viewers expecting the radiance of Mediterranean light. Upon his return from North Africa, Delacroix became increasingly interested in the repercussions of the relationships among colors, as well as the interaction of complementaries and the issue of reflections: "Come to Barbary," he wrote to Villot, "you will experience the exquisite and extraordinary influence of the sun, which gives penetrating life to everything."[9]

The painter's profound originality and the key to his approach—which has disconcerted more than one viewer—can be summed up thus: never describe, only suggest,

starting from elements borrowed from the marvelous repertoire of forms and colors accumulated in six months, but transformed by the power of reverie and emotion. As Delacroix later wrote in his *Journal:* "I began to make something tolerable of my African journey only when I had forgotten the trivial details and remembered nothing but the striking and poetic side of the subject. Up to that time, I had been haunted by this passion for accuracy that most people mistake for truth."[10]

Arlette Sérullaz

1. *Correspondance,* vol. 1, p. 502.

2. Delacroix to Jean-Baptiste Pierret, January 25, 1832, *Correspondance,* vol. 1, p. 307.

3. Delacroix to Pierret, February 8, 1832, *Correspondance,* vol. 1, pp. 310–11.

4. Delacroix to Armand Bertin, April 2, 1832, *Correspondance,* vol. 1, p. 327.

5. Département des Arts Graphiques, Musée du Louvre, Paris, RF 1712 *bis,* folios 28 recto, 29 recto, 30 recto; M. Sérullaz, 1984, vol. 2, no. 1756, repro.

6. Delacroix to Pierret, February 8, 1832, *Correspondance,* vol. 1, p. 310.

7. Département des Arts Graphiques, Musée du Louvre, Paris, RF 1712 *bis,* folios 5 verso, 31 recto; M. Sérullaz, 1984, vol. 2, no. 1756, repro.

8. Delacroix to Bertin, April 2, 1832, *Correspondance,* vol. 1, p. 327.

9. Delacroix to Villot, February 29, 1832, *Correspondance,* vol. 1, p. 317.

10. *Journal,* October 17, 1853 (Norton, 1951, p. 198).

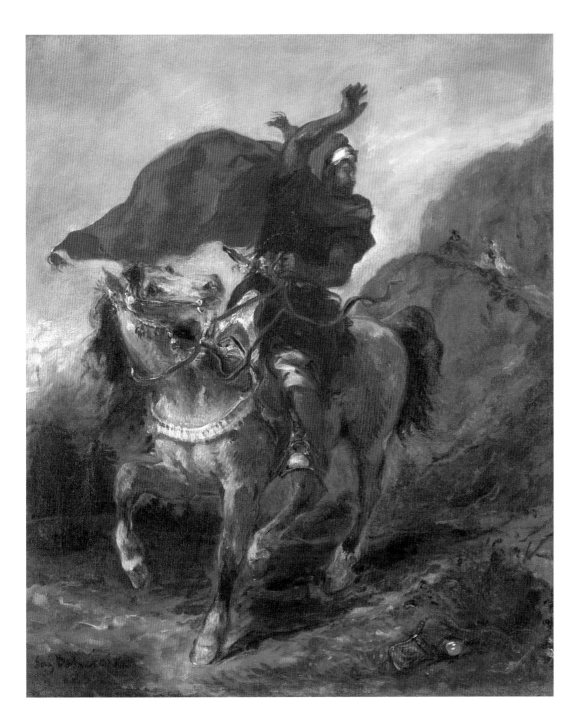

99. *Arab Chieftain Signaling to His Companions*

1851
Oil on canvas; 22 x 18⅛ inches (55.9 x 46 cm)
Signed and dated at lower left:
Eug Delacroix / 1851
Norfolk, Virginia, The Chrysler Museum of
Art, Gift of Walter P. Chrysler, Jr. (83.588)

Delacroix left for Champrosay at the end of the day on June 5, 1849, and stayed there until the beginning of July, dividing his time between walks in the forest of Sénart, evenings spent with the Villot family, and the working out—at a regular pace—of a number of paintings. On June 26, summarizing the work he had accomplished since his arrival, Delacroix noted in his *Journal:* "I roughed out, from the day I got here through the 26th, the day I go back to Paris for two days: *Tam O'Shanter.*—a small *Ariane.*—*Daniel in the Lions' Den*—on paper.—A *Giaour by the Sea.*—*An Arab on a Horse* coming down a mountain.—*A Samaritan.*"[1] According to Lee Johnson, this list gives us good reason to surmise that Delacroix worked on this painting from 1849.[2] Because he occupied himself simultaneously with commissions from collectors

or dealers and with important decorative projects assigned through official channels, it probably took him quite a while to finish these paintings.

After admiring the canvas during the exhibition at the boulevard des Italiens in 1860, Zacharie Astruc expressed his enchantment: "Canvas dazzling with light, stately and lively. The movements of the horse and rider were picked out by a man of action. Another jewel is the *Arab Followed by His Horse*. The Arab walks ahead, carrying his lance; the horse, with a pearl gray coat, comes after, its head lowered. In a coquettish posture, it tosses its mane, it rakes the ground with its hoof before stamping, it ripples its muscles like a young tiger on its feet. The Arab's garb has been exquisitely executed. As to the horse, this work, with boldness in every line, can only astonish. How it lives and moves! What fire! What intelligence! Delacroix loves horses as Arabs do, and his artistic passion leads him to create incomparable creatures."[3]

A. S.

1. *Journal*, June 26, 1849, p. 197.
2. Johnson, 1986, vol. 3, no. 386, p. 195.
3. Astruc, 1860, p. 37.

Fig. 1
EUGÈNE DELACROIX, *Arabs in Front of the Walls of Tangier*, 1836–37, watercolor on paper, New York, The Pierpont Morgan Library, The Thaw Collection.

100. *View of Tangier with Two Seated Arabs*

1852
Oil on canvas; 18⅞₆ x 22⅗₆ inches
(47.2 x 56.4 cm)
Signed at lower left: *Eug. Delacroix*
The Minneapolis Institute of Arts, Gift of Georgiana Slade Reny (93.67)

In this canvas, Delacroix took up with variations the subject of a watercolor that he had executed when he returned from North Africa (fig. 1). An autograph notation is found in one of the notebooks he used: "View of Tangier, seated Moors, tomb of a saint. Watercolor already old: 1836 or 37."[1] Some years later the painter apparently lent the watercolor to Pierre Andrieu (1821–1892), his student and collaborator: "Lent Andrieu the small watercolor of *Walls of Tangier; Two Arabs Seated*, one in his haik, standing, etc., to make a lithograph (delivered in April)."[2] In the meantime, he had transferred the composition, with considerable modifications, to canvas. The standing Arab figure seen from the back in the watercolor is replaced by the frontal view of a woman next to an aloe plant. In addition, the almost square format adopted for the painting gives the sky with moving clouds greater prominence. Finally, in the background, at the extreme right, the diminution of a knoll allows a glimpse of the luminous sea to appear.

The exact date of the commission by the dealer Weill is not known. When André Joubin published the 1932 edition of Delacroix's *Journal*, he mentioned that at the end of the diary of 1852, he had found different notes concerning the receipt

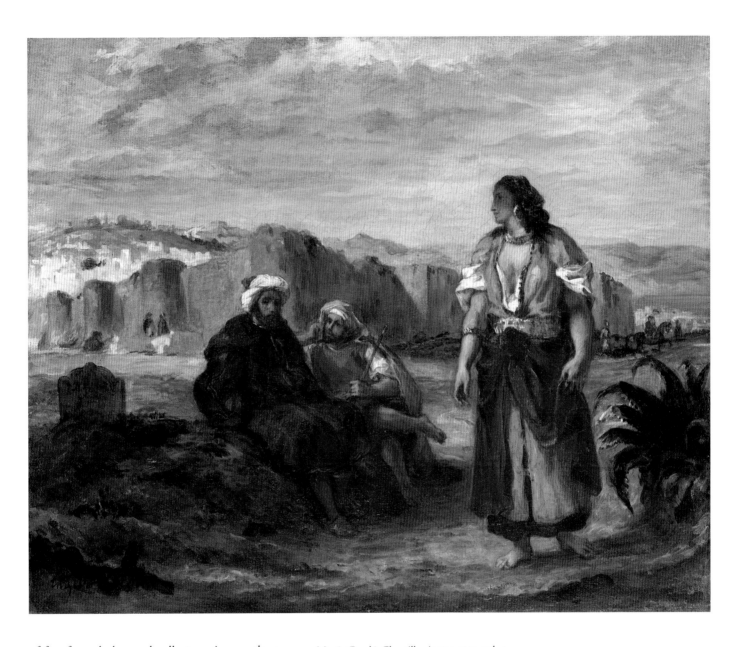

of fees from dealers and collectors. Among these appeared the following record, which Lee Johnson dates to January 1853: "1st deal with Weill: *View of Tangier/Orange Seller/Saint Thomas/The Bride of Abydos.* 1,500 [francs]," and below that: "From Weill, I have received on the 1st of February, upon delivery of the *View of Tangier,* 500 [francs]."[3] The work would have been finished by the summer of 1852, since Adolphe Moreau said that he saw it in Delacroix's studio at 54, rue Notre-Dame-de-Lorette, just as Édouard Renouard (1802–1857) was drawing the view of the painter's studio that appeared in the September 25, 1852, issue of *L'Illustration,* accompanied by an article by A. J. Du Pays entitled "Visite aux ateliers."

A. S.

1. Musée Condé, Chantilly; Arama, 1992, vol. 4.
2. *Journal,* January 1, 1859, p. 735.
3. *Journal,* undated, following November 30, 1852, p. 317.

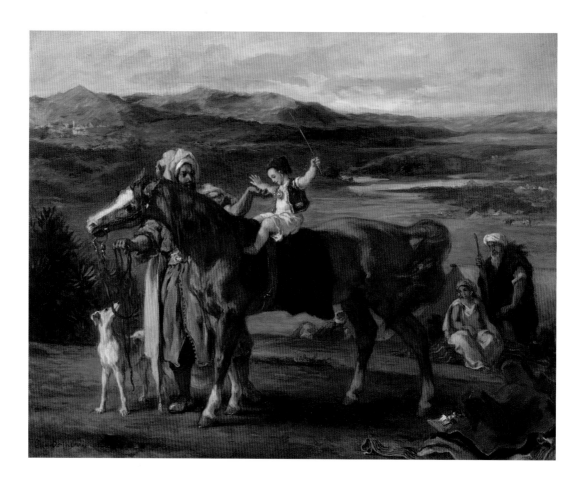

101. *The Riding Lesson*

1854
Oil on canvas; 25⁹⁄₁₆ x 31⅞ inches (64 x 81 cm)
Signed and dated at lower left:
Eug. Delacroix 1854.
Chicago, private collection
Exhibited in Philadelphia only

Also called *The Arab Family, Arabian Education,* and *Horsemanship,*[1] this painting was given a different name by Delacroix in his *Journal:* "In the morning worked on the *Arab Teaching His Son to Ride.*"[2] If Paul Mantz is to be believed, "this painting . . . rolled off the artist's brush in a morning's impulse,"[3] but the subject had been suggested to the artist many years earlier, perhaps after seeing in England a canvas representing "an Arabian man putting his child on horseback."[4] In any case, the work must have been finished in August 1854, as it was sent to an exhibition at Amsterdam's Academy of Fine Arts that opened September 5 of the same year (no. 61). Delacroix expected to find a buyer there, according to André Joubin—his asking price was four thousand francs—but when his hopes were not realized, the artist was left feeling somewhat bitter.

When it was shown at the Exposition Universelle of 1855, *The Riding Lesson* charmed most of the critics. While Paul Mantz did not hesitate to call the work a "marvel of color and spiritual grace,"[5] Pierre Petroz declared, "One cannot ask of this naïve scene a more unspoiled or peaceful landscape."[6] And Théophile Gautier's lyrical commentary offered the readers of the *Moniteur universel* a chance to slip into fantasy:

It is the first riding lesson given to a six- or seven-year-old Bedouin by his father. The child, perched on the withers of a handsome chestnut horse whose shanks he can barely grip, tries to remain steady, relying on his father to catch him should he fall. The deeply entranced expression of the child, the solemn satisfaction of the father, the intelligent compliance of the noble animal, which seems agreeable to such child's play, are expertly rendered. The heat of summer has not yet turned the green carpet, stretching out as far as the eye can see, into the color of a lion's coat, and the tender hue brings out the rich tones of the foreground.— In a corner the mother sits, swathed in her burnoose, looking on with a smile conveying joy mixed with fear. This is only a sample of M. Delacroix's African gallery, but it suffices to demonstrate his superiority in this genre.[7]

A. S.

1. Galerie Georges Petit, Paris, *Une collection particulière (Mme de Cassin),* October–November 1884, lot 17.

2. *Journal,* June 28, 1854 (Pach, 1937, p. 392).

3. Mantz, 1855, p. 172.

4. The inscription, written in English, is on folio 43 verso of the album in the Département des Arts Graphiques, Musée du Louvre, Paris, RF 23 355; see M. Sérullaz, 1984, vol. 2, no. 1749.

5. Mantz, 1855.

6. Petroz, 1855.

7. Gautier, 1855(a).

102. *Bathers*
or *Turkish Women Bathing*

1854
Oil on canvas; 36½ x 31 inches (92.7 x 78.7 cm)
Signed and dated at lower left:
Eug. Delacroix / 1854
Hartford, Connecticut, Wadsworth
Atheneum, The Ella Gallup Sumner and
Mary Catlin Sumner Collection Fund (1952.300)

On August 12, 1854, Delacroix wrote in his *Journal,* "I called on Berger this afternoon to bring him my picture of the *Women Bathing.* At his place I saw a picture by [Nicaise] de Keyser [1813–1887] who is very much esteemed by collectors. My own, of which I have a pretty slight opinion—having painted it under unsympathetic conditions—seemed to me to be a masterpiece by comparison."[1] Now that the circumstances of the painting's genesis are known in detail, the connotation of self-criticism of the last phrase, which no one seems to have noticed up to this point, becomes clear. Two unpublished documents found in the archives of Achille Piron have recently appeared that permit the entire history of the canvas to be retraced.

On February 1, 1854, Delacroix received a letter signed "Berger rue de la Douane n° 7" that reads:

One of my correspondents who has a gallery of modern painters requested me to ask you if you would be willing, for a fee of 3,000 to 3,500 francs, to paint for him a picture following the program given below, in the genre of Van de Werff engraved in the Musée Français, and when you might be able to deliver it. I will pay you in cash on its receipt. For information, you may address Messieurs Diaz & the baron G. Wappers of Brussels, who have recently executed paintings for me. I hope to hear from you soon and that you will set up an appointment. . . . Program: on a canvas of 91 by 76 cm [a sketch is attached in the margin]. In the foreground 2 or 3 nymphs dancing in graceful postures, a man or shepherd at the side playing the flute or

some other instrument, figures of considerable size, and partly draped (see the sketch) in the background a statue, trees &. . . .

On March 14, the same Berger sent Delacroix a second letter, adding more details: "Program canvas of 90 by 103 cm [the sketch is attached in the margin with the label *Le bain champêtre* (The bath in the country)]."

5 to 6 young women, very graceful in form, bathe or prepare to bathe in a stream of running water in a wood or a grove. One of them is shown at the moment of diving into the water, the second is already in the water up to her waist, a third is swimming, 2 or 3 others in the background stand or sit on the bank in a variety of graceful postures.

The subject must be chaste in design, the figures covered by drapery around the breasts, and when they are standing facing front, below the waist, in such a way that their nudity remains seemly. You might look at Lehmann's painting of bathers [the last word is crossed out]; see the engraving in *L'Artiste* of January 1850 or the painting of bathers by Diaz; see the engraving in *L'Artiste* of November 1, 1852: For the fee of 3,800 francs and to be delivered next August, Berger rue de la Douane n° 7, Paris, March 14, 1854.

Monsieur Eugène Delacroix, Paris
I am submitting to you the above program for a painting that I beg you to execute for me with the most scrupulous attention; it is for a particular gallery of modern painters, it will be placed on public display for a fee of three thousand eight hundred francs.[2]

Thus, contrary to what has always been written, *Bathers,* which Moreau and then Robaut catalogued under the title *Turkish Women Bathing,* undoubtedly because of the Oriental look of the clothing and the jewels worn by the five women, is not a work of the imagination—far from it.[3] Surprising as it seems, Delacroix acceded to the eccentric requests of his mysterious commissioner. Comparisons with compositions on the same subject by the Dutch painter Adriaen van der Werff (1659–1722), by Henri Lehmann (1814–1882), and by Narcisse Diaz de la Peña (1808–1876) are eloquent. There is no proof that Delacroix was so conscientious as to consult the reproductions referred to in Berger's letter,[4] but neither is there proof to the contrary. Analogies can be seen between the paintings of Diaz de la Peña and Delacroix.

According to the *Journal,* the painter must have set to work rather quickly, taking advantage of the tranquillity of his small house in Champrosay: "April 13. . . . Worked on the *Women Bathing* all the morning, and from time to time strolled into the garden or out into the country."[5] In the days that followed, the working out of the canvas was well under way, benefiting from the observations that Delacroix made while walking in the forest:

Took up work again on my picture of *The Women Bathing*. Since coming here I am beginning to understand the *principle* of the trees better, although the leaves are not yet fully out. They must be modelled with a coloured reflection, as in treating flesh; the method seems even more suitable in their case. The reflection should not be entirely a reflection. When you are finishing you must increase the reflection in places where it appears necessary, and when you paint on top of light or grey passages the transition is less abrupt. I notice that one should always model with masses that turn, as one would in objects not composed of an infinity of small parts, such as leaves. But as the latter are extremely transparent, the tone of the reflection plays an important part in their treatment.

Note:

(1) The general tone, which is neither entirely *reflection,* nor *shadow,* nor yet *light,* but is *almost everywhere transparent.*

(2) The edge is colder and darker; this will mark the passage from the reflection into *light,* which must be indicated in the lay-in.

(3) The leaves that lie wholly in the shadow cast from those above, which it is best merely to indicate.

(4) The *matt passages in the light,* which must be painted in last.

You must always argue it out in this way and above all, bear in mind the direction from which the light is coming. If it comes from behind the tree, the latter will be almost entirely reflection. It will present the appearance of a mass of reflection in which a few touches of *matt tone* are scarcely visible; if, on the other hand, the light comes from behind the beholder, i.e., facing the tree, the branches on the other side of the trunk instead of receiving reflected light will be massed in a *shadow* tone that is unbroken and *completely flat.* To sum up, the flatter the different tones are laid on, the more lightness the tree will have.[6]

The painting was definitely finished on June 22, 1854, the day Delacroix wrote in his *Journal:* "Finished the paintings of *Arab Lying in Wait for a Lion* and of the *Women at the Fountain.*—At least ten days are needed to apply the siccative."[7] On August 12 he brought it to Berger, whom André Joubin identified as Jean-Jacques Berger (1790–1859), the prefect of the Seine.[8] Re-examining the two letters that Piron carefully preserved, however, shows that this identification is untenable. It seems unlikely that a prefect would serve as an agent for a dealer who wished to remain anonymous and not only sign a contract in his stead but also pay—in cash—the fee.

Whatever the case, the imposed theme of the *Bathers,* unusual in Delacroix's oeuvre, gave him the opportunity to compete with Gustave Courbet (1819–1877), deliberately or not—even to surpass him. Delacroix himself had roundly upbraided his colleague for the vulgarity of the famous *Bathers* that Courbet exhibited at the Salon of 1853 (Musée Fabre, Montpellier):

> But what are the two figures supposed to mean? A fat woman, back-view, and completely naked except for a carelessly painted rag over the lower part of the buttocks, is stepping out of a little puddle scarcely deep enough for a foot-bath. She is making some meaningless gesture, and another woman, presumably her maid, is sitting on the ground taking off her shoes and stockings. You see the stockings; one of them, I think, is only half-removed. There seems to be some exchange of thought between the two figures, but it is quite unintelligible. The landscape is extraordinarily vigorous, but Courbet has merely enlarged a study that can be seen near his picture; it seems evident that the figures were put in afterwards, without any connexion with their surroundings.[9]

Except for the theme, the two works share nothing in common. Delacroix evidently took particular pains with every detail. The transparency of the water, the dappling of the light filtering through the foliage, the refinement of the colors, and the harmonious rhythm of the women's poses all contribute to the exquisite and shimmering effect of this canvas.

A. S.

1. *Journal,* August 12, 1854 (Pach, 1937, p. 411).

2. Archives Piron, Archives des Musées Nationaux, Paris.

3. Moreau, 1873, p. 274; Robaut, 1885, no. 1240, repro.

4. Lehmann's *Bathers* was engraved by G. de Montaut for *L'Artiste,* January 1, 1850, p. 80; that of Diaz de la Peña appeared in *L'Artiste,* November 1, 1852, opposite p. 112.

5. *Journal,* April 13, 1854 (Norton, 1951, p. 224).

6. *Journal,* April 29, 1854 (Norton, 1951, p. 228).

7. *Journal,* June 22, 1854, p. 435.

8. *Journal,* p. 451 n. 2.

9. *Journal,* April 15, 1853 (Norton, 1951, p. 172).

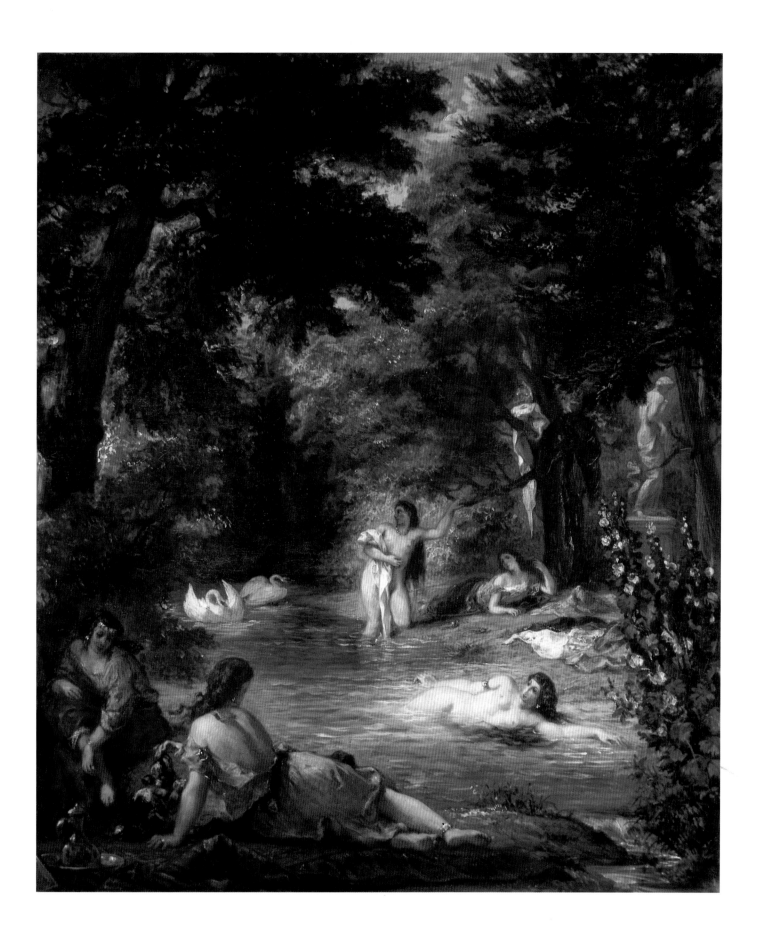

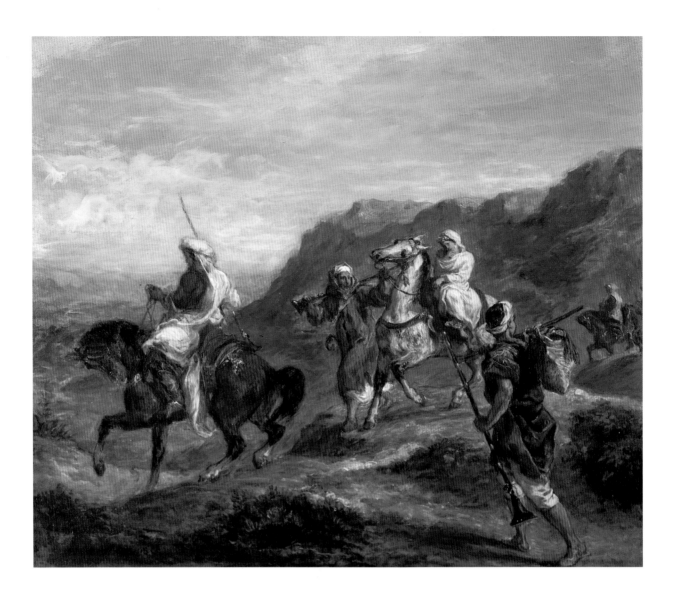

103. *Arabs Traveling*

1855
Oil on canvas; 21¼ x 25⅝ inches (54 x 65 cm)
Signed and dated at lower left:
Eug. Delacroix. 1855
Providence, Rhode Island School of Design,
Museum of Art (35.786)

On April 5, 1832, leaving Meknes for Tangier with the comte de Mornay's delegation, Delacroix came across a group of Arabs traveling with their families near the Sebou River: "Lovely valley at right. In the distance. . . . Women traveling. Bent over their horses. The one who was isolated by the side of the road to let us pass. A swarthy man leading the horse. The children on horseback behind the father."[1] Twenty-three years later, the memory of that encounter inspired this canvas, painted for Anatole Demidoff according to a notation in the *Journal* dated February 1, 1856—"A. Demidoff, *Arabs Traveling*"[2]—although it appeared in none of the Demidoff sales.[3]

As in *Moroccan Troops Fording a River* (cat. 105), unquestionably commissioned by Demidoff, the viewer is immediately struck by the peaceful beauty of the scene. Slowly advancing within the large-scale design, each figure seems lost in a reverie that cannot be disturbed. Through the magic of his brush, Delacroix once again transformed a genre subject into an almost timeless evocation. The colored notations Delacroix scattered throughout the pages of the Moroccan notebooks have assumed an eternal guise.

A. S.

1. Département des Arts Graphiques, Musée du Louvre, Paris, RF 1712 *bis,* folios 27 verso, 28 recto; M. Sérullaz, 1984, vol. 2, no. 1756, repro.
2. *Journal,* February 1, 1856, p. 568.
3. January 1863, February 1870, and March 1880.

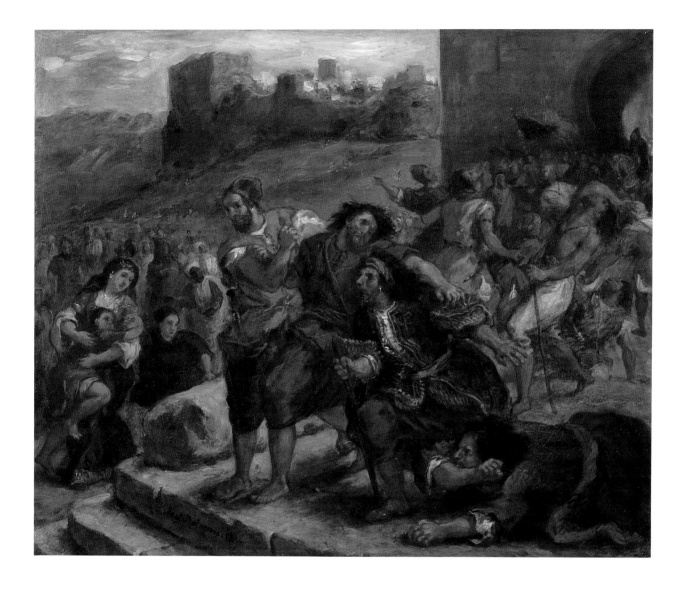

104. *The Fanatics of Tangier*

1857
Oil on canvas; 18½ x 22¹⁄₁₆ inches (47 x 56 cm)
Signed and dated near lower left, on a step:
Eug. Delacroix. 1857.
Toronto, Art Gallery of Ontario (62.5)

The scene shows the members of the Aissa sect leaving Tangier for the celebration traditionally called a *moussem*. It has often been assumed that Delacroix was present at the gathering of this religious group before its annual pilgrimage to the tomb of Sidi Ben Aissa, its founder, at Meknes. This spectacle, unsettling for a Westerner, could then inspire Delacroix to execute upon his return from North Africa a watercolor and two paintings, the first exhibited at the Salon of 1838 (fig. 1) and the second, this canvas now in Toronto, executed twenty years later.

Maurice Arama, who compiled a precise chronology of the French delegation's visit to Morocco, has demonstrated that this hypothesis is unlikely: the pilgrimage of the Aissa worshipers took place at the time of the ceremonies commemorating the prophet Muhammad's birthday; in 1832 these would have been held in August. Although Delacroix made no notes on the subject, which was also the case for the Jewish wedding and the audience of Moulay Abd er-Rahman, this does not preclude that he could have observed this episode during his last days in Morocco (June 1–8, 1932). In Tangier, the members of the Aissa sect

Fig. 1
EUGÈNE DELACROIX, *The Fanatics of Tangier*, 1838, oil on canvas, The Minneapolis Institute of Arts.

customarily gathered near the garden of the British consulate. That year, they would have then had more than two months to reach Meknes. In the absence of precise records, the possibility that the artist documented these remarkable costumes while he was with the delegation cannot be ruled out.[1]

Not as well known as the painting of 1838, this small canvas presents a completely reworked version, which is much more striking. A comparison of the two shows that in adopting the smaller format, Delacroix had to tighten and reorganize the composition. The highly colored representation of the ecstatic dance of the Aissa celebrants gave way to an intensely dramatic evocation of their ritual ceremony. Instead of placing us among the spectators of their strange contortions, Delacroix forces us to follow them in their shrieking progression through the city. Their agitation has reached its high point, bordering on the uncontrollable, while in the first version the participants simply gesticulate as they advance alongside the houses, almost recalling ancient processions. The hallucinatory expressions of some of the characters, reminiscent of those of the damned clinging to the boat in *The Barque of Dante* (1822, Musée du Louvre, Paris), reinforce the malignant atmosphere of the scene, which may incite a certain discomfort in the viewer.

Delacroix included this painting among several sent to Champrosay on March 27, 1856: "Bring to the country painting for Beugniet, sketch for Dutilleux; *Wounded Arab Dismounting from His Horse.* . . . Bring Edgar Poe, the *Four Seasons,* of M. Hartmann . . . the *Fanatics.*"[2]

In his preface to the sale catalogue of 1858, Théophile Gautier found this version equal in quality to the first:

> Through one of the city gates, the procession, screaming, raging, stamping, streams into the countryside accompanying the ecstatic worshipers in the throes of these diabolical contortions they believe to be prompted by the Holy Spirit. It is unimaginable with what verve, what fury, what power M. Delacroix has entangled and contorted these groups and how much his tumultuous and fierce execution confers reality on this strange, dreamlike scene, such that we do not know if we are seeing the ceremonies of the Aissa sect at Blida or the dances of the whirling dervishes in Constantinople.[3]

Later, Charles Ponsonailhe, at the time of the exhibition held at the École des Beaux-Arts in 1885, considered the canvas a "highly developed rough sketch, but absolutely marvelous in its movement."[4]

A. S.

1. Arama, 1992, vol. 5, pp. 249–50.
2. *Journal,* March 27, 1856, p. 573.
3. Gautier, 1858, p. iv.
4. Ponsonailhe, 1885.

105. *Moroccan Troops Fording a River*

1858
Oil on canvas; 23⅝ x 28¾ inches (60 x 73 cm)
Signed and dated at lower left:
Eug. Delacroix / 1858
Paris, Musée d'Orsay, Bequest of comte Isaac de Camondo, transferred from the Musée du Louvre (RF 1987)

In all likelihood, the memories of specific river crossings made during the journeys from Tangier to Meknes and back in the spring of 1832 were the inspiration for this painting; yet, when he composed it, Delacroix no longer exactly recalled the picturesque incidents that had punctuated his passage. On March 9, 1832, the artist had noted in one of his notebooks:

> Late departure from the Alcázar camp. Rain. Entered Alcázar and crossed the town. Crowd, soldiers striking heavy blows with straps; horrible streets; pointed roofs; storks on all the houses, on the tops of the mosques. They seem very large for such buildings. All in brick. Jewesses at the garret windows. Went through a big passage-way lined with hideous shops, roofed with badly joined bamboo. Reached the edge of the river. Big olive trees at the edge. Dangerous slope.[1]

The following day: "Crossed the river Emda, which winds in three branches." On April 5, after leaving Meknes, the mission encountered the same river. On April 7, they had to cross "the Wharrah River" (Wadi Ouerrha), which fortunately was not very deep. On April 11 a different passage led them to "a very muddy river" (Wadi Mharhar).[2]

The San Donato sale catalogue indicates that the painting was commissioned in 1858, but there are grounds for disputing that assertion, following the precedent of Lee Johnson.[3] According to a note, admittedly rather vague, of April 14, 1856, that Delacroix made in the *Journal*—"I still have to do . . . the painting for M. Demidoff . . . 3,000"[4]—

the artist apparently received a commission from Anatole Demidoff at the beginning of that month. Given the number of works in progress that year, Delacroix's delay in finishing the painting is understandable. In his review of the San Donato sale, Théophile Gautier did no more than place *Moroccan Troops Fording a River* among Delacroix's works of "exceptional quality" that made up the collection.[5]

A. S.

1. Département des Arts Graphiques, Musée du Louvre, Paris, RF 1712 *bis;* quoted in *Journal*, March 9, 1832 (Pach, 1937, p. 111).

2. Département des Arts Graphiques, Musée du Louvre, Paris, RF 1712 *bis,* folios 10 verso, 11 recto, 11 verso, 28 recto, 29 recto; M. Sérullaz, 1984, vol. 2, no. 1756, repro.

3. San Donato sale, Paris, 26, boulevard des Italiens, February 21, 1870, lot 27; Johnson, 1986, vol. 3, no. 406, p. 205.

4. *Journal*, April 14, 1856, p. 577.

5. Gautier, *L'Illustration,* February 5, 1870, p. 102.

106. *View of Tangier from the Seashore*

1858
Oil on canvas; 31¹⁵⁄₁₆ x 39⁵⁄₁₆ inches
(81.1 x 99.8 cm)
Signed and dated at lower left:
Eug. Delacroix / 1858.
The Minneapolis Institute of Arts, Bequest of
Mrs. Erasmus C. Lindley in memory of her
father, Mr. James J. Hill (49.4)

According to Delacroix's *Journal,* the artist set out
to paint this canvas in the summer of 1856 for the
dealer Tedesco, for whom he would make other
works inspired by Morocco (cat. 138). On July 8, at
Champrosay, where he was staying for several days,
Delacroix commented: "Began for Tedesco the
Landscape of Tangier from the Seashore."[1] He re-
ferred to it again on August 15: "I worked on
Seashore at Tangier, as I could not get to the church
[of Saint-Sulpice]."[2] However, there is no way to
know when Tedesco took delivery of the canvas, as
no additional information has come to light.

Delacroix roughed out his composition using a
rapidly made sketch that he had retained from one
of his visits to Tangier in 1832.[3] The idea of the
whole reappeared on the profusely annotated sheet
of a study[4] that also bears material on *Moroccan
Troops Fording a River* (cat. 105). Had Delacroix
also (as Robaut suggested, somewhat misreading a
remark of September 12, 1854, in the *Journal*[5])
found the initial idea while observing fishermen
haul their boat onto shore near Fécamp? There is
certainly no basis for this assertion, and the viewer
is hard-pressed to find anything in this canvas that
recalls Normandy. When presented at the exhibi-
tion held at the boulevard des Italiens "for the
benefit of the fund to assist painters, sculptors, ar-
chitects," this view of Tangier, then titled *Seascape
from the African Coast,* attracted the attention of
Théophile Gautier: "A rough road scales the rocks,
and a hot sky, luminous and soft, unrolls like an
ancient velarium over this entire rugged nature,
wild and still. It is curious that the turbulent
Delacroix knows so well how to render the impas-
sive serenity of the Middle East."[6] Zacharie Astruc
did not restrain from communicating his enthusi-
asm to his readers:

> Even more beautiful—and this time very powerful—the
> *Seascape from the African Coast* smiles, shines in a pure en-
> velope of light. The landscape is delicious; the sea sparkles;
> the sky is filled with refreshing breezes. And the small,
> white village on the rocks! . . . How simple, how great it is!
> the soul is transported by such a sight. . . . Oh! the light in
> this canvas is a marvel! Art can progress no further in its
> creation. Here, the artist has focused all of his powers—a
> life filled with observation. His genius has reached its ulti-
> mate bounds. On contemplating it, the soul experiences an
> ideal intoxication. This large blue sea, perpetually renewed
> by the simple planes of color, rises and falls. My lips are
> thirsty for its limpid water.[7]

A. S.

1. *Journal,* July 8, 1856, p. 588.
2. *Journal,* August 15, 1856, p. 590.
3. Département des Arts Graphiques, Musée du Louvre,
Paris, RF 10 112; M. Sérullaz, 1984, vol. 2, no. 1632, repro.
4. Département des Arts Graphiques, Musée du Louvre,
Paris, RF 9513; M. Sérullaz, 1984, vol. 1, no. 467, repro.
5. *Journal,* September 12, 1854, pp. 468–69; Robaut, 1885,
no. 1348.
6. Gautier, 1860 (c).
7. Astruc, 1860, pp. 44, 46.

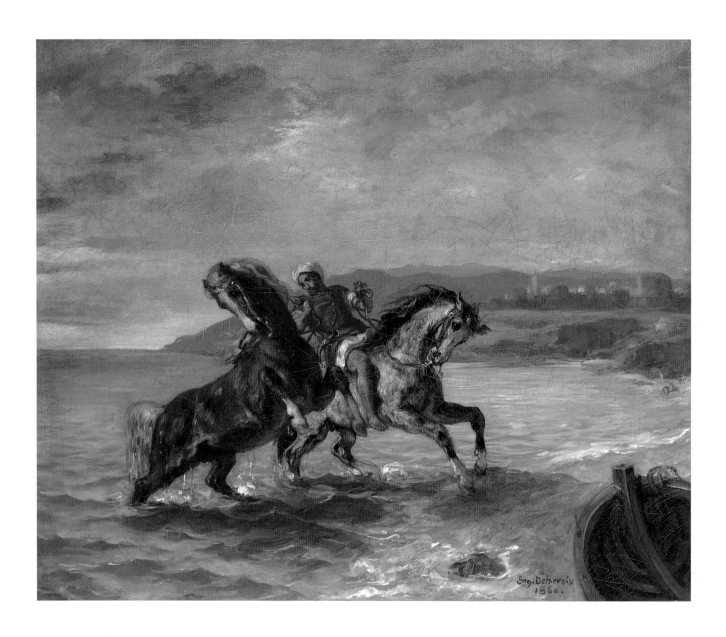

107. *Horses Coming Out of the Sea*

1860
Oil on canvas; 19¹¹⁄₁₆ x 24 inches (50 x 61 cm)
Signed and dated at lower right:
Eug. Delacroix / 1860.
Washington, D.C., The Phillips Collection
(0486)

"I do not believe that the Impressionist school produced a more luminous morsel, one more deeply infused with the freshness of morning, veiled in a more transparent mist," observed Philippe Burty after noticing this canvas in the exhibition of 1885.[1] It was begun perhaps on March 10, 1858, if it is indeed the work referred to in the

Journal that day: "The view of Dieppe with *The Man Who Comes Out of the Sea with Two Horses.*"[2] The work was clearly underway on September 5 of the same year: "I made great progress on some paintings: *The Horses Coming Out of the Sea.*"[3] However, it was not finished until two years later, in 1860, when Delacroix was engaged in the work at the church of Saint-Sulpice: "What I have done in the space of three weeks or a month and more, until today June 14 [*sic*] . . . is incredible. I've finished for Estienne the *Horses Fighting in a Stable,* the *Horses Coming Out of the Sea, Ugolino.*"[4]

A peaceful counterpoint to the fight between two horses in a stable (cat. 108), this composition brings together in a perfect synthesis two themes the painter had always cherished: the representation of spirited horses and the evocation of the seashore. If—as it would certainly seem—the ramparts seen in the distance belong to a Moroccan city, the boat

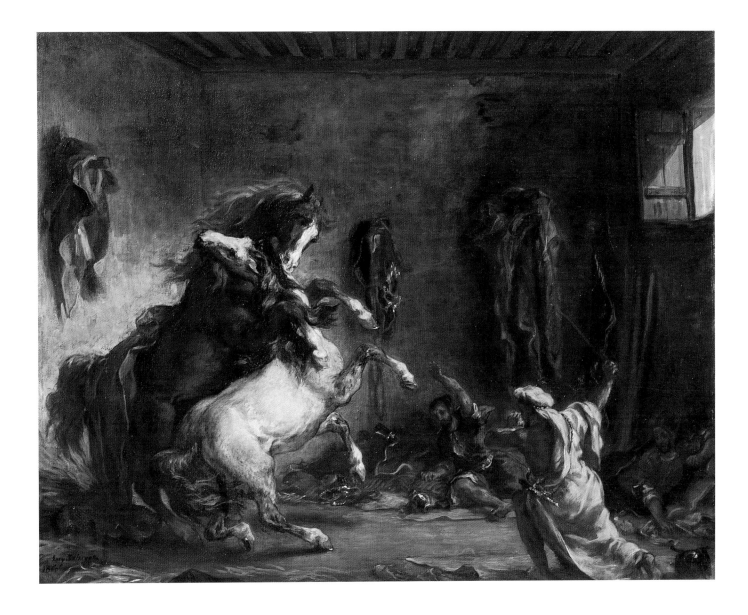

visible in the lower right corner nonetheless calls to mind the one Delacroix put in his most famous seascape, *The Sea at Dieppe* (cat. 53).

<div align="right">

A. S.

</div>

1. Burty, 1885.
2. *Journal,* March 10, 1858, p. 711.
3. *Journal,* September 5, 1858, p. 731.
4. *Journal,* April 14, 1860, p. 780; note the discrepancy in the month.

108. *Horses Fighting in a Stable*

1860
Oil on canvas; 25⅞ x 31⅞ inches (64.5 x 81 cm)
Signed and dated at lower left:
Eug. Delacroix / 1860
Paris, Musée d'Orsay, Bequest of comte Isaac de Camondo, transferred from the Musée du Louvre (RF 1988)

From two tiny sketches drawn hastily on one of the pages of the small notebook that he almost always carried with him in Morocco, and from notes scrawled all around them, Delacroix transposed to canvas an incident he had witnessed on January 29, 1832, while walking around Tangier

soon after the arrival of the French delegation.[1] But instead of representing the scene as it had occurred, in the open air, the painter enclosed his composition within a dark stable, in which the dim illumination provided by the open window has the effect of emphasizing the savagery of the confrontation between the two steeds, while the three Arabs relegated to the right watch helplessly.

On June 19, 1854, Delacroix included this subject among various projects of Moroccan inspiration: "Small subjects: *Two Horses Fighting.— Horse Displayed to Arabs.—Barber of Meknes.— Mercenaries.—Horseman.*"[2] However, it seems that he did not begin the work until two years later, at Champrosay: "I roughed in . . . the *Arab Horses Fighting in a Stable* (Morocco), and a small subject: *Unbound Horse Whose Master Is Preparing to Saddle and Who Plays with a Dog.*"[3] On June 14, 1860, the painting was done,[4] a superb illustration of the artist's admiration for the Arabian horses whose behavior he had full leisure to study during his visit to North Africa:

They have, under their native sky, a special spirit of pride, of energy, which they lose in moving to a different climate. They not uncommonly dump their rider rudely in order to devote themselves to battles that can last for hours. They sink their teeth into each other like tigers, and nothing can pry them apart. The raucous and excited snorts that escape from their scarlet nostrils like the respiration of locomotives, their manes disheveled or matted with blood, their ferocious jealousies, their deadly animosities: everything about them, attitudes and character, raises them to the level of poetry.[5]

A. S.

1. Département des Arts Graphiques, Musée du Louvre, Paris, RF 39 050, folios 10 verso, 11 verso; M. Sérullaz, 1984, vol. 2, no. 1756, repro.
2. *Journal,* June 19, 1854, p. 434.
3. *Journal,* May 26, 1856, p. 581.
4. *Journal,* June 14, 1860, p. 780.
5. Quoted in Silvestre, 1855, pp. 65–66.

VI

RELIGIOUS ASPIRATION

The prevailing art historical image of Eugène Delacroix is that of a revolutionary painter who rejected the established formal vocabulary and iconographic themes of his profession. Another side to the artist, however, is revealed through his religious paintings. From an early age, Delacroix was greatly inspired by religious themes—which were, after all, deemed the most noble in history painting. Appropriately, he looked to build his career by regenerating the works of certain classical masters—Raphael, Titian, and Rubens—who had served Christianity with such passion, whether under Renaissance Neoplatonism or the Baroque splendors of the Counter-Reformation. Delacroix followed their example, sometimes with little restraint, when executing his first commissions—which were, in fact, religious paintings.

During the same years when he was producing his imposing Salon works, some of which—such as *The Barque of Dante* (1822, Musée du Louvre, Paris)—were directly inspired by the Romantic spirit, and others which—such as *The Massacre at Chios* (1824, Musée du Louvre, Paris) and *Liberty Leading the People* (1830, Musée du Louvre, Paris)—were based on contemporary events, Delacroix was also portraying religious themes. He depicted these without the slightest renunciation of his secularist convictions, applying the classical principles learned at the studio of his master, Pierre-Narcisse Guérin (1774–1833). His early religious works include *A Blind Man* (c. 1821, private collection)[1] and *Mary Magdalene at the Foot of the Cross* (1829, location unknown), paintings that have unfortunately gone unnoticed. Significantly, the same year that his *Death of Sardanapalus* (Musée du Louvre, Paris), which appalled the critics, was exhibited at the 1827–28 Salon, the painter also presented his first religious masterpiece, which went unremarked amid the scandal—*The Agony in the Garden* (church of Saint-Paul-Saint-Louis, Paris), commissioned in 1824 for twenty-four hundred francs by the comte de Chabrol, Prefect of the Seine. Inspired by the theatrical quality of the Italian painters, particularly the Bolognese school, and the Spanish masters such as Murillo, Zurbarán, and Goya, this ambitious and tragic work, with its strong contrasts, was Delacroix's first genuine success in a genre that he was to develop fully in the following years.

In fact, the painter's religious work was one of the important factors in his full-fledged campaign that began in 1830 to regain the support of the public after its hostile

reaction to *The Death of Sardanapalus*. Delacroix wished to convince his colleagues and the critics as well as clients from government and ecclesiastical institutions that they should look beyond the shocking exploits of his youth and recognize him as one of the great artists of his time, not because of his provocations, but, more significantly, because of his aspirations to revive, in his own way, the great tradition of the Renaissance and seventeenth-century masters. Two surprising examples of this new turn in his career are *Christ on the Cross* (Musée des Beaux-Arts, Vannes), shown at the Salon of 1835, and *Saint Sebastian* (church of Saint-Michel, Nantua),[2] the only painting he exhibited at the Salon of 1836.

It was in this period that Delacroix regularly began to depict the great Christian themes. Some of these works were done as official commissions, such as the superb *Lamentation* he painted in 1843–44 for one of the chapels of the church of Saint-Denis-du-Saint-Sacrement in Paris (cat. 124 fig. 1), inspired as much by Tintoretto and Titian as by Rosso Fiorentino (1494–1540). Others were the product of a strictly personal inspiration, such as *The Education of the Virgin* of 1842,[3] which Delacroix had wanted to give to the parish of Nohant, located near the home of his friend George Sand, whom he was visiting at the time (the painting's landscape is based on the novelist's garden). It is in this spirit—placing religion in the forefront of his work but simultaneously attempting to revitalize its importance by putting it on the same level as science, philosophy, legislation, and poetry—that he chose to decorate four pendentives on the ceiling of the Palais Bourbon library with a series devoted to theology (see cat. 95). The paintings in the series portray three subjects from the Old Testament—*Adam and Eve*, *The Tribute Money*, and *The Babylonian Captivity*—and one from the Gospels, *The Beheading of John the Baptist* (see cat. 129). This presumed devotion to the grand genre of religious painting—which Delacroix treated with as much rigor, originality, and passion as he did his literary paintings based on Shakespeare or his Arab combats recalling his trip to Morocco—did not prevent him from reviving certain themes of classical religious painting. Some of his subjects recalled, for example, questionable events in Catholic history, as in the *Entry of the Crusaders into Constantinople* (cat. 88), which evokes the notorious bribery and general political corruption of the Fourth Crusade. Another such work is *Interior of a Dominican Convent in Madrid* (1831, Philadelphia Museum of Art), exhibited at the Salon of 1834 and inspired by the novel *Melmoth the Wanderer*, written by Irish novelist Charles Robert Maturin in 1820 and known to Delacroix in the 1821 translation. The story dramatizes a cruel episode of the Inquisition.

It is important to understand the role played by Delacroix's family background in determining his personal relationship with Catholicism. The artist's family, the product of a profoundly rationalist cultural and intellectual milieu, was committed to the secular principles of the French Revolution. Because of this upbringing, the painter developed an admiration for the eighteenth-century encyclopedists and shared Denis Diderot's polemical atheism, Voltaire's sober anticlericalism, and Jean-Jacques Rousseau's romantic pantheism. He was deeply marked as well by Cartesian logic, which in the seventeenth century had attempted to demonstrate rationally the existence of God. Delacroix would have liked to follow Descartes's example and prove, through his intelligence, erudition, and inner feelings, what his mind refused to accept spontaneously. On May 20, 1856, Delacroix copied into his *Journal* several lines by Descartes, in which the great French philosopher expressed his doubts on the subject of death and resurrection: "In regard to our state after our life ends, leaving aside what faith teaches us, I confess that through natural reasoning alone, we can do much speculation to our advantage, and have great

hopes, but without any assurance whatsoever."[4] This cold analysis was mirrored in the cry of anguish the painter had expressed more than thirty years earlier, in 1822—a cry that was to spark his inner search for spirituality throughout his life and inspire a number of his works: "Can it be possible that He does not exist? . . . If the universe had been produced by chance, what would *conscience* mean, or *remorse,* or *devotion*? O! If only, with all the strength of your being, you could believe in that God who invented duty, all your doubts and hesitations would be resolved."[5]

Delacroix was obsessed by the idea of God's existence and the notion of life after death. Numerous quotations from various authors, patiently copied in his *Journal,* indicate that in the artist's final years the agnosticism of his youth was progressively supplanted by a genuine metaphysical torment. He unleashed his anger at the world's injustice, violence, and hate, which for him were an unsatisfactory reflection of a loving God: "Why, if a man is his work of predilection, abandon him to hunger, to dirt, to massacre, and to the terrors of a life of hazard. . . . "[6] In the entry dated January 31, 1860, the painter expounded at length on the soul and death, basing his thoughts on Diderot's *Jacques the Fatalist and His Master:*

> *On the Soul:* Jacques found it hard to believe that what we call *the soul,* that intangible *being*—if the word *being* may properly be applied to that which has no body, that is not self-evident, nor even like the wind . . . Can this *being,* whose existence he feels and may not question, continue to live when its habitation of bone and flesh, in which the blood circulates and the nerves perform their functions, has ceased to be the active workshop, the laboratory of life that maintains itself amidst opposing elements and despite many accidents and vicissitudes? . . . What becomes of the soul when paralysis or imbecility have driven it to its last refuge, and it is at length compelled by the final extinction of life and its eternal exile to separate itself from a body that is now no more than clay? And once finally banished from that body which some call its prison, is the soul present at the final scene of mortal decomposition. . . .[7]

Despite these moments of doubt and confusion, Delacroix, as he grew older, apparently came to regard some of his theological questions in relative terms. On October 12, 1862, several months before his death, on a quiet vacation in Augerville at the home of his cousin Pierre-Antoine Berryer, he wrote serenely:

> God is within us. He is the inner presence that causes us to admire the *beautiful,* that makes us glad when we do right, and consoles us for having no share in the happiness of the wicked. It is he, no doubt, who breathes inspiration into men of genius, and warms their hearts at the sight of their own productions. Some men are virtuous as others are geniuses and both are inspired and favoured by God.[8]

The artist's doubts about his faith and the contradictions in his religious convictions, which caused him such inner torment, did not ever hinder his artistic development and in no way prevented him from regularly painting subjects from the New Testament (the Old Testament inspired him less than did scenes from the life of Christ), particularly after 1850. In fact, this personal search for spirituality appears to have been one of Delacroix's essential motivations. The painter had a perfect understanding of the creative potential of the relationship that had existed for centuries between religion and art. On November 2, 1854, he wrote in his *Journal:* "I was much impressed by the Requiem Mass. I thought of all that religion has to offer to the imagination, and at the same time of its

appeal to man's deepest feelings."[9] This statement foreshadowed one of the artist's most personal aesthetic analyses, dealing with the creative possibilities of religion: "Christianity, on the contrary, addresses itself to the life within. The soul's aspirations and the renunciation of the senses are difficult to express in marble and stone: it is painting's role, on the other hand, to give expression to almost anything."[10] Despite this argument for a renewal of religious pictorial art, the painter—contradicting the thesis of a former director of the Beaux-Arts, Frédéric de Mercey, whose *Études sur les Beaux-Arts depuis leur origine jusqu'à nos jours*[11] Delacroix had read with interest—pondered the link between Christianity and the art of his era:

> Indifference to matters of religion must necessarily bring with it indifference to matters of art; if art, as is claimed, can be nothing else than the expression of the dominant belief, the day on which that belief is shaken sees art totter with it; and later when incredulity comes to triumph, the artist and the priest succumb to the same blow. The history of art formally contradicts these systematic assertions. As we look over that history we see that if art is born and develops at the same time as religions, it is only at about the time of their decadence that it attains perfection.[12]

In his 1931 study (see cats. 119 to 123), Raymond Régamey extensively examined what he considered to be the two most prevalent themes in Delacroix's religious painting: manifestations of the supernatural and sainthood persecuted. The second theme, handled in such scenes from the life of Christ as *The Beheading of John the Baptist* (cat. 129) and the martyrdom of Saint Stephen (cats. 111 and 140), appears in his paintings more frequently than the first, which deals essentially with Christ's miracles.

It is not Delacroix's choice of subjects, nor even his innovative treatment of them, that imparts such a personal and creative quality to his religious art. After all, these traditional subjects, through their dramatic and spiritual power, have inspired great painters of every era. Delacroix's originality resided in his ability to "feel" these subjects, to portray famous scenes from the Gospels with a humanistic and rationalistic spirit. He related first and foremost to Christ's physical torment and anguish—that is, Christ's human dimension, comprehended through the artist's own doubts and disbeliefs, rather than by his reflection on Christ's divine aspect. The artist imposed his own hierarchy on his choice of subjects for religious painting: in selecting episodes from the life of Christ, he gave priority to the themes of solitude and suffering, as seen in his different versions of *The Agony in the Garden* (church of Saint-Paul-Saint-Louis, Paris; Rijksmuseum, Amsterdam), in the poignant *Christ at the Column* (Musée des Beaux-Arts, Dijon), in the sublime *Road to Calvary* (cat. 128), and, of course, in numerous variations of *Christ on the Cross* (cats. 119 to 123).

Delacroix's portrayal of *The Agony in the Garden* and his comment on one of his own paintings, *Christ on the Cross* (p. 288 fig. 1), in the visitors' book of the Salon of 1835—where he quoted the famous question from the Gospels, "My God, my God, why hast thou forsaken me?" (Matthew 27:46)—indicate that he was already dealing with the notions of doubt and inconstant faith at this time. He developed the same theme in several paintings inspired by episodes from the Old Testament, including *Daniel in the Lions' Den* (1849, Musée Fabre, Montpellier) and other works based on the lives of the saints, such as *Mary Magdalene with Angel* (1845, Oskar Reinhart Collection, Winterthur) and *Mary Magdalene in the Wilderness* (1843–45, Musée Eugène Delacroix, Paris). Dramatizing, in his many Lamentation scenes (cats. 124 to 126), the anguish, sorrow, and turmoil that grip Christ's parents, disciples, and friends in confronting the Savior's

death, Delacroix brings the viewer—as he brought himself—back to the powerful theme of skepticism in the face of divine revelation. *The Supper at Emmaus* (cat. 112), *Jesus Walking on the Water* (1852, Fogg Art Museum, Cambridge, Massachusetts), *The Incredulity of Saint Thomas* (1846, Wallraf-Richartz Museum, Cologne), and *Christ on the Sea of Galilee* (cats. 113 to 118) are variations on the theme, expressing the abandonment experienced when one's faith is tested.

By depicting the confrontation between the resurrected Christ and the skeptical Saint Thomas, or the disbelief of the disciples at Emmaus, or the emotional turmoil of the apostles on the boat pitching in the storm while Christ slept (cats. 113 to 118), Delacroix chose some of the most evocative episodes of the New Testament for an agnostic such as himself, for these scenes embody the doubts and anxieties of the Christian faced with the divine manifestations of Christ. The theme of doubt, which occupied the rationalist and positivist thinkers of the nineteenth century, could only fascinate—and perhaps even reassure—a man such as Delacroix, who refused to consider the Christian faith as a revealed truth. On the contrary, for Delacroix, to believe in God represented a daily intellectual, philosophical, and emotional effort, a sort of spiritual gamble akin to that of Pascal (1623–1662), another of his favorite authors.

Yet, it was the artist's very entanglement in his own spiritual contradictions, as well as his aspiration to create religious works as important as those of his illustrious forerunners, that enabled him to paint biblical scenes thoroughly conveying the evangelical message—that of love and compassion for those around us, qualities that must prevail over pride and human vanity. This is exemplified by such tender and compassionate works as *The Education of the Virgin*[13] and *The Good Samaritan* (cat. 109). It is the simplicity of this message, it seems, that reconciled Delacroix with the church and appeased his metaphysical fears, prompting him to write, on November 2, 1854, one of the most surprising observations in his *Journal,* far removed in its humility and simplicity from his usual intellectual and aesthetic pursuits:

> *Blessed are the meek, blessed are the peacemakers*: what other religion has ever made gentleness, resignation and simple goodness the sole aim of man's existence. *Beati pauperes spiritu:* Christ promised heaven to the poor in spirit, that is, to the simple-hearted; this utterance is not so much intended to humble our pride in the human mind as to show us that a simple heart is better than a brilliant intellect.[14]

Vincent Pomarède

1. Johnson, 1981, vol. 1, no. 155, pl. 137.

2. Johnson, 1986, vol. 3, no. 422, pl. 230.

3. Johnson, 1986, vol. 3, no. 426, pl. 234.

4. *Journal,* May 20, 1856, p. 580.

5. *Journal,* October 12, 1822 (Norton, 1951, p. 9).

6. *Journal,* November 23, 1857 (Pach, 1937, p. 612).

7. *Journal,* January 31, 1860 (Norton, 1951, p. 394).

8. *Journal,* October 12, 1862 (Norton, 1951, p. 411).

9. *Journal,* November 2, 1854 (Norton, 1951, p. 265).

10. Delacroix, 1857.

11. Paris, 1855.

12. *Journal,* March 29, 1860, p. 773.

13. Private collection; Johnson, 1986, vol. 3, no. 426, pl. 234.

14. *Journal,* November 2, 1854 (Norton, 1951, pp. 265–66).

109. *The Good Samaritan*

c. 1849–51
Oil on canvas; 14½ x 11¾ inches (36.8 x 29.8 cm)
Signed at lower right: *Eug. Delacroix*
Waterhouse Collection

Delacroix exhibited *The Good Samaritan,* based on the well-known parable, at the Salon of 1850–51 along with four other paintings: *The Raising of Lazarus, The Giaour Pursuing the Ravishers of His Mistress, Woman Combing Her Hair,* and *Lady Macbeth Sleepwalking* (cat. 82). In the Salon catalogue (no. 780), Delacroix summarized the action of the painting in a sentence: "The Good Samaritan, having bandaged the traveler's wounds, puts him on his mount to take him to the inn."

In this painting Delacroix has drawn upon a challenging message from the Gospels, a parable from Luke conveying one of Christ's most provocative teachings:

> A certain man went down from Jerusalem to Jericho, and fell among thieves, which stripped him of his raiment, and wounded him, and departed, leaving him half dead. And by chance there came down a certain priest that way: and when he saw him, he passed by on the other side. And likewise a Levite, when he was at the place, came and looked on him, and passed by on the other side. But a certain Samaritan, as he journeyed, came where he was: and when he saw him, he had compassion on him. And went to him, and bound up his wounds, pouring in oil and wine, and set him on his own beast, and brought him to an inn, and took care of him (Luke 10:30–34).

When he has finished telling the story, Christ asks one of his listeners, "Which now of these three,

thinkest thou, was neighbour unto him that fell among the thieves?" Although members of two of the most respected classes in Palestine appear in the story—a priest and a Levite—it is the Samaritan—a foreigner, and a heretical one at that—who behaves charitably.

The parable's nonconformist suggestion of judging individuals not by their social position or religious role, but by their actions and capacity for love and charity, naturally appealed to Delacroix, who detested social conventions and hypocrisy. Delacroix's personal creed was "God is within us," and this belief, by which he accounted for a person's affinity and aptitude for the arts, also led him to feel sincerely that man could break free from rituals and blind beliefs in order to pursue what is truly essential.

Unlike Luca Giordano (1632–1705), who had painted the Good Samaritan in the process of tending the wounded traveler (Musée des Beaux-Arts, Rouen), or Rembrandt, who showed the Samaritan conveying the traveler to the inn (The Wallace Collection, London)—a more familiar scene, practically a genre painting focusing on the moment when the Samaritan takes the wounded man down from his horse and delivers him to the innkeeper's care—Delacroix emphasized the intimacy that arose between these two men whom chance had so rudely thrown together. He described the affectionate attention of one for the other at the point when the wounded traveler is being raised, with considerable effort, onto the Samaritan's horse or mule. The kind stranger is enlisting all his strength in the service of the unfortunate man. In the scene's landscape of savage grandeur, evoking the steep gorges of Morocco, Delacroix has included the figure of a monk representing the priest or the Levite from the Gospel, who indifferently continues on his way.

According to the *Journal,* Delacroix sketched *The Good Samaritan* during a stay at Champrosay from June 5 to 26, 1849,[1] over a year before exhibiting it at the Salon. His drawing currently at the Louvre (fig. 1) must also date from this period. This drawing, which does not concern itself with details of the landscape, reveals the artist's care in working out the poses of the two figures and the description of their bodies pressed together—the Samaritan tense with physical exertion and the wounded traveler feebly abandoning himself to the arms of his rescuer.

When shown at the Salon, the painting achieved an undeniable success with the critics, who were on the whole favorably disposed toward Delacroix's religious paintings of this period. E. Thierry, comparing it to the best paintings by Tintoretto, in the March 21, 1851, edition of *L'Assemblée nationale,* typified his colleagues' reactions to the canvas:

Fig. 1
Eugène Delacroix, *The Good Samaritan,* c. 1849, graphite on paper, Paris, Musée du Louvre, Département des Arts Graphiques.

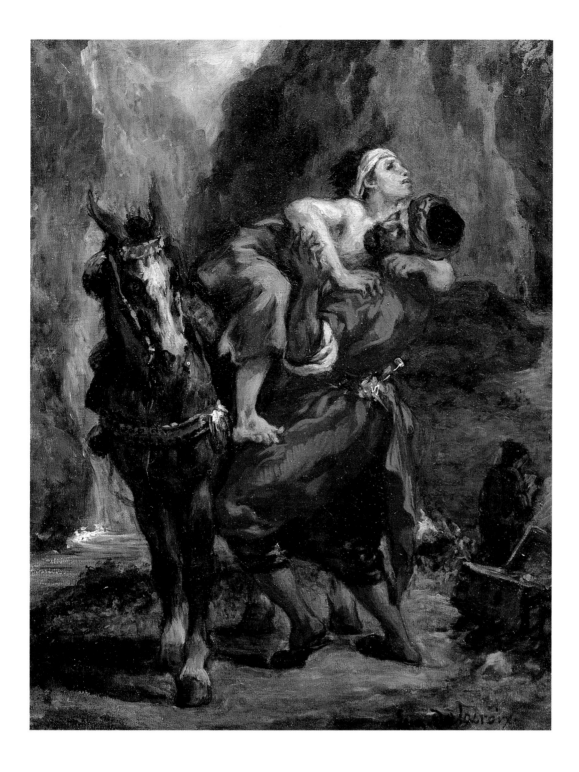

What evidently concerns the painter is the realistic movement of the two figures, the care with which the Samaritan bends his knees, supports the wounded man on his chest, raises him with his back to seat him on the horse as he removes the man's arm from around his neck; what concerns the painter is the double feeling of trust and pain as the young man attempts to give himself over to this benevolent Hercules' care while shrinking from his grasp, so greatly does he dread the anguish of any further movement. There is something intangible about it that the painter has nonetheless managed to capture. . . . There is that truth of suffering and compassion, that truth of pose and posture, that truth of emotion conveyed by the entire body, that

human truth, basically, which the artist cannot ask from the model but must discover within himself, creating it from what he finds there.[2]

Just as literary, but more penetrating and sophisticated, was Théophile Gautier's analysis, in which he mentioned the somewhat "slack" brushwork and commented, with a dose of humor, on the painting's "evangelical unction." However, as in each of his analyses of the work of Delacroix, Gautier admired the strong, masterful treatment of color: "As well, it requires all the master's skill as a colorist to throw a scarlet cloak over the

Samaritan's shoulders without the slightest break in the scene's muted harmony and muffled sadness." In writing about this work, Gautier was thinking mainly of Rembrandt (rather than Tintoretto, whose influence is nevertheless evident in the chromatic choices and the robust treatment of the figures): "Although completely different from Rembrandt's painting in composition, Delacroix's *Good Samaritan* recalls that work's energy and emotional power."[3]

Rembrandt's influence, not visible in the iconography, is in fact evident in the composition, as well as in the aesthetic choices and the poetic universe of *The Good Samaritan*. The figures' poses evoke the two closely intertwined bodies of Rembrandt's *Jacob Wrestling with the Angel* (Gemäldegalerie, Berlin) and the pained tenderness of the father receiving his exhausted son in his arms in the engraving *The Return of the Prodigal Son*, which the Dutch master executed in 1636.

Even before the Salon opened, Delacroix was approached by two individuals in his circle—Victor Hugo's brother-in-law, Paul Foucher, and the sculptor Auguste Préault (1809–1879)—about selling the five works he intended to exhibit that year to one of his most fervent admirers, Hugo's friend, the writer and art critic Auguste Vacquerie (1819–1897). On January 15, 1851, Delacroix informed Foucher of the prices of the paintings that were still in his possession:

> Dear Monsieur Foucher, I hasten to let you know, as you requested, the prices of the paintings that you indicated. These prices are below what I would ask from a collector, and I should be pleased if they met with your friend's approval. For the *Samaritan*, three hundred francs. For the *Giaour*, four hundred francs. For *Le Lever [Woman Combing Her Hair]*, eight hundred francs.[4]

At the same time, Vacquerie received a letter from Préault, reiterating the prices of the paintings still for sale, including *The Good Samaritan*:

> Dear Vacquerie, On the advice of our friend Paul Meurice, I have been to see Eugène Delacroix. Here are the prices I inquired about: three hundred francs for *The Good Samaritan*; four hundred francs for the *Giaour*; eight hundred francs for the woman grooming herself; he no longer has the *Lazarus*; and a thousand francs for *Lady Macbeth*. Go and see Delacroix some morning as soon as possible, 54, rue Notre Dame de Lorette, and you will finish your transaction. He knows how well you like him.[5]

Vacquerie acquired only two canvases at this time: *Woman Combing Her Hair* and *The Giaour*.

Although Gautier stated in his review of the Salon that *The Good Samaritan* already belonged to Vacquerie, the painting's first purchaser was in fact Vacquerie's close friend, Paul Meurice, as can be ascertained from the owner's name lettered on an engraving after *The Good Samaritan*, published in an album of lithographs by Jules Laurens.[6] Vacquerie acquired the work later, no doubt from his friend Meurice.

In 1852 Delacroix painted another *Good Samaritan*, a version quite different in spirit, for the dealer Beugniet; there the Samaritan is represented tending the wounds of the traveler lying on the ground (fig. 2). Both of Delacroix's versions of the subject deeply influenced his contemporaries, as evidenced by Honoré Daumier's treatment of the theme several years later, around 1856, in which the two men are depicted on their way to the inn (Art Gallery, Glasgow). Vincent van Gogh, enthusiastic about Delacroix's work and its religious and aesthetic power, made a copy in May 1890—almost a new version—after Laurens's reversed engraving (Rijksmuseum Kröller-Müller, Otterlo).

V. P.

1. *Journal,* June 17, 1849, p. 197.

2. Thierry, 1851.

3. Gautier, 1851.

4. *Correspondance,* vol. 3, p. 53.

5. Pierre Georgel, "Delacroix et Auguste Vacquerie," *Bulletin de la Société de l'histoire de l'art français,* 1968, p. 166.

6. *Les Artistes anciens et modernes* (Paris: Bertauts, 1857–58), vol. 7, no. 161.

Fig. 2
EUGÈNE DELACROIX, *The Good Samaritan*, 1852, oil on canvas, London, The Victoria and Albert Museum.

110. *Saint Sebastian Tended by the Holy Women*

c. 1850–54
Pastel on paper; 7⁷⁄₁₆ x 10⁷⁄₁₆ inches
(18.2 x 26.5 cm)
Annotated in pen on the verso on a piece of
paper: *Donné par moi à Jenny Le Guillou / le 24
mars 1855 / Eug. Delacroix*
Private collection
Exhibited in Paris only

The day after his return to Paris, following a trip to Dieppe that lasted over a month, from August 17 to September 26, 1854, Delacroix decided to lay out his drawings and engravings. On September 28 he wrote in his *Journal:* "This morning, looking at the small *Saint Sebastian* in pastel on paper, compared with heavily loaded pastels on dark paper, I was struck by the enormous difference in the matter of luminosity, and by the absence of heaviness. In the same way, Flemish painting when compared with that of Venice easily produces in you an appreciation of its lightness."[1] The following year, as suggested by Lee Johnson, and indicated by the inscription on the back, the painter may have given this pastel to Jenny Le Guillou, perhaps for her fifty-fourth birthday.[2] The work is a much smaller version of the painting exhibited at the Salon of 1836, which now hangs in the church at Nantua (fig. 1).

The martyrdom of Saint Sebastian, which had been depicted frequently since the Renaissance, would inspire nearly ten of Delacroix's canvases, all of which depict the episode in much the same way as the 1836 painting: "After his martyrdom,

Fig. 1
EUGÈNE DELACROIX, *Saint
Sebastian Tended by the Holy
Women*, 1836, oil on canvas,
Nantua (Ain), church of Saint-
Michel.

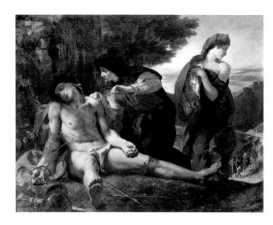

III. *Disciples and Holy Women Carrying Away the Body of Saint Stephen*

1853
Oil on canvas; 58½ x 45½ inches (148 x 115 cm)
Signed and dated at lower left:
Eug Delacroix 1853
Arras, Musée des Beaux-Arts (859.1)

the saint is abandoned at the foot of the tree to which he was bound by his torturers. As the soldiers depart, the holy women prepare to pay their final respects to Sebastian. One of them removes the arrows piercing him."[3]

The source of this pastel is a small painting, carried out in muted tones, that is now in a private collection.[4]

A. S.

1. *Journal,* September 28, 1854 (Pach, 1937, p. 438).
2. Johnson, 1995, no. 37, repro.
3. *Salon de 1836* (catalogue), no. 499.
4. Johnson, 1995, p. 135, repro.

The story of Saint Stephen is recounted in Acts 6 and 7:55–60. Accused of blaspheming Moses and God, Stephen was brought before the Sanhedrin and then dragged out of the city and stoned (see also cat. 140). In choosing not to depict the stoning, Delacroix contributed toward enriching the already abundant iconography of this martyr. The circumstances surrounding the painting's execution are unfortunately not known, although one might discern an allusion to it in the artist's *Journal* in an entry dated December 14, 1847.[1] Another entry indicates that the artist was working on this piece at the outset of 1853: "The hand, resting on the ground, of the woman who wipes the blood of Saint Stephen: halftone of *Cassel earth, white* with *vermilion* and *lacquer.*"[2]

The letters exchanged between Delacroix and Constant Dutilleux (1807–1865), a painter from Arras who was a friend of Delacroix and Corot and the father-in-law of Alfred Robaut, provide the necessary explanations concerning the painting's acquisition by the city of Arras. The city instructed Constant Dutilleux to find out whether Delacroix was interested in a commission. Delacroix replied on March 2, 1859: "If I am late replying to you, it is because your letter had led me to believe that I would receive a visit from M. Daverdoing concerning the painting that the city of Arras is interested in purchasing. The painting intended for him, subject to approval from these gentlemen and both of you, is *The Stoning of Saint Stephen,* the same one that you saw at my house when you last came to Paris, and which you appeared to hold in high regard."[3] The day after the visit from Charles Daverdoing (1813–1895), also a painter and a pupil of Gros, Delacroix sent another letter to Dutilleux:

> I was awaiting Daverdoing's visit before replying to you. . . . My suggestion of offering you the *Saint Stephen* painting seemed to meet with your approval. Perhaps you would have preferred a painting made especially for the destination, but apart from the fact that the work might have been less successful, it would have been totally impossible to deliver it to you soon enough for the funds to be made available within the year. I still have the *Saint Stephen* because there isn't a single collector who wanted it,

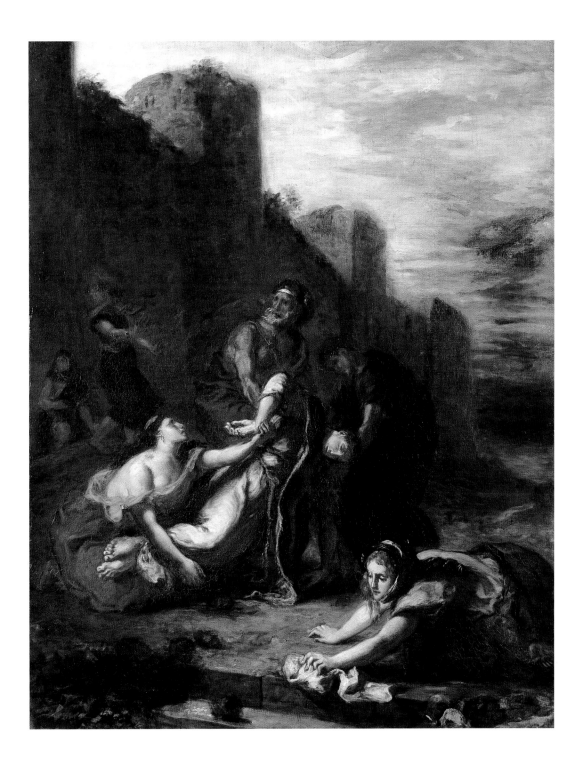

due to its grave subject matter and, above all, its dimensions, although *quite recently* a mere dealer offered me three thousand francs for it.[4]

Two days later, Dutilleux strove to reassure the artist by repeating passages of the letter he had just received from Daverdoing:

"Although I didn't choose this painting, I enjoy looking at it, much more than many of the new paintings by that excellent artist. . . . The figures are not large, but the arrangement of the subject matter and the magisterial color are what have made the painter famous, surrendering himself as he does to his poetic genius." What you have just read indicates beyond a doubt that M. Daverdoing was quite taken with the Saint Stephen. . . . I believe that the Saint Stephen is totally worthy of you, and an excellent work . . . it is a fine acquisition for our city museum, and the gravity of the subject matter, which may have unsettled some collectors, merely represents another gain for its final destination.[5]

Dutilleux and Daverdoing overcame their disappointment at not acquiring a painting commissioned specifically for their city. They were all too aware that their request had been drafted in a

hurry because of budgetary constraints, and they were, ultimately, taken by the painting's beauty, so they let themselves be persuaded of the timeliness of such a purchase. The *Saint Stephen* was delivered April 2. On May 12 Delacroix expressed anxiety to Dutilleux regarding the conditions of payment: "I'll be leaving for the country, so could you be so kind as to tell me beforehand if the conditions of payment for the purchase of the *Saint Stephen* painting by the city of Arras remain the same as M. Daverdoing had indicated: that is, three thousand francs in advance and the remaining one thousand francs in the following fiscal year."[6]

If Delacroix had difficulty in persuading his prospective clients at the outset of the negotiations, it was perhaps because they remembered the criticism the painting had received at the Salon of 1853. Some commentators had deplored—yet again— the complex arrangement of the figures and had reproached the painter for the excessive distortions of the martyr's body: "In the *Saint Stephen,* one may be put off by the strange faces that no artistic system can justify, and by the dislocation of some figures, among which that of the martyr type is particularly mistreated," wrote Louis Peisse in *Le Constitutionnel.*[7] A. de Calonne stated categorically: "Lack of character, none of the figures is a Jewish type . . . flaws sufficient to justify the antipathy of that section of the public whose sensibilities will be offended and whose expectations will not be fulfilled."[8] Some critics could only see, or were only willing to see, an apparently unfinished work, an "over-involved" and "unintelligible" composition "with broken lines throughout, colors clashing in the shadow, and an absence of light."[9] Yet, the painting's detractors, like Henri Delaborde, were receptive to the "dramatic innovation of the scene"[10] or, like Peisse, to the expressive intensity of the light diffused by a "cloudy sky traversed by a sinister reddish glow. Such energy, such transparency of tone, such power of local color in those old city walls, worn away by time! With what somber, venerable majesty they raise their lofty towers into the air! Such an admirable understanding of aerial perspective, which makes them fade from sight as the eye attempts to follow their circular forms!"[11] On closer examination, one cannot help but be struck, as was Théophile Gautier, by the dramatic atmosphere of the scene, which is heightened by the contrast of light and shadow:

Eugène Delacroix understands—and this is one of his many merits—religious painting in its dramatic sense. He succeeds in adding the human element without detracting from the religious character of a scene. His work is full of pathos, perhaps even Byzantine, and we love him all the more for it. Moreover, on these occasions, he knows how muted, sober harmonies soothe the turbulence and extreme intensity of his color. The sky, land, and atmosphere take on an expression of sadness and austerity; the master achieves the same effects through color that others achieve through drawing.[12]

Paying little attention to detail, Delacroix preferred to emphasize what he considered essential. He highlighted the three figures who by themselves symbolize the tragedy that has just occurred. The gesture of tender compassion by the woman who supports the saint's disjointed body corresponds to that of the kneeling woman in the right foreground, who wipes away the bloodstains from the stoning. The desolate expression of the first woman also recalls that of the young Greek embracing his injured father at the far left in *The Massacre at Chios* (Salon of 1824, Musée du Louvre, Paris).

"This painting is pain itself," wrote Paul Mantz in *Revue de Paris,*[13] while Paul de Saint-Victor used even stronger terms in *Le Pays:* "The *Saint Stephen* is one of those tragedies of movement and color in which the great painter gives himself over to pity and pain. . . . Everything converges in this painting to create a poignant expression of religious consternation."[14]

A. S.

1. *Journal,* December 14, 1847, p. 167.
2. *Journal,* January 15, 1853, p. 321.
3. *Correspondance,* vol. 4, pp. 79–80.
4. March 15, 1859, *Correspondance,* vol. 4, p. 83.
5. Dutilleux to Delacroix, Arras, March 17, 1859, Archives Piron, Fondation Custodia, Paris.
6. *Correspondance,* vol. 4, p. 98.
7. Peisse, 1853.
8. Calonne, 1853.
9. Calonne, 1853.
10. Delaborde, 1853.
11. Peisse, 1853.
12. Gautier, 1853.
13. Mantz, 1853.
14. De Saint-Victor, 1853.

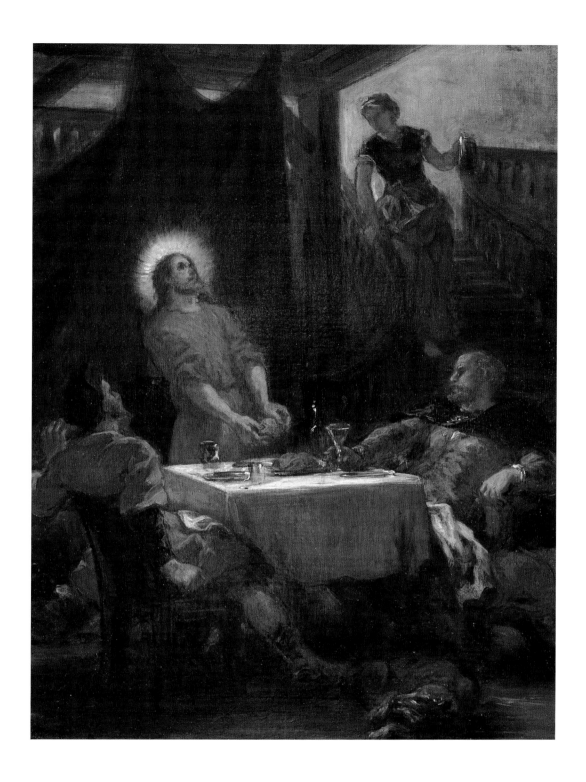

112. *The Supper at Emmaus*

or *The Pilgrims of Emmaus*

1853
Oil on canvas mounted on wood;
22 x 18⅛ inches (56 x 46 cm)
Signed and dated at lower left:
Eug. Delacroix / 1853
New York, The Brooklyn Museum of Art, Gift
of Mrs. Watson B. Dickerman (50.106)

The circumstances surrounding the sale of this
painting immediately upon its completion to
Madame Herbelin (1820–1904), an accomplished
miniaturist and a mutual friend of Delacroix and
Madame Villot, are revealed through numerous
mentions in the painter's correspondence and
Journal. Judging from letters exchanged between
the two during that period, negotiations between
the painter and his client remained extremely
courteous throughout April 1853. In early April the
painter contacted Madame Herbelin: "I have re-
ceived a note from Mme Villot, who was so kind
as to inform me of your wish to own my painting

of the *Pilgrims of Emmaus.* I am eager to express how flattered I am that you would choose one of my works to hang on your wall and view with interest from time to time."[1] On April 12, 1853, the painter wrote in his *Journal:* "During the day Mme Villot, Mme Barbier, and Mme Herbelin came to view my paintings. Mme Herbelin was thrilled with the *Pilgrims of Emmaus* and wishes to purchase it at my asking price."[2]

Later that month Delacroix finally promised the painting to Madame Herbelin: "Last night I saw Mme Villot, who told me of your intention to send me the money for my painting. I begged her to ask you not to send any until the painting was safely in your hands. Please excuse me for not being able to send it to you at present as I shall be exhibiting it at the Salon. Nonetheless, you are already the owner—when sending my paintings, I took the precaution of indicating in a note, which will appear in the catalogue, that the work belongs to you."[3]

The dating of these letters, which themselves indicate nothing more than the day of the week, may be inaccurate, since Delacroix specified in his *Journal* that he had received three thousand francs from Madame Herbelin on April 10, 1853,[4] a date that seems to be incorrect if the other existing references are taken into account. Maurice Sérullaz, who attempted in 1963 to reconstruct the sequence of meetings and correspondence between Delacroix and Madame Herbelin, rightly considered the April 10 date (transcribed into a notebook that has since disappeared) to be incorrect, whether because of an oversight by Delacroix or an error by the copyist.[5]

In any case, it is clear that Madame Herbelin was the owner by the time the Salon opened. The catalogue indicated, as Delacroix had promised, that the painting already belonged to her, and it described the subject portrayed ("They recognize the Savior, whom they had believed to be a disciple like themselves, just after Jesus Christ breaks and blesses the bread to give it out"). Once the Salon was over, the painter wrote to his client on November 8, 1853: "I have just this moment received a letter from M. Villot, who informs me of your return to Paris, so I will send you the *Pilgrims of Emmaus* without delay, and I look forward to seeing it in your hands. I sincerely hope that once you receive it, you will have the same favorable impression that made you so eager to own it, to the great honor of both the painting and its creator."[6] The miniaturist thus came into possession of one of the most controversial paintings exhibited by Delacroix at the Salon of 1853, a canvas that had been compared to the finest works of Rembrandt, Veronese, and Tiepolo, though disliked by certain critics.

Most critics evidently commented on the fact that in treating this Gospel theme Delacroix was ambitiously following the example of past masters, from Fra Angelico (Convent of San Marco, Florence) to Rubens (church of Saint-Eustache, Paris), and Titian and Veronese. The critics remarked on the clear influence of Rembrandt, who was so obsessed by this subject that he painted several versions (Musée du Louvre, Paris; Statens Museum for Kunst, Copenhagen; Musée Jacquemart-André, Paris) and made two engravings, in 1634 and 1654. Delacroix had copied one such work of Rembrandt's; the French painter's estate inventory, included in a study by Henriette Bessis, lists "no. 140, 1 painting depicting *The Pilgrims of Emmaus after Rembrandt* by [Delacroix], 5 F."[7]

Deeply moved by the Dutch master's versions of this theme, Delacroix reproduced the deliberately realistic treatment (the two disciples are seated at the table, in the relaxed pose of friends after a hearty meal), the perspective effect created by the staircase, and the aesthetic idea of the scene unfolding in a dark interior, from which emerges only the massive, luminous silhouette of Christ. But Delacroix has nevertheless created a highly personal work, enriching his palette and composition with memories of Venetian paintings—particularly those by Tintoretto—and infusing the picture with a profound religiosity, produced by the vitality of the standing figure of Christ towering over his disciples.

Once again, Delacroix has chosen an episode from the Gospels, touched upon in Mark (16:12–13) and developed more fully in Luke (24:13–35), that deals with the doubt, confusion, and blindness Christ's disciples experienced after his Passion, followed by the brutal and irrational revelation of his Resurrection: "And it came to pass, as he sat at meat with them, he took bread, and blessed it, and brake, and gave to them. And their eyes were opened, and they knew him; and he vanished out of their sight."

V. P.

1. *Correspondance,* vol. 3, p. 147.

2. *Journal,* April 12, 1853, p. 327.

3. *Correspondance,* vol. 5, pp. 191–92.

4. *Journal,* undated, following November 30, 1852, p. 316.

5. M. Sérullaz, 1963(a), no. 439, repro.

6. *Correspondance,* vol. 3, p. 176.

7. Bessis, 1969, p. 214.

113 to 118. Christ on the Sea of Galilee

The numerous replicas painted by Delacroix on this same theme, frequently using identical iconography, pose a major difficulty in studying the artist's post-1850 production. It is often impossible to distinguish clearly among financial motivations, gestures of friendship, and artistic exploration, since these varying incentives for creating a given work are frequently intertwined. For example, when Delacroix returned to the theme of *The Abduction of Rebecca*, shown at the Salon of 1846 (The Metropolitan Museum of Art, New York), more than a decade later in the painting he exhibited at the Salon of 1859 (cat. 91), he presented a new aesthetic and technical treatment of this subject drawn from Sir Walter Scott. In contrast, the different versions (Musée du Louvre, Paris; private collection)[1] of the *Medea* shown at the Salon of 1838 (Musée des Beaux-Arts, Lille) stemmed from financial motives, dictated by a clearly defined career plan. Similarly, Delacroix made a small-scale replica of *The Death of Sardanapalus* (Philadelphia Museum of Art) in 1844, as a memento of this important work done in his youth, which he was preparing to sell. The painting had been so controversial that he dared not exhibit it, but it was one to which he felt a strong attachment. At the same time, he made a replica of his painting that depicted Byron's *Bride of Abydos*. This version was a commercial commission for the dealer Weill (cat. 83).

Even when the initial iconography, composition, and colors of Delacroix's paintings were dictated by personal inspiration, the creative process was often informed by a close relationship between his private, independent, and often provocative artistic aspirations and his professional commitments to the contemporary art market and collectors, which required him to be fairly open to compromise. After 1850 he seems to have totally integrated this commercial constraint into his career plan and his research, using replicas—and even copies—as a means to resolve the dichotomy in his work between personal creativity and the demands of the market.

Delacroix's many versions of *Christ on the Sea of Galilee* must be understood in this light. These paintings depict the famous episode from the Gospels known as Jesus Calming the Storm, a theme relevant to Delacroix's philosophical and aesthetic concerns during this period. The provenance of these works shows that the many replicas painted for the dealers Petit and Beugniet (cats. 115 and 118) and for friends such as count Grzymala (cat. 116), whom he had met through Frédéric Chopin, were often done on commercial or friendly commissions. Delacroix's personal interest in this subject is demonstrated by the fact that, after his death, the experts Petit and Tedesco found two versions, which they referred to as *Christ Sleeping During the Storm* (cat. 113 and an unidentified painting), in his workshop.[2] The painter had kept these two among his favorite works. At other moments, however, pressed for time, he entrusted the task of copying one or another of his canvases to his assistants in order to deliver the work on the anticipated date. This complicates the attribution of these works and explains the troublesome qualities of certain versions, such as those at the Nasjonalgalleriet in Oslo and the Philadelphia Museum of Art (fig. 1).

In view of Delacroix's many commissions based on the same work, only the six paintings that appear to be entirely his own are included here. Omitted are three other versions in public collections: those of Oslo and Philadelphia, which may have been produced with Pierre Andrieu's assistance or entirely by a collaborator, and the copy in the Boston Museum of Fine Arts, undoubtedly done by Andrieu under the master's supervision. The latter is mentioned in the *Journal* entry of July 3, 1854, as "Repetition, by Andrieu, of Grzymala's *Christ* for B."[3]

Because of the confusion caused by these copies and replicas, the real problem for art historians is to reconstitute their chronological order in order to distinguish, artificially perhaps, those works painted for pleasure or out of aesthetic interest from the "commercial" versions produced in series. In his 1885 catalogue, Alfred Robaut listed all of them under the year 1853, which seems to be inconsistent with the dates deduced from some of the notes in Delacroix's *Journal*. The *Journal* does indicate that two versions of *Christ on the Sea of Galilee* were painted in 1853, one for Grzymala (cat. 116)[4] and the other for François Petit (cat. 115).[5] However, it also refers to another version on which the painter

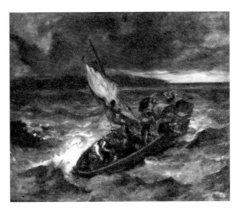

Fig. 1
Attributed to Eugène Delacroix, *Christ on the Sea of Galilee*, 1853–56, oil on canvas, Philadelphia Museum of Art, Gift of Mr. and Mrs. R. Sturgis Ingersoll.

worked in 1854: "Painted a short time on the *Christ on the Sea*: impression of the sublime and of the light" (cat. 118).[6] As well, it mentions what may be a fourth version, entitled *The Boat (La Barque)*, which was painted for the duc de Morny in 1856.[7]

In the absence of contemporary accounts and other information on the first owners of these works, the variants of *Christ on the Sea of Galilee* are difficult to date, especially since the traditional reference point of the Salon, which provides both chronological certitude and the reactions of contemporary critics, does not exist in this case. Delacroix did not exhibit these works at the annual shows.

At the same time, the few preparatory sketches for this set of works, which are of clear aesthetic

113. *Christ on the Sea of Galilee*

c. 1840–45
Oil on canvas; 18 x 21½ inches (45.7 x 54.6 cm)
Kansas City, Missouri, The Nelson-Atkins Museum of Art, Purchase: Nelson Trust through exchange of gifts of the Friends of Art, Mr. and Mrs. Gerald Parker, and the Durand-Ruel Galleries, and Bequest of John K. Havemeyer (89-16)

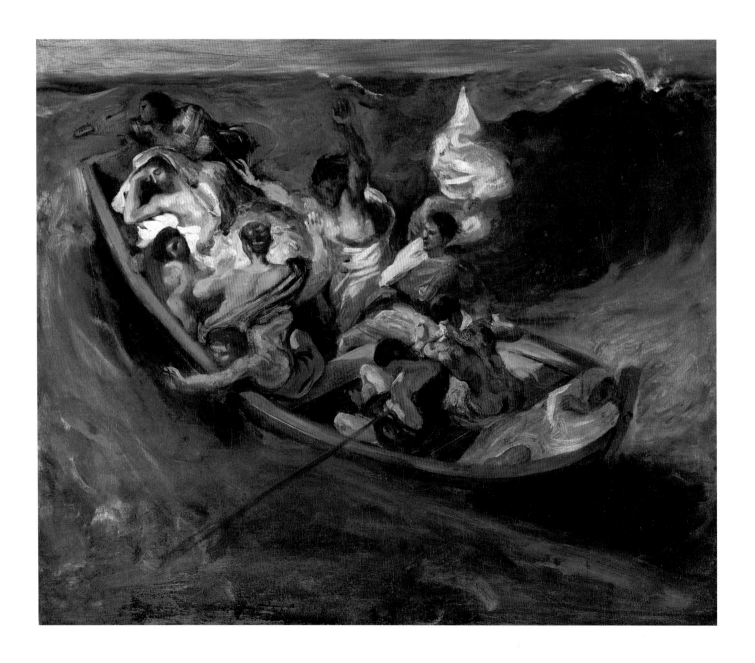

importance because of their interesting compositional variations (see figs. 2, 3, and 4), provide little historical information, with the notable exception of the pencil sketch donated to the Louvre by Véronique and Louis-Antoine Prat in 1990,[8] which is clearly dated 1854 and bears a lovely autograph inscription: *8 août 1854. Le jour où l'envie m'a prise d'aller en Italie* ("August 8, 1854, the day when the desire to travel to Italy came over me"). Another very precise drawing in the Louvre,[9] done in 1854 while the artist was staying in Dieppe, appears to be a study for the boat in the Baltimore version (cat. 118).

Following the example of Lee Johnson, who challenged all of the established dates in this series at the time of the 1962–63 Toronto and Ottawa exhibition, we propose that the Kansas City (cat. 113) and Portland (cat. 114) paintings be considered the oldest—perhaps executed, as Johnson suggested, around 1840–45, the same period as *The Shipwreck of Don Juan* (Musée du Louvre, Paris), which was exhibited at the Salon of 1840. The versions in New York (cat. 115) and in a private Swiss collection (cat. 116) may be later variants, finished about 1853. The paintings at the E. G. Bührle Foundation (cat. 117) and in Baltimore (cat. 118) are correctly dated (the first to 1853 and the second to 1854), but their composition is significantly different from that of the first series.

The six known original versions clearly fall into two groups, distinguished by the appearance of the boat in which Christ and the apostles have embarked. The first group includes four works (cats. 113 to 116) in which Delacroix painted a simple rowboat; the Boston version is a copy of these paintings. The second group, consisting of two paintings (cats. 117 and 118), displays a more complex composition, organized around a boat with sails torn away by the storm. The Oslo and Philadelphia paintings are fairly faithful copies of this second set. The direction of the boat varies: the prow points right in the Bührle version and left in the Baltimore version.

These apparently secondary iconographic changes are, in fact, essential formal variations, radically transforming the poetic universe and the movement of the scene. The boat's form and position produce major changes in the arrangement of the figures and their psychological relationship with the unleashed elements. Thus, in the rowboat series, the nine apostles in the scene are left to their own devices. They are shown in a state of utter disarray, each in a different pose. Two are rowing, while a third is clinging to the tiller. Another is cowering at the bow of the boat, paralyzed with fear, and yet another is pointing at the raging waters of the sea. Four apostles are turned toward Christ, one taking refuge in his ample cloak. On the other hand, in the sailboat series, six apostles are shown, and they are attempting to

Fig. 2
EUGÈNE DELACROIX, *Christ Walking on the Water*, 1850–55, graphite on paper, Rouen, Musée des Beaux-Arts.

Fig. 3
EUGÈNE DELACROIX, *Christ on the Sea of Galilee*, 1853, graphite on paper, Paris, Musée du Louvre, Département des Arts Graphiques.

Fig. 4
EUGÈNE DELACROIX, *Christ on the Sea of Galilee*, c. 1854, graphite on paper, Paris, Musée du Louvre, Département des Arts Graphiques.

hold onto the sails, which are blowing away, except for one apostle, who is beseeching the sleeping Christ. Delacroix always rendered the Gospel account faithfully, according to which Christ fell asleep during the storm.

All the Evangelists except John recounted this miracle of Christ. The texts set it in the midst of his public life when he is teaching by the Sea of Galilee, but historians of the New Testament generally relate it, along with the Miraculous Draught of Fishes and Jesus Walking on the Water, to the cycle of narratives telling of Christ's appearances to his disciples after the Resurrection. In describing this episode, all three Evangelists (Matthew 8:23–27, Mark 4:37–40, and Luke 8:22–25) focused on the apostles' doubt and their admiration when witnessing Christ's powers. Luke's account is undoubtedly the most vivid:

> Now it came to pass on a certain day, that he went into a ship with his disciples: and he said unto them, "Let us go

114. *Christ on the Sea of Galilee*

c. 1840–45
Oil on canvas; 18⅛ x 32¾ inches (46.1 x 55.7 cm)
Signed at lower right, on the boat: *Eug. Delacroix*
Portland, Oregon, Portland Art Museum, Gift of Mrs. William Mead Ladd and her children in memory of William Mead Ladd (31.4)

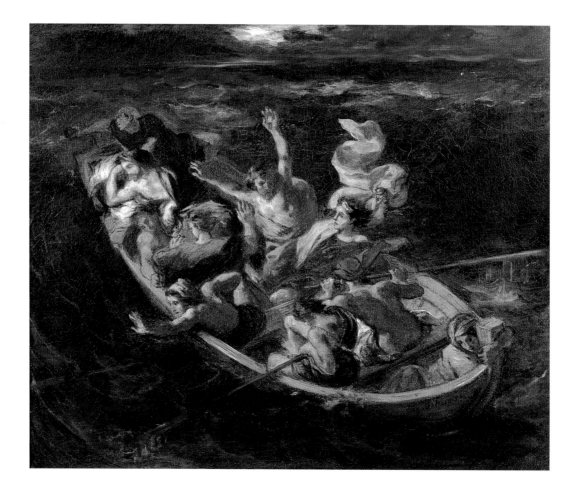

over unto the other side of the lake." And they launched forth. But as they sailed he fell asleep: And there came down a storm of wind on the lake; and they were filled *with water,* and were in jeopardy. And they came to him, and awoke him, saying, Master, master, we perish. Then he arose, and rebuked the wind and the raging of the water: and they ceased, and there was calm. And he said unto them, "Where is your faith?" And they being afraid wondered, saying one to another, What manner of man is this! for he commandeth even the winds and water, and they obey him.

In his treatment of this episode from the Gospel, Delacroix stubbornly pursued his pictorial—but also human, philosophical, and religious—reflections, based on scenes from the Passion and the Resurrection of Christ. This story, which raises the important issue of unconditional faith, provides a perfect complement to the scenes of *The Incredulity of Saint Thomas* (Wallraf-Richartz Museum, Cologne) and *The Supper at Emmaus* (cat. 112), in

115. *Christ on the Sea of Galilee*

c. 1853
Oil on canvas; 20 x 24 inches (50.8 x 61 cm)
Signed at lower left: *Eug. Delacroix.*
New York, The Metropolitan Museum of Art,
H. O. Havemeyer Collection,
Bequest of Mrs. H. O. Havemeyer, 1929
(29.100.131)

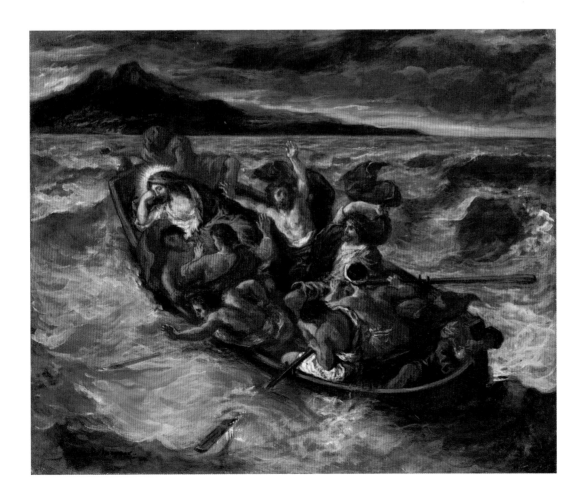

which he portrayed the disciples' moments of doubt and fear, a subject relevant to his own spiritual anxiety.

In dealing with the theme of the calming of the storm, and more generally, the pictorial description of a boat lost in turbulent waters, Delacroix could also refer to many previous works, including some of his own. He was, of course, familiar with Rembrandt's 1633 version, *The Storm on the Sea of Galilee* (Isabella Stewart Gardner Museum, Boston), if only through prints. This painting, which is much more realistic than his own and provides a more agitated portrayal, surely inspired Delacroix's variation on the theme, showing a boat "with sails," which he began in 1853 (cats. 117 and 118). He was also inspired by the colors of Rubens's *Miraculous Draught of Fishes,* which he discovered during his trip to Brussels in 1850, and we know he was impressed by the deep tones Rubens used in

116. *Christ on the Sea of Galilee*

c. 1853
Oil on canvas; 19¹¹⁄₁₆ x 24 inches (50 x 61 cm)
Signed at lower right: *Eug. Delacroix*
Private collection (courtesy of the Nathan Gallery, Zurich)
Exhibited in Paris only

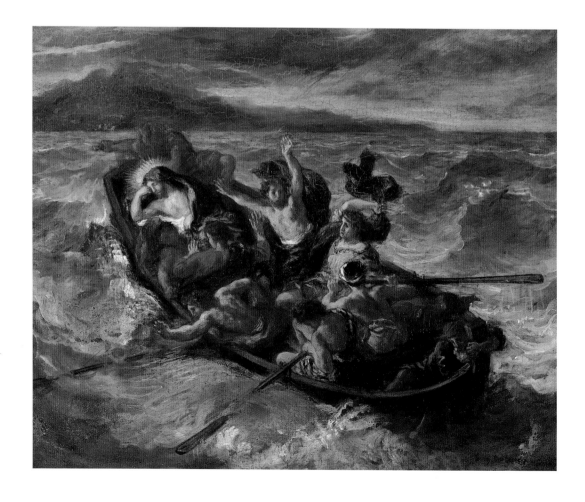

the triptych on the same subject, completed in 1619 for the church of Notre-Dame-de-la-Dyle in Malines (Musée des Beaux-Arts, Nancy). Delacroix referred to these works during a trip to Nancy in 1857, precisely describing his response to their aesthetic qualities: "Two pictures, probably sketches by Rubens . . . impressed me more than anything else . . . they have that indefinable thing which belongs to him alone. . . . Before these pictures I feel that inner movement, that quiver, which a powerful piece of music gives. . . . When one has seen these pictures, which are only hasty sketches, full of a roughness of touch that upsets you in Rubens, there is nothing more that can be looked at."[10] Perhaps he also studied the remarkable *Christ Walking on the Water* by Tintoretto, for we recall that master's treatment of the waves when we see Delacroix's technique in his *Christ on the Sea of Galilee* paintings. And he must surely have

117. *Christ on the Sea of Galilee*

1853
Oil on canvas; 23⅜ x 28¾ inches (60 x 73 cm)
Signed and dated at lower right:
Eug. Delacroix 1853
Zurich, E. G. Bührle Foundation
Exhibited in Paris only

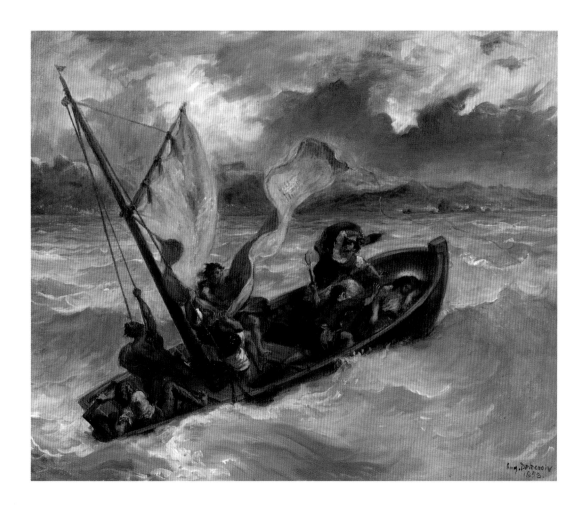

remembered the unfettered violence of Jacob Jordaens's vision in his seventeenth-century painting of this Gospel story—and one of the closest to Delacroix's own.

Quite apart from these sources of inspiration in paintings by the masters, the theme of the boat upon the water is one that had obsessed Delacroix since his youth, as evidenced by the famous *Barque of Dante* in the Louvre and especially *The Shipwreck of Don Juan* (Musée du Louvre, Paris; replica in The Victoria and Albert Museum, London), which, though inspired by Lord Byron's *Don Juan*, clearly seems to be an aesthetic forerunner of the *Christ on the Sea of Galilee* series.

In these works, Delacroix sought to wed his passion for maritime scenes, which had grown stronger still after 1845 because of his frequent trips to Dieppe and Normandy, with the dramatic force of subjects that set man in confrontation with the raging elements. However, the landscapes of these religious paintings are not simply views sketched outdoors during a trip to Normandy and then transposed into a great religious composition; on the contrary, they are totally imaginary. For Delacroix, as for most of his contemporaries, the most beautiful landscape was conceived in the artist's imagination. The dark gray, deep blue, and yellow skies and the forbidding mountains serve as a backdrop for these religious paintings, bringing them to life and heightening their dramatic effect. The settings illustrate the artist's desire to use nature in ways that evoke reflections on human destiny.

Succeeding generations have been perfectly comfortable with this aesthetic approach, which is clearly explained by Paul Signac (1863–1935) in his well-known 1899 study *From Eugène Delacroix to Neo-Impressionism*. Signac extensively discussed the question of the moral role of color in Delacroix's work. The example given by Signac is the painter's use of dark greens to render storm-driven waves, a treatment used repeatedly in the *Christ on the Sea of Galilee* series. "The tragic effect of . . . *The Shipwreck of Don Juan* is due to a dominant dark glaucous green, toned down with mournful blacks; the funereal effect of a white sinister glitter amidst all this gloom completes the harmony of desolation."[11]

In his depiction of *Christ on the Sea of Galilee,* which reflects Delacroix's metaphysical anguish as well as his constant technical exploration, the artist revisited an important theme in religious painting. By emphasizing the meaningful—today we would say subliminal—role of color, Delacroix took his aesthetic research in a new direction, one that would captivate painters in the late nineteenth and the twentieth century.

V. P.

1. Johnson, 1986, vol. 3, no. 344, pl. 154.

2. "No. 176, 1 painting representing *Christ Sleeping During the Storm* by Delacroix, 10 F" and "no. 242, 1 painting representing *Christ Sleeping During the Storm* by Delacroix, 5 F." See Bessis, 1969, pp. 199–222.

3. *Journal,* July 3, 1854, p. 439.

4. *Journal,* June 28, 1853, p. 357.

5. *Journal,* October 10 and 13, 1853, pp. 364, 367.

6. *Journal,* May 29, 1854 (Pach, 1937, p. 388).

7. *Journal,* March 27, 1856, p. 573.

8. Département des Arts Graphiques, Musée du Louvre, Paris, RF 42 6600.

9. Département des Arts Graphiques, Musée du Louvre, Paris, RF 9466.

10. *Journal,* August 9, 1857 (Pach, 1937, pp. 595–96).

11. Paul Signac, *From Eugène Delacroix to Neo-Impressionism,* translated by Willa Silverman (Paris: H. Floury, 1921); quoted in Floyd Ratliff, *Paul Signac and Color in Neo-Impressionism* (New York: Rockefeller University Presss, 1992), p. 233.

118. *Christ on the Sea of Galilee*

1854
Oil on canvas; 23½ x 28⅞ inches
(59.8 x 73.3 cm)
Signed and dated at lower right:
Eug. Delacroix. 1854
Baltimore, The Walters Art Gallery (37.186)

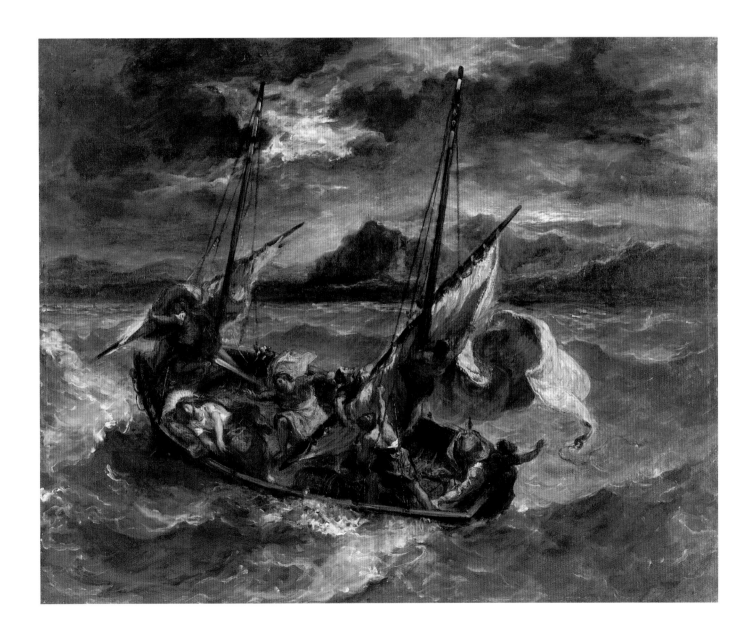

Determined to gain recognition as a painter of religious scenes, Delacroix aspired to attain the same stature as Renaissance and seventeenth-century masters in his treatment of Christian themes. He focused his iconographic and artistic exploration on a few key subjects, which in 1931 Raymond Régamey grouped into two distinct categories: the manifestation of the supernatural and the persecution of the saintly.[1] Régamey (who was a priest) was personally committed to the belief that religion was not simply a matter of suffering, and while correctly assessing Delacroix's fascination for Christ's "power of sacrifice," he nonetheless intentionally played down the painter's irrepressible attraction to poignant scenes from the Passion and the Resurrection.

An alternative analysis of Delacroix's affinity for depicting the suffering of Christ was provided during the painter's lifetime by Charles Baudelaire in his penetrating commentary on the Salon of 1846. Noting first that "perhaps he alone, in this century of nonbelievers, has created religious paintings that were neither empty nor cold, like some works created for competitions, nor pedantic, nor mystical, nor neo-Christian," he went on to explain that "the genuine sadness for which he had a flair was perfectly suited to our religion, a profoundly sad religion, a religion of universal pain, and one which, due precisely to its catholic nature, endows the individual with complete freedom."[2]

His personal path of philosophic investigation would inevitably lead Delacroix to paint the most dramatic scene in the Gospels, the Crucifixion and death of Christ—the one in which, by virtue of its very mystery, the question of Christ's divinity is raised through man's direct and violent confrontation with God. The subject of Christ on the cross, which would figure prominently during the later years of his career, had already absorbed Delacroix in his youth: at the Salon of 1835 he had exhibited a major work inspired by Rubens, *Christ on the Cross,* now in Vannes (fig. 1). This ambitious work by Delacroix is characterized, even at this early date, by the attention paid to the arrangement of the composition and the creation of dramatic effects that, while perhaps diminishing the intensity of the painting, nevertheless infuse it with a spiritual and aesthetic fervor. In addition, Alfred Robaut (1885) reported another *Christ on the Cross,* a small painting (location unknown) dated 1837, which appears to have been part of the Arosa sale of 1878 and the Dolfus sale of 1912. This may be Delacroix's first portrayal of Christ on the cross in the style that he was to develop more fully after 1845.

In November 1845, at the Théâtre de l'Odéon in Paris, Delacroix exhibited a highly expressive sketch (cat. 119) showing Christ dying on the cross, his side already pierced by the Roman soldier's spear. This exhibition took place ten years after he had painted the Vannes *Christ on the Cross* and six years after his first trip to Belgium and Holland, where he had admired the great religious paintings of Rubens, with whose engravings he was already familiar. This oil painting on wood, which would turn out to be a study for a painting exhibited two years later at the Salon (cat. 120)—displaying exactly the same composition and dramatic intensity—was incorrectly dated to 1847 by Robaut, who thought it a replica of the Salon painting. In fact, as noted by Lee Johnson, who thoroughly analyzed the dating of this work, it must have been the painting that belonged to Alexandre Dumas *père* (1802–1870) and that Théophile Thoré discussed in his commentary on the Salon of 1847: "We had already seen an exquisite sketch of this work, belonging to M. Alexandre Dumas, at the Odéon exhibition. The painting [exhibited at the Salon of 1847; cat. 120] possesses a grandeur and spirit that enhances its pleasing color and supremely masterful execution."[3]

The painting in the Odéon exhibition (cat. 119) also captured the attention of Théophile Gautier, who commented on the sketchlike quality of this strange, superbly executed work, which was characterized by its "disorderly brushstrokes and casual draftsmanship," a work that "comes close to the most bizarre and extravagant Tiepolos." The structure of the composition also seemed particularly

Fig. 1
Eugène Delacroix, *Christ on the Cross,* 1835, oil on canvas, Vannes, La Cohue, Musée de Vannes.

119. *Christ on the Cross*
(sketch)

1845
Oil on wood; 14⁹⁄₁₆ x 9⅞ inches (37 x 25 cm)
Rotterdam, Museum Boymans–van Beuningen
(inv. 2625)

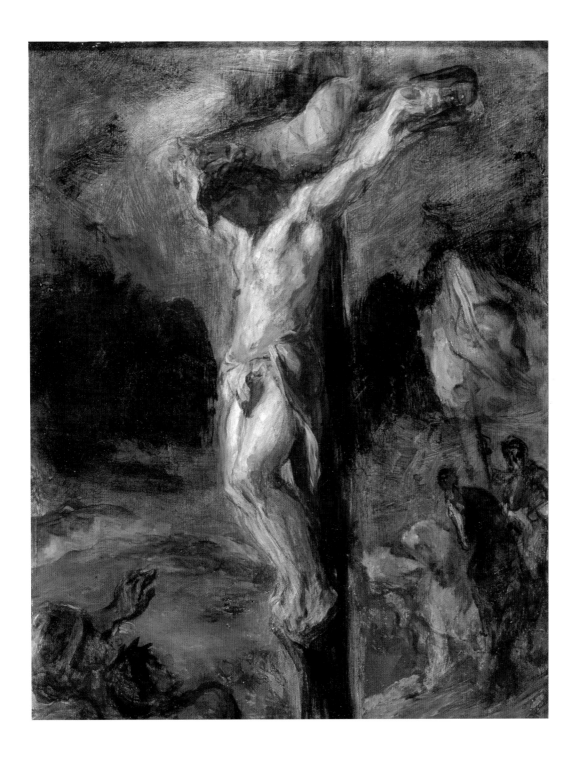

1846
Oil on canvas; 31½ x 25¼ inches (80 x 64.2 cm)
Signed and dated at lower right:
Eug. Delacroix 1846.
Baltimore, The Walters Art Gallery (37.62)

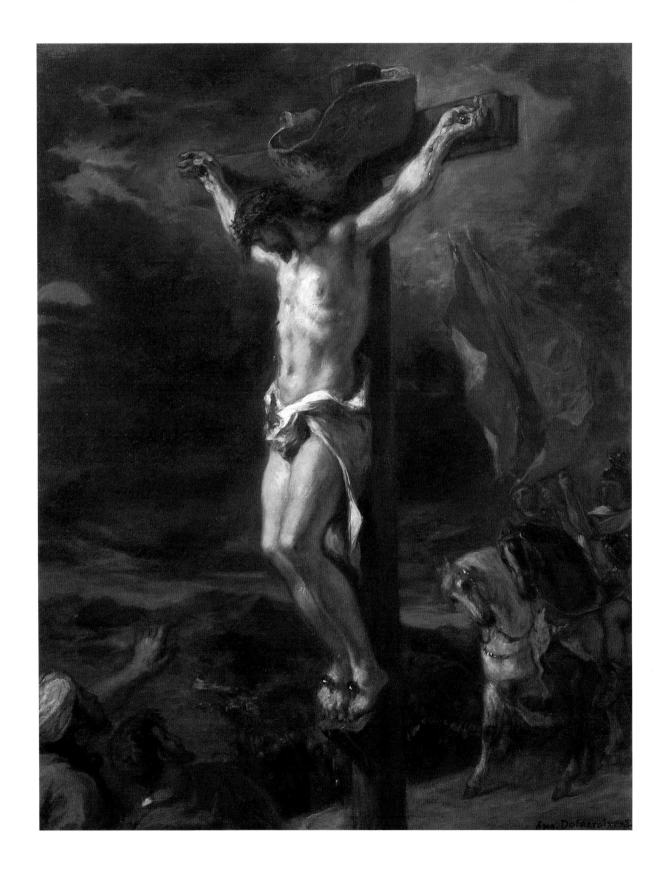

121. *Christ on the Cross*

c. 1847–50
Pastel on paper; 11¼ x 8¼ (28.5 x 21 cm)
Signed at lower left: *Eug. Delacroix.*
Private collection
Exhibited in Philadelphia only

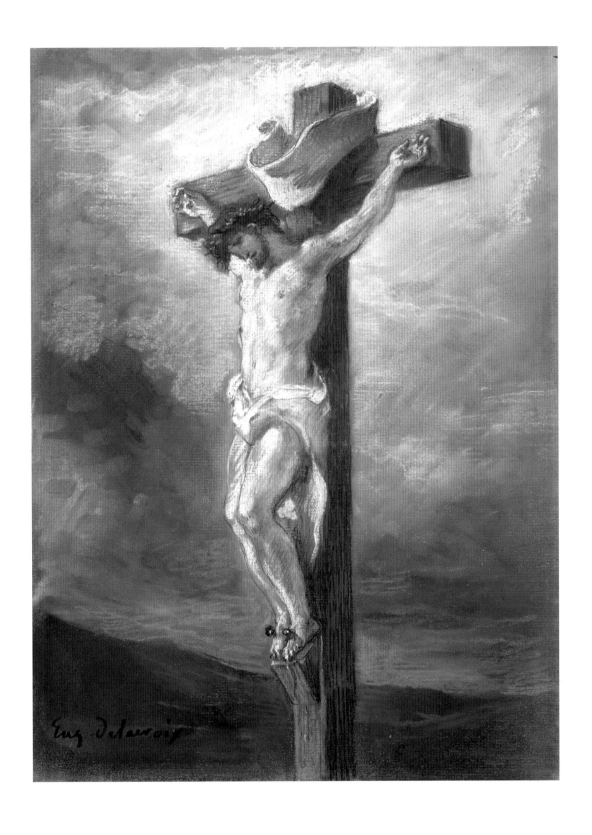

Fig. 2
EUGÈNE DELACROIX, *Christ on the Cross*, c. 1844, oil on wood, Paris, Musée du Louvre.

daring, focusing entirely on the central figure of the crucified Christ and showing, at the right, two horsemen facing the cross and, at the lower left, two figures positioned at the foot of the cross, these four participants each cut off by Delacroix's cropping of the scene. The stormy sky was obviously influenced by studies similar to those the painter would execute between 1849 and 1853, and is also reminiscent of the biblical description of the episode, in which darkness descends upon the earth.

Two years after this work, in 1847, when Delacroix exhibited at the Salon the more finished version (cat. 120), it was acclaimed even by the Parisian critics, who normally were so sparing with their compliments. Théophile Thoré, who found the work totally compelling, aptly remarked: "His Christ . . . recalls the most beautiful Crucifixions painted by Rubens; the poetry and color show a resemblance with painters from Giorgione to Titian. If Eugène Delacroix has not made the Christ with the same spirit and the same aspect as Rubens, then Rubens never existed. . . . Eugène Delacroix is unmatched in his treatment of skies. The infinite is always unfolding before him; that is why some criticize the work as being unfinished."[4]

This widespread enthusiasm reassured the painter, and on May 7, 1847, following a visit to the Salon and another viewing of his painting, he observed with pride: "Felt fairly satisfied with the Christ."[5] A few years later, in one of the first texts devoted to Delacroix's work, Théophile Silvestre described this canvas as one of the artist's most successful: "His Christ dies slowly, his face veiled in a mysterious halftone, before the insolent glare of the mob. As violent as the scene may be, there is no vulgar gasping for breath in this display of agony."[6]

During this period Delacroix energetically defended these new developments in his painting, as evidenced by a letter in which he revealed his concern for protecting his works. It was written

February 9, 1853, to J. P. Bonnet, who owned this painting at the time:

> I have taken the liberty of putting M. Silvestre in touch with you. He is compiling a very interesting work on modern artists, and is eager to obtain your permission to photograph the *Christ*, which you have in your possession, in order that it may be added to the other important photographs in his work. He will take care to mention on the prints that the work comes from your collection. At the same time, you would be helping me personally, for if ever you ceased to be the owner, the painting could fall into the hands of someone who might challenge my right to reproduce it, or who might make such action on my part impossible by simply removing it.[7]

The theme of the crucified Christ was so central to Delacroix's production that in 1848 he offered Joséphine de Forget a *Christ on the Cross* of modest size and sober execution that reflects his aesthetic concerns at the time (fig. 2).

In choosing to illustrate this emblematic episode from the Gospels, Delacroix did not, however, intend it to remain a solitary study, and the painter was able to renew his inspiration whenever commercial considerations, rarely absent from his work during this period, led him to paint new versions of the Crucifixion. Thus, in the first two versions of *Christ on the Cross* (cats. 119 and 120) he invoked the precise moment of the Savior's death, as described by three of the four Evangelists (Matthew, Mark, and Luke). Witnesses to this immensely powerful scene were filled with astonishment and admiration:

> Now from the sixth hour there was darkness over all the land unto the ninth hour. . . . Jesus, when he had cried again with a loud voice, yielded up the ghost. And, behold, the veil of the temple was rent in twain from the top to the bottom; and the earth did quake, and the rocks rent. . . . Now when the centurion, and they that were with him, watching Jesus, saw the earthquake, and those things that were done, they feared greatly, saying, Truly this was the Son of God (Matthew 27:45–54).

In two pastels (cats. 121 and 122) done after 1847 and inspired by the work presented at the Salon, one figure of Christ (cat. 121) is clearly a copy of the Salon painting, while the other (cat. 122), which is reversed, bears less resemblance to that work. The two pastels demonstrate Delacroix's stylistic evolution, for they emphasize Jesus' victory over death and original sin in a more symbolic manner, focusing the action on the figure of Christ alone.

In 1853 Delacroix painted another *Christ on the Cross* (cat. 123), apparently commissioned by an art dealer. A receipt for the dealer Beugniet, dated July 18, 1853, reads: "I have received from M. Beugniet the sum of twelve hundred francs as

122. *Christy on the Cross*

c. 1853–56
Pastel on blue gray paper; 9¾ x 6½ inches
(24.7 x 16.5 cm)
Signed at lower left: *Eug. Delacroix.*
Ottawa, National Gallery of Canada (inv. 15733)
Exhibited in Paris only

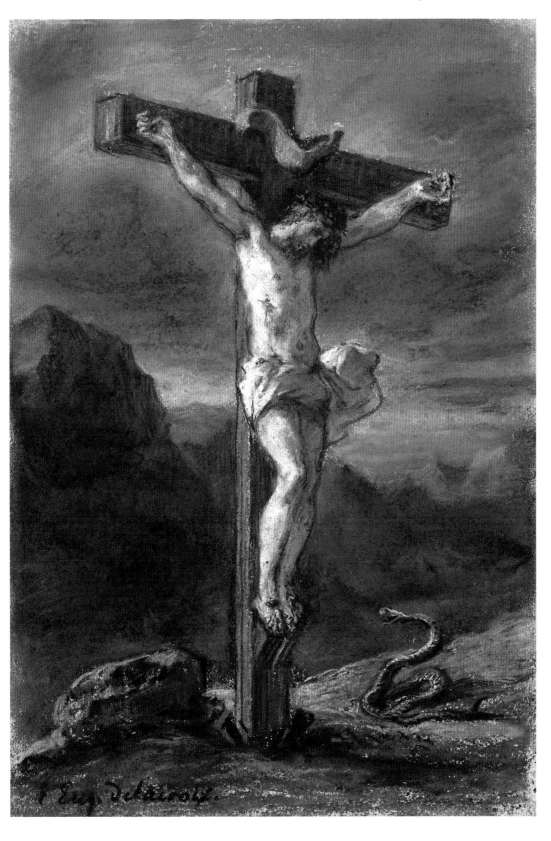

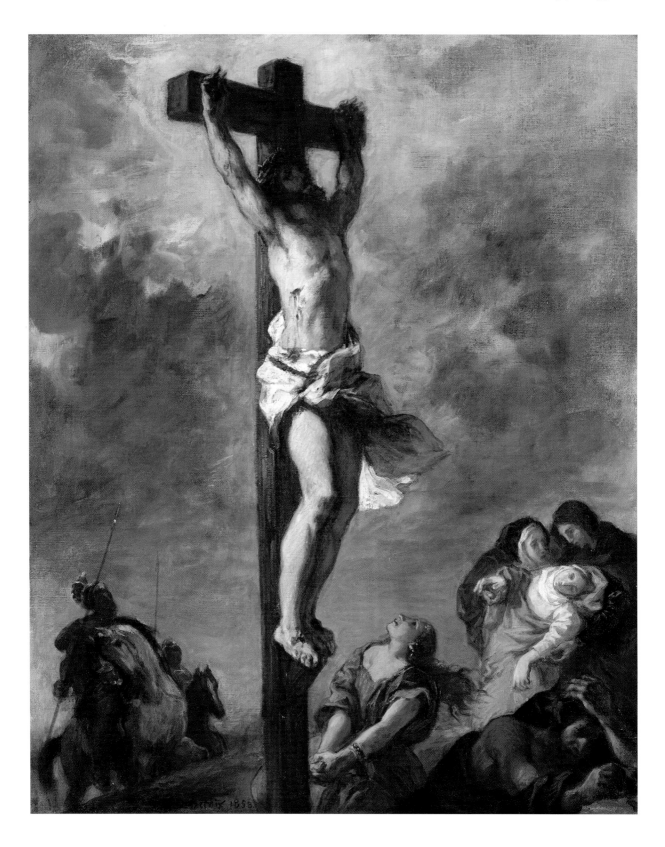

123. *Christ on the Cross*

1853
Oil on canvas; 28⅞ x 23⁷⁄₁₆ inches
(73.3 x 59.5 cm)
Signed and dated at lower left of cross:
Eug. Delacroix 1853.
London, The National Gallery (inv. 6433)

payment for a painting representing Christ on the Cross."[8] The artist also made the following entry in his *Journal* on June 28, 1853: "I have finished, more quickly than I would have thought possible, the *Christ on the Cross* for Bocquet."[9] The painting reveals Delacroix's capacity for renewing his approach. Spurred on by his fascination with the subject, he discovered, in the Gospel of John, a different kind of iconography, frequently used by his predecessors, with a structure, poetic spirit, and dramatic development that inspired him to develop the theme of the Crucifixion in an entirely new manner:

> Now there stood by the cross of Jesus his mother, and his mother's sister, Mary the wife of Cleophas, and Mary Magdalene. When Jesus therefore saw his mother, and the disciple standing by, whom he loved, he saith unto his mother, "Woman, behold thy son!" Then saith he to the disciple, "Behold thy mother!" And from that hour that disciple took her unto his own home. After this, Jesus knowing that all things were now accomplished . . . bowed his head, and gave up the ghost (John 19:25–30).

In this work Delacroix portrays the Virgin fainting into the arms of John and her sister, while Mary Magdalene prays at the foot of the cross. The introduction of these figures, intentionally moved to the far edges of the work and cut off by the border of the canvas, reinforces the religious drama by transforming the formal rhythm and spiritual intentions of the painting.

Several years later, another *Christ on the Cross* (fig. 3), which culminated the multifaceted exploration that Delacroix had carried out since executing the Vannes painting in 1835, completed this set of works inspired by the Crucifixion.

In concluding this study of Delacroix's paintings of *Christ on the Cross*—one of Christianity's most significant and most frequently painted images—we must ask the final question: What inspired the artist to create this series, and which works of art had the greatest impact on his creativity? In terms of their forms, the clear similarity between certain Delacroix paintings (cats. 119 to 121) and the famous *Coup de lance* by Rubens (Musée Royal des Beaux-Arts, Antwerp), painted for the church of the Recollects in Antwerp, has been pointed out frequently and justifiably. Delacroix made two copies of this work (figs. 4 and 5), done from memory and possibly following his second trip to Belgium, in 1850. These paintings reveal the depth of his preliminary research and demonstrate his special attention to Rubens's use of particular shapes and dramatic effects.

Ever since Mantegna (Musée du Louvre, Paris), Tintoretto (Scuola di San Rocco, Venice), and Veronese (Musée du Louvre, Paris), the pictorial representation of Christ on the cross had become an unavoidable stylistic exercise. However,

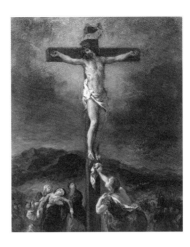

Fig. 3
EUGÈNE DELACROIX, *Christ on the Cross*, 1856, oil on canvas, Bremen, Kunsthalle.

Fig. 4
EUGÈNE DELACROIX, *Coup de lance*, c. 1850, brown ink and wash on paper, New York, The Pierpont Morgan Library.

Fig. 5
EUGÈNE DELACROIX, *Coup de lance*, c. 1850, pastel on paper, Paris, Musée du Louvre, Département des Arts Graphiques.

in discussing Delacroix's religious painting, we cannot deny the direct aesthetic link between him and certain Northern European painters. We must note his admiration for the dramatic and expressive paintings of Jacob Jordaens (Musée des Beaux-Arts, Bordeaux, at the cathedral of Saint-André), Rembrandt (*Christ on the Cross,* church of Le Mas d'Agenais), Karel Dujardin (Musée du Louvre, Paris), and Jan Lievens (*Christ Dying,* Musée des Beaux-Arts, Nancy), from which he drew inspiration. Finally, we should mention the comment by Gautier, who noted that "there is in this livid flesh, bathed in gray shadows, something of the morbidity and chiaroscuro of the *Christ Dying* [by Prud'hon]."[10] As Johnson has observed, these remarks by Gautier, together with Delacroix's important article on Prud'hon that appeared on November 1, 1846,[11] allow us to suppose that Delacroix was influenced by that artist's *Christ on the Cross* (Musée du Louvre, Paris), which had been exhibited at the Salon of 1822. Nevertheless, Prud'hon's influence, real or imagined, cannot diminish that of Rubens and Rembrandt. Delacroix's remarkably vigorous and original variations on their paintings are an unequivocal tribute to these two artists.

<div align="right">V. P.</div>

1. Régamey, n.d. [1931], pp. 171–72.
2. Charles Baudelaire, "Le Salon de 1846," in *Baudelaire: Oeuvres complètes,* edited by Claude Pichois (Paris: Gallimard, 1976), vol. 2.
3. Thoré, 1847(b).
4. Thoré, 1847(b).
5. *Journal,* May 7, 1847 (Norton, 1951, p. 77).
6. Silvestre, 1864.
7. *Correspondance,* vol. 3, p. 139.
8. *Correspondance,* vol. 3, p. 164.
9. *Journal,* June 28, 1853, p. 357.
10. Gautier, 1847.
11. *Revue des Deux Mondes,* November 1, 1846.

Fig. 1
EUGÈNE DELACROIX, *The Lamentation,* 1843–44, oil and wax on plaster, Paris, church of Saint-Denis-du-Saint-Sacrement.

124. *The Lamentation*

1857
Oil on canvas; 14¾ x 17⅞ inches
(37.5 x 45.5 cm)
Signed and dated at lower left:
Eug. Delacroix. 1857.
Karlsruhe, Staatliche Kunsthalle (2661)
Exhibited in Paris only

Here Delacroix returned—with a few variations, the most important of which is the scene's reversal—to the composition in the painting that adorns the chapel of the Virgin at the church of Saint-Denis-du-Saint-Sacrement in Paris (fig. 1). He was commissioned for that earlier work in 1840 and completed it in the winter of 1843–44. A note in the *Journal,* dated March 27, 1856, indicates that he was giving some thought to working on this painting in the country.[1] Following through with this plan, he arrived in Champrosay on May 17; on May 26 he wrote the following note without providing further details: "Advanced . . . the *Pietà.*"[2]

<div align="right">A. S.</div>

1. *Journal,* March 27, 1856, p. 573.
2. *Journal,* May 26, 1856, p. 581.

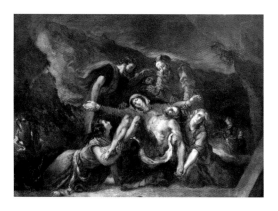

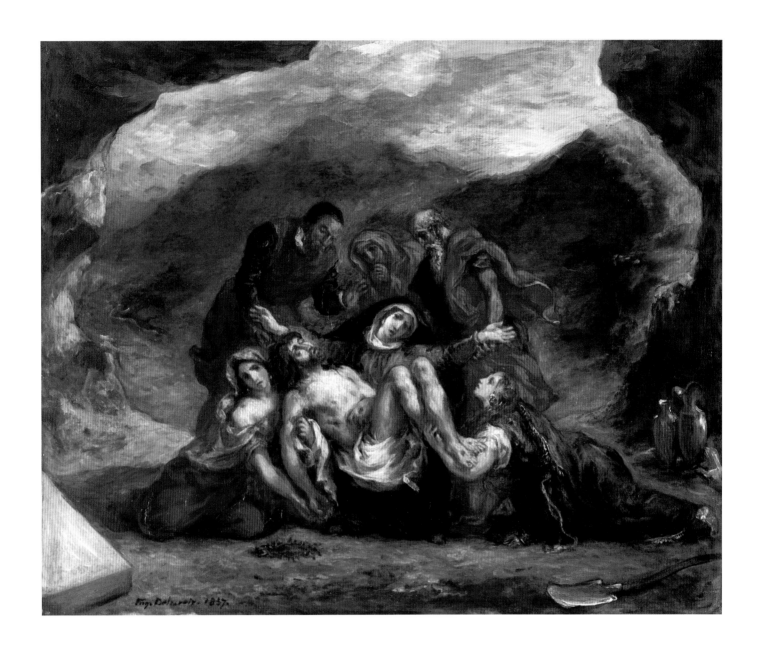

The four Gospels agree in their descriptions of the entombment of Christ on the evening of his Crucifixion (Matthew 27:55–60, Mark 15:42–47, Luke 23:50–54, and John 19:38–41). All ascribe a central role to Joseph of Arimathea, a member of the Sanhedrin tribunal who is reported to have asked Pontius Pilate for the body and organized the burial of Christ. Luke's account, which is the most precise, describes this important episode preceding the Resurrection:

> And, behold, *there was* a man named Joseph, a counsellor; *and he was* a good man, and a just: (The same had not consented to the counsel and deed of them;) *he was* of Arimathea, a city of the Jews: who also himself waited for the kingdom of God. This *man* went unto Pilate, and begged the body of Jesus. And he took it down, and wrapped it in linen, and laid it in a sepulchre that was hewn in stone, wherein never man before was laid.

The Gospel of John includes the figure of Nicodemus—"which at the first came to Jesus by night"—and specifies that the grave was located in a garden, near the place where Jesus had been crucified.

This episode has inspired at least three distinct iconographic themes based on events in the Gospel: the Deposition, when Joseph and his friends take the body of Christ down from the cross, an episode illustrated in the works by the Italian painter Daniele da Volterra (c. 1509–1566) and the Flemish master Peter Paul Rubens (1577–1640); the Lamentation, when the Virgin and the holy women grieve over Christ's body (the traditional pietà portrayed by painters and sculptors of all schools since the Middle Ages); and finally the Entombment, a subject that allows for the most subtle variations in composition and pictorial choices.

Delacroix depicted most of the scenes of the Passion. He painted the Deposition only once, in a work commissioned by Lefebvre in 1849,[1] but in 1843–44 he had already dealt with the theme of grief over the Savior's death in a superb *Lamentation* for the church of Saint-Denis-du-Saint-Sacrement in Paris (cat. 124 fig. 1), a work for which he had made numerous studies. In January 1847 he decided to revisit the theme of the *Lamentation* in a work of ambitious scale for the Salon of 1848 (cat. 125). This painting is in the spirit of the *Lamentation* of 1843–44, but with more attention paid to the nocturnal setting and Delacroix's macabre universe. Employing a vertical rather than a horizontal composition, Delacroix did not center the action on the tortured face of the weeping Virgin as in the famous *Pietà* by

Rosso Fiorentino (1494–1540; Musée du Louvre, Paris), which had inspired his first version on the theme; instead, he precisely depicted the body of Christ, very dramatically illuminated, around which he arranged six figures. Mary is portrayed with the expression of pathos seen in the 1843–44 *Lamentation,* but in a more affectionate and less theatrical pose, supporting her son's head, while John, bare-chested and wearing a red cloak, is kneeling near Christ's feet and sadly contemplating the crown of thorns. A kneeling holy woman, probably Mary Magdalene, is supporting one of Christ's feet and lifting the shroud, while Joseph of Arimathea and another holy woman are standing over the corpse, gazing sadly upon the pain of Jesus' mother, who is being compassionately supported by a third woman, possibly her sister, "the other Mary."

Delacroix's individualized treatment of the theme in this canvas is combined with explicit references drawn from the work of various Italian painters: Rosso Fiorentino, once again, but also Titian (more so Titian's version of *The Entombment* at the Prado in Madrid than the famous version in the Louvre), Veronese, the Bassanos (*The Entombment* in the church of Santa Croce Carmini in Vicenza or another version at the Kunsthistorisches Museum in Vienna), and, in a more modern style, Nicolas Poussin, whose *Lamentation Over the Dead Christ* (Alte Pinakothek, Munich) may be one of the sources for the arrangement of figures and the treatment of Christ's body in this personal version by Delacroix.

Delacroix worked intensively on this painting throughout 1847. He began planning the composition the same day as that of *The Road to Calvary* (cat. 128), which was designed for a prospective commission, ultimately never realized, to decorate the transept at the church of Saint-Sulpice. On January 21, 1847, he wrote in his *Journal:* "Made sketches for three subjects: *Christ Carrying His Cross*, after an old sepia; *Christ on the Mount of Olives,* for Mme Roché; *Christ Laid Out on a Stone, Mourned by the Holy Women.*"[2] The artist then worked extensively on the sketch for the painting throughout the month of February, as three *Journal* entries attest. On February 1 Delacroix noted that he had made his first sketch in white pencil and had decided on a number 100 canvas for the painting.[3] On February 3 he mentioned that he had begun to sketch the sky,[4] and on February 6 he proudly declared that he had sketched all the figures on the canvas itself,[5] undoubtedly relying on a number of studies in which he explored various expressions for the figures (figs. 1 and 2). After

125. *The Lamentation*

1847–48
Oil on canvas; 64 x 52 inches (162.6 x 132.1 cm)
Signed and dated at lower left:
Eug. Delacroix. 1848.
Boston, Museum of Fine Arts, Gift by contribution in memory of Martin Brimmer (96.21)

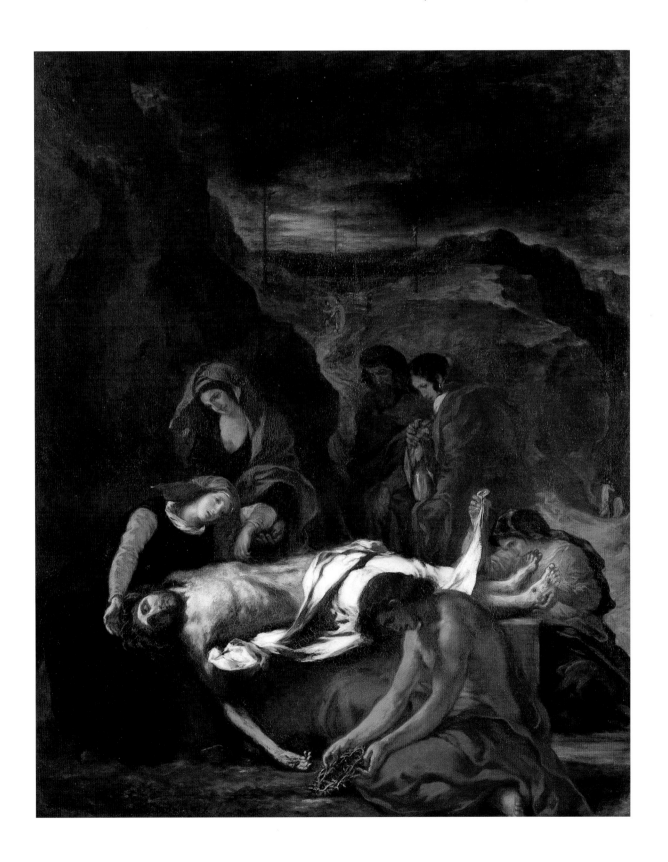

1849
Oil on canvas; 22⅟₁₆ x 18⅜ inches (56 x 47.3 cm)
Signed at lower left of center: *Eug. Delacroix*
Phoenix Art Museum, Gift of Mr. Henry R.
Luce (64.42)

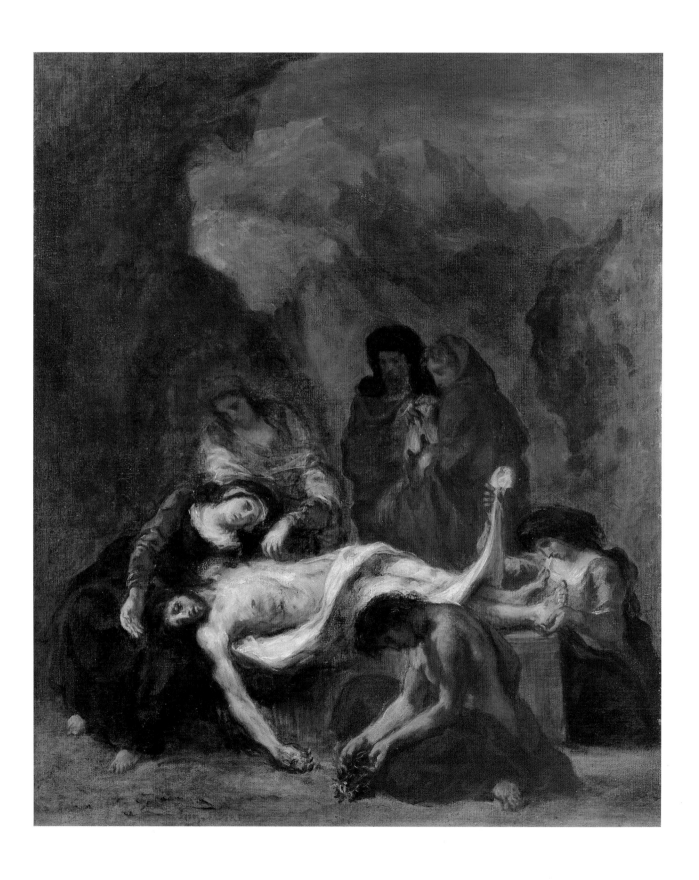

127. *The Entombment*

1858–59
Oil on canvas; 22³⁄₁₆ x 18¼ inches
(56.3 x 46.3 cm)
Signed and dated at lower left of center: *Eug. Delacroix 1859*
Tokyo, The National Museum of Western Art (P. 1975-2)

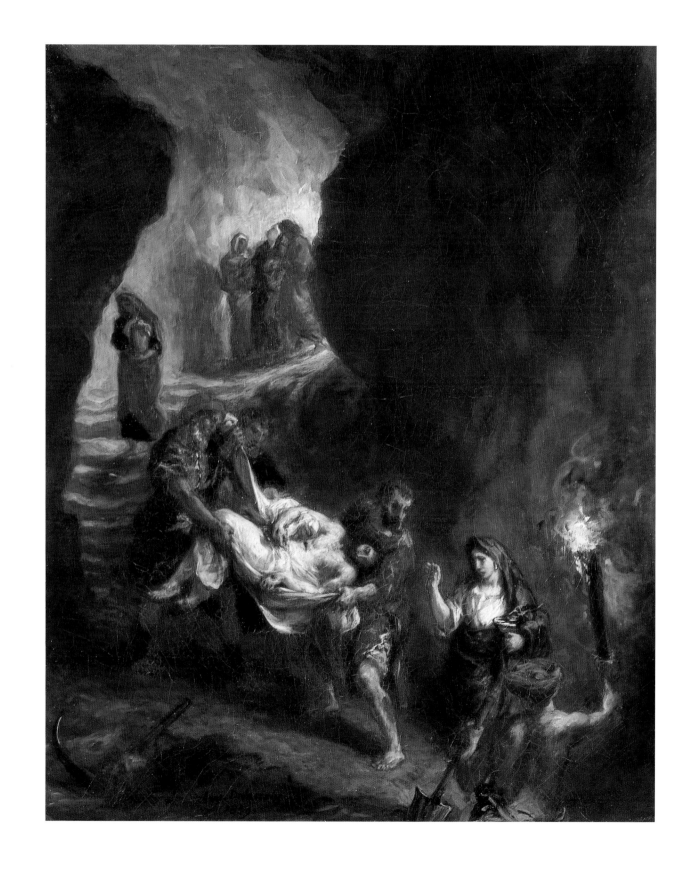

a short gestation period, Delacroix pursued his work, and on February 15 he commented, not without some pride, on how it was progressing:

Felt unwell when I got up. Took up the sketch for the *Entombment* once more, and became so fascinated that it drove away my disorder, but I paid for it that evening with a stiff neck that lasted all through the following day. The sketch is very good. It has lost some of its mystery, but that is the disadvantage of a methodical sketch. With a good drawing to settle the main lines of the composition and the placing of the figures the sketch can be done away with. It almost becomes an unnecessary repetition of the work itself. The qualities of the sketch are retained in the picture by leaving the details vague.[6]

In addition to these remarks about his method of working, Delacroix provided some crucial information concerning his choice of colors: "For the local colour of the Christ I used raw umber, Naples yellow and white; over this, a few tones of black and white slipped in here and there; shadows in a warmer tone. The local colour of the Virgin's sleeves; a grey, rather on the reddish side. The lights, in Naples yellow and black."[7] The entry for March 2 contains additional details about the pigments used in this work:

The color of the rocks in the background, in *Christ at the Tomb:* Light areas—raw umber and white next to Naples yellow and black, with a slightly pinkish hue. Other golden light areas, representing the grass: yellow ocher and black, shaded either dark or light. Shadows: raw umber and burnt green earth. Raw green earth is also mixed with all the colors mentioned above.[8]

Fig. 1
EUGÈNE DELACROIX, *The Entombment*, 1847, graphite on paper, Paris, Musée du Louvre, Département des Arts Graphiques.

From March to August 1847 Delacroix worked on the canvas, first coming to grips with the natural setting—the mountains on March 2 and the rocks on the next day.[9] He then began work on the figure of Mary Magdalene, the bare torso of the disciple contemplating the event,[10] and, in the foreground, the crown of thorns removed from Christ's head. He frequently repainted sections of the canvas, and in his *Journal* noted that he completely reworked the head of Mary Magdalene on July 10 and that of Christ on August 29.[11] Veronese and Titian were never far from his mind when he was working on this piece; the brushwork and aesthetic choices of these painters were clearly the dominant influences on his own creativity.

During this same period, on April 28, 1847, he sold his painting, still unfinished, to a collector who came to visit his studio, Théodore de Geloës, whose address is carefully noted in his *Journal:* "Château d'Osen, near Roermond, Limburg, Holland." The circumstances of this sale and the amount of the transaction are also mentioned: "Next, M. de Geloës, who came to request either the *Christ* or *The Boat.* Once inside my studio, he chose the *Christ at the Tomb* and we agreed on two thousand francs, unframed."[12]

This sale in no way prevented Delacroix from sending his *Lamentation* (cat. 125), along with five other paintings, to the Salon of 1848, where he enjoyed great success. Although A. J. Du Pays complained about finding "amidst that array of subdued and muted colors, . . . like a garish stain, the scarlet of the cloak covering the young man kneeling in front of the body of Christ,"[13] Théophile Gautier countered, "This touch of scarlet, placed abruptly in the foreground, invests the entire canvas with great sorrow,"[14] thus neutralizing aesthetic objections to the work. And Théophile Thoré passionately asserted: "This painting combines the emotion of Le Sueur with the richness and harmony of Rubens."[15]

Two years later, Delacroix himself offered a positive appraisal of this work, after encountering it again in the home of its owner, "whom it had never displeased."[16] Comparing it to another work, he again judged it favorably in 1855:

Unity absent from the composition in general, absent from each separate figure and from every horse. The horses are never modelled in the mass; each detail is added to the rest, and altogether they make an incoherent whole. Just the opposite of what I notice in my *Entombment* (belonging to count de Geloës), which I have in front of me at this moment. Here the details are, generally speaking, mediocre and scarcely bear close inspection, but on the other hand,

the general effect inspires an emotion that astonishes even myself. You cannot tear yourself away from it, and no single detail seems to call for special admiration or distract your attention from the whole. The perfection of this kind of art lies in creating a simultaneous effect.[17]

Delacroix considered this painting successful enough to serve as the model for two subsequent works, in which the arrangement of the figures is identical and the only difference lies in the treatment of the landscape. After completing the first of these two versions in 1849 (cat. 126)—a more vigorous and less detailed work purchased by Adolphe Moreau (1800–1859), grandfather of the famous collector and donor Étienne Moreau-Nélaton—Delacroix produced another version in 1853,[18] commissioned by the dealer Thomas, as a *Journal* entry dated June 28, 1853, attests: "I have finished, more quickly than I would have thought possible, . . . the new version of the *Christ at the Tomb* for Thomas."[19] Confirmation of this second commission is provided in a letter published by Lee Johnson: "I received from Monsieur Thomas the sum of one thousand francs in payment for the small painting depicting Christ in the tomb."[20]

Finally, in 1858 and 1859, Delacroix worked on an original painting dealing with the same theme—this time depicting the Entombment itself—that would become one of his final masterpieces, *The Entombment* (cat. 127). Exhibited at the Salon of 1859, this work was conceived as a pendant to *The Road to Calvary* (cat. 128), shown the same year.

In his 1931 study, Raymond Régamey stressed the value of hanging reproductions of these two painted "sketches" side by side (such a comparison is possible now in this exhibition). Régamey astutely contrasted the "relatively dark ascending spiral" of *The Road to Calvary* (cat. 128) with the "luminous spiral of the descending cortege" of *The Entombment* (cat. 127), where, "as in Rembrandt's work, most of the light emanates from the sacred body rather than from the torches."[21] The similar dimensions of the two paintings and the strange but readily apparent complementary nature of their compositions lead one to the surprising conclusion that Delacroix painted this final *Entombment* in a style that he defined as early as 1847, when he began designing *The Road to Calvary*.

Régamey also pointed out that in *The Entombment*, Rubens was no longer Delacroix's aesthetic point of reference, with the possible exception of a few isolated echoes of works such as *The Entombment of Christ* (church of Saint-Géry,

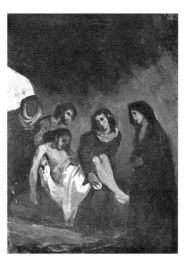

Cambrai). Rather, the link was to Rembrandt and his remarkable nocturnal portrayals of this event, in which the figures are illuminated by torchlight and by the mysterious radiance emanating from the inanimate body of Christ. This influence can be traced to Rembrandt's easel paintings, including *The Lamentation* (National Gallery, London) and *The Entombment* (Hunterian Museum, Glasgow, and Alte Pinakothek, Munich), as well as to his etchings, such as *The Descent from the Cross* (1633) and, especially, *The Descent from the Cross by Torchlight* (1654). Delacroix spent many years developing the iconography of this scene. He painted an initial watercolor version, inspired by Titian, which he gave to his friend Élisabeth Boulanger (fig. 3). However, after thoroughly exploring the iconographic potential of Italian Renaissance painting, the artist ultimately opted for the mystery and dramatic spirituality found in Rembrandt.

Although the bright reds seen in various parts of these paintings, which are skillfully distributed on the clothing of some of the figures, are a tribute to the Venetian painters, and although these works are invested with a profound religiosity inspired by the Baroque mysticism of Rembrandt and other Northern European painters, Delacroix's unique artistry is displayed in the astonishingly free and

expressive execution. Many of his contemporaries, carried away by the beauty and intense spirituality of these works, shared the reaction of the art critic Lescure, who, while attending the Salon of 1859, was impelled to cry out, "I am a Christian!"

V. P.

1. *Journal,* March 13, 1849 (Norton, 1951, p. 93); Johnson, 1986, vol. 3, no. L178.

2. *Journal,* January 21, 1847, p. 118.

3. *Journal,* February 1, 1847, p. 126.

4. *Journal,* February 3, 1847 (Pach, 1937, p. 141).

5. *Journal,* February 6, 1847 (Pach, 1937, p. 143).

6. *Journal,* February 15, 1847 (Norton, 1951, pp. 64–65).

7. *Journal,* February 15, 1847 (Norton, 1951, p. 65).

8. *Journal,* March 2, 1847, p. 137.

9. *Journal,* March 2–3, 1847 (Norton, 1951, pp. 68–69).

10. *Journal,* March 3, 1847 (Norton, 1951, p. 69).

11. *Journal,* July 10, 1847 (Pach, 1937, p. 170); *Journal,* August 29, 1847, p. 162.

12. *Journal,* April 28, 1847, p. 150.

13. Du Pays, 1848.

14. Gautier, 1848.

15. Thoré, 1848.

16. *Journal,* February 16, 1850, pp. 223–24.

17. *Journal,* December 11, 1855 (Norton, 1951, p. 307).

18. Private collection; Johnson, 1986, vol. 3, no. 459, pl. 244.

19. *Journal,* June 28, 1853, p. 357.

20. Johnson, 1986, vol. 3, no. 459, p. 240 n. 1.

21. Régamey, n.d. [1931], pp. 176–77.

128. *The Road to Calvary*

1847–59
Oil on wood; 22⁷⁄₁₆ x 18⁷⁄₈ inches
(57 x 48 cm)
Signed and dated at lower right:
Eug. Delacroix 1859
Metz, La Cour d'Or, Musées de Metz
(inv. 11.458)

In a display of enthusiasm over a new but as yet unconfirmed monumental project to decorate the transept at the church of Saint-Sulpice in Paris, Delacroix jotted down various possibilities for mural paintings in a *Journal* entry dated January 23, 1847: "Four excellent subjects for the Saint-Sulpice transept thus far: 1. *The Carrying of the Cross.* Christ near the center of the work, buckling under the weight; Saint Veronica, etc.; in the foreground, the ascending thieves, etc.; lower down, the Virgin, the friends, etc.; people and soldiers."[1]

In the same entry, Delacroix also mentioned three other possible works that had the potential to form a coherent decorative program revolving around the theme of the Redemption: "*The Placing in the Sepulchre,* an *Apocalypse,* and *The Angel Turning Back the Assyrian Army.*" Moreover, it also describes in detail the composition of a work now known as *The Entombment* (cat. 127) that he would create ten or so years later, forming a pair with *The Road to Calvary* at the Salon of 1859:

> The cross at the top, with executioners and soldiers carrying the ladders and tools. The thieves' bodies remain on their crosses; angels pouring perfume on the cross or crying. In the middle, Christ being carried by the men and followed by the holy women; the group going down toward a cave where disciples prepare the tomb. Men lifting the stone; angels holding a torch. The foot of the mountain, play of light, etc.[2]

Although the Saint-Sulpice commission had not been officially confirmed, Delacroix indicated during this period that he had already "planned out the *Carrying of the Cross,*" the first work in this series that originally was to ornament the church. On January 21 and 23, and again on February 12, he mentioned having worked on *Christ Carrying His Cross,* which was inspired by "an old sepia."[3] The specific stages of the work's development have not been determined, but we do know that it never actually evolved into a mural. Was Delacroix working on a simple study at this time—perhaps one of the two drawings in the Louvre (figs. 1 and 2)—thus mapping out a composition that he would not use as the basis for an oil painting until a few years later? Was the work unrelated to the Saint-Sulpice project, and was it only later that he considered integrating this theme into his decorative program?

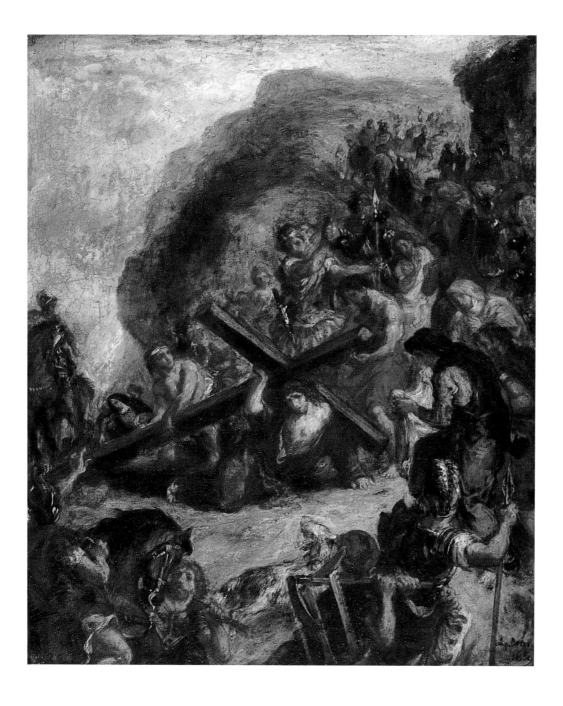

Was it a *modello* for a future decorative work—the first stage of a monumental project? That would explain why it is painted on a wood panel and in a spirited style, perhaps a study to be presented to a prospective client.

In any event, it seems certain that this piece was conceived in conjunction with a painting of the Entombment, a theme also included in the initial plans for the Saint-Sulpice project. This is confirmed by a *Journal* entry dated January 21, 1847: "Made sketches for three subjects: *Christ Carrying His Cross,* after an old sepia; *Christ on the Mount of Olives,* for Mme Roché; *Christ Laid Out on a Stone, Mourned by the Holy Women.*"[4] Delacroix's simultaneous reflections on these two aspects of the Passion, which were obviously

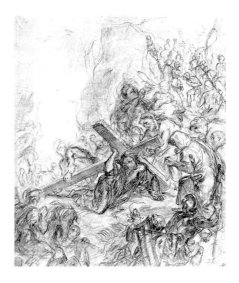

Fig. 1
EUGÈNE DELACROIX, *The Road to Calvary,* 1847–48, graphite on paper, Paris, Musée du Louvre, Département des Arts Graphiques.

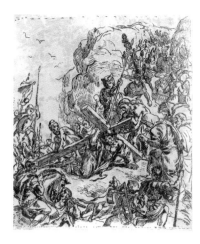

Fig. 2
EUGÈNE DELACROIX, *The Road
to Calvary,* 1847–48, brown ink
on tracing paper, Paris, Musée
du Louvre, Département des
Arts Graphiques.

linked in his mind during this period, must have led to the production of the large *Lamentation* painted for the Salon of 1848 (cat. 125), an independent work with no direct connection to the unrealized commission. It was ten years later that Delacroix painted his *Entombment* (cat. 127) exhibited at the Salon of 1859 along with his *Road to Calvary* and a *Christ on the Cross* (undoubtedly the one at the Kunsthalle in Bremen).

The Road to Calvary does not appear to have been completed during this period, because the commission for the transept at Saint-Sulpice was definitely canceled and replaced (following an agreement reached with the Prefect of the Seine on March 22, 1847) by a commission for the chapel of the Saints-Anges, which was not officially awarded to Delacroix until April 28, 1849.[5] The painter was very much involved with this project in his final years.

Delacroix remained the owner of *The Road to Calvary* until 1861, sometimes keeping it in his studio and sometimes in his room. It served as inspiration for a small painting completed in 1857, *Christ Carrying the Cross.*[6] As his *Journal* indicates, he studied the work on occasion. In a significant entry dated March 15, 1858, he commented on the color values used in this painting:

> I am in my room, looking at the small versions of the *Trajan* and *Christ Going Up to Calvary.* The first is much lighter than the second. . . . In the *Christ,* the landscape, especially in the background, is almost indistinguishable from the dark portions of the figures. The standard technique is to paint the background in pale halftones—not as light as the flesh, of course, but enough to cause the brown accessories . . . to stand out, in order to remove the objects from the foreground.[7]

Pleased with the aesthetic qualities of this religious work—which never became a mural and which he does not appear to have finished in this period—Delacroix decided he would definitely exhibit it at the Salon of 1859. In the meantime, he painted a replica that was bequeathed to Devilly in

1864; it was exhibited at the 1885 retrospective (no. 57), then almost certainly destroyed in 1944 during a bombing raid.

Numerous painters have depicted the stream of sorrowful humanity that followed Jesus up to Calvary, an episode that is merely hinted at by the Evangelists, three of whom said that the cross was not carried by Christ, but rather by Simon of Cyrene, a passerby whose services were commandeered at the last minute by the soldiers (Matthew 27:32–34, Mark 15:21, and Luke 23:26–28). John (19:17–18) is the only one to assert that Jesus was "bearing his cross" to the site of his execution. Luke, on the other hand, is the only Evangelist to emphasize the presence of the "great company of people" who followed Jesus to the site of his Crucifixion, including the women who "also bewailed and lamented him," to whom Jesus said: "Daughters of Jerusalem, weep not for me, but weep for yourselves, and for your children." All the Evangelists report that Jesus was crucified along with two thieves who accompanied him on the road to Calvary.

The legendary episodes of this arduous ascent, during which Christ fell under the weight of the cross three times, and his subsequent encounter with Saint Veronica, who wiped his brow, are from the Apocrypha, more specifically, from one of the oldest of these texts, the Gospel of Nicodemus, which dates to about the fifth century.

Despite the questionable authenticity of the accounts of these events, which undeniably appealed to the Christian imagination, painters have chosen to depict this episode ever since the Renaissance, emphasizing Christ's physical suffering and exploring the artistic possibilities presented by the crowd described in Luke's account. In Venice both Tintoretto (Scuola di San Rocco) and Tiepolo (church of Santa Alvise) created paintings that exploited the potential of this group making its way up to Calvary. Tintoretto used two distinct registers, which had some influence on Delacroix's composition. Delacroix may also have referred to Raphael's famous *Bearing of the Cross,* painted for the church at the Monastery of Santa Maria dello Spasimo in Palermo (Prado, Madrid), or to a similar work by Francesco Bassano, which was already housed in the Louvre at this time.

Despite these influences, Delacroix once again created his own version of the religious theme, basing his composition on one of Rubens's most beautiful masterpieces, *The Ascent to Calvary,* which was painted for the high altar of the Afflighem Abbey in Hekelgem (Royal Museums of Fine Arts of Belgium, Brussels). Rubens's paint-

ing had been universally admired and frequently copied since its creation, as the fine version painted by Erasmus II Quellinus (1607–1678) attests. (Originally painted for the church of the Augustinians in Antwerp, this imitation was sent to the church of Saint-Catherine in Honfleur in 1805.) Delacroix was in a position to make frequent studies of Rubens's painting—which he had undoubtedly seen in Brussels in 1839—because of his access to Paulus Pontius's engraving after Rubens. We also know that he executed a replica "from memory" of another version attributed to Rubens, displayed at the time at the Musée des Beaux-Arts in Bordeaux.

There are, of course, numerous structural differences between these two paintings by Rubens and Delacroix. In fact, Delacroix completely reworked the Flemish painter's iconography: Saint Veronica is kneeling before Christ in both canvases, but she is wiping his brow in the Rubens and merely offering him a cloth in the Delacroix; the apostles support the fainting Virgin in the foreground of the Rubens, whereas they accompany Saint Veronica in the Delacroix, where Mary is in the background far from her son; the two thieves follow Christ in the Rubens but precede him in the Delacroix. Having chosen a much more open background, Delacroix framed his composition less tightly than had Rubens. Finally, Delacroix's vivacious, agitated brushwork enhances the painting's dynamism and creates a torturous, poetic universe. Given these factors, one sees that the artist has made this work very much his own.

Perhaps as a result of the painter's insistence on measuring himself against the greatest artists of all time, or the critics' mounting impatience with his apparent obsession with revisiting particular themes, the response to the eight works Delacroix exhibited at the Salon of 1859 was particularly unfavorable. With regard to this *Road to Calvary,* the painter was careful to point out in the Salon catalogue (no. 819) that "this work was to be rendered on a much larger scale at Saint-Sulpice, in the chapel of the Baptismal Fonts, which now serves a different purpose." Despite this, the critics were no more pleased with this piece than with Delacroix's two other religious paintings—*Christ on the Cross* (Kunsthalle in Bremen) and *The Entombment* (cat. 127). Maxime Du Camp vehemently attacked Delacroix at the height of the artist's fame, just two years after the painter had been admitted into the Institut:

> Has death, then, also struck down M. Eugène Delacroix? I mean the premature death that paralyzes the hand, blinds

the eye, and deprives the mind of any notion of the apt and true. What are these ghostly paintings being exhibited under his name? . . . Content with his success at the Exposition Universelle, M. Delacroix should return to the literary endeavors he loves and to the music that is clearly his forte.[8]

Fortunately, several other writers, including Émile Perrin and Zacharie Astruc, were enthusiastic about the trilogy of religious paintings shown at the Salon. However, even the compliments of his staunchest defenders failed to console the painter, who was deeply wounded by the particularly virulent attacks of certain critics, which his age and situation made much more unbearable. Alexandre Dumas was thus unable to assuage the artist's anger with this impassioned statement: "The Delacroix canvases exhibited this year may be small, but their conceptual grandeur is such that the painting's dimensions disappear. Looking at them, one cannot help but think: these are mere sketches I see before me; the paintings will measure sixty feet."[9] Nor did the painter take any comfort in the obvious excitement of Baudelaire: "Delacroix's imagination! Never has it flinched before the arduous peaks of religion! The heavens belong to it, no less than hell, war, Olympus and love. In him you have the model of the painter-poet."[10]

After this exhibition, Delacroix decided that he would never again show his works at the Salon but continued to display them at events he considered to be less official—or rather, less likely to attract the attention of the critics. And it was indeed at one of these provincial exhibitions, the Exhibition Internationale de Metz, held in 1861, that he found a purchaser—the city of Metz itself—for his *Road to Calvary.* In the wake of its unqualified local success, this religious painting found an ardent defender in the artist Charles Laurent Maréchal (1801–1887), who was a friend of Delacroix's. A native of Metz and a collector, Maréchal took it upon himself to ensure that the painting was acquired by the city's municipal museum.

Reproducing the minutes of the Metz town council meetings during which the purchase of this work was debated, André Bellard,[11] in 1950, then Maurice Sérullaz, in 1963, have disproved Alfred Robaut's assertion that "the collector who owned [this painting] was asking four thousand francs," but "the funds raised in the subscription totaled only two thousand francs. Delacroix paid the remaining two thousand out of his own pocket."[12] A letter sent to the painter by the mayor of Metz on November 28, 1861, clearly summarizes the circum-

stances in which the work was acquired and specifies the portion of the purchase price raised by the municipality.[13] The reappearance of an unpublished letter sent to the artist by his friend Charles Laurent Maréchal confirms the conditions of this sale:

> Dear Delacroix, the resolution of the municipal council has been approved by the prefecture. Please send me a proxy allowing me to receive the sum of 1,440 fr. from the city . . . in addition to the 1,560 in funds raised by the subscription toward the price of the painting. The latter amount is now available to you and I will have my banker send it where you please. If the rest of the money is made available before my departure (which has been delayed by another twelve to fifteen days), I will bring it to you; otherwise, I will also have it sent to you by my banker.[14]

Contrary to what Robaut would have had us believe, the painter Maréchal was in no sense the owner of this work, but merely a friendly intermediary who asked Delacroix to lower his price from four thousand to three thousand francs when the funds raised turned out to be lower than the asking price—a fact borne out by another unpublished letter: "Dear Delacroix, your painting was purchased yesterday for the price of three thousand fr. The decision was unanimous and was not referred to the fine arts commission. Your generosity did much to expedite this process. However, it would have counted for nothing had the city not been in an exceptional financial position."[15]

V. P.

1. *Journal,* January 23, 1847, p. 119.

2. *Journal,* January 23, 1847, p. 119.

3. *Journal,* January 21, 1847, p. 118; January 23, 1847 (Pach, 1937, p. 131); *Journal,* February 1, 1847, p. 126.

4. *Journal,* January 21, 1847, p. 118.

5. Archives Nationales, Paris, F^{21}24.

6. Location unknown; Johnson, 1986, vol. 3, no. L183—or private collection, Japan; Johnson, 1986, vol. 3, no. S9, pl. 325.

7. *Journal,* March 15, 1858, p. 711.

8. Du Camp, 1859.

9. Dumas, 1859(a).

10. Quoted in *The Painter of Modern Life and Other Essays,* translated and edited by Jonathan Mayne (London: Phaidon, 1964), p. 49.

11. *Bulletin des musées de France,* no. 10 (December 1950), pp. 261–63.

12. Robaut, 1885, no. 1377, repro.; M. Sérullaz, 1963(a), no. 496, repro.

13. A copy of this letter is in the municipal archives at Metz; the original letter was kept by Delacroix's executor, Achille Piron.

14. Archives Piron, Archives des Musées Nationaux, Paris.

15. Archives Piron, Archives des Musées Nationaux, Paris.

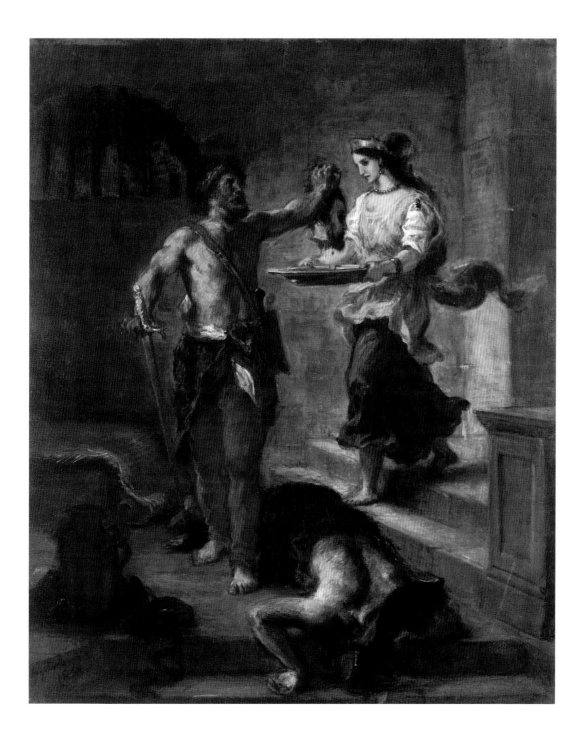

129. *The Beheading of John the Baptist*

1856–58
Oil on canvas; 22¹/₁₆ x 18⅛ inches (56 x 46 cm)
Signed and dated at lower left:
Eug. Delacroix / 1858.
Bern, Musée des Beaux-Arts (1759)

John the Baptist had been imprisoned for denouncing the incestuous union of Herod Antipas and Herodias, the wife of his brother. Herodias, in collusion with her daughter, Salome, ordered John beheaded. In both of his treatments of the subject, Delacroix depicted the moment when the young woman presents the executioner with the platter on which the head of the victim is to be placed (Matthew 14:3–11, Mark 6:17–28, and Luke 3:19–20). This painting repeats the theme of one of the four pendentives in the theology dome of the Palais Bourbon library, a project Delacroix completed in 1847. In his later painting, no longer constrained by a complicated architectural framework, the artist was able to alter the composition significantly—by emphasizing the prison setting, for example. The arrangement of the figures is also different: the female figure is more supple and mobile, and the executioner is in a more frontal pose. Far in the background, the heads of curious onlookers observe the scene unfolding before their

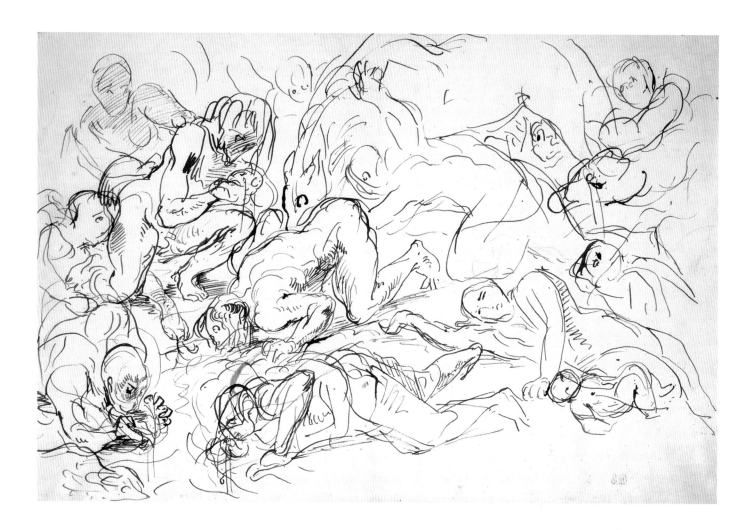

eyes—a conscious or unconscious reference to the madmen surrounding Tasso, who was confined to an asylum and whom Delacroix had portrayed in *Tasso in the Hospital of Saint Anna* (1824, E. G. Bührle Foundation, Zurich).

According to the *Journal,* Delacroix started to work on the figure of John the Baptist in early December 1856.[1] He probably returned to it while in Champrosay, after an interruption of over four months due to illness:

> Monday, May 18, 1857. I have begun to paint at last, after more than four and a half months of enforced idleness. I began with the *Saint John and Herodias,* which I am doing for Robert, at Sèvres. Worked at it all the morning and enjoyed myself.
>
> Walked in the forest in the middle of the day in spite of the heat, and managed to take up my palette before dinner even after this rather tiring excursion.[2]

A. S.

1. *Journal,* December 9, 1856 (Norton, 1951, p. 323).
2. *Journal,* May 18, 1857 (Norton, 1951, p. 364).

130. *Moses Striking the Rock*

1858 (?)
Brown ink over graphite on paper;
11¹¹⁄₁₆ x 17½ inches (29.7 x 44.5 cm)
Cambridge, The Syndics of the Fitzwilliam Museum (2031 A)
Exhibited in Philadelphia only

Distinguished by its feverish, whirling pen strokes, this drawing, which cannot be linked to any subsequent painting, illustrates an Old Testament story (Numbers 20:2–11). Arriving in the desert of Zin, the children of Israel settled in Kadesh, but since there was a shortage of water,

> they gathered themselves together against Moses and against Aaron. . . . And Moses and Aaron went from the presence of the assembly unto the door of the tabernacle of the congregation, and they fell upon their faces: and the glory of the Lord appeared unto them. And the Lord spake unto Moses, saying, Take the rod, and gather thou the assembly together, . . . and speak ye unto the rock before their eyes; and it shall give forth his water, and thou shalt

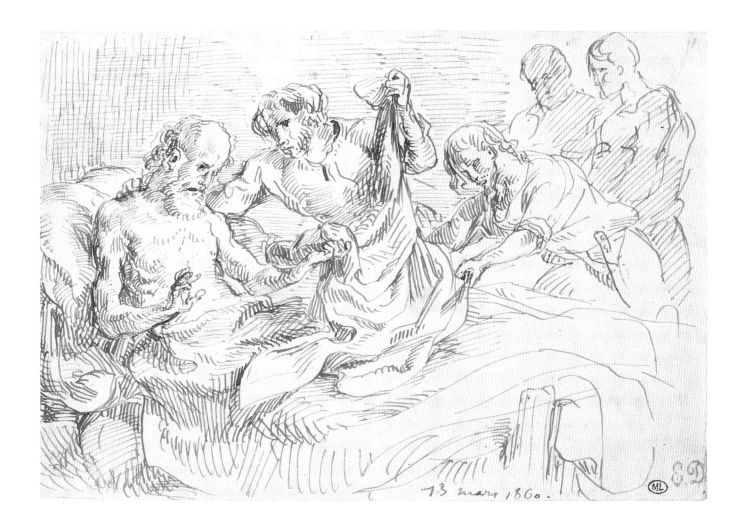

bring forth to them water out of the rock: so thou shalt give the congregation and their beasts drink.

Heeding Yahweh's command, Moses gathered the people together, "and with his rod, he smote the rock twice: and the water came out abundantly, and the congregation drank, and their beasts *also*."

In the *Journal* entry for January 25, 1854, Delacroix mentioned a *"Striking the Rock* for the Ministry of State."[1] On May 23, 1858, at the end of a long list of possible subjects, he again mentioned: *"Striking the Rock*. Israelites drinking thirstily, camels, etc."[2] Finally, on September 20 of the same year, the scene began to take shape: "Men, women, tired animals, camels, rushing toward the source."[3] Since a camel's head and the outline of a horse can be seen among the entangled figures in the drawing, one can reasonably assume it describes this work and that Delacroix started it in 1858.

A. S.

1. *Journal,* January 25, 1854, p. 400.
2. *Journal,* May 23, 1858, p. 720.
3. *Journal,* September 20, 1858, p. 734.

131. *Jacob Beholding Joseph's Coat*

1860
Brown ink on paper; 5¼ x 7¹³⁄₁₆ inches
(13.4 x 19.9 cm)
Dated at lower right: *13 mars 1860*
Paris, Musée du Louvre, Département des Arts
Graphiques (RF 9534)
Exhibited in Paris only

A zinc engraving of this drawing was reproduced in the magazine *L'Art,*[1] where it appears with cross-hatching and no date. It is also reproduced in Eugène Véron's *Les Artistes célèbres: Eugène Delacroix.*[2]

Given the subject, composition, and style, it is possible to associate this work with the later series of pen-and-ink studies inspired by the Old and New Testaments Delacroix produced in early 1862 (cats. 141 to 150).

A. S.

1. April 23, 1882.
2. Veron, 1887, p. 93.

VII

THE FINAL WORKS

After having thrown himself unstintingly into the completion of the chapel of the Saints-Anges in the church of Saint-Sulpice (begun in 1849, it was formally inaugurated in July 1861), Delacroix found it difficult to return to painting. He had tried with every means available to make the public aware of his great undertaking, but he did not obtain the response he had desired. A letter to his collaborator, Pierre Andrieu (1821–1892), of October 17, 1861, indicates that the artist, nonetheless, entertained no thoughts of abandoning his brushes: "It seems to me, as to you, that our work has already been finished for a long time. I have forgotten the enormous problems it gave me; like the ant, I am ready to go back to work after the ruination of my labors."[1] A month later he confided to his friend Charles Soulier: "My health, thank heavens, is as good as it can be. The activity involved in the work for Saint-Sulpice did my constitution good, seeing that I still feel its influence."[2] This optimistic statement, issued from the quiet retreat of Champrosay, glossed over a debilitating state of health that Delacroix was experiencing. During the winter of 1861–62, a fever again forced him to take to his bedroom; while preventing him from painting, it did not stop him from drawing. Although he had confessed to Paul de Saint-Victor in February 1862 that he was not working and was in a terrible mood,[3] he soon began a series of drawings in the same technique and format illustrating various scenes from the Old and New Testaments (cats. 141 to 150); these form a kind of graphic extension of the murals for Saint-Sulpice. At the end of the year, once more working in the tranquillity of Champrosay, the artist must have spent a part of his days drawing on paper some final variations on the human figure.[4] In between, and in spite of various ailments that kept him confined to his bedroom, Delacroix faithfully applied himself to painting. He must have worked right up to his death. Some twenty-odd canvases, executed or finished during 1862, show that the painter struggled to overcome an understandable discouragement: "At the moment I am in the grip of a disagreeable illness that doesn't leave me enough energy even to clean my palette and brushes. I'd rather leave them hard and in bad shape the next day than even to stretch my hand out to touch them."[5] Notable among the canvases is a smaller version of the *Medea* shown in the Salon of 1838 that the city of Lille had acquired (Musée des Beaux-Arts, Lille). The smaller painting, *Medea About to Kill Her Children* (1862, Musée du Louvre, Paris), was sold to

Jacob Péreire through his supplier Étienne-François Haro in March. Delacroix noted several technical elements of it in his *Journal:* "Highlighted areas of the child, in the *Medea: vermilion, dark white, indigo, white.* Areas of shadow: *white vermilion, zinc green; bright tone of highlight: lake, white, yellow ocher, white.*"[6]

At Constant Dutilleux's insistence Delacroix made another, even smaller, version of the *Medea* for the Société des Amis d'Art d'Arras.[7] It would be followed by *Hercules Bringing Alcestis Back from the Underworld* (cat. 135); *Ovid Among the Scythians*[8] (a small variation of a painting exhibited at the Salon of 1859 [cat. 95]); *The Sultan of Morocco and His Entourage* (E. G. Bührle Foundation, Zurich), which was the last version of the large painting belonging to the Musée des Augustins in Toulouse and exhibited at the Salon of 1845; *Saint Stephen Borne Away by His Disciples* (cat. 140); *The Tribute Money,*[9] a late but considerably different version of one of the pendentives in the theology dome in the Palais Bourbon library; and *Horses at a Fountain* (cat. 136).[10] During the year of 1862 Delacroix also finished *Moroccan Chieftain Receiving Tribute,*[11] which had been well along by June 1860 and whose overall design returned to the composition used for the painting shown at the Salon of 1838 (Musée des Beaux-Arts, Nantes). Other works of 1862 include a seascape in which, beyond the arch of a rock, a boat can be seen striking a shoal[12] and two tiger studies, *Tiger Growling at a Snake* (cat. 133) and *Tiger Playing with a Tortoise.*[13]

At the beginning of 1863 Delacroix managed to finish and sign two canvases steeped in memories of his visit to North Africa: *An Arab Camp at Night* (cat. 138) and *Arabs Skirmishing in the Mountains* (cat. 139), bought by Tedesco on April 12 for forty-five hundred francs. The winter does not seem to have aggravated the illness that had sent the artist into a lengthy decline; in February and March he even accepted a few invitations to dinner and official events. The swiftly executed drawing of a feline (cat. 134) that he offered to Jenny Le Guillou on Easter, April 5, betrays some hesitation in the strokes, which testifies to the fragility of the artist's health. Nevertheless, his remission lasted long enough for Constant Dutilleux to be the happy beneficiary; in early May Delacroix directed to this faithful admirer a "small" *Tobias and the Angel* (cat. 146 fig. 1) of such doubtful quality, it seemed to him, that he also urged upon his friend a small canvas, *Lion Seizing a Crocodile,* "still wet in certain spots:"[14] "When I saw you looking at the little sketch of *Tobias* the day before yesterday and holding it in your hands, I thought it very poor, although I had enjoyed doing it."[15] On May 8 Dutilleux endeavored to appease the fears of the master he so deeply venerated: "Allow me to contradict your opinion of the Tobias. It is of an exalted style (I would say biblical if such great words were not abused today) and of a sobriety of color and effect that only mature talents can achieve. It is well done and beautiful, like everything you create."[16]

At the end of May Delacroix's physical condition deteriorated: "I have had nothing to celebrate about my health," he confided to Andrieu, "and, as it were, I have done nothing about it since I saw you. The cold that I've had for some three months is bad enough, and to it I've added the afflictions of a fall I took on the corner of a piece of furniture, which has really shaken me up. My eyes are also in bad shape from reading too much, since I cannot work. I go off on jaunts for a change of air, and I hope that the country will quickly put me back in working order, which will cure my boredom and gloom." Disinclined to launch himself into "great undertakings," the painter declared, "Passion must give way to reason. I have reached an age where I must resign myself to privations."[17] On May 26 the painter left for Champrosay with "the prescription of complete rest and silence," as he could not "utter a word without coughing."[18] By the begin-

ning of August his condition had become so serious that he had to return to Paris. Despite his weakness, he dictated his will on August 3 and 6, but assured his cousins Berryer and Riesener as well as Andrieu that the worst was over: "I am much better now, but it will be a long convalescence."[19] Over the next few days the artist grew steadily worse. On August 13, at seven o'clock in the morning, he released his last sigh.

Going through, one by one, the paintings made from 1862 to 1863, some of them still unfinished—as is the case of the *Tobias* offered to Dutilleux, the *Lion Seizing a Crocodile* acquired by Haro at the posthumous sale of 1864, and *Botzaris Attacks the Turkish Camp and Is Fatally Wounded* (cat. 137)—one is struck by the heterogeneity of the subjects, most of them taken from themes treated earlier: felines, scenes drawn from literature and history, religious and mythological subjects, and recollections of North Africa. As he could not sustain the intense rhythm of work that he was used to, Delacroix had to resort to this stratagem. He made no attempt to conceal it, as demonstrated by his response to Dutilleux when the latter commissioned another painting for Arras: "The amount of time that you have set for the work is not enough, so I would prefer not to, seeing that it was your idea, make you something that I've already studied and that leaves no room for the reworkings to which I am exposed while dealing with a new subject; I will make for you a small reproduction, with slight differences, of the *Medea*."[20] However, four canvases escaped this decision to rework older subjects (besides the *Tobias,* cats. 136, 138, and 139). With the exception of *Arabs Skirmishing in the Mountains, Moroccan Chieftain Receiving Tribute, Botzaris,* and *Medea,* the late revisions by Delacroix are generally small in format, on average no more than 14 by 20 inches (35 by 50 cm). They all share a harmony of saturated colors, sublimated by a golden light that enhances the lyrical atmosphere of each. Paradoxical as it may seem, the sole nocturnal painting of the series (cat. 138) is in the same vein.

Thus, these last reinterpretations of familiar subjects should not be seen as evidence of a creative power on the wane. On the contrary, at the end of his life, Delacroix, who voluntarily withdrew within himself, preferred pictorial or graphic investigation to the precise interpretation of a subject. What mattered above all was to suggest an atmosphere, a state of being, and to give free rein to the reverie "by suppressing details that are useless, offensive, or foolish."[21] Far from constraining his power of invention, this process, which depended on memory, allowed him to enrich his compositions with new elements, among which landscape played an essential role.

"The first quality in a picture is to be a delight for the eyes. This does not mean that there need be no sense in it; it is like poetry which, if it offend the ear, all the sense in the world will not save from being bad. They speak of *having an ear* for music: not every eye is fit to taste the subtle joys of painting. The eyes of many people are dull or false; they see objects literally, of the exquisite they see nothing."[22] Written in June 1863, this reflection serves as a testament; it sums up perfectly the idea that inspired Delacroix to the last. Come to the end of his life, the painter undoubtedly retained in his memory this thought of his friend Philarète Chasles, recorded on one of the pages of a Moroccan notebook: "In great minds, maturity and age are the time of the great harvest, the period of the most powerful meditations. It is the last word of experience."[23]

Arlette Sérullaz

1. *Correspondance,* vol. 4, pp. 277–78.

2. *Correspondance,* vol. 4, p. 285.

3. *Correspondance,* vol. 4, pp. 302–3.

4. Département des Arts Graphiques, Musée du Louvre, Paris, RF 9549; M. Sérullaz, 1984, vol. 1, no. 847, repro.

5. Delacroix to Mme Joséphine de Forget, Wednesday [August 20, 1862], *Correspondance,* vol. 4, p. 332.

6. *Journal,* March 11, 1862, p. 802.

7. Formerly in the collection of the vicomtesse de Noailles; Johnson, 1986, vol. 3, no. 344, pl. 154.

8. Private collection, Bern; Johnson, 1986, vol. 3, no. 345, pl. 143.

9. Location unknown; Johnson, 1986, vol. 3, no. 341, pl. 155.

10. Sold to Tedesco on October 6, 1862.

11. Formerly in the collection of the vicomtesse de Noailles; Johnson, 1986, vol. 3, no. 416, pl. 225.

12. Private collection, Zurich; Johnson, 1986, vol. 3, no. 490, pl. 289.

13. David Rockefeller collection, New York; Johnson, 1986, vol. 3, no. 207, pl. 30.

14. Kunsthalle, Hamburg; Johnson, 1986, vol. 3, nos. 474 and 210, pls. 277 and 32.

15. *Journal,* May 8, 1863 (Norton, 1951, p. 413).

16. Archives Piron, Fondation Custodia, Paris.

17. *Correspondance,* vol. 4, p. 374.

18. Delacroix to Louis Guillemardet, June 3, 1863, *Correspondance,* vol. 4, p. 376.

19. *Correspondance,* vol. 4, p. 381.

20. *Correspondance,* vol. 4, p. 305.

21. *Journal,* April 28, 1854 (Norton, 1951, p. 227).

22. *Journal,* June 22, 1863 (Norton, 1951, p. 414).

23. Musée Condé, Chantilly, folio 5.

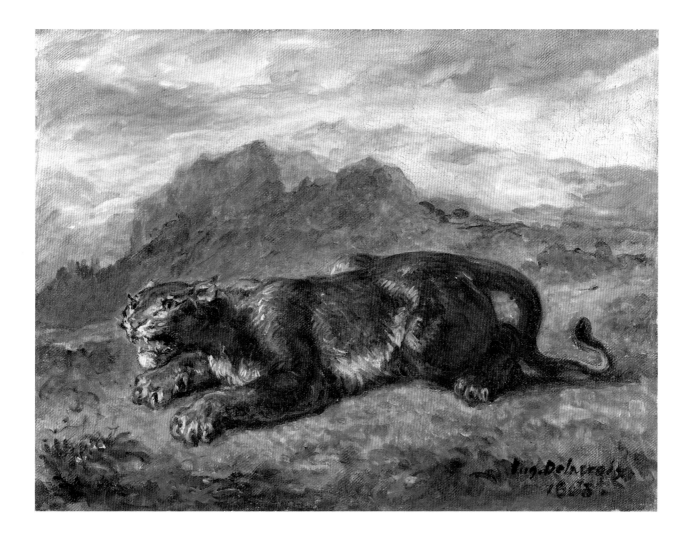

132. *Lioness Ready to Spring*

1863
Oil on canvas; 11⅝ x 15⅜ inches (29.5 x 39 cm)
Signed and dated at lower right:
Eug. Delacroix / 1863.
Paris, Musée du Louvre (RF 1397)

Eugène Delacroix made this work, which distills the essence of his animal studies, not long before his death. He sought a perfect synthesis between an austere treatment of the landscape—a reminiscence of North Africa painted in bright and luminous hues with a light, fluid texture—and the quiet power of the feline poised to spring. Simply and effectively, he depicted the animal's physical stance, combining its power and agility with the beauty of its coat, over which his brush lingered without becoming mired in anatomical details.

This late masterpiece was preceded by several studies. We know of a pastel representing a tiger in the same position (Cleveland Museum of Art), as well as various sketches of lionesses poised to spring, which Delacroix had drawn from life around 1830.

Freed from the anecdote found in some of his more commercial animal pictures, the focus of this canvas is its rapid execution—the lightness and brightness of the colors chosen for the landscape, and the vibration of the highlights that enliven the reflections on the lioness's coat. Purposefully eschewing gratuitous exoticism, Delacroix instead sought to paint the feline's timeless beauty in a landscape of wild and eternal grandeur. He thus carried out the reflection he had noted in his *Journal* while accumulating notes for his dictionary of the fine arts. Discussing the representation of horses and other animals, he had written: "The antique is the model to be followed here, as in everything else."[2]

V. P.

1. Musée du Louvre, Département des Arts Graphiques, Paris, RF 10 467 and RF 10 605; M. Sérullaz, 1984, vol. 1, nos. 1047 and 1055, repro.
2. *Journal,* January 13, 1857 (Norton, 1951, p. 333).

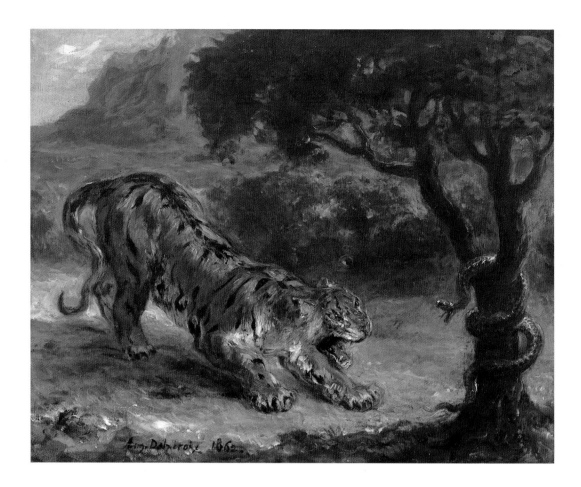

133. *Tiger Growling at a Snake*

1862
Oil on canvas; 13 x 16¼ inches (33 x 41.3 cm)
Signed and dated at lower left:
Eug. Delacroix 1862.
Washington, D.C., The Corcoran Gallery of
Art, William A. Clark Collection (26.76)

Executed in a manner similar to that of *Tiger Startled by a Snake* (cat. 20), this work shows a late variation on a theme that the artist had treated several times in the preceding two decades: a feline attacking or menaced by a reptile. Aside from the painting in Hamburg and a pastel made about 1848, which represented a tiger in the same position (cited by Lee Johnson), two other similar compositions must be noted: *Lion with Hare* (c. 1853, King's College, Cambridge) and *Lion Clutching a Snake* (cat. 18 fig. 1). One can discern a noteworthy but somewhat artificial difference among the various works: the lion, "king of animals," always dominates the reptile, whereas the tiger appears wary of the snake. Unlike the painting in Hamburg, in which the feline seems to be

startled, in this work the tiger is ready to spring, and Delacroix sought to express the taut muscles and the animal's strength. The landscape, less luminous and fluid than others painted after 1860, repeats many familiar elements: bright sky, wild and rocky background, and a tree that he had copied during his walks in the forest of Sénart.

As with *Tiger Startled by a Snake,* Johnson drew attention to the iconographic similarity between the reptile Delacroix painted in this canvas and the one drawn by William Harvey (1796–1866) for a vignette engraved in *The Tower Menagerie,* published in 1829, which depicts a child facing a snake. This source may have inspired Delacroix, although from the presence of the reptile entwined around the tree, one cannot help thinking of the traditional iconography of the serpent in the story of Adam and Eve, which Delacroix might have used in a purely visual sense, without regard to the biblical reference.

V. P.

134. *Feline Walking Toward the Right, in a Landscape*

1863
Brown ink on paper; 4⅝ x 5⅛ inches
(11.6 x 12.9 cm)
Inscribed at lower left and dated at lower right
in brown ink: *à Jenny. / 5 avril / 63 / Pâques*
Paris, Musée du Louvre, Département des Arts
Graphiques (RF 31 282)
Exhibited in Philadelphia only

This drawing, with an inscription attesting that it
was made on Easter 1863, is one of the last memen-
tos of Delacroix. The somewhat wavering lines be-
tray his failing state of health; he would die on
August 13. It may have been part of an album
offered by Jenny Le Guillou to Constant Dutilleux
that included studies of felines, some exotic sub-
jects, and a religious scene. More precisely, it
should be placed among the group of drawings
that the painter dedicated to his faithful house-
keeper at various periods: *Two Iowa Indians* (1845,
"given to Jenny Le Guillou, Eugène Delacroix");[1]

Right Profile View of a Lion ("to Jenny Leguillou, 4
Dec. 1857");[2] *Tiger Licking Blood* ("20 Feb. 58,
Jenny");[3] and *Trotting Horse* (fig. 1).

A. S.

1. Robaut, 1885, no. 951, repro.
2. Verninac sale, Hôtel Drouot, Paris, December 8, 1948,
lot 3, repro.
3. Robaut, 1885, no. 1358.

Fig. 1
Eugène Delacroix, *Trotting
Horse*, 1858, brown ink on paper,
private collection.

135. Hercules Bringing Alcestis Back from the Underworld

1862
Oil on cardboard mounted on wood;
12¾ x 19¼ inches (32.3 x 48.8 cm)
Signed and dated at lower left, near center:
Eug. Delacroix 1862.
Washington, D.C., The Phillips Collection
(0485)

During the final years of his career, Delacroix received several requests from collectors for small copies of his large series of decorative paintings from about 1850. This late work is an original replica of one of eleven pieces illustrating the exploits of Hercules that embellished the lunettes between the doors and windows of the Salon de la Paix in the old Hôtel de Ville in Paris, destroyed by fire in 1871 (cat. 65).

Before transferring his decorative compositions onto the final canvas that was mounted on the walls of the Salon de la Paix, Delacroix first worked out the details with numerous preparatory studies and at least one oil sketch, refining the entire composition. These studies remained in his studio until his death and then were inherited, along with most of the other sketches for the Hôtel de Ville, by his student and collaborator on the project, Pierre Andrieu (1821–1892). Since he thus had numerous examples of his studies for the Salon de la Paix readily at hand, Delacroix could easily refer to them—just as he used the resource of his own capacious memory—whenever a collector asked for a copy of an element of the deco-

ration. This painting, although a replica done ten years after the original version, displays vigor and technical virtuosity more expressive of a sketch than a definitive work.

It is easy to identify the episode depicted here by Delacroix, a subject, naturally, very similar to that of the mural in the Salon de la Paix. Admetus, king of Thessaly, had offended the goddess Artemis, hence his wife, Alcestis, poisoned herself, offering her own life in exchange for that of her husband. She was rescued from the underworld by Hercules, Admetus's friend, who challenged Hades, the god of the underworld, in order to bring her back to life. This mythological scene, known in many versions (in one, Hercules does not intervene and Alcestis is saved instead by Persephone), is usually cited as a model of conjugal love. It offered Delacroix the opportunity for a triple pictorial effect: the representation of Hercules with his strange and heavily muscled anatomy; the fantastic image of Hades or of another infernal figure, who screams amid the flames of hell as he sees his victim escape; and the evocation of Admetus's tenderness and emotion upon his reunion with Alcestis.

The iconography of the original compositions for the Salon de la Paix is known, despite their destruction, through three groups of works: engravings published in 1856 and 1882 (fig. 1), a series of drawings by Pierre Andrieu, and several extant sketches by Delacroix. Therefore, one can pinpoint the modifications between the first version of the decorative painting for the Hôtel de Ville, made between 1852 and 1854 and the replica of 1862. In the replica, rectangular in format, the kneeling Admetus kisses the arm of his wife, held in Hercules' arms. In the original canvas, which was arched, Delacroix painted Admetus simply looking up at Hercules with gratitude. In the 1862 version Delacroix also added several background figures dressed as priests, grouped around a sacrificial altar, and he emphasized the figure of Hades, at the right, by enlarging it. Finally, the landscape of the replica looks rougher—one might almost say, more Moroccan—and less classical.

This last replica thus represents, yet again, a rereading by Delacroix of a theme significant in his mature art. Made a year before his death, it displays his astonishing abilities as a colorist.

V. P.

Fig. 1
Hercules Bringing Alcestis Back from the Underworld, engraving after the drawing by Pierre Andrieu (1821–1892) for one of the lunettes in the Salon de la Paix by Eugène Delacroix, from M. Vachon, *L'Ancien Hôtel de Ville de Paris, 1553–1871* (Paris: A. Quantin, 1882).

HERCULE ET ALCESTE.

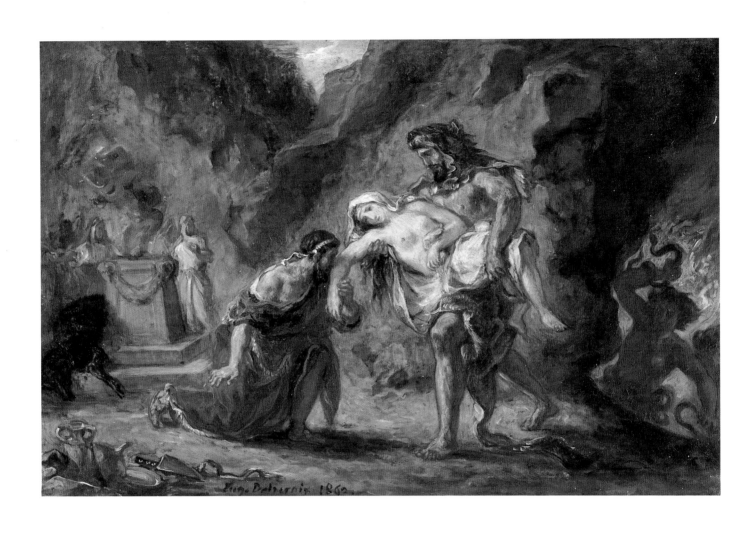

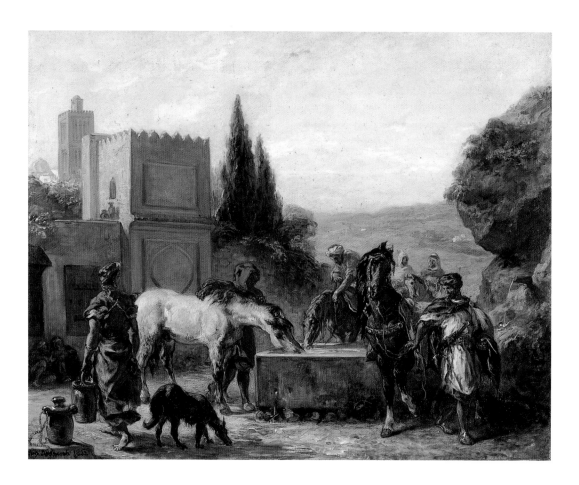

136. *Horses at a Fountain*

1862
Oil on canvas; 29 x 36⅜ inches (73.7 x 92.4 cm)
Signed and dated at lower left:
Eug. Delacroix 1862.
Philadelphia Museum of Art, Purchased with
the W. P. Wilstach Fund (W1950-1-2)

The only documentary information available on
the subject of this painting is the receipt Delacroix
signed on October 6, 1862, confirming a new pur-
chase by the dealer Tedesco: "I received from
Monsieur Tedesco the sum of *two thousand francs* as
a fee for a painting depicting a trough in Morocco."[1]

In contrast to many of the paintings inspired
by specific memories of Morocco, the scene repre-
sented here does not seem to be taken from any of
the numerous observations in Delacroix's travel
notebooks of 1832. On the other hand, there is a
pencil sketch in a private collection that shows the
point of departure for the composition; the origi-
nal lacked the architectural forms at left.

With its restrained atmosphere tinged with
melancholy, the classicism of the poses, and the
warm harmony of colors dominated by dark reds,
greens, and browns, this canvas ranks among the
most refined works that Delacroix produced in his
final year.

A. S.

1. Bibliothèque Nationale de France, Département des
Manuscrits, Paris, fr. 24 019.

137. *Botzaris Attacks the Turkish Camp and Is Fatally Wounded*

c. 1862
Oil on canvas; 23⅝ x 28¾ inches (60 x 73 cm)
Toledo, Ohio, The Toledo Museum of Art
(1994.36)

"I must make a large sketch of *Botzaris: the Turks, terror-stricken and caught unawares, hurl themselves against one another,*" wrote Delacroix in his *Journal* on April 12, 1824.[1] Two years later, a letter addressed to the architect Bénard establishes that the subject continued to interest him: "Please forgive me, sir, for my impertinent request. I am taking the liberty of writing you to ask for the most notable deeds and facts that you remember from your readings on the current Greek war: naturally, those that most lend themselves to painting. . . . Recalling your interest in Greece, I have turned toward you. . . . P.S. I refer more to specific deeds, such as the sacrifice of Botzaris."[2]

At the time, a request like this would not have raised any eyebrows. Marcos Botzaris led the Greek troops in their attack against the Turkish forces at Karpenisi in 1823; he was killed in the assault and immediately became an extemely popular hero. However, Delacroix did not follow through on the project, and there must have been a specific new incentive to make him return at the end of his life to this incident from the Greek War of Independence. In fact, in its overall design this sketch foreshadows a more ambitious work commissioned by a Marseille merchant, Théodore Emmanuel Rodoconachi. According to the letter written by the latter to Delacroix, they had been discussing the commission for some time:

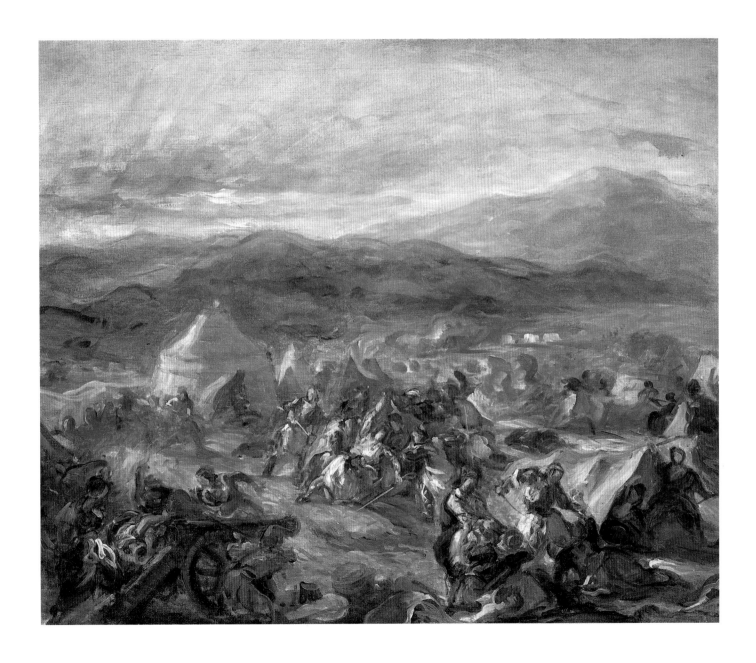

I hope to have the portraits that I promised you next week. As soon as I receive them, I will get them to you. As to the sketches of costumes you asked for, in a month I will definitely have the one of the Suliots, which is different from the fustanella. Yesterday I wrote to Athens to get the historic drawings of Botzaris's army. If it is possible to get them, we will.

A contract drawn up by Rodoconachi himself later confirmed the commission:

> Monsieur Eugène Delacroix agrees to reproduce for Monsieur Rodoconachi in an oil painting the death of Marcos Botzaris, an episode in modern Greek history. Monsieur Théodore É. Rodoconachi, or his heirs, agree to pay on receipt of said painting Mons. Eugène Delacroix or his beneficiary the sum of eight thousand francs in cash. Duplicate enclosed; Marseille, September 14, 1860.[3]

In 1863 the painting was far from being finished. On June 21 of that year, Delacroix wrote to Rodoconachi's agent:

> I have done nothing all this winter, and for a long while the effects of my grave illness will prohibit any kind of work. I would not want to abuse Monsieur Rodoconachi's indulgence. . . . If he is anxious about this delay, I would pray him not to consider our agreement binding, and that agreement would be in all respects null and void. If the opposite is the case, please assure him of the care that I will put into finishing this painting, which for me is a labor of love.[4]

Two months later, the painter died. The painting, along with the sketch, was included in the posthumous sale. Later, for reasons unknown, it was cut into numerous pieces, one of which is located in a private collection in Paris.[5] Painted with broad brushstrokes, with garish tones that make the lighting even more oppressive, the scene is animated by a sense of the epic that may be surprising coming from an artist whose strength had inexorably diminished. Théophile Silvestre's comment about the unfinished canvas could also be applied to the sketch: "Botzaris attacking the Turkish camp would have become a magnificent painting after two weeks of work."[6]

A. S.

1. *Journal,* April 12, 1824, p. 66.
2. February 1826, *Correspondance,* vol. 1, pp. 176–77.
3. Archives Piron, Archives des Musées Nationaux, Paris.
4. Unpublished letter, Musée Eugène Delacroix, Paris.
5. Johnson, 1986, vol. 4, no. M6, pl. 318.
6. Silvestre, 1864, p. 14.

138. *An Arab Camp at Night*

1863
Oil on canvas; 21⅝ x 25⅝ inches (55 x 65 cm)
Signed and dated near lower center:
Eug. Delacroix 1863.
Budapest, Szépmüvészeti Múzeum (72.7.B)

There is little information about this canvas, which is one of the rare night scenes that Delacroix painted from his memories of Morocco. On April 14, 1860, Delacroix noted in his *Journal* his astonishment at having accomplished so much work in the space of three weeks to a month, after a long convalescence. *An Arab Camp at Night* is among the items he listed that he had finished or had well under way.[1]

Undoubtedly, this is the work referred to as *Arabs Around a Fire* on April 28 of the same year, with a price of twenty-five hundred francs.[2] Yet not until April 12, 1863, is there any mention of a receipt, for the sum of forty-five hundred francs for *Arabs Skirmishing in the Mountains* (cat. 139) and *An Arab Camp at Night,* sold to Tedesco.[3] This indicates that the artist exploited African subjects until the end. The works finished during the year of his death demonstrate that his unflagging imagination allowed him to rework this theme often without any loss of richness.

The subject of the composition evokes the stopovers that punctuated the French party's journey from Tangier to Meknes and back, between March and April 1832. The picture gains its unity from the contrasting illumination distributed by the fire's glow, which is partly masked by the hieratic figure of an Arab warming himself. The poses of his companions, crouched or stretched out on the ground, correspond across the composition, which is balanced by the silhouettes of Arabs seen from the back at either end. The moonlight, filtered by clouds, emphasizes the unreal qualities of the scene, in which the imaginative definitely takes precedence over the picturesque and anecdotal.

A. S.

1. *Journal,* April 14, 1860 (Norton, 1951, p. 403).
2. *Journal,* April 28, 1860, p. 781.
3. *Correspondance,* vol. 4, p. 372.

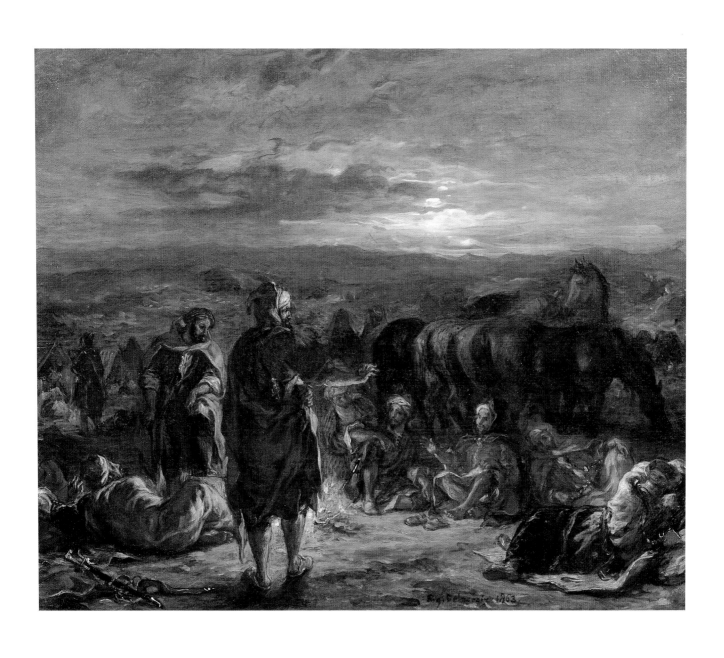

139. *Arabs Skirmishing in the Mountains*

1863
Oil on canvas; 36¼ x 29⅛ inches (92 x 74 cm)
Signed and dated at lower center:
Eug. Delacroix 1863.
Washington, D.C., National Gallery of Art,
Chester Dale Fund (2329)

Despite his worsening state of health, until the end, Delacroix continued to paint Moroccan subjects he retained in his memory. This one, a beautifully balanced composition, was sold to Tedesco along with *An Arab Camp at Night* (cat. 138). For these two canvases, the artist received forty-five hundred francs from the dealer. The identification of the subject is not clear. Whereas Delacroix called it *Arabs Skirmishing in the Mountains,* Alfred Robaut, following the example of Achille Piron, without any particular justification, titled it *The Collection of Arab Taxes,* implying a skirmish between Arabs and tax collectors.[1] Even if Delacroix had in mind the explanation of the customs administrator Sidi Ettayeb Biaz that he had carefully written down in one of his notebooks—"March 12 [1832]. . . . Biaz, crossing with us, told us they did not build bridges to make it easier for them to stop thieves and collect taxes and arrest the rebellious"[2]—there is nothing in the painting to confirm that it owes anything to this remark.

The harmonious organization of the different planes is striking. A curving line begins on the foreground at left and ultimately vanishes in the pass, crowned by massive fortifications.

A. S.

1. See Johnson, 1986, vol. 3, no. 419, p. 211.
2. Département des Arts Graphiques, Musée du Louvre, Paris, RF 1712 *bis,* folio 14 recto; M. Sérullaz, 1984, vol. 2, no. 1756, repro.; quoted in *Journal,* March 12, 1832, p. 103.

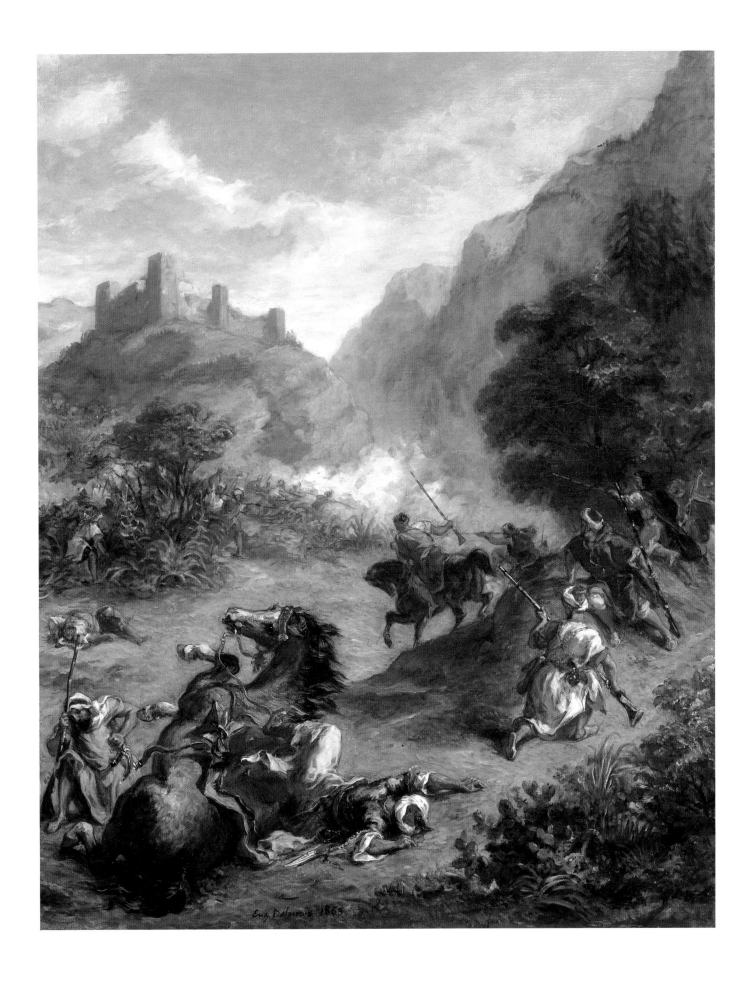

Eug. Delacroix 1862

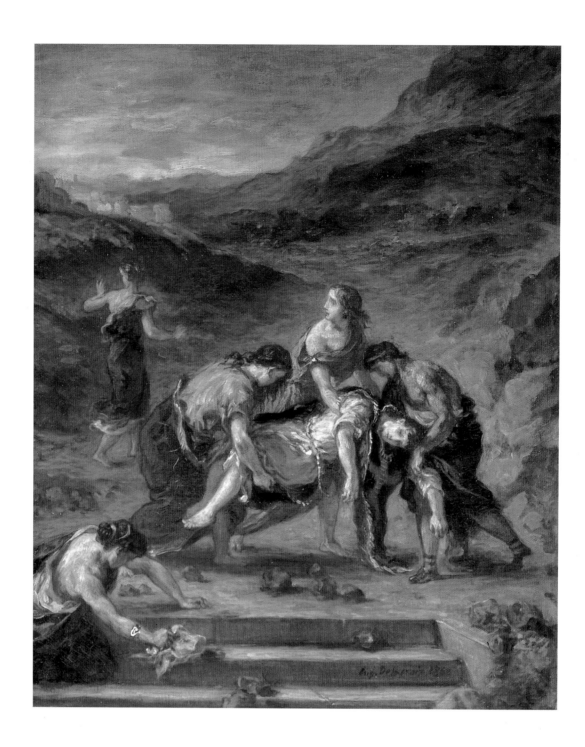

140. *Saint Stephen Borne Away by His Disciples*

1862
Oil on canvas; 18⅜ x 15 inches (46.7 x 38 cm)
Signed and dated at lower right, on a step:
Eug. Delacroix 1862
Birmingham, England, The University of
Birmingham, The Trustees of
the Barber Institute of Fine Arts (62.1)

From the theme of Saint Stephen he had treated
in 1853 (cat. 111) and 1860,[1] Delacroix drew a final
variation, in reduced format, in which the scene is
integrated into a vast, desolate landscape that ac-
centuates the dramatic isolation of the inanimate
martyr and his disciples. Although he retained the
figure of the woman wiping blood from the steps
in the foreground—moved from right to extreme
left—Delacroix considerably changed the organi-
zation of the central group to a frontal presenta-
tion, recalling the depiction of a warrior's funeral
rites in ancient bas-reliefs.

A. S.

1. Johnson, 1986, vol. 3, no. 471, pl. 258.

141 to 150. Religious Drawings from the Winter of 1862

On January 1, 1862, Delacroix wrote to thank his longtime friend Madame Cavé for her gift for Saint-Sylvestre (New Year's Eve)—a new dressing gown.[1] Was he wearing it during the next several weeks, a period in which he wrote next to nothing in his *Journal*? We know from a letter to Paul de Saint-Victor, dated February 17, 1862, that he found those winter days gloomy and nonproductive: "I've been sick for over a month, and idle."[2] This idleness, however, did not prevent the artist's practice of his famous "daily prayer"—the drawn study: *Nulla dies sine linea*. The ten drawings dated January and February 1862 bear this out in an extraordinary way.

All the drawings are of nearly the same dimensions, on the same kind of very thin paper, which the ink bled through (this probably explains why no drawing was made on the verso). All were done with pen and brown ink—a very thick pen, most likely with a nib made of reed, which produces both scratches and large pools. One drawing also carries highlights in brown wash, fairly well diluted. Seven of the compositions are horizontal, the other three, vertical.

Of these ten drawings, all of religious subjects, nine are dated, in the artist's hand, between January 2 and February 24, 1862. Three carry the date January 2 (cats. 141 to 143); three, February 18 (cats. 144 to 146); and three, February 24 (cats. 147 to 149). The series seems to stop there, at least momentarily, but other studies of the same type may well resurface in the years to come. The tenth study, *Mary Magdalene at the Feet of Christ* (cat. 150), although not dated by Delacroix, definitely belongs to the same group; one of its owners, perhaps Étienne Moreau-Nélaton, who bequeathed other drawings to the Musée du Louvre, wrote in pencil at the bottom of the composition, "toward the end of his life / 1862." His precise dating seems to indicate that he knew of other pages from the series.

Today, the ten drawings are divided among five cities: museums in Amiens, Bremen, Bucharest, and Princeton each possess one; in Paris, the Louvre has two—the last work mentioned above (cat. 150) and *The Denial of Saint Peter* (cat. 141), the slightly larger drawing with the brown wash (given in 1977 by Max and Rosy Kaganovitch). The other four belong to a private collection in Paris.

This highly characteristic group is not easy to identify in the artist's posthumous sale of 1864. It probably belongs to lot 375,[3] comprising twenty-eight sheets on various religious subjects, notably an *Ecce Homo* (also treated in one of the ten drawings, cat. 148), or to lot 376,[4] comprising twenty-nine sheets, including *Jacob Beholding Joseph's Coat*

(cat. 131), done in a technique similar to this group but dated earlier, March 13, 1860, and with a more detailed treatment. In any case, the ten drawings carry the studio stamp (Lugt 838 a), which indicates that they were dispersed in 1864. A close examination of the paper support shows that each sheet bears slight signs of having been torn on one of the long sides, which validates the theory that they came from a notebook from which sheets were separated, undoubtedly by Delacroix himself, who would have removed each of these fragile sheets from their binding before using them. (None of the drawings shows any sign of contact with other barely dry sheets, which could not have been avoided had they remained in a notebook; in addition, the way in which the stamp of the posthumous sale was carefully affixed on each sheet proves that they were already separated in 1864.)

Above all, these fascinating drawings captivate through their graphic quality, which combines an extraordinary economy of means and a highly effective expressive character. Despite the entangled lines, the rapidly drawn oval shapes, and the emphatic hatching, the scenes that Delacroix evoked are immediately identifiable. They seem to indicate a period concerned exclusively with episodes from the life of Christ and, thus, the New Testament, until the reappearance of *Tobias and the Angel* (cat. 146), dated February 18. Not only does the latter illustrate a passage from the Old Testament; it also has a clear relationship to the painting of the same subject (cat. 146 fig. 1), which must have been worked out over a short space of time, at least in its initial idea, since Delacroix mentioned it in his *Journal* on January 25, 1862: "*Tobias Restores His Father's Sight.*"[5] Another drawing in the group, *Christ and the Blind Man of Jericho* (cat. 147), also is related to a painting of the same name that came up for sale in 1986[6] and that Lee Johnson correctly dated to 1862–63. At this time, the eight other drawings cannot be connected to subsequent painted compositions.

In view of this late graphic production, comparisons with Rembrandt are obvious, primarily for technical reasons: the authority with which the pen is handled, the energy of the smallest accent, the bold virtuosity of a genius who no longer worried about drawing clearly or agreeably and instead sought exceptional readability overall. But the great Dutch painter's name also springs to mind when we see the spirituality of these rapidly drawn evocations of significant religious episodes. Is it necessary to compare the simple faith of Rembrandt—a reader of the Bible so imbued with the holy book that he came to transcribe it in shadows and

light—and the likely absence of faith of Delacroix, a Voltairean and a skeptic, whose diffuse pantheistic spirituality could find only vague reasons to believe in a superior being rather than in the spectacle of nature or in the potential transcendence of human genius. Such an approach would tell us nothing of substance.

But how, then, can we explain (in the absence, as noted, of any biographical details about that winter) the succession of these drawings possessing a truly special power? The very choice of subject, in which Christ appears seven times out of ten (absent only in *The Denial of Saint Peter* [cat. 141], *The Three Marys at the Sepulchre* [cat. 143], and *Tobias and the Angel* [cat. 146]), shows how much Delacroix was moved by the suffering yet triumphant figure, as in *Mary Magdalene at the Feet of Christ* (cat. 150), in which the unbearable brilliance of the divine visage is expressed by a few ink lines that burst from the sphere of his head. In addition, the faces are not filled out, the hands and feet no more than evoked. Likewise, the shadows and the natural elements are established by only a few parallel lines. In places where Delacroix insisted on a detail, it is because it served to make the scene immediately recognizable, such as the cock at the upper right in *The Denial of Saint Peter,* the lantern at the lower right in *The Kiss of Judas* (cat. 144), or the fish in *Tobias and the Angel.* Thus, each scene can be easily recognized, except for the sheet in Bucharest (cat. 149), which could be a casting out of a devil from someone possessed (Matthew 8:16 or Mark 1:32–34) or a death of

Sapphira, in which Christ does not appear. We will surely never know why Delacroix, in the winter of 1862, following a mysterious but insistent pattern (three instances of three drawings dated the same day), created this group of drawings so specific, so identifiable—and which represent for him a rare foray into the pure investigation of the graphic sign, simultaneous with a superior semiology—on behalf of a sacred legend. In any case, at a time when he was deliberately concealing, in his *Journal* as well as in his *Correspondance,* the approach of debilitation and death that would loom the following year, we see the aging artist yielding to this supreme simplification, to this urgency of expression that Walter Friedländer marked as the sign of old age in the great geniuses of painting[7]— including Poussin and Titian—and that Delacroix could not have attained in the same degree in his painting. The freedom of a great draftsman includes this ability to go beyond the limits of his own art.

Louis-Antoine Prat

1. *Correspondance,* vol. 4, p. 298.

2. *Correspondance,* vol. 4, p. 303.

3. Robaut, 1885, no. 1796.

4. Robaut, 1885, no. 1795.

5. *Journal,* January 25, 1862, p. 801.

6. Sale, Sotheby's, Monaco, June 21, 1986, lot 76, repro.

7. Walter Friedländer, "Poussin's Old Age," *Gazette des Beaux-Arts,* vol. 104 (July–August 1962), pp. 249–64.

141. *The Denial of Saint Peter*

1862
Brown ink and brown wash on paper;
5¾ x 8½ inches (14.5 x 21.5 cm)
Dated at lower right in brown ink: *2 janvier 62.*
Paris, Musée du Louvre, Département des Arts
Graphiques (RF 36 499)
Exhibited in Philadelphia only

The episode in which Peter denies Christ three times follows that of Christ's arrest and his appearance in court before Caiaphas, the high priest. Peter, sitting in the courtyard of the palace, is recognized first by one maidservant, then by another, and finally by a group of men. Each time, the apostle heatedly denies it: "I know not the man." And immediately the cock crows. Peter then remembers what Jesus had told him: "Before the cock crow, thou shalt deny me thrice" (Matthew 26:69–75, Mark 14:66–72, Luke 22:56–62, and John 18:17, 25–27).

L.-A. P. and A. S.

142

143

144

142. The Miraculous Draught of Fishes

1862
Brown ink on paper; 5 x 8⅛ inches
(12.8 x 20.6 cm)
Dated at lower right in brown ink: *2 janvier 62.*
Bremen, Kunsthalle (65/129)
Exhibited in Philadelphia only

The scene corresponds to a text at the end of the Gospel of John (21:1–12), describing the last appearance of Jesus to his disciples, on the Sea of Tiberias (the Sea of Galilee), when the fish were not biting. Jesus, whom the disciples failed to recognize, told them where to cast their net: "They cast therefore, and now they were not able to draw it for the multitude of fishes. Therefore that disciple whom Jesus loved saith unto Peter, It is the Lord" (John 21:6–7).

Of all the biblical drawings made in the first two months of 1862, *The Miraculous Draught of Fishes* is one of the most remarkable, along with *Tobias and the Angel* (cat. 146), in terms of its calligraphic investigations.

L.-A. P. and *A. S.*

143. The Three Marys at the Sepulchre

1862
Brown ink on paper; 5⅜ x 8³⁄₁₆ inches
(13.6 x 20.8 cm)
Dated at lower right in brown ink:
2 janvier 1862
The Princeton University Art Museum, Gift of Frank Jewett Mather, Jr. (1941-114)
Exhibited in Paris only

According to the Gospel of Mark (16:1–6), after the resurrection of Christ, when the Sabbath was past:

Mary Magdalen, and Mary the mother of James, and Salome, had bought sweet spices, that they might come and anoint [Jesus]. And very early in the morning the first day of the week, they came unto the sepulchre at the rising of the sun. And they said among themselves, Who shall roll us away the stone from the door of the sepulchre? And when they looked, they saw that the stone was rolled away:

for it was very great. And entering into the sepulchre, they saw a young man sitting on the right side, clothed in a long white garment; and they were affrighted. And he saith unto them, Be not affrighted: Ye seek Jesus of Nazareth, which was crucified: he is risen; he is not here: behold the place where they laid him.

The date on this drawing has sometimes been read as January *12* rather than *2;* however, Delacroix usually separated his figures distinctly, as can be seen in the drawings dated February 18 and 24, so we remain convinced that here he wrote not *12,* but *2.*

L.-A. P. and *A. S.*

144. The Kiss of Judas

1862
Brown ink on paper; 5⅛ x 8 inches
(13 x 20.4 cm)
Dated at lower center in brown ink: *18. fᵛ. 62*
Amiens, Musée de Picardie (3098.645)
Exhibited in Philadelphia only

The kiss of Judas, recounted in all four Gospels, was the prearranged sign that told the soldiers of the high priest to carry out the arrest of Jesus. In the story of the Passion, this episode precedes the scene of Peter's denial (cat. 141) and Pontius Pilate's questioning of Jesus (cat. 145). It figures on a list of subjects for paintings (unfortunately not dated) that also includes "Jesus presented to the people by Pilate. Jesus before Caiaphas. The high priest tears his garments. . . . Mary Magdalene drying the feet of Christ."[1]

L.-A. P. and *A. S.*

1. Archives Piron, private collection.

145. *Christ Before Pilate*

1862
Brown ink on paper; 5¼ x 8⅛ inches
(13.3 x 20.5 cm)
Dated at lower right in brown ink: *18 f ʳ. 62*
Paris, Prat Collection
Exhibited in Paris only

After Christ's arrest, the soldiers brought him first before the high priest Caiaphas and then before Pontius Pilate. After Pilate's questioning, Christ was scourged and given his crown of thorns (Matthew 27:2, 11–26, Mark 15:1–15, Luke 23:1–7, 13–25, and John 19:28–40).

L.-A. P. and *A. S.*

146. *Tobias and the Angel*

1862
Brown ink on paper; 8⅛ x 5¼ inches
(20.5 x 13.3 cm)
Dated at lower right in brown ink: *18 f ʳ.62.*
Paris, Prat Collection
Exhibited in Paris only

The subject comes from the Book of Tobit (6:2–6) in the Apocrypha. The young Tobias, son of Tobit, leaves at the behest of his blind father to reclaim ten talents of silver that belonged to them. On the way he is accompanied by an angel:

> And as they went on their journey, they came in the evening to the river Tigris, and they lodged there. And when the young man went down to wash himself, a fish

leaped out of the river, and would have devoured him. Then the angel said unto him, Take the fish. And the young man laid hold of the fish, and drew it to land.

The composition of the drawing is very close to that of the small painting Delacroix presented to Constant Dutilleux in May 1863, now in the Oskar Reinhart collection in Winterthur (fig. 1).

Delacroix knew the interpretations by Titian and Rembrandt on this theme. In December 1847 he wrote in his *Journal* that he owned a watercolor after Titian's *Tobias Guided by the Angel;*[1] in July 1850 he mentioned having seen Rembrandt's *Tobias Curing His Father* in Brussels, at the residence of the duke of Arenberg.[2]

L.-A. P. and *A. S.*

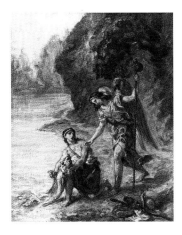

Fig. 1
EUGÈNE DELACROIX, *Tobias and the Angel,* 1863, oil on canvas, Winterthur, Switzerland, Oskar Reinhart Collection.

1. *Journal,* December 1847, p. 168.
2. *Journal,* July 9, 1850 (Norton, 1951, p. 124).

147. *Christ and the Blind Man of Jericho*

1862
Brown ink on paper; 5¼ x 8⅛ inches
(13.3 x 20.5 cm)
Dated at lower right in brown ink: *24 fʳ.62.*
Paris, Prat Collection
Exhibited in Philadelphia only

The episode of Christ curing a blind man outside Jericho is recounted in Matthew (20:29–34), Luke (18:35–43), and Mark (10:46–52). Matthew's account specifies two blind men; Luke's and Mark's only one, but the end of the story is identical. Jesus, having heard the appeal of the blind man, asks him, "'What wilt thou that I shall do unto thee?' And he said, Lord, that I may receive my sight. And Jesus said unto him, 'Receive thy sight: thy faith hath saved thee.' And immediately he received his sight, and followed him, glorifying God" (Luke 18:41–43).

An oil sketch of the same subject, more finished, was auctioned in Monaco in 1986.[1] At the time, Lee Johnson was able to identify it with lot III of Delacroix's posthumous studio sale.

L.-A. P. and *A. S.*

1. Sale, Sotheby's, Monaco, June 21, 1986, lot 76, repro.

148. *Ecce Homo*

1862
Brown ink on paper; 7¾ x 5¼ inches
(19.8 x 13.2 cm)
Dated at lower right in brown ink: *24 fʳ.62.*
Paris, Prat Collection
Exhibited in Philadelphia only

Torn between the desire to release Jesus and fear of a violent reaction from the Jews, Pontius Pilate proposed to the crowd assembled before the court to choose between freeing Jesus and freeing the thief Barabbas (Matthew 27:15–26, Mark 15:6–15, Luke 23:13–25, and John 18:28–40, 19:4–16):

> And he said unto them the third time, Why, what evil hath he done? I have found no cause of death in him: I will therefore chastise him, and let him go. And they were in-stant with loud voices, requiring that he might be cru-cified. And the voices of them and of the chief priests pre-vailed. And Pilate gave sentence that it should be as they required. And he released unto them him that for sedition and murder was cast into prison, whom they had desired; but he delivered Jesus to their will (Luke 23:22–25).

From this dramatic scene Delacroix chose the moment when Jesus was delivered to the Jews, symbolically represented in the foreground at left by a truncated silhouette with arm outstretched. The focus of the composition, set on a diagonal be-ginning at the head of the figure at left in the fore-ground and ranging up the stairway, is the figure of Jesus going down the stairs, held by two soldiers, with Pilate, washing his hands, behind him.

L.-A. P. and *A. S.*

149. *Christ Casting Out a Devil (?)* or *The Death of Sapphira (?)*

1862
Brown ink on paper; 5¼ x 8⅛ inches
(13.4 x 20.6 cm)
Dated at lower right in brown ink: *24 f^r.62.*
Bucharest, Muzeul Naţional de Artă al
României (221/24810)

The identification of this scene is uncertain. It
could depict one of many episodes recounted by
Matthew, Mark, or Luke in which Jesus cast out
devils from a possessed person. Alternatively,
Delacroix may have been inspired by the story of
Ananias and Sapphira:

> But a certain man named Ananias, with Sapphira his wife,
> sold a possession, And kept back part of the price, his wife
> also being privy to it, and brought a certain part, and laid it
> at the apostles' feet. But Peter said, Ananias, why hath
> Satan filled thine heart? . . . Thou hast not lied unto men,
> but unto God. And Ananias, hearing these words fell
> down, and gave up the ghost. . . . His wife, not knowing
> what was done, came in. And Peter [spoke] unto
> her. . . . Then fell she down straightaway at his feet, and
> yielded up the ghost (Acts 5:1–12).

L.-A. P. and *A. S.*

150. Mary Magdalene at the Feet of Christ

1862
Brown ink on paper; 8⅛ x 5⁵⁄₁₆ inches
(20.7 x 13.5 cm)
Annotated at lower left in pencil, in an un-
known hand (by Étienne Moreau-Nélaton?):
vers la fin de sa vie / 1862
Paris, Musée du Louvre, Département des Arts
Graphiques (RF 9548)
Exhibited in Paris only

In a few strokes of the pen, which compose a kind
of weaving on the paper, Delacroix masterfully
summarized the scene, vividly detailed by Luke
(7:36–50), of the sinner pardoned and loved.
Omitting the Pharisee and his guests, astonished
at the arrival of a woman who prostrates herself at
Jesus' feet—which she washes with her tears,
wipes with her hair, and anoints with perfume—
Delacroix concentrated on the remarkable en-
counter and communicated profound intensity
with an extraordinary economy of means. The
figure of Christ stands out clearly on the part of the
sheet left fairly open, whereas Mary Magdalene,
emphasized by superimposed lines placed close to-
gether, remains in the shadow.

L.-A. P. and *A. S.*

In his *Journal* entry for January 9, 1856, Eugène Delacroix mentioned for the first time his ideas for the subjects of these four ambitious decorative paintings. In scattered, sometimes elliptical notes, he named various mythological episodes in which the iconography could be connected with the theme of the seasons: "Eurydice. Figures conversing in the shadows, etc. (Spring).—Meleager offering the wild boar's head to Atalanta. (Autumn).—Juno and Aeolus. Ulysses' fleet. (Winter). —Earth asks Jupiter to end his injuries, etc. Phaëthon; in the distance streams and nymphs, etc.—Ceres looking for her daughter. The nymph Arethusa tells her about the kidnapping. Harvesters in the distance. (Summer).— Bacchus finding Ariadne. (Autumn).—Diana at her bath. Actaeon. The dogs go in the water, etc.—Boreas carrying off Orithyia. Her family in tears; river, her father, or anybody else."[1]

Even while other proposals were being made and before any definite decisions were taken in favor of one theme over another, the various mythological scenes corresponding to the four future paintings had already been envisioned. Yet Delacroix, having apparently chosen the story of Eurydice for spring and the meeting between Juno and Aeolus for winter, still hesitated between different episodes for autumn and summer. On March 27 of the same year, we learn, again from the *Journal,* that these iconographic thoughts did not arise purely from the painter's creativity but from a private commission, given to Delacroix by one M. Hartmann: "Brought to the country . . . the *Four Seasons,* of M. Hartmann."[2] On May 26, he wrote that he was applying himself diligently to the sketches of these decorations in order to submit them to this client before beginning work on the definitive paintings: "I worked a great deal at Champrosay. . . . Got much further with the sketches for M. Hartmann, the *Ugolin,* the *Pietà,* etc."[3] A rarely quoted letter confirms this information as well as the commission, which must have been given to Delacroix by M. Hartmann before January 9, 1856, when the painter noted his initial ideas. On February 6, 1856, Delacroix wrote to Hartmann:

> Monsieur, I would be most grateful if you would find it possible to settle on the measurements of the panels for your music room with your architect. That would give me the freedom to make the sketches when I find myself with some free time. I expect that it will take me a bit of time to throw myself entirely into work you would like me to do that I was unwilling to put off. Once the sketches are done, the definitive execution will follow more easily.[4]

Delacroix had previously prepared for these oil sketches with various pencil or ink studies of the whole or of details for each of the four compositions. Alfred Robaut specified that sixteen sheets in the painter's posthumous sale were "initial thoughts and studies from nature made for the four decorative compositions."[5] Three of these now belong to the Musée du Louvre (figs. 1 and 2 and RF 9546).

Despite his steady work, Delacroix bitterly complained on June 29 about the sluggishness of his inspiration: "I was not happy yesterday, on arriving [at Champrosay], with what I had left here, the *Erminia,* the *Bois-Guilbert Abducting Rebecca,* the sketches for Hartmann, etc."[6] However, the painter had appeared enchanted, a month earlier, with the experience entailed by the commission, and he had taken great pains in working out the four oil sketches, conscientiously noting in his *Journal* the various ways he could combine different pigments:

> Charming half tint for the background of earth, rocks, etc. In the rock behind Ariadne, the tone of *raw umber and white* with *yellow lake.* Warm tone for the flesh next to *lake* and *vermilion: zinc yellow, zinc green, cadmium,* a bit of

Fig. 1
EUGÈNE DELACROIX, *Half-Length Nude on Her Back,* 1856–57, graphite on paper, Paris, Musée du Louvre, Département des Arts Graphiques.

Fig. 2
EUGÈNE DELACROIX, *Half-Length Nude, Back View, Raising Her Arm,* 1856–57, graphite on paper, Paris, Musée du Louvre, Département des Arts Graphiques.

umber, vermilion.—Green in the same mode: *bright chrome, yellow ocher, emerald green*. The *bright chrome* works better than all that, but it is tricky, I must leave out the *zincs*.— Nice nuance combining this tone with that of *lake* and *white*.—*Prussian blue, red ocher, neutral green* which works well in the skin.—*Yellow lake, yellow ocher, vermilion.— Raw sienna. Cassel.*—these greenish tones make an excellent local color with a tone of *Van Dyck red* or *Indian red* and *white* blended with a mixed gray itself blended.—*Umber, cobalt white*. Pretty gray.—This tone, with *vermilion lake*, creates a half tint charming for youthful skin.—With *Italian earth vermilion*, the warmest local color.[7]

In his splendid oil sketches, Delacroix experimented with techniques adapted to the classical subjects selected for this commission. Like the decorative compositions themselves, the sketches remained in the painter's studio until his death, and three of them are known today (figs. 3–5).[8] With their original colors and refined execution, they exhibit the imagination and fire that the painter brought to the preparation of the four large paintings, which were conceived, nevertheless, with a purely classical iconography. It is true that during this period Delacroix got to know M. Hartmann, who fell into the habit of visiting his studio, and that he became somewhat interested in this unusual client, which made him determined to present him with four works of a superior order: "This evening I had a visit from M. Hartmann, who came to ask me for my copy of Raphael's portrait of a man. We talked theology the whole time. He is a fervent Protestant."[9]

This odd patron thus abruptly entered into the last years of Delacroix's career, life, and work. The doubts and confusions of most of the painter's biographers on the subject of this collector's identity have clouded the circumstances of the artist's meeting with various members of the Hartmann family, especially with Jacques Félix Frédéric Hartmann (1822–1880). One of the most interesting patrons of his time, he was already an ardent collector of the work of Théodore Rousseau (1812–1867)—which may be how Hartmann came to know Delacroix—and, after the deaths of Rousseau and Delacroix, became one of the most faithful patrons and collectors of Jean-François Millet (1814–1875).

The first biographies of Delacroix described "M. Hartmann," whose acquaintance with the painter began in 1856, as an "Alsatian industrialist" (Étienne Moreau-Nélaton)[10] or a "politician, former peer of France" and a "banker of Colmar" (André Joubin).[11] They attributed the commission for four paintings to André-Frédéric Hartmann

Fig. 3
EUGÈNE DELACROIX, *Spring— Orpheus and Eurydice* (sketch), 1856–59, oil on canvas, Montpellier, Musée Fabre.

Fig. 4
EUGÈNE DELACROIX, *Summer—Diana and Actaeon* (sketch), 1856–59, oil on canvas, Cairo, Mahmoud Khalil Museum.

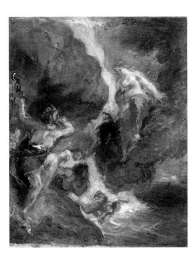

Fig. 5
EUGÈNE DELACROIX, *Winter— Juno and Aeolus* (sketch), 1856–59, oil on canvas, private collection.

(1772–1861), son of André Hartmann (1746–1837), a former dyer who learned his trade in France, then in Germany, before establishing an important textile factory in the valley of Munster that at the time of his death employed more than four thousand workers. Having taken over his father's factory, André-Frédéric Hartmann diversified its manufacturing activities, opening branches in Paris (32, rue du Sentier), Lyon (12, rue Impériale), and Beaucaire (rue des Couverts). Elected from Colmar to the Chamber of Deputies, he entered the Chamber of Peers in 1845 and became one of Alsace's most important political and industrial personalities. He died in 1861, and it seemed obvious to Delacroix's first biographers that the painter did not deliver the four compositions because of the death of this man who commissioned them.

However, as Lee Johnson pointed out in 1986,[12] André-Frédéric Hartmann was a very old man—he died at age eighty-nine—whose personality does not at all correspond to that of Delacroix's patron, who bought *The Abduction of Rebecca* (cat. 91) from the painter in 1858 and in 1860 commissioned a replica of *The Sultan of Morocco and His Entourage* (perhaps the painting in the E. G. Bührle Foundation, Zurich). Moreover, a bill, preserved by Achille Piron and rediscovered since the publication of Johnson's work, shows that one of these two paintings—most likely, *The Sultan of Morocco*—was delivered in 1862, that is, a year after the death of André-Frédéric Hartmann. In addition, there was a Hartmann who bought works at the posthumous sale of the painter in 1864, three years after André-Frédéric's death, including *The Triumph of Amphitrite* and *The Triumph of Bacchus* (E. G. Bührle Foundation, Zurich; see cat. 68). Rejecting André-Frédéric Hartmann as the commissioner of the *Seasons,* Lee Johnson nominated one of his nephews, Henri Hartmann, an associate of the family factory, who died in Munster in 1881. Jenny Le Guillou, Delacroix's housekeeper, confirmed in the inventory made after the painter's death that "the four unfinished paintings . . . were commissioned by H. Hartmann, of Munster (Haut-Rhin), for a consideration of twelve thousand francs payable immediately on delivery of said paintings and against which sum he has paid nothing."[13] This reference is so close to this Henri Hartmann that it could appear sufficiently conclusive. But might not "H. Hartmann" be a misreading of "M. Hartmann"?

Nevertheless, rehearsing the genealogy of the Hartmanns affords several clarifications about the role played by each in the family enterprise and broadens our understanding of the personality of the member who commissioned *The Four Seasons.* The founder of the dynasty, André Hartmann, had three sons, including André-Frédéric, already mentioned, and Henri, who was a deputy of Colmar. The latter had seven sons, among them Jacques Félix Frédéric—to whom we will return—and Henri, the only one of this name noted by Johnson. Henri Hartmann (1820–1881), an engineer and chemist, had a part in the management of the family factory, developing a new process for bleaching textiles that significantly increased the daily output. Henri and Jacques Félix Frédéric married two sisters, Blanche and Aimée Sanson-Davilliers, and the two households lived at the same Paris address (18, rue de Courcelles), which created some confusion about their individual activities. In their Parisian residence, the two Hartmann brothers set up a music salon, which gained a respectable reputation in the capital, and for which Jacques Félix Frédéric Hartmann would commission—as proved by the letter cited above—*The Four Seasons.* Lawyer, mayor of Munster, member of the administrative council for Haut-Rhin and deputy until the annexation of Alsace by Germany, Jacques Félix Frédéric Hartmann was the one of the two brothers who adored painting. Starting in 1850, he made efforts to become acquainted with painters, while continuing to manage the textile business.

Thus, the various theories cited above, including that of Johnson—who made the distinction between the commissioner of Delacroix's paintings and André-Frédéric Hartmann, who died in 1861—all have the drawback of omitting entirely the decisive role played in the family by Jacques Félix Frédéric Hartmann, the exceptional patron and collector. He had met Théodore Rousseau by 1852—through the painter François Louis Français (1814–1897), who, like Hartmann, came from Les Vosges—and he invited Rousseau to Munster. Although the painter never went to Alsace, he sold the industrialist many canvases, including *The Farm in Les Landes* and *Gorges of Apremont,* two paintings exhibited at the Salon of 1859. Jacques Félix Frédéric asked for another work to replace *Gorges of Apremont,* which he did not like after all, and Rousseau painted a different picture for him, *The Village of Becquigny* (The Frick Collection, New York), which was left unfinished at his death. The correspondence between the two men, which bears out their warm relationship, spells out in various negotiations and the frequent invitations to visit the Hartmanns in Alsace, which the painter deflected indefinitely.[14] After a momentary reverse of fortune—to which we will return—

Jacques Félix Frédéric, wishing to help the painter, who was always short of money, introduced him around 1860 to another member of this considerable family, his older brother Alfred, also a collector, who immediately commissioned a "painting of the Alps."

Although we cannot entirely rule out the factor of confusion among the various members of the Hartmann family—there is no reason why André-Frédéric Hartmann could not have begun a collection later continued by one of his nephews—the passionate love of art demonstrated by Jacques Félix Frédéric[15] points to him as the commissioner of *The Four Seasons,* the more so as the theme of the seasons seems to have literally obsessed him all his life. Having tried to obtain from Théodore Rousseau a series of paintings on this subject, in 1868 he finally commissioned a new series of the *Four Seasons* from Millet (who managed to finish only three of the four before his death). The frustrated Hartmann, who was never able to assemble all *Four Seasons* from the same artist, was missing the panel for *Winter.* The Hartmanns' business affairs must have recovered, for Millet, having presented pastel sketches for each composition, had expected to be paid twenty-five thousand francs for the series, that is, more than double what Delacroix was to have received several years earlier.

The recent reappearance of the archives and documents inherited by the executor of Delacroix's estate and his residual legatee, Achille Piron,[16] finally confirmed the relationship between Jacques Félix Frédéric Hartmann and Eugène Delacroix. Several unpublished letters have supplied many details about the various stages of the negotiations between the two men on the subject of the four paintings.

For some time we have known, from a letter Delacroix wrote to Auguste Lamey, that a distinct rift suddenly materialized between the painter and his client at the beginning of 1859, but its cause remained unknown. On June 24, 1859, Delacroix wrote to Lamey: "I'm sorry you have not . . . made your visit to Munster; I think it impossible for us to go together. I cannot show myself there because some unpleasantness has arisen between one of the Hartmanns and myself."[17]

From the Piron archives we have learned that sometime in the first half of the year Frédéric Hartmann canceled the order for the four paintings, pleading serious financial problems. An unpublished letter to the painter expressing contrition, dated December 4, 1859, returns to this extraordinary decision and attempts to revive the relationship between the two men:

Monsieur, I appeal to your benevolence and forbearance. In writing to you several months ago to cancel the commission for the four paintings that I asked you to do several years ago, I was giving in too quickly to fears awakened by the distressing circumstances in which we had found ourselves and by the substantial financial losses that we had suffered. All of us in Alsace had been convinced that we were on the brink of a new period of war that led us to curtail our spending. But since then (and I hope this frankness will do me no harm in your eyes, as I have valued your friendship highly) this letter has weighed on my conscience, indeed, weighed heavily. I therefore beg you to think of it as if it had never arrived; in tearing it up you will be doing me a big favor. Please be good enough to tell me that you have destroyed it and forgotten it and that you consent to consider our agreement still in force. In order to settle it properly, it is clearly understood, if after all you are willing to agree to it, as you are under no obligation to me anymore, I repeat, it is clearly understood that I and my heirs undertake to pay you twelve thousand francs for the four panels representing the Seasons for which you made sketches at my behest, which twelve thousand francs is to be paid the very day that said panels are delivered. . . . If, as I hope, your response is in this direction, I would be most grateful if you would give me the exact measurements of these panels, which I believe you wanted to make somewhat smaller. Frédéric Hartmann. Munster, December 4, 1859.[18]

Hartmann's reference to his "heirs" in this letter, which could as easily be the reflex of an old man as that of a legally prudent businessman, is one of the elements that makes it unviable to rule out André-Frédéric Hartmann as the commissioner of the *Seasons.* In any case, the painter must have destroyed the first letter written by Frédéric Hartmann canceling the commission, as this letter has not come down to us with the other documents in his estate amassed by Achille Piron. The situation's reversal seems to have mollified Delacroix, who during this period, galvanized by a run of inspiration, asserted in his *Journal:* "It is incredible the amount of work that I have been able to do in the last three weeks, or just over a month, down to today, June 14th. . . . have made great headway with the four pictures of the 'Seasons' for Hartmann, etc."[19] At the time, Delacroix must have been putting considerable effort into the definitive paintings, which he had worked on steadily until 1857 and then, apparently, put aside in 1858 in order to prepare his entry—his last—for the Salon of 1859 (cats. 91, 94, 95, 127, and 128). It was undoubtedly—between the end of 1859 and mid-1862 that he brought the execution of the four paintings to the state in which we know them today.

Yet the checkered history of this commission does not end there: Frédéric Hartmann showed himself to be a truly strange patron in a letter of September 14, 1860, in which he questioned—and, in the end, acceded to—the price for a copy of *The Sultan of Morocco and His Entourage,* commissioned from Delacroix some years earlier, and then confirmed the price agreed upon for *The Four Seasons:*

> Monsieur, I understand your note from your point of view, but putting yourself in my place, you understand that I cannot agree to what you ask of me. I could not possibly have said that I remembered that it had been a matter of 2,500 francs because, in fact, I do not remember it at all. After that, for me to pretend, out of politeness, that I do remember a detail that I absolutely have forgotten did not seem to be proper between men such as you and me. I thus found it preferable to tell you frankly that I retain the memory of 2,000 francs as . . . settled between us. I am, very simply, capable of a faulty memory, which I hope you will forgive. But since you assert it to be so, that suffices for me, and I beg you not to entertain the least doubt. I would be most grateful, and it would be a shame . . . for you to suffer the consequences of my mistake. I must tell you besides, not that the difference means little to me (I fully appreciate the value of a 500-franc bill, both plus and minus), but that at this price I think I have done very well. I say this to you since we are discussing money. But I hope you realize that for me your painting has a price that goes beyond money: it enchants me; I identify readily enough with the feeling that you have inspired and I follow you into an ideal world where I enjoy some delightful moments. I would have sent you the 500 fr in question already, but it is Sunday; our offices are closed and I do not have that much on me. I am leaving an order that it be sent to you. As I am leaving Paris tomorrow morning at 7 o'clock, I will not have the pleasure of seeing you. I would like to repeat that I move time around and I am so busy that it is almost excusable that I forget what I have agreed to. In order to avoid a repetition in regard to the panels that you are willing to do for me, I think it wise to say here that the price we agreed upon is twelve thousand francs. Please retain the note in which I acknowledge that I owe you 500 francs remaining to be paid for *The Emperor of Morocco* and twelve thousand francs for the four panels that you intend to deliver. Frédéric Hartmann.[20]

In placing his address on this letter—"M. Frédéric Hartmann, Jr. 32, rue du Sentier, Paris"—the industrialist also confirmed his position in the Hartmann family, as his uncle André-Frédéric had not yet died.

With the various financial transactions ironed out, the delicate question of the dimensions of the works, linked to the decorative nature of the compositions, had to be addressed once again. On January 3, 1861, Delacroix wrote in his *Journal* that he had given the measurements to "M. Fritz Hartmann for the panels of the Seasons: 1.92 x 1.62 [meters]."[21] The incursion of a new name in this story is confusing. Two possibilities present themselves. Perhaps, as Johnson suggests, this refers to Fritz Schouch, Henri Hartmann's brother-in-law, who could have served as the intermediary for obtaining the measurements and to whom Delacroix mistakenly gave the last name Hartmann in his daily notes. The alternative, which I strongly favor, is that the name results from an error of transcription or interpretation of the manuscript of the *Journal.* One of Frédéric Hartmann's given names was Félix, which could easily be mistaken for Fritz if handwritten. Delacroix may well have used that name for the industrialist in his private notes; in fact, some relatives called Frédéric Hartmann by his other given name, Jacques, as seen in a letter written by one of his colleagues.

Meanwhile, the business of the dimensions grew increasingly more complex. On May 21, 1861, Hartmann asked Delacroix if it was still possible to change the dimensions of the paintings "noticeably" one last time:

> Munster, May 21, 1861, I would like to ask you how far along are my panels that I await with an impatience that you can understand but that would never become intrusive. In case a modification is still possible, I would like to request that you reduce the measurements in height and width, as much as is possible, while retaining the proportions. I can install them as they are, but it would be infinitely more convenient for me if they were noticeably smaller, from 1 m 30 to 1 m 20 in height, preferably 1 m 20. I know that my panels are already in progress and set, but more in conception than on the canvas, at least I think so. That is why I take the liberty of proposing this modification to you, to which I imagine you would find no objection, as it palpably reduces your work. But it goes without saying that if it in any way whatsoever causes a major shift for you, you mustn't even dream of it. This reduction of measurements would be extremely helpful to me, but I would not insist on it unless it could be done easily and in a way that would decrease your work. I thus leave it entirely up to you. There is no need even to take the trouble of responding: you do what you wish and what you can do, and that will be fine. I very much hope that I can return to Paris soon and have the pleasure of seeing you. Please accept my most sincere respects. Frédéric Hartmann.[22]

This last letter offers definitive confirmation of the role played by Jacques Félix Frédéric Hartmann in

commissioning *The Four Seasons*, since André-Frédéric Hartmann, the "other Frédéric," had died three weeks earlier.

Be that as it may, reopening the matter of dimensions that had already been set, even though the collector left the choice entirely up to Delacroix, may have annoyed or troubled the artist. Fighting against his own failing health, Delacroix was fully caught up in the execution of the murals for the church of Saint-Sulpice, his last decorative work, inaugurated on July 22 and opened to the public on August 21 of that year. In any case, the painter was in no hurry to deliver the four compositions, since during the winter of 1862 he was considering exhibiting them at the Salon of 1863, as demonstrated by a letter he wrote to Paul Beurdeley on May 13, 1863:

Unfortunately, I cannot satisfy the flattering desire you expressed to see my paintings of the *Seasons*, which I almost finished this winter but did not bring to completion when I learned, two months before the Salon, that they could not be accepted. They are no longer even in Paris, as I have sent them to the country, where I intend to finish them. I hope that next year I will have an opportunity to show them somewhere.[23]

A little over a year after the painter's death, the four paintings, still unfinished, were inventoried at Champrosay during an appraisal of Delacroix's second studio—"2) The 4 unfinished canvases representing *The Four Seasons*, by M. Delacroix, 2,000 francs"[24]—while, at the same time, the four oil sketches turned up in the Paris studio: "187) 4 canvases, *studies for the Four Seasons*, by the same [Delacroix], 150 francs." And, after Jenny Le Guillou confirmed that these compositions had not been delivered and, therefore, not paid for by Frédéric Hartmann, *The Four Seasons* were included in the posthumous sale of 1864.

It is curious that their commissioner did not try to buy them, since Étienne-François Haro's winning bid at the auction came to forty-nine hundred francs for all four, much less than the twelve thousand francs specified at the time they were commissioned. The Alsatian industrialist, who perhaps remained in financial difficulties that prevented him from topping Haro's bid, nonetheless acquired, for 1,525 francs, two overdoor decorations, *The Triumph of Bacchus* and *The Triumph of Amphitrite*.[25] Aesthetically akin to *The Four Seasons*, these unfinished paintings may have partially replaced the four works that escaped him for good.

Bought by Haro, the dealer who was closest to Delacroix and who in time became a true confidant, *The Four Seasons* went next into the prestigious collection of the journalist and publisher Émile de Girardin (1806–1881), the founder of many newspapers and developer of the popular press. After his death, the series passed twice through the hands of the dealer Paul Durand-Ruel and ended up in the United States, where it was bought about 1924 by Albert Gallatin, a congenial collector who left in his amusing autobiography some interesting information, albeit sometimes a bit farfetched, about the four compositions:

The four large paintings of the Seasons by Delacroix which hung for so many years in my house in 67th. Street had passed from one dealer to another since they had been sold, unfinished, from Delacroix's studio at his death till they came into the hands of the firm of Cottier; no private collector had ever owned them. I asked old Durand-Ruel once about the statement in a book that one of them had been repainted, and he replied that he would never have bought them twice if he had thought so.[26]

After recalling, not without some pride, that throughout a weekend the famous James J. Hill had offered him double what he had paid for the four paintings, Gallatin recounted how he had been forced to sell the *Seasons*—which he replaced by a painting of flowers by Delacroix (cat. 29)—after moving to a new apartment with a much lower ceiling. He never succeeded in learning the name of the new owner.

In bringing up the state of one of the works in the series, Gallatin drew attention to another delicate question surrounding the history of these four paintings: the participation of one of Delacroix's collaborators in their execution before the painter's death or their partial finishing by another hand after the posthumous sale. At the time of the posthumous sale, some of his friends had found them in satisfactory condition; yet in 1885 Alfred Robaut asserted that "public opinion holds these four canvases to have been retouched by an unknown hand."[27] He emphasized the ways they could have been altered to make them look less unfinished, a characteristic that apparently made them hard to sell. Such alterations could have been made while the paintings were in the possession of Haro, who had a reputation—perhaps false—for having Delacroix's works "finished," and who may have asked Pierre Andrieu to touch them up in the master's style, perhaps at the time of Girardin's posthumous sale. A restoration carried out undoubtedly in the 1930s, before they entered the collection of the Museu de Arte in São Paulo, eliminated the most glaring of these retouches and

returned to these final compositions of Delacroix the transparency and liveliness that the painter had given them.

On the other hand, it is not out of the question that Delacroix asked his favorite collaborator, Pierre Andrieu, for assistance on one or the other of the four decorative compositions. At the time, the two men were working together on several of Delacroix's commissions, in which the execution looks completely autograph—the student's contributions no doubt confined to minor elements. Johnson points out that *Winter* might include some parts carried out by Pierre Andrieu, and *Spring* is thought by some to have been retouched by Delacroix's collaborator. Yet comparison of the oil sketches of these decorative compositions—especially the one in the Musée Fabre, Montpellier—and the paintings in São Paulo reinforces the belief that the master himself transposed his designs to the canvases. In these works his vigorous brushstroke and his method of blending colors have attained an inimitable perfection.

Precisely because they are unfinished, the four canvases fully reflect Delacroix's creative intentions. *Summer* seems to be the most finished of the group and *Winter* the least. *Spring* and *Summer* offer illustrations of angry gods: in the former, Orpheus's wife Eurydice has been fatally bitten by a snake; in the latter, a furious Diana transforms the vain hunter Actaeon into a deer that will be devoured by dogs. *Autumn,* in contrast, indicates the love and protection that the gods sometimes dispense to mortals; the painting depicts the marriage of Ariadne, the daughter of King Minos who had been abandoned by Theseus on the island of Naxos, and Bacchus, the god of wine who rescued her. Finally, in *Winter,* inspired by Virgil's tale, Juno is shown asking Aeolus, the god of winds, to destroy the fleet of Aeneas.

Because of this iconography and the formal solutions adopted by Delacroix, art historians have suggested that *Spring* and *Summer,* two scenes in the woods, and *Autumn* and *Winter,* two seascapes with strange rock arches recalling Andrea Mantegna's decorations for the *studiolo* of Isabella d'Este, must have formed pairs, intended to be hung as pendants, the one next to or opposite the other.

It is curious that this commission in his last years led Delacroix to return to the theme of *The Four Seasons,* which he had previously addressed in 1821 in his first decorative series. For the dining room of the tragedian François-Joseph Talma (1763–1826), he had painted four overdoor decorations representing classical allegories inspired by the rhythm of the seasons.[28] The iconography of the Hartmann *Seasons,* however, is infinitely more complex than that of the isolated figures of the Talma *Seasons.* It combines the influences of ancient Roman painting (the paintings found at Stabiae have been suggested as the source for *Spring*), Renaissance painting, and Mannerism for *Summer* and *Autumn.* It also includes references to Nicolas Poussin, as in the female figure in the background of *Spring,* drawn from *Orpheus and Eurydice* in the Musée du Louvre—a homage by Delacroix to the classical master. Even though Rubens can be found in these compositions—the nymphs of *Summer* strongly recall the naiads in the gallery of Marie de'Médici, greatly admired and studied by the Romantic painter—Delacroix drew the style mainly from Italian Mannerist and Baroque painting. In the late works of Titian, as well as those of Pietro da Cortona and Guercino, he found the heightened facture and learned iconography of these compositions.

The mythological subjects, evoking the poetic and sensual universe of Ovid, and the numerous references to Baroque and classical iconography, astonish us by their systematic character, forming a final testimony to the career of a painter who had gone beyond Romanticism. Through destiny—or, perhaps, the will of the painter, who failed to finish them—these four decorative compositions, despite a deliberately artificial setting, avoided foundering in academicism. Instead, with their handling, chromatic harmony, and poetic serenity, they offer a profane, classical, and Mannerist counterpoint to the tormented spiritual testament of the chapel of the Saints-Anges in the church of Saint-Sulpice, executed during the same period.

V. P.

1. *Journal,* January 9, 1856, p. 563.
2. *Journal,* March 27, 1856, p. 573.
3. *Journal,* May 26, 1856, p. 581.
4. Département des Arts Graphiques, Musée du Louvre, Paris (BS b5 L 29).
5. Posthumous sale of Delacroix's works, Hôtel Drouot, Paris, February 17–19, 1864, lot 379, sold for 31 francs for the lot; Robaut, 1885, p. 449.
6. *Journal,* June 29, 1856, p. 587.
7. *Journal,* May 8, 1856, pp. 578–79.
8. Johnson, 1986, vol. 3, nos. 244–47, pls. 62–65. The fourth sketch, *Autumn,* location unknown, was on the market in 1989.
9. *Journal,* December 29, 1857, p. 704 (see Pach, 1937, p. 616).
10. Moreau-Nélaton, 1916, vol. 2, p. 195.
11. *Journal,* p. 704 n. 5, p. 920.

12. Johnson, 1986, vol. 3, p. 63.

13. Bessis, 1969, p. 210 n. 2.

14. Twenty autograph letters from Hartmann to Théodore Rousseau are preserved in the Département des Arts Graphiques, Musée du Louvre, Paris, Bequest of Étienne Moreau-Nélaton (BS b22).

15. R. Schmitt, "Jacques Félix Frédéric Hartmann, grand notable d'Alsace, 1822–1880," in *Annuaire de la Société d'histoire du val et de la vallée de Munster,* 1968.

16. Archives Piron, Archives des Musées Nationaux, Paris.

17. *Correspondance,* vol. 4, p. 109.

18. Archives Piron, Archives des Musées Nationaux, Paris.

19. *Journal,* April 14, 1860 (Norton, 1951, p. 403); note the discrepancy in the date.

20. Frédéric Hartmann to Delacroix, Archives Piron, Archives des Musées Nationaux, Paris.

21. *Journal,* January 3, 1861, p. 797.

22. Frédéric Hartmann to Delacroix, Archives Piron, Archives des Musées Nationaux, Paris.

23. *Correspondance,* vol. 4, pp. 372–73.

24. Bessis, 1969, p. 210.

25. E. G. Bührle Foundation, Zurich; see cat. 68.

26. *The Pursuit of Happiness by Albert Gallatin: The Abstract and Brief Chronicles of the Time* (New York: Scribner, 1950), p. 200.

27. Robaut, 1885, no. 1434.

28. Location unknown; Johnson, 1981, vol. 1, nos. 94–97, pls. 82–83.

1856–63
Oil on canvas; 78 x 65¼ inches (198 x 165.7 cm)
São Paulo, Museu de Arte de São Paulo
Assis Chateaubriand (67/1952)

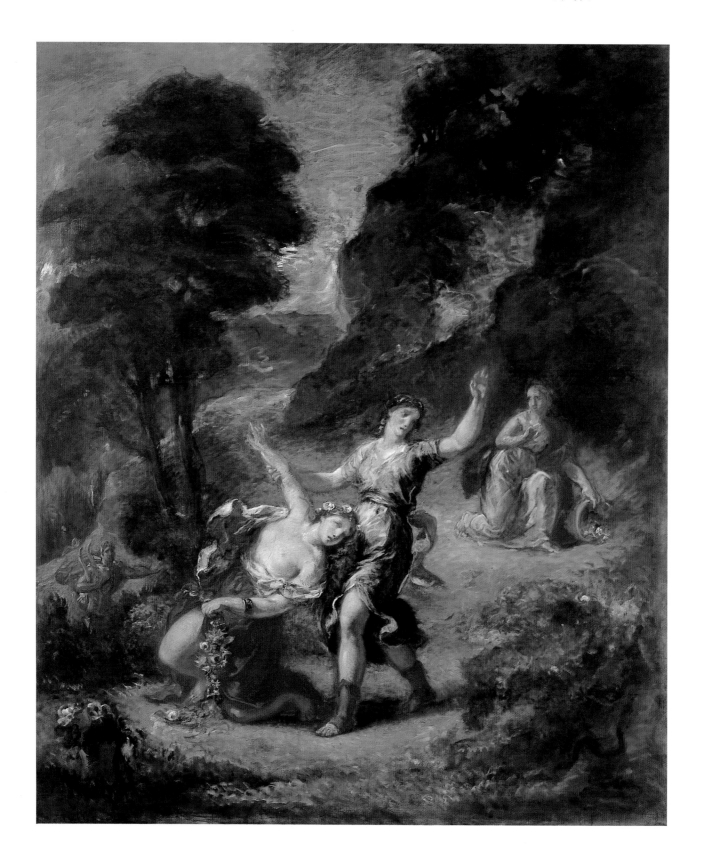

152. *Summer—Diana and Actaeon*

1856–63
Oil on canvas; 78 x 65¼ inches (198 x 165.7 cm)
São Paulo, Museu de Arte de São Paulo
Assis Chateaubriand (68/1952)

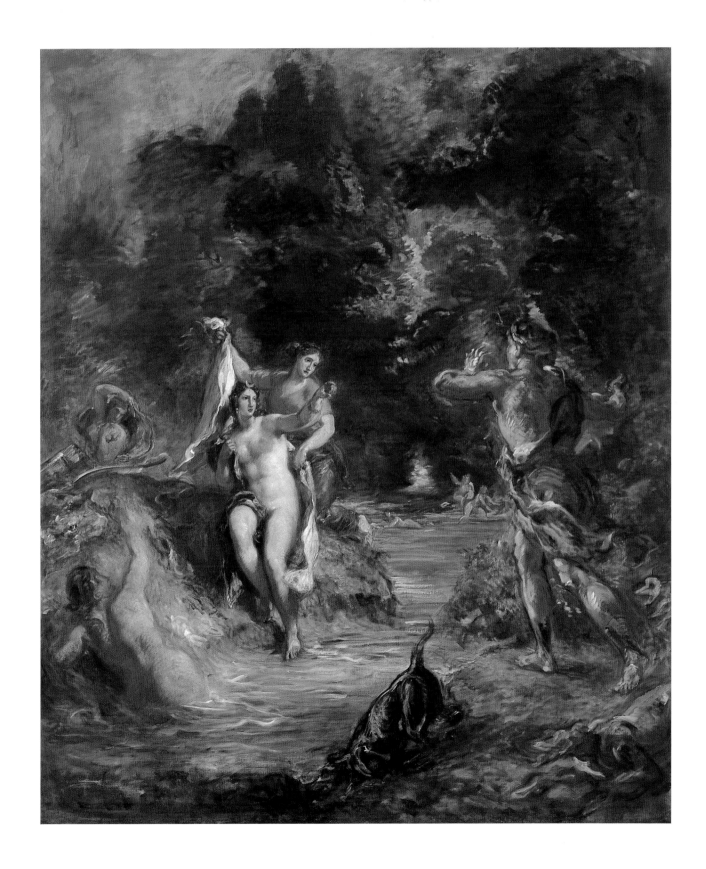

1856–63
Oil on canvas; 78 x 65¼ inches (198 x 165.7 cm)
São Paulo, Museu de Arte de São Paulo
Assis Chateaubriand (69/1952)

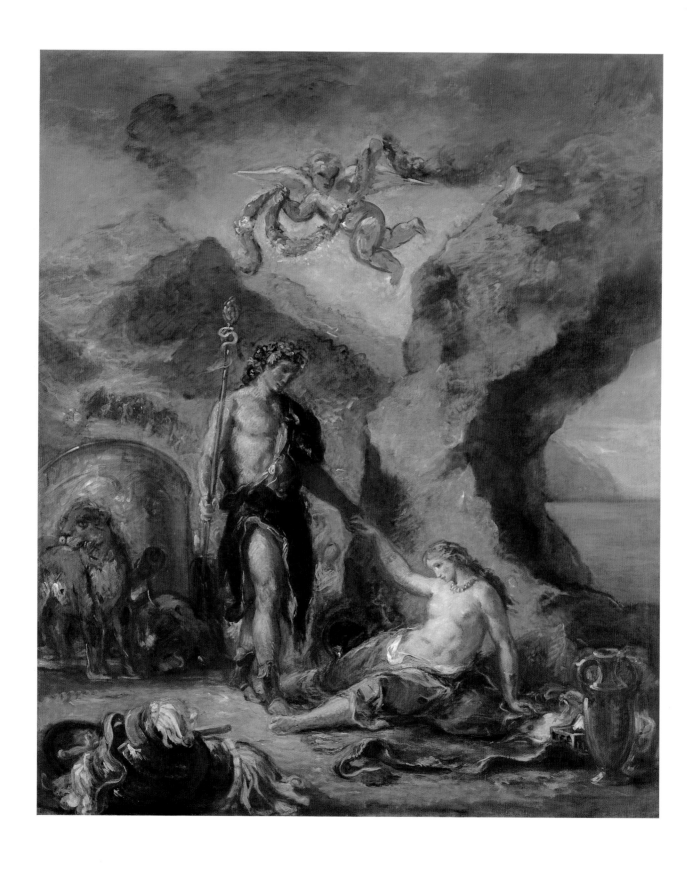

154. *Winter—Juno and Aeolus*

1856–63
Oil on canvas; 78 x 65¼ inches (198 x 165.7 cm)
São Paulo, Museu de Arte de São Paulo
Assis Chateaubriand (70/1952)

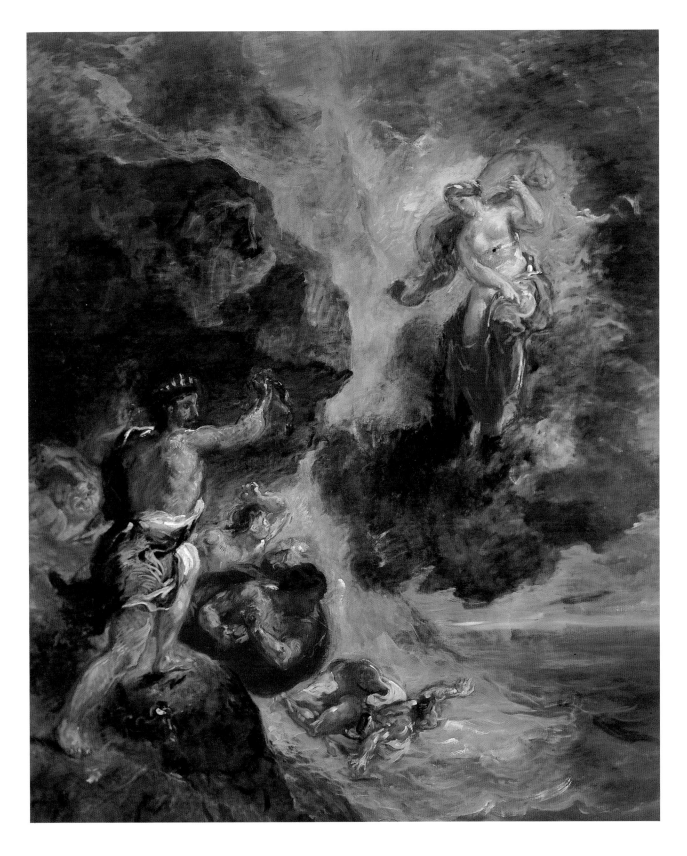

Appendix to the Catalogue

Provenance, Bibliography, and Exhibition History

1. *Felines and Hunts*

1. *Lion Mauling a Dead Arab*

c. 1847–50
Watercolor and graphite on paper;
8⅝ x 10⅝ inches
(22 x 27 cm)
Private collection (courtesy of the Nathan
Gallery, Zurich)

PROVENANCE
Delacroix Atelier, marked at lower right (Lugt 838a);
sold posthumously, Paris, Hôtel Drouot, February
22–27, 1864, lot 462 (catalogued as a drawing); ac-
quired by M. Normand (350 francs); Normand col-
lection; Donatis collection, 1885; baron Joseph Vitta
collection; Paul Arthur Chéramy collection; sale,
Chéramy, Paris, Galerie Georges Petit, May 5–7,
1908, lot 303, repro.; Jacques Dubourg; Dr. Peter
Nathan collection, Zurich; private collection.

BIBLIOGRAPHY
Robaut, 1885, no. 1054, repro.; Johnson, 1986, vol. 3,
under no. 178.

EXHIBITIONS
1885, Paris, no. 258; 1930, Paris, no. 616; 1987(b),
Zurich, no. 67; 1987–88, Frankfurt, no. I-30,
p. 221, repro.

2. *Reclining Tiger*

c. 1847–49
Brown ink on paper; 4¾ x 7¹⁵⁄₁₆ inches
(12.1 x 20.2 cm)
Paris, Musée du Louvre, Département des Arts
Graphiques (RF 36 803)

PROVENANCE
Delacroix Atelier, marked at lower right (Lugt 838a);
sold posthumously, Paris, Hôtel Drouot, February
22–27, 1864, perhaps lot 481 or part of lot 487 or 495;
acquired by Dr. René Marjolin; Mme René Marjolin
collection; M. and Mme Jean Psichari; sale, Psichari,
Paris, Galerie Georges Petit, June 7, 1911, lot 10; ac-
quired by Schoeller (70 francs); Claude Roger-Marx
collection; collection of Mme Paulette Asselain, née
Roger-Marx; given to the Musée du Louvre in 1978,
marked at lower right (Lugt 1886a).

BIBLIOGRAPHY
M. Sérullaz, 1963(a), no. 409, repro.; M. Sérullaz,
1984, vol. 1, no. 1086, repro.

EXHIBITIONS
1925, Paris, no. 82; 1930, Paris, no. 625; 1952,
London, no. 79; 1956, Venice, no. 73; 1963(a), Paris,
no. 404.

3. *Heads of Roaring Lions and Lionesses*

c. 1850
Black ink over pencil on paper; 8¼ x 10½ inches
(21 x 26.7 cm)
Dijon, Musée des Beaux-Arts (DG 105)

PROVENANCE
Delacroix Atelier, marked at lower right (Lugt 838a);
sold posthumously, Paris, Hôtel Drouot, February
22–27, 1864, perhaps lot 484 or part of lot 485, 486,
or 487; acquired by Pierre Granville in 1953;
Kathleen and Pierre Granville collection; given to
the Musée des Beaux-Arts, Dijon, in 1969.

EXHIBITIONS
1954, Paris, no. 102; 1963(c), Paris, no. 157; 1963–64,
Bern, no. 182; 1964, Bremen, no. 265.

4. *Lioness About to Attack, Another
Reclining*

c. 1850
Brown ink on paper; 6⅞ x 8⅝ inches
(17.5 x 22 cm)
Signed at lower right in brown ink:
Eug. Delacroix
Private collection (courtesy of the
Nathan Gallery, Zurich)

PROVENANCE
Sale, Paris, Hôtel Drouot, June 26, 1986, lot 12,
repro.; acquired by Nathan Gallery, Zurich; Dr.
Peter Nathan collection, Zurich.

EXHIBITIONS
1987(b), Zurich, no. 84; 1987–88, Frankfurt, no. I-15,
repro.

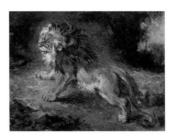

5. *Lion Stalking Its Prey* or *Lion Watching
Gazelles*

c. 1850
Oil on canvas; 9⅝ x 13¼ inches (24.5 x 33.5 cm)

Signed at lower left: *Eug. Delacroix.*
Private collection

PROVENANCE
According to Johnson, the *Petit Lion* was given by
Delacroix to his friend Jean-Baptiste Pierret on
February 24, 1850 (*Journal*, p. 225); collection of
Pierret's widow, 1864; Goupil and Company after
December 9, 1872; sold by Goupil and Company to
M. Schwabacher, December 18, 1872; Schwabacher
collection, Paris; sale, Schwabacher, Paris, Hôtel
Drouot, May 9, 1874, lot 15 (*Lion*) (7,250 francs);
Laurent-Richard collection, Paris; sale, Laurent-
Richard, Paris, Hôtel Drouot, May 23, 1878, lot 19;
acquired by Jean Dollfus (3,260 francs); Jean Dollfus
collection, Paris; sold, Paris, Hôtel Drouot, March 2,
1912, lot 33, repro.; acquired by Bernheim-Jeune
(9,700 francs); sold by Bernheim-Jeune to M.
Bourgarel, May 8, 1912 (Bernheim-Jeune archives,
cited by Johnson); Bourgarel collection; repurchased
by Bernheim-Jeune from M. Breckpot, December
12, 1913; sold by Bernheim-Jeune to M. Prévost,
December 18, 1915; Prévost collection; sale, Prévost,
November 26, 1920, lot 12, repro.; acquired by
Bernheim-Jeune (16,500 francs); sold by Bernheim-
Jeune to M. Von Grundhen, March 1, 1921; bought
by David David-Weill at Atri, March 5, 1926
(40,000 francs); David David-Weill collection; Mme
David-Weill, 1970; private collection.

BIBLIOGRAPHY
Robaut, 1885, no. 1249, repro.; Johnson, 1986, vol. 3,
no. 182, pl. 14; Daguerre de Hureaux, 1993, p. 323.

EXHIBITIONS
Possibly 1864, Paris, no. 168b (*Un Lion*); 1885, Paris,
no. 62 (*Lion regardent des gazelles*); 1972, Paris, no.
13; 1987(a), Zurich, no. 75, pp. 202–3, 330, repro.

6. *Lion Clutching Its Prey*

c. 1852
Black ink on paper; 4¹⁵⁄₁₆ x 7⅞ inches
(12.5 x 20 cm)
Dated at lower right in black ink: *27 f ʳ. 52.*
Dijon, Musée des Beaux-Arts (DG 377)

PROVENANCE
Verninac collection; sale, Verninac, Paris, Hôtel
Drouot, December 8, 1948, lot 6; acquired around
this time by Pierre Granville; Kathleen and Pierre
Granville collection; given to the Musée des Beaux-
Arts, Dijon, in 1969.

EXHIBITION
1954, Paris, no. III.

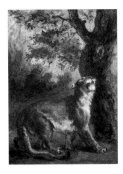

7. *Lioness Stalking Its Prey* or *The Puma*
or *Lioness Standing by a Tree*

c. 1852–54
Oil on wood; 16⁵⁄₁₆ x 12 inches (41.5 x 30.5 cm)
Signed at lower right: *Eug. Delacroix*
Paris, Musée d'Orsay, Bequest of Alfred
Chauchard (RF 1815)

PROVENANCE
According to the painter Jean Gigoux, this painting
was given by Delacroix to the landscape painter
Constant Troyon as thanks for the purchase of
Christ on the Sea of Galilee (cat. 118); collection of
Mme Troyon, mother of the artist, 1864; at Constant
Troyon's death, given by Mme Troyon to M.
Robert, director of the Sèvres factory, where Troyon
had begun his career; M. Robert collection; collec-
tion of the painter Émile Van Marcke, Troyon's
friend, and, like him a ceramic painter at the Sèvres
factory; sale, Émile Van Marcke Atelier, Paris,
Galerie Georges Petit, May 11, 1891, lot 352 (*Tigre
aux aguets*) (22,000 francs); Arnold, Tripp and
Company and Le Roy and Company from May 22,
1891, to June 17, 1891 (these two galleries had bought
the work for, respectively, two parts and one part of
the total sale price; Arnold, Tripp archives, cited by
Johnson); Alfred Chauchard collection, Paris; be-
queathed to the Musée du Louvre in 1906; entered
the museum in 1909; transferred from the Musée du
Louvre to the Musée d'Orsay in 1986.

BIBLIOGRAPHY
Robaut, 1885, no. 1390, repro. (*Lionne guettant une
proie*); M. Sérullaz, 1963(a), no. 436, fig. p. 330;
Johnson, 1986, vol. 3, no. 188, pl. 17; Daguerre de
Hureaux, 1993, p. 325.

EXHIBITIONS
1864, Paris, no. 34 (*Lionne*); 1930, Paris, no. 180 (*Le
Puma*); 1951, Paris, no. 7; 1963(a), Paris, no. 501;
1973, Paris; 1974, Paris; 1975, Paris.

8. *Struggle Between a Lion and a Tiger*

c. 1854
Graphite on paper; 12¹⁵⁄₁₆ x 9½ inches
(31.3 x 24.2 cm)
New York, The Metropolitan Museum of Art,
Bequest of Gregoire Tarnopol, 1979, and Gift
of Alexander Tarnopol, 1980 (1980.21.13)

PROVENANCE
Delacroix Atelier, marked at lower right (Lugt 838a);
sold posthumously, Paris, Hôtel Drouot, February
22–27, 1864, possibly part of lot 467 (22 sheets ac-
quired by several collectors); Georges Aubry collec-
tion; Maurice Gobin collection; Gregoire Tarnopol
collection; Alexander Tarnopol collection; given to the
Metropolitan Museum of Art, New York, in 1980.

EXHIBITIONS
1930, Paris, no. 615; 1937, Paris, no. 24; 1991, New
York, no. 53, repro.

9. *Two Studies of a Struggle Between a Lion
and a Tiger*

c. 1854
Graphite on paper; 8⁹⁄₁₆ x 12⅛ inches
(21.8 x 30.9 cm)
Paris, Musée du Louvre, Département des Arts
Graphiques (RF 9482)

PROVENANCE
Delacroix Atelier, marked at lower right (Lugt 838a);
sold posthumously, Paris, Hôtel Drouot, February
22–27, 1864, without doubt as lot 470 (355 francs);
Alfred Robaut collection, marked on verso; Étienne
Moreau-Nélaton collection; bequeathed to the
Musée du Louvre in 1927, marked at lower left
(Lugt 1886a).

BIBLIOGRAPHY
M. Sérullaz, 1984, vol. 1, no. 1134, repro.

EXHIBITIONS
1930, Paris, no. 614; 1951, Paris, no. 17; 1963(b), Paris,
no. 99; 1982, Paris, no. 351.

10. *Arabs Stalking a Lion*

c. 1854
Oil on canvas; 29⅛ x 36¼ inches (74 x 92 cm)
Signed and dated at lower right:
Eug. Delacroix. 1854.
St. Petersburg, The State Hermitage Museum
(inv. 3853)

PROVENANCE

Commissioned by the dealer Weill in 1854; Nikolai Kusheleff-Besborodko collection, St. Petersburg, c. 1862; bequeathed to the Museum of the Imperial Academy of Beaux-Arts of St. Petersburg in 1862; entered the State Hermitage Museum in 1922.

BIBLIOGRAPHY

Journal, pp. 405, 411, 415, 416; Johnson, 1986, vol. 3, no. 193, pl. 21; Daguerre de Hureaux, 1993, pp. 199, 202, 326, repro.

EXHIBITION

1964, Edinburgh and London, no. 200, repro.

11. *Tiger Hunt*

1854
Oil on canvas; 28¹³⁄₁₆ x 36⁷⁄₁₆ inches
(73.5 x 92.5 cm)
Signed and dated at lower right:
Eug. Delacroix. / 1854.
Paris, Musée d'Orsay, Bequest of Alfred Chauchard (RF 1814)

PROVENANCE

Commissioned by the dealer Weill in 1854; sale, Weill, Paris, February 19, 1856, lot 20 (2,100 francs); Charles Bardon collection; sale, Bardon, Paris, Hôtel Drouot, April 22, 1861, lot 15 (2,590 francs); Tabourier collection; Prosper Crabbe collection, Brussels, after 1864; sale, Crabbe, June 12, 1890, lot 4; acquired by Le Roy and Company (76,000 francs); Alfred Chauchard collection, Paris; bequeathed to the Musée du Louvre in 1906; entered the museum's collection in 1909; transferred from the Musée du Louvre to the Musée d'Orsay in 1986.

BIBLIOGRAPHY

Journal, pp. 430, 436, 446–47; Henriet, 1854, p. 115; Moreau, 1873, p. 278; Robaut, 1885, no. 1081, repro.; Johnson, 1986, vol. 3, no. 194, pl. 12; Daguerre de Hureaux, 1993, p. 199, fig. pp. 202, 326; Daguerre de Hureaux and Guégan, 1994, pp. 42–43; Rautmann, 1997, p. 302, fig. 292.

EXHIBITIONS

1930, Paris, no. 161; 1933, Paris, no. 196; 1939, Zurich, no. 358, repro.; 1939, Basel, no. 253, repro.; 1945, Paris, no. 10; 1946(a), Paris, no. 9; 1946(b), Paris, no. 9; 1949, Paris; 1963, Bordeaux, no. 48, repro.; 1966, Paris, no. 25, repro.; 1968, Paris; 1969, Kyoto and Tokyo, no. H-36, repro.; 1971, Paris; 1974, Paris; 1981, Stockholm, no. 19, repro.

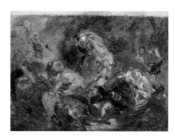

12. *Lion Hunt* (compositional study)

1854
Oil on canvas; 33⅞ x 45¼ inches (86 x 115 cm)
Paris, Musée d'Orsay (RF 1984-33)

PROVENANCE

Delacroix Atelier, wax seal on verso; sold posthumously, Paris, Hôtel Drouot, February 17–19, 1864, lot 144; acquired by the painter Léon Riesener, cousin and friend of the artist (1,300 francs); Léon Riesener collection, Paris; sale, Riesener, Paris, Hôtel Drouot, April 11, 1879, lot 222 (withdrawn at 500 francs); collection of Léon Riesener's widow until 1885; collection of her daughter, Mme Lauwick, until 1930; collection of Mme Georges Itasse, youngest granddaughter of Léon Riesener, until 1930; acquired by the Musée d'Orsay in 1984.

BIBLIOGRAPHY

Journal, pp. 403, 416, 420, 431; Moreau, 1873, pp. 200, 319, no. 148; Robaut, 1885, no. 1230, repro.; M. Sérullaz, 1963(a), no. 467, repro.; Johnson, 1986, vol. 3, no. 197, pl. 22; Daguerre de Hureaux, 1993, pp. 199, 201, fig. p. 205; Daguerre de Hureaux and Guégan, 1994, pp. 42–43, repro.; Rautmann, 1997, p. 298, fig. 288, pp. 299, 326; Jobert, 1997, p. 265, fig. 220.

EXHIBITIONS

1864, Paris, no. 140; 1885, Paris, no. 169; 1930, Paris, no. 156, repro.; 1933, Paris, no. 194, repro.; 1952, London, no. 39; 1963(a), Paris, no. 466, repro.; 1969, Paris; 1971, Paris; 1981, Stockholm, no. 21, repro.

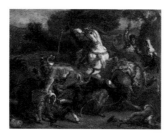

13. *Lion Hunt*

1855
Oil on canvas; 21¼ x 29⅛ inches (54 x 74 cm)
Signed and dated at lower right: *Eug. Delacroix. 1855* [or *1856*?]
Stockholm, Nationalmuseum (NM 6350)

PROVENANCE

Possibly executed in 1854 as a study for the group in the Bordeaux painting (cat. 14), then completed and signed in 1855 or 1856 to be sold to the merchant Détrimont (2,000 francs); sold by Détrimont to M. Goldschmidt or Goldsmith (2,500 francs); Adolf Liebermann de Walhendorf collection; sale,

Liebermann de Walhendorf, Paris, Hôtel Drouot, May 8, 1876, lot 24 (withdrawn at 19,300 francs); Fop Smit, Rotterdam; Durand-Ruel c. 1895; Henri Heugel collection; sale, Heugel, Paris, Galerie Georges Petit, May 26, 1905, lot 5, repro.; acquired by M. Bauml (65,000 francs); A. F. Klaveness collection, Oslo, c. 1929; Philip and Grace Sandblom collection, Lund (Sweden); given to the Nationalmuseum, Stockholm, in 1970.

BIBLIOGRAPHY

Journal, pp. 416, 420; Robaut, 1885, no. 1278, repro.; Johnson, 1986, vol. 3, no. 199, pl. 24; Daguerre de Hureaux, 1993, pp. 201, 204, 206, 326, repro.; Daguerre de Hureaux and Guégan, 1994, pp. 42–43; Rautmann, 1997, p. 303, fig. 293; Jobert, 1997, p. 265, fig. 221.

EXHIBITIONS

1963–64, Bern, no. 83; 1981, Stockholm, no. 23, repro.

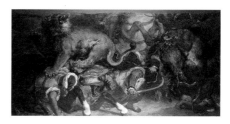

14. *Lion Hunt* (fragment)

1855
Oil on canvas; 68⅛ x 141¾ inches (173 x 360 cm); original size: 102⅜ x 141⅜ inches (260 x 359 cm)
Signed and dated at lower center right: *Eug. Delacroix 1855.*
Bordeaux, Musée des Beaux-Arts (Bx E 469, then Bx M 6994)

PROVENANCE

Commissioned by the French government, March 20, 1854 (12,000 francs); sent by the State to the Musée des Beaux-Arts, Bordeaux, in November 1855; partially destroyed in a fire in the Bordeaux city hall, December 7, 1870.

BIBLIOGRAPHY

Journal, pp. 403, 416, 420, 440, 447, 492, 500, 501; *Correspondance*, vol. 3, pp. 207, 217, 218, 301, and vol. 4, p. 277; Baudelaire, 1855; Petroz, 1855; Lecomte, 1855; Mantz, 1855, pp. 171, 172; Gautier, 1855(a); About, 1855, pp. 179–80; Du Camp, 1855, pp. 94–115; Gebauer, 1855, p. 41; Loudun, 1855, p. 117; Vignon, 1855, p. 205; La Forge, 1856, p. 43; Dubosc de Pesquidoux, 1857, p. 130; Cantaloube, 1864, p. 39; Moreau, 1873, pp. 192, 200; Vallet, 1883, no. 52; Robaut, 1885, no. 1242, repro.; Tourneux, 1886, pp. 94, 98, 135; M. Sérullaz, 1963(a), no. 466, repro.; Johnson, 1986, vol. 3, no. 198, pl. 23; Daguerre de Hureaux, 1993, pp. 199–206, fig. pp. 204, 326; Daguerre de Hureaux and Guégan, 1994, pp. 42–43; Rautmann, 1997, p. 300, fig. 290, p. 301; Jobert, 1997, pp. 264–65, fig. 219.

EXHIBITIONS
1855, Paris, no. 2939; 1857, Bordeaux, no. 154; 1930, Paris, no. 157, repro.; 1933, Paris, no. 197a; 1939, Zurich, no. 363; 1939, Basel, no. 255; 1963(a), Paris, no. 465; 1981, Stockholm, no. 22, repro.

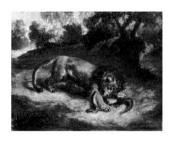

15. *Lion and Caiman* or *Lion Clutching a Lizard* or *Lion Devouring an Alligator*

1855
Oil on mahogany panel; 12⁹⁄₁₆ x 16½ inches (32 x 42 cm)
Signed and dated at lower right:
Eug. Delacroix / 1855.
Paris, Musée du Louvre (RF 1395)

PROVENANCE
Collection of the singer Jean-Baptiste Faure; sale, Faure, Paris, 26, boulevard des Italiens, June 7, 1873, lot. 10, repro. (20,800 francs); baron Arthur Rothschild collection in 1885; Georges-Thomy Thiéry collection, c. January 1889; bequeathed to the Musée du Louvre in 1902.

BIBLIOGRAPHY
Robaut, 1885, no. 1281, repro.; M. Sérullaz, 1963(a), no. 474; Johnson, 1986, vol. 3, no. 200, pl. 26; Daguerre de Hureaux, 1993, p. 329.

EXHIBITIONS
1885, Paris, no. 186 *(Lion maintenant un lézard)*; 1930, Paris, no. 167; 1949, Paris, no. 29, repro.; 1951, Paris, no. 5; 1963(a), Paris, no. 474, repro.; 1967, Paris, no. 7, repro.; 1969, Kyoto and Tokyo, no. H-37, repro.

16. *Lion Devouring a Rabbit*

c. 1851–56
Oil on canvas; 18¼ x 21⅞ inches (46.5 x 55.5 cm)
Signed at lower right: *Eug Delacroix.*
Paris, Musée du Louvre (RF 1394)

PROVENANCE
In the collection of Alfred Arago (son of the physician and astronomer François Arago), c. 1864; Laurent-Richard collection; sale, Laurent-Richard, Paris, Hôtel Drouot, April 7, 1873, perhaps lot 16, repro.; acquired by M. Gauchez for John Wilson (31,050 francs); John Wilson collection; sale, Wilson, Paris, 3, avenue Hoche, April 27, 1874, lot 95, repro.

(32,500 francs); baron Arthur Rothschild collection, c. 1885; Georges-Thomy Thiéry collection, c. January 1889; bequeathed to the Musée du Louvre in 1902.

BIBLIOGRAPHY
Moreau, 1873, p. 281; Robaut, 1885, no. 1229, repro.; Ponsonailhe, 1885, p. 176; Johnson, 1986, vol. 3, no. 203, pl. 26; Daguerre de Hureaux, 1993, pp. 198, 327, fig. p. 199.

EXHIBITIONS
1864, Paris, no. 147; 1885, Paris, no. 185; 1930, Paris, no. 168; 1966, Paris, no. 26, repro.; 1968, Paris; 1974, Paris; 1975, Paris.

17. *Young Woman Attacked by a Tiger* or *Indian Woman Bitten by a Tiger*

1856
Oil on canvas; 20⅛ x 24⅛ inches (51 x 61.3 cm)
Signed and dated at lower center right:
Eug. Delacroix. 1856.
Stuttgart, Staatsgalerie (inv. 2695)

PROVENANCE
Described as in the house of Étienne-François Haro, c. 1864; Georges Petit, c. 1884; noted again at Haro's in 1887; acquired by Bernheim-Jeune, April 15, 1891 (25,000 francs); sold by Bernheim-Jeune to Kuyper, April 1891; Fop Smit, Rotterdam; Durand-Ruel, Paris; sold by Durand-Ruel to Boussod, Valadon and Company, February 9, 1893; resold by Boussod, Valadon and Company to Durand-Ruel, July 13, 1897 (Boussod and Valadin archives, cited by Johnson); Charles T. Yerkes collection, U.S.A., sale Yerkes, New York, April 5, 1910, lot 38, repro.; acquired by Durand-Ruel ($6,300); sold by Durand-Ruel to Bernheim-Jeune, May 6, 1910; sold by Bernheim-Jeune to Mancini, November 25, 1912; Brame, 1963; Nathan Gallery, Zurich, 1964; acquired by the Staatsgalerie, Stuttgart, in 1964.

BIBLIOGRAPHY
Robaut, 1885, no. 1200, repro.; Johnson, 1986, vol. 3, no. 201, pl. 25; Daguerre de Hureaux, 1993, p. 199, fig. pp. 201, 326; Daguerre de Hureaux and Guégan, 1994, pp. 67–68, repro.

EXHIBITIONS
1864, Paris, no. 40 *(Jeune femme emportée par un tigre)*; 1885, Paris, no. 48 *(Indienne mordue par un tigre)*; 1963–64, Bern, no. 84; Bremen, no. 76; 1987(a), Zurich, no. 102, pp. 246, 248, 334, repro.

18. *Lion Playing with a Tortoise*

1857
Brown ink and brown wash over graphite on paper; 7⁹⁄₁₆ x 9⅝ inches (19.2 x 24.2 cm)
Signed at lower right in brown ink:
Eug Delacroix
Dated and annotated at lower left in brown ink: *Augerville 17 oct. 57.*
Rotterdam, Museum Boymans–van Beuningen

PROVENANCE
Given by Delacroix to the violinist Alexandre Batta, according to Robaut (1885, no. 1325).

BIBLIOGRAPHY
Robaut, 1885, no. 1325, repro.

EXHIBITIONS
1885, Paris, no. 313; 1964, Edinburgh and London, no. 182, pl. 98.

19. *Seated Feline Seen from Behind, Licking Its Paw*

c. 1855–63
Brown ink on blue paper; 5³⁄₁₆ x 4 inches (13.1 x 10.2 cm)
Paris, Musée du Louvre, Département des Arts Graphiques (RF 9682)

PROVENANCE
Delacroix Atelier, marked at lower right (Lugt 838a); sold posthumously, Paris, Hôtel Drouot, February 22–27, 1864, undoubtedly part of lot 485 (43 sheets divided into 11 lots, acquired by Messrs. Mouteau, Bordier, Arosa, Tesse, Wyatt, Lecomte, Dieterle, Mène, Piot, Huet, Dumaresq) or lot 487 (79 sheets divided into 6 lots); Étienne Moreau-Nélaton collection; bequeathed to the Musée du Louvre in 1927, marked at lower left (Lugt 1886a).

BIBLIOGRAPHY
Robaut, 1885, part of no. 1844 or 1845; M. Sérullaz, 1984, vol. 1, no. 1073, repro.

EXHIBITION
1982, Paris, part of no. 348.

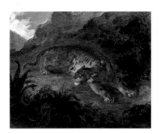

20. Tiger Startled by a Snake

c. 1858
Oil on paper mounted on mahogany panel;
12¾ x 15⅞ inches (32.4 x 40.3 cm)
Signed at lower right: *Eug. Delacroix*
Hamburg, Kunsthalle (inv. 2400)

PROVENANCE
Sale, Paris, Hôtel Drouot, February 3, 1960; acquired by M. Delacour (440 francs); sale, Paris, May 8, 1861, lot 19 (280 francs); Paul Van Cuyck collection; sold after Van Cuyck's death, Paris, Hôtel Drouot, February 7, 1966, lot 8; acquired by Brame (2,750 francs); Herman collection, 1873 (according to Moreau, who confused this work with cat. 134); John Wilson collection, c. 1874; sale, Wilson, Paris, 3, avenue Hoche, March 14, 1881, lot 145; acquired by H. Petit (24,100 francs); E. Secrétan; sale, Secrétan, Paris, Hôtel Drouot, July 1, 1889, lot 17, repro.; acquired by M. Montaignac (37,500 francs); Georges Seney collection, New York; sale, Seney, New York, Mendelssohn Hall, February 11, 1891, lot 235; Georges Petit; sold by Georges Petit to Boussod, Valadon and Company, December 1897; sold by Boussod, Valadon and Company to Theodor Behrens, Hamburg, December 1897; acquired by the Kunsthalle, Hamburg, in 1925.

BIBLIOGRAPHY
Moreau, 1873, p. 278; Robaut, 1885, no. 1354, repro.; Johnson, 1986, vol. 3, no. 196, pl. 20; Daguerre de Hureaux, 1993, p. 326.

EXHIBITIONS
1951, Paris, no. 33, repro.; 1964, Bremen, no. 84; 1987(b), Zurich, no. 100, pp. 242, 334, fig. p. 243.

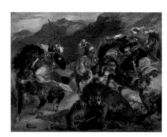

21. Lion Hunt

1858
Oil on canvas; 36⅛ x 46¼ inches
(91.7 x 117.5 cm)
Signed and dated at lower right:
Eug. Delacroix 1858.
Boston, Museum of Fine Arts, S. A. Denio Collection (95-179)

PROVENANCE
Sale, Paris, Hôtel Drouot, March 30, 1863, lot 9; acquired by Durand-Ruel (4,700 francs); Adolph E. Borie collection, Philadelphia, 1867–80; Mrs. Borie collection, Philadelphia, from February 1880 until 1887; Erwin Davis collection, New York; sale, Davis, New York, March 19–20, 1889, lot 143 ($11,800); Durand-Ruel, New York, 1889–95; acquired by the Museum of Fine Arts, Boston, with funds provided by S. A. Denio in 1895 ($21,000).

BIBLIOGRAPHY
Journal, p. 717; Moreau, 1873, p. 280 (confused with cat. 23); Robaut, 1885, no. 1349, repro.; M. Sérullaz, 1963(a), no. 492, repro.; Johnson, 1986, vol. 3, no. 204, pl. 28; Daguerre de Hureaux, 1993, p. 327; Daguerre de Hureaux and Guégan, 1994, pp. 42–43; Jobert, 1997, fig. 223.

EXHIBITIONS
1930, Paris, no. 176A; 1962–63, Toronto and Ottawa, no. 22; 1963(a), Paris, no. 488; 1964, Edinburgh and London, no. 67; 1981, Stockholm, no. 28; 1987(a), Zurich, no. 113, pp. 266, 336, fig. p. 267.

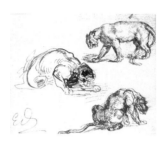

22. Three Studies of Lions

1859
Black ink on paper; 6⅞ x 8¾ inches
(17.5 x 22.2 cm)
Signed at lower left in black ink: *ED*
Dijon, Musée des Beaux-Arts (DG 526)

PROVENANCE
Hippolyte Lebas collection; sale, Lebas, Paris, Hôtel Drouot, December 2, 1867, lot 152 (80 francs); Rapilly collection in 1871; acquired by Pierre Granville in 1961; Kathleen and Pierre Granville collection; given to the Musée des Beaux-Arts, Dijon, in 1969.

BIBLIOGRAPHY
Robaut, 1885, no. 1392, repro.

EXHIBITION
1963, Bordeaux, no. 132, pl. 74.

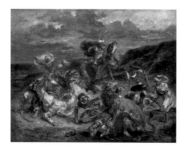

23. Lion Hunt

1861
Oil on canvas; 30⅟₁₆ x 38⅟₁₆ inches
(76.3 x 98.2 cm)
Signed and dated at lower left:
Eug. Delacroix. / 1861.
The Art Institute of Chicago, Potter Palmer Collection (1922.404)

PROVENANCE
Possibly sold c. 1860 by Delacroix to Vaisse for 2,500 francs (according to Johnson); comte d'Aquila collection; sale, comte d'Aquila, Paris, Hôtel Drouot, February 21–22, 1868, lot 7 (14,505 francs); Jean-Baptiste Faure collection, c. 1885; R. Austin Robertson collection, New York; sale, Austin Robertson, New York, April 7, 1892, lot 147, repro.; acquired by Potter Palmer, Chicago ($13,000); Mrs. Berthe Honoré Palmer collection, c. 1918; given to the Art Institute of Chicago in 1922.

BIBLIOGRAPHY
Journal, p. 781; Moreau, 1873, p. 280 (confused with cat. 21); Ponsonailhe, 1885, p. 174; Vachon, 1885, repro.; Robaut, 1885, no. 1350, repro.; Tourneux, 1886, p. 144; M. Sérullaz, 1963(a), no. 524, repro.; Johnson, 1986, vol. 3, no. 205, pl. 29; Daguerre de Hureaux, 1993, p. 206, fig. pp. 203, 329; Daguerre de Hureaux and Guégan, 1994, pp. 42–43; Jobert, 1997, fig. 222.

EXHIBITIONS
1885, Paris, no. 76; 1930, Chicago, no. 43, repro.; 1930, Paris, no. 191, repro.; 1956, Venice, no. 42; 1963(a), Paris, no. 521; 1964, Edinburgh and London, no. 75, repro.; 1981, Stockholm, no. 29, repro.

II. *THE FEELING FOR NATURE*

24. Flower Studies

c. 1845–50
Watercolor over graphite on paper;
12³⁄₁₆ x 8³⁄₁₆ inches (31 x 20.9 cm)
Paris, Musée Eugène Delacroix (M.D.1980.1)

PROVENANCE
Delacroix Atelier, marked at lower right (Lugt 838a); sold posthumously, Paris, Hôtel Drouot, February 22–27, 1864; Mme Hélène Adhémar; given under permanent loan reserve to the Musée Delacroix in 1980; entered the museum in 1982.

BIBLIOGRAPHY
A. Sérullaz, 1996, no. 279, p. 7, fig. 11.

25. Bouquet of Flowers

1848 (?)
Watercolor over graphite on paper;
8⅛ x 10⅜ inches (20.5 x 26.4 cm)
Montpellier, Musée Fabre (876.3.101)

PROVENANCE
Delacroix Atelier, marked at lower left (Lugt 838a);
sold posthumously, Paris, Hôtel Drouot, February
22–27, 1864, part of lot 625; acquired by Constant
Dutilleux (200 francs); Constant Dutilleux collec-
tion; sale, Dutilleux, Paris, Hôtel Drouot, March 26,
1874, lot 19; acquired by Théophile Silvestre for Alfred
Bruyas (400 francs); Alfred Bruyas collection; be-
queathed to the Musée Fabre, Montpellier, in 1876.

BIBLIOGRAPHY
Robaut, 1885, no. 776, repro.; M. Sérullaz, 1963(a),
no. 327, repro.

EXHIBITION
1963(a), Paris, no. 330.

26. Flower Studies: Indian Roses, Marigolds, and Geraniums

1848
Graphite on paper; 10 x 14¹⁵⁄₁₆ inches
(25.5 x 38 cm)
Dated at lower right in pencil: *13 oct.*
[crossed out] *nov 1848*
Annotated overall in pencil: *rose d'inde / rose
d'inde / rose d'inde / souci / souci*
Paris, Prat Collection

PROVENANCE
Delacroix Atelier, marked at lower right (Lugt 838a);
sold posthumously, Paris, Hôtel Drouot, February
22–27, 1864, part of lot 625; Prat collection, Paris,
marked at lower right (not noted by Lugt).

BIBLIOGRAPHY
Johnson, 1995, under no. 10, fig. 15.

27. Flower Studies

c. 1848–49
Pastel on paper; 9⁷⁄₁₆ x 12³⁄₁₆ inches
(24 x 30.9 cm)
Private collection (courtesy of the Galerie
Schmit, Paris)

PROVENANCE
Probably sold by the Delacroix Atelier, Paris, Hôtel
Drouot, February 22–27, 1864, part of lot 621; ac-
quired by Alfred Stevens; Alfred Stevens collection,
Brussels; collection of Pierre Stevens, his son (see an-
notations on verso, in pen, in Pierre Stevens's hand);
David David-Weill collection; private collection.

BIBLIOGRAPHY
Robaut, 1885, part of no. 1830; Johnson, 1995, no. 46,
repro.

EXHIBITION
1936, Brussels, no. 102.

28. Foliage and Arch with Morning Glories

c. 1848–49
Pastel on gray paper; 12¹⁄₁₆ x 18 inches
(30.6 x 45.7 cm)
New York, The Metropolitan Museum of Art,
Bequest of Miss Adelaide Milton de Groot
(67.187.4)

PROVENANCE
Delacroix Atelier; sold posthumously, Paris, Hôtel
Drouot, February 22–27, 1864, lot 616; acquired by
Casavy (210 francs); Charles Paravey collection; sale,
Paravey, April 13, 1878; Wildenstein, New York,
1952; Miss Adelaide Milton de Groot collection; be-
queathed to the Metropolitan Museum of Art, New
York, in 1967.

BIBLIOGRAPHY
Robaut, 1885, part of no. 1073, repro.; Johnson, 1986,
vol. 3, under no. 502, repro. fig. 57; Johnson, 1995,
no. 10, repro.; Rautmann, 1997, p. 290, fig. 278.

EXHIBITIONS
1952, London, no. 67; 1991, New York, no. 17, repro.

29. A Basket of Flowers Overturned in a Park

c. 1848–49
Oil on canvas; 42¼ x 56 inches
(107.3 x 142.2 cm)
New York, The Metropolitan Museum of Art,
Bequest of Miss Adelaide Milton de Groot
(67.187.60)

PROVENANCE
Delacroix Atelier; sold posthumously, Paris, Hôtel
Drouot, February 17–19, 1864, lot 88; acquired by
M. Sourigues (7,250 francs); Sourigues collection;
sale, Sourigues, Paris, Galerie Georges Petit,
February 28, 1881, lot 14; acquired by Durand-Ruel
(10,300 francs); Vice-Admiral Bosse collection, 1885;
Albert Gallatin collection, New York, in 1936;
Wildenstein, New York, 1944–56; Miss Adelaide
Milton de Groot, New York, 1956; bequeathed to the
Metropolitan Museum of Art, New York, in 1967.

BIBLIOGRAPHY
Cailleux, 1849; Peisse, 1849; Champfleury, 1849,
p. 167; Desnoyers, 1849; Gautier, 1849; anonymous,
1849; Haussard, 1849; Thierry, 1849; Du Camp, 1855,
pp. 9, 112; Cantaloube, 1864, p. 39; Moreau, 1873,
pp. 184, 192, 314; Robaut, 1885, no. 1072, repro.;
Johnson, 1986, vol. 3, no. 502; Daguerre de Hureaux,
1993, pp. 303, 322; Johnson, 1995, p. 48, repro. (for
the pastel); Rautmann, 1997, p. 290, fig. 280; Jobert,
1997, fig. 215.

EXHIBITIONS
1849, Paris, no. 504 (*Fleurs*); 1854, Bordeaux, no. 157
(*Fleurs*); 1855, Paris, no. 2941 (*Fleurs*, two paintings
under the same number); 1864, Paris, no. 308; 1885,
Paris, no. 239b; 1944, New York, no. 28, repro.; 1952,
London, no. 31, repro.; 1964, Edinburgh and
London, no. 50, repro.

30. Still Life with Flowers and Fruit

c. 1848–49
Oil on canvas; 42⅝ x 56⅜ inches
(108.4 x 143.3 cm)
Philadelphia Museum of Art, John G. Johnson
Collection (cat. 974)

PROVENANCE
Delacroix Atelier, wax seal on verso; sold posthu-
mously, Paris, Hôtel Drouot, February 17–19, 1864,
lot 90 (*Corbeille posée dans un jardin, contenant des*

raisins, des pêches, etc.); acquired by Achille Piron (7,000 francs); Achille Piron collection; sold posthumously, Paris, Febvre, April 21, 1865, lot 2 (3,000 francs); Durand-Ruel in 1873; Fanien collection, 1873–78; Georges Petit, 1884; Durand-Ruel, and then sold directly to the American collector John G. Johnson, as shown by a letter from Durand-Ruel to Johnson, November 1888; John G. Johnson collection, Philadelphia, possibly from 1889, but certainly in 1892 (catalogued in the Johnson collection list as no. 82); bequeathed to the City of Philadelphia in 1917, at the Philadelphia Museum of Art since 1933.

BIBLIOGRAPHY
Journal, p. 178; Cailleux, 1849; Peisse, 1849; Champfleury, 1849, p. 167; Desnoyers, 1849; Gautier, 1849; anonymous, 1849; Haussard, 1849; Du Pays, 1849; Thiérry, 1849; Du Camp, 1855, pp. 9, 112; Cantaloube, 1864, p. 39; Moreau, 1873, pp. 184, 192, 314; Robaut, 1885, no. 1041, repro.; Johnson, 1986, vol. 3, no. 502; Daguerre de Hureaux, 1993, pp. 303, 322.

EXHIBITIONS
1849, Paris, no. 505 *(Fleurs et fruits);* 1854, Bordeaux, no. 158 *(Fruits);* 1855, Paris, no. 2942 *(Fleurs et fruits);* 1885, Paris, no. 234; 1944, New York, no. 25.

31. *A Vase of Flowers on a Console*

1849–50
Oil on canvas; 53⁷⁄₁₆ x 40⁷⁄₁₆ inches
(135 x 102 cm)
Montauban, Musée Ingres (M.N.R. 162; D.51.3.2)

PROVENANCE
Delacroix Atelier until his death; bequeathed by the artist to Eugène François Charles Legrand, solicitor, perhaps after having been withdrawn from the sale after the painter's death (Paris, Hôtel Drouot, February 17–19, 1864) by Achille Piron, to be given to Legrand (see Geneviève Lacambre in Musée d'Orsay, Paris, *Les Oubliés du Caire* [Paris: Réunion des Musées Nationaux, 1994], no. 15, p. 52); Eugène François Charles Legrand collection, Paris; collection of Legrand's widow in 1885; sale, Paris, Hôtel Drouot, June 24, 1942, lot 28, repro.; sold to Martin Fabiani, Paris, by the Kaiser Wilhelm Museum of Krefeld (2,200,000 francs, inv. no. 295; archives of the Ministry of Foreign Affairs, C 430 P84); assigned to the Musée du Louvre by the Office des Biens Privés in 1950; transferred from the Musée du Louvre to the Musée Ingres, Montauban, April 10, 1952.

BIBLIOGRAPHY
Journal, pp. 184, 185, 277; *Correspondance,* vol. 2, pp. 372–73, 375; Du Camp, 1855, p. 112; Burty, 1878, p. ix; Robaut, 1885, no. 1069, repro.; Johnson, 1986,

vol. 3, no. 503, pl. 300; Daguerre de Hureaux, 1993, p. 322; Rautmann, 1997, p. 196, fig. 182, p. 197; Jobert, 1997, fig. 213.

32. *Bouquet of Flowers in a Vase* or *Two Vases of Flowers*

c. 1848–49
Oil on cardboard; 17¾ x 23³⁄₁₆ inches
(45 x 59 cm)
Bremen, Kunsthalle (796-1959/15)

PROVENANCE
Delacroix Atelier; bequeathed by him to his friend baron Charles Rivet; baron Charles Rivet collection, 1864–72; comtesse de Lenclos collection, inherited from baron Rivet in 1952; Jacques Dubourg, 1951 or 1952; Wildenstein, July 1952; Marianne Feilchenfeldt, Zurich; acquired by the Kunsthalle, Bremen, in 1959.

BIBLIOGRAPHY
Burty, 1878, p. v (attested to August 3, 1863); Robaut 1885, no. 1012, repro. *(Deux vases de fleurs);* M. Sérullaz, 1963(a), no. 403, repro.; Johnson, 1986, vol. 3, no. 499, pl. 296; Daguerre de Hureaux, 1993, p. 322; Rautmann, 1997, p. 290, fig. 279.

EXHIBITIONS
1864, Paris, no. 107; 1885, Paris; 1952, London, no. 32; 1963(a), Paris, no. 403; 1963–64, Bern, no. 64; 1964, Bremen, no. 60, repro.

33. *Bouquet of Flowers*

1849
Watercolor, gouache, and pastel highlights over graphite sketch on gray paper;
25⁹⁄₁₆ x 25¾ inches (65 x 65.4 cm)
(on two sheets of different sizes)
Paris, Musée du Louvre, Département des Arts Graphiques (RF 31 719)

PROVENANCE
Delacroix Atelier; sold posthumously, Paris, Hôtel Drouot, February 22–27, 1864; acquired by Achille Piron (2,000 francs); Achille Piron collection; sold posthumously, Paris, Febvre, April 21, 1865; acquired by Victor Chocquet (300 francs); Victor Chocquet collection; sale, Mme Chocquet, Paris, July 1–4, 1899, lot 111; acquired by Ambroise Vollard; Paul

Cézanne collection, as part of an exchange agreed to by the artist with Ambroise Vollard; César Mange de Haucke collection; bequeathed to the Musée du Louvre in 1965; transferred from the Musée du Louvre to the Musée Delacroix in 1970.

BIBLIOGRAPHY
Burty, 1878, p. viii (attested to August 3, 1863); Robaut, 1885, no. 1042, repro.; M. Sérullaz, 1984, vol. 1, no. 1233, repro.

EXHIBITIONS
1964, Edinburgh and London, no. 165; 1982, Paris, no. 298.

34. *Flower Bed with Hydrangeas, Scillas, and Anemones*

1849 (?)
Watercolor over graphite on paper;
7⅜ x 11⅝ inches (18.7 x 29.6 cm)
Annotated at lower center in pencil: *feuille d'hortensia jaune / les autres sur le devant plus foncé*
Paris, Musée du Louvre, Département des Arts Graphiques (RF 4508)

PROVENANCE
Delacroix Atelier, marked at lower right (Lugt 838a); sold posthumously, Paris, Hôtel Drouot, February 22–27, 1864, part of lot 625 (77 sheets); Victor Chocquet collection; sale, Mme Chocquet, Paris, July 1–4, 1899, lot 119; Edgar Degas collection; sale, Paris, March 26–27, 1918, lot 116; acquired by the Musée du Louvre, marked at lower left (Lugt 1886a).

BIBLIOGRAPHY
M. Sérullaz, 1984, vol. 1, no. 1232, repro.

EXHIBITIONS
1930, Paris, no. 717; 1932, Paris, no. 50; 1934, Paris, no. 35; 1937, Paris, no. 2; 1956, Venice, no. 58; 1963(b), Paris, no. 82, pl. XVI; 1963–64, Bern, no. 216, fig. 26; 1964, Bremen, no. 238, fig. 120; 1969, Kyoto and Tokyo, no. A-10, repro.; 1982, Paris, no. 296.

35. *White Daisies and Zinnias*

1849 or 1855 (?)
Watercolor and gouache over graphite on gray
paper; 9⅞ x 7⅞ inches (25 x 20 cm)
Paris, Musée du Louvre, Département des Arts
Graphiques (RF 3440)

PROVENANCE
Delacroix Atelier, marked at lower right (Lugt 838a);
sold posthumously, Paris, Hôtel Drouot, February
22–27, 1864, part of lot 625; acquired by the Society
of the Friends of the Louvre and given to the mu-
seum in 1907, marked at lower left (Lugt 1886a).

BIBLIOGRAPHY
Robaut, 1885, part of no. 1825; M. Sérullaz, 1984, vol.
I, no. 1231, repro.

EXHIBITIONS
1934, Paris; 1936, Brussels, no. 149; 1939, Zurich, no.
265; 1939, Basel, no. 191; 1963(b), Paris, no. 83.

36. *Flower Studies with a Branch of Fuchsia*

1855
Graphite and watercolor on paper;
5⅞ x 7¾ inches (15 x 19.6 cm)
Annotated at upper right in pencil: *boutons*
On the verso: studies of flowers and foliage in
graphite and watercolor
Paris, Musée du Louvre, Département des Arts
Graphiques (RF 9803)

PROVENANCE
Delacroix Atelier, marked at lower center (Lugt
838a); sold posthumously, Paris, Hôtel Drouot,
February 22–27, 1864, part of lot 625 (77 sheets);
Étienne Moreau-Nélaton collection; bequeathed to
the Musée du Louvre in 1927, marked at lower right
(Lugt 1886a).

BIBLIOGRAPHY
M. Sérullaz, 1984, vol. I, no. 1236, repro.

EXHIBITIONS
1952, Paris, no. 32; 1963(b), Paris, no. 67.

37. *A Garden Path at Augerville*

c. 1855
Pastel on paper; 11¹³⁄₁₆ x 16½ inches (30 x 42 cm)
Private collection, England

PROVENANCE
Bequeathed by Delacroix in 1863 to Ferdinand
Leroy, director of the Caisse des Travaux of Paris,
the drawing does, however, carry the seal of the
Delacroix Atelier at lower right (Lugt 838a); as sug-
gested by Johnson, it is probable that at the artist's
death, F. Leroy made his choice from among the
pastels that already had been marked for sale; private
collection, England.

BIBLIOGRAPHY
Johnson, 1995, no. 50, repro.

EXHIBITION
1964, Edinburgh and London, no. 176.

38. *Forest Scene Near Sénart*

c. 1850
Oil on canvas; 12¹¹⁄₁₆ x 18⅛ inches (32.2 x 46 cm)
Private collection (courtesy of the Nathan
Gallery, Zurich)

PROVENANCE
Delacroix Atelier, wax seal on verso; sold posthu-
mously, Paris, Hôtel Drouot, February 17–19, 1864,
part of lot 219 (grouped as *Quinze études diverses de
paysages*); acquired by M. Aubry (180 francs); Aubry
collection, Paris; Vuillier, May 1898; sold by Vuillier
directly to Louis de Launay (according to Johnson);
Louis de Launay collection from 1898; collection of
the descendants of Louis de Launay in 1986; private
collection.

BIBLIOGRAPHY
Johnson, 1986, vol. 3, no. 482a, pl. 280; Daguerre de
Hureaux, 1993, p. 323.

39. *Patch of Forest with an Oak Tree*

c. 1853
Watercolor over graphite on paper;
12⁵⁄₁₆ x 8⅞ inches (31.5 x 22.5 cm)
New York, The Pierpont Morgan Library,
Thaw Collection

PROVENANCE
Delacroix Atelier, marked at lower left (Lugt 838a);
sold posthumously, Paris, Hôtel Drouot, February
22–27, 1864; Alfred Beurdeley collection (mark of
the Beurdeley collection and sale at lower left, Lugt
421); ninth Alfred Beurdeley sale, Paris, Galerie
Georges Petit, December 1–2, 1920, lot 121; Boutet
collection; Roulier collection; Brame and Lorenceau,
1990; Mr. and Mrs. Eugene Victor Thaw collection,
New York; The Pierpont Morgan Library, Thaw col-
lection, New York.

EXHIBITION
1991, New York, no. 68, repro.

40. *Autumn Landscape, Champrosay*

1853–56
Oil on canvas; 10¹³⁄₁₆ x 15¹⁵⁄₁₆ inches
(27.5 x 40.5 cm)
Private collection

PROVENANCE
Delacroix Atelier, wax seal on verso; sold posthu-
mously, Paris, Hôtel Drouot, February 17–19, 1864,
perhaps lot 217, 218 (after M. Sérullaz), or 219 (after
Johnson, who believes that this study is part of a lot
entitled *Quinze études diverses de paysages*); according
to Robaut, possibly bought by the painter Frédéric
Bazille at the sale after Delacroix's death; Frédéric
Bazille collection, Montpellier and Paris; collection
of Pierre Leenhardt, son-in-law of Bazille, April 1897;
sale, Leenhardt, Paris, May 4, 1922, lot 20, repro.
(8,225 francs; *Vue prise aux environs de Champrosay.
Paysage d'automne, le soir*); sale, Paris, Hôtel Drouot,
May 6, 1925, lot 93 (10,200 francs); Georges Aubry
collection, 1930; sale, Aubry, Paris, Hôtel Drouot,
March 11, 1933, lot 81, repro.; David David-Weill col-
lection, Paris; collection of David-Weill's widow,
1963; private collection.

BIBLIOGRAPHY
Journal, pp. 368–69, 573; Robaut, 1885, no. 1801, 1802, or 1803, repro.; M. Sérullaz, 1963(a), no. 445, repro.; Johnson, 1986, vol. 3, no. 483, pl. 283.

EXHIBITIONS
1930, Paris, no. 213; 1954, Paris, no. 72; 1963(a), Paris, no. 479.

41. *Panoramic View of the Vallée de la Tourmente*

1855
Watercolor on paper; 8¼ x 10⅜ inches
(21 x 26.3 cm)
Paris, Musée du Louvre, Département des Arts
Graphiques (RF 9448)

PROVENANCE
Delacroix Atelier, marked at lower left (Lugt 838a);
sold posthumously, Paris, Hôtel Drouot, February
22–27, 1864; Étienne Moreau-Nélaton collection;
bequeathed to the Musée du Louvre in 1927, marked
at lower right (Lugt 1886a).

BIBLIOGRAPHY
M. Sérullaz, 1984, vol. 1, no. 1141, repro.

EXHIBITIONS
1930, Paris, no. 695; 1935, Paris, no. 12; 1948, Paris,
no. 29; 1969, Paris.

42. *Landscape Near Ante*

1856
Oil on canvas; 10¹³⁄₁₆ x 23⁷⁄₁₆ inches (27.5 x 59.5 cm)
Private collection (courtesy of the Galerie
Schmit, Paris)

PROVENANCE
Delacroix Atelier, wax seal on verso; sold posthu-
mously, Paris, Hôtel Drouot, February 17–19, 1864,
lot 219 (after Johnson) or 221 (after M. Sérullaz); sale,
Paris, Hôtel Drouot, February 24, 1936, lot 69,
repro.; David David-Weill collection, Paris; collec-
tion of David-Weill's widow, 1963; private collection.

BIBLIOGRAPHY
Journal, pp. 593, 594; Robaut, 1885, no. 1803 or 1805;
M. Sérullaz, 1963(a), no. 484, repro.; Johnson, 1986,
vol. 3, no. 485, pl. 285.

EXHIBITION
1963(a), Paris, no. 480.

43. *Trees in a Park*

1856 (?)
Pastel on gray paper; 10¼ x 14⅜ inches
(26 x 36.5 cm)
Private collection (former collection of David
David-Weill)

PROVENANCE
Delacroix Atelier, red wax seal on verso; sold posthu-
mously, Paris, Hôtel Drouot, February 22–27, 1864,
perhaps part of lot 606 (8 pastels acquired by Messrs.
Petit, Fontaine, Zambaco, Meurice); David David-
Weill collection; private collection.

BIBLIOGRAPHY
Robaut, 1885, perhaps part of no. 1815; Johnson, 1995,
p. 177, no. XXV (as location unknown).

EXHIBITION
1930, Paris, no. 684a.

**44. *Landscape at Champrosay* or
*George Sand's Garden at Nohant***

1858
Graphite on paper; 10¼ x 15⅞ inches
(26.1 x 40.3 cm)
Dated at lower right in pencil:
14 mai Samedi 1858
Amsterdam, Rijksmuseum (RP-T-1956-38)

PROVENANCE
Delacroix Atelier, marked at lower right (Lugt 838a);
sold posthumously, Paris, Hôtel Drouot, February
22–27, 1864, part of lot 603 (46 sheets divided into
several lots acquired by Messrs. Wyat, Baÿvet, C.
Dutilleux, Boissier, Robaut, Meunier) or lot 604 (36
sheets divided into several lots and acquired by
Messrs. Bornot, Cadart, Stevens, Rivet, Lambert,
Robaut); Wertheimer; acquired by the
Rijksmuseum, Amsterdam, in 1956.

45. *Landscape Near Cany*

1849
Watercolor over graphite on paper;
4⅝ x 4⅝ inches (11.8 x 11.8 cm)
Dated and annotated at lower right in pencil:
10 oct. / Cany
Annotated overall in pencil: *ciel à travers les ar-
bres / croissant d'érable* [?] */ ocr[e] oc[re] / bl[anc]
/ v[ert] / v[ert]*
On the verso: sketch of rigging in graphite
Paris, Musée du Louvre, Département des Arts
Graphiques (RF 9790)

PROVENANCE
Alfred Robaut collection, code and annotations on
the verso, on the doubled sheet; Étienne Moreau-
Nélaton collection; bequeathed to the Musée du
Louvre in 1927, marked at lower right (Lugt 1886a).

BIBLIOGRAPHY
M. Sérullaz, 1984, vol. 1, no. 1163, repro.

EXHIBITIONS
1930, Paris, no. 658; 1935, Paris, no. 17; 1963(b), Paris,
no. 80; 1982, Paris, no. 317; 1993–94, Paris, no. 87,
p. 54, repro.

46. *Landscape at Les Petites-Dalles*

1849
Watercolor over graphite on paper;
4⅝ x 13½ inches (11.8 x 34.3 cm)
Dated and annotated at lower left in pencil:
petites dalles 14 8.
Annotated overall in pencil: *vert / vert jaune
herbes / id brun / mont à travers les arbres*
On the verso: landscape in graphite and
splashes of watercolor; dated at lower right in
pencil: *14.8*
Paris, Musée du Louvre, Département des Arts
Graphiques (RF 9426)

PROVENANCE
Alfred Robaut collection, code on verso; Étienne
Moreau-Nélaton collection; bequeathed to the
Musée du Louvre in 1927, marked at lower right
(Lugt 1886a).

BIBLIOGRAPHY
M. Sérullaz, 1984, vol. 1, no. 1161, repro.

EXHIBITIONS
1930, Paris, no. 659; 1963(b), Paris, no. 81; 1982,
Paris, no. 314; 1993–94, Paris, no. 88, p. 54, repro.

47. *Cliffs in Normandy*

1849 (?)
Watercolor over graphite on paper;
6⅞ x 9 inches (17.4 x 22.9 cm)
Annotated at upper right in pencil by Alfred
Robaut: *J*
Paris, Musée du Louvre, Département des Arts
Graphiques (RF 35 828)

PROVENANCE
Delacroix Atelier, marked at lower left (Lugt 838a);
sold posthumously, Paris, Hôtel Drouot, February
22–27, 1864, part of lot 595 (21 sheets divided into 10
lots acquired by Messrs. Piron, Cadart, Robaut,
Tesse, Bornot, Legrand); Alfred Robaut collection;
Henri Rouart collection; sale, Rouart, Paris,
December 16–18, 1912, lot 83; Claude Roger-Marx
collection; given to the Musée du Louvre in 1974,
marked at lower right (Lugt 1886a).

BIBLIOGRAPHY
Robaut, 1885, part of no. 1807; M. Sérullaz, 1963(a),
no. 406, repro.; M. Sérullaz, 1984, vol. 1, no. 1160,
repro.

EXHIBITIONS
1930, Paris, no. 693; 1937, Paris, no. 80; 1939, Zurich,
no. 202; 1952, London, no. 61; 1963(a), Paris, no. 215;
1982, Paris, no. 315; 1993–94, Paris, no. 77, p. 77,
repro.

48. *Cliffs of Étretat*

1849 (?)
Watercolor over graphite on paper;
5⅞ x 7¹³⁄₁₆ inches (15 x 19.9 cm)
Montpellier, Musée Fabre (876.3.102)

PROVENANCE
Delacroix Atelier, marked at lower right (Lugt 838a);
sold posthumously, Paris, Hôtel Drouot, February
22–27, 1864, part of lot 595 (21 sheets divided into 10
lots acquired by Messrs. Piron, Cadart, Robaut,
Tesse, Bornot, Legrand); acquired by Alfred Robaut
(310 francs); Constant Dutilleux collection; sale,
Dutilleux, Paris, March 26, 1874, lot 18, repro.; ac-
quired by Théophile Silvestre for Alfred Bruyas (500
francs); Alfred Bruyas collection; bequeathed to the
Musée Fabre, Montpellier, in 1876.

BIBLIOGRAPHY
Robaut, 1885, no. 1031, repro.; M. Sérullaz, 1963(a),
no. 405, repro.

EXHIBITIONS
1963(a), Paris, no. 396; 1993–94, Paris, no. 69, repro.

49. *Cliffs of Étretat*

1849 (?)
Watercolor with gouache highlights on paper;
5¹¹⁄₁₆ x 9⅜ inches (14.5 x 23.8 cm)
Rotterdam, Museum Boymans–van Beuningen
(F 11 163)

PROVENANCE
Delacroix Atelier, marked at lower left (Lugt 838a);
sold posthumously, Paris, Hôtel Drouot, February
22–27, 1864, part of lot 595 (21 sheets divided into 10
lots acquired by Messrs. Piron, Cadart, Robaut,
Tesse, Bornot, Legrand); Pierre Geismar collection,
marked at lower right (Lugt 2078b); F. Koenigs col-
lection; D. G. van Beuningen collection; given to the
Museum Boymans, Rotterdam, in 1940.

BIBLIOGRAPHY
Robaut, 1885, part of no. 1807; M. Sérullaz, 1963(a),
no. 407, repro.

EXHIBITION
1963(a), Paris, no. 216.

50. *Boats Aground on a Riverbank*

1852
Watercolor over graphite on paper;
4⅝ x 7¹¹⁄₁₆ inches (11.8 x 19.6 cm)
Dated at lower right in pencil: *6 7ᵇ lundi*
Annotated overall in pencil: *galet / sable / talus /*
sable / lac / jaune g. de Suède
New York, The Pierpont Morgan Library,
Bequest of John S. Thacher (1985.35)

PROVENANCE
John S. Thacher collection; bequeathed to the
Pierpont Morgan Library, New York, in 1985.

EXHIBITION
1991, New York, no. 70, repro.

51. *View of the Duquesne Quay at Dieppe*

1854
Graphite on paper; 6⅞ x 13⁷⁄₁₆ inches
(17.5 x 34.2 cm)
Dated and annotated at the lower right in
pencil: *du quai Duquesne 2 7ᵇʳᵉ. 54.*
Paris, Musée du Louvre, Département des Arts
Graphiques (RF 3710)

PROVENANCE
Delacroix Atelier, marked twice at lower left (Lugt
838a); sold posthumously, Paris, Hôtel Drouot,
February 22–27, 1864, part of lot 600 (following
Robaut; the sale catalogue lists 20 watercolors that were
divided into 11 lots acquired by Messrs. Richy, Stevens,
Dehau, Robaut, Ladame, Boissier, Andrieu . . .);
Alfred Robaut collection; sale, Robaut, Paris,
December 18, 1907, lot 67; acquired by the Musée du
Louvre (360 francs), marked at lower right (Lugt
1886a).

BIBLIOGRAPHY
Robaut, 1885, no. 1268, repro.; M. Sérullaz, 1984, vol.
1, no. 1174, repro.

EXHIBITIONS
1930, Paris, no. 660, repro.; 1937, Paris, no. 13; 1963,
Bordeaux, no. 127; 1964, Edinburgh and London,
no. 179; 1969, Kyoto and Tokyo, no. D-31, repro.;
1982, Paris, no. 318; 1993–94, Paris, no. 56, repro.

52. *View of the Port of Dieppe*

1854
Watercolor and gouache over graphite on
paper; 9⅓ x 12⅓ inches (23.7 x 31.3 cm)
Dated and annotated at the lower right with
brush: *7 7ᵇʳ. jeudi / Chanteurs.*
New York, The Pierpont Morgan Library,
Bequest of John S. Thacher (1985.44)

PROVENANCE
Delacroix Atelier, marked at lower right (Lugt 838a);
sold posthumously, Paris, Hôtel Drouot, February
22–27, 1864, part of lot 600 (20 watercolors divided
into 11 lots acquired by Messrs. Richy, Stevens,
Dehau, Robaut, Ladame, Boissier, Andrieu . . .); M.
Y_____ collection; sale, Paris, Palais Galliera, June 29,
1962, lot 5, repro. (*Les Chartreux à Marseille*); John S.
Thacher collection; bequeathed to the Pierpont
Morgan Library, New York, in 1985.

EXHIBITION
1991, New York, no. 71, repro.

53. *The Sea at Dieppe*

1852
Oil on wood; 13¾ x 20ⁱ⁄₁₆ inches (35 x 51 cm)
Paris, Musée du Louvre (RF 1979-46)

PROVENANCE
Delacroix Atelier, red wax seal on verso; sold posthumously, Paris, Hôtel Drouot, February 17–19, 1864, lot 98; acquired by comte Duchâtel (3,650 francs); Duchâtel collection; Alfred Beurdeley collection; first Beurdeley sale, Paris, May 6–7, 1920, lot 35, repro.; collection of Marcel Beurdeley, his son; bequeathed to the Musée du Louvre in 1979.

BIBLIOGRAPHY
Journal, p. 308; Robaut, 1885, no. 1245, repro.; M. Sérullaz, 1963(a), no. 453, repro.; Johnson, 1986, vol. 3, no. 489, pl. 288.

EXHIBITIONS
1864, Paris, no. 49; 1885, Paris, no. 70; 1930, Paris, no. 162B; 1963(a), Paris, no. 457; 1970, Paris; 1993–94, Paris, no. 55, p. 40, repro.

54. *The Sea at Dieppe*

1854 (?)
Watercolor with gouache highlights on paper;
9¹⁄₁₆ x 12 inches (23 x 30.5 cm)
Private collection (courtesy of the Nathan Gallery, Zurich)

PROVENANCE
Delacroix Atelier, marked at lower right (Lugt 838a); sold posthumously, Paris, Hôtel Drouot, February 22–27, 1864, part of lot 600 (20 watercolors divided into 11 lots acquired by Messrs. Richy, Stevens, Dehau, Robaut, Ladame, Boissier, Andrieu . . .); Louis A. Shaw collection, Boston; Eugene V. Thaw collection, New York; Dr. Peter Nathan collection, Zurich; private collection.

BIBLIOGRAPHY
Robaut, 1885, part of no. 1775; M. Sérullaz, 1963(a), no. 454, repro.

EXHIBITIONS
1963(a), Paris, no. 448; 1963–64, Bern, no. 203; 1964, Bremen, no. 307; 1986, Tübingen and Brussels, no. 138, repro.; 1987–88, Frankfurt, no. J-6, repro.

55. *Sunset on the Sea*

1854 (?)
Watercolor over graphite on paper;
9 x 13¹¹⁄₁₆ inches (22.8 x 35.4 cm)
Annotated at lower right in pencil: *sur la pointe des vagues verticalement sous le soleil, paillettes / lumineuses dans un espace très circonscrit*
Vienna, Graphische Sammlung Albertina
(24 099)

PROVENANCE
Delacroix Atelier, marked at lower right (Lugt 838a); sold posthumously, Paris, Hôtel Drouot, February 22–27, 1864, part of lot 600 (20 watercolors divided into 11 lots acquired by Messrs. Richy, Stevens, Dehau, Robaut, Ladame, Boissier, Andrieu . . .); entered the collection of the Albertina, Vienna, in 1924.

BIBLIOGRAPHY
Stuffmann, 1987–88, under no. J-6 and fig. J-5a.

EXHIBITION
1964, Bremen, no. 306, fig. 133.

56. *Sunset on the Sea*

1854 (?)
Watercolor on paper; 10¹⁄₁₆ x 13⁷⁄₁₆ inches
(25.5 x 34.5 cm)
Private collection (courtesy of the Galerie Schmit, Paris)

PROVENANCE
Delacroix Atelier, marked at lower right (Lugt 838a); sold posthumously, Paris, Hôtel Drouot, February 22–27, 1864, part of lot 600 (20 watercolors divided into 11 lots acquired by Messrs. Richy, Stevens, Dehau, Robaut, Ladame, Boissier, Andrieu . . .); Léon Riesener collection, stamped at lower right (Lugt 2139); sale, Riesener, Paris, Hôtel Drouot, April 10–11, 1879, part of lot 244; E. Joseph Rignault collection, stamped at lower left (Lugt 2218); Georges Aubry collection; David David-Weill collection; Mme David-Weill collection; private collection.

BIBLIOGRAPHY
Robaut, 1885, part of no. 1775; M. Sérullaz, 1963(a), no. 455, repro.; M. Sérullaz, 1984, p. 12, fig. 3.

EXHIBITIONS
1930, Paris, no. 708; 1963(a), Paris, no. 449; 1987(b), Zurich, no. 79, repro.; 1987–88, Frankfurt, no. 55, repro.; 1993–94, Paris, no. 66, p. 44, repro.

57. *Seascape*

1854 (?)
Watercolor on paper; 11 x 17¹⁵⁄₁₆ inches
(28 x 45.6 cm)
Annotated along the right border in pencil:
presque toujours brume grisatre violete [*sic*] */ à l'horizon entre le ton de la mer / et le bleu du ciel / par le beau temps / les montagnes / violatres / le ton de la mer / paraissant d'un vert / charmant mais / melé de vert* ["de vert" crossed out] *d'arc en ciel / où le vert domine*
Private collection

PROVENANCE
Delacroix Atelier, marked at lower right (Lugt 838a); sold posthumously, Paris, Hôtel Drouot, February 22–27, 1864, part of lot 600 (20 watercolors divided into 11 lots acquired by Messrs. Richy, Stevens, Dehau, Robaut, Ladame, Boissier, Andrieu . . .); private collection.

BIBLIOGRAPHY
Robaut, 1885, part of no. 1775.

EXHIBITION
1991, New York, no. 69, repro.

58. *Study of the Sky at Sunset*

c. 1849
Pastel on paper; 7½ x 9⁷⁄₁₆ inches (19 x 24 cm)
Frankfurt, Städelsches Kunstmuseum (16728)

PROVENANCE
Delacroix Atelier; sold posthumously, Paris, Hôtel Drouot, February 22–27, 1864, lot not identified; Alfred Robaut collection, Paris; Raymond Koechlin collection, Paris; Mme Heim-Gairac collection, 1988; acquired by the Städelsches Kunstmuseum, Frankfurt.

BIBLIOGRAPHY
Robaut, 1885, no. 1085; Johnson, 1995, no. 41, repro.

EXHIBITIONS
1885, Paris, no. 373; 1987–88, Frankfurt, no. J-4.

59. *Study of the Sky at Sunset*

c. 1849
Pastel on gray paper; 7½ x 9⁷⁄₁₆ inches
(19 x 24 cm)
Paris, Musée du Louvre, Département des Arts
Graphiques (RF 3706)

PROVENANCE
Delacroix Atelier; sold posthumously, Paris, Hôtel
Drouot, February 22–27, 1864, part of lot 610, 611,
or 613; Alfred Robaut collection, Paris; sale, Robaut,
Paris, Durand-Ruel, December 18, 1907, lot 68; ac-
quired by the Musée du Louvre, marked at lower
right (Lugt 1886a).

BIBLIOGRAPHY
Robaut, 1885, no. 1085, repro.; M. Sérullaz, 1984, vol.
1, no. 1215, repro.; Johnson, 1995, no. 42, repro.;
Rautmann, 1997, fig. 317.

EXHIBITIONS
1885, Paris, no. 373; 1930, Paris, no. 702; 1963(b),
Paris, no. 86, pl. XVII.

60. *Vast Plain Against the Sky at Sunset*

c. 1849
Pastel on paper; 7½ x 9⁷⁄₁₆ inches (19 x 24 cm)
Paris, Musée du Louvre, Département des Arts
Graphiques (RF 3770)

PROVENANCE
Delacroix Atelier; sold posthumously, Paris, Hôtel
Drouot, February 22–27, 1864, perhaps part of lot
664; perhaps Alfred Robaut collection, Paris; perhaps
Paul Arthur Chéramy collection, Paris; Étienne
Moreau-Nélaton collection, Paris; bequeathed to the
Musée du Louvre in 1927, marked at lower right
(Lugt 1886a).

BIBLIOGRAPHY
M. Sérullaz, 1984, vol. 1, no. 1217, repro.; Johnson,
1995, no. 43, repro.

EXHIBITIONS
1930, Paris, no. 700; 1935, Paris, no. 15; 1966, Paris,
no. 29; 1982, Paris, no. 329.

61. *Study of the Sky at Dusk*

c. 1849
Pastel on gray paper; 7½ x 9⁷⁄₁₆ inches
(19 x 24 cm)
Paris, Musée du Louvre, Département des Arts
Graphiques (RF 23 315)

PROVENANCE
Delacroix Atelier, marked at lower left; sold posthu-
mously, Paris, Hôtel Drouot, February 22–27, 1864,
part of lot 610, 612, or 613; Alfred Robaut collection,
Paris; sale, Robaut, Paris, Durand-Ruel, December
18, 1907, lot 71; Raymond Koechlin collection, Paris;
bequeathed to the Musée du Louvre in 1933, marked
at lower right (Lugt 1886a).

BIBLIOGRAPHY
Robaut, 1885, no. 1084, repro.; M. Sérullaz, 1984, vol.
1, no. 1216, repro.; Johnson, 1995, no. 40, repro.

EXHIBITIONS
1885, Paris, no. 372; 1930, Paris, no. 704, repro.;
1963(b), Paris, no. 87; 1966, Paris, no. 16; 1969, Paris;
1974, Paris; 1982, Paris.

62. *Sunset*

c. 1850
Pastel on paper; 8³⁄₁₆ x 10¼ inches
(20.8 x 26 cm)
Private collection

PROVENANCE
Possibly Delacroix Atelier (according to Johnson)
sold posthumously, Paris, Hôtel Drouot, February
22–27, 1864 (one of 17 *Études de ciel* grouped under
lot 608); Alfred Robaut collection, Paris; baron Vitta
collection, Paris; Hazlitt, Gooden and Fox, London,
1988; acquired by the current owner (according to
Johnson); private collection.

BIBLIOGRAPHY
Johnson, 1995, no. 44, repro.

EXHIBITIONS
1930, Paris, no. 706, repro.; 1991, New York, no. 16,
repro.

III. *ALLEGORIES AND MYTHOLOGIES*

63. *The Triumph of Genius*

1849–51
Brown ink over graphite on paper;
10⅜ x 13¹³⁄₁₆ inches (26.3 x 35.1 cm)
Annotated in pencil at lower center: *serpent;*
and at lower right: *plus grand le monstre*
New York, The Metropolitan Museum of Art,
Rogers Fund, 1961 (61.160.1)

PROVENANCE
Delacroix Atelier, marked at lower right (Lugt 838);
sold posthumously, Paris, Hôtel Drouot, February
22–27, 1864, part of lot 378; Alfred Sensier collec-
tion, Paris; sale, Sensier, Paris, Hôtel Drouot,
December 12, 1877, lot 355; Philippe Burty collection,
Paris; sale, Burty, Paris, Hôtel Drouot, March 4–5,
1891, lot 71; Walter Feilchenfeldt, Amsterdam, then
Zurich; acquired in Switzerland by the Metropolitan
Museum of Art, New York, with the Rogers Fund,
in 1961.

BIBLIOGRAPHY
Journal, pp. 37, 212, 281, and 416; Robaut, 1864, pl.
42; Robaut, 1885, no. 728, repro.; M. Sérullaz,
1963(a), no. 294, repro.

EXHIBITIONS
1885, Paris; 1956, Venice, no. 70; 1963(a), Paris, no.
297, repro.

64. *Apollo Victorious Over the Serpent
Python* (oil sketch)

1850
Oil on canvas; 54⅛ x 40⅛ inches
(137.5 x 102 cm)
Brussels, Musées Royaux des Beaux-Arts de
Belgique (inv. 1727)

PROVENANCE
Delacroix Atelier; sold posthumously, Paris, Hôtel
Drouot, February 17–19, 1864, lot 28; withdrawn

from the sale by Achille Piron, legal and testamentary executor for Delacroix; Achille Piron collection, Paris; sold posthumously, Paris, Febvre, April 21, 1865; acquired by Arthur Stevens for the Musées Royaux des Beaux-Arts de Belgique (6,100 francs).

BIBLIOGRAPHY
Correspondance, vol. 3, pp. 37–38; Moreau, 1873, p. 258; Robaut, 1885, no. 1110, repro.; M. Sérullaz, 1963(a), no. 419, repro.; Johnson, 1989, vol. 5, no. 576, pl. 51; Johnson, 1988, pp. 35–36; Daguerre de Hureaux, 1993, pp. 274, 275, 323, 324, p. 275, repro.; Rautmann, 1997, p. 262, fig. 247; Jobert, 1997, p. 216, fig. 177.

EXHIBITIONS
1861–62, Paris; 1930, Paris, no. 132; 1956, Venice, no. 31; 1963(a), Paris, no. 419, repro.

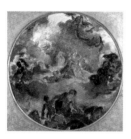

65. *Peace Come to Console Men and Restore Abundance* or *The Disconsolate Earth Lifting Her Eyes Heavenward to Secure an End to Her Misfortunes*

Central panel of the ceiling of the Salon de la Paix in the Hôtel de Ville in Paris
(oil sketch)
1852
Oil on canvas; diameter 30⅕⁄₁₆ inches (77 cm)
Paris, City of Paris, Musée du Petit Palais (inv. P.I.550)

PROVENANCE
Delacroix Atelier; sold posthumously, Paris, Hôtel Drouot, February 17–19, 1864, lot 31 *(La Paix vient consoler les hommes);* acquired by Sir Frederick Leighton (1,260 francs); Frederick Leighton collection; Paul Arthur Chéramy collection, Paris; sale, Chéramy, Paris, Galerie Georges Petit, May 5–7, 1908, lot 168; Gonse collection, Paris; Georges Aubry collection, Paris; sale, Aubry, Paris, March 11, 1933, lot 85, repro.; acquired by the Musée Carnavalet.

BIBLIOGRAPHY
Journal, pp. 286, 287; Moreau, 1873, p. 310; Robaut, 1885, no. 1240, repro.; M. Sérullaz, 1963 (a), no. 459; Johnson, 1989, vol. 5, no. 579, pl. 54; Daguerre de Hureaux, 1993, pp. 277–83, 324, 364, p. 280, repro.; Rautmann, 1997, p. 276, fig. 251; Jobert, 1997, p. 220, fig. 183.

EXHIBITIONS
1928, Paris, no. 21; 1930, Paris, no. 133, repro.; 1939, Zurich, no. 346; 1952, London, no. 34; 1963(c), Paris, no. 1, then 1963(a), Paris, no. 459; 1987(a), Zurich, no. 81, pp. 204–5, repro.

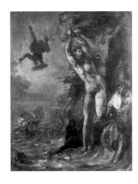

66. *Perseus and Andromeda*

1849–53
Oil on cardboard mounted on wood;
17 x 13¼ inches (43.2 x 33.6 cm)
The Baltimore Museum of Art, The Cone Collection, formed by Dr. Claribel Cone and Miss Etta Cone of Baltimore, Maryland (BMA 1950.207)

PROVENANCE
Delacroix Atelier, wax seal on verso; sold posthumously, Paris, Hôtel Drouot, February 17–19, 1864, lot 64 *(Andromède délivrée par Persée);* acquired by Jadin (850 francs); Jadin collection, Paris; sale, Paris, Galerie Féral, March 29, 1893, lot 15 (1,120 francs); Leo and Gertrude Stein, Paris, 1904; Cone collection, Baltimore, before 1929; bequeathed by Miss Etta Cone to the Baltimore Museum of Art in 1949.

BIBLIOGRAPHY
Silvestre, 1855, p. 82; anonymous, 1862; Robaut, 1885, no. 1001, repro.; Johnson, 1986, vol. 3, no. 306, pl. 130; Daguerre de Hureaux, 1993, pp. 164, 324, 325, 333; Jobert, 1997, p. 284.

EXHIBITION
1864, Paris, no. 1.

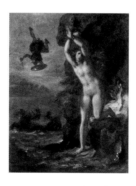

67. *Perseus and Andromeda*

1853
Oil on paper mounted on canvas;
17¼ x 12¹¹⁄₁₆ inches (43.8 x 32.2 cm)
Signed at lower left: *Eug. Delacroix.*
Stuttgart, Staatsgalerie (inv. no. 2636)

PROVENANCE
Sold by Delacroix to Henri Didier, March 10, 1853 (600 francs); sale, Didier, Paris, Hôtel Drouot, December 12, 1854, lot 22; acquired by Adolphe Moreau, Sr. (485 francs); collection of Adolphe Moreau, Sr., until his death in 1859; collection of Adolphe Moreau, Jr., until 1866; sold by Adolphe Moreau, Jr., to Durand and Brame, December 10,

1866 (3,000 francs; acquisition and sale mentioned in the inventory of the Moreau collection, private archives) Durand and Brame, Paris; Antoine Marmontel collection, Paris; sale, Marmontel, Paris, Hôtel Drouot, May 11, 1868, lot 11 (3,000 francs); Georges Petit, 1885; Duché collection, December 1887; sale, June 10, 1958, Paris, Galerie Charpentier, lot 246; Tooth's, London, 1963; acquired by the Staatsgalerie, Stuttgart, in 1963.

BIBLIOGRAPHY
Silvestre, 1855, p. 82; Moreau, 1873, p. 255; Johnson, 1986, vol. 3, no. 314, pl. 131; Jobert, 1997, p. 284.

EXHIBITIONS
1861–62, Paris; 1885, Paris, no. 235; 1964, Bremen, no. 51; 1964, Edinburgh and London, no. 59, repro.; 1987(a), Zurich, p. 216.

68. *Triton Bearing a Winged Genius on His Shoulders*

c. 1860
Brown ink on paper; 6¹¹⁄₁₆ x 8¹¹⁄₁₆ inches (17 x 22 cm)
Annotated in pencil in an unknown hand [by Alfred Robaut?]: *1863 / 1421*
Paris, Musée du Louvre, Département des Arts Graphiques (RF 9552)

PROVENANCE
Property of Jenny Le Guillou, Delacroix's housekeeper; given by Le Guillou to the painter Constant Dutilleux after Delacroix's death; Constant Dutilleux collection, Paris, until his death in 1865; perhaps collection of Alfred Robaut, his son-in-law, Paris; Étienne Moreau-Nélaton collection, Paris; bequeathed to the Musée du Louvre in 1927.

BIBLIOGRAPHY
Robaut, 1885, no. 1421, repro.; M. Sérullaz, 1984, vol. 1, no. 885, repro.

69. *Nude Man Crouching*

c. 1850 (?)
Brown ink on paper; 6¼ x 8 inches (15.8 x 20.3 cm)
Annotations near the top in pencil in the hand of Alfred Robaut, almost invisible; sketch of a composition in a frame at right.

On the verso of the old mount was an annotation in another hand, in black ink:
Arabe à l'affût / provenant de la vente d'Eugène Delacroix nº 453 du catalogue / ce dessin a appartenu à Monsieur Robaut / et a été publié par lui dans le catalogue / raisonné et illustré de l'oeuvre du Maître / sous le nº 1229
Paris, Musée du Louvre, Département des Arts Graphiques (RF 9462)

PROVENANCE
Delacroix Atelier, marked at lower right (Lugt 838a); sold posthumously, Paris, Hôtel Drouot, February 22–27, 1864, part of lot 453; Alfred Robaut collection, annotations on recto and code on verso; given by Robaut to M. Julien, following an exchange, in March 1886 (annotated by Robaut); Julien collection; Étienne Moreau-Nélaton collection; bequeathed to the Musée du Louvre in 1927, marked at lower right (Lugt 1886a).

BIBLIOGRAPHY
Robaut, 1885, no. 1229, repro.; M. Sérullaz, 1984, vol. I, no. 881, repro.

EXHIBITIONS
1930, Paris, no. 484; 1963(b), Paris, no. 89.

70. *Three Studies of a Nude Woman Reclining and Sketch of a Head*

1850–55
Brown ink and graphite (head) on paper; 10⁷⁄₁₆ x 16⅝ inches (26.5 x 42.3 cm)
Paris, Musée du Louvre, Département des Arts Graphiques (RF 4617)

PROVENANCE
Delacroix Atelier, marked at lower left (Lugt 838a); sold posthumously, Paris, Hôtel Drouot, February 22–27, 1864, part of lot 653 (74 sheets divided into 5 lots acquired by Messrs. Gigoux, Wyatt, Diéterle, de Laage); Roger Galichon collection; bequeathed to the Musée du Louvre in 1918, marked at lower right (Lugt 1886a).

BIBLIOGRAPHY
Robaut, 1885, part of no. 1905; M. Sérullaz, 1984, vol. I, no. 905, repro.

EXHIBITIONS
1930, Paris, no. 578; 1934, Paris, no. 42; 1936, Brussels, no. 123; 1963, Bordeaux, no. 162; 1969, Kyoto and Tokyo, no. D-18, repro.; 1982, Paris, no. 292.

71. *Nude Women Bathing*

1854
Brown ink over graphite sketch on paper; 9¹¹⁄₁₆ x 15⁷⁄₁₆ inches (25.2 x 39.2 cm)
Annotated in pencil at lower right: *les nus empresses d'oublier les maux de la vie, d'autre avec regret*
Cambridge, The Syndics of the Fitzwilliam Museum (no. 2031B)

PROVENANCE
Delacroix Atelier, marked at lower left (Lugt 838a); sold posthumously, Paris, Hôtel Drouot, February 22–27, 1864, part of lot 626 or 661; collection of the painters Charles Ricketts and Charles Shannon (Lugt 506a); lent to the Fitzwilliam Museum, Cambridge, from 1933 to 1937; bequeathed to the museum in 1937.

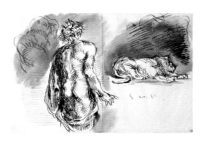

72. *Semi-Nude Man, from the Back, and Reclining Lion*

1856
Brown ink and brown wash on paper; 9³⁄₁₆ x 14⅛ inches (23.3 x 35.8 cm)
Dated in brown ink at right: *5 nov. 56*
Annotated on verso in pencil at lower right, in another hand: *voir tableau 37ᶜ* [?] / *chez M. Brun* [line marked out] / [illegible word] *1898 = 6. 400 / 0ᵐ 31 x 0,50*
Paris, Musée du Louvre, Département des Arts Graphiques (RF 9483)

PROVENANCE
Étienne Moreau-Nélaton collection; bequeathed to the Musée du Louvre in 1927, marked at lower right (Lugt 1886a).

BIBLIOGRAPHY
M. Sérullaz, 1984, vol. I, no. 829, repro.

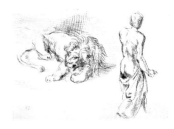

73. *Reclining Lion and Semi-Nude Man, from the Back*

c. 1857 (?)
Brown ink on paper; 8⅜ x 12¹⁄₁₆ inches (21.3 x 30.7 cm)
Rotterdam, Museum Boymans–van Beuningen (F II 83)

PROVENANCE
Delacroix Atelier, marked at lower left (Lugt 838a); sold posthumously, Paris, Hôtel Drouot, February 22–27, 1864; Paul Huet collection.

BIBLIOGRAPHY
Robaut, 1885, no. 724, repro.

EXHIBITION
1964, Edinburgh and London, no. 181, pl. 99.

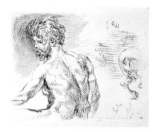

74. *Half-Length Bearded Man, from the Back, Turned Toward the Left, and Horse's Buttocks*

1857
Brown ink on paper; 8¼ x 10¹¹⁄₁₆ inches (20.9 x 27.1 cm)
Dated in brown ink at lower right: *3. 7ᵇʳᵉ 57*; annotated below: *revᵗ. de Pl.ʳᵉˢ*
Paris, Musée du Louvre, Département des Arts Graphiques (RF 9511)

PROVENANCE
Delacroix Atelier, marked at bottom toward the right (Lugt 838a); sold posthumously, Paris, Hôtel Drouot, February 22–27, 1864; Alfred Robaut collection, code and annotations on verso; Étienne Moreau-Nélaton collection; bequeathed to the Musée du Louvre in 1927, marked at lower right (Lugt 1886a).

BIBLIOGRAPHY
Robaut, 1885, no. 1320, repro.; M. Sérullaz, 1984, vol. I, no. 830, repro

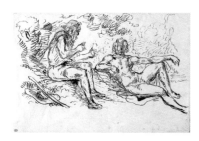

75. *Old Shepherd and Nude Young Man Conversing in a Landscape*

c. 1858–62
Brown ink on paper; 7¹⁵⁄₁₆ x 12¹⁄₁₆ inches
(20.1 x 30.6 cm)
Annotated in pencil at lower right, in the hand of Alfred Robaut: *M. V.* [Villot] *doit en avoir la peinture à la détrempe*
Annotated on the verso in pencil: *Villot n'en avait-il pas une peinture à la détrempe?*; and in brown ink: *reproduit dans l'ART 1882*
Paris, Musée du Louvre, Département des Arts Graphiques (RF 9527)

PROVENANCE
Alfred Robaut collection; Étienne Moreau-Nélaton collection; bequeathed to the Musée du Louvre in 1927, marked at lower left (Lugt 1886a).

BIBLIOGRAPHY
Robaut, 1885, no. 1385, repro.; M. Sérullaz, 1984, vol. I, no. 566, repro.

EXHIBITION
1930, Paris, no. 525.

76. *Three Semi-Nude Figures, One a Woman Holding a Flower*

1859
Brown ink on paper; 9¹⁄₁₆ x 11⁷⁄₁₆ inches
(23 x 29.1 cm)
Dated and annotated in brown ink at lower center: *Str⁸. 27 aout / 59.*
Paris, Musée du Louvre, Département des Arts Graphiques (RF 9526)

PROVENANCE
Delacroix Atelier, marked at bottom toward the right (Lugt 838a); sold posthumously, Paris, Hôtel Drouot, February 22–27, 1864, part of lot 628 (16 sheets); Alfred Robaut collection, code on verso; Étienne Moreau-Nélaton collection; bequeathed to the Musée du Louvre in 1927, marked at lower right (Lugt 1886a).

BIBLIOGRAPHY
Robaut, 1885, no. 1401, repro.; M. Sérullaz, 1984, vol. I, no. 838, repro.

77. *Three Studies of Nude Women at Their Toilette*

1859
Brown ink on paper; 8¹¹⁄₁₆ x 13¾ inches
(22 x 35 cm)
Dated and annotated in brown ink at lower right: *27 aout Stras^b 59.*
Eric G. Carlson Collection

PROVENANCE
Delacroix Atelier, marked at bottom toward the right (Lugt 838a); sold posthumously, Paris, Hôtel Drouot, February 22–27, 1864, perhaps part of lot 648 (63 sheets divided into 9 lots acquired by Messrs. Lejeune, Mamola, Dejean, Robaut, Sensier, Burty, de Laage); Félix Bracquemond collection; Ed. Sagot collection; private collection, Ohio; Eric G. Carlson collection.

BIBLIOGRAPHY
Robaut, 1885, no. 1400, repro.; Badt, 1946, fig. 11 (reproduces only the left figure).

78. *Two Studies of a Nude Man*

1860
Brown ink on paper; 9¼ x 14¹⁄₁₆ inches
(23.5 x 35.7 cm)
Dated in brown ink at the center: *6 f^r. 1860.*
Besançon, Musée des Beaux-Arts et d'Archéologie (D 2401)

PROVENANCE
Delacroix Atelier, marked at lower center (Lugt 838a); sold posthumously, Paris, Hôtel Drouot, February 22–27, 1864, perhaps part of lot 653 (74 sheets divided into 5 lots acquired by Messrs. Gigoux, Wyatt, Diéterle, de Laage); Jean Gigoux collection, marked at lower left (Lugt 1164); bequeathed to the museum in Besançon in 1894, marked at lower left (Lugt 238a).

BIBLIOGRAPHY
Robaut, 1885, perhaps part of no. 1905.

EXHIBITION
1964, Edinburgh and London, no. 185.

79. *Sheet of Studies with Semi-Nude Man and Feline Advancing Toward the Right*

1860
Brown ink on paper; 12⅜ x 8⅜ inches
(31.4 x 21.3 cm)
Dated and annotated in brown ink at lower right: *9 aout Champrosay / 60.*
Paris, Musée du Louvre, Département des Arts Graphiques (RF 9733)

PROVENANCE
Étienne Moreau-Nélaton collection; bequeathed to the Musée du Louvre in 1927, marked at upper right (Lugt 1886a).

BIBLIOGRAPHY
M. Sérullaz, 1984, vol. I, no. 840, repro.

IV. *LITERARY INSPIRATION*

80. *The Death of Lara*

1847–48
Oil on canvas; 20¹⁄₁₆ x 25⅝ inches (51 x 65 cm)
Signed and dated at lower left:
Eug. Delacroix / 1857.
Private collection

PROVENANCE
Mme Benjamin Delessert collection, 1864; Mme Gabriel Delessert collection, 1887 (Moreau, 1873, p. 13); sale [Mme G. Delessert], Paris, Hôtel Drouot, June 16, 1894, lot 2; withdrawn from the sale at 12,100 francs (annotated by Robaut, no. 1006 *bis*); E. Simon collection, May 1895; sale, Paris, March 11, 1909, lot 26, repro.; acquired by Oppenheimer (13,500 francs); Otto Gerstenberg collection, Berlin, 1921; Walter Scharf collection, Obersdorf, Allgau (Germany); private collection.

BIBLIOGRAPHY
Thoré, 1848; Haussard, 1848; De Saint-Victor, 1848, p. 666; Clément de Ris, 1848(b), p. 59; Du Pays,

1848; Montlaur, 1848; Jan, 1848; Mercey, 1848(b), pp. 291–92; Gautier, 1848; Silvestre, 1855, p. 84; Piron, 1865, p. 109; Moreau, 1873, p. 183; Robaut, 1885, no. 1006, repro.; M. Sérullaz, 1963(a), no. 387, repro.; Johnson, 1986, vol. 3, no. 290, pl. 107; Daguerre de Hureaux, 1993, pp. 150, 322.

EXHIBITIONS
1848, Paris, no. 1159; 1864, Paris, no. 4; 1885, Paris, no. 54; 1963(a), Paris, no. 390; 1964, Bremen, no. 80, repro.

81. *The Death of Lara*

1858
Oil on canvas; 24³⁄₁₆ x 19¹¹⁄₁₆ inches
(61.5 x 50 cm)
Signed and dated at lower left:
Eug. Delacroix. / 1858.
Private collection (courtesy of the Nathan Gallery, Zurich)

PROVENANCE
Baron collection; sale, Baron, Paris, March 23, 1861, lot 17 (2,300 francs); Soultzener collection, 1873; housed with the Soultzener family until c. 1885; Bernheim-Jeune, Jr.; sold by Bernheim-Jeune to Neil Demelette, December 10, 1909 (Bernheim-Jeune archives, cited by Johnson); Neil Demelette collection until c. 1908; Martin collection; Wildenstein, New York, 1952; acquired in France by Emil Bührle, 1953; Emil Bührle collection, Zurich; acquired from the Bührle Foundation by Dr. Peter Nathan, Zurich; private collection.

BIBLIOGRAPHY
Moreau, 1873, p. 249; Robaut, 1885, no. 1355, repro.; M. Sérullaz, 1963(a), no. 493, repro.; Johnson, 1986, vol. 3, no. 328, pl. 146; Daguerre de Hureaux, 1993, pp. 148, 150, 327, repro.; Jobert, 1997, pp. 276–78, fig. 233.

EXHIBITIONS
1885, Paris, no. 206; 1930, Paris, no. 177, repro. *Album,* p. 91; 1952, London, no. 44; 1963(a), Paris, no. 490; 1987(a), Zurich, no. 110, pp. 260, 261, 336, repro.

82. *Lady Macbeth Sleepwalking*

1849–50
Oil on canvas; 16¹⁄₁₆ x 12¹³⁄₁₆ inches
(40.8 x 32.5 cm)
Signed at lower right: *Eug. Delacroix.*
Fredericton, New Brunswick, Canada,
Beaverbrook Art Gallery,
Gift of Mr. and Mrs. John Flemer

PROVENANCE
Given by Delacroix to Théophile Gautier (according to Moreau, 1873, p. 186); Théophile Gautier collection; sale, Gautier, Paris, Hôtel Drouot, January 14, 1873, lot 24; acquired by Brame (7,000 francs); I. Tabourier collection, 1878; sale, Tabourier, June 20, 1898, lot 17, repro.; acquired by Durand-Ruel (15,000 francs); sold by Durand-Ruel to [Charles] Hosmer, Montreal, January 11, 1899 (Durand-Ruel archives, cited by Johnson); collection of Elwood B. Hosmer, his son; collection of Mrs. Howard W. Pillow, his daughter, Montreal, from 1962–64 until c. 1971; after that date with the National Gallery of Canada, Ottawa, and then to the Beaverbrook Art Gallery, Fredericton, New Brunswick, from 1983.

BIBLIOGRAPHY
Journal, p. 197; Banville, 1851; Montaiglon, 1851, p. 3; Peisse, 1851; Pillet, 1851; Desplaces, 1851; Galimard, 1851; Petroz, 1851; Courtois, 1851(a), 1851(b); Clément de Ris, 1851, p. 4; Mantz, 1851; Dauger, 1851; Arnoux, 1851; Du Pays, 1851, p. 119; Geoffroy, 1851; Rochery, 1851; Sabatier-Ungher, 1851; Gautier, 1851; Calonne, 1851; Thierry, 1851; Fizelière, 1851; Mirbel, 1851, p. 24; Vignon, 1851, p. 99; Silvestre, 1855, p. 84; Gautier, 1857, p. 227; de Saint-Victor, 1863; Piron, 1865, p. 110; Moreau, 1873, pp. 186, 253; Robaut, 1885, no. 117, repro.; Johnson, 1986, vol. 3, no. 299, pl. 115; Daguerre de Hureaux, 1993, p. 223; Jobert, 1997, p. 260.

EXHIBITIONS
1850–51, Paris, no. 779; 1864, Paris, no. 15; 1885, Paris, no. 217; 1962–63, Toronto and Ottawa, no. 15, repro.; 1964, Edinburgh and London, no. 51.

83. *The Bride of Abydos*

c. 1849–51
Oil on wood; 22¹⁄₁₆ x 17¾ inches (56 x 45 cm)
Signed at lower right: *Eug. Delacroix*
Lyon, Musée des Beaux-Arts (B-1039)

PROVENANCE
Collection of T.; sale by T., Paris, Hôtel Drouot, December 24, 1858, lot 9 (1,350 francs); Th. Leroy collection; sale, Leroy, Paris, May 13, 1882; acquired by Édouard Frère (15,500 francs); Édouard Frère collection; sold posthumously, Paris, Hôtel Drouot, November 29, 1889, lot 214; acquired by the dealer Montaignac (15,050 francs; noted by Robaut, 1885, no. 1182 *bis*); Georges I. Seney collection, New York; sale, Seney, New York, January 31, 1891, lot 256; Louis Mante collection, June 1892; Joseph Gillot collection; given to the Musée des Beaux-Arts of Lyon in 1913.

BIBLIOGRAPHY
Silvestre, 1855, pp. 81–83; Moreau, 1873, p. 247; Robaut, 1885, no. 1182, repro.; M. Sérullaz, 1963(a), no. 416, repro.; Johnson, 1986, vol. 3, no. 300, pl. 123; Daguerre de Hureaux, 1993, p. 150; Guégan, 1994, p. 118, 119, repro.

EXHIBITIONS
1885, Paris, no. 81; 1952, London, no. 26; 1963(a), Paris, no. 402; 1963–64, Bern, no. 69; 1964, Bremen, no. 62; 1987(a), Zurich, no. 71, pp. 194, 195, 330, repro.

84. *The Bride of Abydos*

c. 1852–53 (?)
Oil on canvas; 13⅞ x 10⅝ inches (35.3 x 27 cm)
Signed at lower left: *Eug Delacroix*
Paris, Musée du Louvre (RF 1398)

PROVENANCE
Sold by Delacroix to the dealer Weill in the spring of 1853 (Johnson, 1972, p. 580); Louis Barré collection (?); sold posthumously, Paris, Hôtel des Commissaires-priseurs, February 4, 1858, lot 10 (1,270 francs); George Sand collection; sale [Sand],

Paris, Hôtel Drouot, April 23, 1864, lot 15; John J. Wilson collection; sale [Wilson], Paris, Hôtel Drouot, April 27, 1874, lot 97; acquired by Théodore Melot (32,050 francs); Théodore Mélot collection until 1885; acquired by Arnold, Tripp and Company in association with Le Roy and Company, February 25, 1891; sold by Arnold, Tripp and Company and Le Roy and Company to an unidentified collector, April 9, 1891 (Arnold, Tripp archives, cited by Johnson); Antony Roux collection (J. Guiffrey, *La Collection Thomy-Thiéry au musée du Louvre* [Paris: Librairie de l'art ancien et moderne, 1903], p. 21); Georges-Thomy Thiéry collection; bequeathed to the Musée du Louvre in 1902.

BIBLIOGRAPHY
Silvestre, 1855, pp. 81–83; Robaut, 1885, no. 772, repro.; Véron, 1887, p. 66, p. 71, repro.; Johnson, 1986, vol. 3, no. 311, pl. 124; A. Sérullaz, 1988, fig. 5; Daguerre de Hureaux, 1993, p. 150, p. 149, repro.; Daguerre de Hureaux and Guégan, 1994, pp. 74–75, repro.; Guégan, 1994, p. 120, p. 121, repro.; Rautmann, 1997, p. 292, fig. 281.

EXHIBITIONS
1930, Paris, no. 107; 1946(a), Paris, no. 7; 1948, Paris, no. 67; 1963, Bordeaux, no. 28, repro.; 1969, Kyoto and Tokyo, no. H-19, repro.; 1988, Paris.

85. *The Bride of Abydos*

1857
Oil on canvas; 18½ x 14¹⁵⁄₁₆ inches (47 x 38 cm)
Signed and dated at lower left:
Eug. Delacroix. / 1857.
Fort Worth, Texas, Kimbell Art Museum

PROVENANCE
Given by Delacroix to his landlord, M. Hurel, in March 1858; Hurel collection until c. 1889; E. Le Roy and Company, Paris; sale, Le Roy and Company to Knoedler; sale, Knoedler to Mme Soucaret, June 1913 (Knoedler archives, cited by Johnson); Mme Soucaret collection; Mme Dhainaut collection; sale, Mme Dhainaut, Paris, Galerie Georges Petit, May 19, 1924, lot 6, repro.; acquired by Marchal Diehl (70,500 francs); private collection, Switzerland; acquired by the Kimbell Art Museum, Fort Worth, in 1985.

BIBLIOGRAPHY
Silvestre, 1855, pp. 81–83; annotated by Robaut, 1885, no. 6b; Johnson, 1986, vol. 3, no. 325, pl. 125; Johnson, 1991, p. 151; Daguerre de Hureaux, 1993, p. 150, repro.; Jobert, 1997, p. 278, fig. 234.

EXHIBITION
1987(a), Zurich, no. 105, pp. 252, 335, p. 253, repro.

86. *Desdemona Cursed by Her Father*

1852
Oil on canvas; 23¼ x 19⁵⁄₁₆ inches (59 x 49 cm)
Signed and dated at lower right:
Eug. Delacroix / 1852
Reims, Musée des Beaux-Arts

PROVENANCE
Acquired by Arnold, Tripp and Company in association with two other merchants, March 30, 1892 (25,000 francs); sold to Henry Vasnier, June 9, 1892 (62,000 francs; Arnold, Tripp archives, cited by Johnson); Henry Vasnier collection, Reims; bequeathed to the Reims museum in 1907.

BIBLIOGRAPHY
Silvestre, 1855, p. 81; annotated by Robaut, 1885, no. 697b; M. Sérullaz, 1963(a), no. 431, repro.; Johnson, 1986, vol. 3, no. 309, pl. 117; Daguerre de Hureaux, 1993, p. 158, p. 157, repro.; Jobert, 1997, p. 284, fig. 246.

EXHIBITIONS
1930, Paris, no. 149, repro.; 1939, Zurich, no. 351, repro.; 1963(a), Paris, no. 428; 1964, Edinburgh and London, no. 55; 1969, Kyoto and Tokyo, no. H-32, repro.

87. *Marfisa and Pinabello's Lady*

1850–52
Oil on canvas; 32¼ x 39¾ inches (82 x 101 cm)
Signed and dated at lower left:
Eug. Delacroix / 1852
Baltimore, The Walters Art Gallery (37.10)

PROVENANCE
Sold by Delacroix to the collector J. P. Bonnet (1,500 francs); J. P. Bonnet collection, Paris; sale, Bonnet, Paris, Hôtel de Ventes Mobilières, February 19, 1853, lot 9; acquired by Buloz (1,100 francs); Buloz collection, Paris; sale, Buloz, Paris, Hôtel Drouot, May 20, 1881; possibly acquired by Étienne-François Haro (25,100 francs, according to Johnson); possibly sold to Balay by Haro (according to Robaut); Balay collection, 1885; jointly acquired by Arnold, Tripp and Company, Paris, and Knoedler, New York, October 23, 1901 (30,007.70 francs, according to the Arnold, Tripp archives, cited by Johnson); Knoedler, New

York, until 1904; Henry Walters collection, Baltimore, 1904; bequeathed to the city of Baltimore in 1931; The Walters Art Gallery, Baltimore.

BIBLIOGRAPHY
Journal, pp. 223, 278; Moreau, 1873, pp. 115, 247; Robaut, 1885, no. 1198, repro.; M. Sérullaz, 1963(a), no. 429, repro.; Johnson, 1986, vol. 3, no. 303, pl. 127; Daguerre de Hureaux, 1993, pp. 163, 164, 324, repro. p. 163; Jobert, 1997, p. 287, fig. 247.

EXHIBITIONS
1885, Paris, no. 107 *(Marphise et Doralice)*; 1930, Paris, no. 148; 1962–63, Toronto and Ottawa, no. 16, repro.; 1963(a), Paris, no. 426; 1987(a), Zurich, no. 84, pp. 210–11, repro.

88. *Entry of the Crusaders into Constantinople (April 12, 1204)*

1852
Oil on canvas; 32⅛ x 41⅜ inches (81.5 x 105 cm)
Signed and dated at lower left:
Eug. Delacroix 1852.
Paris, Musée du Louvre, Gift of Étienne Moreau-Nélaton (RF 1659)

PROVENANCE
Sold by Delacroix to the collector J. P. Bonnet; J. P. Bonnet collection, Paris; sale, Bonnet, Paris, Hôtel des Ventes Mobilières, February 19, 1853, lot 11 (erroneously described as a "première pensée du tableau de Versailles"); acquired by Adolphe Moreau, Sr. (3,350 francs, not 3,199 francs as is generally written; see *Inventaire de la collection Moreau,* private archives); collection of Adolphe Moreau, Sr., until his death in 1859; collection of Adolphe Moreau, Jr., from 1859 until his death in 1881; collection of his widow, Mme Adolphe Moreau, née Nélaton, from 1881 until her death in 1897; Étienne Moreau-Nélaton collection, 1897–1907; given to the French State for the Musée du Louvre, July 26, 1906 (estimated at the time to be a donation of 100,000 francs); exhibited at the Musée des Arts Décoratifs, 1907–1934; transferred, with the whole of the Étienne Moreau-Nélaton gift, to the Musée du Louvre in 1934.

BIBLIOGRAPHY
Journal, p. 510; *Correspondance,* vol. 3, p. 139; Silvestre, 1855, p. 82; Feydeau, 1858; Gautier, 1860(a); 1860(b), p. 202; Astruc, 1860, p. 38; Moreau, 1873, pp. 122, 254–55; Robaut, 1885, no. 1189, repro.; M. Sérullaz, 1963(a), no. 433, repro.; Johnson, 1986, vol. 3, no. 302, pl. 94; Daguerre de Hureaux, 1993, pp. 85–86, 104, 106, 107, 108, 111, 112, 114, 302, 318, and 324; Rautmann, 1997, p. 92; Jobert, 1997, fig. 203.

EXHIBITIONS
1860, Paris, no. 165; 1885, Paris, no. 149; 1930, Paris, no. 146; 1963(a), Paris, no. 430; 1973, Paris.

89. *Weislingen Captured by Goetz's Men*

1853
Oil on canvas; 28⅞ x 23⅜ inches
(73.3 x 59.3 cm)
Signed and dated at lower left:
Eug. Delacroix / 1853
St. Louis, The Saint Louis Art Museum,
Emelie Weindal Bequest Fund (75:1954)

PROVENANCE
Sold by Delacroix to the merchant Beugniet,
December 1853 (1,200 francs); Charles Bardon collection, 1860; sale, B. [Bardon], Paris, Hôtel Drouot,
April 22, 1864, lot 14 (3,600 francs); Meyer collection, Vienna (?); sale, *Galerie d'un amateur de Vienne*
[Meyer], Paris, Hôtel Drouot, April 27, 1866, lot 20
(8,850 francs); Edwards collection; sale, Edwards,
Paris, Hôtel Drouot, March 7, 1870, lot 11, repro.;
probably withdrawn from the sale or transferred to a
family member (at the time of the exhibition of the
painting in London in 1871, it was reported as
belonging to M. C. Edwards; see Johnson); C.
Edwards collection, 1871; Adolphe E. Borie collection, Philadelphia, until 1880; Mrs. Adolphe E. Borie
collection until 1887; George C. Thomas collection,
Philadelphia; T. S. Blakeslee collection, Philadelphia
(?); sold by Blakeslee to Durand-Ruel, New York,
November 30, 1909 (Durand-Ruel archives, cited by
Johnson); Durand-Ruel, Paris, February 1910; sold
by Durand-Ruel to Bernheim-Jeune, May 6, 1910;
Bernheim-Jeune; sold by Bernheim-Jeune to
Miethke, February 7, 1911 (Bernheim-Jeune archives,
cited by Johnson); Dr. Hermann Eissler collection,
Vienna, 1922; Tanner, Zurich; private collection,
Zurich; consigned to Marianne Feilchenfeldt; sold
by Marianne Feilchenfeldt to the Saint Louis Art
Museum, in October 1954.

BIBLIOGRAPHY
Journal, p. 360, 361, 368, 873; *Correspondance*, vol. 3,
p. 182; Silvestre, 1855, p. 81; Gautier, 1860(a), 1860(b),
p. 202 (reprinted in Théophile Gautier, *Tableaux à
la plume* [Paris: G. Charpentier, 1880]); Astruc, 1860,
pp. 38–39; Silvestre, 1864, p. 58; Moreau, 1873, p.
249; Robaut, 1885, no. 1169, repro.; M. Sérullaz,
1963(a), no. 440, repro.; Johnson, 1986, vol. 3, no.
315, pl. 134; Daguerre de Hureaux, 1993, pp. 128, 129,
repro.; Jobert, 1997, p. 237, fig. 228.

EXHIBITIONS
1860, Paris, no. 70; 1930, Paris, no. 143; 1962–63,
Toronto and Ottawa, no. 19, repro.; 1963(a), Paris,
no. 439; 1964, Edinburgh and London, no. 58.

90. *Scene from the War Between the Turks and Greeks*

1856
Oil on canvas; 25⅞ x 32⅛ inches
(65.7 x 81.6 cm)
Signed and dated at lower left:
Eug. Delacroix / 1856.
Athens, Pinacothèque Nationale, Musée
Alexandre Soutzos (5618)

PROVENANCE
Painted for the dealer Thomas at the beginning of
1856; Wertheimberg collection; sale [Wertheimberg],
Paris, Hôtel Drouot, December 7–8, 1871, lot 2;
acquired by Cornu for baron Gustave de Rothschild
(21,000 francs); baron Gustave de Rothschild collection; Gérard de Chavagnac collection; sold to
Durand-Ruel, February 9, 1925; sold by Durand-
Ruel to Spielmann Brothers, London, March 21,
1925; Ernest Masurel collection, 1926; sale, Paris,
Hôtel Drouot, June 21, 1978, lot 64, repro.; acquired
by the Greek government, with the support of
Messrs. Niarchos and Goulandris.

BIBLIOGRAPHY
Robaut, 1885, no. 1296, repro.; Johnson, 1986, vol. 3,
no. 323, pl. 138; Johnson, 1991, p. 62; Jobert, 1997,
p. 298, fig. 264.

EXHIBITIONS
1930, Paris, no. 171; 1996–97, Bordeaux, Paris, and
Athens, no. 32, repro. (French edition).

91. *The Abduction of Rebecca*

1858
Oil on canvas; 41⅜ x 32⅛ inches (105 x 81.5 cm)
Signed and dated at lower center, on the stone:
Eug. Delacroix 1858.
Paris, Musée du Louvre (RF 1392)

PROVENANCE
The painting is recorded in the inventory after the
artist's death (no. 440: "one painting representing
the abduction of Rebecca. It is recognized that the
painting is not part of the inheritance and that it was

remitted to M. Delacroix to make [word missing,
perhaps copy or replica?]," Bessis, 1969, pp.
199–222); despite Achille Piron's testimony, documents found in his archives suggest that the painting
was sold by Delacroix to Jacques Félix Frédéric
Hartmann in 1858; Oppermann collection, Paris,
1865 (according to Piron); Hartmann collection,
Mulhouse; sale, Hartmann, Paris, Hôtel Drouot,
May 11, 1876, lot 10 (20,000 francs); F. Kramer
collection, 1878; bought by Arnold, Tripp and
Company, April 21, 1882, from an unspecified collector (45,000 francs), the price being shared with
Bague and Company (Arnold, Tripp archives, cited
by Johnson); sold to É. Secrétan, April 21, 1882
(60,000 francs); É. Secrétan collection, Paris; comte
de Jaucourt collection, Paris; Georges-Thomy Thiéry
collection, Paris, January 1889; bequeathed to the
Musée du Louvre in 1902.

BIBLIOGRAPHY
Journal, pp. 581, 587, 731; Rousseau, 1858, p. 266;
Dumas, 1859(a), p. 10; Saint-Victor, 1859; Tardieu,
1859; Richard, 1859; Belloy, 1859; Mantz, 1859, p. 137;
Houssaye, 1859; Rousseau, 1859; Lavergne, 1859; Du
Pays, 1859, p. 339; Gautier, 1859(a); Fournel, 1859,
p. 157; Perrier, 1859, p. 295; Lescure, 1859;
Montaiglon, 1859, p. 442; Astruc, 1859, pp. 225–75;
Aubert, 1859, p. 148; Du Camp, 1859, p. 32;
Dumesnil, 1859, p. 82; Fouquier, 1859, p. 7; Stevens,
1859, p. 34; Moreau, 1873, p. 195; Robaut, 1885, no.
1383, repro.; Tourneux, 1886, pp. 98–103; M.
Sérullaz, 1963(a), no. 501, repro.; Johnson, 1986, vol.
3, no. 326, pl. 103; Daguerre de Hureaux, 1993, pp.
136, 137, 292, 303, 320, 327, repro.; Rautmann, 1997,
p. 220, fig. 204; Jobert, 1997, p. 274, fig. 231.

EXHIBITIONS
1859, Paris, no. 824; 1928, Paris; 1930, Paris, no. 175,
repro.; 1939, Zurich, no. 366; 1939, Basel, no. 257;
1946(a), Paris, no. 10; 1946(b), Paris, no. 10; 1948,
Paris, no. 49; 1952, Paris, no. 18; 1963(a), Paris, no.
499, repro.; 1963–64, Bern, no. 89; 1964, Bremen,
no. 83, repro.; 1964, Edinburgh and London, no. 68;
1969, Kyoto and Tokyo, no. H-39, repro.; 1973,
Paris; 1974, Paris; 1987(a), Zurich, no. 111, p. 262,
repro.

92. *The Death of Desdemona*

1858
Oil on canvas; 25⁹⁄₁₆ x 21⅝ inches (65 x 55 cm)
Private collection (courtesy of the Nathan
Gallery, Zurich)

PROVENANCE
Delacroix Atelier, wax seal on verso; sold posthumously, Paris, Hôtel Drouot, February 17–19, 1864,
lot 125; acquired by Jules Dieterle (390 francs); Jules
Dieterle collection; sold posthumously, Paris, Hôtel
Drouot, February 24, 1890, lot 9; bought by Jules
Dieterle's son; Dieterle collection (?); sold by

Dieterle to Marcel Guérin's daughter in 1919; Watelin collection; sale, Watelin, Paris, November 17, 1919, lot 6 (6,500 francs); sale, Paris, Hôtel Drouot, October 27, 1975, lot 100, repro.; Peter Nathan collection, Zurich; private collection.

BIBLIOGRAPHY
Robaut, 1885, no. 1769; Johnson, 1986, vol. 3, no. 327, pl. 144.

EXHIBITION
1987(a), Zurich, no. 109, pp. 258, 259, 335, repro.

93. *Hamlet and Horatio in the Graveyard*

1859
Oil on canvas; 11⅝ x 14³⁄₁₆ inches (29.5 x 36 cm)
Signed and dated at lower right:
Eug. Delacroix / 1859.
Paris, Musée du Louvre (RF 1399)

PROVENANCE
Cachardy collection; sale, Cachardy, Paris, Hôtel Drouot, December 8, 1862, lot 11 (1,600 francs); baronne Nathaniel de Rothschild collection, 1873–85; Georges-Thomy Thiéry collection; bequeathed to the Musée du Louvre in 1902.

BIBLIOGRAPHY
Cadol, 1859, pp. 174–75; Mantz, 1859; Houssaye, 1859, p. 295; Rousseau, 1859; Du Pays, 1859, p. 339; Gautier, 1859(a); Lescure, 1859; Astruc, 1859, pp. 268–70; Auvray, 1859, p. 19; Dumas, 1859(a) [also printed in Dumas, 1859(b), p. 10]; Dumesnil, 1859, pp. 82–83; Fouquier, 1859, p. 7; Stevens, 1859, p. 33; Moreau, 1873, pp. 195, 250; Robaut, 1885, no. 1388, repro.; M. Sérullaz, 1963(a), no. 503, repro.; Johnson, 1986, vol. 3, no. 332, pl. 119; Daguerre de Hureaux, 1993, p. 154, repro.; Jobert, 1997, p. 279, fig. 235.

EXHIBITIONS
1859, Paris, no. 825; 1885, Paris, no. 188; 1930, Paris, no. 182; 1948, Paris, no. 39; 1963(a), Paris, no. 500.

94. *Erminia and the Shepherds*

1859
Oil on canvas; 32¼ x 40¹⁵⁄₁₆ inches (82 x 104.5 cm)
Signed and dated at lower right:
Eug. Delacroix 1859.
Stockholm, Nationalmuseum (NM 2246)

PROVENANCE
Sold by Delacroix to the dealer Tedesco, March 29, 1859 (2,000 francs); Durand-Ruel, London, 1871; Salomon Goldschmidt collection, 1873; sold posthumously, Paris, Galerie Georges Petit, May 17, 1888, lot 28, repro.; acquired by Porto-Riche (25,400 francs); Porto-Riche collection; S. D. Warren collection, New York; sale, Warren, New York, January 8, 1903, lot 116; acquired by Montaignac ($7,200); Montaignac collection; sold by Montaignac to Boussod, Valadon and Company, February 7, 1903; sold by Boussod, Valadon and Company to baron Denys Cochin, May 15, 1903 (Boussod, Valadon archives; cited by Johnson); resold by Cochin to Boussod, Valadon and Company, January 15, 1907; sold by Boussod, Valadon and Company to Bernheim-Jeune, January 23, 1907; sold by Bernheim-Jeune to Louis Sarlin, July 11, 1907 (Bernheim-Jeune archives; cited by Johnson); Louis Sarlin collection, Paris; sale, Sarlin, Paris, March 2, 1918, lot 29; H. Heilbuth, Copenhagen; given to the Nationalmuseum, Stockholm, by the Friends of the Museum in 1920.

BIBLIOGRAPHY
Journal, pp. 390, 577, 587, 588; *Correspondance,* vol. 4, pp. 81, 90; Dumas, 1859(a), pp. 10–11; Saint-Victor, 1859; Tardieu, 1859; Mantz, 1859, p. 136; Houssaye, 1859; Rousseau, 1859; Du Pays, 1859; Gautier, 1859(a); Fournel, 1859, p. 157; Perrier, 1859, p. 296; Lescure, 1859; Astruc, 1859, p. 264; Aubert, 1859, p. 148; Du Camp, 1859, p. 32; Dumesnil, 1859, p. 83; Fouquier, 1859; Lépinois, 1859; Stevens, 1859, p. 34; Moreau, 1873, p. 194; Robaut, 1885, no. 384, repro.; M. Sérullaz, 1963(a), no. 500, repro.; Johnson, 1986, vol. 3, no. 331, pl. 150; Johnson, 1992, pp. 379–84; Daguerre de Hureaux, 1993, pp. 165, 166, 304, 328, p. 166, repro.; Jobert, 1997, p. 287, fig. 248.

EXHIBITIONS
1859, Paris, no. 823; 1930, Paris, no. 184, repro.; 1963(a), Paris, no. 497; 1987(a), Zurich, no. 115, pp. 272–75, repro.

95. *Ovid Among the Scythians* or *Ovid in Exile*

1859
Oil on canvas; 34½ x 51¼ inches (87.6 x 130 cm)
Signed and dated at lower right:
Eug. Delacroix / 1859.
London, The National Gallery (NG 6262)

PROVENANCE
Commissioned in March 1856 by the banker and politician Benoît Fould, brother of Napoléon III's finance minister, Achille Fould (6,000 francs); Benoît Fould died in July 1858 before having received delivery of the commissioned painting, as his widow confirmed (according to an unpublished letter in the Archives Piron, Archives des Musées Nationaux, Paris); collection of Benoît Fould's widow, Paris; collection of Mme de Sourdeval, niece of Benoît Fould, Paris, 1892; collection of Mme Charles Demachy, daughter of Mme de Sourdeval; collection of baronne Ernest Sellière, daughter of Mme Charles Demachy; sold by the heirs of baronne Ernest Sellière to César de Hauke; sold to the National Gallery, London, in 1956.

BIBLIOGRAPHY
Journal, pp. 190, 390, 571, 573, 577, 581, 598, 839; *Correspondance,* vol. 3, p. 320, vol. 4, p. 75; Dumas, 1859(a), p. 10; Saint-Victor, 1859; Tardieu, 1859; Belloy, 1859; Mantz, 1859, p. 137; Houssaye, 1859; Rousseau, 1859; Du Pays, 1859; Gautier, 1859(a); Fournel, 1859; Perrier, 1859, p. 296; Baudelaire, 1859, pp. 240–42; Lescure, 1859; Montaiglon, 1859; Du Camo, 1859, p. 33; Gautier, 1859(b); Dumesnil, 1859, p. 82; Fouquier, 1859, p. 7; Jourdan, 1859, p. 34; Lépinois, 1859, p. 196; Stevens, 1859, p. 32; Astruc, 1860, pp. 259–61, 265, 274; Moreau, 1873, p. 194; Robaut, 1885, no. 1376, repro.; M. Sérullaz, 1963(a), no. 479, repro.; Johnson, 1986, vol. 3, no. 334, pl. 142; Daguerre de Hureaux, 1993, pp. 165, 167, 304, 326, 328, 329, repro. p. 167; Daguerre de Hureaux and Guégan, 1994, p. 105; Rautmann, 1997, p. 230, fig. 212; Jobert, 1997, p. 268, fig. 224.

EXHIBITIONS
1859, Paris, no. 822; 1861–62, Paris; 1930, Paris, no. 183; 1964, Edinburgh and London, no. 69, repro.; 1987(a), Zurich, no. 114, pp. 268–69, repro.

96. *Amadis de Gaule Delivers a Damsel from Galpan's Castle*

1860
Oil on canvas; 21½ x 25¾ inches
(54.6 x 65.4 cm)
Signed and dated at lower left:
Eug. Delacroix 1860
Richmond, Virginia Museum of Fine Arts,
The Adolph D. and Wilkins C. Williams Fund
(57.1)

PROVENANCE
Sold by Delacroix to Claudius Gérantet, Saint-
Étienne, with the dealer Cachardy as intermediary
(2,000 francs); Claudius Gérantet collection;
acquired at Saint-Étienne by the dealer Gustave
Tempelaere in November 1898 (noted by Robaut);
sold by Gustave Tempelaere to Arnold, Tripp and
Company, November 11, 1898 (36,000 francs,
according to Robaut and to the Arnold, Tripp
archives; cited by Johnson); sold by Arnold, Tripp
and Company to Knoedler, New York, July 19, 1899
(100,000 francs, according to Robaut, and 58,000
francs, according to the Arnold, Tripp archives, cited
by Johnson); sold by Knoedler, New York, to H. S.
Henry, Philadelphia, in August 1899; sale, Henry,
New York, January 25, 1907, lot 15, repro. *(La
Délivrance de la princesse Olga);* acquired by I.
Montaignac ($11,100); Montaignac collection;
Charles Viguier collection, Paris, 1910; Blot collec-
tion, Paris; Dr. H. Graber collection, Zurich, 1939;
Raeber Gallery, Basel; acquired by Knoedler, New
York, from a collector in Basel, February 25, 1954;
sold by Knoedler, New York, to the Virginia
Museum of Fine Arts, Richmond, in 1957.

BIBLIOGRAPHY
Journal, p. 720; M. Sérullaz, 1963(a), no. 508, repro.;
Johnson, 1986, vol. 3, no. 336, pl. 151; Daguerre de
Hureaux, 1993, p. 328.

EXHIBITIONS
1939, Zurich, no. 371; 1962–63, Toronto and
Ottawa, no. 24, repro.; 1963(a), Paris, no. 505; 1969,
Kyoto and Tokyo, no. H-41, repro.; 1987(a), Zurich,
no. 118, pp. 278–79, repro.

97. *Demosthenes Declaiming by the Seashore*

1859
Oil on paper mounted on wood;

19⁹⁄₁₆ x 23⁷⁄₁₆ inches (49 x 59.5 cm)
Signed and dated at lower left, below the rock:
Eug. Delacroix. 1859.
Dublin, The National Gallery of Ireland
(inv. 964)

PROVENANCE
Francis Petit, 1860; A. de Knieff collection, Paris (ac-
cording to the Carlin sale catalogue); Carlin collec-
tion, Paris; sale, Carlin, Paris, Hôtel Drouot, April
29, 1872, lot 7, repro.; acquired by M. Bryce (27,400
francs); Bryce collection, Paris; sale, Bryce, Paris,
March 16, 1877, lot 13; acquired by M. Rigaud
(19,400 francs); Henri Rigaud collection, Paris; sale,
Rigaud, Paris, Hôtel Drouot, April 3, 1933, lot 4,
repro. (asking price 35,000 francs); Georges
Bernheim and Company, Paris; sold by Georges
Bernheim and Company to the National Gallery of
Ireland, Dublin, in 1934.

BIBLIOGRAPHY
Gautier, 1860(a); 1860(b), p. 202; Astruc, 1860;
Moreau, 1873, p. 259; Robaut, 1885, no. 1373, repro.;
Ponsonailhe, 1885, p. 182; Johnson, 1986, vol. 3, no.
330, pl. 148.

EXHIBITIONS
1860, Paris, no. 167; 1885, Paris, no. 170.

98. *Ugolino and His Sons in the Tower*

1856–60
Oil on canvas; 19¹¹⁄₁₆ x 24 inches (50 x 61 cm)
Signed and dated at lower right:
Eug Delacroix 1860.
Copenhagen, Ordrupgaard

PROVENANCE
Painted for the dealer Estienne in June 1860; Brame,
January 1887 (put up for sale at 30,000 francs);
Charles Leveque collection, 1892; Baillehache collec-
tion, 1916; collection of Wilhelm Hansen,
Ordrupgaard, Copenhagen, 1918–36; collection of
Hansen's widow until 1951; in 1952 entered the col-
lections of the Ordrupgaard museum, founded by
Wilhelm Hansen in 1918.

BIBLIOGRAPHY
Cantaloube, 1864, p. 217; Robaut, 1885, no. 1063,
repro.; Johnson, 1986, vol. 3, no. 337, pl. 158;
Daguerre de Hureaux, 1993, pp. 158, 160, 161, 328,
repro.; Rautmann, 1997, p. 230, fig. 211.

EXHIBITIONS
1930, Paris, no. 187, repro.; 1964, Edinburgh and
London, no. 72, repro.

v. *THE LESSON OF MOROCCO*

99. *Arab Chieftain Signaling to His Companions*

1851
Oil on canvas; 22 x 18⅛ inches (55.9 x 46 cm)
Signed and dated at lower left:
Eug Delacroix / 1851
Norfolk, Virginia, The Chrysler Museum of
Art, Gift of Walter P. Chrysler, Jr. (83.588)

PROVENANCE
Baron Michel de Trétaigne collection, 1860; sale,
Trétaigne, Paris, Hôtel Drouot, February 19, 1872,
lot 20, repro. (14,000 francs); Sarlat collection, 1885;
Knoedler, New York, 1889; sold by Knoedler to
Cottier and Company, New York, May 1, 1894;
Alexander M. Byers collection, Pittsburgh, 1930–44
(?); John Frederick Byers collection, Pittsburgh,
1948–62; Mrs. Frederick Byers collection, Westbury,
Long Island, 1964; Eugene V. Thaw, New York,
1976; collection of Walter P. Chrysler, Jr.; given to
the Chrysler Museum of Art, Norfolk, in 1983.

BIBLIOGRAPHY
Journal, p. 197; Silvestre, 1855, p. 81; Astruc, 1860, p.
37; Moreau, 1873, p. 271; Robaut, 1885, no. 1187,
repro.; Johnson, 1986, vol. 3, no. 386, pl. 194; Arama,
1987, no. 33, p. 212, repro.; Arama, 1992, p. 10, repro.

EXHIBITIONS
1860, Paris, no. 172; 1864, Paris, no. 94; 1885, Paris,
no. 202; 1944, New York, no. 33, repro.

100. *View of Tangier with Two Seated Arabs*

1852
Oil on canvas; 18⁹⁄₁₆ x 22³⁄₁₆ inches
(47.2 x 56.4 cm)
Signed at lower left: *Eug. Delacroix*
The Minneapolis Institute of Arts, Gift of
Georgiana Slade Reny (93.67)

PROVENANCE
Sold by Delacroix, February 1, 1853, to the dealer

Weill; Durand-Ruel; Adolphe E. Borie collection, Philadelphia; Mrs. Adolphe E. Borie collection, Philadelphia, 1880–87 (?); James J. Hill collection, Saint Paul, Minnesota; Mrs. James J. Hill collection; collection of Mrs. Georgiana Slade Reny, her grand-daughter, Saint Paul; given to the Minneapolis Institute of Arts in 1993.

BIBLIOGRAPHY
Journal, p. 317; Silvestre, 1855, p. 82; Moreau, 1873, p. 155, n. 1; Johnson, 1986, vol. 3, no. 390, pl. 198; Arama, 1987, no. 44, repro. (reversed); Arama, 1994–95, p. 77, repro.

101. *The Riding Lesson*

1854
Oil on canvas; 25⅛₆ x 31⅞ inches (64 x 81 cm)
Signed and dated at lower left:
Eug. Delacroix 1854.
Chicago, private collection

PROVENANCE
Bouruet collection, 1864; collection of Mme de Cassin, later marquise Landolfo-Carcano, 1884; sale, Landolfo-Carcano, Paris, Galerie Georges Petit, May 30–31, 1912, lot 25, repro.; acquired by Tauber (140,100 francs); Tauber until c. 1930; Stephen Clark, New York, 1934; acquired by Knoedler, New York, in 1937; sold by Knoedler to Paul Rosenberg in 1937; David David-Weill collection; collection of David-Weill's widow until 1970; private collection, Chicago, since 1973.

BIBLIOGRAPHY
Journal, p. 436; *Correspondance*, vol. 3, p. 228, n. 3, p. 230, n. 2; Baudelaire, 1855 (reprinted in Charles Baudelaire, *Baudelaire: Oeuvres complètes* [Paris: Michel Lévy Frères, 1968], vol. 5, p. 240; cf. Claude Pichois, ed., *Baudelaire: Oeuvres complètes* [Paris: Gallimard, 1976], vol. 3, p. 594); Petroz, 1855; Mantz, 1855, p. 172; Gautier, 1855(a); Du Camp, 1855, p. 112; Piron, 1865, p. 110 (mistakenly dated 1858); Moreau, 1873, p. 192; Robaut, 1885, p. 497, no. 1237, repro.; Tourneux, 1886, pp. 94–98; M. Sérullaz, 1963(a), no. 464, repro.; Johnson, 1986, vol. 3, no. 395, pl. 205; Jobert, 1997, p. 171, fig. 141.

EXHIBITIONS
1854, Amsterdam, no. 61; 1855, Paris, no. 2938; 1864, Paris, no. 135; 1930, Paris, no. 162; 1963(a), Paris, no. 464; 1987(a), Zurich, no. 98, p. 238, p. 239, repro.

102. *Bathers* or *Turkish Women Bathing*

1854
Oil on canvas; 36½ x 31 inches (92.7 x 78.7 cm)
Signed and dated at lower left:
Eug. Delacroix / 1854
Hartford, Connecticut, Wadsworth Atheneum, The Ella Gallup Sumner and Mary Catlin Sumner Collection Fund (1952.300)

PROVENANCE
Commissioned from Delacroix by M. Berger, suggested as J. J. Berger, Prefect of the Seine (according to Joubin); Goupil collection, 1864 (?); sale, Paris, March 4, 1868 (5,000 francs, according to Moreau, 1873, p. 274); comte de Lambertye collection; sale, Lambertye, Paris, Hôtel Drouot, December 17, 1868, lot 19 (7,800 francs); John Saulnier collection, Bordeaux, 1873; sale, Saulnier, Paris, Hôtel Drouot, June 5, 1886, lot 39 *(Femmes d'Alger au bain);* acquired by M. Jagoux (15,500 francs; annotated by Robaut, no. 1240 *bis*); Jagoux collection; Ferdinand Blumenthal collection, 1910; comte Cecil Pecci-Blunt collection, 1928; M. and Mme R. L. collection, 1948; Paul Rosenberg, New York; acquired by the Wadsworth Atheneum, Hartford, in 1952.

BIBLIOGRAPHY
Journal, pp. 410, 413, 418–19, 451; *Correspondance*, vol. 3, p. 310; Moreau, 1873, p. 274; Robaut, 1885, no. 1240, repro.; M. Sérullaz, 1963(a), no. 457, repro.; Johnson, 1986, vol. 3, 1986, no. 169, pl. 6; Daguerre de Hureaux, 1993, pp. 191, 196, 197, repro.; Daguerre de Hureaux and Guégan, 1994, pp. 72–74, repro.

EXHIBITIONS
1864, Paris, no. 303 (2nd supplement); 1885, Paris, no. 197 *(Baigneuses dans un parc.—Orient);* 1963(a), Paris, no. 451; 1987(a), Zurich, no. 97, pp. 236, 334, 237, repro.

103. *Arabs Traveling*

1855
Oil on canvas; 21¼ x 25⅝ inches (54 x 65 cm)
Signed and dated at lower left:
Eug. Delacroix. 1855
Providence, Rhode Island School of Design, Museum of Art (35.786)

PROVENANCE
Perhaps collection of Anatole Demidoff, prince of San Donato; baron Michel de Trétaigne collection, 1864; sale, baron de Trétaigne, Paris, Hôtel Drouot, February 19, 1872, lot 18, repro. (300,000 francs); baronne Nathaniel de Rothschild collection, 1873; Henri de Rothschild collection, 1928; Georges Bernheim, 1933; sold by Bernheim to Knoedler, New York, in July 1935; Martin Birnbaum, November 1935; acquired by the Rhode Island School of Design, Providence, in 1935.

BIBLIOGRAPHY
Journal, p. 568; Moreau, 1873, pp. 102, 275; Robaut, 1885, no. 1277, repro.; M. Sérullaz, 1963(a), no. 426, repro.; Johnson, 1986, vol. 3, no. 399, pl. 208; Arama, 1987, no. 53, repro.; Daguerre de Hureaux, 1993, pp. 191, 194, repro.; Daguerre de Hureaux and Guégan, 1994, pp. 30–31, repro.

EXHIBITIONS
1864, Paris, no. 94 *(Arabes dans la montagne);* 1885, Paris, no. 187; 1928, Paris, no. 30; 1930, Paris, no. 166, repro. *Album*, p. 90; 1933, Paris, no. 198; 1944, New York, no. 37; 1962–63, Toronto and Ottawa, no. 20, repro.; 1963(a), Paris, no. 476.

104. *The Fanatics of Tangier*

1857
Oil on canvas; 18½ x 22⅛₆ inches (47 x 56 cm)
Signed and dated near lower left, on a step:
Eug. Delacroix. 1857.
Toronto, Art Gallery of Ontario (62.5)

PROVENANCE
Perhaps sold by Delacroix to the dealer Weill; sold by Weill, Paris, January 2, 1858, lot 11; acquired by David Michau (2,900 francs); David Michau collection; sold posthumously, Paris, rue Chaveau-Lagarde, October 11, 1877, lot 16; acquired by Brame (10,000 francs); baron de Beurnonville collection; sale, Beurnonville, Paris, Hôtel Drouot, April 29, 1880, lot 13, repro.; acquired by Perreau (12,000 francs); Perreau collection; acquired by Boussod, Valadon and Company, October 24, 1881; sold by Boussod, Valadon and Company to Brame, October 24, 1882 (Goupil-Boussod archives; cited by Johnson); Jules Warnier collection, Reims, 1885; Van den Eynde collection, Brussels, 1889; sale, Mme G. Van den Eynde, Paris, Hôtel Drouot, May 18–19, 1897, lot 7, repro. (36,200 francs); Dieulafoy collection; acquired by Wildenstein, c. 1920; sold by Wildenstein to Emil Staub, Männedorf, Switzerland, in 1926; collection of Emil Staub-Terlinden's widow, Männedorf, 1930–45 (?); Wildenstein, Paris and New York, 1945–62; acquired by the Art Gallery of Ontario, Toronto, in 1962.

BIBLIOGRAPHY
Journal, p. 573; Gautier, 1858, pl. IV; Moreau, 1873, p. 177, n. 2; Robaut, 1885, no. 1316, repro.; M. Sérullaz,

1963(a), no. 490, repro.; Johnson, 1986, vol. 3, no. 403, pl. 177; Arama, 1987, p. 175, n. 97, repro. pp. 112–13 and no. 52; Arama, 1992, p. 65, repro.; Arama, 1994–95, p. 75, repro.; Rautmann, 1997, pp. 167–68, figs. 158, 160; Jobert, 1997, fig. 123.

EXHIBITIONS

1885, Paris, no. 231; 1928, Paris, no. 34; 1930, Paris, no. 173, repro. *Album*, p. 94; 1939, Zurich, no. 365; 1944, New York, no. 39; 1952, London, no. 34; 1962–63, Toronto and Ottawa, no. 21, repro.; 1963(a), Paris, no. 486; 1964, Edinburgh and London, no. 65; 1987(a), Zurich, no. 106, pp. 252, 253, 335, repro.

105. *Moroccan Troops Fording a River*

1858
Oil on canvas; 23⅝ x 28¾ inches (60 x 73 cm)
Signed and dated at lower left:
Eug. Delacroix / 1858
Paris, Musée d'Orsay, Bequest of comte Isaac de Camondo, transferred from the Musée du Louvre (RF 1987)

PROVENANCE

Commissioned from Delacroix in 1856 by Anatole Demidoff, prince of San Donato (3,000 francs); sale, San Donato, Paris, 26, boulevard des Italiens, February 21, 1870, lot 27; acquired by Petit (14,800 francs); Edouard Kums collection, Anvers; sale Kums, Anvers, May 17, 1898, lot 5, repro.; acquired by Durand-Ruel, acting on behalf of Isaac de Camondo (84,000 francs); Isaac de Camondo collection; bequeathed to the Musée du Louvre, 1908; entered the museum in 1914; transferred to the Musée d'Orsay in 1987.

BIBLIOGRAPHY

Journal, p. 577; Piron, 1865, p. 110; Robaut, 1885, no. 1347, repro.; Johnson, 1986, vol. 3, no. 406, pl. 215; Arama, 1987, no. 50, repro.; Daguerre de Hureaux, 1993, p. 191, p. 194, repro.; Daguerre de Hureaux and Guégan, 1994, pp. 106–7, repro.

EXHIBITIONS

1930, Paris, no. 176; 1933, Paris, no. 200; 1951, Paris, no. 6; 1963, Bordeaux, no. 54, repro.; 1967, Paris, no. 8; 1994–95, Paris, no. 99, p. 225, repro.

106. *View of Tangier from the Seashore*

1858
Oil on canvas; 31¹⁵⁄₁₆ x 39⁵⁄₁₆ inches (81.1 x 99.8 cm)
Signed and dated at lower left:
Eug. Delacroix / 1858.
The Minneapolis Institute of Arts, Bequest of Mrs. Erasmus C. Lindley in memory of her father, Mr. James J. Hill (49.4)

PROVENANCE

Painted for the dealer Tedesco; Salomon Goldschmidt collection, 1860; sold posthumously, Paris, May 17, 1888, lot 31, repro.; acquired by Fanien (50,000 francs); Fanien collection; sold by Fanien to Boussod, Valadon and Company, March 2, 1892; sold by Boussod, Valadon and Company to James J. Hill, Saint Paul, Minnesota, May 27, 1892 (Goupil-Boussod archives; cited by Johnson); James J. Hill collection; Mrs. James J. Hill collection; collection of her daughter, Mrs. E. C. Lindley, New York; given to the Minneapolis Institute of Arts in 1949.

BIBLIOGRAPHY

Journal, pp. 588, 590; Gautier, 1860(c); Astruc, 1860, pp. 44, 46; Piron, 1865, p. 11; Robaut, 1885, no. 1348, repro.; Johnson, 1986, vol. 3, no. 408, pl. 218; Arama, 1987, no. 56, repro.; Daguerre de Hureaux and Guégan, 1994, pp. 86–87, repro.; Jobert, 1997, pp. 171–72, fig. 142.

EXHIBITIONS

1860, Paris, no. 348 (supplement); 1962–63, Toronto and Ottawa, no. 23, repro.; 1964, Edinburgh and London, no. 66, repro. (exhibited in London only); 1994–95, Paris, no. 101, repro.

107. *Horses Coming Out of the Sea*

1860
Oil on canvas; 19¹¹⁄₁₆ x 24 inches (50 x 61 cm)
Signed and dated at lower right:
Eug. Delacroix / 1860.
Washington, D.C., The Phillips Collection (0486)

PROVENANCE

Commissioned by the dealer Estienne in 1858; marquis du Lau collection; sale, marquis du Lau, Paris, Hôtel Drouot, May 5, 1869, lot 7; acquired by M. Edwards (16,000 francs); Edwards collection; sale, Edwards, Paris, Hôtel Drouot, March 7, 1870, lot 9; acquired by Fanien (14,500 francs); Fanien collection; Faure collection; sale, Faure, Paris, 26, boulevard des Italiens, June 7, 1873, lot 8, repro.; acquired by Laurent-Richard (26,500 francs); Laurent-Richard collection; sale, Laurent-Richard, Paris, Hôtel Drouot, May 23, 1878, lot 14, repro.; acquired by Alfred Mame, Tours (16,100 francs); Alfred Mame collection; sale, Mame, Paris, Galerie Georges Petit, April 26, 1904, lot 74, repro.; acquired by Haro (30,200 francs); Mme Esnault-Pelterie collection, 1906; sold by Mme Esnault-Pelterie to Bernheim-Jeune, November 15, 1912; sold by Bernheim-Jeune

to Troplowitz, October 23, 1915 (Bernheim-Jeune archives; cited by Johnson); baron Denys Cochin collection; sale, Cochin, Paris, Galerie Georges Petit, March 26, 1919, lot 13, repro. (42,500 francs); Emil Staub collection, Männedorf, Switzerland, 1921; collection of Emil Staub-Terlinden's widow, Männedorf, 1936–45; acquired by the Phillips Collection, Washington, D.C. in 1945.

BIBLIOGRAPHY

Journal, pp. 711 (?), 731, 780, 781; Burty, 1878 (will of August 3, 1863); Burty, 1885; Robaut, 1885, no. 1410, repro.; M. Sérullaz, 1963(a), no. 505, repro.; Johnson, 1986, vol. 3, no. 414, pl. 219; Arama, 1987, no. 55, repro.; Arama, 1992, p. 33, repro.; Daguerre de Hureaux, 1993, p. 206, p. 209, repro.

EXHIBITIONS

1885, Paris, no. 136; 1928, Paris, no. 38; 1930, Paris, no. 189; 1939, Zurich, no. 370; 1944, New York, no. 42, p. 49, repro.; 1963(a), Paris, no. 502.

108. *Horses Fighting in a Stable*

1860
Oil on canvas; 25⁷⁄₁₆ x 31⅞ inches (64.5 x 81 cm)
Signed and dated at lower left:
Eug. Delacroix / 1860
Paris, Musée d'Orsay, Bequest of comte Isaac de Camondo, transferred from the Musée du Louvre (RF 1988)

PROVENANCE

Commissioned from Delacroix by the dealer Estienne; Allou and Erler collection; sale, Allou and Erler, Paris, Hôtel Drouot, February 12, 1872, lot 13; acquired by Durand-Ruel (17,000 francs); John Saulnier collection, Bordeaux, 1873; Charles Hayem collection, 1885; Isaac de Camondo collection; bequeathed to the Musée du Louvre in 1908; entered the Louvre in 1914; transferred to the Musée d'Orsay.

BIBLIOGRAPHY

Journal, pp. 581, 665, 704, 780; Moreau, 1873, p. 275; Robaut, 1885, no. 1409, repro.; M. Sérullaz, 1963(a), no. 506, repro.; Johnson, 1986, vol. 3, no. 413, pl. 223; Arama, 1987, no. 57, repro.; Daguerre de Hureaux, 1993, p. 206, repro.; Daguerre de Hureaux and Guégan, 1994, p. 46, repro.; Rautmann, 1997, fig. 249; Jobert, 1997, p. 171, fig. 135.

EXHIBITIONS

1885, Paris, no. 96; 1930, Paris, no. 190; 1933, Paris, no. 201; 1945, Paris, no. 11; 1946(a), Paris, no. 11; 1946(b), Paris, no. 11; 1956, Venice, no. 39; 1963(a), Paris, no. 503; 1964, Edinburgh and London, no. 73; 1969, Kyoto and Tokyo, no. 40, repro.; 1973, Paris; 1994–95, no. 102, repro.

VI. RELIGIOUS ASPIRATION

109. *The Good Samaritan*

c. 1849–51
Oil on canvas; 14½ x 11¾ inches
(36.8 x 29.8 cm)
Signed at lower right: *Eug. Delacroix*
Waterhouse Collection

PROVENANCE
Sold directly by Delacroix to Paul Meurice, a friend of August Vacquerie and Victor Hugo, at the beginning of 1851 (300 francs); Paul Meurice collection, Paris, at least until 1858; sold by Meurice before 1878 to Auguste Vacquerie, who had bought two other paintings from the Salon of 1850–51; Auguste Vacquerie collection, Paris, at least until 1895 and probably until his death in 1897; Mme Albert Esnault-Pelterie collection from before 1900 until 1938 (wax seal of the collection on verso, on the frame); collection of Mme Germaine Popelin, her daughter; collection of Mme Jacques Meunié, née Popelin, granddaughter of Mme Albert Esnault-Pelterie; sale, London, Sotheby's, March 20, 1992, lot 34; Waterhouse Collection.

BIBLIOGRAPHY
Journal, p. 197; *Correspondance,* vol. 3, p. 53; Montaiglon, 1851; Peisse, 1851; Desplaces, 1851; Courtois, 1851; Galimard, 1851; Clément de Ris, 1851, p. 4; Mantz, 1851; Arnoux, 1851; Du Pays, 1851; Rochery, 1851; Sabatier-Ungher, 1851; Gautier, 1851; Calonne, 1851; Thiérry, 1851; Vignon, 1851, p. 99; Moreau, 1873, p. 186; Robaut, 1885, no. 1168; M. Sérullaz, 1963(a), no. 414, repro.; Johnson, 1986, vol. 3, no. 437, pl. 246; Rautmann, 1997, p. 327, fig. 318.

EXHIBITIONS
1850–51, Paris, no. 780; 1864, Paris, no. 29; 1885, Paris, no. 224; 1930, Paris, no. 138; 1963(a), Paris, no. 409, repro.

110. *Saint Sebastian Tended by the Holy Women*

c. 1850–54
Pastel on paper; 7⁷⁄₁₆ x 10⁷⁄₁₆ inches (18.2 x 26.5 cm)
Annotated in pen on the verso on a piece of paper: *Donné par moi à Jenny Le Guillou / le 24 mars 1855 / Eug. Delacroix*
Private collection

PROVENANCE
Given by Delacroix to Jenny le Guillou, March 24, 1855; baron Joseph Vitta collection; Georges Heilbrun collection; Pierre Bérès collection; sale, Bérès, London, Sotheby's, November 30, 1993, lot 7, repro.; private collection.

BIBLIOGRAPHY
Journal, p. 478; Johnson, 1995, no. 37, repro.

EXHIBITION
1930, Paris, no. 375A.

111. *Disciples and Holy Women Carrying Away the Body of Saint Stephen*

1853
Oil on canvas; 58½ x 45½ inches (148 x 115 cm)
Signed and dated at lower left:
Eug Delacroix 1853
Arras, Musée des Beaux-Arts (859.1)

PROVENANCE
Acquired in 1859 by the city of Arras (4,000 francs) with Constant Dutilleux as intermediary, following a visit to the artist's studio by the painter Charles Daverdoing on March 14, 1859; payment made in two installments: 3,000 francs immediately and 1,000 francs in the following fiscal year.

BIBLIOGRAPHY
Journal, pp. 167, 321; *Correspondance,* vol. 3, p. 218, and vol. 4, pp. 79–80, 83–84, 87, 98; Mérimée, 1853; Peisse, 1853; Calonne, 1853, p. 147; Delécluze, 1853; Tillot, 1853; Du Pays, 1853, p. 380; Delaborde, 1853, pp. 1137, 1138 (reprinted in Henri Delaborde, *Mélanges sur l'art contemporain* [Paris, 1866], pp. 72–74); Saint-Victor, 1853; Gautier, 1853; Mantz, 1853, pp. 81, 83; Viel-Castel, 1853, p. 630; Clément de Ris, 1853, p. 179; Henriet, 1853, p. 4 (reprinted in Frédéric Henriet, *Coup d'oeil sur le Salon de 1853* [Paris, 1853], pp. 13–14); Arnoux, 1853; Boyeldieu d'Auvigny, 1853, pp. 57, 58; Madelène, 1853, pp. 29–31; Vignon, 1853, pp. 78, 80; Silvestre, 1855, p. 84; Silvestre, 1864, p. 38; Moreau, 1873, pp. 186, 201; Robaut, 1885, no. 1211, repro.; M. Sérullaz, 1963(a), no. 437, repro.; Johnson, 1986, vol. 3, no. 449, pl. 257; Daguerre de Hureaux, 1993, p. 230, repro.; Jobert, 1997, p. 293, fig. 253.

EXHIBITIONS
1853, Paris, no. 350 *(Après le martyre de Saint Étienne, des disciples et des saintes femmes viennent pieusement relever son corps pour l'ensevelir);* 1885, Paris, no. 5; 1928, Paris, no. 26; 1930, Paris, no. 151; 1937, Paris, no. 321; 1939, Zurich, no. 354; 1939, Basel, no. 247; 1952, London, no. 40; 1963(a), Paris, no. 434; 1973, Paris.

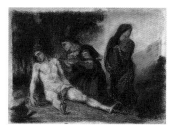

112. *The Supper at Emmaus* or *The Pilgrims of Emmaus*

1853
Oil on canvas mounted on wood; 22 x 18⅛ inches (56 x 46 cm)
Signed and dated at lower left:
Eug. Delacroix / 1853
New York, The Brooklyn Museum of Art, Gift of Mrs. Watson B. Dickerman (50.106)

PROVENANCE
Sold by Delacroix to Mme Herbelin, a miniaturist, in April 1853, before the Salon (3,000 francs); delivered to Mme Herbelin in November 1853, after the Salon; Fanien collection, 1873; Monjean collection; Charles Levesque collection, 1885; Watson B. Dickerman collection, New York, 1916; given by Mrs. Watson B. Dickerman to the Brooklyn Museum of Art, New York, in 1950.

BIBLIOGRAPHY
Journal, p. 316; *Correspondance,* vol. 3, pp. 147, 176, 218, vol. 4, pp. 191, 192; Peisse, 1853; Delécluze, 1853; Tillot, 1853, p. 381; Delaborde, 1853, p. 1137; Saint-Victor, 1853; Gautier, 1853; Calonne, 1853, p. 147; Mantz, 1853, p. 80; Viel-Castel, 1853, p. 630; Clément de Ris, 1853; Henriet, 1853; Arnoux, 1853; Madelène, 1853, p. 30; Gautier, 1860(a); Gautier, 1860(b), p. 200; Moreau, 1873, p. 187; Robaut, 1885, no. 1992, repro.; M. Sérullaz, 1963(a), no. 439, repro.; Johnson, 1986, vol. 3, no. 458, pl. 266; Daguerre de Hureaux, 1993, pp. 228, 229, 304, 325, p. 228, repro.; Jobert, 1997, p. 294, fig. 251.

EXHIBITIONS
1853, Paris, no. 351; 1864, Paris, no. 32; 1885, Paris, no. 129; 1944, New York, no. 34; 1962–63, Toronto and Ottawa, no. 17, repro.; 1963(a), Paris, no. 436, repro.

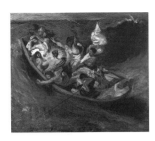

113. *Christ on the Sea of Galilee*

c. 1840–45
Oil on canvas; 18 x 21½ inches (45.7 x 54.6 cm)
Kansas City, Missouri, The Nelson-Atkins
Museum of Art, Purchase: Nelson Trust
through exchange of gifts of the Friends of Art,
Mr. and Mrs. Gerald Parker, and the Durand-
Ruel Galleries, and Bequest of John K.
Havemeyer (89-16)

PROVENANCE
Delacroix Atelier; sold posthumously, Paris, Hôtel
Drouot, February 17–19, 1864, lot 131 *(Esquisses, Jésus
endormi dans la barque pendant le tempête);* acquired
by M. Filhston (1,570 francs); Fihlston collection;
Mme Soultzener collection from 1873 to the end of
1885; M. Veneau collection; sold by Veneau to
Durand-Ruel, Paris, June 16, 1909; sold by Durand-
Ruel to Bernheim; Bernheim-Jeune, from December
30, 1909; sold by Bernheim-Jeune to Georg
Reinhart, Winterthur, September 29, 1913
(Bernheim-Jeune archives, cited by Johnson); Georg
Reinhart collection, Winterthur; collection of Mme
Hafter-Reinhart, her daughter, Zurich, until 1962;
sale, London, Sotheby's, November 22, 1983, lot 9,
repro.; acquired by Wheelock Whitney (£104,500);
Wheelock Whitney collection, New York, 1983–85;
Richard L. Feigen and Company, 1989; Nelson-
Atkins Museum of Art, Kansas City, 1990.

BIBLIOGRAPHY
Moreau, 1873, p. 262; Robaut, 1885, no. 1217, repro.;
Johnson, 1986, vol. 3, no. 451, pl. 262; Daguerre de
Hureaux, 1993, pp. 210–11, 232, 233, 319, 325, 326,
335, p. 233, repro.; Rautmann, 1997, p. 292, fig. 282.

EXHIBITIONS
1885, Paris *(Barque du Christ)*; 1939, Basel, no. 248;
1963–64, Bern, no. 77.

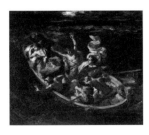

114. *Christ on the Sea of Galilee*

c. 1840–45
Oil on canvas; 18⅛ x 32¾ inches
(46.1 x 55.7 cm)
Signed at lower right, on boat: *Eug. Delacroix*
Portland, Oregon, Portland Art Museum, Gift
of Mrs. William Mead Ladd and her children
in memory of William Mead Ladd (31.4)

PROVENANCE
Mlle Micheline Dziekanska collection (inscribed in
ink on the frame); Van Praet collection, Brussels,
1873–88; collection of Paul Devaux, his nephew,
until c. 1892; acquired by Henri Garnier together
with the former collection of Van Praet in January
1893; sold by the court following the bankruptcy of
Henri Garnier, Paris, Galerie Georges Petit,
December 3, 1894, lot 43, repro.; acquired by
Durand-Ruel in a joint partnership with Boussod,
Valadon and Company (9,700 francs); Durand-Ruel
surrendered its share to Boussod, Valadon and
Company, May 30, 1895 (Durand-Ruel archives;
cited by Johnson); Boussod, Valadon and Company,
Paris; sold by Boussod, Valadon and Company to
Cottier and Company, New York, July 1, 1895
(Goupil-Boussod archives, cited by Johnson);
Cottier and Company, New York; Ingles collection,
Portland; William Mead Ladd collection, Portland,
from 1913 to January 1931; lent to the Portland Art
Museum, 1913–30; entrusted to Dr. Louis Ladd,
New York, 1930–31; given by Mrs. William Mead
Ladd to the Portland Art Museum in February 1931.

BIBLIOGRAPHY
Moreau, 1873, p. 262 (Moreau points out a signature
at the left); Robaut, 1885, no. 1219, repro; M.
Sérullaz, 1963(a), no. 448, repro.; Johnson, 1986, vol.
3, no. 452, pl. 262; Daguerre de Hureaux, 1993, pp.
210–12, 232, 233, 319, 325, 328, p. 233, repro.;
Rautmann, 1997, p. 292, fig. 283; Jobert, 1997, p.
294, fig. 260.

EXHIBITIONS
1944, New York, no. 36; 1962–63, Toronto and
Ottawa, no. 18, repro.; 1963(a), Paris, no. 442;
1987(a), Zurich, no. 93, repro.

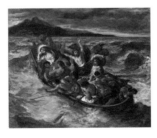

115. *Christ on the Sea of Galilee*

c. 1853
Oil on canvas; 20 x 24 inches (50.8 x 61 cm)
Signed at lower left: *Eug. Delacroix.*
New York, The Metropolitan Museum of Art,
H. O. Havemeyer Collection,
Bequest of Mrs. H. O. Havemeyer, 1929
(29.100.131)

PROVENANCE
Painted for the dealer François Petit in 1853; Bouruet-
Aubertot collection, 1860 (according to Johnson); sale,
M. R.-L. L., lot 11; John Saulnier collection,
Bordeaux, 1885; sale, Saulnier, Paris, Hôtel Drouot,
June 5, 1886, lot 35, repro.; withdrawn from the sale at
14,000 francs; sale, Saulnier, Paris, Sedelmeyer
Gallery, March 25, 1892, lot 8, repro. (26,000 francs);
Durand-Ruel, Paris; H. O. Havemeyer collection,
New York, 1892; bequeathed to the Metropolitan
Museum of Art, New York, in 1929.

BIBLIOGRAPHY
Journal, pp. 364, 367; Silvestre, 1855, p. 81; Gautier,

1860(a), p. 202; Madelène, 1864, p. 17; Moreau, 1873,
p. 262; Robaut, 1885, no. 1215, repro.; Johnson, 1986,
vol. 3, no. 454, pl. 263; Daguerre de Hureaux, 1993,
pp. 210–12, 232, 233, 319, 325, 326, 333; Rautmann,
1997, p. 292, fig. 284 and detail, fig. 256.

EXHIBITIONS
1860, Paris, perhaps no. 349; 1864, Paris, perhaps no.
125; 1885, Paris, no. 201; 1987(a), Zurich, no. 95,
repro.

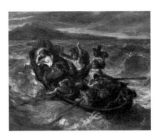

116. *Christ on the Sea of Galilee*

c. 1853
Oil on canvas; 19¹¹⁄₁₆ x 24 inches (50 x 61 cm)
Signed at lower right: *Eug. Delacroix*
Private collection (courtesy of the Nathan
Gallery, Zurich)

PROVENANCE
Perhaps painted in spring 1853 for count Grzymala, a
friend of Frédéric Chopin; Grzymala collection,
Paris; Bouruet-Aubertot collection, 1860 (Johnson);
Verdier collection, Paris; Joseph Crabbe collection,
Brussels, 1873; Durand-Ruel, Paris; collection of
Frémyn (notary for the Orléans family), Paris; sale,
Frémyn, Paris, Galerie Durand-Ruel, April 8, 1875,
lot 21 (17,500 francs); possibly in the Perreau collec-
tion (Johnson); Boussod, Valadon and Company,
Paris, October 24, 1881; sold by Boussod, Valadon
and Company to M. Hollender, Brussels, December
10, 1881 (Goupil-Boussod archives; cited by
Johnson); collection of Paul Gallimard, Jr., from
1885 to the end of 1908; Paul Cassirer collection,
Amsterdam, 1932; baron H. Thyssen-Bornemisza
collection, Lugano, 1937; acquired by Fritz Nathan,
Zurich, in December 1937; Fritz Nathan collection,
Zurich, until 1972; private collection.

BIBLIOGRAPHY
Journal, p. 357; Silvestre, 1855, p. 81; Moreau, 1873, p.
262; Robaut, 1885, no. 1215 *bis*, repro.; M. Sérullaz,
1963(a), no. 449, repro.; Johnson, 1986, vol. 3, no.
453, pl. 263; Daguerre de Hureaux, 1993, pp. 210–12,
232, 233, 319, 325, 326, 333; Rautmann, 1997, p. 292,
fig. 285.

EXHIBITIONS
1860, Paris, perhaps no. 349 (according to Johnson);
1864, Paris, perhaps no. 125; 1885, Paris, no. 82; 1950,
Paris; 1956, Venice, no. 33; 1963(a), Paris, no. 443;
1963–64, Bern, no. 78; 1964, Bremen, no. 70, repro.;
1964, Edinburgh and London, no. 61; 1987(a),
Zurich, no. 94, repro.

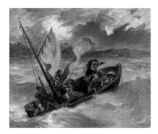

117. *Christ on the Sea of Galilee*

1853
Oil on canvas; 23⅝ x 28¾ inches (60 x 73 cm)
Signed and dated at lower right:
Eug. Delacroix 1853
Zurich, E. G. Bührle Foundation

PROVENANCE
Baptistin Guilhermoz collection, 1860; Davin collection; sale, Davin, Paris, Hôtel Drouot, March 29, 1862, lot 8; acquired by Émile Péreire (4,700 francs); Émile Péreire collection, Paris, until 1864; Charles Edwards collection; sale, Edwards, Paris, Hôtel Drouot, March 7, 1870, lot 6, repro.; withdrawn from the sale at 28,000 francs; Carlin collection, Paris; sale, Carlin, Paris, April 29, 1872, lot 6; acquired by M. Vaysse, Marseille (27,500 francs); Vaysse collection, Marseille; sold by Vaysse to Goupil and Company, Paris, in May 1873; sold by Goupil and Company to Schwabacher, June 3, 1873 (Goupil-Boussod archives, cited by Johnson); Schwabacher collection; repurchased by Goupil and Company from Schwabacher in May 1878; sold by Goupil and Company to baron Edmond de Beurnonville in June 1878 (20,000 francs; Goupil and Company archives; cited by Johnson); sale, baron de Beurnonville, Paris, Hôtel Drouot, April 29, 1880, lot 12, repro. (20,000 francs); Henri Hecht collection, 1885; Joseph Gillot collection, Lyon, 1892; acquired by Emile Bührle from a Swiss dealer in 1950; Emile Bührle collection, Zurich, until 1956; E. G. Bührle Foundation collection, Zurich.

BIBLIOGRAPHY
Correspondance, vol. 4, p. 250; Silvestre, 1855, p. 81; Astruc, 1860; Gautier, 1860(a), p. 202; Thoré, 1864, p. 197; Madelène, 1864, p. 17; Moreau, 1873, p. 262; Robaut, 1885, no. 1220, repro.; Johnson, 1986, vol. 3, 1986, pl. 264; Daguerre de Hureaux, 1993, pp. 210–12, 232, 233, 319, 326, 335.

EXHIBITIONS
1864, Paris, no. 77; 1885, Paris, no. 110 *(La Barque).*

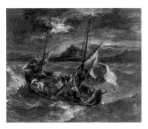

118. *Christ on the Sea of Galilee*

1854
Oil on canvas; 23½ x 28⅞ inches
(59.8 x 73.3 cm)
Signed and dated at lower right:
Eug. Delacroix. 1854
Baltimore, The Walters Art Gallery (37.186)

PROVENANCE
Sold by Delacroix to the dealer Beugniet (1,200 francs, according to Jean Gigoux); Beugniet, Paris (Beugniet stamp on verso); possibly acquired by the painter Constant Troyon directly from Beugniet, 1854 (1,600 francs, according to Jean Gigoux); Constant Troyon collection, Paris; collection of Mme Troyon, mother of the artist, Paris; possibly given by Mme Troyon to M. Frémyn, a notary and executor of Constant Troyon's inheritance; Frémyn collection, Paris; sale, Liebig and Frémyn, Paris, Galerie Durand-Ruel, April 8, 1875, lot 21; Tabourier collection, Paris; Viot collection, 1885; sale, Viot, Paris, Hôtel Drouot, May 25, 1886, lot 2, repro.; acquired by M. Levesque (49,000 francs); Levesque collection, Paris; Henry Walters collection, Baltimore, in 1887; The Walters Art Gallery, Baltimore.

BIBLIOGRAPHY
Journal, p. 598; Cantaloube, 1864, p. 41; Moreau, 1873, p. 262 (Moreau cites 1853 as the date on the painting); Robaut, 1885, no. 1214, repro. (Robaut also cites 1853); Johnson, 1986, vol. 3, no. 456, pl. 265; Daguerre de Hureaux, 1993, pp. 210–12, 232, 233, 319, 325, 326, 335, repro.

EXHIBITIONS
1864, Paris, no. 33; 1885, Paris, no. 229; 1956, Venice, no. 34, repro.; 1963(a), Paris, no. 444, repro.; 1964, Edinburgh and London, no. 63, repro.; 1987(a), Zurich, no. 96, repro.

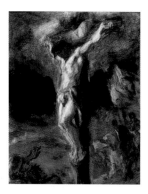

119. *Christ on the Cross* (sketch)

1845
Oil on wood; 14⁷⁄₁₆ x 9⅞ inches (37 x 25 cm)
Rotterdam, Museum Boymans–van Beuningen
(inv. 2625)

PROVENANCE
Collection of Alexandre Dumas, *père,* Paris, 1845; perhaps sold by Alexandre Dumas to Paul Meurice (certain historians believe that the work was sold directly to Meurice by Delacroix, but Théophile Thoré attests to the presence of the work in the collection of Alexandre Dumas in 1845); Paul Meurice collection, Paris, 1885; sold posthumously, Paris, Hôtel Drouot, May 25, 1906, lot 80; withdrawn from the sale or sold to a member of Meurice's family; collection of Mme Albert Clemenceau-Meurice, descendant of Paul Meurice, Paris, in 1927; collection of the dealer, collector, and art historian Vitale Bloch, c. 1960; acquired by the Museum Boymans–van Beuningen, with the aid of the Vereeniging Rembrandt in 1961.

BIBLIOGRAPHY
Gautier, 1845(b); Mantz, 1845, p. 62; Thoré, 1847(b); Silvestre, 1855, p. 82; Robaut, 1885, no. 995, repro.; Johnson, 1986, vol. 3, no. 432, pl. 240; Daguerre de Hureaux, 1993, pp. 223, 225, 317, 318, 320, 325, 326, 327, 332, 339, 223, repro.; Rautmann, 1997, p. 276, fig. 267.

EXHIBITIONS
1845(b), Paris; 1885, Paris, no. 146; 1930, Paris, no. 119A; 1963, Bordeaux, no. 38; 1963–64, Bern, no. 56, pl. 21; 1964, Bremen, no. 52, repro.; 1969, Kyoto and Tokyo, no. H-25, repro.; 1973, Paris; 1986, Nice, no. 6, repro.; 1987(a), Zurich, no. 60, repro.

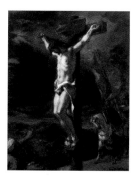

120. *Christ on the Cross*

1846
Oil on canvas; 31½ x 25¼ inches (80 x 64.2 cm)
Signed and dated at lower right:
Eug. Delacroix 1846.
Baltimore, The Walters Art Gallery (37.62)

PROVENANCE
Sold by Delacroix, with *Une odalisque,* to Van Isaker, March 16, 1847, for 1,500 francs (per Moreau-Nélaton, Escholier, and M. Sérullaz) or sold by the artist to the singer Paul Baroilhet, before the Salon of 1847 (per Johnson); Van Isaker collection, Anvers, or Paul Baroilhet collection, Paris; Van Cuyck collection; J. P. Bonnet collection, Paris; sale, Bonnet, Paris, Hôtel des Ventes Mobilières, February 19, 1853, lot 10; acquired by M. de Bréville (4,100 francs); Bréville collection; Solar collection; Osiris collection; Gavet collection; Fanien collection, 1873; sold by Fanien to Georges Petit (76,000 francs); Defoer collection, 1883; sale, Defoer, Paris, Galerie Georges Petit, May 22, 1886, lot 10, repro.; acquired by Montaignac for Henry Walters, Baltimore (29,500 francs); Henry Walters collection, Baltimore, 1887; bequeathed to the city of Baltimore in 1931; The Walters Art Gallery, Baltimore.

BIBLIOGRAPHY

Journal, p.154; *Correspondance,* vol. 3, p. 139; Karr, 1847, p. 78; Thoré, 1847(a), 1847(b); Mirbel, 1847; Gautier, 1847; Clément de Ris, 1847, pp. 75, 107; Haussard, 1847; Molay Bacon, 1847; Vaines, 1847, p. 251; Menciaux, 1847; Trianon, 1847, p. 220; anonymous, 1847, p. 137; Delaunay, n.d. [1847]; Mantz, 1847, pp. 12–18; Petroz, 1855; Perrier, 1855, p. 72; Mantz, 1855, p. 177; About, 1855, pp. 178–79; Gebauer, 1855, p. 41; Silvestre, 1855, p. 24; Moreau, 1873, pp. 152, 182, 197, 260; Robaut, 188, no. 986, repro.; Tourneux, 1886, pp. 83–85, 94–98; M. Sérullaz, 1963(a), no. 360, repro.; Johnson, 1986, vol. 3, no. 433, pl. 241; Daguerre de Hureaux, 1993, pp. 223, 225, 317, 319, 320, 325, 326, 327, 332, 339, repro.; Jobert, 1997, p. 292, fig. 249.

EXHIBITIONS

1847, Paris, no. 459; 1855, Paris, no. 2909; 1885, Paris, no. 52; 1963(a), Paris, no. 363; 1987(a), Zurich, no. 60, repro.

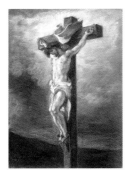

121. *Christ on the Cross*

c. 1847–50
Pastel on paper; 11¼ x 8¼ (28.5 x 21 cm)
Signed at lower left: *Eug. Delacroix.*
Private collection

PROVENANCE

Possibly offered by Delacroix to the dealer Étienne-François Haro or his wife; Étienne-François Haro collection, Paris; Paul Rosenberg, New York, 1961; private collection.

BIBLIOGRAPHY

Perhaps *Journal*, p. 119; Robaut, 1885, no. 997, repro.; Johnson, 1995, no. 35, repro.

EXHIBITION

1987–88, Frankfurt, no. 43, repro.

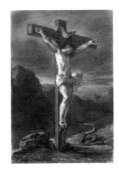

122. *Christ on the Cross*

c. 1853–56
Pastel on blue gray paper; 9¾ x 6½ inches
(24.7 x 16.5 cm)
Signed at lower left: *Eug. Delacroix.*
Ottawa, National Gallery of Canada
(inv. 15733)

PROVENANCE

Possibly Mme Louise Rang-Babur collection, La Rochelle, c. 1885; Mallet collection, Paris; Mme Philippe Vernes collection, Paris, 1930 (received by inheritance from the Mallet collection); sale, Mme Vernes, Paris, Palais Galliera, December 9, 1967, lot A; Marianne Feilchenfeldt, Zurich; acquired by the National Gallery of Canada, Ottawa, in 1968.

BIBLIOGRAPHY

Johnson, 1995, no. 36, repro.

EXHIBITIONS

1930, Paris, no. 752; 1963, Bordeaux, no. 159; 1991, New York, no. 15.

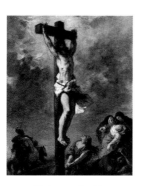

123. *Christ on the Cross*

1853
Oil on canvas; 28⅞ x 23⁷⁄₁₆ inches
(73.3 x 59.5 cm)
Signed and dated at lower left of cross:
Eug. Delacroix 1853.
London, The National Gallery (inv. 6433)

PROVENANCE

Painted for a dealer in 1853, possibly Beugniet or Bocquet; Davin collection, Paris, 1860; sale, Davin, Paris, Hôtel Drouot, March 14, 1863, lot 8 (4,000 francs); Charles Noël collection, Paris; sale, Noël, Paris, Hôtel Drouot, February 23, 1891, lot 12, repro.; acquired by Henri Heugel (18,250 francs); Henri Heugel collection, Paris; sale, Heugel, Paris, Galerie Georges Petit, May 26, 1905, lot 6, repro.; acquired by Bernheim-Jeune (15,000 francs; Bernheim-Jeune archives; cited by Johnson); Bernheim-Jeune, Paris; baron Denys Cochin collection, Paris, 1910; sale, Cochin, Paris, Hôtel Drouot, March 16, 1919, lot 11,

repro. (51, 000 francs); Jules Strauss collection, 1928; sale, Strauss, Paris, Galerie Georges Petit, December 15, 1932, lot 39, repro.; sale, Paris, Palais Galliera, November 29, 1974, lot 9; Alfred Daber, 1975; acquired by the National Gallery, London, in 1976.

BIBLIOGRAPHY

Journal, p. 375; *Correspondance,* vol. 3, p. 164; Henriet, 1854; Silvestre, 1855, p. 82; Moreau, 1873, p. 263; Robaut, 1885, nos. 1223, 1038, repro.; Johnson, 1986, vol. 3, no. 460, pl. 267; Daguerre de Hureaux, 1993, pp. 223, 225, 317, 319, 325, 326, 327, 332, 339.

EXHIBITIONS

1860, Paris, no. 160; 1928, Paris, no. 27; 1930, Paris, no. 154.

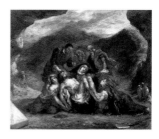

124. *The Lamentation*

1857
Oil on canvas; 14¾ x 17⅞ inches (37.5 x 45.5 cm)
Signed and dated at lower left:
Eug. Delacroix. 1857.
Karlsruhe, Staatliche Kunsthalle (inv. 2661)

PROVENANCE

Possibly sold by Delacroix to Bouruet-Aubertot; Bouruet-Aubertot, 1864; sale, Bouruet-Aubertot, Paris, Hôtel Drouot, February 22, 1869, lot 7; withdrawn from sale and transferred to a collector, possibly Gavet; sold by Gavet to Laurent-Richard (c. 16,000 francs); Laurent-Richard collection; sale, Laurent-Richard, Paris, Hôtel Drouot, May 23, 1878, lot 15, repro.; Albert de Saint-Albin collection; John Balli collection, London; sale, Paris, Hôtel Drouot, May 22, 1913, lot 11, repro.; acquired by Laroche Gand (26,700 francs); Laroche Gand collection; Le Roy and Company, Paris; Mme Walter Feilchenfeldt, Zurich; acquired by the Staatliche Kunsthalle, Karlsruhe, in 1978.

BIBLIOGRAPHY

Journal, pp. 573, 581; Moreau, 1873, p. 263; Robaut, 1885, no. 769, repro.; Johnson, 1986, vol. 3, no. 466, pl. 272.

EXHIBITION

1864, Paris, no. 130.

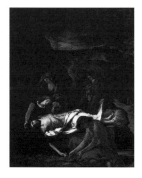

125. *The Lamentation*

1847–48
Oil on canvas; 64 x 52 inches (162.6 x 132.1 cm)
Signed and dated at lower left:
Eug. Delacroix. 1848.
Boston, The Museum of Fine Arts, Gift by
contribution in memory of Martin Brimmer
(96.21)

PROVENANCE
Sold by Delacroix to Théodore de Geloës, April 28,
1857 (2,000 francs); Théodore de Geloës collection,
Paris, until 1870; collection of the singer Faure, Paris;
sale, by Faure, Paris, Galerie Durand-Ruel, June 7,
1873, lot 7, repro.; acquired by Durand-Ruel (60,000
francs); perhaps Brame, Paris; baron E. de
Beurnonville collection; sale, baron de Beurnonville,
Paris, Hôtel Drouot, April 29, 1880, lot 11, repro.;
acquired by Brame (34,000 francs); M. Tavernier
collection, Paris; sale, Paris, Galerie Georges Petit,
June 11, 1894, lot 5, repro.; acquired by Durand-Ruel
(88,000 francs); Durand-Ruel, New York; acquired
for the Museum of Fine Arts, Boston, in memory of
Martin Brimmer in 1896.

BIBLIOGRAPHY
Journal, pp. 118, 126, 127, 129, 132, 137, 138, 150, 160,
162; *Correspondance,* vol. 2, pp. 25, 302; de Mercey,
1848(a), p. 292; Thoré, 1848; Haussard, 1848;
Clément de Ris, 1848(a), p. 59; de Saint-Victor, 1848;
Du Pays, 1848, p. 89; Montlaur, 1848; Gautier, 1848;
Perrier, 1855, p. 72; Gebauer, 1855, p. 41; Silvestre,
1855, p. 81; Forge, 1856, p. 47; Robaut, 1873, pp. 183,
188; Robaut, 1885, no. 1043, repro.; M. Sérullaz,
1963(a), no. 383, repro.; Johnson, 1986, vol. 3, no.
434, pl. 242; Daguerre de Hureaux, 1993, pp. 221,
223, 224, 235, 236, 304, 316, 322, 323, 328, repro.;
Rautmann, 1997, fig. 300.

EXHIBITIONS
1848, Paris, no. 1157; 1855, Paris, no. 2910; 1930, Paris,
no. 121; 1944, New York, no. 24; 1963(a), Paris, no.
385; 1964, Edinburgh and London, no. 45, repro;
1969, Kyoto and Tokyo, no. H-26, repro.

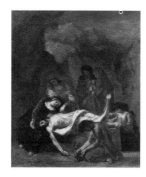

126. *The Lamentation*

1849
Oil on canvas; 22¹/₁₆ x 18⅝ inches (56 x 47.3 cm)
Signed at lower left of center: *Eug. Delacroix*
Phoenix Art Museum, Gift of Mr. Henry R.
Luce (64.42)

PROVENANCE
Acquired by Adolphe Moreau, Sr., from the dealer
Weill, December 31, 1849 (205 francs); collection of
Adolphe Moreau, Sr., Paris, until his death in 1859;
collection of Adolphe Moreau, Jr., until March 1870;
sold by Adolphe Moreau, Jr., in March 1870 to
Brame and Durand-Ruel (15,000 francs); Laurent-
Richard collection; sale, Laurent-Ruel, Paris, Hôtel
Drouot, April 7, 1873, lot 13, repro.; acquired by
Durand-Ruel (29,000 francs); collection of the
notary Frémyn, 1878; Albert Spencer collection, New
York; sale, Spencer, New York, Chikezing Hall,
February 28, 1888, lot 33 (10, 600 francs); Alfred
Corning Clark collection, New York, 1889; Stephen
C. Clark collection; Knoedler, New York, 1935; sold
by Knoedler to R. W. Edmiston in 1936; R. W.
Edmiston collection; William H. Taylor collection,
West Chester; Knoedler, New York; sold by
Knoedler to Mrs. Henry Luce in 1950; given by Mr.
Henry R. Luce to the Phoenix Art Museum in 1964.

BIBLIOGRAPHY
Feydeau, 1858, p. 294; Moreau, 1873, p. 265; Robaut,
1885, no. 1037, repro.; Johnson, 1986, vol. 3, no. 435,
pl. 243; Daguerre de Hureaux, 1993, pp. 221, 223,
224, 235, 236, 304, 316, 322, 323, 328.

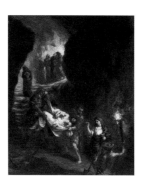

127. *The Entombment*

1858–59
Oil on canvas; 22³/₁₆ x 18¼ inches
(56.3 x 46.3 cm)
Signed and dated at lower left of center:
Eug. Delacroix 1859
Tokyo, The National Museum of Western Art
(P. 1975-2)

PROVENANCE
Mme Alfred Magne collection, 1885; Mme
Constantin collection; sold by Mme Constantin to
Bernheim-Jeune, February 13, 1905; sold by
Bernheim-Jeune to Mante the same day (Bernheim-
Jeune archives; cited by Johnson); M. A. Bergaud
collection, 1910; Antonio Santamarina collection,
Buenos Aires, 1939; sale, Santamarina, London,
Sotheby's, April 2, 1974, lot 4; acquired by Peter
Nathan (£65,000); Peter Nathan, Zurich; acquired
by the National Museum of Western Art, Tokyo, in
1975.

BIBLIOGRAPHY
Dumas, 1859(a), pp. 10, 13; de Saint-Victor, 1859;
Tardieu, 1859; Belloy, 1859, p. 3; Mantz, 1859, p. 138;
Lescure, 1859; Houssaye, 1859, p. 295; Rousseau, 1859;
Du Pays, 1859, p. 339; Gautier, 1859(a); Fournel,
1859; Perrier, 1859, p. 294ff.; Baudelaire, 1859, p. 332;
Montaiglon, 1859, p. 442ff.; Astruc, 1859, pp.
261–74; Aubert, 1859, pp. 146, 148ff.; Du Camp,
1859, p. 32; Dumesnil, 1859, p. 81ff.; Fouquier, 1859,
p. 71; Jourdan, 1859; Lépinois, 1859, p. 197; Stevens,
1859, pp. 31ff.; Moreau, 1873, p. 193; Robaut, 1885,
no. 1380, repro.; Johnson, 1986, vol. 3, no. 470, pl.
275; Daguerre de Hureaux, 1993, pp. 221, 223, 224,
235, 236, 304, 316, 322, 323, 328, 235, repro.;
Rautmann, 1997, p. 312, fig. 301; Jobert, 1997, p. 295,
fig. 257.

EXHIBITIONS
1859, Paris, no. 820; 1963, Bordeaux, no. 55; 1987(a),
Zurich, no. 116.

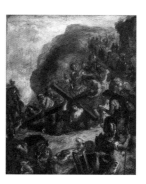

128. *The Road to Calvary*

1847–59
Oil on wood; 22⁷/₁₆ x 18⅞ inches (57 x 48 cm)
Signed and dated at lower right:
Eug. Delacroix / 1859
Metz, La Cour d'Or, Musées de Metz
(inv. 11.458)

PROVENANCE
Acquired in 1861 by the city of Metz from Delacroix,
at the proposal of the Metz painter and collector
Charles Laurent Maréchal, for 3,000 francs (of which
1,560 francs was given by the artists and notables of
Moselle and 1,440 francs was taken from the muni-
cipal budget of the city of Metz).

BIBLIOGRAPHY
Journal, pp. 118, 119, 131, 656, 711; *Correspondance,*
vol. 4, p. 251, n. 1; Dumas, 1859(a), p. 10; de Saint-
Victor, 1859; Tardieu, 1859; Richard, 1859; Dubosc de
Pesquidoux, 1859; Cadol, 1859, p. 257; de Belloy,
1859, p. 3; Mantz, 1859, pp. 135–39; Lescure, 1859;
Houssaye, 1859, p. 295; Rousseau, 1859; Delaborde,

1859; Lavergne, 1859; Du Pays, 1859, p. 339; Gautier, 1859(a); Fournel, 1859, pp. 157–59; Perrier, 1859, pp. 292–96; Chesneau, May 1859, pp. 164–66; Baudelaire, 1859, p. 333; Montaiglon, 1859, p. 442; anonymous, 1859, p. 15; Astruc, 1859, pp. 264ff.; Aubert, 1859, pp. 146, 148ff.; Auvray, 1859, pp. 19–21; Du Camp, 1859, pp. 32–34; Dumesnil, 1859, pp. 78–83; Duplessis, 1859, p. 176; Fouquier, 1859, p. 71; Jourdan, 1859, pp. 33–35; Lépinois, 1859, p. 196; Stevens, 1859, pp. 26–34; Moreau, 1873, p. 193; Robaut, 1885, no. 1377, repro.; Tourneux, 1886, pp. 98–103; M. Sérullaz, 1963(a), no. 496, repro.; Johnson, 1986, vol. 3, no. 469, pl. 274; Daguerre de Hureaux, 1993, pp. 234, 236, 304, 328, 334, p. 234, repro.; Jobert, 1997, p. 294, fig. 259.

EXHIBITIONS
1859, Paris, no. 819 (La Montée au Calvaire; le Christ succombant sous la croix); 1864, Paris, no. 159; 1928, Paris, no. 35; 1930, Paris, no. 186, repro.; 1939, Zurich, no. 369, p. xxi; 1939, Basel, no. 259; 1952, London, no. 46; 1956, Venice, no. 38; 1963(a), Paris, no. 493; 1963–64, Bern, no. 90; 1964, Bremen, no. 85; 1964, Edinburgh and London, no. 70; 1973, Paris; 1986, Nice, no. 19, repro.

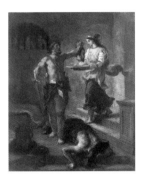

129. *The Beheading of John the Baptist*

1856–58
Oil on canvas; 22⅟₁₆ x 18⅛ inches (56 x 46 cm)
Signed and dated at lower left:
Eug. Delacroix / 1858.
Bern, Musée des Beaux-Arts (1759)

PROVENANCE
Painted for M. Robert, Sèvres; Robert collection; Lambert de Sainte-Croix collection, 1885; Montaignac collection; sold by Montaignac to Boussod, Valadon and Company, August 26, 1903; acquired by M. Camention, October 31, 1907; Camention collection; Salavin collection; Leonardo Benatov collection; acquired in Paris by the Musée des Beaux-Arts of Bern in January 1953 (80,000 Swiss francs).

BIBLIOGRAPHY
Journal, pp. 600, 663–64; Robaut, 1885, no. 858, repro.; M. Sérullaz, 1963(a), no. 495, repro.; Johnson, 1986, vol. 3, no. 468, pl. 273; Daguerre de Hureaux and Guégan, 1994, pp. 32, 116, repro. p. 117.

EXHIBITIONS
1885, Paris, no. 124; 1951, Paris, no. 2; 1952, London, no. 28; 1963(a), Paris, no. 492; 1963–64, Bern, no. 86; 1964, Bremen, no. 82.

130. *Moses Striking the Rock*

1858 (?)
Brown ink over graphite on paper;
11⅟₁₆ x 17½ inches (29.7 x 44.5 cm)
Cambridge, The Syndics of the Fitzwilliam Museum (2031 A)

PROVENANCE
Delacroix Atelier, marked at lower right (Lugt 838a); sold posthumously, Paris, Hôtel Drouot, February 22–27, 1864, possibly part of lot 375 (28 sheets divided into 5 lots acquired by Messrs. Gerspach, Robaut, Étienne, Leman) or lot 376 (29 sheets divided into several lots acquired by Messrs. de Cornemin, Marjolin, Robaut, Cadart); Charles Ricketts and Charles Shannon collection; lent to the Fitzwilliam Museum, Cambridge, 1933–37; bequeathed in 1937.

BIBLIOGRAPHY
Robaut, 1885, part of no. 1795 or 1796.

EXHIBITION
1964, Edinburgh and London, no. 184, pl. 101.

131. *Jacob Beholding Joseph's Coat*

1860
Brown ink on paper; 5¼ x 7⅟₁₆ inches (13.4 x 19.9 cm)
Dated at lower right: *13 mars 1860.*
Paris, Musée du Louvre, Département des Arts Graphiques (RF 9534)

PROVENANCE
Delacroix Atelier, marked at lower right (Lugt 838a); sold posthumously, Paris, Hôtel Drouot, February 22–27, 1864, part of lot 376 (29 sheets divided into several lots acquired by Messrs. de Cornemin, Marjolin, Robaut, Cadart); Alfred Robaut collection (code and annotations on verso); Étienne Moreau-Nélaton collection; bequeathed to the Musée du Louvre in 1927, marked at lower right (Lugt 1886a).

BIBLIOGRAPHY
Robaut, 1885, no. 1415, repro.; M. Sérullaz, 1984, vol. 1, no. 484, repro.

EXHIBITIONS
1930, Paris, no. 529; 1982, Paris, no. 66.

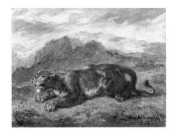

132. *Lioness Ready to Spring*

1863
Oil on canvas; 11⅞ x 15⅜ inches (29.5 x 39 cm)
Signed and dated at lower right:
Eug. Delacroix / 1863.
Paris, Musée du Louvre (RF 1397)

PROVENANCE
Carlin collection; sale, Carlin, Paris, Hôtel Drouot, April 29, 1872, lot 11; acquired by Isaac de Camondo (9,000 francs); comte Isaac de Camondo collection; Georges-Thomy Thiéry collection; bequeathed to the Musée du Louvre in 1902.

BIBLIOGRAPHY
Moreau, 1873, p. 281 (Panthère); Robaut, 1885, no. 1456, repro.; Johnson, 1986, vol. 3, no. 209, pl. 31; Daguerre de Hureaux, 1993, p. 329.

EXHIBITIONS
1930, Paris, no. 199; 1949, Paris, no. 30; 1963(c), Paris; 1970, Paris; 1974, Paris; 1975, Paris.

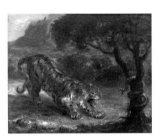

133. *Tiger Growling at a Snake*

1862
Oil on canvas; 13 x 16¼ inches (33 x 41.3 cm)
Signed and dated at lower left:
Eug. Delacroix 1862.
Washington, D.C., Corcoran Gallery of Art, William A. Clark Collection (26.76)

PROVENANCE
Marquis de Lambertye collection; sale, marquis de Lambertye, Paris, Hôtel Drouot, February 4, 1865, lot 12 (1,820 francs); Paul Van Cuyck collection; sold posthumously, Paris, Hôtel Drouot, February 7, 1866, lot 7 (2,705 francs); comte d'Aquila collection; sale, comte d'Aquila, Paris, Hôtel Drouot, February 21, 1868, lot 8 (8, 020 francs); collection of Constant Hermant, known as Hermann, violinist; sale, Hermann, Paris, Hôtel Drouot, February 10, 1879, lot 8, repro. (7,000 francs); Th. Leroy collection; sale, Leroy, Paris, Hôtel Drouot, May 13, 1882, lot 16 (13,500 francs); Mary J. Morgan collection, New

York; sale, Morgan, New York, Chikezing Hall, March 3, 1886, lot 188; acquired by Knoedler ($4,450); sold by Knoedler to James J. Hill, Saint Paul, in April 1886; sold by James J. Hill to Durand-Ruel in May 1889; Henry M. Johnston collection, New York, c. 1889; sale, Johnston, New York, February 28, 1893, lot 68 ($6,500); Knoedler, New York; sold by Knoedler to H. S. Henry, Philadelphia, in 1899; sale, Henry, New York, January 25, 1907, lot 13; acquired by William A. Clark, Washington; given to the Corcoran Gallery of Art, Washington, D.C., in 1926.

BIBLIOGRAPHY
Moreau, 1873, p. 280 (erroneously dated 1860); Robaut, 1885, no. 1445, repro.; Johnson, 1986, vol. 3, no. 206, pl. 30; Daguerre de Hureaux, 1993, p. 329.

EXHIBITION
1987(a), Zurich, p. 294, fig. p. 295.

134. *Feline Walking Toward the Right, in a Landscape*

1863
Brown ink on paper; 4⅝ x 5⅛ inches (11.6 x 12.9 cm)
Inscribed at lower left and dated at lower right in brown ink: *à Jenny. / 5 avril / 63 / Pâques*
Paris, Musée du Louvre, Département des Arts Graphiques (RF 31 282)

PROVENANCE
Collection of Mme Julien Pillaut, née Augusta Marceline Bodin; given to the Musée du Louvre in 1960, marked at lower right (Lugt 1886a).

BIBLIOGRAPHY
M. Sérullaz, 1984, vol. 1, no. 1974, repro.

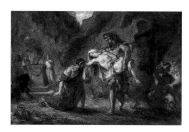

135. *Hercules Bringing Alcestis Back from the Underworld*

1862
Oil on cardboard mounted on wood; 12¾ x 19¼ inches (32.3 x 48.8 cm)
Signed and dated at lower left, near center: *Eug. Delacroix 1862.*
Washington, D.C., The Phillips Collection (0485)

PROVENANCE
Alluard collection, Limoges; sold posthumously, Paris, Hôtel Drouot, May 24, 1888, lot 10; acquired by Arnold, Tripp and Company (8,000 francs); Arnold, Tripp and Company, Paris; sold by Arnold, Tripp and Company to J. Mancini, October 25, 1898 (10,000 francs); Gallice, Paris, until May 9, 1900; Bernheim; Bernhein-Jeune, Paris, offered for sale in September 1899 (30,000 francs); acquired by Ernest Cronier, Paris, January 11, 1902; Ernest Cronier collection, Paris; sale, Cronier, Paris, December 4, 1905, lot 56; acquired by Paul Arthur Chéramy (17,400 francs); Paul Arthur Chéramy collection, Paris; sale, Chéramy, Paris, Petit-Haro, May 5, 1908, lot 151; acquired by Schoeller (32,500 francs); newly noted in the Paul Arthur Chéramy collection, 1908– 13; second Chéramy sale, April 15, 1913, lot 16; acquired by Dikran Khan Kelekian; sale, Dikran Khan Kelekian, New York, January 30, 1922, lot 111; Duncan Phillips collection, Washington, D.C.; The Phillips Collection, Washington, D.C.

BIBLIOGRAPHY
Johnson, 1986, vol. 3, no. 342, pl. 159.

136. *Horses at a Fountain*

1862
Oil on canvas; 29 x 36⅜ inches (73.7 x 92.4 cm)
Signed and dated at lower left: *Eug. Delacroix 1862.*
Philadelphia Museum of Art, Purchased with the W. P. Wilstach Fund (W1950-1-2)

PROVENANCE
Sold by Delacroix to the dealer Tedesco, October 6, 1862 (2,000 francs); sale, Paris, April 23, 1866, lot 14; acquired by Khalil Bey (5,300 francs); sale, Khalil Bey, Paris, Hôtel Drouot, January 16–18, 1868, lot 21; acquired by Constant Say (15,000 francs); collection of comtesse de Tredern, née Say, 1885; sold by

the comtesse de Tredern to Bernheim-Jeune, March 21, 1910; sold for Bernheim-Jeune, with Boussod, Valadon and Company as intermediary, to Georges Petit in May 1911 (Bernheim-Jeune and Goupil-Boussod archives; cited by Johnson); Baillehache collection, 1916; Prince of Wagram collection, Germany, 1931; Chester Beatty collection, London, 1939; Paul Rosenberg, New York, 1950; acquired by the Philadelphia Museum of Art with the W. P. Wilstach Fund in 1950.

BIBLIOGRAPHY
Journal, p. 780; Robaut, 1885, no. 1442, repro.; Johnson, 1986, vol. 3, no. 415, pl. 224; Arama, 1987, no. 63, p. 215, repro.; Daguerre de Hureaux and Guégan, 1994, p. 20, repro.

EXHIBITIONS
1930, Paris, no. 197A; 1994–95, Paris, no. 103, repro.

137. *Botzaris Attacks the Turkish Camp and Is Fatally Wounded*

c. 1862
Oil on canvas; 23⅝ x 28¾ inches (60 x 73 cm)
Toledo, Ohio, The Toledo Museum of Art (1994.36)

PROVENANCE
Delacroix Atelier, red wax seal on verso; sold posthumously, Paris, Hôtel Drouot, February 17–19, 1864, lot 100; acquired by Mme Godard, née de Thomas (1,000 francs); Mme Godard collection; Godard-Decrais collection; Jacques Dupont collection; sale, Paris, Hôtel Drouot, March 29, 1994, lot 78, repro.; Richard L. Feigen, London; acquired by the Toledo Museum of Art in 1994.

BIBLIOGRAPHY
Robaut, 1885, no. 1408; M. Sérullaz, 1963(a), no. 529, repro.; Johnson, 1986, vol. 3, no. 346, pl. 160.

EXHIBITIONS
1930, Paris, no. 181, repro.; 1963(a), Paris, no. 525; 1996–97, Bordeaux, Paris, and Athens, no. 33, repro. (French edition).

138. *An Arab Camp at Night*

1863
Oil on canvas; 21⅝ x 25⅝ inches (55 x 65 cm)

Signed and dated near lower center:
Eug. Delacroix 1863.
Budapest, Szépmüvészeti Múzeum (72.7.B)

PROVENANCE
Commissioned from Delacroix by the dealer
Tedesco (2,500 francs); Doll and Richards, Boston;
acquired from Doll and Richards by Knoedler, New
York, in January 1914; sold by Knoedler to baron
Francis de Hartvany, Budapest, in September 1914;
acquired by the Szépmüvészeti Múzeum, Budapest,
in 1972.

BIBLIOGRAPHY
Journal, pp. 780, 781; *Correspondance,* vol. 4, p. 372;
Johnson, 1986, vol. 3, no. 418, pl. 226; Arama,
1994–95, p. 89, repro.

139. *Arabs Skirmishing in the Mountains*

1863
Oil on canvas; 36¼ x 29⅛ inches (92 x 74 cm)
Signed and dated at lower center:
Eug. Delacroix 1863.
Washington, D.C., National Gallery of Art,
Chester Dale Fund (2329)

PROVENANCE
Sold by Delacroix to the dealer Tedesco, April 12,
1863 (2,000 francs); Édouard André collection, 1878
to c. 1890 (noted by Robaut); A. Schmit collection;
sold by Schmit to Durand-Ruel, Paris, February 4,
1893; resold by Durand-Ruel, Paris, to Durand-Ruel,
New York, December 12, 1895 (Durand-Ruel
archives; cited by Johnson); sold by Durand-Ruel,
New York, to M. C. D. Borden, March 6, 1895; sale,
Borden, New York, February 13, 1913, lot 77;
acquired by Holst ($16,000); James J. Hill collec-
tion, Saint Paul, Minnesota; Mrs. James J. Hill col-
lection; Louis W. Hill collection, Saint Paul, 1930–48;
collection of Jerome Hill, his son, in 1961; acquired by
the National Gallery of Art, Washington, D.C., with
the Chester Dale Fund in 1966.

BIBLIOGRAPHY
Correspondance, vol. 4, p. 372; Piron, 1865, p. 111; M.
Sérullaz 1963(a), no. 532, repro.; Johnson, 1986, vol.
3, no. 419, pl. 227; Arama, 1987, no. 61, p. 215, repro.;
Arama, 1992, p. 112, repro.; Daguerre de Hureaux,
1993, p. 191, p. 195, repro.; Daguerre de Hureaux and
Guégan, 1994, p. 47, p. 15, repro.; Jobert, 1997, p.
168, fig. 133.

EXHIBITIONS
1885, Paris, no. 239B (Addenda); 1930, Paris, no.
199A; 1962–63, Toronto and Ottawa, no. 25, repro.;
1963(a), Paris, no. 527; 1991, New York, no. 14, repro.

140. *Saint Stephen Borne Away by His Disciples*

1862
Oil on canvas; 18⅜ x 15 inches (46.7 x 38 cm)
Signed and dated at lower right on a step:
Eug. Delacroix 1862
Birmingham, England, The University of
Birmingham, The Trustees of the Barber
Institute of Fine Arts (62.1)

PROVENANCE
Possibly Paul Tesse collection, 1864; acquired by
Étienne Moreau-Nélaton at a sale in Paris, Hôtel
Drouot, before June 1880 (2,625 francs); exchanged
by Moreau-Nélaton in June 1880 with Warocquier,
Brussels, but reacquired by the French collector in
1886 (Moreau-Nélaton archives; cited by Johnson);
Solvay collection; Wildenstein, 1956; acquired by the
Barber Institute of Fine Arts, Birmingham, in
February 1962.

BIBLIOGRAPHY
Robaut, 1885, no. 1212, repro.; M. Sérullaz, 1963(a),
under no. 437; Johnson, 1986, vol. 3, no. 472, pl. 259;
Jobert, 1997, p. 293, fig. 252.

EXHIBITIONS
Perhaps 1864, Paris, no. 68 *(à M. Tesse);* 1963,
Bordeaux, no. 57, repro.; 1987(a), Zurich, no. 125,
pp. 292, 293, 337, repro.

141. *The Denial of Saint Peter*

1862
Brown ink and brown wash on paper;
5¾ x 8½ inches (14.5 x 21.5 cm)
Dated at lower right in brown ink: *2 janvier 62.*
Paris, Musée du Louvre, Département des Arts
Graphiques (RF 36 499)

PROVENANCE
Delacroix Atelier, marked at bottom center (Lugt
838a); sold posthumously, Paris, Hôtel Drouot,
February 22–27, 1864, part of lot 375 (28 sheets
divided into 5 lots acquired by Messrs. Gerspach,
Robaut, Étienne, Leman) or lot 376 (29 sheets
divided into several lots acquired by Messrs. de

Cornemin, Marjolin, Robaut, Cadart); Max and
Rosy Kaganovitch collection; given to the Musée du
Louvre in 1977, marked at lower left (Lugt 1886a).

BIBLIOGRAPHY
Robaut, 1885, part of no. 1795 or 1796; Prat, 1979,
p. 101 and n. 4; M. Sérullaz, 1984, vol. 1, no. 494,
repro.; Prat, 1992, p. 29, fig. 4.

EXHIBITIONS
1963–64, Bern, no. 339; 1964, Bremen, no. 313
(Jugement de Salomon); 1964, Edinburgh and
London, no. 186; 1982, Paris, no. 68; 1986, Nice,
no. 29, repro.

142. *The Miraculous Draught of Fishes*

1862
Brown ink on paper; 5 x 8⅛ inches
(12.8 x 20.6 cm)
Dated at lower right in brown ink: *2 janvier 62.*
Bremen, Kunsthalle (65/129)

PROVENANCE
Delacroix Atelier, marked at lower right (Lugt 838a);
sold posthumously, Paris, Hôtel Drouot, February
22–27, 1864, part of lot 375 (28 sheets divided into 5
lots acquired by Messrs. Gerspach, Robaut, Étienne,
Leman) or lot 376 (29 sheets divided into several lots
acquired by Messrs. de Cornemin, Marjolin, Robaut,
Cadart); acquired by the Kunsthalle, Bremen, in
1965, marked at lower right (L. 292).

BIBLIOGRAPHY
Robaut, 1885, part of no. 1795 or no. 1796; Prat,
1979, p. 101 and n. 5; Prat, 1992, p. 29, fig. 3.

143. *The Three Marys at the Sepulchre*

1862
Brown ink on paper; 5⅜ x 8³⁄₁₆ inches
(13.6 x 20.8 cm)
Dated at lower right in brown ink:
2 janvier 1862
The Princeton University Art Museum, Gift of
Frank Jewett Mather, Jr. (1941-114)

PROVENANCE
Delacroix Atelier, marked at lower center (Lugt

838a); sold posthumously, Paris, Hôtel Drouot, February 22–27, 1864, part of lot 375 (28 sheets divided into 5 lots acquired by Messrs. Gerspach, Robaut, Étienne, Leman) or lot 376 (29 sheets divided into several lots acquired by Messrs. de Cornemin, Marjolin, Robaut, Cadart); collection of Frank Jewett Mather, Jr.; given to the Princeton University Art Museum in 1941.

BIBLIOGRAPHY
Robaut, 1885, part of no. 1795 or no. 1796; Prat, 1979, p. 101 and n. 6; Prat, 1992, pp. 29, 30, fig. 5.

EXHIBITION
1962–63, Toronto and Ottawa, no. 37, repro.

144. *The Kiss of Judas*

1862
Brown ink on paper; 5⅛ x 8 inches
(13 x 20.4 cm)
Dated at lower center in brown ink: *18. f ʳ. 62*
Amiens, Musée de Picardie (3098.645)

PROVENANCE
Delacroix Atelier, marked at lower left (Lugt 838a); sold posthumously, Paris, Hôtel Drouot, February 22–27, 1864, part of lot 375 (28 sheets divided into 5 lots acquired by Messrs. Gerspach, Robaut, Étienne, Leman) or lot 376 (29 sheets divided into several lots acquired by Messrs. de Cornemin, Marjolin, Robaut, Cadart); Canon Dumont collection; bequeathed to the Musée de Picardie, Amiens, in 1929.

BIBLIOGRAPHY
Robaut, 1885, part of no. 1795 or no. 1796; Prat, 1979, p. 100, fig. 1, pp. 101, 104, no. 1; Prat, 1992, p. 30, fig. 7.

EXHIBITION
1986, Nice, no. 31, repro.

145. *Christ Before Pilate*

1862
Brown ink on paper; 5¼ x 8⅛ inches
(13.3 x 20.5 cm)
Dated at lower right in brown ink: *18 fr. 62*
Paris, Prat Collection

PROVENANCE
Delacroix Atelier, marked at lower left (Lugt 838a); sold posthumously, Paris, Hôtel Drouot, February 22–27, 1864, part of lot 375 (28 sheets divided into 5 lots acquired by Messrs. Gerspach, Robaut, Étienne, Leman) or lot 376 (29 sheets divided into several lots acquired by MM. de Cornemin, Marjolin, Robaut, Cadart); Vuillier; acquired by Louis de Launay, May 3, 1899; Louis de Launay collection; Bruno de Bayser, 1981 (catalogue, 1981, Paris, no. 16, repro.); Prat collection, Paris, marked at lower right (not cited by Lugt).

BIBLIOGRAPHY
Robaut, 1885, part of no. 1795 or 1796; M. Sérullaz, 1984, vol. 2 (Addenda), p. 424, under no. 496; Prat, 1992, pp. 30, 31, fig. 8.

EXHIBITION
1986, Nice, no. 30, repro.

146. *Tobias and the Angel*

1862
Brown ink on paper; 8⅛ x 5¼ inches
(20.5 x 13.3 cm)
Dated at lower right in brown ink: *18 f ʳ 62.*
Paris, Prat Collection

PROVENANCE
Delacroix Atelier, marked at lower left (Lugt 838a); sold posthumously, Paris, Hôtel Drouot, February 22–27, 1864, part of lot 375 (28 sheets divided into 5 lots acquired by Messrs. Gerspach, Robaut, Étienne, Leman) or lot 376 (29 sheets divided into several lots acquired by Messrs. de Cornemin, Marjolin, Robaut, Cadart); collection of the widow of Caïus Trollé; sale, Paris, Hôtel Drouot, April 30, 1913, part of lot 53; acquired by Louis de Launay; Louis de Launay collection; Bruno de Bayser, Paris, 1991; Prat collection, Paris, marked at lower left (not cited by Lugt).

BIBLIOGRAPHY
Robaut, 1885, part of no. 1795 or no. 1796; Prat, 1992, pp. 30–31, fig. 6.

147. *Christ and the Blind Man of Jericho*

1862
Brown ink on paper, 5¼ x 8⅛ inches
(13.3 x 20.5 cm)
Dated at lower right in brown ink: *24 f ʳ.62.*
Paris, Prat Collection

PROVENANCE
Delacroix Atelier, marked at lower right (Lugt 838a); sold posthumously, Paris, Hôtel Drouot, February 22–27, 1864, part of lot 375 (28 sheets divided into 5 lots acquired by Messrs. Gerspach, Robaut, Étienne, Leman) or lot 376 (29 sheets divided into several lots acquired by Messrs. de Cornemin, Marjolin, Robaut, Cadart); Louis de Launay collection (possibly catalogued as *Tobie guérissant son père*); Bruno de Bayser, 1991; Prat collection, Paris, marked at lower right (not cited by Lugt).

BIBLIOGRAPHY
Robaut, 1885, part of no. 1795 or no. 1796, repro.; Prat, 1992, pp. 30, 31, fig. 9.

148. *Ecce Homo*

1862
Brown ink on paper; 7¾ x 5¼ inches
(19.8 x 13.2 cm)
Dated at lower right in brown ink: *24 f ʳ.62.*
Paris, Prat Collection

PROVENANCE
Delacroix Atelier, marked at lower left (Lugt 838a); sold posthumously, Paris, Hôtel Drouot, February 22–27, 1864, part of lot 375 (28 sheets divided into 5 lots acquired by Messrs. Gerspach, Robaut, Étienne, Leman) or lot 376 (29 sheets divided into several lots acquired by Messrs. de Cornemin, Marjolin, Robaut, Cadart); Galerie de Staël, Paris, 1992; Prat collection, Paris, marked at lower left (not cited by Lugt).

BIBLIOGRAPHY
Robaut, 1885, part of no. 1795 or no. 1796; Prat, 1992, pp. 30, 32, fig. 10.

149. *Christ Casting Out a Devil* (?)
or *The Death of Sapphira (?)*

1862
Brown ink on paper; 5¼ x 8⅛ inches
(13.4 x 20.6 cm)
Dated at lower right in brown ink: *24 f ʳ.62.*
Bucharest, Muzeul Naţional de Artă al
României (221/ 24810)

PROVENANCE
Delacroix Atelier, marked at lower center (Lugt
838a); sold posthumously, Paris, Hôtel Drouot,
February 22–27, 1864, part of lot 375 (28 sheets
divided into 5 lots acquired by Messrs. Gerspach,
Robaut, Étienne, Leman) or lot 376 (29 sheets
divided into several lots acquired by Messrs. de
Cornemin, Marjolin, Robaut, Cadart); Paul Prouté,
Paris, c. 1931; acquired for (and by) the Toma Stelian
Museum, Bucharest, in 1931; transferred with all of
the collections to the Muzeul Naţional de Artă al
României in 1950.

BIBLIOGRAPHY
Robaut, 1885, part of no. 1795 or no. 1796.

150. *Mary Magdalene at the Feet of Christ*

1862
Brown ink on paper; 8⅛ x 5⁵⁄₁₆ inches
(20.7 x 13.5 cm)
Annotated at lower left in pencil, in an
unknown hand (Étienne Moreau-Nélaton?):
vers la fin de sa vie / 1862
Paris, Musée du Louvre, Département des Arts
Graphiques (RF 9548)

PROVENANCE
Delacroix Atelier, marked at lower right (Lugt 838a);
sold posthumously, Paris, Hôtel Drouot, February
22–27, 1864, part of lot 375 (28 sheets divided into 5
lots by Messrs. Gerspach, Robaut, Étienne, Leman)
or lot 376 (29 sheets divided into several lots
acquired by Messrs. de Cornemin, Marjolin, Robaut,
Cadart); Étienne Moreau-Nélaton collection;
bequeathed to the Musée du Louvre in 1927, marked
at lower right (Lugt 1886a).

BIBLIOGRAPHY
Robaut, 1885, part of no. 1795 or no. 1796; M.
Sérullaz, 1984, vol. 1, no. 494, repro.; Prat, 1992, p.
29.

EXHIBITIONS
1930, Paris, no. 531; 1963(b), Paris, no. 105, repro., pl.
XXIII; 1982, Paris, no. 67.

151. *Spring—Orpheus and Eurydice*

1856–63
Oil on canvas; 78 x 65¼ inches (198 x 165.7 cm)
São Paulo, Museu de Arte de São Paulo
Assis Chateaubriand (67/1952)

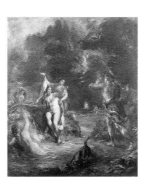

152. *Summer—Diana and Actaeon*

1856–63
Oil on canvas; 78 x 65¼ inches (198 x 165.7 cm)
São Paulo, Museu de Arte de São Paulo
Assis Chateaubriand (68/1952)

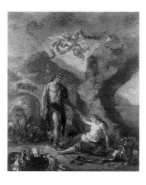

153. *Autumn—Bacchus and Ariadne*

1856–63
Oil on canvas; 78 x 65¼ inches (198 x 165.7 cm)
São Paulo, Museu de Arte de São Paulo
Assis Chateaubriand (69/1952)

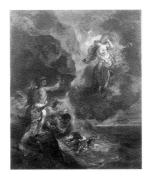

154. *Winter—Juno and Aeolus*

1856–63
Oil on canvas; 78 x 65¼ inches (198 x 165.7 cm)
São Paulo, Museu de Arte de São Paulo
Assis Chateaubriand (70/1952)

PROVENANCE
Commissioned in January 1856 by the Munster
manufacturer Jacques Félix Frédéric Hartmann but
never finished or delivered by the painter; Delacroix
Atelier, stamped in wax on the verso; sold posthu-
mously, Paris, Hôtel Drouot, February 17–19, 1864,
lots 101–14 (unfinished paintings, *Panneaux décoratifs
figurant les Quatre Saisons. Eurydice, cueillant des
fleurs dans une prairie, est piquée par un serpent; Diane
surprise au bain par Actéon; Bacchus revenant des Indes
rencontre Ariane abandonnée; Junon implore d'Éole
qu'il détruise la flotte d'Énée*); acquired by Étienne-
François Haro (1,500 francs, 1,550 francs, 850 francs,
and 1,000 francs); Durand-Ruel, Paris, 1873, Émile
de Girardin collection, Paris, perhaps from 1875; sold
posthumously, Paris, Hôtel Drouot, May 24, 1883,
lots 12–15; the four works were auctioned together
for 30,000 francs; possibly Durand-Ruel, Paris;
Cottier and Company, New York; James S. Inglis
collection, New York; sale, Inglis, New York,
American Art Galleries, March 9, 1910, lots 119–122
(*Automne* and *Printemps* reversed); Albert Gallatin
collection, New York, 1924; Wildenstein, New York,
until 1952; acquired by the Museu de Arte, São
Paulo, 1952.

BIBLIOGRAPHY
Moreau, 1873, p. 316; Robaut, 1885, nos. 1434, 1428,
1430, and 1432, repro.; Johnson, 1986, vol. 3, pp.
62–67, and no. 248, pl. 66, no. 249, pl. 67, no. 250,
pl. 68, no. 251, pl. 69; Camesasca, "Les Saisons
Hartmann" in exhibition catalogue Martigny,
Gianadda Foundation, *Trésors du musée de São
Paulo: de Raphaël à Corot*, 1988, pp. 184–95.

EXHIBITIONS
1864, Paris, nos. 50–53; 1944, New York, nos. 43–46;
1952, London, nos. 47–50; 1987(a), Zurich, nos.
120–23, repro.

The Technique of Eugène Delacroix: A Historical Approach

David Liot

Introduction

With a regularity and a precision that compel admiration, Eugène Delacroix copied into his Journal *long lists of the pigments used in his paintings. These lists reveal the complexity of the painter's chromatic combinations. Frequently intended for the collaborators on his immense decorative compositions, they also functioned as aides-mémoire recording technical discoveries he had made, recipes suggested to him by contemporaries, and procedures worth trying.*

Despite their precision, these diverse notes, as passionate as they are, do not in themselves constitute proof for the art historian that the painter indeed used these various procedures in his paintings. The usual discrepancy between theory and practice might well have led him to make other technical choices. In fact, since we do not know the circumstances of his professional disclosures, these pages of Delacroix's Journal *could have been only working proposals that were never implemented, mere intellectual speculations without material analogues. Fortuitously, the recent discovery of the professional account books preserved in the archives of Achille Piron (Archives des Musées Nationaux, Paris) has provided us with evidence that such was not the case. Two notebooks—one listing expenditures for materials used at the church of Saint-Sulpice, begun on June 25, 1854, and the other containing day-by-day records of orders for pigments from the artist's supplier Étienne-François Haro in 1858 and 1859—offer ample corroboration for the* Journal *entries. The notebooks indicate, for example, that the painter indeed ordered from Haro most of the pigments mentioned in his private writings. These precious documents make it possible after all to reconstitute his palette.*

Results of the first detailed scientific studies and laboratory analyses now complement the information provided by these sources, enriching our knowledge of Delacroix's technique, in particular his touch and his sense of color. It is to be hoped that more systematic investigations will be undertaken in the future—investigations that may challenge some of our accepted ideas concerning the painter's aesthetic and the art of his time.

Vincent Pomarède

Touch

As early as October 1853, Delacroix envisioned writing a dictionary of the fine arts intended for pedagogic use, consisting of short articles on the technique of painting. Within the framework of this project, left incomplete at his death, the painter drafted a number of articles, in particular the entries "Touch," "Execution," "Impasto," "Contour," and "Realism."

With reference to Rubens ("the prodigious relief of his figures"), Delacroix insisted emphatically on the importance of projection—both illusionistic and real—and on the signifying role of pictorial material. This theme recurs regularly in his *Journal* and in his correspondence, and it was a constant feature of his exchanges with his assistants. It served above all as a means of rejecting academic painters and their slick facture. Opposed to David and Ingres—those "cold" advocates of contour and flat tone— Delacroix valued touch as the bearer of meaning, as a necessary "indication of thought."[1] On January 3, 1844, Louis de Planet, one of Delacroix's assistants for the execution of the pendentives in the library of the Chambre des Députés at the Palais Bourbon, reported the "mistakes of the day" that the master had pointed out during his visits; the words underscore the obsession with relief that sometimes led Delacroix to value impasto. "Always use a lot of impasto, pay no attention to the outlines," advised the artist regarding the pendentive *Ovid Among the Scythians.*[2]

However, despite his fascination with Théodore Géricault and "his paste of colors," Delacroix always sought to control his own "plastic ardors." "To work obdurate material in order to vanquish it by patience," he wrote in his *Journal* when he was still young.[3] Self-control and restraint—sometimes almost to the point of caricature—characterized this young artist trained by the Neoclassical Pierre-Narcisse Guérin. Thus two facets of Delacroix's personality can be seen: first, a free and spontaneous disposition, anticipating Fauvism; second, a temperament that was domesticated and marked by classicism. This ambivalence—Charles Baudelaire spoke of a double character—in which moderation could not exist without overflow, engendered a unique and inimitable formal alchemy.

"Prodigious relief"

"I remark also that his principal quality, if it is possible to choose one quality in particular, is the prodigious relief of his figures, in other words, their prodigious vitality," Delacroix wrote in his *Journal* in 1860.[4] His passion for Rubens needs no demonstration, and relief is the quality of Rubens's work that he most appreciated—as opposed to the flatness of academic painting. With regard to Rubens's hunt pictures, Delacroix added in the same *Journal* entry, "It's a matter of realizing the problem of the relief and solidity that is found only in the greatest painters."

This fascination for Rubensian relief seems to have increased during the final years of his life. In a *Journal* entry from 1847, we see him contemplating the Rubensian excesses—the "exaggerations" and "bloated forms"—that he considered above all a source of inspiration. Then, in 1849 he questioned his reaction to "extreme facility, boldness of touch."[5] Eleven years later, he wrote the phrase about "prodigious relief." This mixture of distance and fascination clearly expresses his double approach. These fluctuations of judgment echo the formal variety of his work and demonstrate the variability of Delacroix's opinions.

More than color, it was the surface contrasts typical of Rubens's canvases that seduced the painter. He associated them with life. This "ferment of life," in the words of René Huyghe,[6] is found throughout Delacroix's own work. Baudelaire noted after the master's death: "We admire in him the violence, the sudden quality of the gestures, the turbulence of the compositions, the magic of the color."[7]

When he is talking about relief, Delacroix sometimes seems to think like a sculptor. He sought to struggle with a "material difficult to work like marble."[8] This rapprochement between painting and sculpture first appeared in his youth, and it was apparently reinforced by his friendships with the sculptors Antoine-Louis Barye, Auguste Préault, and Honoré Daumier. His rejection of contour led him to cultivate the "drawing by middles" practiced by his friends. Also called drawing by ovolos, this "ancient system of eggs" was applied by Delacroix to painting. He modeled by masses, shaping and constructing his figures with successive ovals, a procedure that permitted a steady transition from lights to darks: "From light to extreme darkness there rose in stages an entire construction of ovolos of different forms, more or less shaded, that formed the architecture of the whole figure and articulated the relief."[9] This respect for sculpture—for art involving touch—was a way of setting himself apart from "the exclusive partisans of form and contour," the advocates of academic smoothness. "Sculptors are your superiors," he peremptorily lashed out at them in his *Journal,* adding a few lines later: "With your slate-colored skies and dull, flat flesh-tones you cannot produce an effect of projection."[10]

Delacroix sometimes executed his grisailles with impasto so the glazes would catch on it. According to Louis de Planet, he did not hesitate to exaggerate the relief of certain parts so that, in the light, they would be more conspicuous. His collaborator—who was charged with executing a copy of *The Jewish Wedding* under his direction—spoke as well about "kinds of color heaps" that made the luminous parts seem to project. "This will even be a safeguard against the future, for if the varnish should disappear as a result of accidents of some sort, these well-drawn, thickly handled masses will always remain. The painting will then resemble those ancient reliefs, worn down, whose every finesse has been stripped away by time, in which all that remains are the large masses and dispositions in depth, but which, mutilated as they are, still retain indelible marks of beauty."[11]

Studying certain works by Delacroix during their restoration confirmed the importance of contrasts achieved by using thinly applied color and impasto simultaneously. After close study of *The Prisoner of Chillon,* for example, the restorer indicated that, in the background, "the pictorial material, quite thin in the browns, becomes even thinner and leaves the preparation exposed in some areas."[12] This remark allows us to surmise, in this case, the use of thin color for the shadows and impasto for the lights. Louis de Planet recounts that when he failed to use sufficient impasto in the grisaille of the pendentive of *The Death of Pliny the Elder* (Palais Bourbon library, Paris), Delacroix himself intervened to thicken significantly the handling in the light areas.[13] These thin passages, which also left some of the underpainting exposed, reinforced the impression of depth.

"Rendering thought in painting"

In his essay for the dictionary of the fine arts, Delacroix attached great importance to the section titled "Execution." Two concepts appear there that, yet again, manifest a certain ambivalence: on the one hand, a strong interest in the work's epidermis, the bearer of meaning; on the other hand, a concern that this not appear to be the unique goal.

Execution should remain above all a means—the outermost pictorial layer (the skin) being no more than a bridge between the feeling and the viewer.

Far from advocating pure painting, Delacroix sought to shed light on the Idea, which remained the essential justification for his creative work. Thus he copied an article by the music critic Scudo, published in 1857 in the *Revue des Deux Mondes*. Its premise was: "In the arts, ideas and form interpenetrate one another almost as intimately as do the soul and the body."[14]

In Delacroix's view, a work's material aspect should be the fruit of expert control, not of a risky spontaneity. According to his intellectual rationale, traces of the artist's tools were not desirable. Later, Paul Signac was to call technical virtuosity into question, affirming in his reading of Delacroix's *Journal:* "The hand will have very little importance; only the mind and the eye of the painter will have a role to play."[15]

"This infernal facility of the brush"

Nevertheless, the tools employed are frequently described in Delacroix's *Journal,* his correspondence, and the writings of his assistants. "Famished for palettes and brushes,"[16] the painter was conspicuous by his meticulousness: the cleanliness of his tools, the careful preparation of his palettes. Brushes—extensions of the artist's hand—were weapons to be used in a short, sensual battle with the material, an engagement that should leave no trace. Yet the first gush, fiery and free, was apparently something to be subdued. This quest for liberty, so romantic, so studied, did not preclude the need for order and rigor in this artist, who remained for René Piot the "last of the classics."[17] Thus, in the years of his maturity, Delacroix did not hesitate to call into question the "easy brush, the coquettish touch of [Richard Parkes] Bonington and others"[18] that he had pursued so ardently in his youth. On January 3, 1844, Louis de Planet wrote the following regarding his collaboration on the pendentives of the Chambre des Députés: "When I've done a portion with much impasto and with brushstrokes that are too thick, brush it lightly with a soft, long brush to link and flatten it a bit. These harsh asperities annoy M. Delacroix later, when he wants to rework the painting."[19]

In 1853 Delacroix admired Rubens's *Saint Just,* in particular its smooth facture without abrupt projections, the result of the artist's having used soft rather than stiff brushes. On that occasion Delacroix expounded on the differences between the former and the latter. Stiff brushes, he noted, leave asperities, traces, and "furrows impossible to dissimulate." As early as 1824—the year of *The Massacre at Chios,* a beacon painting of Romanticism—the young and impetuous artist had explained: "The great thing is to avoid this infernal facility of the brush."[20]

"To work obdurate material in order to vanquish it by patience"

This need for order, apparent throughout his career, is related to his concern to make "thought" visible, for this goal would be hindered by handling that was too visible, too free. Delacroix maintained that the artist should efface himself by making his craft inconspicuous, thereby leaving the spectator free to dream:

> The painter thinks less about expressing his subject than about making his own skill, his own dexterity, shine; from that, beautiful execution, the deft touch, the superlatively rendered piece . . . Ah!

Poor fellow! While I'm admiring your dexterity, my heart freezes and my imagination folds its wings.

The truly great masters do not proceed in this way. No, they are certainly not devoid of the charm of execution, far from it, but it is not this sterile, material execution, which can inspire only the admiration one feels for a tour de force.[21]

Assuredly, Delacroix did not look favorably on artists of the eighteenth century. He contemplated this subject at Valmont, in Normandy, comparing the paintings hanging on the walls of the salon of his cousin Louis-Auguste Bornot. "In a word, I have often asked myself why extreme facility, boldness of touch, do not shock me in Rubens yet are detestable practices in the Vanloo."[22] He criticized this "unfortunate facility," these "marks of a stamp of weakness." Thus he established a hierarchy of touch: the good and the bad, the latter being that which is an end in itself. A work's formal qualities should remain a means in the service of "thought," of feeling.

Delacroix was astonished by the relief and vigorous handling of Courbet's *Bathers* (Musée Fabre, Montpellier), which he found vulgar, summing up his views as follows: "It is the vulgarity and uselessness of the thought that are abominable."[23]

Touch and color

Delacroix does not directly associate touch with color in his dictionary. In his definition of touch he stresses relief, the enhancing of the various levels of depth in a composition: "Properly used, touch serves to articulate more appropriately the different levels of depth of objects. When emphatic, it makes them come forward; the contrary makes them recede."[24] Here also, comparison of the painter's craft with that of the sculptor seems essential. Using thick material, the artist models and shapes masses. This first spontaneous gush is sometimes associated with color,[25] sometimes not.

Execution of the oil sketch—spontaneous, free, rapid—was a key moment for Delacroix, for the result carried within it the vital "indication of the thought." Apparently, however, he sometimes reworked these sketches by laboriously applying different layers, "a system of hatchings and continual retouches," according to Charles Blanc, who criticized the procedure on technical grounds: "This technique is manifestly contradictory. Rapidity of execution is inconsistent with interminable finishing in several layers applied over an extended period."[26]

This initial layer, executed with much impasto, structured the composition and formed "the bed of the painting" that Delacroix had noted in certain unfinished works by Titian.[27] This was not always identical to the "bed of the painting" described by Delacroix's admirers, the artists and critics who focused primarily on the novel aspects of his color, which is composed of touches that "dress" and irradiate the material—applied in a way dubbed *flochetage,* or "flossing." Thus Frédéric Villot, curator at the Louvre, explained that "likening the brush to a weaver's shuttle, [he sought] to shape a fabric whose multicolored threads crisscrossed and interrupted one another at every instant."[28] This decomposition of colors into juxtaposed touches was a technique suggested to Delacroix by English painters (Bonington, Constable) during his trip to England in 1825—a technique refined, thanks to his voyage to Morocco in 1832, by his realization of the role of light and of colored shadows, as well as by the use of complementary colors. The use of small juxtaposed brushstrokes to set colors vibrating—considered by Signac the source of Impressionism—is often invoked by Delacroix's admirers, but without mention of relief and the effect of projection.

Conversely, Delacroix's detractors, who said little about his color, expressed contempt for his irregular facture and emphasized the absence from his work of slick, smooth surfaces, qualifying his canvases as *tartouillades* ("accretive hodgepodges"—a derogatory term occasioned by the exhibition of *The Barque of Dante* at the Salon of 1824) and *barbouillages informes* ("shapeless daubs").[29]

"Viewed from a distance sufficient to render the brushstrokes invisible, this painting produces a remarkable effect. Viewed from close up, the touch is so choppy, so incoherent," we read in the *Annales du musée et de l'École moderne des beaux-arts* in 1828.[30] This criticism reveals above all the discomfort occasioned by the artist's distinctive touch, his pictorial "handwriting": according to Delacroix himself, the finest passage in *The Barque of Dante* was the head of "the man facing front, to the rear, and who tries to climb into the boat, having passed his arm over the side"—painted with "extreme rapidity and briskness" when he was "electrified" by the reading of a canto from Dante by his friend Pierre-Marie Piétri.[31] The fact that this work was described as a *tartouillade,*[32] a characterization referring back to its raw material, is indicative of the public perception of the painter's technique, considered by some critics at the beginning of his career to be incompetent and deliberately provocative.

"I am a man prone to reworking"

The notion of incompleteness was extremely important to Delacroix, who never drafted the projected article titled "Finish" for his dictionary. "Looking very closely at the most finished of works, one still discovers traces of touches and accents."[33] For him, the place of touch in the finished painting, the painter's unique signature, was essential and innovative. It recorded something of the creative process and appealed to the Romantic taste for sketches and ruins, thought to have a powerful effect on the soul. This reclamation of the role of touch in the finished work also shows his desire to find subsequent extensions of each painting, so that it became merely the departure point for a wave of "pictorial variation," which sometimes included a number of replicas.[34] He further revealed his taste for a lack of finish in his rejection of contours that delimit and enclose. "Adding the finishing touches," he wrote in a letter, "is very difficult. The danger arises when one reaches a point where reworking is no longer useful, and I am a man prone to reworking."[35]

VARNISH

In February 1845, Delacroix wrote to the scholar Eudore Soulié: "Dear Monsieur, I send you a shipment of paintings. I dare to ask that you do everything possible to protect them from the rain. My paintings are varnished with egg whites, and the slightest drop of water will make dreadful stains."[36] On February 7, 1849, he noted in his *Journal:* "I am experiencing with the painting *Women of Algiers* how agreeable and even necessary it is to paint on varnish." On February 24, 1852, he wrote: "Pérignon told me *how to provisionally varnish a painting:* it is with gelatine like that sold by butchers, which one dissolves in a little water and applies to the painting with a sponge. To remove it, one again uses warm water." The same year, on October 4, he mentioned with regard to his supplier: "Haro uses, to give his paintings a matte surface, wax dissolved in turpentine, with the addition of a little oil of lavender; to remove this matte coating, he uses turpentine mixed with

water. One has to beat hard to achieve this mixture. This matte coating, rubbed with linen, provides a varnish that does not have the drawbacks of the others."[37]

Countless descriptions of recipes for the production of original technical solutions, like this one, underscore the importance Delacroix accorded the use of varnish. In his view, it could be used in all strata of the pictorial bed: below, above, between, and within the various layers of the material. As a result, the greatest prudence must be exercised when restoring his paintings. On February 7, 1849, he noted: "One must find a means of rendering only the lower levels of varnish invulnerable to subsequent varnish-removal operations, or first varnish the oil sketch with a varnish that cannot be removed, like that of Desrosiers or of Soehnée, I think, or varnish with [word missing] in the first place, or do likewise at the end."[38]

Transparency

In 1825 Delacroix took a trip to England that permitted him to deepen his knowledge not only of colors but also of English technique. It was probably after meeting Bonington that he discovered copal varnish.[39] A note in the restoration dossier for *The Murder of the Bishop of Liège* records the advice given by Jean Gabriel Goulinat, head of the restoration studio of the Musées Nationaux, to a commission in October 1962: "This varnish cannot be thinned because part of the yellowing of the painting is due to its having been *painted* with copal varnish. Furthermore, it is also *varnished* with copal varnish—which gave the painting a magnificent luster. One cannot alter this varnish without attenuating this extraordinary transparency."[40] The reasons for this double use, both within the material and on its surface, seem to have been both aesthetic (a taste for transparent effects) and preservative, for the outer layer of varnish constitutes a hard protective matrix.

Published in 1830, J. F. L. Mérimée's treatise on oil painting dwells at length on the various varnishes that can be mixed with colors. The use of copal varnish with colors is described in some detail, for it "gives the colors much transparency and brilliance."[41] Of diverse origins (South America, Africa, India, etc.), copals are resins resistant to many solvents. They form a film that is hard and brilliant. Apparently, the painter often referred to their protective qualities: "Everything should be varnished with copal,"[42] he is reported to have asserted with confidence, persuaded that his works in which varnish had been mixed with the colors would be well preserved. Delacroix coated the entirety of his palette with copal before using it.

According to Théophile Silvestre, this varnish, so often mentioned by the painter, had the capacity of crystallizing the pictorial material, of "fixing immediately the accents of his touch," and above all of rendering it "invulnerable to the restorers and ravagers of paintings."[43] But legitimate questions arise concerning this ambiguous interest in the transparency and "colored glazes" characteristic of academic technique—the technique of Delacroix's rival Ingres. The projected dictionary articles titled "Glazes," "Transparency," and "Varnish" were never written—because of a lack of time, to be sure, but perhaps also because their subjects made Delacroix uneasy. Paradoxically, it is in the entry "Impasto" that varnish and glazes are evoked, and then indirectly: "Artists who dread the effect of varnish, which is always to make the painting smooth," are advised to "calculate the contrast between the impasto and the glaze."[44] There is no outright rejection of glazes, but rather, on an aesthetic level, a call for a new exploitation of them without relation to Neoclassical facture.

Thus in *The Murder of the Bishop of Liège,* Delacroix used both a fluid touch and glazes, but he applied the latter to surfaces full of contrast and projection.[45] He did not care for the brilliant and gaudy effect of a varnish that impoverished the material beneath it. He reproached the painters Antoine-Jean Gros and François Gérard for the lack of thickness in the paintings they executed in 1824 for the dome of the Panthéon. He literally mocked the pendentives by the latter artist, condemning their "frightful colors" and explaining that "the slickness of the painting manages to shock and gives everything an unbearable thinness."[46] A painting with neither relief nor contrast was theoretically unacceptable. Without touch, "feeling" could not assume its proper place.

An impenetrable matrix

Mérimée affirmed in his treatise *De la peinture à l'huile* ("On oil painting"):

> One should conclude that the preservation of a painting will be better ensured if one first varnishes it lightly with some good copal varnish, and then applies to this first varnish, after it has dried completely, a layer of mastic varnish. The latter will be yellow after several years; but since it is easily removed, it can be replaced when it has lost its transparency. Copal varnish, being extremely hard, will not be damaged when the varnish covering it is removed: thus it will protect the painting, and there will be less risk of removing the glazes when one removes the mastic varnish.[47]

In 1862 Villot had noted the excellent condition of *The Murder of the Bishop of Liège* upon its return from the International Exhibition in London.[48] He observed that, while the painting had been all but invisible, it had been possible to wash it with "four pails of water to remove the thick crust of dust and soot" without risk to the work, and it had no need of being revarnished. According to Jean Gabriel Goulinat, head of the restoration studio in the Louvre, the excellent condition of the paint layer resulted from the use of copal varnish as a siccative and as a protective layer.[49]

Likewise, Étienne Moreau-Nélaton reported that *Still Life with Lobsters,* exhibited at the Salon of 1827, was in perfect condition when it entered the Louvre in 1906 because copal varnish had been mixed with the colors, a procedure intended to increase the work's brilliance and protect it from alteration.[50] Obviously, this optimism—excessive—should not make us forget how poorly certain of the painter's works have aged, including some of the ones executed with experimental techniques.

"It would be desirable never to use varnish"

Delacroix paid close attention to restoration work carried out on the works still in his possession, but also on those in museums. He sought to be present during these interventions and sometimes even performed them himself, notably retouching his canvases when they were worn—for example, *The Barque of Dante,* on which he observed a disturbing evolution of cracks. "I consider it very important that my painting be retouched by myself, and when I speak of retouches I have in view only the repair of cracks unfortunately too numerous that will have remained after restretching."[51]

On these questions, a veritable dialogue unfolded between the painter and the famous firm of Haro's, Au Génie des Arts, which had been located since 1826 in the Saint-Germain quarter. The firm specialized in the sale of art supplies and in art restoration, and

Delacroix engaged its services for a great many of his works, notably the *Sardanapalus* when it was sold to a collector, John Wilson, in 1846. (The services in that case included varnish removal, rolling, transport, and so forth.)[52]

Especially during the last years of his life, Delacroix apparently distrusted varnish removal, which he considered dangerous for the work. He expressed concern, for example, about one of his versions of *Christ on the Sea of Galilee* (cat. 115): "If it proves necessary to remove the varnish before it is retouched, in my eyes it will be a dishonored painting. Varnish removal is regarded as a trifling thing: it is extremely harmful; I much prefer a hole in a painting."[53] Wary of restorations of major paintings like *The Wedding at Cana* by Varennes, carried out under Villot's direction, he also had doubts about the advisability of removing the varnish from *The Massacre at Chios*, whose shadows lost their transparency as a result—"as they did in the Veronese." Delacroix went on to reproach his supplier and restorer Haro for having ruined the portraits of his brothers by Léon Riesener.[54]

After having explored the resources of copal varnish after his English sojourn, Delacroix, at the end of his career, put questions to himself not about varnish removal but about varnishing. Troubled, he discovered with interest, in 1858, the paintings by Rubens whose varnish had been removed on Villot's instructions. "It would be desirable never to use varnish,"[55] he exclaimed on discovering the freshness of Rubens's colors, especially the lighter ones. A general yellowing of the varnish had obscured the contrasts between the cool darks and the lights, thereby disturbing the overall harmony of the compositions.

This modification of cool tones produced by layers of varnish poses special aesthetic problems with regard to Delacroix's own works. When contemplating a cleaning of the sketch for the *Sardanapalus*,[56] the members of the restoration committee that met in 1959 took issue with the slight thinning of the varnish effected in 1956. They opted for removal of more varnish in order to recover the original cool tones.

"All these paintings will soon perish"

"Delacroix loved to try all the new products proposed to him by paint merchants, which often did grave harm to his paintings."[57] This significant observation by Louis de Planet clearly sums up the master's intention to further the technical advance of painting—an intention brought to the fore in the unrealized project for the dictionary of the fine arts, which would have been concerned primarily with technique and to a much lesser extent with the history of art.

He was open to every new experiment, but, paradoxically, he complained ceaselessly about the declining quality of art materials in his period (a view often confirmed by restorers of our own day), which he attributed "to the progress of *knavery* of all kinds, which falsifies the materials used in making colors, oils, varnishes, thanks to industry."[58] Delacroix was perpetually dissatisfied with new products that did not help to shorten the drying time of pictorial material. In his pursuit of rapid and spontaneous execution—which necessitated successive reworkings, the superimposition of layers of color, and a short drying time—he had to contend with irreversible degradations of the paint layer, resulting in cracks, especially in dark areas.[59] A thorough study of this problem would be of the greatest interest to restorers and historians. In a letter of 1864, Delacroix offered the following advice to Paul Huet, who had queried him about drying time: "Ask Haro for the siccative that I use; by adding a smaller or larger amount of oil, one can control the drying

time at will, one can even make [the paint] dry instantly and glaze everything immediately afterward, whereas the other siccative requires at least twenty-four hours."[60] Nonetheless, some years earlier, in a moment of prescience, the artist had reflected in his *Journal* on the discrepancy in the practice of modern painters between the means available to them and the nature of their formal investigations: "With our moderns, a depth of intention and sincerity shines even in their faults. Unfortunately, their material processes are not on the same level as those of their predecessors. All these paintings will soon perish."[61]

Unless otherwise noted, all of the paintings discussed in this essay are in the Musée du Louvre, Paris.

1. *Dictionnaire des Beaux-Arts d'Eugène Delacroix* (Paris: Hermann, éditeurs des Sciences et des Arts, 1996), p. 202.

2. De Planet, 1929, p. 93.

3. *Journal*, July 20, 1824, p. 91 (see Norton, 1951, p. 48).

4. *Journal*, October 21, 1860, p. 790 (see Norton, 1951, p. 406).

5. *Journal*, March 6, 1847, and October 9, 1849, pp. 140, 208.

6. Huyghe, 1963, p. 257.

7. Charles Baudelaire, *Baudelaire: Oeuvres complètes*, ed. Claude Pichois (Paris: Gallimard, 1976), vol. 2, p. 754.

8. *Journal*, July 20, 1824, p. 91 (see Norton, 1951, p. 48).

9. Piot, 1931, p. 49.

10. *Journal*, March 27, 1853, p. 324 (see Norton, 1951, pp. 169–70).

11. De Planet, 1929, p. 25.

12. P. Paulet, restoration report, March 26, 1960; dossier no. 1322, Archives du Service de Restauration des Musées de France, Versailles.

13. De Planet, 1929, p. 28. On this subject, see the exhibition catalogue *Eugène Delacroix à l'Assemblée nationale* published by the Réunion des Musées Nationaux (Paris, 1995), especially "La Restauration des peintures murales" by Nathalie Volle, and "Étude du laboratoire pour une approche de la technique et de l'artiste" by Sylvie Colinart, Lola Faillant-Dumas, and Élisabeth Martin.

14. *Journal*, January 25, 1857, p. 632.

15. Paul Signac, *From Eugène Delacroix to Neo-Impressionism*, 3rd ed. (Paris: Floury, 1921); quoted in Floyd Ratliff, *Paul Signac and Color in Neo-Impressionism*, translated by Willa Silverman (New York: Rockefeller University Press, 1992).

16. Delacroix to Frédéric Villot, August 5, 1845, *Correspondance*, vol. 2, p. 229.

17. Piot, 1931.

18. *Journal*, November 22, 1853, p. 384 (see Norton, 1951, p. 210).

19. De Planet, 1929, p. 94.

20. *Journal*, July 20, 1824, pp. 90–91; *Journal*, March 18, 1853 (see Norton, 1951, p. 169).

21. *Journal*, June 21, 1844, pp. 868–69.

22. *Journal*, October 9, 1849, p. 208. Delacroix used the phrase "the Vanloo" to designate the entirety of eighteenth-century painting.

23. *Journal*, April 15, 1853, pp. 327–28.

24. *Dictionnaire* (see note 1), p. 203.

25. Baudelaire was insistent about the difficulty of modeling directly with color, a technique mastered perfectly by Delacroix in *The Last Words of Marcus Aurelius*, exhibited at the Salon of 1845 (Musée des Beaux-Arts, Lyon).

26. Charles Blanc, *Les Artistes de mon temps* (Paris: Firmin-Didot, 1876).

27. See the article "Ébauche" (Oil Sketch) in the *Dictionnaire* (see note 1).

28. Quoted in Huyghe, 1990, p. 96.

29. Quoted in Signac (see note 15), p. 61.

30. C. P. Landon, quoted in Signac (see note 15), p. 61.

31. *Journal*, December 24, 1853, p. 394.

32. Delécluze, 1822.

33. *Dictionnaire* (see note 1), p. 303.

34. René Jullian, "Delacroix et la musique du tableau," *Gazette des Beaux-Arts*, March 1976.

35. Delacroix to Constant Dutilleux, April 1859, *Correspondance*, vol. 4, p. 91.

36. Delacroix to Soulié, February 1845, *Correspondance*, vol. 2.

37. *Journal*, February 7, 1849, February 24, 1852, and October 4, 1852, pp. 175, 293, 310.

38. *Journal*, February 7, 1849, p. 175.

39. Huyghe, 1990, p. 93.

40. *The Murder of the Bishop of Liège*, dossier no. 1542, Archives du Service de Restauration des Musées de France, Versailles.

41. J. F. L. Mérimée, *De la peinture à l'huile* (Paris: Huzard, 1830).

42. Alfred Bruyas, *La Galerie Bruyas, musée de Montpellier* (Paris: G. Sloye, 1876).

43. Bruyas (see note 42).

44. *Dictionnaire* (see note 1), p. 85.

45. Michèle Toupet, "L'Assassinat de l'évêque de Liège," *Revue du Louvre et des musées de France*, no. 2 (1963).

46. *Journal*, January 19, 1847, p. 117.

47. Mérimée (see note 41), p. 101.

48. Frédéric Villot, preface to *Catalogue de vente des tableaux, aquarelles etc. provenant du cabinet de M. F. V.*, Paris, February 11, 1865.

49. On this subject, see dossier 1542, Archives du Service de Restauration des Musées de France, Versailles; and Toupet (see note 45).

50. Moreau-Nélaton, 1916, vol. 1.

51. Delacroix to comte de Nieuwerkerke, February 15, 1860, *Correspondance,* vol. 4, p. 151.

52. André Joubin and Étienne François Haro, "Entre Ingres et Delacroix," *L'Amour de l'art,* March 1836.

53. Delacroix to Francis Petit, May 25, 1861, *Correspondance,* vol. 4, p. 249.

54. *Journal,* June 27, 1854, p. 436.

55. Delacroix to Constant Dutilleux, May 8, 1858, *Correspondance,* vol. 4, p. 41.

56. The varnish on the painting was thinned slightly by P. Michel in 1956, and then more was removed in 1959 in accordance with the determination reached in the commission meeting of March 20, 1959; dossier 264, Archives du Service de Restauration des Musées de France, Versailles.

57. De Planet, 1929, p. 85.

58. *Journal,* July 29, 1854, pp. 445–46.

59. Ségolène Bergeon, *Science et patience ou la restauration des peintures* (Paris: Réunion des Musées Nationaux, 1990), p. 196. It was long thought that cracks in the dark passages of certain works by Ary Scheffer, Géricault, and Delacroix resulted from the use of bitumen. Analyses carried out in 1985 revealed no bitumen but, rather, the use of an oil binder made to dry too quickly in the presence of an excess of lead (report by J. Petit and H. Valot, Centre National de la Recherce Scientifique).

60. *Correspondance,* vol. 4, p. 95.

61. *Journal,* September 13, 1857, p. 678.

About, Edmond. *Voyage à travers l'exposition des Beaux-Arts (peinture et sculpture)*. Paris: Hachette, 1855.

Anonymous. "Salon de 1847." *L'Illustration,* May 1, 1847.

Anonymous. "Revue des Beaux-Arts: Exposition des Tuileries." *Le Pays,* August 4, 1849.

Anonymous. *Notice sur les principaux tableaux de l'Exposition de 1859: Peintres français.* Paris, 1859.

Anonymous. *Le Courrier artistique,* vol. 2, no. 1 (June 15, 1862).

Anonymous. "Chronique." *L'Artiste,* April 1, 1863.

Arama, Maurice. *Le Maroc de Delacroix*. Paris: Les éditions du Jaguar, 1987.

Arama, Maurice. *Delacroix: Le Voyage au Maroc: Regards croisés*. Paris: Les éditions du Sagittaire, 1992.

Arama, Maurice. "Le Voyage" in Institut du Monde arabe, Paris, *Delacroix: Le Voyage au Maroc,* September 27, 1994–January 15, 1995.

Arnoux, Jacques. "Salon de 1850–1851." *La Patrie,* February 22, 1851.

Arnoux, Jacques. "Salon de 1853." *La Patrie,* September 3 and 5, 1853.

Astruc, Zacharie. *Les 14 Stations du Salon de 1859.* Paris: Poulet-Malassis et de Broix, 1859.

Astruc, Zacharie. *Le Salon intime: Exposition au boulevard des Italiens.* Paris: Poulet-Malassis et de Broix, 1860.

Aubert, Maurice. *Souvenirs du Salon de 1859.* Paris: J. Tardieu, 1859.

Auvray, Louis. *Exposition des Beaux-Arts: Salon de 1859.* Paris: Librairie d'Alphonse Taride, 1859.

Badt, Kurt. *Eugène Delacroix: Drawings.* Oxford: Bruno Cassirer, 1946.

Banville, T. de. "Le Salon de 1851." *Le Pouvoir,* January 10, 1851.

Baudelaire, Charles. "Exposition universelle." *Le Pays,* May 26 and June 3, 1855 (reprinted in *Baudelaire: Oeuvres complètes,* vol. 2, ed. Claude Pichois. Paris: Gallimard, 1976).

Baudelaire, Charles. "Salon de 1859." *Revue française,* June 10 and 20, July 1 and 20, 1859 (reprinted in *Oeuvres complètes,* see above).

Baudelaire, Charles. "L'Oeuvre et la vie d'Eugène Delacroix: 1863." *L'Opinion nationale,* September 2, November 14 and 22, 1863 (reprinted in *Oeuvres complètes,* see above).

Belloy, A. de. "Salon de 1859." *L'Artiste,* n.s., vol. 7 (May 1, 1859).

Bessis, Henriette. "L'Inventaire après décès de Delacroix." *Bulletin de la Société de l'histoire de l'art français. Année 1969.* Paris, 1971, pp. 199–222.

Boyeldieu d'Auvigny, L. *Guide aux Menus-Plaisirs: Salon de 1853.* Paris: J. Dagneau, 1853.

Burty, Philippe. *Lettres d'Eugène Delacroix (1815 à 1863) recueillies et publiées par M. Philippe Burty.* Paris: A. Quantin, 1878.

Burty, Philippe. "Eugène Delacroix à l'École des Beaux-Arts." *L'Illustration,* March 21, 1885.

Cadol, E. "Revue du Salon." *L'Univers illustré,* April 30, 1859.

Cailleux, L. "Salon de 1849." *Le Temps,* June 28 and 29, 1849.

Calonne, A. de. "Exposition de 1850–1851." *L'Opinion publique,* March 18, 1851.

Calonne, A. de. "Salon de 1853." *Revue contemporaine,* vol. 8, 2nd year (June–July 1853).

Cantaloube, Amédée. *Eugène Delacroix: L'homme et l'artiste, ses amis et ses critiques.* Paris: Dentu, 1864.

Champfleury [Jules Husson-Fleury]. "Salon de 1849." *La Silhouette,* July 15, 1849.

Chesneau, Ernest. "Libre étude sur l'art contemporain: Salon de 1859." *Revue des races,* vol. 14 (May 1859).

Clément de Ris, L. "Salon de 1847." *L'Artiste,* April 4 and 18, 1847.

Clément de Ris, L. "Salon de 1848." *L'Artiste,* March 26, 1848.

Clément de Ris, L. "Salon de 1848: Eugène Delacroix, Duveau, Diaz, Gérôme, Lehmann, Fernand Boissard." *L'Artiste,* April 2, 1848.

Clément de Ris, L. "Le Salon." *L'Artiste,* February 1, 1851.

Clément de Ris, L. "Salon de 1853: V. Peintres de genre." *L'Artiste,* July 15, 1853.

Clément de Ris, L. "Artistes contemporains: Eugène Delacroix." *Revue française,* 3rd year, vol. 8 (1857).

Clément de Ris, L. *Les Musées de province.* Paris, 1859.

Correspondance, see Joubin, André.

Courtois. "Salon de 1850: Sculpture.—Peinture." *Le Corsaire,* January 21, 1851.

Courtois. "Salon de 1850: Peinture." *Le Corsaire,* January 28, 1851.

Daguerre de Hureaux, Alain. *Delacroix.* Paris: Hazan, 1993.

Daguerre de Hureaux, Alain, and Stéphane Guégan. *L'ABCdaire de Delacroix en Orient.* Paris: Flammarion, 1994.

Dauger, A. "Salon de 1851." *Le Pays,* February 9, 1851.

Decamps, A. "Salon de 1838." *Le National,* March 18, 1838.

Delaborde, Henri. "Salon de 1853." *Revue des Deux Mondes,* June 15, 1853.

Delaborde, Henri. "L'Art français." *Revue des Deux Mondes,* May 15, 1859.

Delaborde, Henri. *Éloge d'Eugène Delacroix, lu dans la séance publique annuelle du 28 octobre 1876.* Paris: Firmin-Didot, 1876.

Delacroix, Eugène. "Description détaillée de la bibliothèque du Palais Bourbon." *Le Constitutionnel,* January 31, 1848.

Delacroix, Eugène. "Questions sur le Beau." *Revue des Deux Mondes,* July 15, 1854.

Delacroix, Eugène. "Des variations du Beau." *Revue des Deux Mondes,* July 15, 1857.

Delacroix, Eugène. *Oeuvres littéraires: Études esthétiques.* 2 vols. Paris: Crès et Cie., 1923.

Delacroix, Eugène. *Journal, 1822–1863.* Paris: Plon, 1996.

Delaunay, A. *Catalogue complet du Salon de 1847.* Paris: Au bureau du Journal des artistes, s.d. [1847].

Delécluze, E. J. "Salon de 1822." *Moniteur universel,* May 18, 1822.

Delécluze, E. J. "Exposition de 1853." *Le Journal des débats,* June 3, 1853.

Delteil, L. *Le Peintre-graveur illustré.* 31 vols. Paris, 1906–30.

Desnoyers, L. "Salon de 1849." *Le Siècle,* July 27, 1849.

Desplaces, Auguste. "Lettres sur le Salon." *L'Union,* January 20, 1851.

Dubosc de Pesquidoux, L. de. *Voyage artistique en France.* Paris: Michel Lévy frères, 1857.

Dubosc de Pesquidoux, L. de. "Salon de 1859." *L'Union,* April 27, 1859.

Du Camp, Maxime. *Les Beaux-Arts à l'Exposition universelle de 1855: Peinture. Sculpture.* Paris: Librairie nouvelle, 1855.

Du Camp, Maxime. *Le Salon de 1859.* Paris: Librairie nouvelle, 1859.

Dumas, Alexandre. "Salon de 1859, à Paris." *L'Indépendance belge,* April 22, 1859. (a)

Dumas, Alexandre. *L'Art et les artistes contemporains au Salon de 1859.* Paris: Librairie nouvelle, 1859. (b)

Dumesnil, Henri. *Le Salon de 1859.* Paris: J. Renouard, 1859.

Du Pays, A. J. "Salon de 1848." *L'Illustration,* April 8, 1848.

Du Pays, A. J. "Salon de 1849." *L'Illustration,* August 11, 1849.

Du Pays, A. J. "Salon de 1850." *L'Illustration,* February 27, 1851.

Du Pays, A. J. "Salon de 1853." *L'Illustration,* June 11, 1853.

Du Pays, A. J. "Salon de 1859." *L'Illustration,* May 21, 1859.

Duplessis, Georges. "Salon de 1859." *Revue des Beaux-Arts,* vol. 10 (1859).

Feydeau, Ernest. "Voyage à travers les collections particulières de Paris: Collection de M. Adolphe Moreau." *L'Artiste,* May 2, 1858.

Fizelière, A. de la. "Revue du Salon." *Le Siècle,* April 21–22, 1851.

Florisoone, Michel. *Delacroix.* Paris: Braun, s.d. [1938].

Florisoone, Michel. "Comment Delacroix

a-t-il connu les *Caprices* de Goya." *Bulletin de la Société de l'histoire de l'art français, Année 1957,* 1958, pp. 131–44.

Forge, A. de la. *La Peinture contemporaine en France.* Paris: Amyot, 1856.

Fouquier, H. *Études artistiques: Lettres sur le Salon de 1859.* Marseille: Arnaud, 1859.

Fournel, V. "Le Salon de 1859." *Le Correspondant,* May 25, 1859.

Galimard, A. "Salon de 1850–1851." *Le Daguerréotype théâtral,* January 23, 1851.

Gautier, Théophile. "Salon de 1841." *Revue de Paris,* April 1841.

Gautier, Théophile. "Le Salon de 1845." *La Presse,* March 18, 1845.

Gautier, Théophile. "Salon de 1845." *La Presse,* November 17, 1845.

Gautier, Théophile. "Salon de 1847." *La Presse,* April 1, 1847 (reprinted in *Salon de 1847.* Paris: J. Hetzel, Warnod et Cie, 1847).

Gautier, Théophile. "Salon de 1848." *La Presse,* April 26, 1848.

Gautier, Théophile. "Salon de 1849." *La Presse,* August 1, 1849.

Gautier, Théophile. "Salon de 1850–1851: 7ᵉ article: M. Eugène Delacroix, Robert Fleury, Louis Boulanger." *La Presse,* March 8, 1851.

Gautier, Théophile. "Salon de 1853." *La Presse,* June 25, 1853.

Gautier, Théophile. "Le Salon de la Paix." *Moniteur universel,* March 25, 1854.

Gautier, Théophile. "Exposition universelle de 1855: Peinture. Sculpture. XVII: M. Eugène Delacroix." *Moniteur universel,* July 25, 1855. (a)

Gautier, Théophile. *Les Beaux-Arts en Europe–1855.* Paris: Michel Lévy, 1855, chapter 14. (b)

Gautier, Théophile. "Les Primes de l'artiste." *L'Artiste,* 6th series, vol. 3 (March 22, 1857).

Gautier, Théophile. Preface to sale catalogue [Weill], Paris, January 20, 1858.

Gautier, Théophile. "Exposition de 1859, chapitre 5." *Moniteur universel,* May 21, 1859.

Gautier, Théophile. "Histoire de l'art dramatique en France depuis 25 ans." *Histoire,* vol. 4. Paris: Hetzel, 1859.

Gautier, Théophile. "Tableaux de l'école moderne: Exposition au profit de la caisse de secours des artistes peintres, sculpteurs, architectes." *Moniteur universel,* February 6, 1860. (a)

Gautier, Théophile. "Exposition de tableaux modernes tirés de collections d'amateurs." *Gazette des Beaux-Arts,* February 15, 1860. (b)

Gautier, Théophile. Exposition de tableaux modernes: Toiles nouvelles.—Bonington, E. Delacroix, Ricard, Riesener, Gudin, Zichy, etc." *Moniteur universel,* May 5, 1860. (c)

Gebauer, E. *Les Beaux-Arts à l'Exposition universelle.* Paris: Librairie Napoléonienne, 1855.

Geoffroy, L. de. "Le Salon de 1850." *Revue des Deux Mondes,* March 1, 1851.

Guégan, Stéphane. *Delacroix et les Orientales.* Paris: Flammarion, 1994.

Guiffrey, Jules Marie Joseph, and Marcel P.

Guiffrey. *Inventaire général des dessins du musée du Louvre et du musée de Versailles: École française,* vol. 4, *Corot—Delacroix.* Paris, 1909.

Haussard, P. "Salon de 1847." *Le National,* April 8, 1847.

Haussard, P. "Salon de 1848." *Le National,* March 23, 1848.

Haussard, P. "Salon de 1849." *Le National,* August 7, 1849.

Henriet, Frédéric. "Salon de 1853." *Nouveau Journal des théâtres,* August 4, 1853.

Henriet, Frédéric. "Le Musée des rues, I, le marchand de tableaux." *L'Artiste,* November 15, 1854.

Houssaye, Arsène. "Salon de 1859." *Le Monde illustré,* May 7, 1859.

Huyghe, René. *L'Universalité de Delacroix.* Paris: Hachette, 1963.

Huyghe, René. *Delacroix ou le combat solitaire.* Paris: Laffont, 1990.

Jan, L. "Salon de 1848." *Le Siècle,* April 11, 1848.

Jobert, Barthélemy. *Delacroix.* Paris: Gallimard, 1997.

Johnson, Lee. "Delacroix and *The Bride of Abydos.*" *The Burlington Magazine,* vol. 114, no. 834 (September 1972), pp. 579–85.

Johnson, Lee. *The Paintings of Eugène Delacroix: A Critical Catalogue.* 6 vols. Oxford: Clarendon Press, 1981–89 (*1816–1831,* vols. 1 and 2, 1981; *1832–1863,* vols. 3 and 4, 1986; *The Public Decorations and Their Sketches,* vols. 5 and 6, 1989).

Johnson, Lee. "A New Oil Sketch for *Apollo Slays Python.*" *The Burlington Magazine,* vol. 130, no. 1018 (January 1988), pp. 35–36.

Johnson, Lee. *Eugène Delacroix: Further Correspondence, 1817–1863.* Oxford: Clarendon Press, 1991.

Johnson, Lee. "Ermina and the Wounded Tancred, a New Tasso Subject by Delacroix." *Apollo,* n.s., no. 370 (December 1992), pp. 379–83.

Johnson, Lee. *Delacroix: Pastels.* London: John Murray; New York: George Braziller, 1995.

Joubin, André, ed. *Delacroix: Correspondance.* 5 vols. Paris, 1936–38 (*1804–1837,* vol. 1, 1936; *1838–1849,* vol. 2, 1937; *1850–1857,* vol. 3, 1937; *1858–1863,* vol. 4, 1938; *Supplément et tables,* vol. 5, 1938).

Joubin, André, "Documents nouveaux sur Delacroix et sa famille," *Gazette des Beaux-Arts,* March 1933, pp. 173–86.

Jourdan, L. *Les Peintres français: Salon de 1859.* Paris: Librairie nouvelle, 1859.

Journal, see Delacroix, Eugène.

Karr, A. *Les Guêpes illustrées: Les Guêpes au salon.* Paris: J. Hetzel, Warnod et Cie., 1847.

La Forge, A. de. *La Peinture contemporaine en France.* Paris: Amyot, 1856.

Lagrange, Léon. "Eugène Delacroix." *Le Correspondant,* n.s., vol. 25 (March 1864).

Lavergne, C. "Exposition de 1859. 2ᵉᵐᵉ article.

Vue générale du Salon.– Les critiques.— L'art chrétien et spiritualiste.—L'art naturaliste et mercantile." *L'Univers,* May 20, 1859.

Lecomte, J. "Exposition universelle de 1855, Beaux-Arts, II, M. Ingres. M. Delacroix." *L'Indépendance belge,* June 20, 1855.

Lépinois, E. B. de. *L'Art dans la rue et l'art au Salon.* Paris: Dentu, 1859.

Lescure, M. de. "Le Salon de 1859." *Gazette de France,* March 3 and June 14, 1859.

Loudun, E. *Exposition universelle des Beaux-Arts: Salon de 1855.* Paris: Ledoyen, 1855.

Lugt, Frits. *Les Marques de collections de dessins & d'estampes. . . .* Amsterdam, 1921. Supplement. The Hague, 1956.

Madelène, Henry de la. *Le Salon de 1853.* Paris: Librairie nouvelle, 1853.

Madelène, Henry de la. *Eugène Delacroix à l'exposition du boulevard des Italiens.* Paris: Lainé et Harvard, 1864.

Mantz, Paul. "Exposition de l'Odéon." *L'Artiste,* November 23, 1845.

Mantz, Paul. *Salon de 1847.* Paris: F. Sartorius, 1847.

Mantz, Paul. "Le Salon. III, MM. Eugène Delacroix et Descamps." *L'Événement,* February 5, 1851.

Mantz, Paul. "Le Salon de 1853." *Revue de Paris,* July 1, 1853.

Mantz, Paul. "Exposition universelle: Le Salon de 1855." *Revue française,* August 10 and September 10, 1855.

Mantz, Paul. "Salon de 1859." *Gazette des Beaux-Arts,* May 1, 1859, pp. 129–41.

Mantz, Paul. Preface to *Catalogue de l'exposition Eugène Delacroix au profit de la souscription destinée à élever à Paris un monument à sa mémoire.* Paris: École nationale des beaux-arts, 1885.

Marotte, Léon, and Charles Martine. *Eugène Delacroix: Soixante-dix aquarelles, dessins, croquis reproduits par Léon Marotte et publiés avec un catalogue raisonné par Charles Martine,* vol. 7, *Dessins de maîtres français.* Paris: Helleu et Sergent, 1928.

Menciaux, A. de. "Salon de 1847." *Le Siècle,* April 25, 1847.

Mercey, F. de. "Le Salon de 1848." *Revue des Deux Mondes,* March 1, 1848.

Mercey, F. de [F. de Lagenevay, pseud.]. "Le Salon de 1848." *Revue des Deux Mondes,* April 15, 1848.

Mérimée, Prosper. "Salon de 1853." *Moniteur universel,* May 16–17, 1853.

Mirbel, E. de. "Salon Review." *Le Commerce,* March 30, 1847.

Mirbel, E. de. "Salon de 1850–1851." *La Révolution littéraire,* vol. 1, no. 1 (1851).

Molay, Bacon E. du. "Salon de 1847." *La Patrie,* April 11, 1847.

Montaiglon, Anatole de. "Salon de 1851: M. Eugène Delacroix." *Le Théâtre: Journal de la littérature et des arts,* January 15, 1851.

Montaiglon, Anatole de. "La Peinture au Salon de 1859." *Revue universelle des arts,* vol. 9, no. 5 (August 1859).

Montlaur, E. de. "Salon de 1841." *Revue du progrès,* April 23, 1841.

Montlaur, E. de. "Salon de 1848." *Le Salut public,* April 8, 1848.

Moreau, Adolphe. *E. Delacroix et son oeuvre.* Paris: Librairie des bibliophiles, 1873.

Moreau-Nélaton, Étienne. *Delacroix raconté par lui-même,* 2 vols. Paris: Henri Laurens, 1916.

Norton, Lucy, trans. *The Journal of Eugène Delacroix: A Selection,* ed. Hubert Wellington. London: Phaidon, 1951.

Pach, Walter, trans. *The Journal of Eugène Delacroix.* New York: Friede, 1937.

Peisse, Louis. "Salon de 1849." *Le Constitutionnel,* July 8, 1849.

Peisse, Louis. "Salon de 1850." *Le Constitutionnel,* January 15, 1851.

Peisse, Louis. "Salon de 1853; III. Peinture d'histoire." *Le Constitutionnel,* May 31, 1853.

Perrier, Charles. "L'Exposition universelle des beaux-arts." *L'Artiste,* June 10, 1855.

Perrier, Charles. "Le Salon de 1859." *Revue contemporaine,* 2nd series, vol. 9 (May 31, 1859).

Perrin, E. "Le Salon de 1859; III. Eugène Delacroix." *Revue européenne,* May 31, 1859.

Petroz, P. "Salon de 1850." *Le Vote universel,* January 28, 1851.

Petroz, P. "Exposition universelle des Beaux-Arts, III, Eugène Delacroix." *La Presse,* June 5, 1855.

Pillet, F. "Salon de 1850–1851." *Moniteur universel,* January 15, 1851.

Piot, René. *Les Palettes de Delacroix.* Paris: Librairie de France, 1931.

Piron, Achille. *Eugène Delacroix: Sa vie et ses oeuvres.* Paris: Imprimerie de Jules Claye, 1865.

Planet, Louis de. *Souvenirs de travaux de peinture avec M. Eugène Delacroix.* Paris: Armand Colin, 1929.

Ponsonailhe, C. "L'Exposition de l'oeuvre d'Eugène Delacroix." *L'Artiste,* 1885.

Prat, Louis-Antoine. "Un ensemble de dessins de Delacroix au musée de Picardie à Amiens." *Revue du Louvre et des musées de France,* vol. 2 (1979).

Prat, Louis-Antoine. "Drawings by Delacroix: Two Errors, Three Discoveries." *Drawing,* vol. 14, no. 2 (July–August 1992), pp. 28–32.

Rautmann, Peter. *Delacroix,* trans. Denis-Armand Canal and Lydie Échasseriad. Paris: Citadelles & Mazenod, 1997; Munich: Hirmer, 1997.

Régamey, Raymond, *père. Eugène Delacroix–L'époque de la chapelle des Saints-Anges (1847–1863).* Paris: La Renaissance du livre, s. d. [1931].

Richard, L. "Salon de 1859. Peinture. II. Eugène Delacroix.–Bénédict Masson.–

Troyon.–Isabey.–Hébert.–Yvon.–Muller.–Madame Browne." *Le Courrier du dimanche,* April 24, 1859.

Robaut, Alfred. *Eugène Delacroix: facsimilés de dessins et croquis originaux.* Paris, 1864.

Robaut, Alfred. "Trois cartons pour vitraux par Eugène Delacroix." *L'Art,* vol. 17, no. 231 (June 1, 1879).

Robaut, Alfred. *L'Oeuvre complet de Eugène Delacroix: Peintures, Dessins, Gravures, Lithographies. Catalogué et reproduit par Alfred Robaut. . . .* Paris: Charavay frères, 1885 (copy annotated by Robaut in the Bibliothèque Nationale de France, Paris).

Rochery, Paul. "Le Salon de 1851." *La Politique nouvelle,* vol. 1, no. 1 (March 2, 1851).

Rousseau, Jean. "Petite Chronique des arts." *L'Artiste,* April 18, 1858.

Rousseau, Jean. "Salon de 1859." *Le Figaro,* May 10, 1859.

Rudrauf, Lucien. "De la bête à l'ange (les étapes de la lutte vitale dans la pensée et l'art d'Eugène Delacroix)." *Acta Historiae Artium Academia Scientiarum Hungaricae,* vol. 9, nos. 3/4 (1963).

Sabatier-Ungher, F. "Salon de 1851. 9ᵉ article. Peinture passionnelle–Peinture d'histoire. MM. Courbet.–Delacroix. (suite). . . ." *La Démocratie pacifique,* March 2, 1851.

Saint-Victor, Paul de. "Exposition de 1848." *La Semaine,* March 26, 1848.

Saint-Victor, Paul de. "Exposition de 1853." *Le Pays, journal de l'Empire,* June 23, 1853.

Saint-Victor, Paul de. "Salon de 1859." *La Presse,* April 22, 1859.

Saint-Victor, Paul de. "Bibliothèque de la Chambre des députés." *La Presse,* September 22, 1863.

Sérullaz, Arlette. "Delacroix et Byron." *Le Petit Journal des grandes expositions,* 1988.

Sérullaz, Arlette. "Musée Eugène Delacroix: dix années d'acquisitions (1985–1995)." *Le Petit Journal des grandes expositions,* 1996.

Sérullaz, Maurice. *Eugène Delacroix: Album de croquis,* vol. 1, facsimile, vol. 2, text. Paris: Quatre Chemins-Éditart, 1961.

Sérullaz, Maurice. *Mémorial de l'exposition Eugène Delacroix organisée au musée du Louvre à l'occasion du centenaire de la mort de l'artiste.* Paris: Réunion des Musées Nationaux, 1963. (a)

Sérullaz, Maurice. *Les Peintures murales de Delacroix.* Paris: Les Éditions du Temps, 1963. (b)

Sérullaz, Maurice. *Inventaire général des dessins. École française. Dessins d'Eugène Delacroix,* 2 vols. Paris: Réunion des Musées Nationaux, 1984.

Sérullaz, Maurice. *Delacroix.* Paris: Fayard, 1989.

Silvestre, Théophile. *Histoire des artistes vivants: Études d'après nature.* Paris: Blanchard, 1855.

Silvestre, Théodore. *Eugène Delacroix: Documents nouveaux.* Paris: Michel Lévy frères, 1864.

Stevens, Mathilde. *Impressions d'une femme au Salon de 1859.* Paris: Librairie nouvelle, 1859.

Stuffmann, Margret. "Delacroix Landschafts-darstellungen" in Städtische Galerie im Städelschen Kunstinstitut, Frankfurt, *Eugène Delacroix: Themen und Variationen. Arbeiten auf Papier,* September 24, 1987–January 10, 1988.

Tardieu, A. "Salon de 1859." *Le Constitutionnel,* April 22, 1859.

Thierry, E. "Salon de 1849." *L'Assemblée nationale,* August 29, 1849.

Thierry, E. "Exposition de 1851." *L'Assemblée nationale,* March 21, 1851.

Thoré, Théophile. "Salon de 1847." *Le Constitutionnel,* March 17, 1847. (a)

Thoré, Théophile. "Salon de 1847." *Le Constitutionnel,* April 14, 1847. (b)

Thoré, Théophile. "Salon de 1848." *Le Constitutionnel,* March 17, 1848.

Thoré, Théophile [William Bürger, pseud.]. "La Galerie de MM. Péreire." *Gazette des Beaux-Arts,* 1864, pp. 193, 297.

Tillot, C. "Exposition de 1853: Revue du Salon." *Le Siècle,* June 4, 1853.

Tourneux, Maurice. *Eugène Delacroix devant ses contemporains, ses écrits, ses biographes, ses critiques.* Paris: Jules Rouam, 1886.

Trianon, H. "Salon de 1847." *Le Correspondant,* vol. 19 (April 25, 1847).

Vachon, Marius. *Maîtres modernes: Eugène Delacroix à l'École des Beaux-Arts.* Paris: L. Baschet, 1855.

Vaines, M. de. "Salon de 1847." *Revue nouvelle,* April 15, 1847.

Vallet, E. "La *Chasse aux lions* d'Eugène Delacroix." *Courrier de l'art,* vol. 3 (December 27, 1883).

Véron, Eugène. *Les Artistes célèbres: Eugène Delacroix.* Paris: Librairie de l'Art, 1887.

Viel-Castel, Horace de. "Salon de 1853." *L'Athenaeum français, Journal universel de la littérature, de la science et des Beaux-Arts,* July 2, 1853.

Vignon, Claude. *Salon de 1850–1851.* Paris: Garnier, 1851.

Vignon, Claude. *Salon de 1853.* Paris: Dentu, 1853.

Vignon, Claude. *Exposition universelle de 1855: Beaux-Arts.* Paris: Librairie A. Fontaine, 1855.

List of Exhibitions Cited

1845 (a), Paris, Salon.

1845 (b), Paris, Théâtre de l'Odéon.

1847, Paris, Salon, Musée Royal, from March 16.

1848, Paris, Salon, Musée National du Louvre, from March 15.

1849, Paris, Salon, Palais des Tuileries, from June 15.

1850–51, Paris, Salon, Palais National, from December 30.

1853, Paris, Salon, Menus-Plaisirs, from May 15.

1854, Amsterdam, *Tentoonstelling van Schilder en Andere Werken van Levende Kunstenaars te Amsterdam in den Jare 1854,* Academy of Fine Arts, from September 5.

1854, Bordeaux, Exposition de la Société des amis des arts de Bordeaux, from November 12.

1855, Paris, Exposition Universelle, *Ouvrages de peinture des artistes vivants, étrangers et français,* Palais des Beaux-Arts, from May 15.

1857, Bordeaux, Exposition de la Société des amis des arts de Bordeaux, from March 8.

1857, Paris, Salon, Palais des Champs-Élysées, from June 15.

1859, Paris, Salon, Palais des Champs-Élysées, from April 15.

1860, Paris, *Tableaux de l'École moderne tirés des collections d'amateurs et exposés au profit de la Caisse de secours des artistes,* Galerie Martinet, 26, boulevard des Italiens.

1861–62, Paris, *Exposition de peinture,* Galerie Martinet, 26, boulevard des Italiens, from June 15.

1864, Paris, *Oeuvres d'Eugène Delacroix,* Société nationale des beaux-arts, boulevard des Italiens, from August 13.

1885, Paris, *Exposition Eugène Delacroix au profit de la souscription destinée à élever dans Paris un monument à sa mémoire,* École nationale des Beaux-Arts, March 6–April 15.

1925, Paris, *Aquarelles et dessins d'Eugène Delacroix,* Galerie Dru.

1928, Paris, *Delacroix,* Galerie Rosenberg, January 16–February 18.

1930, Chicago, *Loan Exhibition of Paintings, Water Colors, Drawings and Prints by Eugène Delacroix, 1798–1863,* The Art Institute of Chicago, March 20–April 20.

1930, Paris, *Centenaire du romantisme: Exposition Eugène Delacroix,* Musée du Louvre, June–July.

1932, Paris, *Eugène Delacroix et ses amis,* Atelier Delacroix, June–July.

1933, Paris, *Delacroix au Maroc,* Musée de l'Orangerie.

1934, Paris, *Exposition de peintures et de dessins d'Eugène Delacroix,* Atelier Delacroix.

1935, Paris, *Paysages de Delacroix et lithographies provenant des donations Étienne Moreau-Nélaton au Musée du Louvre et à la Bibliothèque Nationale,* Atelier Delacroix.

1936, Brussels, *Ingres–Delacroix,* Palais des Beaux-Arts.

1937, Paris, *Tableaux, aquarelles, dessins, gravures, lithographies (de Delacroix) provenant du Musée du Louvre, donations Étienne Moreau-Nélaton, Baron J. Vitta ou prêtés par divers amateurs,* Atelier Delacroix.

1938, New York, *Gros, Géricault, Delacroix: Loan Exhibition of Paintings and Drawings for the Benefit of the Sauvegarde de l'art français,* M. Knoedler and Company, November 21–December 10.

1939, Basel, *Eugène Delacroix,* Kunsthalle, April 22–May 29.

1939, San Francisco, *French Romantic Artists: An Exhibition of Paintings, Drawings and Watercolors by Gros, Géricault, Delacroix, with Prints of the Romantic Period,* San Francisco Museum of Art, April 19–May 14.

1939, Zurich, *Eugène Delacroix,* Kunsthalle, January 28–April 5.

1941, New York, *French Painting from David to Toulouse-Lautrec: Loans from French and American Museums and Collections,* The Metropolitan Museum of Art, February 6–March 26.

1944, New York, *Delacroix,* Wildenstein, October 18–November 18.

1945, Paris, *Chefs-d'oeuvre de Delacroix (1798–1863),* Atelier Delacroix, July 31–October 1.

1945, Washington, D.C., *Eugene Delacroix, 1798–1863: A Loan Exhibition,* Phillips Memorial Gallery, January 14–February 26.

1946 (a), Paris, *Chefs-d'oeuvre de Delacroix (1798–1863),* Atelier Delacroix, May–November.

1946 (b), Paris, *Delacroix et son temps (Gros–Géricault–Courbet),* Atelier Delacroix, November.

1948, New York, *Loan Exhibition of Masterpieces by Delacroix and Renoir for the Benefit of the New York Heart Association,* Paul Rosenberg & Co., February 16–March 13.

1948, Paris, *Delacroix et l'Angleterre,* Atelier Delacroix.

1949, Paris, *Delacroix et le paysage romantique,* Atelier Delacroix, from May.

1951, Paris, *Delacroix et l'orientalisme de son temps,* Atelier Delacroix, from May 11.

1952, London, *Eugène Delacroix (1798–1863),* Wildenstein, June–July.

1952, Hartford (Connecticut), *The Romantic Circle: French Romantic Painting, Delacroix and His Contemporaries,* Wadsworth Atheneum, October 15–November 30.

1952, Paris, *Delacroix et les maîtres de la couleur,* Atelier Delacroix, from May 17.

1954, Paris, *Gros, Géricault, Delacroix,* Galerie Bernheim, from January 9.

1956, Venice, *XXVIII Biennale di Venezia, Delacroix alla Biennale,* June–September.

1962–63, Toronto and Ottawa, *Delacroix,* The Art Gallery of Toronto, December 1, 1962–January 7, 1963, and The National Gallery of Canada, January 12–February 9, 1963.

1963, Bordeaux, *Delacroix, ses maîtres, ses amis, ses élèves,* Galerie des Beaux-Arts, May 17–September 30.

1963 (a), Paris, *Delacroix, 1798–1863: Exposition du centenaire,* Musée du Louvre, May–September.

1963 (b), Paris, *Delacroix: Dessins,* Musée du Louvre, Cabinet des Dessins.

1963 (c), Paris, *Delacroix: Citoyen de Paris,* Musée Delacroix, March–September.

1963, San Francisco and Oakland, *Drawings, Watercolors and Prints by Eugène Delacroix in West Coast Collections,* Achenbach Foundation for Graphic Arts, California Palace of the Legion of Honor, October 12–November 10, and Oakland, Mills College Art Gallery, November 17–December 15.

1963–64, Bern, *Eugène Delacroix,* Kunstmuseum, November 16–January 19.

1964, Bremen, *Eugène Delacroix,* Kunsthalle, February 23–April 26.

1964, Edinburgh and London, *Delacroix: An Exhibition of Paintings, Drawings and Lithographs,* Royal Scottish Academy, August 15–September 15, and Royal Academy of Arts, October 1–November 8.

1966, New York, *Romantics and Realists: A Loan Exhibition for the Benefit of the Citizens' Committee for Children of New York, Inc.,* Wildenstein, April 7–May 7.

1966, Paris, *Delacroix et les paysagistes romantiques,* Musée Delacroix, May 19–July 19.

1967, Paris, *Eugène Delacroix, son atelier et la critique d'art,* Musée Delacroix, June–August.

1968, Paris, *Delacroix, René Piot (1866–1934) et la couleur,* Musée Delacroix, March 22–August 15.

1969, Kyoto and Tokyo, *Exposition Delacroix,* Municipal Museum, May 10–June 8, and National Museum, June 14–August 3.

1969, Paris, *Delacroix et son temps (costumes et souvenirs),* Musée Delacroix, April–September.

1970, Paris, *Delacroix et l'Impressionnisme,* Musée Delacroix, April–September.

1971, Paris, *Delacroix et le Fauvisme,* Musée Delacroix, May 26–September.

1972, Paris, *Delacroix et le Fantastique (de Goya à Redon),* Musée Delacroix, May 10–November.

1973, Paris, *Delacroix et la peinture libérée,* Musée Delacroix, May–September.

1974, Paris, *Delacroix et Paul Huet, précurseurs de l'impressionnisme,* Musée Delacroix, June 26–December 10.

1975, Paris, *Delacroix et les peintres de la nature,* Musée Delacroix, June 24–December 25.

1981, Stockholm, *Delacroix'lejonjakter,* Nationalmuseum, October 1–December 6.

1982, Paris, *Revoir Delacroix,* Musée du Louvre, Cabinet des Dessins.

1986, New York, *Jean-Baptiste Camille Corot (1796–1875), Eugène Delacroix (1798–1863): An Exhibition, Paintings, Drawings, Watercolors,* Salander-O'Reilly Galleries, n.d. [1986].

1986, Nice, *Delacroix: Peintures et dessins d'inspiration religieuse,* Musée National du Message Biblique Marc Chagall, July 5–October 6.

1986, Southampton (New York) and New York, *In Support of Liberty: European Paintings at the 1883 Pedestal Fund Art Loan Exhibition,* The Parrish Art Museum, June 29–September 1, and National Academy of Design, September 18–December 7.

1986, Tübingen and Brussels, *Ingres et Delacroix, dessins et aquarelles,* Kunsthalle, September 12–October 26, and Palais des Beaux-Arts, November 7–December 21.

1987 (a), Zurich, *Eugène Delacroix,* Kunsthaus, June 5–August 23. See Frankfurt, 1987–88.

1987 (b), Zurich, *Eugène Delacroix Zeichnungen, Aquarelle Graphik,* Kunsthaus, June 5–August 23.

1987–88, Frankfurt, *Eugène Delacroix, Themen und Variationenarbeiten auf papier,* Städtische Galerie im Städelschen Kunstinstitut, September 24, 1987–January 10, 1988.

1988, Paris, *Delacroix et Byron: Chassériau et Shakespeare,* Musée Delacroix, May 10–August 14.

1989, New York, *Eugène Delacroix (1798–1863), Paintings and Drawings, Peter Paul Rubens (1577–1640), Three Oil Sketches,* Salander-O'Reilly Galleries, November 15–December 30.

1989, Tokyo and Nagoya, *Delacroix et le romantisme français,* National Museum of Western Art, August 5–October 1, and City Museum of Fine Arts, October 10–November 23.

1989–90, Montreal, *Discerning Tastes: Montreal Collectors, 1880–1920,* The Montreal Museum of Fine Arts, December 8, 1989–February 15, 1990.

1991, New York, *Eugène Delacroix (1798–1863): Paintings, Drawings and Prints from North American Collections,* The Metropolitan Museum of Art, April 10–June 16.

1992, Boston, *Prized Possessions: European Paintings from Private Collections of Friends of the Museum of Fine Arts, Boston,* Museum of Fine Arts, June 17–August 16.

1993–94, Paris, *Delacroix et la Normandie,* Musée Delacroix, October 22, 1993–January 24, 1994.

1994–95, Paris, *Delacroix: Le Voyage au Maroc,* Institut du Monde arabe, September 27, 1994–January 15, 1995.

1996–97, Bordeaux, Paris, and Athens, *La Grèce en révolte: Delacroix et les peintres français,* Musée des Beaux-Arts, June 14–September 8, 1996, Musée Delacroix, October 8, 1996–January 13, 1997, and Pinacothèque Nationale, Musée Alexandre Soutzos, February 12–August 25, 1997.

1997, Pittsburgh, *Collecting in the Gilded Age: Art Patronage in Pittsburgh, 1890–1910,* Frick Art & Historical Center, April 6–June 24.

1998, Paris, *Delacroix: Le Trait romantique,* Bibliothèque Nationale de France, April 7–July 12, 1998.

1998, Rouen, *Delacroix: La Naissance d'un nouveau romantisme,* Musée des Beaux-Arts, April 5–July 15.

Index of Names
and Places

INDEX OF ILLUSTRATED
WORKS BY DELACROIX

Photography Credits